YALE UNIVERSITY PRESS
PELICAN HISTORY OF ART
Founding Editor: Nikolaus Pevsner

Kenneth John Conant
CAROLINGIAN AND ROMANESQUE ARCHITECTURE
800 TO 1200

Kenneth John Conant, Professor of Architecture in Harvard University, Emeritus, and Honorary President of the Archaeological Institute of America, and of the Society of Architectural Historians, was trained as an architect, and during his years of graduate study at Harvard investigated the Cathedral of Santiago de Compostela, his study of which, published in 1926, remains the standard monograph on the subject. In 1927 he began his study of the Abbey Church of Cluny, where he excavated a number of critical areas, and his work on this complex and several of its daughter monasteries continued throughout his lifetime and was published in his many articles and in his monograph *Cluny – Les Églises et la Maison du Chef d'Ordre* (1968). He also worked on Montecassino, on aspects of American archaeology, and on the Early Christian Church. Professor Conant was made Officier of the Legion of Honour, and he received the medal for archaeology of the Académie d'Architecture, Paris, for his work on Cluny. He was a Corresponding Fellow of the British Academy. The present volume received the Hitchcock Award of the Society of Architectural Historians of America. Professor Conant died in 1984.

Kenneth John Conant

CAROLINGIAN AND ROMANESQUE

ARCHITECTURE 800 TO 1200

Yale University Press · New Haven and London

First published 1959 by Penguin Books Ltd
Fourth edition 1978. New impression 1993 by Yale University Press
20 19 18 17 16 15 14 13 12 11 10 9 8 7 6

Copyright © Kenneth John Conant, 1959, 1966, 1974, 1978

Set in Monophoto Ehrhardt, and printed in Hong Kong through World Print Ltd

Designed by Gerald Cinamon and Inge Dyson

ISBN 0-300-05298-7

Library of Congress catalog card number 78-149801

To my two namesakes
Ken and Kenny

This new edtion, in addition to routine minor rectifications, contains text changes suggested by increasing knowledge of the development of the Romanesque style, and figures have been introduced which tend to make this development clearer. The text has new material on Montecassino, Saint-Benoît-sur-Loire, Saintes, Cluny, Florence, and Saint-Denis. It presents the great church at Cluny as embodying the classic moment of the Romanesque, with Saint-Denis and Sens Cathedral as the first Gothic churches provided with flying buttresses of systematic design.

The original drawings were made or adapted by Donald Bell-Scott, further drawings were done for this edition by Ian Stewart, and the maps were drawn by Sheila Waters.

CONTENTS

The present volume is devoted to the genesis, development, and transformation of Romanesque architecture and is concerned with the principal artistic effort of four centuries, but the chronological limits are not as strict as this statement would imply. To understand Romanesque architecture well, it is necessary to understand the monasticism and the incipient medievalism of Late Classical times, before the creative spirit of the Carolingian Age gave them a special direction. Following the epoch of mature Romanesque achievement, the after-life of the Romanesque extended into the thirteenth and fourteenth centuries in regions where the style offered a sufficient answer to local needs, and expressed the local temper well.

General works on Romanesque architecture are not numerous. In view of the enduring value of Paul Frankl's *Frühmittelalterliche und romanische Baukunst*, rather encyclopaedic in character, a freer pattern has been adopted for this treatise, which is somewhat more personal, cast when possible in the form of a narrative. The theme of the book is carried by church architecture, but that is natural in the work of an author who is academically the heir of Herbert Langford Warren and his teachers Henry Hobson Richardson and Charles Eliot Norton, the latter an intimate friend of John Ruskin.

The greatest direct indebtedness of the author is, however, to his mentor, colleague, and friend, Arthur Kingsley Porter, whose wide-ranging re-study of Romanesque art and chronology resulted in considerable activity on the part of art historians. His interest in Cluny, shown in important work of his own, was responsible for several significant studies in the Cluniac ambient by Americans during the period when

Dr Joan Evans was engaged on her comprehensive publications in England, and M. Charles Oursel on his learned works concerning Cluniac and Cistercian art in Burgundy. M. Marcel Aubert, to whom the author is much beholden for many kindnesses, was at the same time preparing his encyclopaedic work on Cistercian architecture in France.

With all these materials now available, it is possible to present – as such – the monastic accomplishment in church architecture. The reader will find here, following an account of the renewal in Charlemagne's time, a record of the architectural advances by which the highly organized conventual establishment and the beautifully articulated great monastic church were achieved. This record, during Romanesque times, brings forward a synthesis of traditional forms culminating at Cluny and Cîteaux. Its foil, in our exposition, is the flowering of the many and varied regional styles, some of them carried forth by missionaries or colonists as the Romanesque area expanded into Spain, the Holy Land, middle Europe, and Scandinavia.

In the Holy Roman Empire there was a particularly wide panorama of interesting regional styles: older architectural forms were perfected and embellished, and the noble monuments which resulted in such great numbers have been admired ever since the Romanesque centuries. But they do not show the drive for logical synthesis in structure which characterized the North-western region. Therefore at the end of our work we refer to Romanesque Normandy, England, and the Île-de-France in contrast with the Empire; the result of their effort in architecture was the creation of a new

structural unit which had elements drawn from all of the older types of vaulting, but surpassed them all. Fully developed, this unit – the typical ribbed groin-vaulted bay with its spur or flying buttress – was universally applicable, and became the mainspring of Gothic architecture. It was further remarkable in that designers, by its use, could reinterpret and carry on all of the effects achieved in local varieties of the parent Romanesque. By making clear these facts the author hopes to enrich the reader's appreciation both of Romanesque and of Gothic architecture.

The author wishes to express his gratitude to the medievalists who have been mentioned for the benefits which have come from their scholarly work and their counsel. He is grateful for the generosity of the Hon. John Nicholas Brown, who made excavations at Cluny possible through the Mediaeval Academy of America; he also owes thanks to Miss Helen Kleinschmidt, to Dr Harry H. Hilberry, to Dr Elizabeth Read Sunderland, and to Dr Alice Sunderland Wethey for their work in fitting parts of the Cluniac puzzle together; to Dr Isabel Pope Conant for thoughtful criticism; and to Mrs Hart Chapman and to Mrs Judy Nairn for expert handling of the manuscript.

Special thanks are due to Dr Turpin C. Bannister for a searching review and discussion of the text while it was in proof. And thanks are most particularly due to the Editor, Professor Sir Nikolaus Pevsner, who is deeply versed in the subject matter of the volume; his work on the manuscript was that of a wise colleague and friend, far exceeding the merely editorial function.

KENNETH JOHN CONANT
28 June 1954

Maps

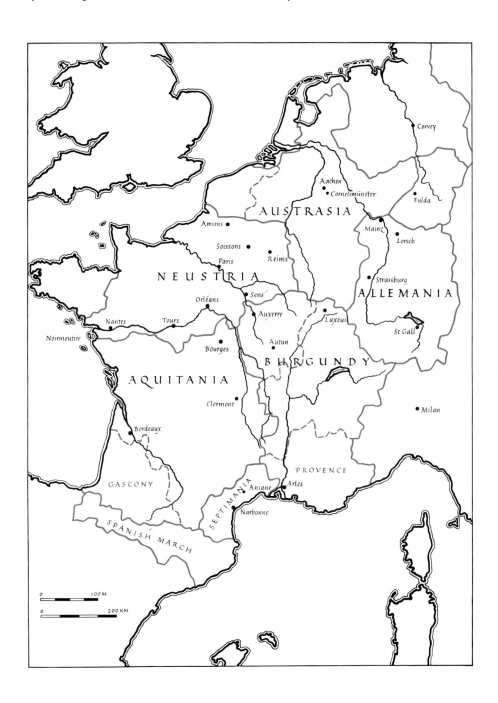

Corvey

Aachen
Cornelimünster
Fulda

AUSTRASIA

Mainz
Lorsch

Amiens

Soissons
Reims
Paris

NEUSTRIA

Strassburg

ALLEMANIA

Orléans
Sens
Auxerre
Luxeui
St Gall

Nantes
Tours
Bourges
Autun

Noirmoutier

BURGUNDY

AQUITANIA

Clermont

Milan

Bordeaux

PROVENCE

GASCONY
SEPTIMANIA
Aniane
Arles

Narbonne

SPANISH MARCH

0 100 M

0 200 KM

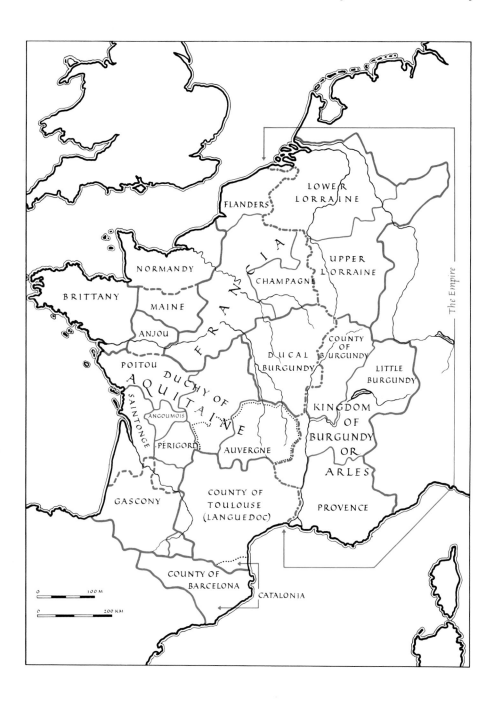

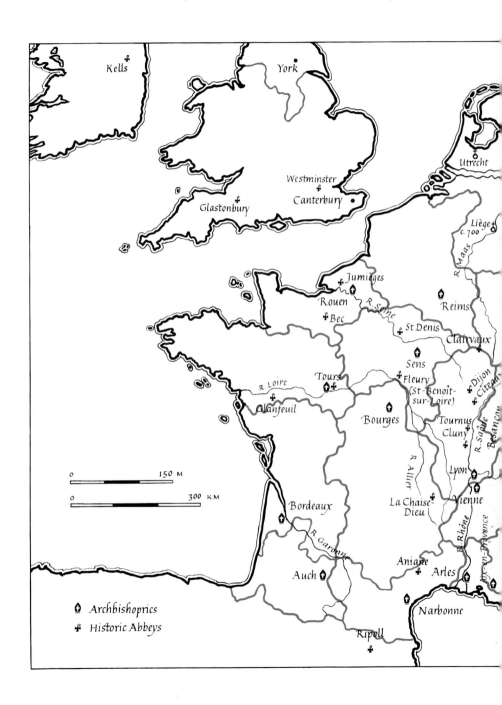

Kells

York

Utrecht

Westminster

Canterbury

Glastonbury

Liège
c. 700

R. Maas

Jumièges

Rouen

Bec

R. Seine

Reims

St Denis

Clairvaux

Sens

Tours

Fleury
(St-Benoît-
sur-Loire)

Dijon
Cîteaux

R. Loire

Glanfeuil

Bourges

Tournus
Cluny

Besançon

R. Saône

R. Allier

Lyon

0 — 150 M

0 — 300 KM

Bordeaux

La Chaise-
Dieu

Vienne

R. Rhône

R. Garonne

Aniane

Aix-en-Provence

Auch

Arles

♙ Archbishoprics

✠ Historic Abbeys

Narbonne

Ripoll

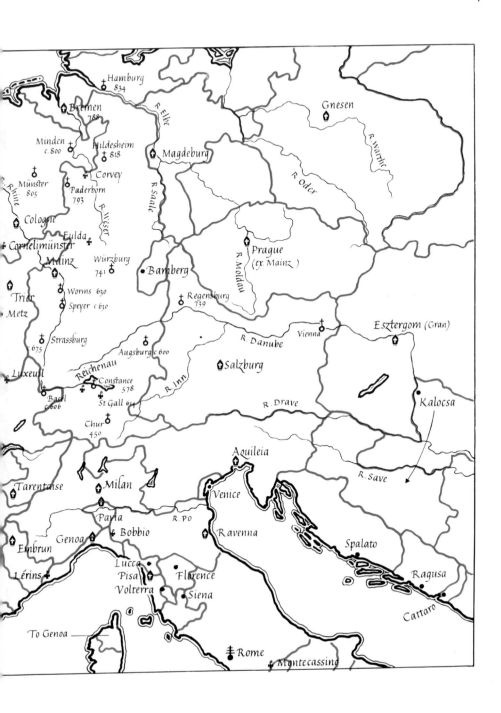

Hamburg 834
Bremen 788
Gnesen
R. Elbe
Minden c. 800
Hildesheim 818
Magdeburg
Münster 805
Corvey
Paderborn 793
R. Weser
R. Warthe
R. Rhine
Cologne
R. Saale
R. Oder
Fulda
Cornelimünster
Mainz
Würzburg 741
Bamberg
Prague (ex. Mainz)
R. Moldau
Trier
Worms 630
Speyer c 630
Regensburg 739
Vienna
Esztergom (Gran)
Metz
Strassburg c 675
R. Danube
Luxeuil
Augsburg c 600
Reichenau
Salzburg
Kalocsa
Constance 578
R. Inn
Basel c 606
St Gall 614
R. Drave
Chur 450
Aquileia
Tarentaise
Milan
Venice
R. Save
Pavia
R. Po
Ravenna
Embrun
Genoa
Bobbio
Spalato
Lérins
Lucca
Pisa
Florence
Ragusa
Volterra
Siena
To Genoa
Cattaro
Rome
Montecassino

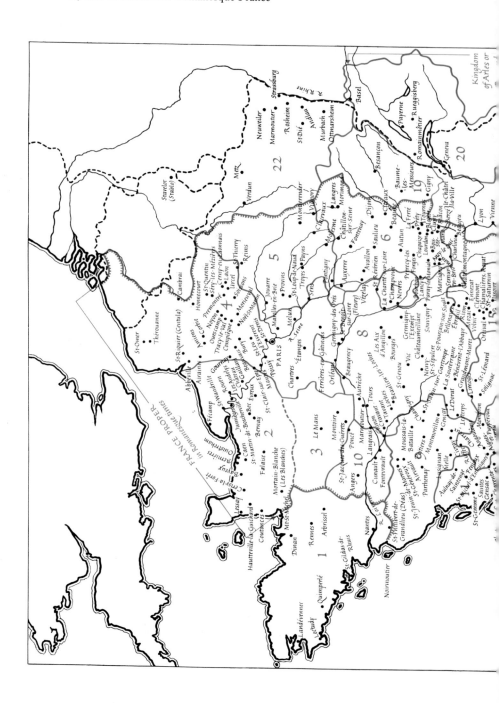

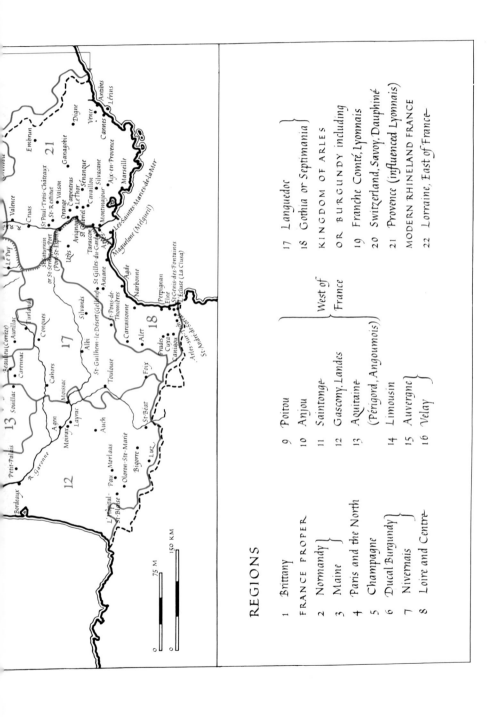

REGIONS

1 Brittany

FRANCE PROPER

2 Normandy ⎫
3 Maine ⎭

4 Paris and the North

5 Champagne

6 Ducal Burgundy ⎫
7 Nivernais ⎭

8 Loire and Centre⎤

9 Poitou
10 Anjou
11 Saintonge⎫ West of
12 Gascony, Landes ⎬ France
13 Aquitaine ⎭
 (Périgord, Angoumois)

14 Limousin
15 Auvergne ⎫
16 Velay ⎭

17 Languedoc
18 Gothia or Septimania ⎫

 KINGDOM OF ARLES

 OR BURGUNDY including

19 Franche Comté, Lyonnais

20 Switzerland, Savoy, Dauphiné

21 Provence (influenced Lyonnais)

 MODERN RHINELAND FRANCE

22 Lorraine, East of France

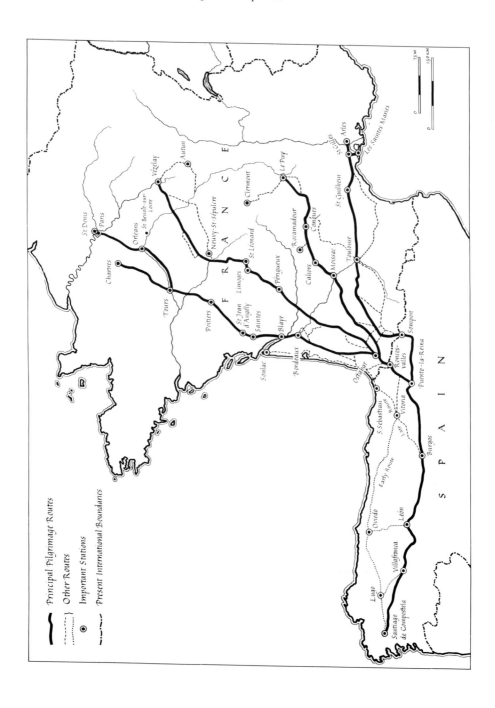

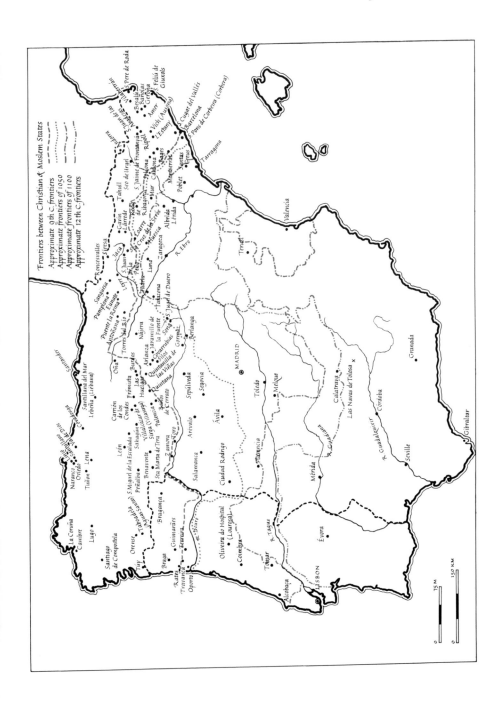

Frontiers between Christian & Moslem States

Approximate 9th C. frontiers
Approximate frontiers of 1050
Approximate frontiers of 1100
Approximate 12th C. frontiers

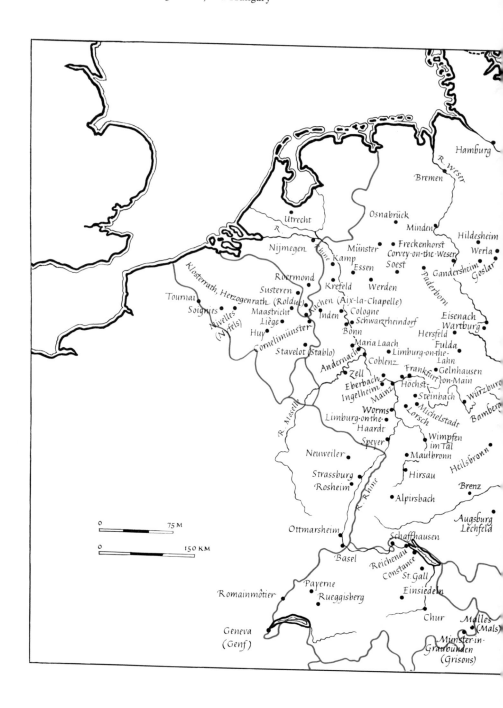

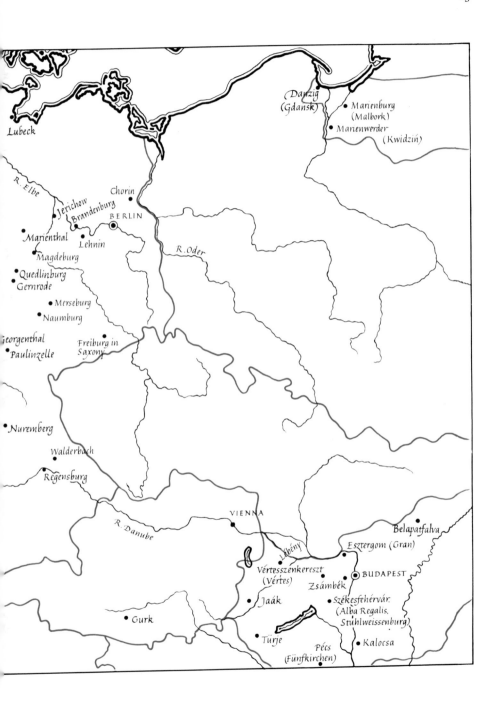

Lubeck

Danzig
(Gdansk)

Marienburg
(Malbork)

Marienwerder

(Kwidzín)

R. Elbe

Jerichow
Brandenburg

Chorin

BERLIN

Marienthal
Lehnin

Magdeburg

R. Oder

Quedlinburg
Gernrode

Merseburg

Naumburg

Georgenthal
Paulinzelle

Freiburg in
Saxony

Nuremberg

Walderbach

Regensburg

VIENNA

R. Danube

Belapatfalva

Lébény

Esztergom (Gran)

Vértesszenkereszt
(Vértes)

Zsámbék

BUDAPEST

Jaák

Székesfehérvár
(Alba Regalis,
Stuhlweissenburg)

Gurk

Türje

Pécs
(Fünfkirchen)

Kalocsa

Kirkwall

St Andrews

Lindisfarne

Jarrow
Durham

Fountains
York

Barton on Humber

Mellifont
Kells
Tara
Dublin
Kildare
Glendalough
Scattery Is
Cashel
Dingle
Skellig
Michael

Chester

Lincoln
Southwell
Nottingham
Derby
Five Boroughs
Leicester
Stamford
Peterborough
Ely
Northampton
Earls Barton
Cambridge
Bury St Edmunds
(Little) Maplestead
N. Elmham
Norwich

Pembridge
Hereford
Kilpeck
Worcester
Deerhurst
Gloucester
Tintern
Oxford
Iffley
Wing
St Albans
LONDON
Greenstead
Rochester
Canterbury

Malmesbury
Bradford-on-Avon
(Old) Sarum
Salisbury
Westminster
Waverley
Worth
Battle
Hastings
Glastonbury
Athelney
Winchester
Lewes
Breamore

Exeter
Buckfast

0 75 M

0 150 KM

Tur Abdin
(near Amida, Nisibis)

Kalat Seman

Aleppo

R. Euphrates

Antioch

Saône
c.1120

Hama

Kyrenia

Bellapais
Castria

CYPRUS

Maraat
c.1150-86

Safita, or Chastel Blanc c.1140-50, 1202

Palmyra

Tortosa
c.1140 Chastel Rouge

Krak des Chevaliers c.1100-1271

Arima

Colliat
c.1140

Homs

Tripoli
12th cent. Nephin

Akkar
c.1170

Giblet
ancient Biblos; after c.1104

Le Moinestre Arab until c.1110

Beirut

Baalbek

Sidon
c.1228

c.1124-1240

Damascus

Belfort

Mousmieh (Phaena)

Tyre
c.1117 Scandelion

Subeiba c.1129-32

Toron c.1107

Montfort c.1227
c.1203-12 Acre

Saphet c.1102-1240

Nazareth

Ch.Pelerin
or Athlith c.1218-40

× Mt.Tabor

Basra

Caesarea

Belvoir c.1140-1168

Ajlun c.1184-5

Sebastieh

Joppa

Ramleh

Montgizard

c.1137-41 Ibelin

Jerusalem

Blanchaguarda c.1137

Bethlehem

Ascalon c.1155

Gaza

Beth-
Gibelin
c.1137

Darum

Kerak de Moab
c.1138-1187

Montréal c.1115-1187

Ile de Graye c.1116

0 ————— 75 M

0 ————— 150 KM

(Dates are approximate

■ Crusader castles and
fortified cities

▲ Moslem strong points

● Other sites

CAROLINGIAN AND

ROMANESQUE ARCHITECTURE

800 TO 1200

THE PRE-ROMANESQUE
AND PROTO-ROMANESQUE STYLES

CHAPTER I

THE PREPARATION FOR MEDIEVAL ARCHITECTURE

THE INSTITUTIONAL BACKGROUND

The Leaders

The year 800 came to a Western world ready for a great revival of many things which Antiquity held dear. The barbarian torment and the civil strife which had overturned the faltering late Empire were far from ended, but the forces of order were decisively rallied, and great men like Charlemagne and his companions were finding, in the pattern of classic life and thought, the ways in which the half Roman, half German medieval world could be organized. The consular dignity conferred in 508 upon Clovis, who was already King of the Franks in 476, when Romulus Augustulus was deposed, had implications which began to be realized as the Frankish settlers showed their sturdy worth and their power to build an enduring state. The implications were further realized when Charlemagne's grandfather, Charles Martel, repulsed the Saracenic advance near Poitiers in 732; when his father, Pepin, aided in establishing the papal Patrimony; and most of all when Charlemagne himself created a pan-Germanic state with an orderly political system, and enlarged the boundaries of Christendom by his conquests.

It is fair to say that the great triangle formed by the Rhine, the Loire, and the sea, quiescent before, now put forward almost all the grand conceptions on which the new medieval world of government, philosophy, and art was to be based. Charlemagne extended the area to include all the mid-continental Germans, promoted the Christianization of this vast dominion, and bound it by strong ecclesiastical and political links to Rome. By his care for the Roman Church he gave new impetus to that institution, which was perhaps the greatest single inheritance from Antiquity, and by active favours to learning he made a beacon of his court.

Thus, by the year 800, learning and legal system were being advanced again, and the monasteries, by addressing themselves to Rome's old task of administrative and economic development, were forming the groundwork on which any lasting renaissance perforce would rest. This society, which had been confused and peripheral, found its direction and its unifying principle; it made a synthesis of Germanic culture with traditional late Roman forms and persistent influences from Byzantine and Oriental lands, under the confident and energetic Charlemagne, whose coronation as Roman Emperor

at Christmastide, 800, happily marks a symbolic new beginning.

Artistic initiative stirred, and new aesthetic forms were created which eventually became symbols of the age. The creation of Carolingian art, with its reflexes of oriental, northern, and Mediterranean origin, is a very complex phenomenon, and only the architecture can concern us here; suffice it to say that the fecund and dynamic character so notable in the other arts is equally found in the architecture. In architecture also, designers had the opportunity to merge what was good in all the old forms within the ample horizon of vast civic and religious conceptions, though the architects were relatively more dependent on Mediterranean models. The abounding energy and initiative of the Emperor himself, and the great gifts for understanding, organization, and synthesis which were possessed by the great masters of the Palace – Alcuin and Einhard particularly – were strongly felt in architecture. The brilliant ideas developed by the church architects of Charlemagne's day were of enduring importance. They have been interpreted in successive styles throughout the centuries, up to modern times.

The leading Carolingian architects anticipated certain Romanesque characteristics, but scholars hesitate to say that Romanesque architecture properly so called began in the Carolingian Renaissance. They prefer to reserve the term for the better integrated art which flourished from the time of Otto the Great (936–73) in western Europe, and receded before Gothic art from about 1130 onward. This is perhaps because Carolingian painting, manuscripts, and sculpture differ more sharply than architecture from acknowledged Romanesque works. Because the Roman component is very important, the name Carolingian Romanesque is suitable for the architecture. For the discerning historian can see that the general programme of early medieval architecture was already understood at the court of Charlemagne and that charac-

teristic Romanesque features or elements were created and used, though not on the scale nor with the great assurance of later times. The Carolingian Romanesque was inventive; it was also experimental – Romanesque in the test-tube rather than a well-knit, fully articulated style.

The Architectural Ambit

It is important to realize in this connexion that the Carolingian Romanesque was an architecture intended for relatively small groups of people, and not a great urban architecture such as classic architecture had been. The population of the entire Roman Empire in Hadrian's time is believed to have been about 55,000,000. There were several cities approaching 1,000,000 in population, but all were in the south and east. The cities in the north and west had always been small, and the countryside rather sparsely peopled. In the late classical period the population of the Empire declined, particularly in the cities, Rome being an extreme example with a decline from nearly 1,000,000 to its nadir of about 10,000. Constantinople, which maintained a population of nearly 1,000,000 in the Middle Ages, seemed fabulous to visitors from the West. Medieval London had only about 25,000 people, and all England only 5,000,000, while the German urban centres had from 5000 to 10,000 people; France was relatively more settled and prosperous. It seems clear that most of the building operations were traditional, and were done, even in late medieval times, on the modest scale which we associate with villages.[1] The conditions of society were such that the solutions developed in Roman and barbarian times for the various problems of ordinary architecture were still sufficient, so that there was little occasion for the exercise of new ingenuity in such work. Ambitious projects involving new problems were few in number, and with rare exceptions they were long

under construction even when favoured by exceptional resources and other circumstances.

The impulse for novel architectural development came chiefly from the monasteries. A monastery of importance often served nearly all the needs of a thousand persons or more, and thus presented architectural problems on the scale of a whole town. Yet its design would be more monumental, and integrated in a more sophisticated manner than that of a town, with the consequence that novel problems would arise spontaneously.

Monasticism

Monasticism itself came to Carolingian times with the strong Roman imprint given to an originally Egyptian and cenobitical institution by St Benedict of Nursia (*c.* 480–543). There is indeed something of Roman grandeur and durability in the Rule which he compiled for his own monastery of Montecassino about 529. This Rule made its way throughout Western Christendom on its own merits, and acted as an international constitution in the early Middle Ages when temporal government had broken down, and the monastic commonwealth remained as the only stable community.[2]

The way of Roman churchmanship in Gaul was smoothed by Pepin III, who introduced the Roman, and prohibited the Gallican, liturgy in the Frankish kingdom, 754–68. Charlemagne reinforced the tendency by imposing on all monks a rule of Benedictine character, Roman in spirit (789).

Benedictinism itself, then in relative decline because of upheavals, was enormously benefited by Charlemagne and his successors from 779 onward, when a reform was inaugurated under St Benedict of Aniane (died 822). A splendid new monastery was built at Aniane, which lies near Saint-Guilhem-le-Désert or Gellone in Languedoc, between Arles and Narbonne. It drew on all the resources of art and liturgy for its magnificence. Priories on identical lines were soon founded. Louis the Pious, who succeeded Charlemagne in 814, built the Cornelimünster on the Inden, near Aachen, for Benedict, and instructed him to regularize monastic life in the Emperor's dominions.[3]

The groups of men who withdrew from the ordinary pursuits of the world to live together under the rule of an abbot, taking vows of poverty, chastity, obedience, and stability, found rich rewards in the spiritual pattern of the monastic liturgies. Such communities became oases of Christian life in the midst of wild country or social chaos; sound and strong, the monastic institute was able to accept manifold opportunities to preserve piety and learning, to aid communications by furnishing hospitality to wayfarers of every degree, and to enlarge the borders of Christianity by missionary endeavour.

Although the monks were individually vowed to poverty, the communities received great gifts of land and endowment; and in general they managed their quite considerable resources well. The monks patiently developed and improved their properties, which were often largely uncultivated or desolate when given, and by this process a typical monastery would become the garner and the agricultural capital for a considerable surrounding area; because of large land holdings it would have certain administrative and judicial functions too, in addition to being the spiritual capital. Much invective against usurping and unsuccessful administrators has come down to us in the texts, and this fact tends to obscure the excellent general record of the monasteries as orderly and peaceful islands within a society which was struggling out of deep confusion. Their industry laid the foundations of economic recovery in Europe after the Dark Ages. The larger monasteries presented intricate administrative problems, and were the accepted schools for men of business and government. In addition they were the

training places for talent in the arts, and the refuge of intellectual activity.

Thus the monasteries did yeoman service in creating all four of the bases on which medieval civilization was to rest: (1) economic revival, (2) the fusion of the Latin and the Teutonic peoples, in which the conversion of the invaders, the unified world view presented by Christianity, and its common mode of thought were fundamental, (3) the afterlife of Roman law in the monastic Rule, the canon law of the Church, and the Holy Roman Empire, (4) the feudal system, which set up new hierarchies of power, and enabled the monastic orders to extend their influence and their benefits generally.

The great monasteries, thus developing as imposing financial, educational, and territorial corporations, were far larger, more complex, and more influential than they had ever been in Antiquity. Since many of their architectural problems were new, their architecture became the living and growing architecture of the time.

PRIMITIVE AND LOCAL
ARCHITECTURAL TRENDS

With the creation of a central power in the north of Europe, it would be natural to expect Northern influences in architecture from the year 800 onwards. The situation is well expressed in Charles Rufus Morey's reference to 'the naive effort of the barbarian races themselves to revive the Rome which their fathers had ruined', and his definition of Romanesque art as that 'which reflects the gradual sinking of Latin culture below the Celtic and Teutonic surface'. The architecture of these migrant and primitive peoples could hardly have the superb beauty, the 'coiling vitality' of their works of minor art, but as their compositions sought out the eccentric effects of nature itself, so their architecture always was both functional and organic.[4]

In the North-east, where primeval timber was abundant, the adze was the builder's prin-

1. Lojsta, palace (restored). Original of *c.* 1000

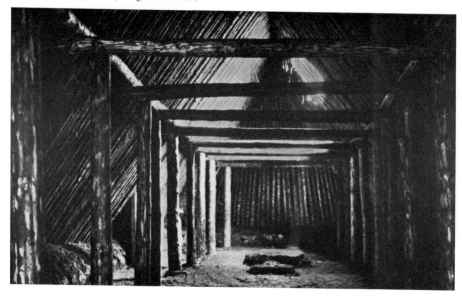

cipal tool, and a traditional log-wall construction developed which came to its culmination in the Russian medieval spire churches.

In the West, more sophisticated tools were used, and several schemes of more efficient, lighter construction were worked out. In the palace halls there was evidently joinery of a high order adorned with intricate carving, of which the wagons and sledges found with the Norse grave-ships probably offer us specimens. At Lojsta on the Isle of Gotland a palace ruin ascribed to the period about A.D. 1000 has been restored, and here one may see how handsome the primitive wooden forms can be, even without the lavish carving and colour which the original work doubtless possessed [1, 36A]. Accumulating evidence shows that halls of the Lojsta type were used all over northern Europe for many centuries in noble, domestic, farm, and (later) church construction [4A]. They may even be responsible for the introduction of the 'bay system' in stone-built Romanesque.

2. Greenstead, wooden Saxon church (part), 1013, brick base modern

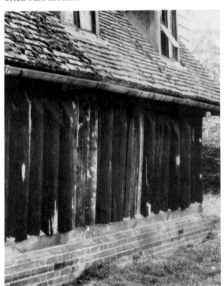

Palisade wall construction was used by the Saxons, and a solitary example of their work, dated 1013, still exists in the church at Greenstead, Essex [2]. Wooden frames with vertical sheathing and braced mast construction were used by the Norse. The clinker construction of the Scandinavian ships is essentially like weather-boarded construction in building. It may go back as far as the third century A.D. 'Half-timber' construction among the barbarians may also be fairly ancient, as Strzygowski believed.

Excavations in the Gallo-Roman area have shown that Roman work in outlying regions must often have adjoined that of the barbarian settlers; indeed it seems likely that the barbarian builders near the borders of the Empire learned something also from the Romans.[5]

The prosperous household among the Germans would have a hall like that at Lojsta, or a more sophisticated building of similar character. Subsidiary buildings of the same sort would gather, arranged about courtyards, and the number of such courts would be the measure of the household's importance. It is probable that the 'proliferating quadrangles' of the great monasteries carry on something of this mode of agglomeration.[6]

Such 'vernacular' or folk architecture was of course far from adequate for the needs of an imperial building programme, but being rooted and native in the north, it would be bound to have some effect on any imported style. Specifically, the mode of design where framed wooden compartments make up a building is quite different from that of classic architecture in brick, stone, or concrete. Even in the first attempts at strict imitation, the local habits and conditions would inevitably make themselves felt. Northern builders prefer austere shapes, for their climate is severe on involved exterior forms. Northern roofs are steep, in order to evacuate rain more quickly and diminish the hazard of snow and ice. The exterior materials

which resist the weather well are nearly all either red or grey, so that the colour range is limited.

Yet in the Carolingian period the northern 'vernacular' architecture was obviously so simple that almost any really monumental new development would be largely dependent on Roman sources. The elements, the items, the features of great buildings would be Roman, but the *manner* of their employ would be affected by northern artistic discipline and taste. During the Carolingian period both Roman and native elements were used increasingly, with admirable inventiveness, in church architecture.

THE PERSISTENCE OF ROMAN
ARCHITECTURAL IDEAS AND PRACTICE

The Romanesque which came after the Carolingian period profited by these experiments, and by the dreadful experience of the Viking and Hungarian invasions. These incursions, with their burnings of towns and churches, occasioned a considerable effort to build fireproof churches in the ensuing period of revival, after the middle of the tenth century. Perforce the designers drew on the constructional experience of imperial Roman vaulted architecture. The *widespread* and *successful* use of Roman types of vaulting as a *controlling feature* in design marks a distinction between the newer, Romanesque, architecture, and the older Carolingian.

Examples of the ancient Roman style were built throughout nearly the entire area in which the Romanesque later flourished. The Roman manner of building, although it degenerated in the Dark Ages, remained as an ideal, and was never quite lost in practice. A Roman architect and a Roman engineer would easily have understood the work of their Romanesque continuators.

Yet there are obvious differences. Apart from commemorative works and garden architecture, only the Roman temples had a character which we should now call fully monumental. All other types of building, even the most ambitious, tended to have plain or uninteresting exteriors, and the layout of the cities gave little opportunity, apart from the fora, for individual structures to present imposing effects, or to become dynamic elements in the city picture and the landscape. Such effects are achieved almost as a matter of course first in medieval, then in Renaissance, Baroque, and neo-classical planning. On the contrary, Roman civic works were often masked from the street or forum by enclosing porticoes, so that the compositions were inward-looking; typically they had the classical horizontality and self-contained unity.

In contrast the Romanesque, through bold imagination, came to be characterized by free, active, and arresting combinations of architectural forms. The Romanesque contributed greatly to the development of highly articulated, expressive exterior and interior design. It laid the foundation of Gothic successes in that field, and thus it underlies still further achievements of Renaissance and modern date: a notable differentiation, surely, from the Roman.

Romanesque variety developed out of Roman unity. For, from the first years of our era, the architecture of the city of Rome was the model throughout the whole area of the Western Empire. Provincial approximations, often imperfect because of different materials and other conditions, nevertheless departed little in essential structure, and not at all in ideals, from the august exemplars in the imperial city. The growing centralization of the state, the constantly increasing property holdings of the Emperor (amounting, it is said, to about a quarter of the area of the Empire in Diocletian's time), and the consequent spread of uniform control in the designing of buildings, encouraged quite general conformity in practice to the architecture and engineering of the capital.

Although Rome's primacy in architecture departed during the fifth century, its imposing

Early Christian churches remained as an active inspiration while new ideals were developing for the Romanesque. Other types of building made static rather than dynamic contributions, but retained prestige as classic works. Even the wretched estate of medieval Rome – shrunken to a fraction of its ancient size, and scourged by malaria, private warfare, and disturbers from abroad – did not prevent high-minded popes from maintaining the dignity of the ancient traditions of the Church, and with that dignity something of the lofty ideals of ancient architecture.

Ancient Rome created no new monumental types after the Christian Roman basilica. Later designers, struggling on new problems without Rome's leadership, worked on a regional basis. Departing from the common and Roman theme, though conscious of its significance, the provincial architects and engineers capitalized on the special variations in materials, skills, climate, and predisposition which former conditions, under the Romans, had tended to minimize. They even gained from such self-imposed limitations. Buildings with such local savour could be constructed more cheaply and would command the affection of folk in the locality from the very fact of being 'their own'. The result was, in the many regional schools of Romanesque architecture, a rich variety unexampled in the parent imperial style.

THE TRANSITION FROM ROMAN
TO EARLY MEDIEVAL ARCHITECTURE

Rome was indeed not built in a day; but by the beginning of the fourth century of our era it had been built, and the grandiose civic and religious organs of the Empire were becomingly housed. Coming in a time of decay, this meant that the wonderful system of working co-ordination which had produced these buildings would wither away through disuse. The tradition of masonry vaulting on a grand scale was lost in this manner. Ordinary, every-day, 'vernacular'

architecture continued to be built. Indeed it continued to be built for centuries, often with little change because it was well adapted to current needs. Just as the wooden architecture of the north was the 'background architecture' there, so the 'vernacular' architecture of the old Roman districts was the background architecture of the south. Almost the only demand for large new buildings came from the Church, and in consequence ecclesiastical architecture became the premier architecture from the time of Constantine onward.

The imperial architects achieved brilliant results in the new Early Christian architecture. After the Peace of the Church (313), they put the imprint of unmistakable Roman grandeur on the Constantinian basilicas of Old St Peter's in the Vatican [3] and St Paul's outside the Walls. The churches which had been destroyed throughout the Empire during the persecution of Diocletian (303–4) were generally replaced with new buildings of this same basilican character – typically with a gateway of approach, an atrium, a wooden-roofed nave and aisles, and an apse, often with a transept and perhaps sacristies adjoining it.

Eastern Christendom was able to continue the traditions of Roman vaulted architecture as a living style, and apply them successfully to the problems of church building, though under strong oriental influence. When the architects began to build masonry domes in churches, the Byzantine style was constituted, in the time of Justinian (specifically, with the design of St Sophia in Constantinople, 532).

Carolingian designers usually had to be satisfied with cheaper buildings – basilicas roofed in wood. It is characteristic that they sought models in the new East Christian style when they attempted ambitious vaulted buildings, but they did not possess the sophisticated techniques by which Byzantine works were achieved. Such Carolingian works acquired a local savour because the builders had to do what they could on

the basis of their Roman commonplace architecture and the wooden architecture of the North.

Yet a traditional feature of church polity maintained the need for church buildings on a grand Roman scale. Originally, each city in Early Christendom had had only a single church, and the whole community expected to meet for services at one building. Increase of numbers meant that this would be a large building. Rome was exceptional in possessing three churches which, when they were built, could accommodate such inclusive services – namely, the cathedral of the Saviour (324, rebuilt as St John Lateran) and the pilgrimage churches of Old St Peter's (323–6; the nave and atrium finished about 400, episcopia later) and St Paul's outside the Walls (386–423). These were built for a community which numbered about 50,000 at the time. As a matter of course the congregations stood at the services, chairs being provided for dignitaries only. Later, when the chief metropolitan centres became entirely Christian, such inclusive assemblies were no longer possible, but the medieval cities of the West, being smaller, were able to maintain the old Roman practice.

No doubt there was a compelling appeal for the bishops and architects of the West alike, in this situation. Fully 15,000 people could crowd into the Ottonian cathedral of Mainz (987–1036).[7] The phenomenon obviously points to an ideal of church building whereby the whole population could be accommodated on both the community and the parochial levels.[8]

With the disintegration of the Roman state in the West, the bishops gained in importance as leaders; civic spirit was moulded by these men, who above all others were desirous of building nobly for the Christian communities, and could command the necessary resources because of the responsibilities which they inherited from the Roman government. Thus, in an odd way, Roman architectural thought is responsible for the huge bulk of the churches which ineffaceably mark the silhouette of medieval towns. The vigour of the utterly un-Roman sky-line of these towns is the measure of the local initiative, imagination, and aesthetic power which was generated in Carolingian, Romanesque, and Gothic times.

The powerful monasteries, when their turn came in the Carolingian period and later, built churches on a comparable scale to house the many altars, to satisfy the extensive requirements for choir space, and to provide an impressive setting for processional liturgies. Like the cathedral of a metropolitan centre, the church of a monastery invariably dominated its ensemble, even when the conventual buildings themselves were veritable cities. The orderly thought which produced these compositions recalls the planning which created the Roman colonial cities. The groupings are picturesque, but it is an ordered picturesqueness, based on an organic distribution of functional elements. From the beginning – even in Constantine's time – the result was strong articulation in plan, and consequently bold shapes in the mass of the church buildings.

To review this process, for better understanding, we may recall that the first of the new elements to appear was the transept, which provided additional capacity to one side and another of the sanctuary and choir platforms. The ascetical Early Christians known as *monazontes*, devoted confraternities, and singers appear to have had a claim on this desirable interior space. In Old St Peter's (323–6) [3] its separate character was indicated by its narrow entrances from the aisles, constricted as they were by columnar screens. Such a T-shaped plan resulted in an elevation of bold form which could easily be distinguished from the civic works of the age. By the fifth century the Greek as well as the Latin cross plan (the former with arms of equal length, the latter with a west arm longer than the others) were also accepted, the latter perhaps suggested by symbolism. All such buildings were easily re-

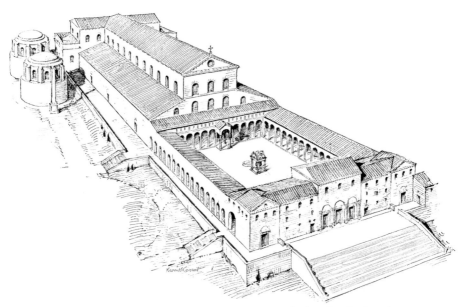

3. Rome, Old St Peter's, 323-6, with additions, to *c.* 500 (the approach, the episcopia, the atrium, the Imperial mausolea). Restoration study. The columns flanking the main portals were moved from recessed lateral porticos, filled in when the episcopia were built. The Triclinium is omitted (K.J.C.)

cognizable as Christian; for the pagan cruciform buildings were small, and not for congregational uses. By contrast, this special purpose of the church was most obvious: the light construction and thin walls, so different from the voluminous imperial vaulted works, admitted of no disguise for the functional interior shapes arising from practical needs.

Pylons and towers were also established by the sixth century as important but ancillary elements. Their advent marks the beginning of a verticality which became increasingly characteristic as Early Christian and Carolingian design gave way to later Romanesque, and that in turn to Gothic, where almost every structural and decorative line feels the vertical impulse. The pylons of the exterior propylaea of the (never finished) late classical temple of Baalbek were inherited by a basilican church erected in its main courtyard by Theodosius. Thus, accidentally, Theodosius's basilica was one of the very first to have a truly monumental entrance

way. This precedent was probably followed in the façades of the Syrian Early Christian churches, but their pylons or dwarf towers, flanking a porch, were attached to the west fronts, and at once gave an unclassical look to the designs.[9]

Towers for fortification were a sign of the new times. They were occasionally built beside Syrian churches during the Late Roman period. In the West the coming of the barbarians and persistent local war made them important; for the church building was usually the most capacious and substantial building in the community, and consequently the refuge.

'Lantern' towers, with windows admitting light above the space in front of the altar, were also brought into church architecture on a practical and functional basis.[10] In the East, masonry domes were replacing such towers by A.D. 500, and Byzantine architecture was the result; the Early Christian lantern towers live on, to the present day, in the central domes of Byzantine, Armenian, and Russian churches.

In the West, mere constructional expediency might have caused low towers to be built at the crossing of the nave and transept in basilican churches, where intersecting trusswork is awkward to construct and ugly to behold. A low tower is easily built at the crossing, with the nave and transept roofs stopping against its walls. Windows are easily introduced into such a tower without much extra weight or risk, and thus by the fifth century such lantern towers were much used in the West, even in churches without transepts.

The use of church bells provided another practical element which distinguished the new Christian style. Small bells were used in Late Roman times to call the faithful to prayer. The monks used them in their liturgies, and for a long time the bell-ringer stood in the space between the sanctuary and the monks' choir, with the bell mounted on a roof turret overhead, often above a lantern.[11]

Because all three of the tower types previously mentioned – fortification, lantern, and belfry towers – appeared in the design of the influential monastic (later collegiate) church of St Martin at Tours, this building was clearly, from our point of view, proto-medieval [4]. The vertical elements had transformed radically and for good the basic Roman basilican theme.[12] Aesthetically and symbolically, this is a matter of great importance. The composition of St Martin was not horizontal, self-contained, and inward-looking, as classical compositions are; rather it was made up of aspiring and intersecting forms. In St Martin, with its two axial towers, the new dynamic mode is unmistakable. Once established, this new mode of composition was instinctively accepted in the Roman area leavened by Frankish immigration and versed in non-classical artistic modes. Once it was well assimilated in Charlemagne's dominion, the Carolingian Romanesque style was fully constituted.

The scheme of the church of St Martin, archaic though it was in medieval terms, and de-

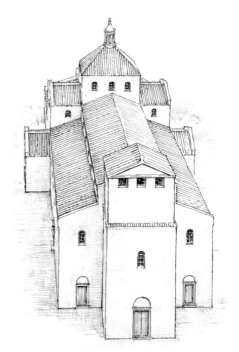

4. Tours, St Martin, as in 470, restoration study. The elements are certain, but all details are hypothetical (K.J.C.)

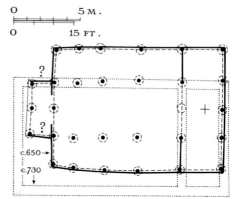

4A. Early South German constructions – Brenz, St Gallen. Restoration based on excavations by Boda Cichy (K.J.C.). Wooden church, c. 650, on stones and chassis; successor church, c. 730, in stone (destroyed)

spite the fact that the original church was replaced in the sixth century, showed its vitality in later works of considerable historical and artistic importance. Among these were the monastic churches of Centula or Saint-Riquier (790–800) [5], Gernrode (961-twelfth century) [75, 76], and Saint-Benoît-sur-Loire (c. 1080, twelfth century) [201, 203]; also the cathedrals of Ely (1083, 1323) [374] and Avignon (twelfth century) [194]. St Louis IX, King of France, was baptized in such a building, of Early Gothic style, at Poissy-sur-Seine. The destroyed Gothic cathedral of Cambrai exemplified the theme handsomely. The flamboyant church at Saint-Riquier is, like the church of Saint-Quentin, an example of such a Gothic building being carried forward and finished in Renaissance times. French colonists brought the new theme to the New World, as is shown by the old church of Saint-Jean-Port-Joli near Quebec (1779). In view of what the Franks and the French achieved with this idea in the development of medieval architecture, there is a happy historic symbolism in the fact that Clovis, their first great king, received the Roman consular insignia in the old church of St Martin at Tours.

THE CAROLINGIAN ROMANESQUE

The character of Carolingian Romanesque may easily be seen in the buildings raised under Charlemagne's own patronage. The themes are in general Roman, and the fabric continues Roman traditions, but there are evident examples of Byzantine and oriental influence. More important still, there is an originality which achieves often captivating effects both in architecture and decoration. The buildings made up an orderly programme, like the political acts of Charlemagne.

Earliest among the churches was a new building at Saint-Denis (later royal pantheon). The old church (built about 475 by St Geneviève and dedicated, according to legend, by Christ himself, 636?) was replaced, beginning about 754, by a new work dedicated in 775. According to careful studies based on partial excavation,[1] this was a wooden-roofed columnar basilica with a spacious transept extending slightly beyond the aisle walls, a lantern tower, and a west end of experimental form. Charlemagne's father, Pepin, was buried at the entrance. To augment the dignity of this part of the church an apse was projected, which would have made the building a 'double-ender' like many notable later Carolingian churches, but two small towers and a porch were ultimately built, linking the church with the more usual type of Romanesque church façade. This early church was based on the traditional Roman basilica; see the plan, illustration 378.

Next among the important churches built by Charlemagne was that which was constructed

in 782 for the monastery of Aniane. Reference has already been made to its great reforming abbot, Benedict of Aniane. Nothing remains of the church, reportedly a magnificent building with a 'westwork' erected on the advice of Charlemagne. The edifice may be ultimately responsible for the early medieval flowering of church arts in the region. It offered a sumptuous beauty to the service of the liturgy.[2] Benedict's project was indeed forward-looking, and it came to full fruition in the North at a later date.

Following this, during the decade after 790, came the most characteristically Northern and energetic of the church designs, the reconstruction of the important monastery of Centula or Saint-Riquier, near Abbeville [5]. The work was on a very considerable scale, and it was carried out when Angilbert was abbot, the 'Homer' of the Palatine Court and one of its liveliest personalities. He leaves the impression that he was an extrovert and a rather showy man; and perhaps this characteristic has something to do with the remarkably novel and monumental character of his buildings.[3] He was linked to Charlemagne by mutual affection, and the building had much direct aid from Charlemagne in the form of generous funds and the furnishing of craftsmen to work in stone, marble, glass, stucco, and wood; moreover, the great patron ordered bases, columns, and mouldings to be specially transported from Rome.

The new church was dedicated to the Saviour and All Saints, but the chief altar, in the apse, was related to the tomb of St Riquier, an ascetic who died in 645.

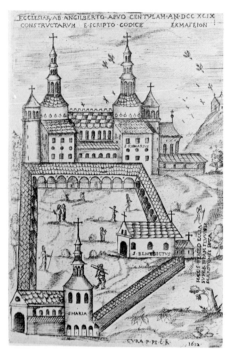

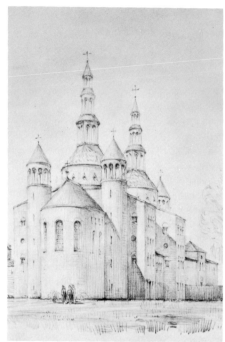

5A and B. Saint-Riquier. Hariulf manuscript drawing of 1088, engraved in 1612 *(left)*,
and sketch restoration as in 800 (K.J.C.; *right*). Excavations show that the tower
of the Chapel of the Virgin and the Apostles *(bottom of 5A)* was based on a symbolic dodecagon
with aisles, not radiating chapels, and that the cloister was a very large triangle

The scheme was basilican, with two axial towers, as at St Martin in Tours, but so imaginatively elaborated and so dynamically composed as to evidence full maturity in the Carolingian Romanesque style. The church was about 250 feet long, and with its atrium measured about 90 feet more. The crossing and the main façade, each crowned by an elaborate tower, reached a height of about 180 feet.[4] The atrium had axial and lateral entrance-ways, each with a tower; the porticoes of the atrium supported an upper passage giving access to a chapel installed in each tower – the earliest example we know of this interesting arrangement.

Grander in scale and more imaginative still was the 'westwork', or entrance element, of the main church, which was the earliest really imposing and boldly articulated façade in church architecture – a historical landmark. At the base there was a vaulted outer vestibule which contained the tomb of Angilbert and a remarkable painted stucco relief of the Nativity on a gold mosaic ground, surely the forerunner of the sculptures which gathered about the portals of Romanesque and Gothic churches. Beyond this there was an inner vestibule which served as narthex or antechurch – in effect a low, shadowed western transept with its vault carried

on a forest of piers and columns. It contained a font and an altar.

The vaults of this whole section of the church served as a platform for a chapel of the Saviour in the form of a tall spire-like central altar space, cut off from the main nave by an arched screen and surrounded on the other three sides by aisles and galleries. The placing and bold form of the chapel were clearly didactic in intent: to emphasize the cult of the Saviour in a rather superstitious period when it tended to be obscured by devotions to local saints and wonder-workers. The growth of medieval feeling since St Martin in Tours was built is well shown by the fact that at Saint-Riquier the entrance element was an entire vertical church, with vestibule, subsidiary altar and font below, and a chief altar, dedicated to the Saviour, at the platform level.

The galleries of the westwork were assigned to a boys' choir during services; the boys sang with great effect as an angel choir in the solemn liturgies, when one or two choirs of men sang in the main church. Two slender round stair turrets of stone flanking the outer vestibule furnished access to the upper parts of the westwork, and composed beautifully with a tall rounded staged tower set over the central space as the Chronicle of Hariulf shows.[5]

New studies conducted by the author indicate that the masonry construction of the westwork extended upward only as far as the base of the round drum, and that this drum, like the spire above [5], was of wood. Two engraved copies of Hariulf's manuscript show the drum opening up into the spire, and suggest a crisscross of beams at the base of the spire. We hear of a church of 735–87 at Saint-Wandrille, near Saint-Riquier, in which the spire was built about a mast, with the supports of the various stages arranged like horizontal wheels on the mast.[6] Possibly the criss-cross of beams at the base of the Saint-Riquier spire supported such

a mast. This scheme of framing for wooden spires has continued in use down to the present time; it was doubtless an original development in medieval carpentry. If the drum and spire were open, as the engravings show, an observer on the pavement at Saint-Riquier would see a most intriguing telescopic effect from below.

Beyond the westwork lay the nave of the main church, basilican, with aisles, and a wooden roof. In the middle of the nave stood the altar of the Cross, as is usual in monastic churches. Space to the west was left open for congregational use and processions, while the area farther east was kept private, the main part of it being marked off by a chancel parapet or screen as the regular choir of the monks. Two minor altars were near the screen – in front of it or beside it (perhaps in the aisles).

The monks' choir probably extended into the crossing of the transept, and the transept as usual had minor altars (four at Saint-Riquier). Here, as was customary, the monks entered the church by the transept when coming for services; typically the altar near the cloister doorway was more important than the other minor altars because relics placed there were venerated by each monk as he entered. The bell-ringer stood between the choir and the main sanctuary of the church, under the belfry. Stucco reliefs (ex gipso) of the Passion, Resurrection, and Ascension decorated this part of the building.

At Saint-Riquier the crossing tower was twin (aequalis) to the drum and spire of the chapel of the Saviour, and, like its mate, was flanked by two tall round stair towers. The main sanctuary extended eastward between and beyond the stair towers, composing handsomely in an arrangement which became traditional.

Immediately east of the crossing there was a sanctuary bay which contained an altar dedicated to St Peter, and behind that the tombs of St Riquier and his two companions. The bay seems to have served as choir space for the

'Throne of St Riquier', a semicircular apse paved at a level higher than the nave, and containing the altar of St Riquier with a baldacchino over it. This apse was marked off by a screen of six marble columns brought from Rome, and thirteen small reliquaries were placed on the beam. Monasteries usually have, in the sanctuary area, an altar for the chief ceremonies, including the capitular mass of the day, and a lesser altar where the morrow mass is said. In this, as in so many other ways, Saint-Riquier was typical.[7]

The wonderful design for Angilbert's church, dedicated in 799, evidently made a sensation, and echoes of it are perceptible in ecclesiastical architecture for centuries.

The westwork theme, that is the theme of a tower-like west block with an entrance and vestibule and a chapel above this, underwent a long development. Fécamp in Normandy had an early westwork, from which, perhaps, the motif passed to England. Reims, a great artistic centre in the ninth century, as the Utrecht Psalter demonstrates, built a cathedral in the great days of Archbishops Ebbo (816–41) and Hincmar (845–82). This building was dedicated in 862, and it seems without question to have been represented on Hincmar's sarcophagus, where the western tower, the nave, the lantern tower at the crossing, and the apse were shown in some detail. From Saint-Riquier, Reims, and also Corbie the motif went to Germany.

The westwork of Reims was the inspiration of that of the cathedral of Hildesheim (dedicated in 872, since rebuilt), and the westwork of Corbie in Picardy inspired that, dedicated in 885, at Corvey on the Weser [22, 23]. In fact, the design of Saint-Riquier had an enduring success in Germany, where its influence can be traced from generation to generation, through centuries. The cathedral of Mainz comes to mind: the building of 978 and its successive transformations through 850 years are merely variations on the Centula theme[8] [78, 333].

There were nine towers in all on Angilbert's main church. It is the first known example of so large a group of towers systematically arranged on one church building.

There can be no doubt that similar groups of later date are in debt to the astonishing original. Examples are Saint-Bénigne at Dijon [108] of 1001–17 with nine towers, Santiago [123] planned with nine, Cluny [149] with seven, and so on to the Early Gothic cathedrals such as Tournai [339] planned with nine, Laon with seven, and Chartres with six at least. All these buildings as planned gave much fuller expression to the vertical impulse than the executed work. All were intended to be much more like Saint-Riquier in external effect.

Before quitting Saint-Riquier we should take note of the two chapels in the cloister. Of the conventual buildings it is not possible to speak; they, like the atrium, have been omitted from the miniature, and have been entirely replaced on a different plan. The arrangement of the old cloister itself, reported as 'triangular', offers difficulties, but the chapels appear to be drawn with knowledge and care.[9] The chapel dedicated to the Ever-Virgin Mother of God and the Holy Apostles was originally a spire-church, dodecagonal with an ambulatory. It was a really exciting northern version of San Vitale in Ravenna. The other chapel (of St Benedict and the Holy Abbots) was a barn church of the primitive or 'vernacular' type, doubtless northern, which we have already considered. This chapel, the lean-to roofs over the transept and lateral parts of the chapel of the Saviour in the main church, the cresting of the church nave, and the three remarkable spires, all confirm the northern imprint on the architecture of Saint-Riquier.

We pass now to a consideration of the best known of Charlemagne's buildings, the Palatine Chapel or Minster at Aachen (Aix-la-Chapelle)[10] [6–10]. It teaches interesting lessons regarding Roman and Byzantine architectural

influences in the north. It was designed by Odo of Metz and begun in 792. The building has always had cathedral rank; it was dedicated in honour of the Virgin by Pope Leo III in 805, and by good fortune has come down to us almost entire, though it underwent restoration in 983 and 1881, and has consequential Gothic and Renaissance additions. The area of the palace courtyard also survives, surrounded by later buildings which incorporate some vestiges of old work [6A and B].

It is easy to divine the general layout of the group as it was in Charlemagne's time. The palace has retained its old axis, north and south, and its arrangement about an oblong courtyard. The Sala Regalis, with an apse added by Charlemagne for the throne, was at the north, on one of the short sides, while the long sides had other apartments and galleries, functionally disposed. There were quarters for officials, clerics, and servitors, for the School, and for the assembly. The imperial apartments were dignified and

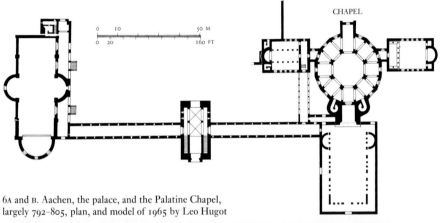

CHAPEL

6A and B. Aachen, the palace, and the Palatine Chapel, largely 792–805, plan, and model of 1965 by Leo Hugot

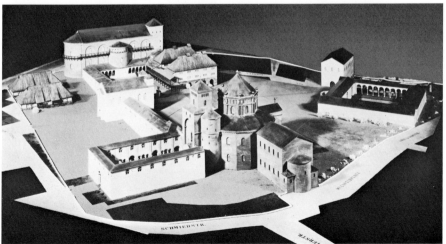

ample; they included a bath and an audience chamber. There is no doubt that the group was intended to be reminiscent of the Lateran Palace in Rome, which gave its name to a part of the establishment, and suggested the placing of a bronze statue brought from Italy. Reminiscences of Ravenna – also a Roman capital – are most clearly seen in the design of the Chapel, which formed the south end of the ensemble.

Rebuilding and additions have destroyed the unity of the Minster group, which, in the beginning, had a noble and easily understood monumentality. The church building was the climax of a vast centralized symmetrical composition measuring about 300 feet on the principal and transverse axes. The whole design was more elaborate than that of San Vitale in Ravenna, which obviously inspired it. There was a monumental entrance way at the western extremity of the main axis, followed by an atrium with galleries on two levels which was dominated by the tall westwork façade of the church. The

courtyard could be crowded if need be with about 7000 people. The Emperor could make official appearances at the tribune in the westwork of the church, which with its niche recalls the façade of the Palace of the Exarchs in Ravenna. Flanking spiral stairways in cylindrical turrets gave access to the throne room in the tribune of the Minster, and continued upward to a chapel which contained Charlemagne's remarkable collection of relics[11] [6A and B].

The Minster itself was a complex composition arranged about a tall vaulted octagonal central space. The westwork connected the Minster at the tribune level with the court and the palace. The throne was in the tribune, directly over the main portal of the church. From each side of the throne area the tribune continued as an annular gallery, divided from the octagonal central space by columnar screens, to a sanctuary of its own opposite the tribune.

At the ground level a deep porch led to the interior [9]. There the visitor finds an annular

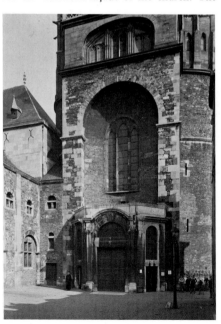

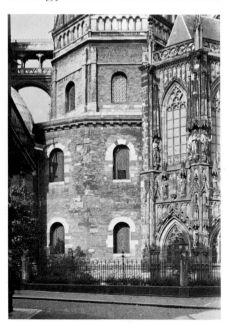

7 to 9. Aachen, Palatine Chapel, 792–805, façade, lateral view, and interior

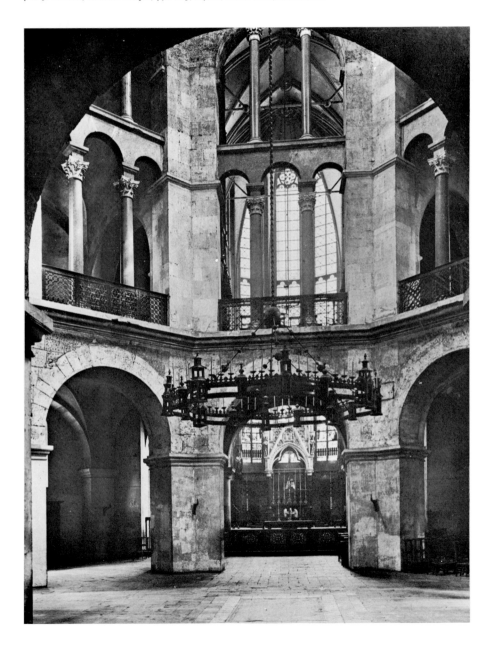

aisle, vaulted and rather dark, which, like the gallery, embraces the octagonal central space. This annular aisle led to a sanctuary opposite the entrance and below the upper sanctuary, where the great Gothic axial chapel now stands, and also provided access to twin chapels of aisled basilican type, now destroyed, which were symmetrically placed on a cross axis, one to the north and one to the south of the main building.

Unlike the galleries, the annular aisle opens on the central space through undivided, big, plain arches, well proportioned with respect to the arches and screens of the gallery above. The exterior wall on both levels is ingeniously arranged with sixteen sides. In the aisles the cardinal and diagonal sides join the eight arches of the octagon in supporting groin vaults, and clever triangular penetrations fill out the vault on the remaining sides. These same sides have ramping triangular vaults above the gallery,

carried on generous diaphragm arches. The triangles thus formed leave the cardinal and diagonal bays of the gallery with a square shape, and here, on the diaphragm arches, eight ramping tunnel vaults are raised. These come into the octagon above the screened arches and provide an unyielding support for the clerestory wall and the high vault. Small pilaster buttresses stiffen the exterior corners of the clerestory effectively.

The tall octagonal central space has a very special character. We must think if it as enriched with several altars and their liturgical furniture, but even so its tallness and the persistent sense of compartmentation make it seem very different from an ordinary church. This lends colour to the idea that Odo of Metz conceived it basically as a tomb house, but the similar and slightly earlier dodecagon at Saint-Riquier was nevertheless a chapel.

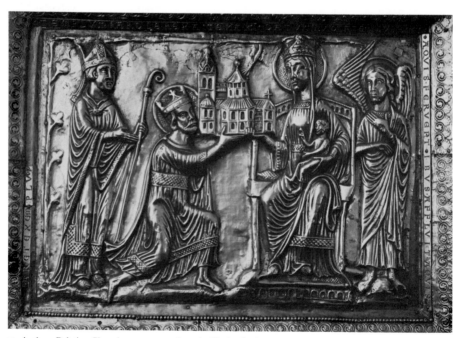

10. Aachen, Palatine Chapel as represented on the Karlsschrein

The net effect produced by the building is not Roman, yet there is an assurance and urbanity which make it a worthy successor to the works of Antiquity. In spite of its resemblance to San Vitale in Ravenna, it is more Roman than Byzantine. Rich fittings, including a mosaic on the central vault (restored in 1881), marble columns and bronze parapets brought from Italy, an organ of Byzantine type (812 or 856, now lost), a splendid pulpit (gift of Emperor Henry II, about 1014), and a huge light crown (given by Frederick Barbarossa in 1168) contributed a superficial Byzantinism, to be sure. In fact, however, the theme of San Vitale was radically simplified. Brick and the Byzantine technique of light terracotta vault construction were not available; the warped and domed Byzantine forms were replaced by tunnel and groin vaults, and on the highest level by an octagonal domical (or cloister) vault, all of Roman inspiration. The fact that Roman ruins had to be demolished to obtain the necessary stone, and that rich materials were scavenged elsewhere, shows what a special effort the Minster was.

Linked by date (806) and by programme with the Minster at Aachen is the interesting Palatine group at Germigny-des-Prés [11-13], near Saint-Benoît-sur-Loire,[12] built for Theodulph, bishop of Orléans, a Goth from Septimania (Provincia Narbonensis), and member of the Imperial court circle. There are slight remains of the painted halls and thermae of the palace, its oratory of God the Creator and Preserver of All Things existed, with little change, until the nineteenth century.[13] Heretofore we have seen how Carolingian architects used Roman, Early Christian, Byzantine, and Germanic forms. At Germigny-des-Prés the tincture is Byzantine and oriental.[14] Moreover, the other examples are grand in scale; Germigny-des-Prés is minuscule – a charming architectural plaything. There is a tower-like square central space, the middle one of a set of nine vaulted compartments sustained on four piers in the middle of the build-

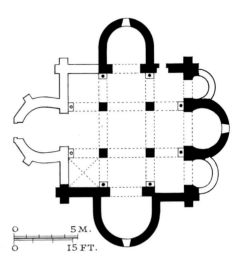

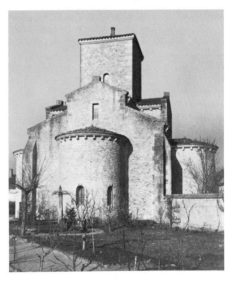

11 and 12. Germigny-des-Prés, Oratory, 806, rebuilt 1867-76, plan and view from the east (the main apse originally had flanking absidioles)

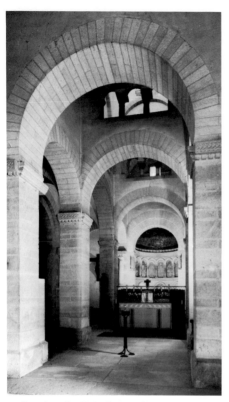

13. Germigny-des-Prés, Oratory, 806,
rebuilt 1867–76, interior

ing. On the main and transverse axes there are
tunnel vaults at an intermediate level, with apses
just beyond, and the corner compartments were
vaulted with little domes on squinches at a
lower level. The corner compartments at the
east opened on lateral apses flanking the main
apse. The oriental flavour of the building is due
to horseshoe arches in plan and elevation. These
were certainly inspired by Visigothic art, and
the plan and elevation of the building may also
have been inspired by old Christian work in
Spain.

But the type is one which we owe to the
Roman world, and its effective development
took place in Armenia and the Byzantine lands.
The general arrangement is anticipated in the
Roman praetorium at Phaena (Mousmieh, near
Damascus),[15] before A.D. 169, and it appears in
the cathedral of Etchmiadzin as rebuilt in 628.[16]
By the tenth century it was established in the
Eastern Empire as the typical 'four-column
church', which is the most important of all the
later Byzantine church types.

The chapel at Germigny-des-Prés antedates
any known Byzantine example, but the strong
oriental flavour makes it clear that the type was
not originated in Neustria. Yet something must
be conceded to the Carolingian architect. He
laid the church out as a 'double-ender' like cer-
tain of the great Carolingian basilicas, though,
unlike them, it had the main entrance cutting
through the western apse. He very ingeniously
and picturesquely placed Carolingian arcaded
'flying screens' under the tower walls, where the
light plays very prettily on them. The rather
barn-like nave is a much later addition.

The central space was formerly about twelve
feet higher than it is at present, and formed a
tall lantern and belfry. Exactly how this was ar-
ranged in Theodulph's time is far from certain,
for the oldest drawings seem to show a Roman-
esque central tower; but we may perhaps sup-
pose that this was a reconstruction resulting
from a fire in the tenth century. In any case the
tall lantern and belfry is a Germanic scheme,
and the oriental elements were, so to speak,
arranged around and below it.[17]

A brutal and ignorant restoration of 1867–
76, carried out over the protests of the Société
française d'Archéologie, has left us with an in-
accurate modern counterfeit of this important
Carolingian monument. Some fragments of the
original were incorporated in the reconstruc-
tion. Interesting remains of its fine decoration
in stucco were destroyed or denatured, the more

regrettably because the rich fittings of the chapel – the furniture in white and coloured marble, the metalwork, and the fabrics – have all been lost.[18]

Connected with Germigny-des-Prés by its horseshoe arches and their stucco decoration is the little church of San Benedetto at Mals or Malles, near Trent. It is dated about the year 800. The horseshoe arches, three in number, look in upon an open, box-like central space, which is the nave. There are traces of fresco decoration. Near-by Münster in Graubünden (Grisons), in Switzerland, is a contemporary and more monumental example of the same arrangement, though without the horseshoe arches.

Another building, in old Neustria, with finer wall-work than those which we have considered, brings up the question of the Gallic masons. It is doubtful that Notre-Dame-de-la-Basse-Œuvre at Beauvais actually dates from the lifetime of Charlemagne, but after being accepted as Carolingian, it is now assigned to the period of 987–98.[19] It is a fragment of the compound early medieval cathedral establishment of Beauvais. The entire tenth-century church of Saint-Pierre, and all the easterly parts of Notre-Dame made way for the celebrated Gothic building [14]. Notre-Dame-de-la-Basse-Œuvre was a handsomely proportioned basilica with a plain interior and a steep roof which gives much character to the fine gable, adorned by a great cross, on the façade. The wall-work is regular and excellent, with pattern-work in the masonry over the windows. Other fragments of such construction, datable to the tenth and early eleventh centuries, point to a well-established school in the north and west of France.

The 'Gallic masons' of the region had an established reputation, which was well deserved. Texts speak of heavy work in large cut stone blocks *more antiquorum* which was occa-

14. Beauvais, Notre-Dame-de-la-Basse Œuvre, eighth century(?) or 987–98

sionally used, but such masonry was ordinarily confined to quoining or alternate coursing, as seen in the tenth-century works for the monks of Saint-Philibert at Grandlieu and at Tournus, where 'Gallic masons' were obviously employed [24, 99].

The more usual Gallic wall-work of good character was composed of much smaller materials – a rough core of rubble enclosed by neatly cut facing-blocks of stubby rectangular form, set with wide mortar joints. Pattern-work facing often recalls the barbarian *cloisonné* style, 'where

everything becomes decoration', but it was derived from the classic Roman *opera* (*reticulatum, spicatum, mixtum*). Occasionally there are whole walls of pattern-work, interspersed sometimes with degenerate gable and panel decoration in relief. The work of the Gallic builders may be traced to England: Benedict Biscop called for Gallic masons about 685, to build Jarrow[20] [15].

eighth-century church of the monastery (at Lorsch) there was a large open court, and the gateway stood free near the entrance to it, like a Roman triumphal arch in its forum;[21] however, the Lorsch gateway was built as a three-arched open hall, like a propylaeum illogically standing unattached. Abbot Richbod is known to have replaced the wooden monastery build-

15. Jarrow, wall-work, *c.* 685

16. Lorsch, monastery, gateway, *c.* 800

The accomplishments of early masons prepared the way for immense Early Romanesque constructions at Poitiers, at Chartres, and elsewhere in the Loire country.

The famous three-arched gateway at Lorsch seems to be connected somehow (perhaps through Verdun and Metz) with their work, because of the excellence of the pattern-work masonry. This feature and the remarkable composite capitals, and other sophisticated details, point to it as an interesting Carolingian example of classical revivalism – an academic design such as might be expected to issue from the court of Charlemagne [16]. In front of the important

ings in stone, and the gateway may have failed to be specially recorded on this account, for such propylaea were used in the ceremonial monastic liturgies as processional stations, just like other parts of the conventual establishment. The direct original of the Lorsch gateway was obviously the propylaeum of similar design at Old St Peter's in Rome [3], where great visiting dignitaries were received. Lorsch repeats the general shape, the arches, the columns, and the windows of the propylaeum of Old St Peter's. A corresponding three-arched gateway was built at Cluny also. The latter became part of the abbot's palace, while the one at Lorsch was

transformed into a chapel, sometimes wrongly identified as the *ecclesia varia*, a chapel of about 860 attached to the church. Nor is this transformation at Lorsch out of line, for the propylaeum of Old St Peter's had an altar of St Mary and could be used as a church upon occasion – as, for example, when the emperor was received at the Vatican Basilica.

Another curious combination of Carolingian medievalism and classical revivalism involving Old St Peter's occurred at Fulda. The first church there was founded by St Boniface (Wynfrith, the great English missionary) in 742; the monastery, one of the great lights of northern Europe, was founded in 744. A small church of 751 was rebuilt after 790 in the form of a basilican nave with its apse flanked by two round towers, as at Saint-Riquier. The relics of St Boniface, who was martyred in 754, were brought to the monastery. To give them a proper setting, a transept and apse were built west of the new nave, on the model of Old St Peter's in Rome, where, in fact, the transept was at the west. The end compartments of Old St Peter's, and even their bulls-eye windows, were reproduced at Fulda; furthermore, the length of the western transept, 250 feet, is close to that of the great original. Behind the new apse a large courtyard was arranged, as at the cathedral of Rome (St John Lateran). The new work at Fulda was projected in 802, dedicated in 819, and provided with its western cloister in 822.

A comprehensive recent study convincingly brings out the importance of Old St Peter's in the Carolingian revival.[22] Old St Peter's stood for the last glorious moments of the ancient capital, in Constantine's golden age of Roman imperial Christianity. The Carolingian architects turned aside from buildings of intermediate date which had resulted from the rise of Byzantine power, the influx of oriental monks, and the succession of Greek and Syrian popes. Santa Anastasia (about 800), Santo Stefano degli Abessini (before 815), and Santa Prassede (about 817) are rightly adduced as examples of basilicas in Rome which, by their imitation of features of Old St Peter's, show the tendency to look into Rome's own past for inspiration, at a time when Charlemagne himself was familiarly called Flavius Anicius Caelus by Alcuin.

Thus, in the sum, we find in Charlemagne's time an architectural revival which was archaizing – but it was far more than that. The new ideas set forth in the major buildings have a basic importance for the whole history of Romanesque architecture. The Basse-Œuvre at Beauvais stands for the fine tradition of Gallic mason work. Lorsch, Fulda, and the Roman churches stand for the will to make Rome live again in a classical revival. Saint-Riquier stands for the northern vigour and bravura which transformed Roman architecture. Aachen with its relative simplicity stands as a northern interpretation of a Byzantine theme, representing the old Roman idea of substantial structure which survives in the heavy Romanesque of medieval Germany. Finally, Germigny-des-Prés typifies Gaul's susceptibility to Byzantine and oriental influences, and its greater receptiveness to sophistications than Germany; thus it is a forerunner of the accomplished, subtle Romanesque of France.

CHURCH ARCHITECTURE
IN THE NORTHERN PART OF THE EMPIRE
UNDER THE LATER CAROLINGIANS

Germany

The famous manuscript plan of *c*. A.D. 820 in the monastic library of St Gall[23] [17] was doubtless prepared in the ambit of Benedict of Aniane, or of Einhard himself, that 'Beseleel, the man filled with the spirit of God, in wisdom and in understanding and in knowledge and in all manner of workmanship', first commissioner of works and director of the imperial workshops. Einhard,

who came from the monastery of Fulda shortly after 790 to be a pupil of Alcuin in the Palace School of Aachen, was intellectually a classicist. He became the personal friend and adviser of Charlemagne and Louis the Pious.[24]

Hence the plan of St Gall presents an authorized conception of a large, well-organized monastery, which might have been built in any prosperous part of the Carolingian realm. It is now clear that the layout was drawn up after a council of 816 at Inden, near Aachen, and this somewhat imperfect copy sent with alternative dimensions by Abbot Heito of Reichenau (806-23) to Abbot Gozbert of St Gall (816-37), who had not attended the council.

The method of drawing and the fact that the plan was not closely followed after the oldest parts of the church were built (at the east, 830-5) have given the impression that it was merely a diagrammatic layout, which is far from being the case. It could easily be translated into modern form and built with little change. The layout was in fact modular (40-foot squares, 2½-foot sub-module) as Walter Horn has shown. Thus we see that the Roman tradition of modular construction was present in Carolingian work, and it was without doubt transmitted to later times.

The group was intended to be constructed on fairly level ground; for the whole scheme is included within a rectangle, slightly diminished at the south-west because of a wane in the parchment. Various small elements like beds, which indicate scale, show that the great rectangle was to measure about 460 by 640 304-millimetre Carolingian feet. The church nave with its apses was to be about 300 feet long, and with its aisles about 90 feet wide; the transept was to be about 120 feet across, and the cloister about 100 feet square.

In imagination we shall visit this group as it is known from the plan. When as visitors we are surprised to find the western or approach side occupied by an area 450 feet wide and 140 feet across assigned to the hostel for poor wayfarers and the quarters for servitors, horses, and farm animals (including a piggery), we must remember that the existence of the monks for whom the group was built was a retired existence, interior to the monastery and centred on the cloister and the altar. The ancillary buildings formed a sort of rind about the essential kernel of church and cloister. From the monks' point of view all the ancillary buildings were in the *background* – not in the foreground, as they appear to the approaching visitor. The terrain to the east of a monastic group tends to be somewhat private; guests are likely to be placed to the north, menial activities to the south, and service courts to the west in the traditional monastic layout; this is true at St Gall.

Only one longitudinal axis runs entirely across the St Gall plan. On it an ample walled avenue extends for 160 feet from the westerly outskirts of the monastery to the entrance system of the main establishment. The importance of this key point of circulation is signalized by the presence of two cylindrical towers, each with a chapel at the summit. The suggestion for the cylindrical towers came ultimately from the stair towers of the narthex of San Vitale in Ravenna, perhaps; but pairs of towers had been built at Fulda, Aachen, and Saint-Riquier before the plan of St Gall was made.[25] Early monasteries often showed lights in such towers.

The arrangement for St Gall, as shown on the plan, differs from all of the others, for the towers were attached outside a semicircular portico, which looked across a little garden strip towards the western apse, and gave entrance on each side of the apse to an aisle of the church.

17. Plan for a monastery, *c*. 820.
Based on a diagram in the Chapter Library, St Gall.
Somewhat regularized; small satellite
buildings omitted. Grid of 40-ft (12·16-metre)
squares in the church, somewhat more
loosely applied elsewhere, based on the church axis

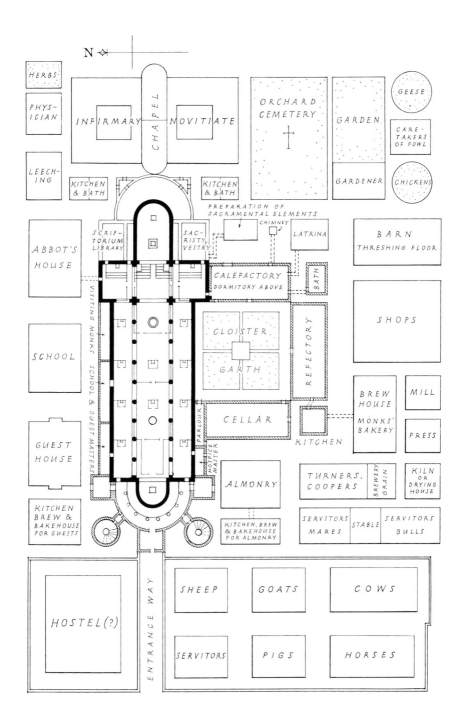

Adjoining the corners of the church there were two vestibules accessible from the portico. That to the left led to a whole range of residential, school, and hospital buildings. The vestibule to the right gave access to the Hospice, the Cloister, and (beyond a wall) to the menial parts of the establishment. The church, which continues the main axis, was by far the most important individual element. The old plan shows it with a single transept, and, like Fulda, newly enlarged in 802-19, with an apse at each end.

For the western apse, dedicated to St Peter, the first designer sacrificed the imposing axial vista which entering visitors expect in great churches. The small lateral entrances indicate that the function of the building is different. The monks' 'Opus Dei' is performed quite without regard to public attendance, which can never be more than incidental. The special character of the monastic regime also shows in the interior arrangement. Although the church was basilican, with nave and aisles like the vast ancient churches designed for public assembly, the pavement area, instead of being open, was cut up by parapet screens into a series of compartments, each with an altar, and accessible by paths, somewhat like corridors. These ways were also used as procession paths.

Thus we find the nave divided, from west to east, into the western choir, the Chapel of St John Baptist (with a font), the chapel of the crucifix (with a large crucifix, typically placed at the altar), and the space in front of the eastern (singers') choir. Each of the aisles had four chapels, making twelve compartments in all within the nave area. And the compartmentation continued in the transept, which had a chapel and an Apostles' altar in each arm, and the monks' choir between.

The sanctuary at St Gall had a special historical interest. Here were sung at festival-time the oldest of extant tropes, composed by the monk Notker – the starting-point for the history of medieval drama and lyric. The sanctuary bay was square, and contained the high altar, dedicated to St Gall, set over a crypt. The altar in the adjoining eastern apse (*pendant* to that of St Peter) was dedicated to St Paul. At the left of the sanctuary was the scribes' room, with the library above – not a large room, for the medieval libraries were numbered in scores or at most a few hundred codices, in addition to the necessary service books. At the right of the sanctuary was the sacristy, with the vestry above, and an annexe where sacramental hosts and chrism were prepared. The passages for circulation in the nave were prolonged across the transept, giving access to the divisions there, and to the crypt, which doubtless had an altar also, raising the number of altars within the church to seventeen.

The monks' entrance from the cloister was by way of the south transept; once arrived at the crossing, he found the main sanctuary to his right and the minor altars stretching off to the left towards the western apse. The 'double-ender' arrangement increased the sense of enclosure, and thus was desirable and natural in a monastic church. Because of its prestige in monastic architecture, the arrangement came to be used in cathedrals too, where it was much less appropriate.

The great axis of St Gall continued from the church to a small curved courtyard, and so into the monastic quarters. These cannot be described here: the reader must be referred to the diagram [17], or follow the itinerary, with a detailed commentary on the monastery's life, in Note 26.

What is known of the type of fabric in all of these structures? The church certainly, and as much of the remainder as possible, had well-built walls of stone. The roofing was of timber, the wide spans being trussed and covered with tin or shingles. Many of the lesser buildings were of timber or half-timber and roofed with shingles, while modest structures like stables, pens, and herdsmen's shelters might be of wat-

tle work and thatch. On looking at the plan of St Gall one is struck with the number of subsidiary buildings which have a central hall with narrow apartments at the side, and which must, therefore, have looked somewhat like basilican churches. Such buildings might be constructed with either framed or masonry walls. In some cases the outer chambers were carried entirely around the central space, as in the Almonry and the School, while in other cases – the Almonry kitchen is an example – the smaller rooms occur along one side only. It is worth noting that such one-sided buildings are frequently represented in Carolingian miniatures; they abound, for instance, in the Utrecht Psalter (about 832). They have been considered fanciful; the truth seems to be that they were a familiar part of the architectural scene in Carolingian times. The subsidiary buildings as represented on the plan give us a lively idea of the lost traditional wooden

'vernacular' architecture of the North in the Middle Ages – a fact of great interest and significance.

One would expect that this very important establishment at St Gall would be surrounded by a stockade, if not an actual girdle wall, emphasizing the fact that it was a world in itself. St Gall was, however, insufficiently protected when the Hungarians attacked it early in the tenth century. Of course, even though it was self-centred, a great monastery did look outward. It had its various possessions from which it received supplies, its various ecclesiastical dependencies, its associations with other monasteries, and its connexions with Rome.

Once a monastery was well established, the monks devoted themselves to managing its operations, rather than to labouring with their own hands. The number of servitors and artisans would be at least equal to the number of ecclesi-

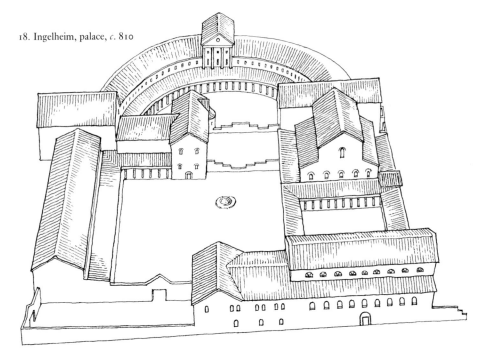

18. Ingelheim, palace, c. 810

astical persons, and might be more. The re-
formed orders, whose members performed
more manual work, usually had less to offer the
reviving medieval world than the illustrious
institutes which strove to be intellectual and
artistic capitals for their respective regions,
granted that to serve as agricultural and indust-
rial capital of a region was indeed a great work
for a monastery to perform.

Another ensemble of considerable impor-
tance which claims attention here is the palace
group at Ingelheim, near Mainz [18].[27] Works
were begun under Charlemagne and finished
under Louis the Pious. Excavations show that
the palace was laid out in the classical manner
and built of masonry. Ranges of various rooms
occupied three sides of a vast court, of which
the fourth side was bounded by a special axial
composition. There the great hall, set broad-
wise at the foot of an atrium, communicated by
galleries with the palace church, which lay at
the east. One is struck by the number of cham-
bers augmented with apses, as if they were cha-
pels; in fact, however, these recesses were com-

monly used to give monumental character to
important rooms of several kinds. They were so
used in the Sacred Palace in Constantinople as
well as in the Lateran Palace at Rome during
this period. The second court at Ingelheim was
semicircular; the festival hall, which lay be-
tween the two courts, was a trefoil. Church
forms predominated in this palace.

We are fortunate in having a description of
the paintings at Ingelheim in an account by
Ermoldus Nigellus. In the church were scenes
of the Old Testament and, opposite, corres-
ponding scenes from the New. Such monu-
mental and lucidly arranged cycles underlie the
didactic schemes developed later by Suger at
Saint-Denis, and others.

The great hall had paintings from secular his-
tory, deeds of ancient kings and heroes, Ninus,
Cyrus, Phalaris, Remus, Hannibal, and Alex-
ander the Great, and, opposite, scenes of a
more contemporary history – the foundation
of Constantinople, and events of the reigns
of Theodoric, Charles Martel, Pepin, and
Charlemagne.[28]

1. Church
2. Dormitory; calefactory underneath
3. Refectory; vestiary above
4. Cellar
5. Monastery gate:
 Chapel of St Januarius above
6. Kitchen
7. Cloister garth
8. Chapel of St Pirminius
9. Latrina

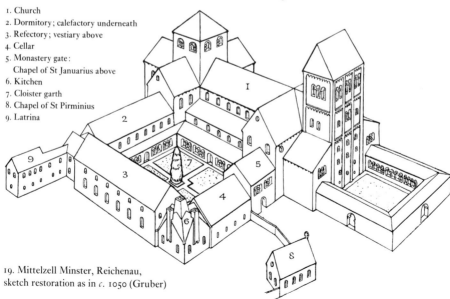

19. Mittelzell Minster, Reichenau,
sketch restoration as in *c*. 1050 (Gruber)

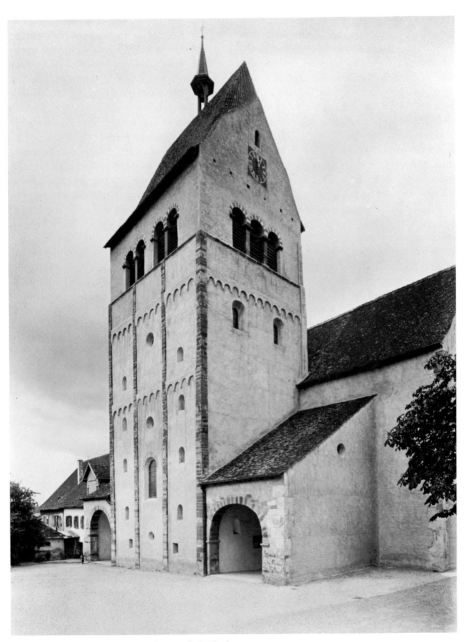

20. Mittelzell Minster, Reichenau, 819, 1048; belfry later

Before the break-up of the empire of Louis the Pious an ephemeral prosperity made possible the construction of many churches. Basilican churches are regularly triapsidal with transept, often with passages and crypt, regularly aisled, and provided with towers and a narthex or at least a narthex only at the west. Among these are St Justin at Höchst, near Frankfurt-on-Main (after 800, or *c*. 825), and Einhard's own church at Steinbach (821).[29] Einhard's church largely survives, and its original form is easily traceable. It had a pylon-like entry with a lateral compartment to each side. The nave terminated in a sanctuary separated by a screen and provided with an apse; lateral chapels with apses formed a sort of dwarf transept which communicated only with the chancel. Each aisle gave access to a cruciform crypt under the corresponding transept, and a more elaborate cruciform crypt lay on the axis between.

Reference should be made to the area, important in early Carolingian history, which lies to the north of Italy. Venerable for age among its bishoprics are Chur (founded about 450), Constance (578), Augsburg (about 600), St Gall (614), Strassburg (*c*. 675), and Regensburg (739). The great early shrine of the region is St Emmeram at Regensburg, where there was already in the eighth century (740-80) an important basilican church of pilgrimage. Burned in 1020, restored under Henry II, it has interesting sculpture of *c*. 1065 in a lateral porch, but has lost character through further rebuilding.

Sentimentally and historically great is Reichenau, the enchanting monastic 'Insula Felix' of Lake Constance.[30] It was a frequent stopping-place on imperial journeys, and a powerful centre for missionary effort. Like a gentler, more accessible Athos, it has had a profound religious influence. Its church architecture is

21. Oberzell, Reichenau, St George, 836 and later

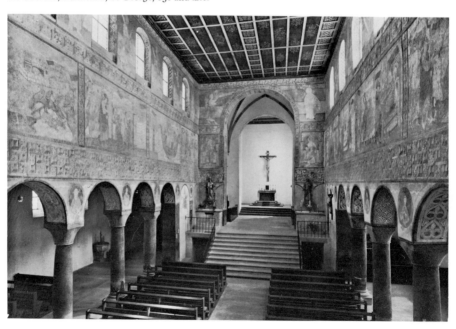

conservative, almost classical. There are three sites – St Peter at Niederzell dating from 799; the Minster at Mittelzell, founded in 724, enlarged and dedicated in 819 (which was further enlarged in the tenth century, and provided with a western apse and tower, dedicated in 1048) [19, 20], and St George, Oberzell, 836 (containing later construction also, including a crypt of 985) [21]. The churches are basilican, set in serene and opulent countryside, with the aura of the monastic centuries still hanging about the scene. The School of Reichenau is famous for its paintings, both miniature and architectural. St George, Oberzell, has a particularly impressive ensemble of old paintings. The churches have survived with forgivable changes down to the present, and there are indeed few places where one may enjoy so satisfactory an impression of a Carolingian painted church.

Corvey on the Weser [22, 23] also helps greatly to visualize the developments of its period. Corvey is 'the New Corbie', founded in 822 by a colony of monks from Corbie in Picardy, not far from Saint-Riquier. Architectural influence came from Saint-Riquier by way of Corbie to Corvey, where a westwork was built between 873 and 885. Though this design, being German, is heavier and less sophisticated, and though, about 1146, the middle of its façade was carried higher between the old pair of stair towers, this westwork is the best existing representative of the Saint-Riquier frontispiece. At Corvey the galleried spire church was not carried up to a rounded pinnacle, but rather to a square tower of the type which the Germans strikingly call a *Helmhaus*.[31]

From the point of view of future developments, this westwork at Corvey was less important than the original east end. The two

22. Corvey on the Weser, westwork, 873–85, looking west

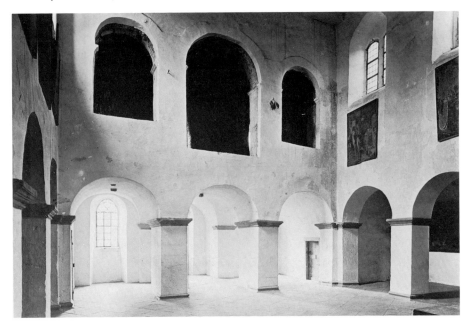

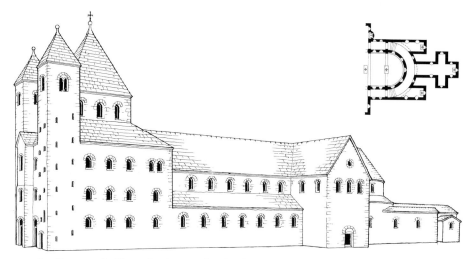

23A and B. Corvey on the Weser, sketch restoration showing westwork of 873–85, with plan of chevet

sanctuary aisles each had a chapel at the end, and these chapels communicated by an annular corridor, curving between them outside the great apse, with a cruciform chapel beyond the apse and on the main axis. Here indubitably we have the germ of the scheme of apse, ambulatory, and radiating chapels which is one of the finest contributions of the Middle Ages to religious architecture. The German churches for generations kept to simpler schemes for these chapels. The idea was developed and systematized chiefly in the area which we now call France.

France

The great architectural achievement of France in the period of Louis the Pious and Charles the Bald is the basic solution of the difficult problem of the apse, ambulatory, and radiating chapels. In large measure the solution was worked out in the basilican school of western France, to which we have already referred.

This problem assumed importance with the greatly increased interest in pilgrimages and the cult of relics. Until the eleventh century the bodies of saints laid away in tombs or sarcophagi were, if possible, left undisturbed. Beginning probably with a reconstruction (c. 600) of the sanctuary of Old St Peter's in Rome, the apses of churches with such relics were often arranged with narrow access corridors under the pavement.[32] Such corridors followed the interior curve of the apse, and connected axially with the tomb chamber, or crypt, under the high altar. The ever-increasing numbers of pilgrims desirous of visiting these tombs put intolerable pressure on the narrow corridors and exiguous crypts. At the same time, there was an increase in the number of ordained priests among the monastic and canonical clergy, which in turn augmented the need for altars and chapels. Additional altars could be used for the exhibition of reliquaries (thus increasing the interest of the pilgrimage) if suitable access could be arranged. Partitioning off the nave, as at St Gall, was impossible in a church where great crowds of pilgrims gathered for festival liturgies. The solution lay in a corridor round the apse, with chapels radiating outward from it.

At Corvey, and at Saint-Riquier in the later crypt, the reliquary chapels lay beyond the church apse. There is good antique precedent for this arrangement, and where it occurs, no very difficult problems arise. But the most conspicuous precedent – that of Old St Peter's in Rome (about 600) – placed the main altar directly above the Apostle's first tomb. In some cases the church sanctuary was elevated because the sacred spot was at or near the level of the nave pavement; this was the case at Old St Peter's. But in other cases the tombs were below ground, and crypts with special systems of access had to be built.

From the time of the construction in Rome of St Paul's outside the Walls, sanctuaries and chapels were customarily oriented. If correctly oriented chapels were attached to the access corridors about the tomb chapel, an awkward angular corridor resulted, and the circulation of a press of pilgrims was difficult. Nevertheless this arrangement marked an advance, and there are two influential examples of it still in existence, which were built in France during the period which we have under consideration.

The venerable monastery on the Isle of Noirmoutier, off the west coast of France near Nantes, built a priory church in 814–19 at Déas, near the Lake of Grandlieu[33] [24-6]. This church had a nave with aisles, a crossing with stubby transepts, and the usual three apses. The island was so situated as to receive the full brunt of the Norse raids which began at this period and continued through a dreadful century. The monks had to abandon Noirmoutier, but they took the relics of their sainted patron Philibert with them to Déas, which thus became Saint-Philibert-de-Grandlieu. A pilgrimage developed, and in 836–9 the monks adapted the priory church very cleverly for this cult. The

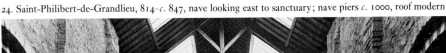

24. Saint-Philibert-de-Grandlieu, 814–c. 847, nave looking east to sanctuary; nave piers c. 1000, roof modern

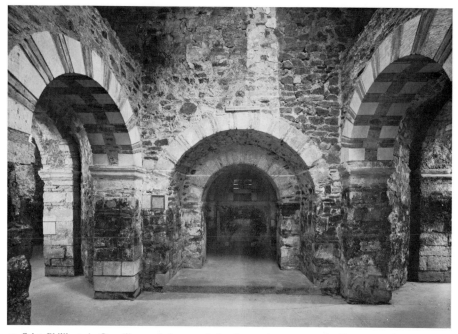

25. Saint-Philibert-de-Grandlieu, ambulatory and chambers under sanctuary, looking west, *c.* 847

original apse was demolished, and a square sanctuary bay was built with a new apse beyond it. Narrow exterior corridors led to a chamber under this apse, where the sarcophagus of St Philibert was installed by 839 and still remains. The sarcophagus chamber and the narrow lateral passages were at ground level; consequently the floor of the church apse was raised above the level of the nave pavement.

In order to provide additional altars and a better approach to the tomb under the apse, the narrow corridors were soon replaced by a series of chapels. These were so arranged that a rather awkward processional path (somewhat like that of Corvey) was provided at the ground level, running entirely around the apse. The path gave access to the sarcophagus chamber from the east, so that pilgrims could visit it without disturbing services in the main part of the church.

The new chapels were placed 'step-wise' or 'ladder-wise' in plan (*en échelon* in French) [26A–C], whence the name of *apse échelon* for this feature, which runs through a whole series of important churches during the entire history of Romanesque and Gothic architecture. The apse échelon of Saint-Philibert-de-Grandlieu was built before 847, but served the monks only until 858, when, the region being overwhelmed by the Norse, the community moved to Cunault in Anjou.

The other important apse échelon of the ninth century is in the crypt of the abbey church of Saint-Germain at Auxerre. Here were venerated the relics of that great fifth-century churchman, who prepared St Patrick for his Irish mission of 432-61. St Germain's tomb was below the church pavement level, and under the main apse. In a reconstruction of 841

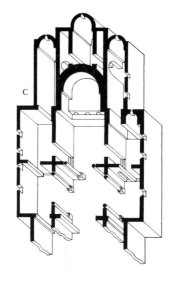

(or a little later) it was included within a little vaulted crypt church possessing a corridor around the tomb chamber. In 850-9 an apse échelon with an angular processional path was ingeniously built around the little crypt church, and extended to join a rotunda at the head of the main axis [26D]. This arrangement of apse éche-lon and rotunda also had an important future in Romanesque and Gothic architecture. It was becomingly inaugurated, for the Emperor Charles the Bald himself caused the relics of St Germain to be installed in the crypt (859). It was then decorated with fine paintings, which are among the oldest murals now existing in France.[34]

In 872 the relics of St Martin were brought to this crypt from Tours, because of further Norse forays. The clergy of St Martin's then had first-hand experience of this remarkable crypt; we shall presently see the result.

At Chartres Cathedral, because of the re-nowned pilgrimage, the church was rebuilt after a fire of 858 with a curved corridor around the apse in the crypt [96] – a great improvement. Furthermore, the rounded apse wall was pier-ced, giving a good view of the apse from the ambulatory and vice versa.[35] Pierced apses go back to Roman times, but the pierced apse with an ambulatory was novel. It produced interest-ing aesthetic effects by uniting the apse and the ambulatory spatially. Felicitous use of this idea was made in the Romanesque style at Jumièges abbey (1037–68) [357], and in the Gothic style at Notre-Dame in Paris (1163).

26. Development of the chevet: A–C *(above)*. *c.* 814–47, Saint-Philibert-de-Grandlieu (Green); D *(below)*. *c.* 850-9, Saint-Germain, Auxerre, crypt (sketch restoration by K.J.C.)

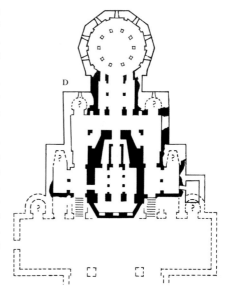

However, the Carolingian architects went farther than this, cleverly uniting the lessons of Saint-Germain at Auxerre (859) with those of Chartres Cathedral (after 858), in a new church of St Martin at Tours, built in 903-18 after a disastrous fire [26, 95, 95A].

Here the aisles and the larger part of the nave were open to the pilgrims who thronged the church. The remainder of the nave contained the canons' choir, which continued eastward to join the sanctuary and apse, with St Martin's tomb at the head, close to the middle of the apse wall. The aisles were continued at approximately the same level into an ambulatory which curved round the outer side of the apse and allowed the faithful to reach 'St Martin's Rest', viewing it from the back through openings in the apse wall. Quite as important, the minor chapels which we have seen obstructing the naves or making awkward corners in the apse échelons of older churches were here built as round absidioles, like those of the crypt of Saint-Germain, Auxerre, but radiating from the outer wall of the ambulatory as a whole. This design was a perfect functional solution, and a genuine integration of the difficult elements of a pilgrimage sanctuary in a monastic church.[36]

The creation of such a remarkable feature as the apse, ambulatory, and radiating chapels is a sign of maturity in the experimental French Carolingian Romanesque. This achievement marks a stage in our exposition; it is a landmark on the road to the mature Romanesque style.

It is logical, therefore, to interrupt our study of French architecture at this point in order to consider developments of Carolingian date and marked national character in Ireland, England, Scandinavia, Spain, and Italy. Localism and practical experiments resulted in successful buildings which, being admired, really affected the mature Romanesque and Gothic styles which later came to these areas from abroad.

Yet the study of these early regional works is not really a digression. Mature Romanesque architecture resulted when one of these successful local styles coalesced with two others. The 'First Romanesque' style of north Italy carried forward the tradition of Roman vaulting. Its contact with Carolingian architecture in the Rhine Valley produced the splendid Rhenish Romanesque. Its synthesis in the Rhône Valley with the Carolingian Romanesque basilican style of the west of France (the style of the Basse-Œuvre at Beauvais, Saint-Riquier, St Martin of Tours, and similar works) resulted in the mature phase of French Romanesque architecture – the dynamic group of styles which underlies Gothic architecture.

26A. Skellig Michael, monastic cluster, c. 823-c. 1064 (K.J.C.) (see pp. 69-70). The usual girdle wall is replaced in large part by the cliff and the precipice

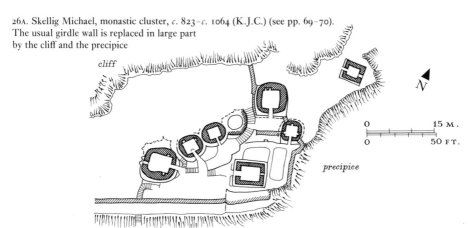

PRE-ROMANESQUE ARCHITECTURE IN THE NORTH,

OUTSIDE THE EMPIRE

Northern design as developed in contact with Roman traditions within the Empire showed great vigour and originality. Outside the area of strong contact with Roman architecture the resources available for building were smaller, the problems simpler, and the results less spectacular. Yet these more remote buildings often have interest in their own right because of independent local conceptions, and the skilful use of local materials and methods – Celtic in Ireland, Germanic in England and Scandinavia. Compositional types here in the North, as well as in pre-Romanesque Spain and Portugal, tend to be additive, or compartmental. Where pre-Romanesque buildings have been preserved they are now seen to have a precious savour, though in the glorious days of the full Romanesque development they must have seemed small, crude, 'home-made' and old-fashioned. For this reason they have been replaced at all of the important sites, and we are left with casual representatives no one of which excited special wonderment in the age in which it was built. These examples show, however, how the invading Romanesque inherited something from the earlier styles, and thus developed local varieties.

IRELAND

Ireland was the first of the pre-Romanesque areas to become creative. Its intellectual importance and ecclesiastical influence, international in scope from about 550, are well known. Remote from Imperial centres and led by an ascetic clergy whose spiritual roots reached back to

Lérins and the Egyptian desert, Ireland quite naturally had an unassuming church architecture. Many of the early structures were undoubtedly of wattle work or palisading, with steep roofs as required by thatch, and no such sophistication as rounded apses. It is known that the royal hall at Tara was basilican.

Buildings of any pretension at all were built with timber framing, *more Scottorum* as the Venerable Bede says (731) of a Lindisfarne church of *c.* 655. It is possible that such structures affected Scandinavian building; for the raiders (795 ff.) became settlers after 834 without losing contact with the mother country. 'Cogitosus', about 800, tells of St Brigid's church at Kildare, which 'occupied a wide area, and was raised to a towering height'. Commonplace buildings, many churches among them, had the shape of simple cottages with steep roofs. In the monasteries and at secular sites these were often multiplied into 'church clusters' instead of being replaced by larger structures; the congregations would gather within and around such church buildings. At monasteries the various conventual structures would be arranged rather casually, within a girdle wall.

A number of buildings in permanent material have survived from Carolingian times, but since their analysis more properly belongs in the volume of the *Pelican History of Art* which is devoted to the art of the British Isles,[1] only brief mention is made of them here.

The island of Skellig Michael [26A] provides a spectacular site for a group of small stone-built monastic buildings, 'clochains', of dry-wall construction with flat corbelled beehive domes,

27. Gallarus Oratory, near Dingle,
seventh century or later

more oriental in character (as we should expect in monastic work) than is usual in Ireland. The simple church and the austere cells are irregularly placed on a shelf 180 feet long and 100 feet wide, of old reached by 670 steps along the face of the rock, which forms a precipice 700 feet high. The group has had its present character since 823, or rather, perhaps, since 860 when it was re-established after Viking raids. The monks left it for the mainland at some time after 1064 [26A].

The Gallarus Oratory near Dingle [27] is an elegant translation into corbelled stone of the cruck house ('all roof, no wall'). It has been variously dated from the seventh century to the eleventh. Kells, a well-known site, famous for its scriptorium, has 'St Columba's House', a shrine-house dating from 804, or perhaps after 918.[2] The church is rectangular in plan, and elegantly tall in proportion. In section the roof is rather like an A. The outer part is of corbelled construction in stone, with a small pointed chamber at the apex. The space below this (represented by the area under the cross-bar of the A) is the tunnel vault over the main walls of the church. 'St Kevin's Kitchen' at Glendalough, really an oratory, is a similar building, of ninth-century style [28]. It became a nave-and-chancel church through the addition of a shed-like sanctuary, now destroyed. A sacristy at the east and a small finger-shaped tower on the ridge were other early additions (about 1000). Near

28. Glendalough, St Kevin's Kitchen
and round tower, *c.* 1000

by stands the relatively large ruined cathedral
of St Mary, formerly roofed in wood. It is stylis-
tically classified as *Primitive* because of its great
simplicity. Associated with it there is a charac-
teristic round tower, classified as *Transitional*
(to Romanesque) in style, 103 feet in height,
16 feet in diameter at the base.

The round tower – tall, delicately tapering,
smartly capped by a conical stone roof – is the
most poetic of the Celtic architectural creations.
No towers are more graceful than these upward-
pointing stone fingers of Ireland. There is no
better example of the bravura of basically
Northern design. It is likely that the beginnings
go back to Carolingian date. Watch-towers and
refuges were needed when the Norse raids be-

gan in 795. The tall tower identified the church
site from a distance; it marked the cemetery,
and served as a belfry and lantern of the dead.
Yet it was constructed as a practical refuge; the
door was set well above the ground and reached
by a ladder, and, moreover, a port made it pos-
sible to overturn the ladder of an attacker. Spiral
stairs and floors of wood occupied the interior,
and loopholes made it possible to throw missiles
from every side. Of one hundred and eighteen
such towers which are reported, thirteen still
exist in fairly perfect condition – the tallest,
120 feet high, on Scattery Island.

Note should be taken also of the Irish high
crosses, of which nearly three hundred medieval
examples have been traced, and of very remark-

able cult objects in metal. It was through such works that the simple little churches were warmed and embellished: in Prior and Gardner's phrase, 'the craft of decoration in Byzantine and Carolingian buildings was the setting of precious objects against a background of structure'.[3] The old Irish churches are indeed widowed now without their furnishings.

Norman influences play upon this architecture in the twelfth century (as at Cormac Mac-Carthy's Chapel on the Rock of Cashel, c. 1124-34 [29], which is in the tradition of St Kevin's at Glendalough) but the Cistercian influence, beginning at Mellifont Abbey in 1142, was more effective. Although such church buildings were more imposing, they were severe, and earlier Irish austerity of design lives on in them.

29. Cashel of the Kings. Buildings now roofless except round tower and Cormac McCarthy's Chapel, of c. 1124-34

Here again, because of extended analysis in the volume devoted to medieval architecture in Britain,[4] only limited mention is given to the architectural works in question. It was a much-divided country which struggled towards unity through the labours of Egbert of Wessex (829-39, the first to bear the title of King of England), Alfred the Great (871-900), Athelstan (924-40), Edgar (959-75), and the great Danish sovereign Cnut (1016-45), who wrought well as an English king.

In the church architecture of the period there are many reminiscences of older forms. The nave-and-chancel plan was widely used both in wood and in stone. The compartmented plan, clearly that of Wilfrid's cathedral at York (767-80), which had thirty altars, survived in smaller buildings. Such a plan existed, for example, at the fabulous pilgrimage shrine of Glastonbury. Excavations show that the *Vetusta Ecclesia*,[5]

originally of late antique date, was augmented by a series of small elements built of stone, with wooden roofing: a nave and *porticus* about 700, and a narthex, chancel, and lateral *porticus* before 900. Further, about 950 St Dunstan added two lateral *porticus* and a tower at the east of the church, as well as a free-standing tower-chapel at the west. This brought the length of the group to about 250 feet. The plan was thus *cloisonné*, and it exemplified the old scheme of two axial towers, which became popular in English pre-Romanesque, Romanesque, and Gothic architecture.

Continental relations were strong in the time of King Edgar (959–75), under whom, with St Dunstan, the reform of the Benedictines made salutary progress in England. St Dunstan, who had been abbot of Glastonbury, became Primate (960), and his companion monk, Ethelwold, Bishop of Winchester (963). Both men were artists and loved the arts, and both were well placed to further the cause of the fine arts by precept and example. Winchester Cathedral [33A] was rebuilt by Ethelwold, about 980, with a great five-stage wooden tower. The organ at Winchester has its place in the history of music and the Winchester school of illumination is justly renowned in the history of manuscripts.

We know from texts that there was in this period a considerable amount of cathedral building, including Canterbury, which was rebuilt as a 'double-ender' with two lateral *porticus*. These monuments, on a fairly grand scale, have all been destroyed. Hence we must form our ideas on the basis of secondary monuments, of which about two hundred survive in whole or part. From the viewpoint of this volume the following ought to be mentioned: Elmham Cathedral,[6] Deerhurst,[7] Wing,[8] Worth,[9] Breamore,[10] Barton-on-Humber,[11] Earls Barton (originally an excellent example of the Saxon 'tower-nave' church),[12] and Bradford-on-Avon.[13] Parenthetically, Pembridge should be mentioned for its fourteenth-century belfry-tower, which closely approximates a Carolingian *turritus apex* [30].

30. Pembridge, belfry tower, fourteenth century (traditional form)

31. Worth, church, tenth century(?), looking east

32. Breamore, church, tenth century(?), tower

Elmham, a ruin, has a slender T-plan, plus an apse and the two compartments which flank the nave just west of the transept. Deerhurst is interesting for its staunch western tower, its lateral compartments (three on each side, with the usual narrow doors of access), its characteristic narrow chancel arch, and its exceptional (destroyed) seven-sided apse. Worth has a round apse, also exceptional [31]. Breamore is interesting for its staged crossing tower [32] and the remains of a Saxon carved rood panel. Barton-on-Humber has its substantial tower, ample, square, and tall, with bluff cut-stone quoining and strips of cut stone in the wall-work, which give a decorative suggestion of framing. This tower formed the middle part of the Saxon church; it was augmented by a smaller compartment on the east, and a similar one on the west. The paired windows, arched or mitred, are characteristically divided by jolly 'mid-wall shafts' with rings. Earls Barton tower is grander [33], and is indeed a favourite Saxon monument. In all of these the masonry is rather

33. Earls Barton, church, tower, tenth century(?)

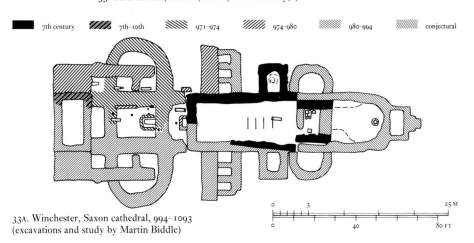

33A. Winchester, Saxon cathedral, 994–1093
(excavations and study by Martin Biddle)

0 5 25 M
0 40 80 FT

34 and 35. Bradford-on-Avon,
St Lawrence, c. 975(?)

rough and 'free-hand', but attractive. The ordinary walls are about 2½ feet thick; special walls may be much thicker.

Among the existing church buildings, St Lawrence at Bradford-on-Avon is perhaps the most satisfactory. It is a nave-and-chancel building, well constructed of cut stone. It has a characteristically narrow chancel arch with interesting reliefs of angels (perhaps from a rood) set in the wall above it [34]. There are narrow doorways on the other three sides of its minuscule nave (25 feet long, 13 feet 8 inches wide, and very high – just over 25 feet). The windows are, as usual, few, small, and placed high in the wall. The lateral doors opened into *porticus*, of which the southern one has been destroyed. Apart from this the exterior is very perfect; it is beautifully proportioned and decorated with elegant shallow arcading [35]. Recently it has

been shown that the lower part of the church probably dates back to Aldhelm (c. 700); it was reworked when the parts above the belt course were added. For this reconstruction, on account of its accomplished character, we prefer the date of 973, in St Dunstan's time.[14]

Sir Alfred Clapham, in summing up this art, rightly says that it 'was a direct offshoot of the Carolingian stem, guarding the salient characteristics of its parent stock' but with a sort of bumbling localism. In the mid eleventh century it was much in need of the vigorous new impulse which came from Normandy to Edward the Confessor's Westminster Abbey.

Enigmatic still is the relationship of the Saxon carvings to the sculptural art of Germany and France. The influence of the Winchester illuminations on French sculpture is admitted, but we do not have sufficient links to connect the

Saxon reliefs – some of considerable interest – with early Romanesque work in Languedoc, Burgundy, and Fleury (Saint-Benoît-sur-Loire).[15]

SCANDINAVIA

The forays of early medieval Scandinavian freebooters are well known, and several of the beautiful ships which were their instrument – so lithe in form, so beautiful in decoration – have been given back to us by archaeological excavation and study. What is not so widely known is the history of the widespread colonization and trade which followed the piratical raids. In the ninth and tenth centuries Swedish dynasts organized the oriental trade by way of the Russian rivers and built the state which became Christian Russia in 989.[16] In the West their colonization of Iceland (847) and Greenland (981) was enduring, but their contact with mainland America (986 ff.) proved ephemeral, like their hold on considerable territories in the British Isles. All Scandinavian architectural work of this earliest period is lost, and is to be deduced only from foundations, fragmentary remains of superstructure, and the traditional features of conservative later buildings.

Sweden and Gotland provide remains which indicate the character of the early palaces and dwellings; at Lojsta on Gotland a palace of some size has been rebuilt on its original foundations. It takes the form of a long rectangular hall with dwarf walls of earth and stones; the entrance is at one end, and the hearth is near the middle. At intervals there are pairs of posts resting on stones in the earthen floor, dividing the interior into a nave and two aisles. Each pair of posts supports a transverse frame for the roof of thatch, which sweeps in an unbroken slope on each side from the dwarf wall to the ridge. A smoke-hole opens over the hearth. The timbers are ,rough in the reconstruction, rather than carved and painted as they doubtless were in the original, but the architectural lines are fine, and

the interior is strikingly handsome [1, 36A]. Halls of this sort had been built for hundreds of years before the latest date – about 1000 – which can be assigned to Lojsta. At Onbacken in Sweden there are remains of a double-aisled 'guild hall'. Like Lojsta this building had frames at intervals to support the roof structure. However, the posts were four in number in each frame. Instead of dwarf walls Onbacken had wooden palisaded walls, vertical or slightly inclined, at some distance outside the frames [36B]. Simpler structures, similar in principle, were grouped in the farm establishments.

The remains of pagan temples in the early period indicate structures of square plan. At Gamla Uppsala, which was probably the greatest pagan cult centre of the region, the medieval church was built largely on the site of the chief temple. Excavation has yielded a part of the stones which supported its timber-work, and the pattern of its plan [36C, 348]. In this case there was a square central compartment, with corner timbers over 2 feet in diameter and a smaller post between on each side. Whether the central compartment was free-standing in a peribolos measuring about 75 by 85 feet, or surrounded by aisles reaching to the enclosing wall, is a matter for debate. In any case the outer wall was supported by light posts, and relatively low, while the large corner timbers indicate a tower-like proportion for the central square. We postulate aisles, with a gabled entrance. Thus the temple was distinguished from the residential and guild halls previously referred to by its wall construction and its centralized plan; it was, however, a relatively late building, not long anterior to its description by Adam of Bremen (about 1070). He calls it a triclinium, and notes that it contained statues of Thor, Odin, and Freya.[17]

At the date mentioned, Christian building was already well advanced in Scandinavia. From neighbouring Germany some influences may be traced or suspected, but the Norse church was set up from Britain, and its architectural his-

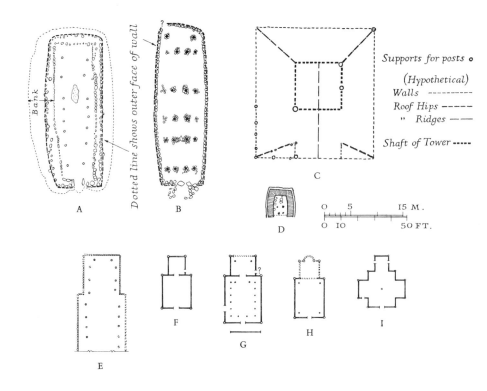

36. Plans of early Scandinavian buildings.

A. Lojsta, palace, *c.* 1000
B. Onbacken, 'Guild Hall'
C. Gamla Uppsala, temple foundations
D. Brattahlid, Thjodhild's church, *c.* 1001
E. Lund, St Mary Minor, *c.* 1000–50

F. Holtålen, church, eleventh century
G. Urnes, church, *c.* 1125
H. Lomen, church, *c.* 1180
I. Nore, church, *c.* 1190
J *(below)*. Garrison hall, Danish reconstruction

tory probably begins there. By the year 900 the Scandinavian population was probably Christian in the British areas controlled by the Norse – the Earldom of the Orkneys, including parts of Scotland; the Kingdoms of the Hebrides, of Dublin, of Northumbria, and of East Anglia; together with the Five Boroughs. Christianization of the North was tardier, but it was well begun by 950, and it was established by law for Norway, Iceland, and Greenland in the year 1000. Inevitably one is led to suppose that many early Christian buildings on the Scandinavian peninsula were simple wooden versions of the nave-and-chancel type of church which was common in England and Ireland at the time, or three-naved halls of the Lojsta or Brenz type [1, 4A].

Thjodhild's tiny church (*c.* 1001), excavated at Brattahlid near Gardar [36D and 39B], resembled Lojsta, except that it had a squarish plan, like a temple, and a wooden façade. The banks and roofing were of sod.

Excavation has revealed the plan of a more ambitious church in Sweden. This is St Mary Minor at Lund, dated after 1000 (by 1050?) [36E]. Its wall-work was like that of Greenstead church in Essex [2] – built, that is, of vertical logs flattened on three sides and joined by splines. The chancel, 25 feet square, was offset from the nave, which was about 33 feet wide from wall to wall. Aisles were marked off in the nave by posts which (two by two) carried the transverse framing of the roof structure. The sanctuary, opening from the nave, had a similar roof construction, except that the posts were carried around at the east end to form a sort of narrow ambulatory. Thus St Mary Minor, though resembling a basilica, was a curious conflation of the basilica, the nave-and-chancel church, and the pagan hall. Unfortunately it is not possible to follow the subsequent history of the timber church in Sweden. Although about 200 were built, not one is extant; only fragments in museums remain.

On the other hand, Norway and Insular Scandinavia have preserved the elements for this his-tory. In Iceland and Greenland there are representatives of pioneer and archaic forms. The old Icelandic sees of Skálholt and Hólar have lost their early buildings, but rustic sites still possess houses with banked lateral walls and interior framing, like a simplified Lojsta. The façades are of wood, and the roof covering is sod rather than thatch. Churches were built in this way, even recently (Flúgumýri, about 1875, and Víðimýri, 1822 [37]. The Stóri-Núpur church in Árnessýsla [38], with aisles, recalls the palace at Lojsta even more strongly. Groups of old barns and houses often seem but little changed in general appearance from the prehistoric farm

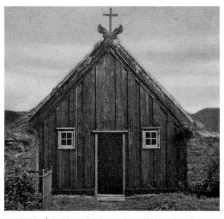

37. Víðimýri, Skagafjörður, view of church, 1822

38. Stóri-Núpur, Árnessýsla, model of framing, 1876

39A *(above and below)*. Gardar, cathedral group, twelfth century

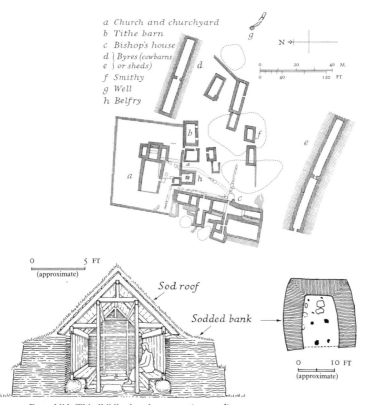

a *Church and churchyard*
b *Tithe barn*
c *Bishop's house*
d ⎱ *Byres (cowbarns*
e ⎰ *or sheds)*
f *Smithy*
g *Well*
h *Belfry*

N ⊹

0 20 40 M.

0 40 120 FT

b

f

e

a

h

c

0 ————— 5 FT
(approximate)

Sod roof

Sodded bank ⟶

0 10 FT
(approximate)

39B. Brattahlid, Thjodhild's church, *c.* 1001 (restored)

establishments of Gotland and elsewhere. Somewhat the same story is told in Greenland, which was evangelized through a mission entrusted to Leif Ericson, shortly before his journey to America (1003). There were ultimately seventeen churches serving about two hundred and eighty households, a monastery, and a nunnery. The White Church (stuccoed), at Kakortok, a perfectly simple little stone-walled building, mentioned in 1306, still survives, roofless; but the cathedral of Gardar (Igaliko), founded in 1124, has been destroyed. Excavations show that it was a small cruciform stone building with a wooden façade and roof construction [39A]. Other buildings in the cathedral group, serving as residences, were built like the traditional Icelandic houses just mentioned. A related group, much simpler, has been identified and excavated at L'Anse aux Meadows, on the tip of Newfoundland. It represents the eleventh-century Norse colonization in Vinland.[18]

Excavations (Trelleborg, Aggersborg, Fyrkat, in Denmark) show that the great Viking military camps were very different from these settlements. Within an encompassing earthwork (circular at Trelleborg [39C]), impressive garrison halls resembling the guild hall at Onbacken [36B] were arranged in fours, forming square courts, and these courts were reduplicated, with passages (each in a quadrant at Trelleborg). The walls were palisaded. Bowed out in plan and supporting big roofs, they softened the strict geometrical system [36J].

Churches built entirely of timber represented an advance on ordinary wooden structures. In 1893 L. Dietrichson had traced three hundred and thirty-two timber churches in all Scandinavia, of which twenty-four were extant, all in Norway. An important church (Trondheim, 996) is reported in the reign of Olaf Tryggvason, under whom the country became officially Christian, and archaeological remains go back

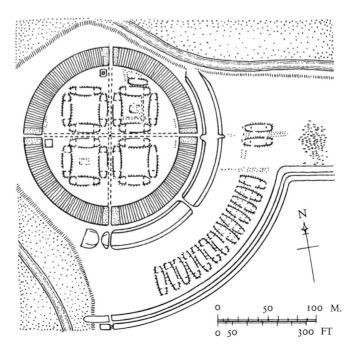

39C. Trelleborg, camp,
c. 1000

to the reign of St Olaf (1015-30), the church in question being that of Garmo (destroyed 1882; elements at Lillehammer). It was a nave-and-chancel church in wood, an example of the oldest, most persistent, and most numerous type of church.[19]

Holtålen church (c. 1050-1100; now in the Trondheim Museum) [36F] is the oldest extant example. It has the typical stout posts at the six salient angles of the nave-and-chancel plan, with rebated sills sustaining an ingenious tongue-and-groove palisade or 'stave' wall construction. About 1060 a church of similar form was built at Urnes. Superb examples of Norse carving survive on the wall planks and doorway of this church – wonderful interlaced animal forms, exultantly vivacious, subtly modelled in flat and bold relief – classic examples of tameless vigour and beauty [40]. Such work must be dependent ultimately, in part, on Irish illumi-

40. Urnes, carvings on flank of church, c. 1060, re-used

nation, but the earlier Norse panels, unlike the Irish works, contain little except animal forms: it was later that scrolls of leafage, ribbons, and human figures were introduced. The doors and doorways of timber churches were often preserved, on account of their beauty, when the churches themselves were destroyed, and this is the case at Urnes, where the door and façade carvings of the nave-and-chancel church of 1060 were built into the north side of a more elaborate church about 1125 [36G].

This church, Urnes II, marks a decisive step toward the classic type of fully developed Norse timber church. The shallow oblong sanctuary has two corner posts as usual, and two interior posts at the east, recalling the arrangement at St Mary Minor in Lund. The nave at Urnes II, somewhat larger than usual, has walls supported by the customary four posts at the outer corners. But within there are sixteen tall free-standing mast-like supports, marking off lateral aisles and a returned aisle at both east and west. The masts rest on stones and a chassis; they are braced all round at mid-height, where their number is augmented by two on the axis (omitted below to make the interior more spacious). Above the aisles the masts carry a clerestory wall, and at the top they are joined together all round by a plate, which carries the trussed roof and a belfry pinnacle. There are suggestions that the designers had basilican churches of stone in mind. The masts, for instance, have Romanesque capitals at mid-height under apparent arches (which are in fact each made up of two adjoining wooden gusset braces). The bridging above the apparent arches suggests a triforium, and the small round vents above ('Windaugen') suggest clerestory windows.

However much the church resembles a basilica, the masted structure is essentially different – a structure of the central type, like a group of flag-poles all bound together circumferentially. It must have been quite striking to see the masts

while such a church was under construction. On completion they extended up into and supported the entire upper structure as well as their share of the aisle roof and the braces which reached to the aisle walls. Despite its oblong shape and the Romanesque-looking carvings, the scheme is in essence that of the tower-like pagan temple at Gamla Uppsala.

The same period (about 1125) shows at Hedal in the Valdres a nave-and-chancel church, where the sanctuary is augmented by an apse, and the whole is circumscribed by an exterior ambulatory with a projecting porch on the axis.

These architectural motifs, combined with the masted scheme of the nave of Urnes II, result in the classic form of the Norse timber church, best represented at Borgund, the oldest extant example (about 1150) [41]. The harmonious effect of the many subtly related parts is no less remarkable than the skilled craftsmanship by which it is achieved. Nave and sanctuary (each with its pinnacle) rise confidently above the arcaded exterior porch, their graceful silhouette breaking into gables, finials and spirelets. The delicate scale and small membering (emphasized by cut shingles – now for safety often replaced by tile) are remarkably effective in the natural setting of rough upland valleys.

Neither Urnes nor Borgund is an important ecclesiastical place, and one naturally looks elsewhere for the genesis of so accomplished and perfect a scheme. One thinks inevitably of King Sigurd Magnusson's Church of the Holy Cross in Kungahälla which was built in 1127, after the King's return from a spectacular pilgrimage to the Holy Land. It was accounted a wonder, but no detailed description of it has survived, and it was destroyed in 1136. Another possible prototype is the church which was constructed along with a palace for King Sigurd's brother Eysten in Bergen, 1117. The structure of the palace halls must have resembled that of simple churches in many respects. Perhaps indeed the

tall masted structure was invented to distinguish the churches by emphatic vertical emphasis from the palaces in such groups; for the palaces would be larger and predominantly horizontal. One is struck, too, by the small scale of the early mast churches; they would look like jewel boxes – indeed, like enlarged versions of church models (a popular form of reliquary) – beside the palaces. Only the later churches are generous in scale.

Such then is the background of the church of Borgund, the details of which may be studied in the diagram [42]. The ingenious A trusses, the various types of bridging, bracing, and gussets are well worth attention, as is also the basic chassis of the building. Pairs of supporting beams cross at right angles, ($\#$), and the masts are raised about the central rectangle. The extended parts of the beams powerfully brace the masted structure and support the aisles and porches. Such a chassis or skid would be supported on stones; there is nothing like it in conventional basilican construction. At Borgund the main masts are twelve in number, with a wide interval, and an upper half-mast, on each flank of the nave.

Grinaker (c. 1160), Lomen [36H], and other churches in the Valdres region dated 1180 or later have four masts carrying the upper structure in what is otherwise a nave-and-chancel church with an apse added. These naves are not very much smaller than those of Urnes II and Borgund, and consequently the scale is larger, forecasting the still ampler scale of the thirteenth century. Strzygowski believed that putative early examples of the four-masted type generated the tradition of masted structure, but without evidence. Free-standing four-masted structures were developed for the belfries of the churches; that of Borgund, with the masts slanted against the swing of the bells, is typical.

Nore church (c. 1190) [36 I] presents a square nave with a post at each corner, and the whole

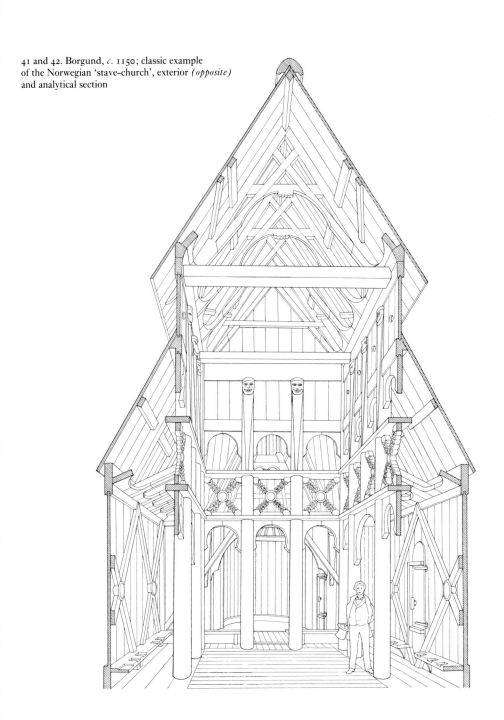

41 and 42. Borgund, *c.* 1150; classic example
of the Norwegian 'stave-church', exterior *(opposite)*
and analytical section

middle part of the construction carried on a single mast. Shallow transeptal recesses and a square sanctuary all have a post at each corner, making seventeen for the whole church. Flå (*c.* 1200) and Nes (*c.* 1240) have the nave-and-chancel plan, plus a rounded apse and a central mast. The whole structure is arranged and braced in stages around this mast, and therefore comes to resemble the central mast of a Carolingian church spire, or the wooden steeple of an American Colonial church. This type flourishes alongside the nave-and-chancel, the quasi-basilican (Lom, Torpo, *c.* 1190; Årdal, *c.* 1200), and the Borgund type (Fantoft, from Fortun, *c.* 1160–80; Gol, now at Bygdøy, Oslo, *c.* 1200; Hegge, *c.* 1210; Ringebu, *c.* 1230; Heddal or Hitterdalen in Telemark, near Hjartdal, *c.* 1250).

In the interiors which have best survived the centuries the wood has largely been left unpainted. The resulting rich tobacco brown with deep velvety shadows is very fine, and it sets off the glint of metalwork in the furnishings and liturgical gear. The bright colours of vestments, the gay hues and sober black of peasant costumes appear to great advantage in this warm atmosphere. The interior carvings of the churches are relatively simple, but they happily accentuate the structural membering, and give a certain movement in the half light. The contrast between the serenity of the Norse church interiors, and the extraordinary verve of their exteriors, is not the least remarkable of their many artistic virtues.

Because the material was perishable, wooden churches began to give way to stone structures as early as 1050. Norman England, with its characteristic heavy masonry construction, began to influence Scandinavia even in the reign of Sigurd Magnusson (1103–30). At that time the Anglo-Norman cousins of the Norse were already at work on the cathedrals of Norwich and Ely; Stavanger Cathedral was being built, from about 1123 onward, in a reflected Romanesque style.

The Scandinavians did not adopt the Irish idea of church clusters, and therefore, as time went on, the mast churches became unsatisfactory not only because of their material, but also because of their small scale and their limited capacity (even with the people standing at services, as was usual in the Middle Ages). The congregations became larger, and the ceremonies more elaborate, involving greater numbers of clergy than in early times. Recent attempts to build mast churches on a modern scale, so as to provide space for sizable gatherings seated in pews, have been aesthetic failures, while the cutting away of masts, and other changes in medieval buildings, for the same purpose, have been most unfortunate.

When the stone-built Romanesque came to Scandinavia, it took on, as in the church of Gamla Uppsala[20] [347, 348], simple and austere Northern forms which make their aesthetic point through the bold and elegant expression of bulk – so much so that modern imitations of French and Italian Romanesque and Gothic works seem unwelcome and intrusive. The earlier buildings in masonry were rather primitive in construction, and thus carry an odd flavour of the First Romanesque which is very appealing. Even the vitality of the timber church tradition had little effect on buildings designed for stone, and it is indeed probable that the architects considered the forms of the wooden buildings as a natural result of their engineering type, and thus not applicable in stone-built work or suitable for any kind of superficial imitation.

PROTO-ROMANESQUE ARCHITECTURE IN SOUTHERN EUROPE

It sounds like a pleasantry to say that Roman architecture is proto-Romanesque – that is to say, a Romanesque architecture coming before the authoritative and constituted medieval style. But there is a kernel of truth in it. The methods of commonplace Roman building were continued with little change during the Dark Ages in the southern and more settled parts of the Empire area, awaiting the time when a grander architecture should be possible.

We have seen that Carolingian Romanesque architecture intellectually marked out this future development. It is only a habit of thought which prevents our calling it simply Romanesque. That term calls up a group of styles of somewhat later date, somewhat more mature structural character, more importantly characterized by vaulting, and richer in plastic embellishment, but not essentially different in conception.

Similarly, the styles of southern Europe which come between Roman and Romanesque might simply be called Romanesque if our habit of thought were different. Two of them are so close to both styles as to merit the name of proto-Romanesque. The architecture of Asturias, Galicia, and neighbouring Portugal in the ninth and tenth centuries was like a laboratory experiment in Romanesque, performed in a remote region and not absorbed into the main current of architectural development. In the Byzantine Exarchate and Lombardy a similar development laid the groundwork for the 'First Romanesque' style, which carried on the living stream of Roman architecture, and contributed something to all the mature Romanesque styles.

THE ASTURIAN STYLE

The Moors came first to Spain in 711 as a small interventionist force under Tarik, for whom Gibraltar is named. The ineffectual Visigothic kingdom crumbled before them, and they embarked on a serious work of conquest which brought them across the Pyrenees into France in 718. They were only halted by Charles Martel in 732 in the famous battle fought between Tours and Poitiers. The new state was not well organized until the middle of the tenth century, and the Moorish borders receded, but the Moslems continued to afflict southern France by forays, and by their fierce, long-continued piracy in the Mediterranean. They drove out the monks of Montecassino in 883 and desolated the monastery; they captured Mayeul, abbot of Cluny, in 972, and held him for ransom; their devastations are reported from Switzerland in 940 and from northern Spain in 997–8.

During the initial period of relative Moorish weakness, Septimania was reconquered (760–8) by Pepin III, after which the Spanish March of Charlemagne (Catalonia and Navarre) was liberated (777). The action at Roncesvalles, celebrated in the Song of Roland, occurred in 778. Barcelona was captured in 801.

In the north-western corner of the peninsula, where the old mountainous Asturian realm of the Suevi (only subdued by the Visigoths about 620) had not been overrun by the Moors, the Spanish Christian state was reconstituted juridically in 713 by the fantastic band of clerical, military, and lay refugees who had been driven

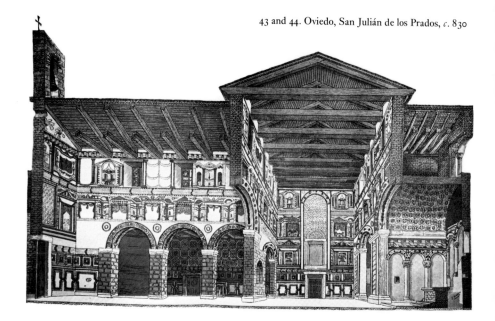

there by the invading Moors. Under Alfonso the Catholic (739–57), the new Kingdom of the Asturias or of Galicia began to expand southward, and to plant Christian colonies in the border zone which had been desolated by the constant raids from both sides. Legend has it that the Apostle St James the Greater aided the Galicians in battle, whence he acquired his name of Matamoros, his rank (maintained even in the twentieth century) of Colonel in the Spanish army, and his association with cockle shells. His supposed tomb, identified as such in 813, became a national shrine almost immediately, and led to the foundation of a Benedictine monastery, Antealtares, in the reign of Alfonso the Chaste (791–842). This king made Oviedo his capital, from which the kingdom was ruled until 914. A metropolitanate was established there in 811.[1]

By the end of the eighth century the architects had constituted a national pre-Romanesque style of considerable technical interest.

The oldest remains go back to about 780, and there are well-preserved examples covering the whole span of the ninth and tenth centuries. Among the chief monuments was the cathedral of Oviedo, founded in 802, which was an interesting group of buildings by a designer named Tioda. A reliquary chapel, the famous Cámara Santa, still survives [58]. Another major monument, now destroyed, was the double cathedral at Santiago de Compostela (879–96), which has been excavated in part, and is known to have resembled other Galician basilicas (Santullano, Lourosa [54C]), though the east end, with the shrine of St James, was rather more open and elaborate. Yet satisfactory representatives of the Asturian style of architecture, painting, and sculpture survive; they are being maintained and cherished.

At some time between 812 and 842 (perhaps about 830) Tioda built for Alfonso the Chaste, adjoining his suburban palace in the fields near Oviedo, the basilican church of San Julián de

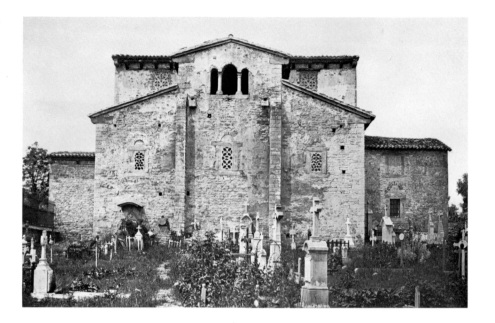

los Prados, or 'Santullano' [43, 44]. The north transept was evidently contiguous to the palace, for the king's tribune opened into it. The transept is relatively wide, roofed in wood, and higher than the rest of the church. The remainder of the building is composed around the transept in the familiar agglomerative Germanic fashion. There is a *porticus* at the south end of the transept; the sanctuary and chapels are oblong tunnel-vaulted compartments, of which the central one, only, is brought to the eaves level of the transept by an upper chamber (perhaps a refuge). The ample nave, likewise wooden-roofed, also reaches merely to the transept eaves. It is provided with aisles, a western porch, and a wall belfry or *espadaña*. The recent restoration has uncovered the rather rough, but good and substantial masonry of the church, and its astonishing interior decorations. These quite unexpectedly turned out to be a symbolic composition in the Pompeian style. Thirty-eight baldacchino motifs are figured, in refer-

ence (it is thought) to the thirty-eight Councils which had thus far been held in the Spanish Church. These paintings are among the most interesting of their kind. Yet this court chapel gives only a hint of the richness of Alfonso the Chaste's buildings at Oviedo: 'everything', says the Monk of Albelda (883), 'the King adorned diligently with arches and columns of marble, with gold and silver, and so with the royal palace, which he decorated with divers pictures, all in the [Visi]gothic way, as they were at Toledo – in church and palace alike'. There were a governmental building and a thermal establishment in Oviedo also in these great days.

One of the most interesting Asturian churches dates from the reign of Ramiro I (843–50). He, incidentally, contended successfully with the Norse raiders of whom we have heard in previous chapters; they did not get a foothold in Spain as they did in England, Ireland, France, and the Two Sicilies. Ramiro's church adjoined

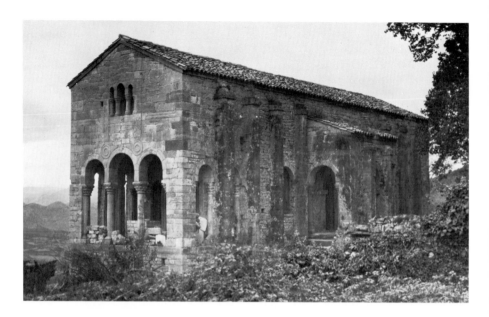

the palace and baths at Naranco, a pleasant hillside place near Oviedo. It was dedicated in 848 to Santa María, and has come down to us in a perfect state, except for the loss of a two-storey compartment on one of the long sides; opposite the entrance, and balancing the entrance porch [45, 46]. The architectural form of the upper part shows that it was built as a belvedere; yet the structure was certainly used for sacred ceremonial in connexion with the king – as for instance when he departed for war.

The existing old parts of the church have no suitable location for an altar, since the ends of the hall were doorways opening on unglazed exterior porches. The best solution of the difficulty is to suppose that the altar stood in the destroyed compartment opposite the existing entrance porch. The altar would then occupy the throne-place of a layout resembling a Germanic palace hall. The long hall itself would be a sort of transept for magnates, and the people, gathered outside the church, would hear the liturgy through the open end compartments.

Similarly, the populace gathered on the slope near the imperial palace hall at Goslar [94, 328] followed the proceedings through openings in the façade of the hall.

In point of development Santa María de Naranco occupies the position for Spain which Germigny-des-Prés has in France, Aachen in Germany, and 'St Columba's House' in Ireland. The masonry work is somewhat rough, but of excellent quality, having ashlar, used with admirable skill, to strengthen it in logical places. The main block of the building has a crypt of three compartments, the central one covered (on dwarf walls) by a heavy and strong tunnel vault with transverse arches of ashlar, one of the first of its kind in the medieval church architecture of the West. The end compartments (of which one was a bath) are ceiled in wood. Each of the crypt compartments sustains a compartment of the superstructure, taller in proportion, lighter and more sophisticated in construction. Pairs of attached columns carved in fine barbaric style carry an interior arcade

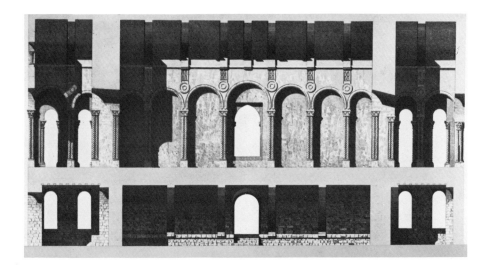

which thins and stiffens the wall, so that it is logically designed to take the thrusts of the tunnel vault above it. The vault again has transverse arches, and an extra arch is placed in the middle over the widest arcade arches (for the size of these is graduated). Under the other transverse arches there is a decorative strap-and-medallion inset which strengthens the wall.

Though it was vaunted as surpassing anything in *Hispania* (Moslem Spain) there is nevertheless a haunting sense that the whole building is somehow in debt to oriental modes of construction, probably through Visigothic and Moslem architectural works as much as anything else. Yet the Germanic aspects of the building must not be forgotten. Its palace hall plan had the effect of making it into a 'transept church' (of a type which is otherwise known in the Tur Abdin in Mesopotamia), but the compositional mode at Naranco is Germanic; for the building is an agglomeration of aspiring and intersecting forms. The flanks are divided into tall bays by slender ashlar spur buttresses.

There is no doubt as to the position and shape of the missing two-storey compartment, in the upper part of which we may suppose the altar to have been placed (in 848), for the mate to this compartment still exists on the opposite side, with its approach stairways and vaulting complete, applied, or 'apposed', to the main chamber in Germanic fashion.

In fact, the building was composed, basically, in the manner of the Saxon church of Bradford-on-Avon [34, 35], except that the Asturian work is vaulted with admirable solidity. The entrance porch and its mate come in just where they are structurally needed to abut the main tunnel vaults – for such vaults, when they have any considerable length, invariably tend to push out their supports and sink at the crown. In Naranco we have an appropriate solution (on a small scale to be sure) of the problem of vaulted church architecture which proved to be obstinately difficult throughout the Romanesque period. It is also worthy of note that the spur buttresses are proportioned like developed

Romanesque buttresses and logically disposed. The embellishment of Santa María de Naranco, while not Romanesque, nevertheless uses degenerate classic motifs, novel combinations, and even minuscule figure sculpture (in the medallions), and therefore we may say that it too gives a hint of future Romanesque forms.

The church of San Miguel de Linio, near Naranco, founded in 848, is a curious and ingenious vaulted building, now incomplete. It was laid out as a columnar basilica with a tunnel-vaulted nave and angular sanctuaries. The four terminal bays of the aisles had transverse tunnel vaults at a high level to abut the nave, and large transennae in these transept-like bays (of which two still exist) gave a good light to the whole interior. San Miguel has remains of paintings and a brave attempt at architectural sculpture.

There are interesting capitals and medallions, as at Naranco; the column bases have carvings, and an ivory book cover was reproduced, enlarged, in flat barbaric style on each jamb of the main portal. There is an odd suggestion of Early Gothic tracery, even, in the interesting transennae or pierced stone window screens of San Miguel.

Entirely vaulted, like Santa María de Naranco, the charming little church of Santa Cristina de Lena [47, 48] must be included as showing an interesting development of the Naranco theme. Santa Cristina has an entrance compartment with a tribune from which one looks up a longitudinal tunnel-vaulted nave to a platform and sanctuary compartment, marked off by a very interesting and fastidiously carved barbaric chancel parapet and arcade. The main

47 and 48 *(opposite and below)*. Santa Cristina de Lena, *c.* 905-10

49 *(right)*. Santa María de Melque, *c.* 900

vault is abutted by chapel-like compartments 'apposed' to the flanks of the nave. All the vaults are tunnel vaults, and all, except that of the tiny entrance way, have transverse arches. All the walls are stiffened by spur buttresses. This church was probably built shortly after 905, or at any rate in the reign of Alfonso III, the Great (866–910).

There remains to be mentioned the engaging little tunnel-vaulted basilican church of Val de Dios, dedicated in 893. It has Moslem-looking horseshoe arches in the sanctuary and the clerestory, and transennae – but also an added lateral porch with prophetic, Romanesque-looking grouped piers carrying a tunnel vault, dated in the tenth century. On a tiny scale, it offers a good solution to difficult problems, and, like Santa María de Naranco, has endured.

THE MOZARABIC STYLE IN NORTHERN SPAIN[2]

Little if anything survives to represent Early Christian basilican architecture as developed by the Visigoths except San Juan Bautista at Baños de Cerrato (661), with its horseshoe arches, its degenerate Roman carvings, and its square-ended sanctuary (one of three, widely spaced, which formerly looked into a wide transept). Vaulted architecture is represented by the church of Quintanilla de las Viñas, where construction appears to have been interrupted by the Conquest, shortly after 711.

What this Late Roman church style became under strong Moorish influence we may infer from the interesting vaulted church of Santa María de Melque, dated about 900 [49]. It is

solidly built of ashlar stone on a cruciform plan, and vaulted, with an effective use of horseshoe arches in the interior design.

Simpler works resembling San Juan de Baños and Melque were built by refugees who were driven out of the Moslem dominions by a recrudescence of intolerance at the end of the ninth century. This episode was a catastrophe for the Visigothic style, which was a city architecture; fine churches were destroyed in the Moslem dominions, and the similar buildings in Christian territories to the north suffered in the great raids of Almanzor at the end of the tenth century. The Christian kingdom, which was centred at León after 914, settled many of the refugees, who were called Mozarabs. Mozarabic architecture under the circumstances was really a local variation on Late Roman archi-

tecture, representing the end of an old tradition. It undoubtedly contributed a certain spice and oriental suavity to Spanish Romanesque. Lobed rosettes, prominent eaves-brackets of oriental character, and horseshoe arches were transmitted to Romanesque by the Mozarabic style. Its influence is probably to be traced in beautifully modelled leafage cut *en épargne* or *en réserve* – that is, rounded back from the ashlar face in Moorish or Saracenic fashion, against a sunk background.

The church of San Miguel de la Escalada, near León [50], is the finest and most accessible of the Mozarabic works. It was part of a monastery built for refugee monks from Córdoba in 912-13. The visitor finds himself in an austere but surprisingly sophisticated ensemble. The architectural membering, the proportions, the

50. San Miguel de la Escalada, near León, *c*. 912-13

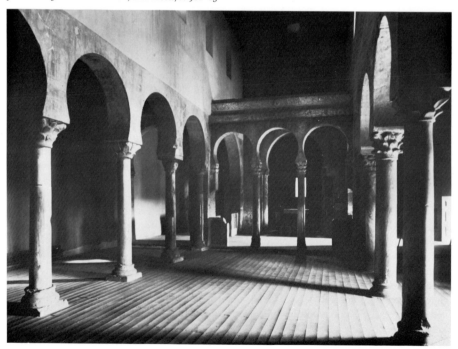

scale, the management of space and light are all very fastidious. The church is basilican and wooden-roofed except for the apses, which are horseshoe-shaped in plan, three in line within a blocky mass of masonry at the east end of the church. Each apse opens through a horseshoe arch. The east bay of each aisle is vaulted, and a chancel screen of elegant horseshoe arches carries the line across the nave. Graceful horseshoe arches divide the nave from the aisles, and the tiny clerestory windows have the same pretty shape, which was once more used when a fine side porch was added about 940; adjoining, there is a heavy tower, with a chapel, of still later construction.

Santiago de Peñalba [51], founded in 919, is a good, but a more rustic building. It is an odd composition of pairs – a nave of two bays, one

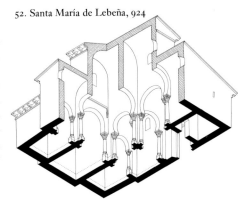

52. Santa María de Lebeña, 924

newly constructed. Like the Asturian buildings, it has a somewhat Romanesque look, but the cornice has characteristic Moorish 'chisel-curl' brackets. In the interior of Lebeña there

51. Santiago de Peñalba, founded 919

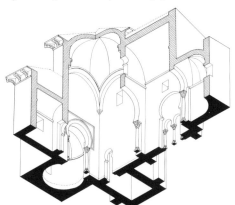

53. Covarrubias, Tower of Doña Urraca, c. 950

of them covered by a lobed dome; a lobed vault over each of the two apses (one of them of horseshoe plan, both of them in angular blocks of masonry); a pair of lateral compartments, forming a sort of transept, at each side of the domed bay.

Santa María de Lebeña, near Santander [52], was built in 924, under Asturian influence; it resembles San Miguel de Linio, which was then

are square piers with addossed columns which look very Romanesque, and suggest that Peninsular skill may have been drawn on in the tenth-century revival of vaulting farther north. However, the bold horseshoe arches give Santa María an unmistakably Moorish atmosphere. The tunnel vaults have a diaphragm in the nave to permit a clerestory. They are transverse in the aisles, and parallel over the sanctuaries. This arrangement is very good statically, and it builds up rather prettily in stages. Miss King said tellingly of it that 'the Spanish temper, like the Byzantine, craved the mystery of enclosed spaces, where light falls stilly ... and ... curved surfaces bound the vision, and brood'.

A rare example of civic architecture of the period is the Tower of Doña Urraca at Covarrubias,[3] dated about 950 [53]. It is heavily built of Moorish-looking ashlar, with a strongly battered profile, and is empty to half-height, where it is tunnel-vaulted. The upper part (now denatured through rebuilding) is entered through a horseshoe-shaped arch at this level. In Catalonia, the interesting horseshoe-arched portico of San Feliú de Guixols has been preserved.

Catalonia entered upon a flourishing epoch at this time, under the Counts of Barcelona, who held it staunchly against the Moors, but were nevertheless in contact, as Septimania had been, with Peninsular civilization and the Moslems. Much history centres in the abbey of Ripoll, which became the dynastic pantheon; in 977 a vaulted church with five apses was consecrated there. Surviving decorative elements of this building have unmistakable Mozarabic character, though it was not built by refugees [71].

Another abbey of importance, San Michel de Cuxa,[4] was founded in 878. Its 'fifty monks, twenty servants, extensive lands, thirty-volume library, five hundred sheep, fifty mares, forty pigs, two horses, five donkeys, twenty oxen, and one hundred other large horned animals' were put under the protection of Miron, Count

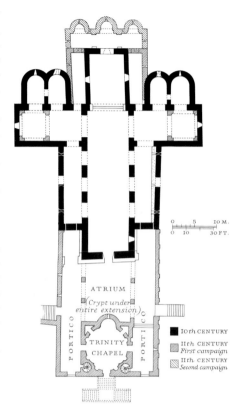

of Conflent and Cerdagne. Within a century of these beginnings the abbey was powerful and had built an important church (955-74) [54]. Parts of this structure which still survive show that it was stylistically Mozarabic, like contemporary Ripoll. It had a plain, long, stoutly constructed wooden-roofed nave and two shorter aisles all opening on an extended transept. A pair of absidioles opened through horseshoe arches into each transept arm, and a deep oblong sanctuary extended eastward on the main axis.

In this period Count Oliba Cabreto made a long visit to Italy, with a year at Montecassino. Returning, he multiplied Benedictine monasteries in his dominions, and much enlarged the Catalan horizon.[5] A Cluniac abbot, Guarin, was installed at Cuxa in 962, and Cluniac in-

fluence is traceable in Catalonia from this time. Cuxa actually represents the reorientation of Catalonia towards France and Italy, and the emergence of a Catalan nationality in the time of the great Abbot Oliba of Ripoll. It is quite fair to state that a national architectural style was adumbrated if not realized in the churches built under the auspices of Oliba and his family.

In Oliba's rebuilding at Cuxa (1009–40), influences from abroad are fused with the abiding east) has long been known. The ruins of the main storey, with its polyfoil nucleus, have recently been uncovered; and it may be that there was an upper level as well. The marble cloister of Cuxa, dated about 1028, is well known. It has been partly rebuilt in the recent restoration, as has the nave of the church.

Oliba's family was connected with the construction of San Pere de Roda,[6] a castle-monastery which stands up splendidly above

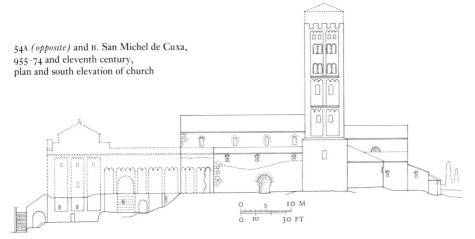

54A *(opposite)* and B. San Michel de Cuxa,
955–74 and eleventh century,
plan and south elevation of church

0 5 10 M
0 10 30 FT

Moorish tradition. Investigations at the church show, for instance, that some of the Mozarabic horseshoe arches were modified in Oliba's rebuilding. Two large towers of Lombardic character were added. East of the old sanctuary an angular ambulatory with three eastern chapels was built; clearly there is a relationship to French examples in the tradition of Saint-Philibert-de-Grandlieu. West of the church of Cuxa, where there had been a stairway and platform, the quatrefoil chapel of the Trinity was built on the axis, leaving an atrium with lateral entrances (as at Parenzo, or at an Ottonian site) in front of the main doors. The Trinity was a vaulted church of the central type with flanking aisles, of which the circular crypt (also with flanking aisles, and a vaulted extension to the the coast near Gerona. As at Cuxa, there was later building strongly influenced from Lombardy, but the temper of the whole church goes back to Oliba's time, and, like Cuxa, it has grand scale and marked local feeling. A text ascribes the interesting chevet to Tassi, who reformed the monastery of San Pere de Roda [55, 56], and obtained royal French and papal diplomas for it before his death in 958. A consecration is reported in 1022. It has been established by Señor Gudiol Ricart that the building took its general character at this time. The oldest work is a crypt with an ambulatory, above which is an apse with an ambulatory. The ambulatory has an upper gallery with windows which light the apse, and altars were installed in it; one thinks of Chartres (858), Charlieu (c. 950), Abbot

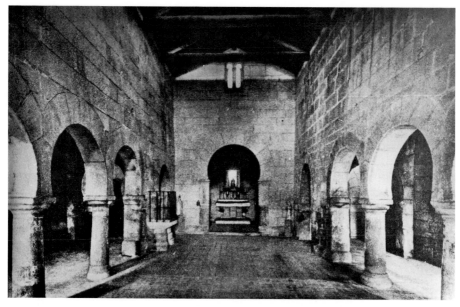

54C. Lourosa, parish church, 912 and later

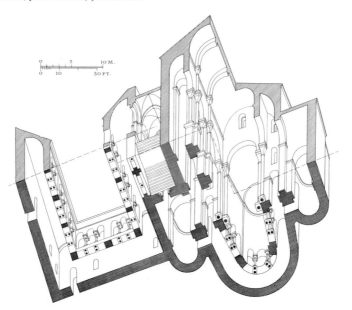

55 and 56 *(above and right)*. San Pere de Roda, near Gerona, consecrated 1022, finished later

Guarin (962), and Saint-Bénigne, Dijon (1001–1017). Excellent ashlar stone was used for the architectural membering. The applied columns, the shape of the voussoirs, and the horseshoe arches in an odd way recall Germigny-des-Prés, which was built by Theodulph, who came from this region.

San Pere de Roda has a trapezoidal sanctuary bay, a transept with absidioles, and a capacious nave with striking T-shaped piers; the latter have applied shafts with a variety of beautiful half-Moorish capitals related to those of Mozarabic Cuxa. Quadrant vaults with transverse arches cover the tall narrow aisles; the nave and transept are covered with tunnel vaulting, with an arch spanning between each opposite pair of piers. This higher and more elaborate nave is believed to be the result of a change of plan in the eleventh century. The resulting design probably influenced the nave of the eleventh-century church of Saint-André-de-Sorède in

French Catalonia – an example noted for its early sculpture also.

While we have followed the convention in calling this Catalan work Mozarabic and Lombard, Señor Gudiol Ricart is nearer the truth in classifying it as a young national style, like the Asturian.[7] Further study of the monuments and systematic presentation would help greatly.

One final Mozarabic monument, in Castile, may be introduced. As a kind of swan song of the style in the eleventh century we have the extraordinary hermitage of San Baudelio de Berlanga, near Burgos [57]. The plan is like that of a Norse single-masted church with an oblong sanctuary, but the superstructure, all vaulted, is very different. Its very blocky and austere exterior conceals an interior of fantastic architectonic richness. A central cylindrical pier rises to sustain a set of eight radiating horseshoe diaphragm arches, which carry a domical vault with a very ingenious little shrine arranged in

57 (below). San Baudelio de Berlanga, eleventh century, with twelfth-century paintings

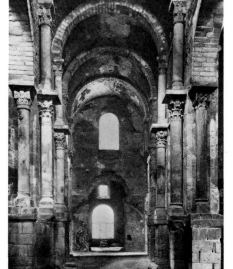
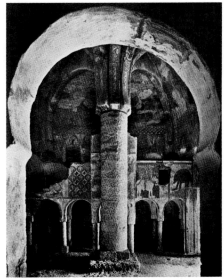

the masonry above the pier. A raised choir, really an oratory, is sustained prettily on a forest of slender shafts placed in *quadrille* (oriental fashion); horseshoe arches carry the platform. Formerly the interior was decorated by an extraordinary series of frescoes, dated about 1150, which symbolize the reorientation of the area, toward France, for the style is quite Romanesque.[8]

The strong tide of influence from the Moorish South of Spain in the tenth century, which we have been considering, also prevented the expansion and further development of the Asturian proto-Romanesque style. When, with the progress of reconquest, the capital was moved to León, the kingdom was much more open to outside influences than distant Asturias and Galicia had been. As the eleventh century progressed, irresistible artistic influences came from France with political reorientation and the reform of the church which was effected by Cluniac monastic clergy from France. The twelfth-century rebuilding of the Cámara Santa in Oviedo [58] shows this clearly.

Conversely, however, knowledge of Moorish architecture increased greatly, from the year 1000 onward, among lay folk, technicians, and churchmen who had contacts with Spain. Such knowledge was widespread in areas where Romanesque architecture was being formed at the time. Saracenic elements are, in consequence, a component of the mature Romanesque style.

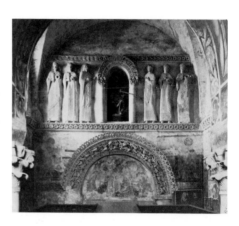

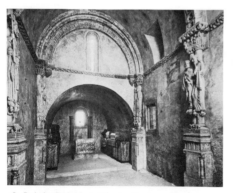

58. Oviedo Cathedral, Cámara Santa, *c*. 802.
The nave somewhat rebuilt, and embellished with sculpture in the twelfth century

THE LOMBARD KINGDOM

The strange Tempietto of Santa Maria in Valle at Cividale[9] [59, 60] is perhaps most easily explicable as a proto-Romanesque work – Roman architecture surviving in a local variation under Saracenic influence, like the Asturian and Mozarabic churches. Santa Maria is traditionally identified with a building built by Peltruda (762–76) at which time the Lombards had south Italian connexions. The building has a groin-vaulted nave and a sanctuary with three parallel tunnel vaults carried in an unstructural fashion upon columns. As is the case with San Baudelio de Berlanga, the exterior is very plain and the interior is very rich; possibly Moslem influence from south Italy is responsible for this. There are no horseshoe arches at Cividale, and we

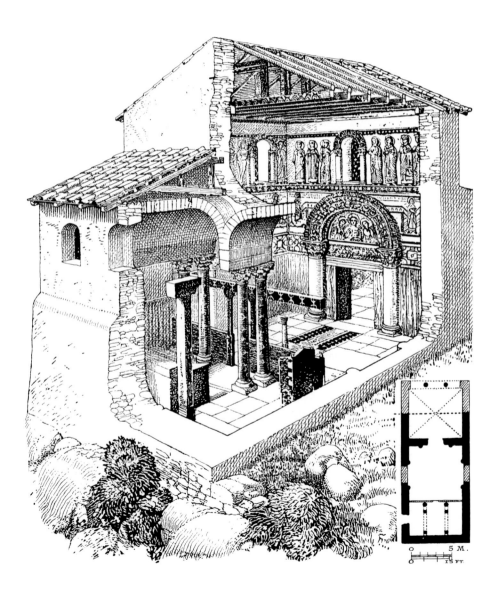

59 *(opposite)* and 60. Cividale, Santa Maria in Valle, the 'Tempietto', *c.* 762–76(?)

should not expect them here at this time; for they spread only after being assimilated into the Moorish art of Spain.

There is clearly some outside influence in the decorative stucco mouldings and bands of the interior of Santa Maria. Stucco work was practised with rare art by the Saracens and Byzantines; also more often than we are likely to remember, by pre-Romanesque and Romanesque sculptors in both France and Germany. What is most remarkable at Cividale is the perfect preservation of a frieze of six beautiful standing figures in stucco, gracefully posed, and boldly modelled like fine Romanesque carvings. They were applied as integral plaques to the wall. Perhaps a refugee from the Byzantine iconoclastic controversy was the artist; even the Byzantinism of the near-by Exarchate and Venice would explain the character of the sculptures.

The Lombards, aggressors against Rome and Montecassino, are generally thought of as destroyers. However, they had a fairly well organized state, with administrative cadres at Pavia, their capital. After the conquest (774) the Franks utilized these cadres, and they aided in the task of setting up Charlemagne's empire.

Yet there are two established facts which give the Lombards a place in the history of proto-Romanesque architecture. Rotharis, the first of their kings to issue laws in his own name, registered the privileges of the builders in 643, and thus had something to do with the organization and revival of architecture in the region. Again, about 714, King Liutprand issued a diploma with respect to a price scale for architectural and structural work.[10]

Milan, the metropolis of Lombardy, had been a great centre in classical times, and came to be so again, especially after the conquest of Lombardy by the Franks under Charlemagne (774). One would expect an architectural revival to begin there, and indeed this occurred in the ninth century. However, King Rotharis's

charter of 643 refers to the builders as *magistri commacini* or *comacini*, and on this basis it has been supposed that there was a guild at Como which created and spread Lombardic architecture. If the Comacine régime was observed over a wide area, *comacini* may have come to mean simply builders, as *lambardos* came to mean masons, even in Spain. That there was a guild organization of some sort, involving established ideas of responsibility, training, and compensation does not admit of doubt, and we owe Lombardic architecture to the creative work of these guildsmen. On the other hand *comacini* is an obscure word, and it cannot be shown to have a connexion with Como, nor can Como be shown to have had a central 'masonic' guild organization of wide importance. The word *comacini* dropped out of use in the early Middle Ages. Because μηχανή in Greek, *machina* in Latin, and *macina* in Italian may mean a frame or scaffold, *magistri comacini* has been interpreted *master-companions of the scaffold*. Because the tradition of architecture was better maintained in the Greek Exarchate than in Lombardy, the name may be connected with some obscure Greek word – or even μηχανικός, which means contriver or designing architect.[11] Whatever the meaning, the *comacini* wrought well in preparing the architectural revival in Lombardy.

THE BYZANTINE EXARCHATE

After Rome's glorious period, the centre of administration for Italy was moved to Milan (in Diocletian's time) and then to Ravenna (402), but the life of the Empire at that time was most vivid in the East. Yet Milan was flourishing in the period, which is that of St Ambrose, its great bishop (374-97), who baptized St Augustine there in 384. The abounding fertility of the Po Valley kept Milan prosperous even during the unhappy rule of the Lombards, and when that was terminated (774), the region came into even closer relationships with its neighbours, papal

Rome and the Exarchate. This latter jurisdiction was set up by the East-Roman Emperor Maurice about 600, was conquered by the Lombards in 752, and, because they threatened the Pope, it was freed from their rule by Pepin III, who gave it to the Roman pontiffs (754–6).

The Byzantine Exarchate, with its continued Eastern connexions, maintained an architecture which was at one and the same time a living continuation of Late Roman architecture and an active outpost of the newly-constituted Byzantine style.[12] No other early medieval style had so august a lineage. As Ravenna paled in turn, the Ravennate style was simplified until it could successfully be put at the service of the struggling barbarian kingdoms. Thus, without a break, it became a proto-Romanesque style. Its roots and its stem are Roman; its branches are authentically the First Romanesque style,

aptly so named by Josep Puig i Cadafalch, who first clearly discerned the significance of this fact. Outside the Exarchate, the style was first used and spread by the Lombards, which justifies its older name, Lombardic. In the end it made an architectural reconquest of a large part of the area of the West-Roman empire, and for that reason the French have called the style *impérial*, or *du Bas-Empire*.

The Exarchate has several important Byzantine monuments, which our exposition takes up merely in their proto-Romanesque aspect.

Galla Placidia's famous tomb [61], built in the decade or two before 450, looks towards Romanesque architecture through its perfectly straightforward brick exterior, with simple corbels and decorative arcading of the sort which becomes the most familiar adornment of the First Romanesque style.

61. Ravenna, Tomb of Galla Placidia, *c.* 450

62. Ravenna, San Vitale, 526-47

San Vitale (526-47) [62] has a number of interesting features. Its plan suggested that of the Palatine Chapel at Aachen, where the columnar screens are simplifications of its pierced apses. The entrance-tower-and-reliquary chapel at Aachen with its stairways is, though differently proportioned, partly dependent on the narthex of San Vitale. This is true of the westwork of Saint-Riquier also. The exterior of San Vitale has decorative arcading and pilaster strips which are bolder and more medieval in form than those of the mausoleum of Galla Placidia – and are hence to be counted in the prehistory of the First Romanesque style.

Flanking the apse at San Vitale there are two pylons somewhat resembling those of the con-

temporary Syrian architecture. In fact, San Vitale has three types of tower – the pylons just mentioned, a round stair tower attached to the narthex, and its mate, carried up to form a cylindrical belfry after the Benedictines took over the church in 910.[13]

Pylons, though they are occasionally seen in the early church architecture of the West, did not have a long history there. The round stair tower continued in use, usually on a small scale. There were exceptions like the Irish round towers, the flanking stair towers of Saint-Bénigne, Dijon (really Lombard First Romanesque), minor towers of certain German churches (like Trier Cathedral), the belfry of Pisa Cathedral (the famous leaning tower), one important

Spanish church (Frómista), and a group of churches in and near Ravenna; but the round tower plays a distinctly minor role in church design. Even the engaging idea of a chapel at the top of a round tower, recorded in the plan of St Gall, was never represented as far as we know in an actual building. The square belfry tower, adumbrated at San Lorenzo in Milan (c. 375), started supposedly with the one added in 754 to the east front of Old St Peter's, spread rapidly to Lombardy and thence, through the First Romanesque style, became almost universal.

A bell large enough to be heard at a distance could not properly and decorously be rung from the crossing space of a church because of its very great inertia. Thus inevitably the exterior belfry wall (bell-cote or wall belfry) and, for greater height, the belfry tower, were developed, the name *campanile* being doubtfully connected with Campania. [14]

The Benedictines, centred at Montecassino, which is in Campania, early adopted bells. Nothing certain remains at Montecassino, yet Benedictines built some of the earliest known belfry towers, in fact square belfries – veritable Roman *turres*, built up integrally from the ground – at Ravenna. Earliest is that of San Giovanni (Benedictine in 893); San Pier Maggiore has a contemporary square belfry, according to Corrado Ricci. A sign of early date in the various belfries of Ravenna, he observes, is the fact that they are not systematic in their location with regard to the churches. [15]

Most important is the fact that the square belfry was adopted early in Lombardy, and spread thence to Burgundy, where it appeared before the end of the tenth century. Through Abbot Odo of Cluny and his successors, who knew Lombardy well, the square belfry became familiar in northern Europe. Both the narthex of Saint-Philibert at Tournus (dated about 990–1019) and that of the second church at Cluny, built between 948 or 955 and 981, surely complete by the year 1000, had a pair of belfries on the west façade, flanking the main door. At Cluny the crossing belfry, instead of being a wooden *turritus apex*, was built as an oblong tower of somewhat Lombard character. This process is a perfect case of a Roman idea living on in the Exarchate, taking medieval form there, and, after being systematized by monastic practice, being spread to Lombardy and thence to great areas of Western Christendom.

Sant'Apollinare in Classe (533–49), though a fine basilica of the ancient type, is also important from the point of view of incipient medievalism. The apse and the lateral chapels at the east end build up in boldly articulated forms which forecast the vigorous handling of masses in medieval architecture. The bold west front has an arcaded axial porch; the adjoining dwarf tower with its mate (now destroyed) made a pair of pylons at the façade. [16] Sant'Apollinare also has an archaic example of the ambulatory crypt like that of Old St Peter's. It is sometimes dated as early as 800; at any rate it is an addition, and probably of the ninth century.

Also interesting for our purpose is the upper part of the Baptistery of Neon in Ravenna, possessing an undated but early example of the pilaster strip with arched corbel-table between, which is to be the hallmark of the First Romanesque style, wherever it is found, in Italy, Dalmatia, France, Spain, Switzerland, and Germany. This part of the Baptistery wall is often ascribed to the eighth century, but it may be earlier.

The same applies to the frontispiece of the so-called Palace of the Exarchs [17] [63]. Here we have a building which is extraordinarily like the mature Romanesque of Lombardy – yet in function like the guard quarters of the Chalki at the main entrance of the Sacred Palace in Constantinople. The porch, guard room with dormitory, courtyard, and chapel of the Saviour, are organized in Byzantine fashion, and were probably built, with the protective palace wall, when the Lombards began to extend their power, after

63. Ravenna, Palace of the Exarchs, after 712

712. All was surely built before the fall of the Exarchate in 752, and is described as old by Agnello, writing before 850. Yet the wall-work of big bricks, the paired openings, the decorative arcading, the vaulting, and the buttressing are practically identical with Lombard Romanesque work produced in the four following centuries.

Corrado Ricci believed that Romanesque terracotta insets – as for example at Pomposa [301] in the porch and campanile built in the eleventh century by Abbot Guido of Ravenna – are of Ravennate origin. Other features of the city's architecture were also widely known and copied. Theobald, bishop of Arezzo, speaks of 'Maginardo *arte architectonica optime erudito*' whom he sent to study in Ravenna in the year 1026. Maginardo moved on a well-travelled road, to a famous source of architectural knowledge.[17]

THE EARLIER ROMANESQUE STYLES

CHAPTER 5

THE 'FIRST ROMANESQUE'

LOMBARDY

The style created about the year 800 in Lombardy became the first really international Romanesque style. Its ramifications were early spread to Dalmatia, to southern France and Catalonia, to Burgundy, to the Rhine country, and even to Hungary. Late Carolingian work, as we shall see, formed a strong, satisfactory, and consistent style in the west of France, with imposing monuments (now lost) to its credit. It had an excellent system of wall construction developed by the Gallic masons, but no tradition for vaulting on a large scale or at high levels. In the other regions named, the incoming Lombardic style pushed local building methods into discard; western France maintained its own traditions unaffected by the 'First Romanesque'.

It was no mere 'style' in the literary sense which was transmitted from the Exarchate to Lombardy, but a living and efficacious system of building, with a particular skill in vaulting. In this we recognize Rome's ancient skill in co-ordination. The practical, working systems which produce a building are more important than literary-minded critics suspect, and can only be appreciated to the full by personal participation in the intricate teamwork by which successful building operations are conducted. This aspect of the art can be traced from Ra-venna to the comacine masters, and thence into the current of Romanesque architecture.

In the Dark Ages there was little building which called for the services of highly instructed professional men, but there was probably never a time when such men were unavailable.

The man who drew the plan of St Gall was like a Greek μηχανικός - the Greek name for an architect - μηχανή being the word for an intricate device of some sort. The ἀρχιτέκτων of the Greeks was a responsible, somewhat independent 'clerk of the works'.[1] William of Volpiano, abbot of Saint-Bénigne, Dijon, was both μηχανικός and ἀρχιτέκτων: 'reverendus abbas magistros conducendo et ipsum opus dictando, insudantes dignum divino cultui templum construxerunt'.[2] Under medieval conditions the patron would generally have a delegate to manage his side of the building operation, which might include supply and transport of materials. Leo of Ostia, who carefully described the rebuilding of Montecassino by Abbot Desiderius, was probably the abbot's delegate. The master builder, like the Greek ἀρχιτέκτων, would direct the various groups of master masons and work gangs. Gangs would have their foremen on a large project, and some would actually come as teams to the site.

The magistri in charge of the practical construction could build a real building, even if the μηχανικός or 'idea man' gave them only a

linear diagram with the chief dimensions as guide, because experience, in that age of conventional and even habitual procedures, dictated the size and material of the walls, as well as the spans and the interior proportions. That is how the plan of St Gall could satisfy an early medieval master. The dimensioned description of the abbey of Cluny of 1043 was made from a similar linear diagram, as we know from the observed fact that many of the dimensions include a room or corridor width plus one wall.

With increasing size and complication in buildings, a more numerous group of professional designers and clerks of the works came into being – the *magistri* par excellence. Evidence for them in the early period is shadowy, but in Gothic times their function is far too well recognized and too specialized to be of recent creation. The myth of the devoted faithful spontaneously raising medieval shrines is dissolving, now that relevant documentary evidence for the buildings has been discovered and studied.[3]

Until the towns and the monasteries became large, the masons necessarily worked as travelling bands. It was the same with bell-founders, glass-makers, stucco workers, fresco painters, and mosaicists, for a longer period. Bernardo, who had a French name, and fifty master masons, many of them indubitably French, were called by bishop Diego Peláez to work (from 1075 onwards) at the remote Galician cathedral of Santiago de Compostela. Yet Abbot Suger at Saint-Denis, only a few miles from medieval Paris, was no better off. When his great church was undertaken (about 1135) he was obliged, as he says, to call craftsmen from various regions and considerable distances.[4]

An *atelier* thus assembled might become rooted; it would give training to local talent, and in time become a centre from which craftsmen could be sent elsewhere. William of Volpiano brought craftsmen from his native Lombardy, and it is believed that they worked on his abbey church in Dijon, begun in 1001. From

the abbey of Fécamp in Normandy, which William ruled, he received the plea: 'In the matter of the craftsmen of our buildings which we are commencing, we beseech that you will hasten to send them to us, for we really need them (*valde nobis necessarii sunt*)' – in a region which was slowly recovering from the devastations and (after 910) the new immigration of the Norsemen.[5]

For a considerable area this process of craft diffusion started in Lombardy. *Lombardus* became the word for mason at an early period. Clearly the more-than-half-Latin Lombard builders were only doing for the revived Empire what their forebears had done for the Roman Empire.

One might call the First Romanesque style the style of this Italian architectural reconquest. It is worth noting also that a large portion of the work was done for the monasteries, which from the early tenth century onwards became increasingly the instrument of papal policy and implemented the first stages of the pontifical conquest of Europe which Gregory VII and Boniface VIII achieved. Rome, revived once again in the Renaissance, made another and more familiar architectural reconquest.

The *magistri comacini*[6] had more than the ancient reputation of Italian builders to recommend them. They had a new type of wall construction, rhythmically decorated and pleasant to look at, which was practical and proved its usefulness over the whole wide area of the First Romanesque style, even where conditions were primitive. They adopted the Byzantine type of oblong brick (which, because of the *magistri*, has come down to us) and built whole walls of it as we do, without form work, instead of making puddled concrete walls faced with triangular tailing brick held by forms, as the Romans did. Such comacine walls were called *opus romanense*. The ancient Romans had used facing stones also, but the First Romanesque wallwork which developed from this was called *opus*

gallicum. The masons merely split small stones roughly to a brick-like shape, and used them like bricks. Irregular stones or rounded river pebbles were laid diagonally and ingeniously 'dressed' into horizontal courses by varying the slopes. This was doubtless suggested by the ancient *opus spicatum* or herringbone work, and it abounds in buildings of the First Romanesque style until the eleventh century. The hearting or core of a stone wall was not puddled in mortar inside a facing and form, but was rather a rough rubble laid with some care.

Insufficient credit is given these men for their skill in finding excellent materials for their mortar, which is almost invariably of good quality, wherever found. It makes the wall-work endur-

ing, and the vaults solid and strong. The walls were often covered with stucco, which was occasionally ruled with false joints to represent ashlar. But stucco, properly applied, has a beauty of its own. It has too often been stripped from interiors; on the exteriors it vanishes in about two hundred years.

Vaults were built, like Roman vaults, over centering or false-work which provided a great supporting mould. Short little boards held in position by trusses and poles formed the bed. Sometimes earth was heaped on the forms and moulded, where the geometry of the vault was difficult. On the form, roughly shaped stones were laid in mortar, and the haunches of the vault were brought up with hearting work. In

64. Milan, San Vincenzo in Prato, eleventh century, in tradition of church of *c.* 814–33, from the south-east

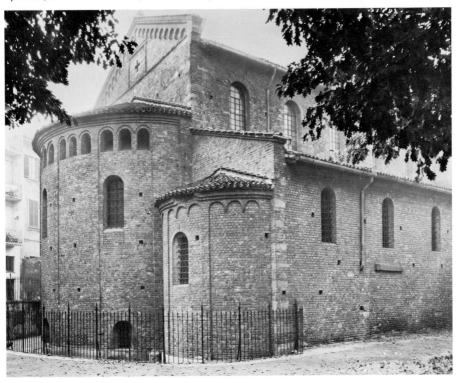

the First Romanesque style, groin vaults were freely used; apses were regularly vaulted, and tunnel vaults were also common. In work which can surely be traced to Lombards, tunnel vaulting is little, and very cautiously, used at high levels. For crossing vaults the Lombards used a derivative of the Roman domical or octagonal cloister vault, rather than the Byzantine dome. The Lombardic crypts, groin-vaulted over a quadrille of columns, are characteristic, and are widely used within the area of the style.

By the tenth century architectural membering of ashlar was again in use. Second-hand columnar capitals and shafts were by this time almost unobtainable. The practice of making big blocks especially for their places brought about a progressive improvement in the masonry.

Milan, the Lombard capital, has lost its Carolingian and First Romanesque buildings. These have, however, a good representative in the simple columnar basilica of San Vincenzo in Prato [64], a brick structure so conservatively rebuilt in the eleventh century that it was accepted (except certain details) as the church of c. 814-33.[7] Its only vaulting is in the three parallel apses, henceforth characteristic of this type of building. This part of San Vincenzo has the tell-tale First Romanesque pilaster strips and arched corbel tables, with typical arched recesses under the eaves of the main apse.

San Pietro at Agliate, near Milan, though now assigned to the eleventh century, well represents work of the date formerly attributed to it, c. 875 [65]. It has a basilican nave and two

65. Agliate, San Pietro, chevet, style of c. 875

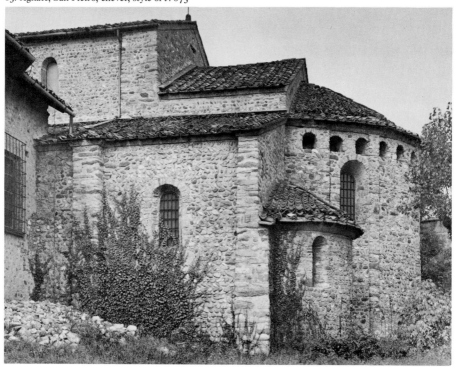

aisles, carried on re-used columns, with a vault over the sanctuary bays and apses at the head of the composition. The builders did not venture a clerestory under the tunnel vaulting of the sanctuary bays, but the apses were pierced with windows as usual, for the thrust of a semidome is much less than that of tunnel or groin vaulting. The sanctuary platform is raised at San Pietro, and there is a spacious groin-vaulted crypt with lateral entrances under this platform, at the pavement level of the church as at Sant'Apollinare in Classe. San Pietro at Agliate is stone-built, of crude but attractive wall-work, and a comparison of the oldest parts with the twelfth-century campanile will show how easily the accomplished mature Romanesque grew out of the more primitive style. In passing, the baptistery should be mentioned as a companion example of a building of the central type (about 900).

Santo Stefano in Verona, rebuilt about 990, has a crypt and an apse, each of which is supplied with an ambulatory, the upper one opening on the main apse through an arched colonnade. Ivrea Cathedral (before 1002) has the wreck of a similar construction.[8]

Before leaving these early buildings, mention should be made of several interesting monuments which show continuing Byzantine influence in Lombardy. San Satiro at Milan (876) is, except for Renaissance additions, a perfect Byzantine four-column church. Its tower, dated about 1043, is one of the earliest of the characteristic Lombard square towers. The apse of Sant'Ambrogio has mosaics dating from about 940, when the present system of crypt, choir apse, and flanking sanctuaries was built.

Three monuments near the borders of Lombardy show the First Romanesque style on the threshold of maturity, lacking only the greater finish of execution and perhaps the sculptural embellishment which are found in the Second Romanesque style. The first of these buildings is the baptistery of Biella, near Novara, a cen-

tralized edifice dated about 1040, with sophisticated use of squinches and buttresses, though rough in construction. More conventional is the stone-built basilica of San Paregorio at Noli,[9] west of Genoa in Liguria. Its exterior is well composed and gracefully decorated with pilaster strips and arched corbel tables. The apses, the crypt, and the aisles are vaulted. Substantial piers of logically grouped elements sustain the vaulting and the high clerestory wall. This was a very acceptable type of building at the time, about 1020–40. The third monument, San Pietro at Civate, near Como and Lecco, is dated about 1040. It is a double-ender, with the entrance passage flanked prettily by two absidioles facing east within the mass of the western apse. These three elements open upon a wooden-roofed nave through three arches beneath a tympanum frescoed with the Victory over Evil. The altar of San Pietro has a remarkable old baldacchino resembling that of Sant'Ambrogio in Milan.

DALMATIA

The further spread of the Lombard style, and the round church type, are both exemplified in San Donato at Zadar (Zara), Yugoslavia, built during the Frankish occupation (812–76) – or at latest before 949, when it was described.[10] This building has an interesting anticipation of the ambulatory with radiating chapels. An annular aisle surrounds the central space, and opens on it through arches, which are single except at the east, where there are three arches resting on columns. Opposite these openings are the three apses. Continuing from the apses (to each side) the enclosing wall has a series of niche recesses.

CATALONIA AND ANDORRA

Westward expansion of the First Romanesque style across the south of France from Lombardy

is certain but not well marked by early monuments, though work of First Romanesque character survives in the cathedral of Vence. The style surely came to Catalonia by land and by sea. The Catalans, then as now living on both slopes of the Pyrenees in Rousillon and the eastern part of the Spanish March of Charlemagne, were in a fortunate period, when the County of Barcelona was flourishing. The new mode at first coalesced with and then supplanted a strongly Mozarabic architectural style. Many good examples were built, and still survive almost unchanged in back-country places which have escaped the devastating effects of later prosperity. The result is that the First Romanesque style is better represented in Catalonia than anywhere else.[11]

It must be noted that the style, with its characteristic masonry work and decorative system, came into a region which built successful tunnel vaults related to Roman, Moslem, and perhaps Provençal examples. The resulting tunnel-vaulted work is more properly called Lombardo-Catalan First Romanesque.

The interest of the style resides in its expert vaulting at an early date, though wooden-roofed churches were also built. Senyor Puig i Cadafalch believes that vaulted construction can be traced back to the middle of the tenth century. He dates the church of L'Écluse (La Clusa), now in French Catalonia (aisled, with three parallel tunnel vaults), about 950; so also Santa María at Amer, dedicated in 949; and Santa Cecilia de Montserrat [66] – an interesting church, perhaps the one dedicated in 957. In that year St Stephen at Bañolas was rebuilt in the same way after being burned by Norsemen. These buildings had their sloping stone roofs

66. Montserrat, Santa Cecilia, 957 or later, from the east

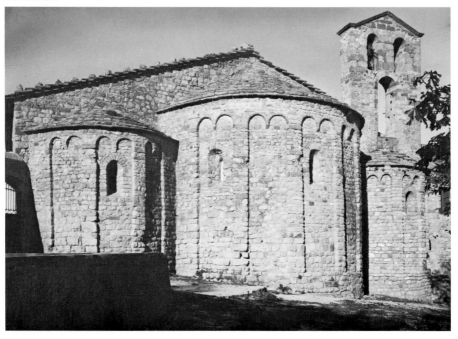

laid directly on a rubble filling above the web of the vault, which is practical in southern but not in northern climates. Conservative opinion (that of Señor Gudiol Ricart in particular) dates the churches somewhat later. Low and unassuming, the structures are very happily related to their setting, with a look of natural objects rather than buildings.

Just after the year 1000 a notable example of this vaulted Lombardo-Catalan style was built on a picturesque spur of the huge mountain mass called the Canigou,[12] above Prades in French Catalonia. Long-continued neglect made a restoration necessary about sixty-five years ago, but the work was well and lovingly done so that the building stands as a witness, complete in its inspiring original setting, to the architecture of that remote age [67-9]. Characteristically it is a monastery (dedicated to St

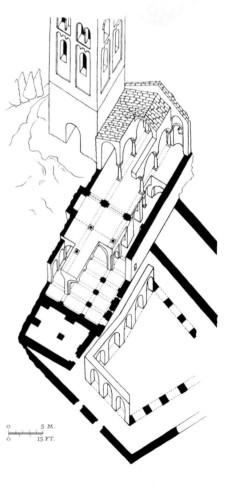

67 and 68. Saint-Martin-du-Canigou, 1001-26 (restored), interior and analytical perspective

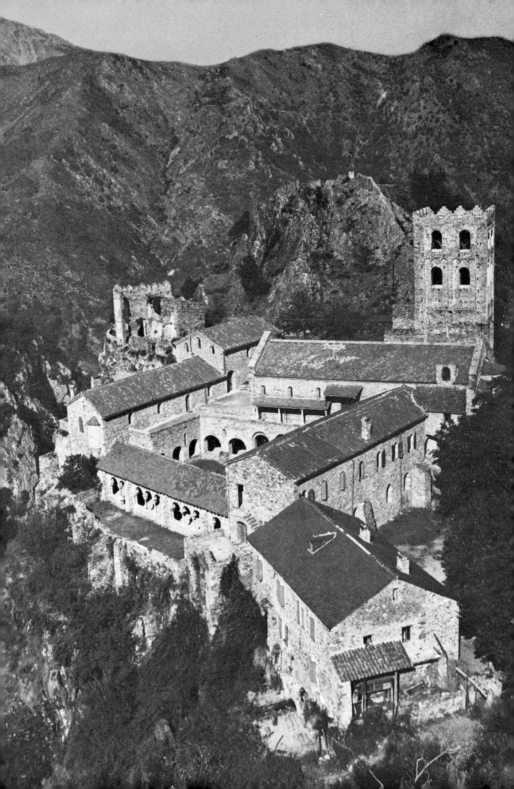

69. Saint-Martin-du-Canigou, 1001–26 (restored), view from the south

Martin) with the austere, solidly built church and conventual quarters arranged about a small cloister. The rooms command lovely views.

A winding approach road leads to and through a splendid big tower, strategically placed and crowned with Moorish stepped battlements which break its substantial mass against the sky as happily as the characteristic pilaster strips and arched corbel tables model its ample surfaces. This tower composes beautifully with the rocky masses and with the building group; it is contiguous to the church on the north-east.

The church is on two levels. Its crypt has tunnel vaulting with transverse arches carried on two files of grouped piers, except at the head, where there are two oblong piers and two columns carrying a set of nine groin vaults just in front of the three apses. Beyond the west end of the church crypt there is another, which supports a platform in front of the church proper. The latter is as long as the two crypts together, and consequently the three church apses extend beyond the crypt apses, towards the east.

For its period, the superstructure of the church is a remarkable achievement. The three long tunnel vaults which cover the nave have only ten interior supports – two sets of four columnar shafts with simply-carved capitals, separated by two grouped piers supporting arches which greatly strengthen the middle part of the building, where a tunnel vault is most likely to collapse. The tower, the lateral recesses (including a chapel with a quadrant vault), and the monastery buildings abut the high vault so well that only a fraction of it collapsed during a century's neglect of the roofing surface after the secularization and abandonment of the site in 1785.

The church interior is lighted only from the ends, which might seem to be a defect in the building – but, in fact, many of the monastic services take place at night. Also, it was usual for the monks to know large parts of their liturgy by heart, and therefore natural light was not so important.

Clearly, Saint-Martin-du-Canigou is an excellent piece of architecture: the more so because it is of early date – 1001 to 1009 (for a preliminary consecration) and 1026. The monk Sclua, who superintended the building, became the first abbot in 1014, apparently after a preliminary regime under Oliba, abbot of Ripoll and Cuxa, later bishop of Vich (Ausona), whom we have already mentioned.[13]

The architecture of the period came to a high point at the monastery of Ripoll under Oliba. A spacious cruciform church with double aisles, transept, and seven apses was begun about 1020 (possibly incorporating some older work), and dedicated to the Virgin on 1 January 1032[14] [70-3]. After many vicissitudes the building was restored (imperfectly, romantically, and too radically), between 1886 and 1893. Its magnificent plan was unmistakably inspired by Old St Peter's in Rome, and the vaulting as unmistakably by Roman imperial works. The nave vault is modern, but parts of the transept vault are old. Santa María de Ripoll was without doubt one of the grandest works in the First Romanesque style. The rough stone, which is usual in the style, and the heavy, obstructive piers (which made the modern tunnel vault possible) give a sombre character, but it must be remembered that the church had extensive fres-

coes, a jewelled altar, and a mosaic pavement with animals and sea monsters. The chief surviving embellishment of the building is a carved doorway of the twelfth century, connected iconographically with manuscripts created in the scriptorium which flourished from about 950.

Ripoll was one of the lights of its age. It had a large library (246 volumes in 1046), and its school was illustrious for works of history, poetry, astronomy, music, and mathematics.[15] The range of Oliba's own activities is indicated by his personal friendships with Pope Benedict VIII, with Gaucelin, the great abbot of Fleury, and (it is said) with Hugh of Semur who became abbot of Cluny shortly after Oliba's death.

The stone sculpture at Saint-Martin-du-Canigou, Cuxa, and Vich is not remarkable; but at Ripoll there are still in existence a few interesting pieces which show the influence of fine Moorish workmanship[16] [71]. With good

70 and 71. Ripoll, Santa Maria, c. 1020-32 (restored 1886-93), interior (nave vault modern), and capital in Moorish style, tenth or eleventh century

72 and 73. Ripoll, Santa María, *c.* 1020-32 (restored 1886-93), plan and view from the south-east

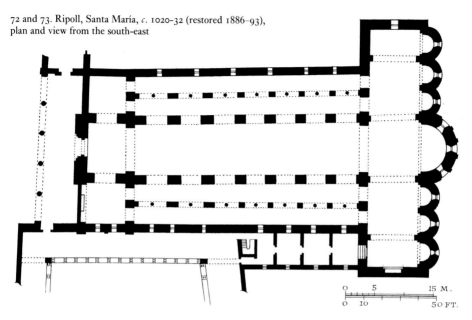

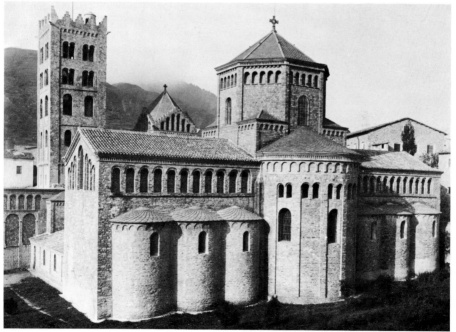

stone-carvers becoming available in Catalonia, and because the *milieu* was intellectual, it may be supposed that some members of Oliba's circle suggested the serious, doctrinal use of figure sculpture on church exteriors – a novelty in Western Christendom. In fact, the use of apocalyptic themes carved in relief on church portals was initiated in early eleventh-century Catalonia, and with it one of the most brilliant episodes in the history of sculpture. Concurrently, the use of figural decoration on the arcades of cloisters inaugurated one of its most poetic episodes.[17]

Such enlarged use of apocalyptic iconography was the more natural in view of the special interest which northern Spain and southern France had in the subject, resulting from imaginatively illustrated and widely circulated manuscripts of the Commentary on the Apocalypse by Beatus of Liébana (780). The church of Saint-Genis-des-Fontaines has the oldest preserved architectural example, a marble lintel dated 1020–1, with Christ in glory, two angels, and six of the apostles. The figure carving is obviously archaic, and hardly glyptic in style: it looks like a copy of stucco-work or metal repoussé [74]. Saint-André-de-Sorède (inspired

by half-Moslem San Pere de Roda, as Señor Gudiol Ricart says) has a similar lintel, more or less contemporary, but showing details of Moslem origin. On the façade of the church of Arles-sur-Tech, later a Cluniac priory, is a cross, datable to 1046, with Christ in glory and the symbols of the four evangelists.[18]

The marble employed is local. It has been used since antiquity. Well-carved altars were made of it and exported; late examples turn up in Cluny (1095) and Toulouse (1096).[19] This same marble was also used for cloister capitals, for example at Cuxa in French Catalonia and at Toulouse.

The intellectual and art-loving Cluniac monks, who used Resurrection iconography in their liturgical processions, had priories at Saint-Béat, Saint-Pons-de-Thomières (1080), and Arles-sur-Tech; it is certain that they collaborated in the spread and development of this sculpture for cloisters and portals. Of this more will be said later. In the architectural constructions of the earlier period there are many scattered examples of sculptural embellishment. They occur between 975 and 1080 in Burgundy, Saxon England, Germany, and Byzantium, but they cannot (at any rate for the present) be con-

74. Saint-Genis-des-Fontaines, church, lintel, 1020–1

nected in so convincing and purposeful a system of stylistic development as can these doctrinal works of French Catalonia, Languedoc, and later Burgundy.

Returning for another moment to Catalonia, we may say that the foreign influences introduced into the architecture about the year 1000 eventually brought the mature Romanesque to that region, but meanwhile many tardy examples of the First Romanesque were still produced. Their apses and towers give much character to the countryside. This is particularly true in Andorra, which is (in a way) but the continuation of Catalonia. Santa Coloma, Andorra, has a handsome round tower of twelfth-century style. Later Catalonia produced many beautifully finished works in the maturer style, which in its turn was much cherished. That is the explanation of the contract signed in 1175 (really in the Gothic period) between the Chapter of the Seo de Urgel and Raimundus Lambardus, who engaged to work on the cathedral with four companion *lambardos*. The church they built is an excellent example of the mature Lombard Romanesque style [233].

This old style was not entirely given up when the Gothic eventually reached Catalonia. Very often the sun-baked sober brown bulk of a thirteenth-century cathedral or a fourteenth-century tower will be essentially Romanesque. The church paintings long retained a Romanesque imprint.[20] The beautiful museum at Barcelona includes re-mounted frescoes, baldacchinos, altar frontals, and many other objects associated with the cult. There is no place where a better contact with certain spiritual aspects of Romanesque art may be attained.

THE KINGDOM OF ARLES

We have already seen the expansion of the Lombard First Romanesque style into Liguria; it moved up the Rhône Valley to Switzerland and Germany in the tenth century. Leaving aside Tournus and the regions around Cluny and Dijon (whither the style was brought about 987 or 1001 by William of Volpiano), we follow it to Romainmôtier,[21] which became Cluniac in 929. For the existing church, the date 996 and later is acceptable, because of the resemblance of the oldest parts of the building to the second church at Cluny (948 or *c*. 955–81) [104, 105].

GERMANY

St Mary, the circular chapel with radiating absidioles on the Feste Marienburg, at Würzburg, has been claimed as a monument of 706, but its identification is not certain and its Lombardic features appear to be of later date.[22] There was a continuing penetration of Germany by Italian influence from Charlemagne's time onwards, but existing examples with 'First Romanesque' features look to the practised eye less like the works of Italian architectural missionaries than like the achievements of Germans trained in the tradition of Carolingian building, yet willing to improve their vaulting technique and to adopt such features as Lombard pilaster strips, arched corbel tables, and block capitals. Good German wall construction, faced with excellent ashlar, was superior to Lombard First Romanesque work, and the grand tradition of Carolingian monumentality was more imposing than anything the Italians could bring to the Northland at the time.

One of the oldest conspicuous buildings showing a German version of the Lombardic pilaster strips and arcading appears to be St Pantaleon in Cologne (begun under Otto the Great, after 966, dedicated in 980) [77]. This church had many outside contacts through its very famous *atelier* of enamellers. Lombardic detail appears early also in Wimpfen (979–98). More doubtful is St Castor, Coblenz, as of the end of the tenth century. A striking example often cited is the façade tower of the church at Mittelzell on the Isle of Reichenau, but this

work, according to recent studies, must be assigned to 1048[23] [20]. The Lombardic themes, once integrated into German architecture, were spread far and wide, and easily reached neighbouring Hungary and Moravia. They also much later reached Russia in a modified form, probably from Germany, and contributed superficially to the elegant beauty of the twelfth-century churches in and about Vladimir. Rascia (naissant Yugoslavia) borrowed Lombardic motifs from early Dalmatian work, and perhaps also from Norman-Apulian buildings across the Adriatic. The imprint of Lombardy was strong at first in Yugoslavia – at Studenitsa (c. 1195), Zhicha (1202-20), and Visoki Dechani (1327-35); a reminiscence survived the change of orientation which made Serbia a Byzantine state, and counts for something in the beauty of churches like that of Manasija, contemporary with the Turkish conquest. Thus the rhythm of the Late Roman pilaster strips and the ripple of their connecting arches lived on to appear in the architecture of the medieval empires, German and Slavonic.[24]

ROMANESQUE ARCHITECTURE IN GERMANY

UNDER THE SAXON AND FRANCONIAN EMPERORS (936-1125)

THE OTTONIANS;
THE OTTONIAN ROMANESQUE

The First Romanesque style which we have followed from Ravenna to Old Russia came as an episode, bringing some technical improvements and an attractive decorative system to the architecture of Germany near the end of the reign of Otto I, the Great (936-73). The independence and great power of German architecture are themselves an external sign of the grandeur of the second imperial Renaissance, called Ottonian.

Since the Carolingian age the country had suffered terribly from wars with the Slavs, the Vikings, the Magyars, as well as from dynastic weakness and internecine feuds. The Saxon dynasty was inaugurated by King Henry I, the Fowler, who reigned from 919 to 936. He began the long process of putting the government in order – assuring the frontier, and refusing to buy off the barbarians. Characteristically he is remembered in architectural history for works of fortification, especially at Merseburg, Werla (near Goslar), and Quedlinburg, where important urban centres subsequently developed.[1]

While the Ottonian church designs are, in the Carolingian tradition, agglomerative, there is a new, commanding skill in the composition of their varied elements, as Louis Grodecki's monograph *L'Architecture ottonienne* (Paris, 1958) admirably proves.

Saxony, because of the dynasty, became the architectural centre of gravity in Germany, and produced or influenced church designs which are among the most impressive of those bequeathed to us by the Early Romanesque. However, the renewal brought about notable construction over a wide area. There was, for instance, a general development of military architecture; many of the sites which are graced by German castles (ultimately numbering nearly 10,000) were fortified at this time. Yet the heart of the people was in the church architecture, and where the churches are preserved, they still breathe the massive unity of the Christian Imperial community. Traditionally in Germany, and in Byzantium (as in England still), the Church was cherished as the spiritual aspect of the community under the sheltering power of an anointed ruler. Conflict with the Popes, who were developing an effective international ecclesiastical government, greatly injured the Empire.

During the confusion which had all but destroyed the Western Empire, the Papacy fell to its nadir. It was monasticism which came to the rescue of the Roman Church. The great monks who reformed the Papacy were accustomed to the unqualified obedience which an abbot receives in his monastery, and this conception, applied to the Papacy, resulted in schism with the Eastern Church (1054, 1245) and a fatal loss of authority by the government of the Western Empire at critical times (1076, 1250).

In medieval Germany it was still unavoidable for the rulers to rely on churchmen and church organization for many essential services and for fiscal support. The ranking abbots retained importance, but the principal bishops could more becomingly act as court figures, and they came to have important governmental

attributions, along with copious resources and considerable power. Under these circumstances the construction of a number of very imposing cathedral buildings in Ottonian and Franconian times needs no further explanation. Groups of buildings are associated with certain bishops, and reflect their taste, in all cases marked by elemental strength and superb grandeur.

Otto the Great (936–73), who renewed the Imperial office in 962, developed Magdeburg as Germany's great bastion against the Slavs. He founded a church here, served by Benedictines from Trier (955), which in 967 became the cathedral. The building was somewhat smaller than the existing Gothic structure, which incorporates columns of porphyry, granite, and marble brought from Italy for the original building. Many details are unclear, yet it is certain that the layout resembled that of the cathedral of Parenzo, with an atrium and baptistery at the

west; the nave was a vast wooden-roofed basilican structure with columnar supports; it is certain also that the eastern apse was flanked by two towers, and that the cathedral was fortified. The church inaugurated a series of related buildings - the cathedrals of Mainz, Augsburg, and Worms among them, but rebuilding has deprived us of these examples also.

Yet Otto the Great's period is well represented in middle Germany by the former convent church of St Cyriakus at Gernrode [75, 76], founded in 961 by Margrave Gero, *defensor patriae* against the Slavs. It is about half the size of Magdeburg's old cathedral. Gernrode is very well constructed in excellent ashlar masonry. Except for the added western apse, transeptal galleries, and exterior arcading above the aisles, Gero's church, recently restored, still exists almost unchanged. It is handsomely austere in the interior, where there is a fine rhythmic alter-

75 and 76. Gernrode, St Cyriakus, 961 and later, view from the south-west and interior

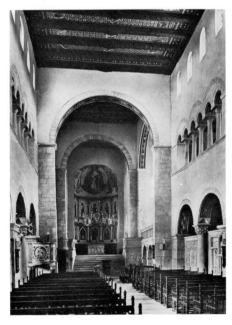

nation of columns under arches with substantial masonry piers.[2] The crossing is strongly marked, and the proportions, here, at the east end, are vertical. The exterior is a graceful interpretation of Saint-Riquier, though without the lanterns. It is said that the Empress Theophano (d. 991) gave funds to complete the work, which is a fine example of bold Ottonian agglomerative composition.

St Pantaleon in Cologne, already mentioned, should be recalled here as a work of the reigns of Otto the Great and Otto II, built with a subsidy from the bishop, Bruno, who was Otto the Great's son. Of the work begun after 966, finished and dedicated in 980, only the westwork with three towers retains its original character [77].

77. Cologne, St Pantaleon, 966–80; porch modern

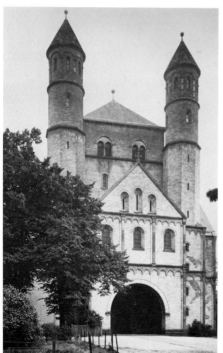

In the reign of Otto II (973–83) the major church enterprise was the new and greater cathedral of Mainz, begun under Archbishop Willigis in 978.[3] Carolingian influence, and influence from Old St Peter's in Rome, were strong in the design, and the grand scale of the building is perceptible to-day, for the majestic lines of the very elaborate existing cathedral were largely determined by Willigis's building. Its red sandstone bulk is sharply detached against a long wooded ridge, and it stands on a low shelf above the Rhine close to the confluence of the Main. This latter river flows directly toward the cathedral, which is thus visible for many miles down the valley. The existing cathedral has reverse orientation, inherited perhaps from Willigis's building, and corresponding to the reverse orientation of Old St Peter's. It was formerly approached, like the latter building, through a propylaeum-chapel of St Mary and an atrium. At Mainz, each of these features would seem to have occupied a square about 120 feet on a side, and the nave, with two aisles, two more. It is supposed that there was already in Willigis's time a western transept about 60 feet wide and 200 feet long with a single apse, and that a church of the central type, perhaps the Constantinian cathedral, lay beyond. Here there would be an analogy with St John Lateran, the cathedral of Rome.

Willigis's cathedral was burnt on its dedication day in 1009, and was reconstructed in similar form (though perhaps with a trefoil west sanctuary which increased the composite length to about 600 feet) by Archbishop Bardo. A new dedication took place in 1036. The new east façade of Mainz Cathedral had a central apse, and the building was consequently a 'double-ender' like Fulda. The flanking round stair turrets of the east façade, and some wall-work, are now ascribed to Bardo's reconstruction. Through this and moreover through many subsequent building episodes – notably in 1060–

78. Mainz Cathedral, restoration study as in 1036 (Kautzsch). Flanking stair turrets still exist

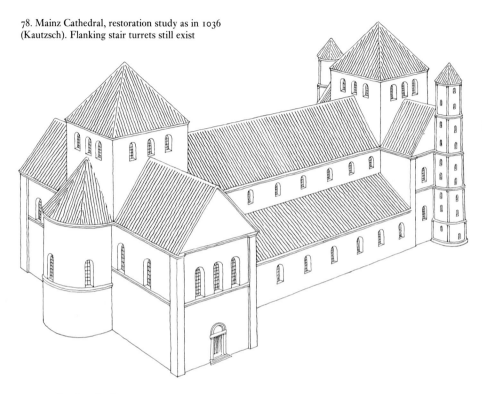

1137 – the Carolingian cachet has been maintained [78, 333].

Charlemagne's age is recalled in the Ruhr country by the western choir and tower of the Minster at Essen, which dates from the reign of Otto II (973–83), Theophano (973–91), or perhaps Otto III (983–1002).[4] A curious half-hexagon with galleries, resembling a fraction of the Palatine Chapel, was built here as a western choir. Above it stands a square façade tower set between two stair turrets. Below the towers was an atrium closed on the west by a baptistery, as is the case at Parenzo Cathedral in Italy, and, with variations, in the Ottonian cathedrals of Magdeburg and Mainz. Such atria were more than merely entrance ways; it is known that they had a special importance in processional liturgies.

Shared between Otto II and Otto III is the original church of Wimpfen im Tal (979–98), a hexagonal building based on Charlemagne's Palatine Chapel at Aachen. Like the plan (recovered by excavation), the façade (dated late in the construction programme and still existing) is simpler than that of Aachen. The doorway is in a deep recess, the bold arch of which carries a gallery; at the corners rise two simple octagonal towers.

In spite of the brilliance of the Emperor and his tutor Gerbert of Aurillac, later Pope Sylvester II (999–1003), and their interest in antiquity at the opening of the new millennium, the reign of Otto III (983–1002) is not well represented in architecture.

Mention should be made, however, of the new cathedral of Augsburg, which was started

in 994 on the scale of the existing large and important building. It had a pair of square towers set flanking the aisles, at the east or entrance façade, which, as in the other Ottonian cathedrals mentioned, has an apse on the axis.[5] The tower arrangement is handsome, and came to be widely used. Italian and French examples of the disposition are well known (Parma Cathedral [308, 309] and Rouen Cathedral), but a connexion cannot be traced; however, Augsburg Cathedral is probably in the lineage of such tower-pairs in near-by Hungary, and thus it was an influential design.

The successor of Otto III was his cousin, the sainted Emperor Henry II (1002–24) of happy memory. Characteristically a great deal of monumental church construction went forward during his reign, and the remains which have come down to us nobly exemplify the temper of the time. He created a new centre of imperial power at Bamberg in the east, where a cathedral and residence were built in the years 1002–12. Henry II was interested in church reform; he grouped a congregation of ten abbeys about the

79. Strassburg Cathedral, restoration study of façade, as in 1015 ff. (Kautzsch)

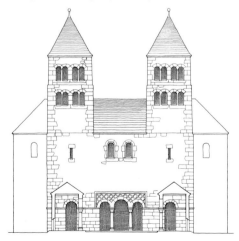

old monastery of St Maximin in Trier, and was friendly to the Cluniac monks. Henry met Abbot Odilo of Cluny at Rome in 1014, the coronation year, presented him with the imperial crown and orb, and is said to have visited the abbey in company with Meinwerk, bishop of Paderborn, in 1015.

Under Henry II, about 1015, a start was made on a great Early Romanesque cathedral at Strassburg. Excavated foundations seem to indicate that this building was planned to have noble square towers at the façade, with a porch between, set directly in front of the aisles and nave respectively[6] [79]. In view of the fact that a similar narthex façade was newly finished at Cluny in 1015, may we suspect direct influence? The paired western towers of Strassburg, being attached directly to the church proper, prefigure the typical cathedral frontispiece, which eventually prevailed over the tripartite Saint-Riquier theme. Strassburg is important too, with Reichenau, as the training ground of Benno of Osnabrück (c. 1028–84), who was in charge of the office of works for Henry III and Henry IV; he built castles for the latter.[7]

The Strassburg façade scheme was adopted in a fair number of buildings in near-by areas. All were basilican in form, with clerestories and wooden roofing, simple in plan and austere in their architectural lines. The list includes the cathedrals of Basel (1019), and Constance (1069–89); the abbeys of Einsiedeln (1031–9), Schaffhausen (1050–64), St Aurelius, Hirsau (1038–71), and Marmoutier (Maursmünster); the latter façade, dating from the twelfth century, has octagonal corner turrets, with a tall and generously proportioned square axial belfry tower behind them.[8]

New construction was initiated under Henry II at Worms Cathedral, which has largely preserved its old character throughout long-continued rebuilding. Henry II's great counsellor, Burchard, bishop of Worms, was responsible for this work.

Henry II and Bishop Meinwerk, together with Odilo of Cluny, arranged the penetration of Cluniac monks into Germany, for the bishop refounded Abdinghof at Paderborn as a Cluniac priory in 1016.[9] The church, dedicated in 1036 and partly replaced in 1058–78 after a fire, is interesting as the first example in north Germany to be built on Cluniac lines.

Beginning in 1009 Bishop Meinwerk also built a cathedral in Paderborn with the western choir in a tremendous square tower, very unmistakably Germanic in feeling, even without the tall steep spire, which is of later date [80].

This imposing tower and its accompanying stair turrets recall, in severe and powerful Ottonian form, the chapel of the Saviour at Saint-Riquier.

The eclectic spirit of Meinwerk is further proved by the construction, in 1017, of the chapel of St Bartholomew near the cathedral by 'Greek' workmen.[10] The aisled interior, made up of domed compartments carried on two files of columns, has a Moslem cast to it which makes us suspect that the Greeks came from the south of Italy. The columns have quite exceptional carved capitals, remarkable for their plastic

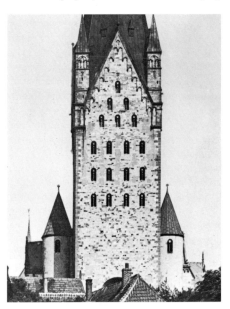

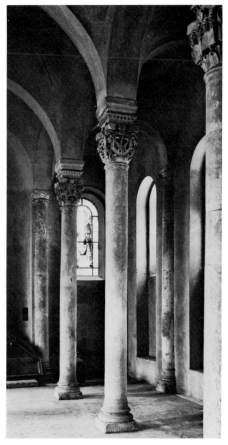

80. Paderborn Cathedral, façade, up to cornice of tower 1009

81. Paderborn, Chapel of St Bartholomew, 1017

vigour in an age when the stone carver was very far behind the bronze caster, the ivory carver, and the repoussé worker [81].

Important too is the connexion with Italy of the builder-bishop Bernward of Hildesheim, who went to the peninsula in Otto III's suite in 1001.

This subject inevitably calls up another north-German church - Bishop Bernward's cherished St Michael at Hildesheim[11] [82-4]. The building, begun about 1001, had a dedication of the crypt in 1015, which is also the date of its celebrated bronze doors, now installed in the cathed-

struction of Willigis's huge cathedral there, and he served as bishop of Hildesheim from 993 to 1022. Some German art historians are inclined to believe that Willigis's church of 978-1009 underlies St Michael, though the latter church showed considerable variations on the theme. Its composition is typical, bold, and skilful.

St Michael now shows every indication of its original arrangement, which in some ways was unusual. The western part has a transept terminated at each end by galleries and a slender exterior stair tower for communication, composing handsomely with a square lantern at the

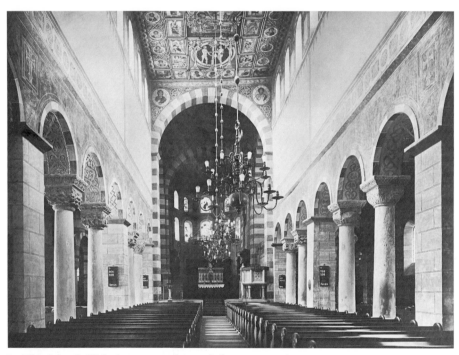

82. Hildesheim, St Michael, 1001-33, 1162, nave before reconstruction

ral; by 1033 St Michael was complete. Reconstruction of the church after severe war damage has given us back the original design, which is credibly ascribed to Bernward himself. He had been at Mainz as subdeacon during the con-

crossing. There are also a spacious sanctuary bay and an apse, beneath which lies the crypt of 1015. The crypt is reached by a semi-subterranean passage built outside the sanctuary and enclosing it. The eastern part of the building

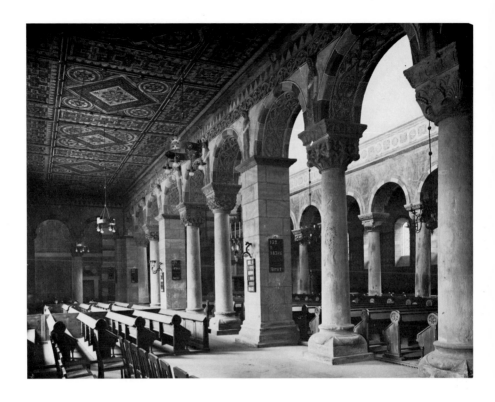

has never had a crypt, and its sanctuary bay was shorter, but otherwise the design was the same as that of the western part. Between these two nearly symmetrical terminations stretches the basilican nave with its aisles. The south aisle served as a sort of interior narthex, since the two main entrances are there. Visitors therefore entered the church 'broadwise', as the monks did. This curious contradiction of the basic basilican plan was logical in a monastic church which followed the theme of Saint-Riquier and St Gall, and is technically very interesting.

The ever-memorable bronze doors in the cathedral were really made for the lateral main entrances of St Michael [84]. As already reported, Bishop Bernward visited Rome in 1001 with Otto III, and he lived for a time in the young emperor's palace on the Aventine, near Santa Sabina. This latter church still possesses a pair of fifth-century carved wooden doors which perhaps suggested the works at Hildesheim.

It was a flourishing period for church art of this sort. One recalls the bronze Easter column made for Bishop Bernward before 1022, now in Hildesheim Cathedral, and Abbot Gaucelin's bronze *analogium* at Saint-Benoît-sur-Loire (about 1026) – also the altar of the Palatine Chapel in Aachen, given by Otto III (983-1002), and the splendid pulpit there given by Henry II, his successor, an admirable achievement indeed, dated between 1002 and 1024.

The gorgeous golden altar frontal presented by the Emperor Henry II to the cathedral of

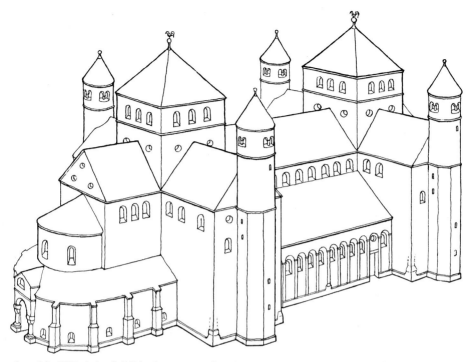

83 and 84. Hildesheim, St Michael, 1001–33, 1162,
aisle before reconstruction
and sketch restoration as in 1001–33

Basel and now in the Cluny Museum in Paris, poses problems also. It is dated about 1020, and obviously represents a different stream of artistic development as well as a different method (repoussé) and a different material. The loss of monuments of this kind through fire, pillage, levies, and remelting is only too well attested by documents. But from the vigour of the Hildesheim doors and the perfection of the Basel frontal a conviction emerges that these cannot be casual or sporadic works. Such understanding and skill as these monuments show presuppose a tradition of basic craftsmanship transmitted from generation to generation. It is quite possible that the vogue of precious altar frontals and other ecclesiastical furniture with figure sculpture delayed the renaissance of figure sculpture in stone by absorbing most of the fine talent available for work of that scale and character.

Sculpture in stone received an occasional impulse, perhaps, from men who were also able to work in some other medium, and were called upon to produce figure sculpture for special positions where only stone would be suitable. This situation would account equally for the carvings on the (destroyed) sarcophagus of Abbot Hincmar of Reims (d. 822)[12] and the figures set over the outer doors of the great abbey church of St Emmeram at Regensburg shortly after 1049. Metal-sheathed statuary and reliefs had formed cores of wood or mastic. The bronze-worker's sense of bulk and his wax model, the repoussé worker's hammer and drill,

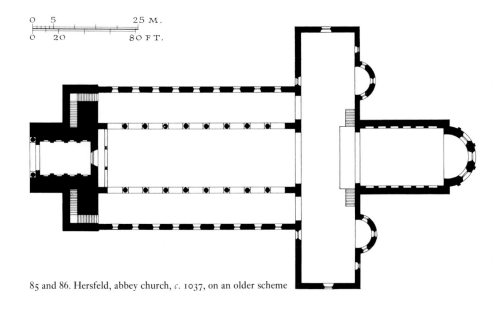

O 5 25 M.

O 20 80 FT.

85 and 86. Hersfeld, abbey church, *c.* 1037, on an older scheme

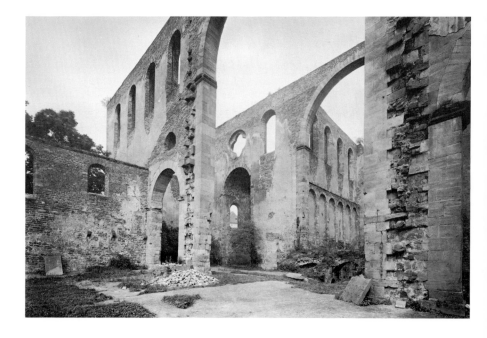

the ivory worker's chisel and finishing process, and (since the designs were painted in elevation on the blocks before being cut, and tinted afterward) even the manuscript and fresco painters' craft were a preparation for the general renewal of figure sculpture in stone.

THE SALIAN OR FRANCONIAN EMPERORS

Under Conrad II, the Salian (1024–39), the cathedral of Strassburg went forward, and a related building, the magnificent abbey church of Limburg an der Haardt (1025–45), was begun.[13] The reforming Abbot Poppo of Stablo, under Cluniac influence, had it built near the *Stammburg* of the Franconians. It inspired many other such structures. Cluniac influence is perhaps ultimately responsible for the western tower pair and the tower at the crossing, but the temper of the building is unmistakably German in its monumental, fastidious austerity, and grand dimensions, over a bold and simple plan. The church is a ruin, like that of Hersfeld (from about 1037, on an older scheme) [85, 86]; both reach into the reign of Henry III (1039–56).[14]

More important, however, is the cathedral of Speyer. It was the dynastic pantheon of the Franconian house, and though like the other *Kaiserdome* – Mainz and Worms – it has been much rebuilt, it has preserved, better than they have done, the simple and assured grandeur which marks the finest buildings of the German Early Romanesque [87–91].

Work was started on the existing structure under Conrad II about 1030, and the remarkable crypt [87] dates from the initial period. The whole area under the transept was marked off by piers into three spacious compartments, each with four stout columns, to carry connecting arches and nine bays of heavy groin vaulting.

87. Speyer Cathedral, crypt, *c.* 1030 and later

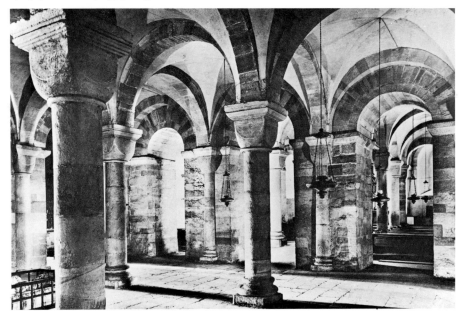

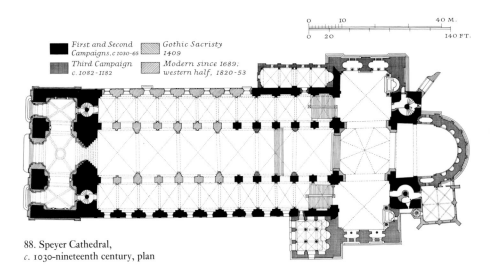

First and Second Campaigns, c 1030-65
Third Campaign c. 1082-1182
Gothic Sacristy 1409
Modern since 1689; western half, 1820-53

88. Speyer Cathedral,
c. 1030-nineteenth century, plan

Nine similar units compose the vault of an area under the sanctuary bay of the church, continuing eastward into a series of six more, fitted into the apsidal hemicycle; thus the crypt under the sanctuary arm of the church is laid out with two files of four columns each. All the columns have 'cubical' (or block) capitals of which the origin is Byzantine or Lombard, but a peculiar weightiness here makes them seem German; indeed, the form was widely used, with interesting variations, in German Romanesque architecture. The simple and ample power of the mature German Romanesque is already patently to be seen in this crypt.

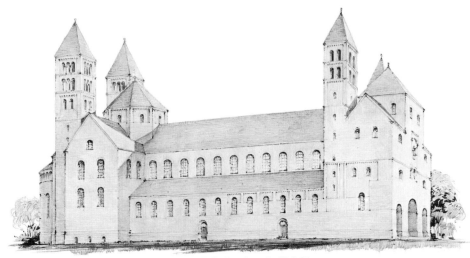

89. Speyer Cathedral, restoration study of north flank as in 1061 (K.J.C.)

The vault of the crypt forms, of course, the platform of the transept and sanctuary of the church proper [88]. These members are enclosed by a massive precipice of wall, with tall stair towers just west of the apse. Westward from the crossing extends the huge nave, with a spacious groin-vaulted aisle on each side. The western wall is about 20 feet thick; it includes a deep double-splayed portal and two spiral stairways in this enormous thickness. The stairways detach themselves as flanking towers at an upper level, and to the west of them a large open porch (with tribune and a great octagonal tower) was laid out. This brought the total length to about 435 feet, which is almost exactly that of Chartres Cathedral. Comparison of the two will strikingly show the overwhelming stout simplicity of the German design [89].

The nave at Speyer has a span of about 45 feet, which is close to that of the cathedral of Beauvais, widest of the High Gothic churches. Its height is approximately twice this dimension. The length of the nave proper, about 235 feet, is about five times its width, and ranks with the grandest and largest achievements of both Romanesque and Gothic. The walls of the nave bear an obvious resemblance in design and scale to a Roman aqueduct, though the model was probably nearer – the exterior elevation of the Basilica at Trier. The nave piers at Speyer measure about 6 by 8 feet plus engaged shafts, which, on the nave side, continue upward as the supports of a tall blank arcade measuring about 85 feet to the soffits. This arcade encloses the aisle and a series of large clerestory windows, and it provided support originally, at a level over ninety feet from the pavement, for a vast timber roof [90]. Construction went forward on the nave from about 1040, under Henry III (1039-56), and there was a dedication in 1061, perhaps when the great church in its wooden-roofed phase had been brought more or less to completion.

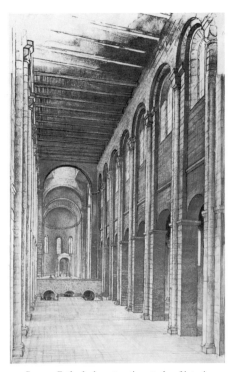

90. Speyer Cathedral, restoration study of interior as in 1061 (K.J.C.)

A new period of construction (1082-1106) starting under Henry IV finally saw the nave vaulted, as was probably intended from the beginning. The ultimate result, achieved under Lothair II (1137), is very impressive, but on account of the overwhelming scale it must be visited to be appreciated [91]. Alternate piers of the original nave were strengthened with shafts and dosserets, so that they now measure nearly ten feet across, in order to sustain six immense double bays of domed-up, unribbed groin vaulting separated by transverse arches. The crowns are about 107 feet (32·61 metres) from the pavement, higher than any other Romanesque nave vault; the basic measure-

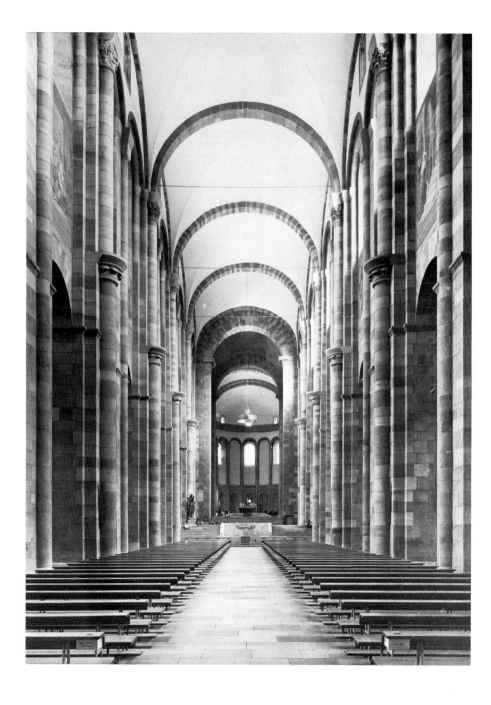

91. Speyer Cathedral, interior of nave, looking west, *c.* 1030–61 and twelfth century

ment was probably 100 Carolingian feet (34 metres or a little less) between two undetermined points. The crossing has a vault half as high again – the loftiest Romanesque vault – in a great octagonal tower carried on squinches, and pierced with two stages of arched windows. This powerful vertical element, though not telescopic, recalls Saint-Riquier, as indeed does the arrangement of two slender stair towers near each of the great octagonal towers.

Gothic Beauvais and Milan have nave vaults reaching to about 158 feet from the pavement, and the highest vault of the crossing tower at Beauvais was about 440 feet from the pavement. But these Gothic designs were built in a style which was engineered specifically to permit breath-taking effects of height. The fair comparisons for Speyer are with Romanesque Cluny III (1088–1130), where the nave was 98 feet high and the major crossing about 119 – or, better still, with the Basilica Nova of Maxentius and Constantine in Rome (A.D. 310 ff. – clear span 83 feet, height 120 feet) – for Speyer is after all basically and solidly Roman in conception. Speyer has something of that serene largeness which is the common possession of all things well inspired from Rome.

The late eleventh- and twelfth-century alterations at Speyer were carried out in a style which is very close to the mature Lombard Romanesque – the eaves gallery, upper clerestory, decorative arcading, pilaster strips, corbel tables, are all close to Lombard originals. In fact, Germany and Lombardy, brought close by imperial politics, coalesced, logically enough, in their architecture at this time. Morey believes that, since sculptors of the day working in Lombardy have signed German names, the artistic developments of Germany in the eleventh century were actually transmitted to Italy and brought about a renaissance of sculpture there.[15]

At Speyer after the ruin of 1689 there was much Baroque rebuilding at the west end of the cathedral (1772–8),[16] but further rebuilding in the Romanesque revival period (*c.* 1820 and later) gave it back its original scheme, though the new work is dry. Speyer is not subtle, but anyone who understands masonry will love the tremendous cliff-like masses of its walls and the heavy over-arching testudo of its vaulting.

Mainz [333, 334] and Worms [331] – the other *Kaiserdome* – were likewise the object of considerable works during this period. So also was the cathedral of Trier [330],[17] a Roman monument transformed into a German cathedral after 1019, in three stages; the years 1039–66 saw a handsome west front built, and an eastward extension was built still later. The famous church of trefoil plan, St Mary in Capitol, Cologne, was built in its first form beginning about 1040 [335, 337]. The abbey church of Maria Laach, a perfect example of the mature German Romanesque, was, to be sure, founded in 1093, but the building was built slowly, in a style quite unaffected by Gothic impulses, though the dedication took place in 1156.

92. Maria Laach, abbey church, founded 1093, dedicated 1156, interior (before modern additions and embellishments)

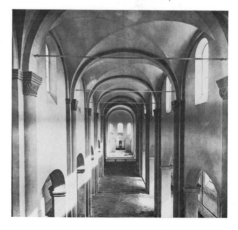

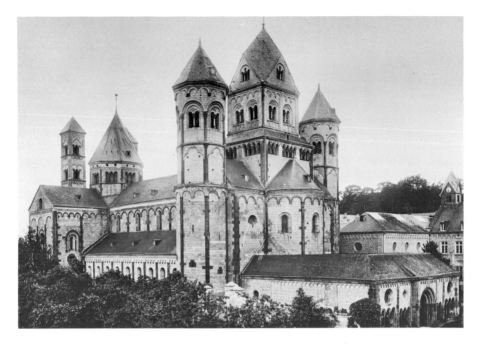

Maria Laach [92, 93] is beautifully set in verdure near the Laacher See, and presents a quite lovely picture of the well-developed German medieval monastery; for the group respects traditional planning. The aspect even of the late buildings harmonizes with the older work, and the church graciously dominates the ensemble.[18] The church exterior, with six towers, is very *mouvementé*; in design it is a later and Lombard-influenced version of St Michael at Hildesheim. A small atrium lies below the western apse. Within, the building is sturdily groin-vaulted on grouped piers in six bays of nave and aisles, which terminate in a transept made up of three great square groin vaults; the sanctuary has a similar bay and a semidome. The architectural forms of the interior are austere, quite in contrast to the exterior. Modern decorations and furniture have somewhat diminished the serenity of this fine design. This serenity is the essential reason for placing the

building among these earlier works of German Romanesque.

It ought to be mentioned at this point that the Pfalz at Goslar [94, 328] is believed to have been built in somewhat its present form by Henry III, whose favourite residence it was. An Aula Regia was built about 1050 which collapsed at least in part in 1132. Reconstructions and extensions have given a twelfth-century flavour to the surviving structure. The Lady Chapel, a two-storey church, near by, was built by Conrad II about 1035, and the Capella Regia at the foot of the slope (later the cathedral) was a work of Henry III. The whole group was an excellent expression of the power which the dynasty and the Empire possessed in Henry's reign.

Another group, little known because so recently excavated, is that of Allerheiligen at Schaffhausen in Switzerland, dated shortly before 1049.[19] Beyond the apse of the church lay

93 *(opposite)*. Maria Laach, abbey church,
founded 1093, dedicated 1156, view from the north-west

94. Goslar, the Pfalz, restoration study as in *c.* 1080; see also 327, 328

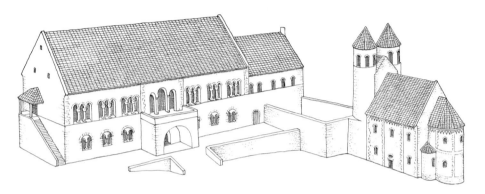

a court in the form of an extended lozenge, with
a triapsidal open-nave chapel at the head of it;
a quatrefoil chapel occupied each of the lateral
points of the lozenge. This scheme was an
imaginative augmentation of the court beyond
the apse of the Lateran Basilica in Rome [283],
and it is a pity that it had to be demolished to
make way for larger medieval constructions.

The maturer German Romanesque style con-
tinued in use, though not exclusively, as late as
the thirteenth century. It is easy to forgive the
Germans their conservatism, when one has ad-
mired and understood these splendid monu-
ments of a glorious historical period. Indeed the
artistic temper of the Germans was so well
expressed in this Romanesque style that all later
styles of architecture in Germany have shown
some influence of its boldness, dignity, and
austerity.

From one point of view it would be logical to
continue our analysis of German Romanesque

architecture at once; for the splendid cluster of
Romanesque monuments of twelfth- and thir-
teenth-century Germany represents the full
power of the Empire, and it is the culmination
of the great renewal of architecture within the
wide lands of central Europe. However, build-
ings of great interest were built, especially in
France, while the Romanesque of Germany
was being created and developed. Therefore, to
avoid too great a departure from chronological
sequence, our plan of exposition now calls for a
study of the French works which, as the Roman-
esque style developed, adumbrated the Gothic
style more and more, without achieving it. Then
it will be appropriate to visit the many and
various regions of the Empire, with their fasci-
nating local styles which remained Roman-
esque, before considering the Romanesque of
Normandy and the Île-de-France, the areas
where the style was actually transformed into
Gothic.

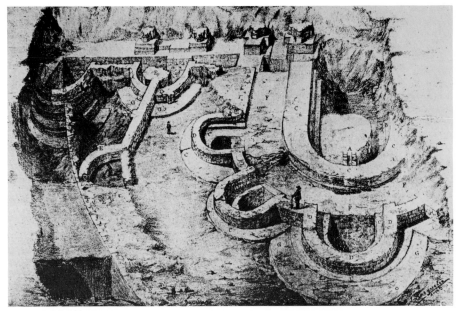

95. Tours, St Martin, tenth, eleventh, and thirteenth centuries, excavations of chevet

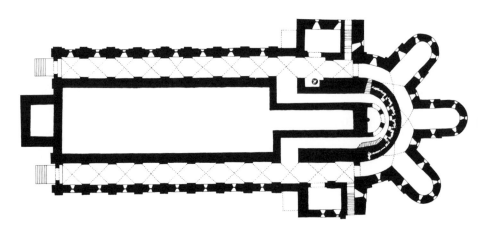

95A. Chartres Cathedral, plan of crypt (H. H. Hilberry). The apse, ambulatory, and radiating chapels of 858 are enclosed within the chevet of the cathedral foundations of 1020–30, which are in turn enclosed by the Gothic foundations of 1194 ff. (not shown)

FRANCE: 900–1050

THE AMBULATORY

We have just passed in review the relatively conservative Early Romanesque styles of Lombardy and Germany. In this architecture we see how an attractive, fairly uniform style resulted when the builders turned to ancient Roman monuments for inspiration, revived the Roman manner of planning, and felt the force of a living stream of influence from Antiquity as the Lombardic First Romanesque spread. The buildings are ordinarily cogent and practical; often competent rather than inspired.

In France it was different. Delivered at last from the 'Norman fury' in 911, when the treaty of Saint-Clair-sur-Epte laid the foundations of the great Norman duchy, France could rebuild. Before long there were signs of an intellectual, spiritual, and architectural revival in the northwest, in Aquitaine, and in Burgundy. That traditional inventive flair, that active skill in composition which had created the silhouette of Saint-Riquier, turned for a century to the more difficult problems of plan and articulation in the major churches. Then during half a century it absorbed the lessons of the First Romanesque style into this more highly evolved pattern of church building, and at the middle of the eleventh century stood ready for its great age.

As already indicated in a previous chapter, it was actually during the last effective Carolingian reign (that of Charles III, 893–923) that the new architectural epoch was ushered in by the reconstruction of St Martin at Tours [95]. The church was dedicated in 918 with a newly built annular aisle or corridor enclosing the sanctuary, and so arranged as to give access to the tomb of St Martin ('St Martin's Rest'),

located at the head of the apse, and also to a series of round chapels attached to the peripheral wall of the corridor. This was the first ambulatory with radiating chapels arranged in what was basically the definitive form, and it brought to fruition the development already referred to in our chapter on Carolingian architecture in France. Because of the chic and skill

96. Chartres Cathedral, apse and ambulatory of crypt, 858 with superincumbent later construction

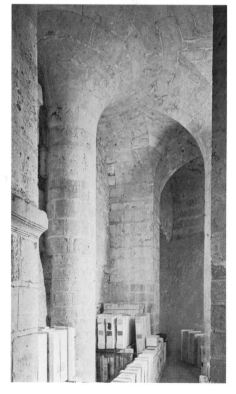

of this solution it may be considered the beginning of specifically French developments in Romanesque architecture.[1]

What existed (most probably by 918, admittedly by 1014) was like the crypt and ambulatory built at Chartres after 858 [95A, 96], plus radiating absidioles. But at Tours, as Dr Carl Hersey, a careful student of the problem, has observed, the high level of the ground water prevented this arrangement from being a crypt: 'St Martin's Rest' was only slightly below the pavement level. The ambulatory and radiating chapels therefore became perforce a boldly articulated exterior adjunct to the apse, and arches like those of Chartres, pierced in the apse at St Martin, united both the ambulatory and the absidioles visually with the sanctuary. The generous size of the absidioles attached to the outside of the ambulatory shows clearly that the corridor itself was not meanly proportioned. It opened towards the sanctuary on the axis, at

97. Vignory, priory church, c. 1050

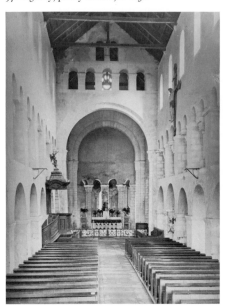

'St Martin's Rest', and perhaps elsewhere as well. There may have been windows in the apse, but possibly it was dark, resembling the apse of Vignory (dated about 1050) [97].[2] The ambulatory and radiating chapels of St Martin as rebuilt after the fire of 997, and dedicated in 1014, were undoubtedly of mature form and proportions, with the apse wall carried on a light columnar arcade. This very beautiful architectural disposition, so acceptable from the point of view both of symbolism and of engineering structure, was a capital contribution to the art of religious building [113(1)].

Other traces of an early stage in the development of the ambulatory and radiating chapels exist in the excavations of the cathedral of Clermont-Ferrand, where masonry of a building dedicated in 946 survives, in the form of a vaulted rectangular crypt enclosed by a half-oval corridor with four angular radiating chapels attached to its periphery.[3] Each of the chapels was arranged as a crypt-shrine or confessio. While the form of the superstructure is not certain, critics follow Louis Bréhier in supposing that the ambulatory was on two levels, and that each of the attached elements was in effect a little oblong church two storeys high, provided, like the main sanctuary, with an altar above its crypt. Thus it was more elaborate than the apse of St Martin of 903-18; perhaps it was better integrated and more open. The work was greatly praised for its beauty, and the name of its author is known – Aléaume (Adelelmus), a cleric who was also skilled in the arts of goldsmithing and sculpture. He made a precious reliquary statue of the Virgin to be set on a column behind the high altar, and seen with wonderment from the ambulatory. Obviously the upper ambulatory opened on the sanctuary.

Worth noting is the fact that at St Martin only the apses of Saint-Germain, Auxerre, were reproduced; at Clermont-Ferrand, only the oblong bays, omitting the rotunda. This explains the even number of radiating chapels, an un-

usual feature which passed to other Auvergnat churches.

It is characteristic that the ambulatory continued to be used, in increasingly sophisticated form, and in connexion with more and more completely vaulted churches. At Clermont-Ferrand a fully developed Romanesque ambulatory replaced Aléaume's design, and a beautiful Gothic chevet replaced that in turn.

BURGUNDIAN DEVELOPMENTS

Progress was early made towards the Romanesque ideal in Burgundy because of the unique conjunction there: easy contact by way of the Loire with the active school of western France; early contacts by way of the Rhône with the Lombard First Romanesque style; strong contact by way of the Saône with the Empire. In addition there was a cult of relics, and, more important, there was an active monastic de-

velopment.[4] All were under way when the Hungarians visited the region with fire and sword in 937 and 955 and stirred the Burgundians to undertake fireproof vaulted construction. The resulting developments in plan and structure make the Burgundian churches of the time very important for the history of medieval architecture.

At St Philibert's Abbey in Tournus a derivative of Aléaume's ambulatory still exists [98-102]. In 949 this abbey was at the end of the long peripatetics of the monks of Noirmoutier, who, driven in 836 from that island to their mainland priory of Déas or Saint-Philibert-de-Grandlieu, as already noted, were once more driven out in 858 and ultimately came with the relics of St Philibert to Tournus in 875. The monastery suffered from the Hungarians in 937. During a schism in the monastery, the Philibertine monks went (945-9) to Saint-Pourçain-sur-Sioule in Auvergne, when the ambulatory of

98. Tournus, Saint-Philibert, c. 950-1120 and later, air view from the south-west

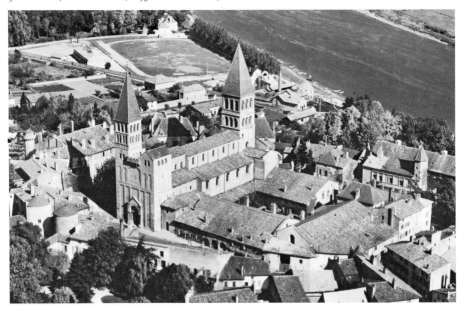

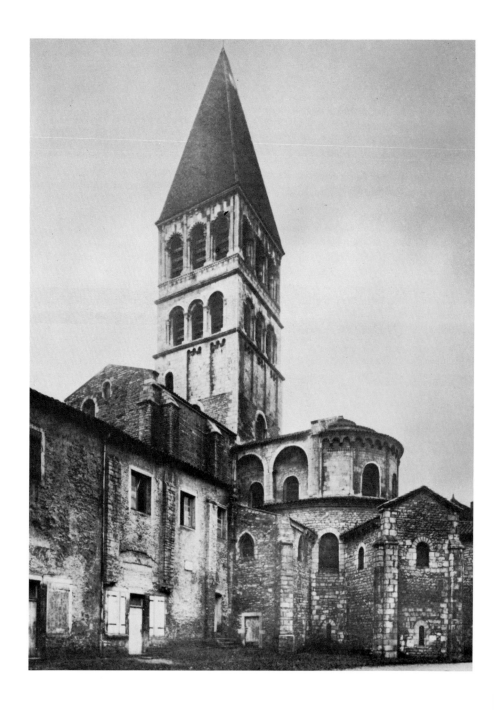

99 *(opposite)*. Tournus, Saint-Philibert, from the south-east. Ambulatory 979–1019, tower 1120

100. Tournus, Saint-Philibert, narthex, *c.* 1000

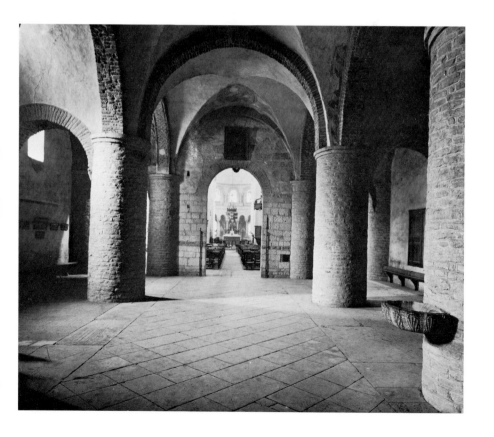

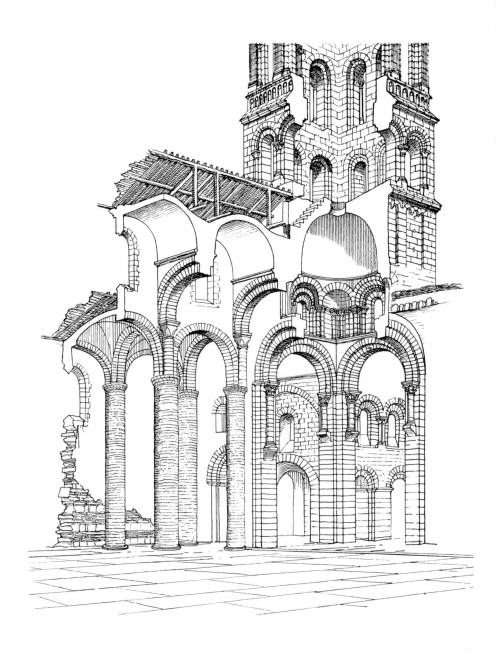

101 and 102. Tournus, Saint-Philibert, analytical perspective
and *(opposite)* cross section and longitudinal section, *c.* 950–1120

the cathedral of Clermont-Ferrand was still a conspicuously new structure.[5] The new church at Tournus, begun about 950, was vaulted in the course of the eleventh century and finished about 1120. It contains a crypt under the high altar for the relics of St Philibert and a place of honour in the central radiating chapel of an enclosing ambulatory for the tomb of St Valérien, who was honoured in the monastery at Tournus before the Philibertines came [102].

nave, with interesting parallel transverse tunnel vaults on diaphragm arches, after 1066. The Chapel of St Michael above the narthex, with primitive sculptures, has interesting quadrant vaults in the aisles, while the nave has a clerestory above with a tunnel vault with transverse arches, and the tie-beams still in position (about 1020, or perhaps later). There is a strong imprint of the west of France on the plan and structure, except in the Chapel of St Michael,

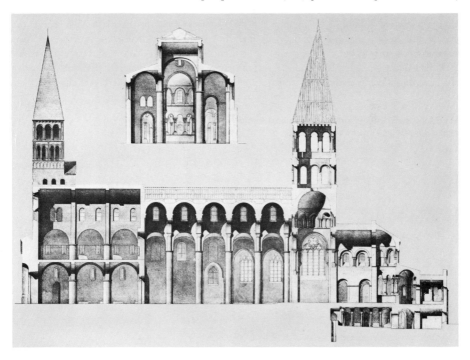

This plan, with its five radiating chapels of oblong plan, was repeated at the level of the main church. The crypt was dedicated in 979, and there is tenth-century work above it, extending past the transept to the massive three-bay narthex. The vaults, however, are later – in the upper ambulatory, after a fire of 1007 or 1008 (dedication 1019); in the sanctuary and at the crossing, about 1120; the high vault of the

where the Lombard characteristics are strong. Pilaster strips and arched corbel tables decorate the exterior there; the original belfries (now augmented by a twelfth-century tower at the north) are Lombard First Romanesque in style. The quadrant vaults of the Chapel of St Michael may be related to those of the triforium gallery of Saint-Bénigne, Dijon, where Lombards were at work from 1001, as we shall see presently.

The memory which goes deepest at Tournus is that of the monks working tenaciously through a century and a half to build an advanced type of church while conditions were still primitive. The sophistication of later builders lost something of the simple nobility which is always evident in sincere early works of architecture.

In passing, reference should be made to interesting work in the ambient of Cluny. The priory church of Charlieu (founded 872) appears to have been rebuilt about seventy years later as a vaulted building with an ambulatory arcade and eastern absidiole, perhaps at the suggestion of Abbot Odo of Cluny, who came from St Martin at Tours. The tunnel vault of the nave doubtless improved the acoustics for chanting, which was Abbot Odo's special forte. An interesting crypt ambulatory with radiating chapels at Saint-Pierre-le-Vif, Sens, dated about 920–40, has also been connected with St Martin through Odo's having 'reformed' Saint-Pierre-le-Vif in 938.[6]

At Cluny[7] itself new problems of plan were undertaken in a rebuilding which stretched over nearly a century after 955, perhaps after a false start on a round ambulatory corridor in 948. It may be said briefly (for we shall return to the Cluniacs) that the Frankish villa where the monks installed themselves in 910, and their church (Cluny I, dedicated in 927), proved insufficient within a generation. Construction of a larger church was undertaken about 955 by

103. Cluny, second abbey church, longitudinal section as in *c*. 1010 (K.J.C.; partly hypothetical)

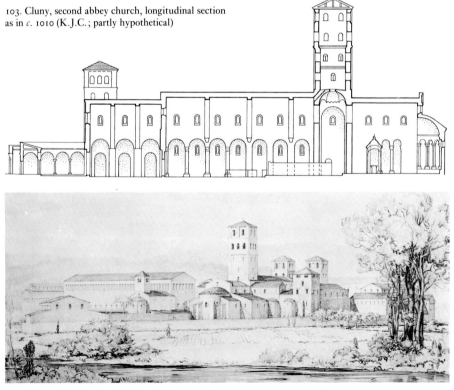

104. Cluny, restoration study of the monastery from the east, as in 1043 (K.J.C.)

105. Cluny, the monastery as in 1050 (K.J.C.)

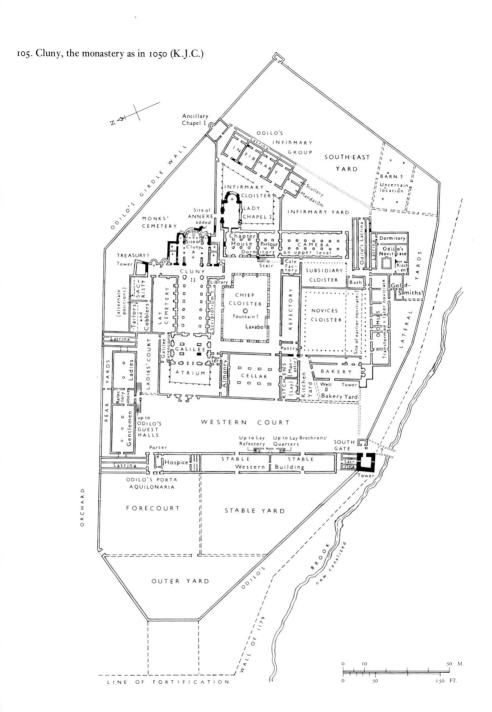

Mayeul, coadjutor (abbot 963-94) – and a systematic rebuilding of the monastery began when the new church (Cluny II) had been dedicated (981), extended by a narthex, and finally tunnel-vaulted (about 1010) [103-5].

Typical Romanesque roofing, with vaults of stone, remarkably enhances the beauty of musical effects – in particular, the musical effects of the linear Gregorian chant and the massive organum. The Cluniacs preferred tunnel vaulting, which gives most felicitous acoustical results, and the fundamental importance of chanting in the services made it worth while to build tunnel vaulting in spite of the grave engineering problems which were encountered. Paul Henry Láng writes: 'It was this music which embodied the Romanesque religious ideal, without which the art of these centuries presents mere samples of architecture, sculpture, or literature.'

The chevet of Cluny II was based on the apse échelon scheme; it had, however, a square sanctuary with flanking corridors for processions. Each of the corridors was flanked by a so-called 'crypt' (really a vaulted secretarium at pavement level), while at the head of each corridor there was a horseshoe-shaped chapel, with the half-oval main apse between, accessible from both corridors, and provided with three altars side by side which were used in sequence for the morrow mass. The narthex was arranged to receive the Sunday procession, which passed round the cloister; it paused for a Galilee station before returning to the church. There were two belfries above the façade of the narthex, and another, of tall proportions, over the crossing. This arrangement, now so common, was a novelty in the tenth century.

The monastery layout was based on a square 300 feet (of 340 millimetres) on a side. It differs from the St Gall plan in having a chapter-house (an important novelty) with a Lady Chapel beyond, frequently visited in liturgical procession. This probably resulted from Abbot Odo's having vowed himself to the Virgin and empha-

sized her cult.[8] The Cluny plan also differed from St Gall in placing the novitiate south of the refectory. The buildings were well built and had a certain warm austerity of design. They were roofed in wood. Recurrence of even dimensions makes it clear that the reconstruction followed a consistent plan to accommodate about 100 monks, finally achieved about 1045 when a poetic cloister with marble columns was finished by Abbot Odilo (994-1048).

Abbot Odilo built extensively throughout the Cluniac group of monasteries, and it is important to know something about his accomplishment. Attentive study of a dimensional description (1043) of a monastery in the Consuetudinary of Farfa, near Rome, which followed Cluniac customs, together with excavations at Cluny by the Mediaeval Academy of America, have made it possible to reconstitute the plan of tenth- and eleventh-century Cluny [105]. This is important because, in principle, all Cluniac monks were professed at Cluny; thus the architecture of the mother house was known, and presumably admired, throughout the whole group of associated houses.

At Cluny some ranges of the buildings, 25 feet in width, were laid out inside the basic 300-foot square, and some outside, so that 325-foot and 350-foot dimensions occur. The ancillary buildings provided 32 places for sick and retired monks, 30 or more for novices, 12 for the abbey's *pauperi* or poor pensioners, about 100 for *famuli* forming the devoted service corps of the monastery; 40 places were provided for men and 30 for women guests in the guest house; the hospice could take in about 100 wayfarers, accommodated perhaps as the delightful capital from San Gil at Luna (Zaragoza) indicates [106]; the group sheltered about 400 in all.

Small, but worthy of notice, is the element indicated as a goldsmiths' and enamellers' shop.[9] It is not certain that a special room was provided for the scriptorium in early eleventh-century Cluny. Space for it was available in or near the

106. Luna (Zaragoza), San Gil, carved capital
showing wayfarers' accommodations, twelfth century

north walk of the cloister, with the armarium for the library close to the transept door. The library at Cluny contained a relatively large number of volumes – 570 in the twelfth century, at a time when Durham reported 546 and Montecassino 70.

The most spectacular of the Burgundian accomplishments in the Early Romanesque style, a very instructive example which summed up the progress of church architecture in the tenth century, was Saint-Bénigne in Dijon. It was the personal achievement of William of Volpiano (near Ivrea and Novara).[10] He is a good example of the noble ecclesiastic; for his godmother was the Empress Adelaide, wife successively of Lothair III and Otto the Great; he was a relative of various grandees of the Empire, with influential connexions in Italy, Burgundy, Lorraine, and Normandy. William was a monk at San Michele de Locedia, near Vercelli, but Abbot Mayeul, exercising Cluny's special privi-

lege, received him, and took him to Cluny in 987. After a term as prior at Saint-Saturnin he was chosen to reform the historic monastery of Saint-Bénigne, which he did effectively with a group of chosen monks from Cluny, and in accordance with Cluniac customs. Abbot William spread these Cluniac customs still further, to other monasteries held by him in personal union. He reformed monastic houses (perhaps too severely) over a wide area, including Normandy. From Norman foundations this influence streamed into England, where Cluny itself was represented directly (at Lewes) from 1077 onward. A thread of Cluniac influence may be traced in Abbot William's architectural work, but he is much more important for his action in launching the Lombardic First Romanesque style in Burgundy. He had personal abilities as a designer, and it seems to be certain that he brought Italian masons, and perhaps also carvers, to Dijon; but some of the work, technically

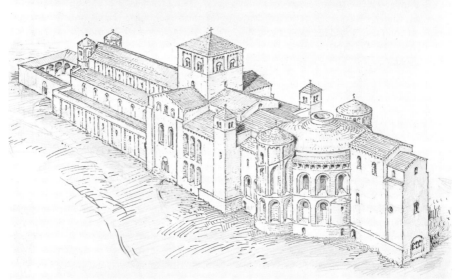

Burgundian, represents local masons. Between them they produced an entirely vaulted church 305 feet long, beginning in the first year of the new millennium (1001) [107-9]. Raoul Glaber was a monk there at the time, and this building was a part of the 'white mantle of churches' which, in his famous phrase, the world then put on. The church had a notable pilgrimage to its tomb of the ancient apostle of Burgundy, but was important for much more than its size and picturesqueness, and the fact that two kinds of masons built it. It was a real architectural epitome, a *summa* of what had thus far been created

in church architecture. We cannot be in error if we attribute its design to the favoured, alert, brilliant, and widely travelled abbot himself. Raoul Glaber writes '*ut diximus, et praesto est cernere, totius Galliae basilicis mirabiliorem atque propria positione incomparabilem perficere disponebat*'.[11]

What elements appeared here? The main church, dedicated in 1016 or 1017, was a highly elaborated basilica; the eastward portion, dedicated in 1018, was a highly elaborated rotunda; so that, in essence, the scheme was that of the Holy Sepulchre in Jerusalem – and consequently a bequest from Early Christian times. The intermediate monument appears to have been Saint-Pierre, Geneva, as built (a funerary basilica) about the year 600. Saint-Bénigne was

107 to 109. Dijon, Saint-Bénigne, 1001-18, crypt (rebuilt 1858), sketch restoration (K.J.C.), and restored plan (A. S. Wethey, K.J.C.)

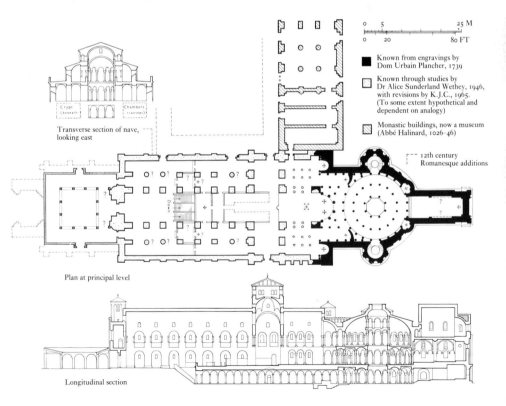

Transverse section of nave, looking east

Plan at principal level

Longitudinal section

○ 5 25 M
○ 20 80 FT

■ Known from engravings by Dom Urbain Plancher, 1739

□ Known through studies by Dr Alice Sunderland Wethey, 1946, with revisions by K.J.C., 1965. (To some extent hypothetical and dependent on analogy)

▨ Monastic buildings, now a museum (Abbé Halinard, 1026-46)

┌─ 12th century
└─ Romanesque additions

vaulted, which is Roman; it had nine towers and turrets, which is Carolingian.

Work continued on the church and adjacent monastic buildings, and there was a general dedication in 1107. A Gothic reconstruction and Revolutionary vandalism have destroyed the building almost completely. The rotunda was well studied by Dom Plancher and presented in his *Histoire générale et particulière de la Bourgogne* (1739); but we owe much of our detailed knowledge of the building to a more recent investigation which makes it possible to describe the building as if it still existed.[12]

The entrance way at the west of the basilican church was a porch with flanking stair towers, a Germanic motif. The nave was double-aisled, like the greatest Early Christian basilicas, but it was built like a Roman stadium or circus; the nave arcades resembled aqueducts. On each side the inner of the two vaulted aisles stepped up to a vaulted gallery, and that to a clerestory wall

110. Southwell Minster, nave, *c.* 1130

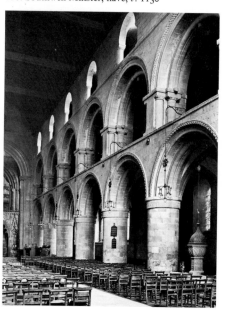

with a wall passage. Between the clerestory walls a tunnel vault was turned, reaching a height of forty-six feet, and well abutted by the stadium-like construction stepping upward towards its spring. In spite of round piers, extra shafts in the gallery, different stonework, and wooden vaulting, the nave of Southwell Minster [110] resembles that which existed at Dijon. The triforium piers at Southwell somewhat recall those at Saint-Bénigne, which were designed Moslem fashion with columnar shafts at the corners, *quadrangulatim statute,* joined by a 'kind of crown' (the upper vaulting?). A tower rose at the crossing. For access to the tomb of St Bénigne there was a descending stairway, near the main west door, and a vast columnar crypt extended under the nave, the transept, and the sanctuary just beyond.

The transept was vaulted, and the clerestory passage continued round it into two remarkable, well-buttressed quadrant-vaulted chambers at the gallery level, flanking the sanctuary bay. The aisles flanking the sanctuary had groin vaults, the apse at the east had arcading, annular passages, and a group of chapels beyond. In this very interesting part of the work we have the germ of the great churches of the Pilgrimage Roads, that wonderful inter-regional group of designs which is the first international manifestation of the mature Romanesque. Saint-Bénigne thus makes the connexion between the Lombardo-Burgundian international First Romanesque style and great later projects which far surpass it.

The system of apses at Saint-Bénigne was a remarkable combination of the échelon, the ambulatory, and the rotunda, on three levels. The ambulatory was reduced to a curving arcaded corridor of graceful proportions; the central absidiole was represented by the rotunda (also on three levels) and the rotunda itself had an apse échelon in the shape of a central square-ended projecting chapel with a small apse at each side of the entrance, at the principal level.

The clerestory passage of the nave communicated with the roof by two stair turrets near the apse, thus bringing the number of towers or turrets on the basilica to five. The passage continued into the rotunda, and was accessible there from the two substantial round stair towers which formed the communication system of that part of the design. A tower was planned just to the east of the rotunda, but ultimately built as a little church with a tower of its own perched illogically on the apse. Later there were other changes in the tower system, so that it is difficult to make out the original scheme – but, if one counts the prominent central well of the rotunda, there were nine towers on the church. It had a remarkably strong and bold silhouette, rather riotous; but all the same, here was an entirely vaulted building rising to the challenge of medieval form in church architecture as conceived by the designers of Saint-Riquier.

Of this strange and wonderful ensemble only the nethermost parts of the eastern half have survived. The apse échelon of the basilica, the ruined tomb in the apsidal space, a forest of stubby columns (some with extraordinarily energetic Early Romanesque capitals) and the eastern chapel were cleared and restored in the nineteenth century. It is possible to obtain only a hint of how curious the rotunda was, with its two stages of double annular aisles supported on a forest of columns, and its dome arranged about a phenomenal arcaded cylindrical well open to the sky through an oculus. Basically, the rotunda went back to the Pantheon in Rome; its stairways connected it with Saint-Riquier; the architectural detail was mostly Lombardic, but the upper cornice of the rotunda had (though perhaps not in 1018) Moorish lobed soffit panels and chisel-curl brackets. The openwork arcaded well oddly recalled the telescopic open-work spires of Saint-Riquier. The small vaulted bays on cylindrical columns of the lower stages of the rotunda recalled familiar Lom-bardic crypts and Moslem vaulted construc-tions. The quadrant or cove vaulting of the upper stage came to be most important in Romanesque architecture as its development continued.

Clearly then Abbot William had his wish; he made the church of Saint-Bénigne *mira-biliorem basilicis totius Galliae*. But the building was not a mature design, and, above all, the basilica was impossibly ponderous. There were twenty-four piers about six by six feet or larger in the basilican part of the church, which thus was made fireproof by vaulting at the cost of seriously blocking up a large part of the interior area. The thirty-two supports of nave and aisles occupied about one-tenth of the floor area west of the crossing – an intolerable proportion which was apparently not remedied by a Ro-manesque reconstruction of the twelfth century: later a Gothic church replaced Abbot William's basilica.

Saint-Bénigne produced a few architectural echoes, though not of the first importance. Wulfric's Octagon of 1050, joining two much older Saxon buildings at the venerable abbey of St Augustine in Canterbury, was inspired by the rotunda at Dijon.[13] 'Becket's Crown' at Canterbury Cathedral is essentially a Gothic rotunda, ultimately inspired from Sens and Dijon; the same may be said of the rotunda of Trondheim Cathedral in Norway. Nearer home, and in the Romanesque style, is the church of Charroux, more obviously derived from William of Dijon's design. However, only the structural advance signalized by Saint-Bénigne was of gen-eral significance in Romanesque architecture.

THE SPACIOUS WOODEN-ROOFED BASILICAS

The high and ample nave of Saint-Philibert at Tournus was for a time (about 1019–66) covered by a wooden roof. There were other elaborate French churches of the time which also had

wooden roofing, but all of them have now been destroyed; indeed it is difficult to present a clear idea of these important designs, which were influential in their period.

For the north of France, the church of Montier-en-Der[14] (960–92) deserves mention for its tall nave with a high clerestory, carried on a handsome arcaded false triforium, ruined in the Second World War, but now restored. The sanctuary was replaced by a fine Gothic chevet in the Middle Ages.

Saint-Remi at Reims had as its titular the ancient churchman who baptized Clovis the Frankish king. Through this association the cathedral of Reims became the French coronation church, while St Remi was honoured in an abbey near by. In 1005 the monastery under-

111. Reims, Saint-Remi, 1005–49; Gothic shafting, upper arcade, and vault (pre-1917 photograph)

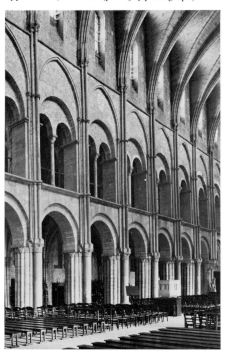

took what was intended to be the largest church in Gaul – a vast basilica originally planned to have double aisles, a transept, and an apse échelon. Collapse due to enforced neglect, while the church was near the front line in the First World War, has cost us most of the original nave, an interesting construction with bundled piers decorated in stucco, and a pretty gallery enriched by arches paired under a series of enclosing arches, somewhat as in the Pilgrimage churches. The tall clerestory wall above the gallery had semicircular exterior buttresses. The transept had returned aisles. The early Romanesque building, somewhat curtailed from the scheme of 1005, was dedicated in 1049 by Pope Leo IX.[15] In later times a Gothic vault was built over the nave [111]. A handsome Early Gothic apse, ambulatory, and radiating chapels which have survived, now terminate the building on the east, and the nave has been well restored.

The next really conspicuous great wooden-roofed basilica was Bishop Fulbert's cathedral of Chartres, begun in 1020 [95A].[16] The tradition at Chartres was basilican. The church of 743 replaced an older building which had a wooden roof; a fire of 858 in the church of 743 necessitated the Carolingian reconstruction – again wooden-roofed – which has been mentioned previously. The latter building was burnt in 1020, and was replaced by Fulbert's church, also a wooden-roofed structure, but unusually imposing and spacious. It so happens that we know the architect's name – Béranger, whom the cathedral chapter referred to as *artifex bonus* when he died (1050). In the new Chartres of 1020 Béranger took the theme of apse, ambulatory, and radiating chapels newly exemplified at Tours (997–1014), and applied it handsomely on the church level, and also in the crypt, where it enveloped the old ambulatory of 858. The three crypt chapels of 1020 still exist with their ambulatory and a long corridor of access on each side [96], for they were built into the sub-

structures of the present Gothic cathedral of
1194–1260.

The main church of 1020 was not much
smaller than the existing cathedral. It had a
westwork and probably a ridge belfry. Its length
of 345 feet on the axis, and the clear nave span
of 54 feet, made it notable for size, and it was
very boldly constructed. The nave and aisles
together had only eighteen interior supports
about 7 feet square in an area measuring about
112 by 205 feet. The supports occupied about
one twenty-fifth of this area, whereas at Saint-
Bénigne, as we have seen, one-tenth of the area
was given up to supports – but Saint-Bénigne
in Dijon was fireproof.

Chartres, with its wooden roof, continued to
be visited by the flames. A fire of 1030 delayed

the dedication of Fulbert's cathedral until re-
pairs were completed in 1037; moreover, Ful-
bert's church suffered again from fire in 1137,
and the whole of the superstructure was ruined
in a memorable disaster, the 'wonderful and
miserable fire' of 1194. Even the stone-vaulted
new Gothic cathedral lost its outer wooden roof
in 1836. Clearly, in more than a thousand years
of successive fires, the wooden roof, for all its
advantages, has been discredited at Chartres.
At many other sites – St Martin at Tours among
them – the wooden-roofed basilica has had an
equally sinister history.

The issue from the situation presented by
Saint-Bénigne (fireproof but impossibly cum-
bersome) and Chartres (seemly, but vulnerable
to fire) was found about 1050 in improved

112. Auxerre Cathedral, crypt, c. 1030

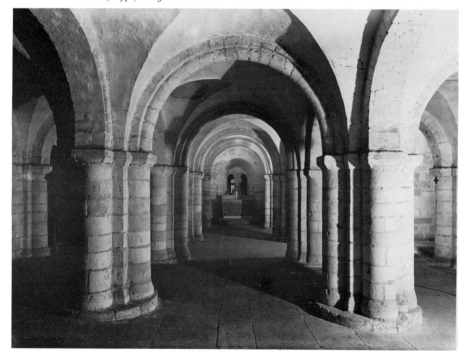

masonry technique – the increased use of ashlar stone, better stereotomy, better foundations, better understanding of stresses, and better handling of vaulting problems. The first half of the eleventh century saw the level of technical accomplishment rise – the crypt of the cathedral of Auxerre (about 1030) [112] shows this – and by the middle of the century the French builders were as fully sophisticated and competent as their colleagues of the *Kaiserdome* on the Rhine. Increasing prosperity and better civil order made greater resources available, for cathedrals and monasteries alike. The developing pilgrimage to Santiago provided the occasion and the resources for the construction of many fine churches and conventual establishments on the Pilgrimage Road. In 1049 one of the great builders of all time, Abbot Hugh of Cluny, took over the destinies of the great Burgundian monastery at a time when it was expanding actively and needed to renew its buildings everywhere.

The extraordinary result achieved within three generations is our best witness to the excellence of the preparatory labours of the Early Romanesque. Paul Henry Láng expresses it very well: 'Wherever we look we behold that *gravitas*, a legacy from Rome's most glorious times, which lends this period a truly aristocratic majesty . . . equalled by an inner force . . .'

THE MATURE ROMANESQUE AS INTER-REGIONAL AND INTERNATIONAL ARCHITECTURE

CHAPTER 8

THE GREAT CHURCHES OF THE PILGRIMAGE ROADS

THE PREPARATION:
GENERAL CONSIDERATIONS

Than longen folk to gon on pilgrimages
And palmers for to seeken straungë strondes

Piety and the open road wrought well for architecture in the second half of the eleventh century. There were many collections of relics in western Europe by that time, and many venerated burial places in the length and breadth of those lands. But Jerusalem, Rome, and Santiago de Compostela drew tides of devoted pilgrims from far and wide, so much so that provision came to be made in hospices and monasteries along the road – most particularly along the road to Santiago, where the palmers were so numerous that a sense of fellowship developed. The pilgrimages indeed appear to us as an attractive social phenomenon of the time. Aymery Picaud, Fidel Fita, Joseph Bédier, Georgiana Goddard King, Arthur Kingsley Porter, Luis Vázquez de Parga, José María

Lacarra, Juan Uría Ríu, Jesús Carro García have written about its poetry, its enchanting legend, its abounding life, and its beautiful architecture.[1] The thought makes one envy Chaucer's squire, en route, of course, to Canterbury –

Syngynge he was, or floytynge, al the day
He was as fresshe as is the moneth of May.

The heart leaps responsively to what Kingsley Porter called 'those long, but delicious kilometres' in fellowship with 'the myriad human beings who trudged unending leagues to lay their gratitude and their remorse, their wealth and their sins at the feet of the Apostle'. With real insight he recognized and expressed 'the inner vitality, whether poetic or spiritual I know not, but still forcefully living at Santiago, and unquenchably beautiful there'.[2]

The ancient monument which was recognized in 813 (on what basis, we do not know) as the tomb of St James the son of Zebedee soon attracted a local pilgrimage, which is heard of as

early as 844. By that time a Benedictine monastery already existed at Compostela. By 860 the festival of Santiago, 25 July, was listed in the martyrology of the cathedral of Metz.[3] This is a most important fact, because ecclesiastics came from all over the Empire and from England to Metz in order to study at the great school of Roman chant which had been established there. Thus an international pilgrimage to Santiago soon began to develop. As early as 893 provision for a hospice is reported. In 951 Godescalc, bishop of Le Puy, made the pilgrimage from France, accompanied by nearly 200 monks.

At this time the little Kingdom of León aspired to empire, and the bishop of Santiago, as early as 979, was styled 'Bishop of the Apostolic See', though not in actual competition with Rome. In 997 Santiago was the object of an important and damaging raid by the great Moorish warrior Almanzor. The pilgrimage persisted and grew in spite of such dangers from the south; despite local war in the Christian lands, and piratical raids on the coast by Moslems and Northmen alike.

There is a thrill in seeing and handling the classic manuscript of the Pilgrimage, the twelfth-century pseudo-Callistine codex, containing Aymery Picaud's Pilgrim's Guide (Book V) following a series of books on the Offices of the church at Compostela, the Miracles of St James (attributed to Pope Calixtus II), the Chronicle of the Life and Translation of St James, and the Chronicle of the Expedition of Charlemagne to Spain (attributed to Archbishop Turpin).

The attributions are false, of course, as is the statement that it was first 'received' in Rome; but it may, as the colophon says, have been 'written in various places – Rome, Jerusalem, Gaul, Italy, Germany, Frisia, and especially at Cluny'. It contains fraudulent letters of Calixtus II and one of Innocent II which dates it 1138. The author, who says himself (book I, ch. XVII) that 'all kinds of iniquity and fraud abound in

the road of the saints', borrowed great names to give a show of authenticity to his work.

Unfortunately the colophon has led to the quite general supposition that the pilgrimage was developed by the abbey of Cluny for its own profit, and lovers of the old Burgundian monastery will be glad to learn that it is now relieved of this onus. There is a phrase in Chapter XIII of Book IV to the effect that in a comparison between regular clergy, 'black' monks and abbots and 'white' canons regular, the last-named *meliorem sanctorum sectem tenent* – that is, imputing superiority to the canons over Cluniac and other Benedictine monks. The phrase cannot have been written at Cluny. The Cluniacs were touchy at this time; for it was not many years since St Bernard's disobliging Apologia to William of Saint-Thierry had stigmatized the monks of Cluny (1124); moreover, in 1132 Abbot Peter the Venerable had rectified Cluniac observances.[4]

The roads of pilgrimage were necessarily the grand routes of communication, and would in any case have had monasteries and hospices on them. Aymery Picaud indicates other establishments in a number of places where Cluny had priories; Cluny itself was not located on any one of the Roads, and the houses described as Cluniac in Spain were for the most part merely associated with the Burgundian abbey through foundation, reform, customs, or ecclesiastical personages. Yet Cluny unquestionably favoured the Pilgrimage, and even more the Spanish crusade for the reconquest of the peninsula. Cluny had influential friends in Spain – chief among them King Alfonso VI, one of whose queens (Constance) was a niece of Abbot Hugh. Cluny supplied great churchmen for the reform and expansion of the Church in Spain, as the Christian states oriented themselves towards the Latin centres of civilization while pushing their boundaries southward. Much Burgundian chivalry took part in this reconquest – in Spain and Portugal both.

113. Comparative plans of the five great churches
of the Pilgrimage type

1. Tours, St Martin (Hersey)
2. Limoges, Saint-Martial (Rousseve)
3. Conques, Sainte-Foi
4. Toulouse, Saint-Sernin
5. Santiago de Compostela (K.J.C.)

With the Cluniac role in the Pilgrimage
better understood, it remains to be said that the
researches of M. Élie Lambert[5] have shown
very well that Orders other than the Cluniac
had considerable numbers of priories on the
Pilgrimage Roads. The whole ensemble of estab-
lishments offering hospitality was rationally
set along the routes, at intervals of some twenty
miles apart – a comfortable day's journeying.
One supposes an instinctive or tacit under-
standing regarding this matter, such as there is
to-day among the principal suppliers of the
roadside commodities of our own times. There
was sufficient place for everyone – Cluniacs,
Augustinians, Hospitallers, confraternities, and
individual doers of good.

In that devoted age, each of the Pilgrimage
Roads would naturally have developed a shrine
of some importance. The international and
inter-regional character of the Pilgrimage is em-
phasized by the fact that the most notable
shrines – one on each road – had very similar
architectural form. These churches transcend
the localism of their period [113, showing all
five].

St Martin at Tours on the Paris-Bordeaux
road, Saint-Martial at Limoges on the Vézelay–
Périgueux road, Sainte-Foi at Conques on the
Le Puy–Moissac road, and Saint-Sernin at Tou-
louse on the Arles–Jaca road, each was a great
church of the peculiar Pilgrimage type, with the
finest of the group at the goal of the pilgrimage,
in Santiago itself. The buildings embody an
accomplished formula for ample, spacious
churches of fireproof construction suitable for
southern lighting and climate. They all show
a skill in design and an assurance in composition

0 30M
0 100FT

which would have been impossible previous to 1050 for structures of this classification. The statical problems were well understood, and the embellishment, particularly with relief sculpture, was increasingly fine in quality and character.

Typically the 'Pilgrimage church' is grand in scale. It has a long nave with aisles and a gallery, a wide transept, and a spacious sanctuary arm, all covered by tunnel vaulting carried to a uniform height – in the case of Santiago, sixty-eight feet [114]. These vaults have trans-

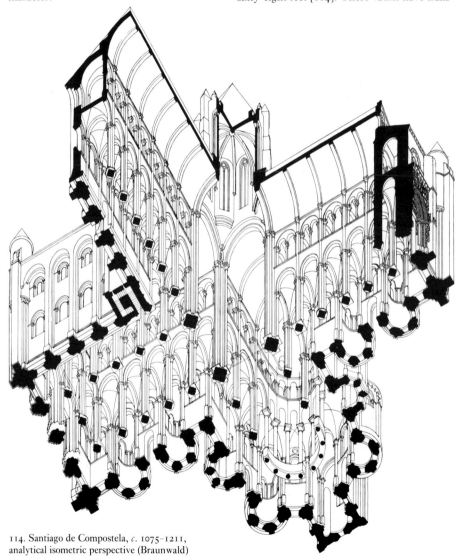

114. Santiago de Compostela, c. 1075-1211, analytical isometric perspective (Braunwald)

verse arches and are sustained, typically, on square piers with four attached shafts, one of which rises up the face of the nave wall to carry the transverse arch. On the ground floor two of the others carry their share of the arches which frame the adjoining aisle bays, and the fourth carries the arch between the groin vaults of the aisle bays. The corresponding shaft in the gallery carries a diaphragm arch which separates two bays of quadrant vaulting so placed as to absorb the thrust of the high vault. In principle the aisles and galleries surround the entire building. This means an ambulatory about the apse, and a small gallery above it, beneath the clerestory windows of the apse. Elsewhere there is no clerestory. To enrich the design, the openings between the piers of the gallery were typically divided by paired arches resting, in the middle, on slender columns, and at the sides on the lateral shafts of the piers, under an enclosing arch which corresponds to the aisle arch – a very pretty arrangement. Light reaches the nave, transept, and apse directly from windows in the end walls and a lantern tower over the crossing; it also filters in from the windows of the aisles and galleries. Since the churches were for canons or for monastic purposes, the naves were blocked at the head by the choir for the clergy. By the eleventh or twelfth century it was customary to enclose these choirs with walls which obstructed the view from the lower part of the nave to the altar. The wide transepts were designed to compensate for this, in view of the pilgrim throngs. For the chant the acoustics of these churches are unexceptionable.

The generous lines and considerable height of these buildings, emphasized by their bold towers and turrets, gave them a fine silhouette and a handsome presence. Those which remain are, after eight hundred years, still among the noblest churches of France and Spain, and the destruction of the others (Saint-Martial at Limoges and St Martin at Tours) is greatly regretted.

St Martin at Tours, forward-looking as usual, built the leading or 'pilot' design, though through later rebuilding it departed from the type which it had helped to create. Saint-Martial at Limoges had not so spacious a transept as the others. Beautifully set, Sainte-Foi at Conques is the smallest and most rustic [118]. Saint-Sernin at Toulouse is exceptional among the group in being partly brick-built. Saint-Sernin was never quite finished, and it has suffered both from medieval additions and modern restorations; moreover, it has lost its suburban setting and its group of conventual structures. Santiago has lost its canons' choir, and the original Romanesque exterior was masked between 1658 and 1750 by Baroque construction (though without spoiling the building).

Santiago has the most commanding situation; Sainte-Foi has the most picturesque surroundings. Santiago and Saint-Martial were built of granite; Santiago and Saint-Sernin were fortified; Santiago, Saint-Sernin, and Sainte-Foi have notable figure sculpture. Santiago alone has a fully developed circuit of aisles and galleries about the building. Santiago alone was planned for the full complement of nine towers, realizing the Carolingian ideal (three were large, two were of medium size, and four were corner turrets). St Martin was planned with five towers, all large; Saint-Martial was planned with two large towers and two or more turrets; Sainte-Foi was planned with a large crossing tower and a smaller stair tower, on the transept.

On the practical side, for comparison with the church of Saint-Bénigne at Dijon, we should note that the nave proper of the cathedral of Santiago and its aisles, fully vaulted, measure about 64 feet in width and 143 feet in length, with 20 interior supports in the form of piers, each measuring about 15 square feet in area. This relationship would hold, roughly, for all of the typical buildings. The nave of Saint-Bénigne, though differently shaped, had almost

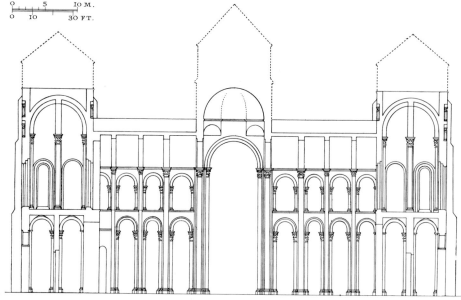

115. Tours, St Martin, restoration study of transept as rebuilt *c.* 1050 ff. (Hersey)

the same area as that of Santiago; 32 piers aggregating 810 square feet were needed to sustain the vault. Two generations of technical progress account for the difference: the piers of the nave of Santiago occupy only 300 square feet, little more than one-third of the area which was required at Saint-Bénigne.

ST MARTIN AT TOURS[6]

The early tenth-century church of St Martin which we have discussed was consumed by fire in 997. The new construction afterwards had the ideal Pilgrimage plan – a long nave, a capacious transept, and the first typically arranged apse, ambulatory, and radiating chapels – but it was wooden-roofed. About 1050, when the transept was rebuilt, groin vaulting was used in the aisles and quadrant vaulting in the galleries, as had been done, a little differently, at Saint-Bénigne, Dijon, in 1001–17. At the highest level there was a ribbed tunnel vault. This typical

Pilgrimage vaulting system might have been extended to the nave, but plans were changed after a fire of 1123.[7]

The reconstructed transept of St Martin was built according to the Pilgrimage formula, but without the inner paired arches of the gallery bays [115]. Heavy tower porches were built at the transept ends (in the tradition of the façade tower of 466–70 at St Martin); a lantern was built at the crossing, and eventually a monumental pair of towers at the west end. The ambulatory of 997–1014, which we would so gladly see, was replaced by an Early Gothic ambulatory after a fire of 1202, but that followed the others in the ruin and demolition which overtook the building late in the eighteenth century.[8]

SAINT-MARTIAL AT LIMOGES[9]

At Saint-Martial in Limoges, it was the art of music which was most effectively cultivated. One may fairly surmise that the musical de-

velopment at Saint-Martial was enriched from St Gall and by the impulse which came from Gerbert of Aurillac, later Pope Sylvester II, whom we have seen at Ripoll in near-by Catalonia – also in one way or another by the multiple contacts of the Pilgrimage Road.[10]

Saint-Martial had become Cluniac at the close of Abbot Odo's career (between 936 and 942) but had seceded from the Congregation. After the abbey had suffered from a disastrous fire in 1053, it was sold (in 1062) by the Count of Limoges, who did not own it, to Cluny, and it thus became Cluniac again under Abbot Hugh. When the new monks came, the old community resisted, and the Cluniacs were obliged to resort to force before they could establish themselves (1063).[11] In happier years which followed, Cluny gave the monks of Saint-Martial a new church of the Pilgrimage type; for Cluny was not arbitrary or conformist in architecture. The new church was nearing completion when it was dedicated in 1095, though the nave, evidently still covered at least in part by wood, suffered from fire in 1167 and eventually had a Gothic vault.

SAINTE-FOI AT CONQUES[12]

The chant transports us spiritually to the Middle Ages. At Conques, in and about Sainte-Foi, we are taken back visually [116–18]. Sainte-Foi is very happily situated on a rugged slope in a remote valley with a pretty village near, which looks much as it did in olden times. The present church, small, elegant in line, and beautifully proportioned, was built slowly and progressively to replace older construction, according to a beautiful plan put into execution by Abbot Odolric about 1050. The nave, which appears to be the oldest part, has bold proportions ($1:2\frac{1}{2}$) corresponding to those in the transept (c. 1050) of St Martin at Tours [113 (3)]. Abbot Bégon (1087–1107) built the cloister, and his tomb is set against certain older portions of the church,

but opinion is unanimous that the church must have been finished about 1130. The tall proportions do not indicate tardy date, but the belfry over the crossing is clearly of the twelfth century, and the boldness of composition of the apse – both internal and external – belongs to a design of the period about 1080. The unfortunate western towers date from the nineteenth century. Before that time a plain front terminating in a double slope (like a Lombardic façade) served as a background for the entrance portal [116].

This west portal at Conques, dated about 1124,[13] is a most remarkable carving, which still (owing to the characteristic arched hood) retains traces of its medieval polychromy, a circumstance which gives us the rare privilege of seeing this composition of the Last Judgement as the

116. Conques, Sainte-Foi, c. 1050(?)–c. 1130, façade before restoration

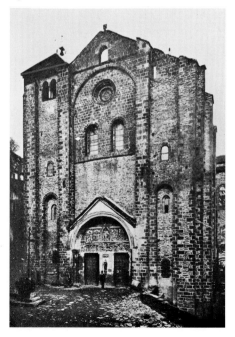

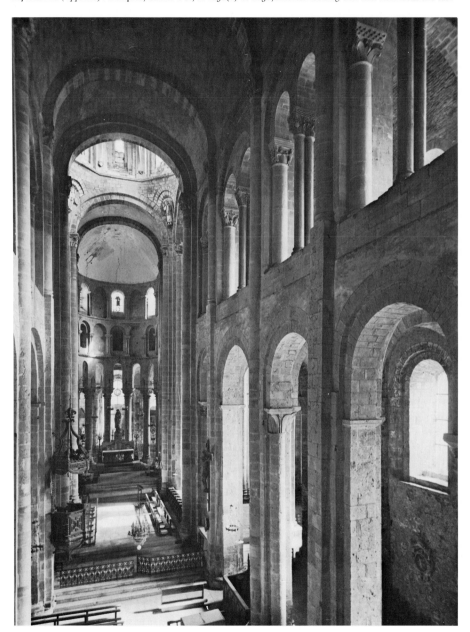

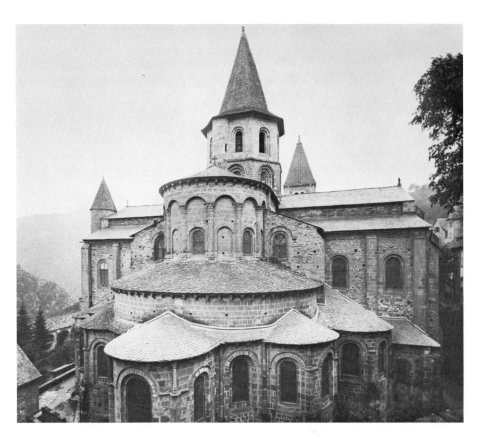

Middle Ages saw it, alive and warm with vivacious movement. The influence of the pilgrimage throngs may be felt in the choice and treatment of the subject – more picturesque, and much more popular in appeal than the apocalyptic vision which was evoked for the more intellectual devotion of the monks of Cluny. Sainte-Foi at Conques never had close connexions with Cluny.

SAINT-SERNIN AT TOULOUSE AND PILGRIMAGE SCULPTURE

Saint-Sernin at Toulouse[14] is by far the most familiar and the most often visited of the Pilgrimage group of churches. It rightly stands for a great moment in the civilization of Languedoc, which had its capital in Toulouse. Except for a short interlude, it was an Augustinian house when the church was being built. At the time it lay on the outskirts of the city, and had a considerable group of conventual structures, arranged about a cloister, on the northern (shaded) side. Before the date of the rebuilding of Conques was suspected, the beginnings of Saint-Sernin were ascribed to the 1060s. Conservative opinion now prefers 1077, when the chapter of canons regular was instituted, or 1082–3, when Bishop Isarne of Toulouse installed Cluniac monks at Saint-Sernin, because

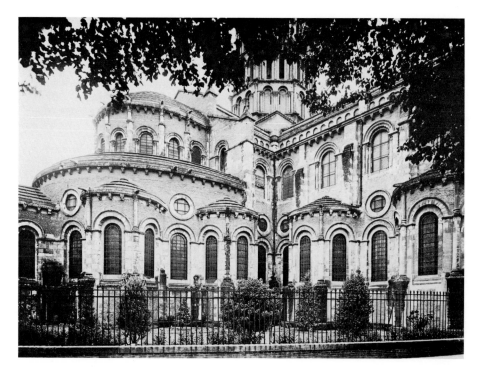

the canons, claiming exemption, refused him obedience.

The chevet of Saint-Sernin [119-21], of typical form, was complete when the later architect of the building, Raymond Gayrard, took over about 1098. Meanwhile the high altar had been consecrated on 24 May 1096 by the Cluniac pope Urban II in the presence of fifteen French and Spanish bishops. A gift for the nave is reported in 1095, which means that the transept was well advanced by then, and in 1118 when Raymond Gayrard died, the splendid double-aisled western arm of the church had been carried up to include the height of the windows of the gallery, but not vaulted. Pope Calixtus II, putative author of the famous pilgrim codex, dedicated an altar (or perhaps the uncompleted building) on 19 July 1119. The west front has been finished off simply, and remains an awk-

ward bulk, bringing the exterior length of the church to a total of 359 feet. In order to support the staged belfry (largely of Gothic date) above the lantern, the four crossing piers have been much enlarged, with resulting strangulation of the interior perspectives, but the exciting exterior silhouette, as seen from the east, is a partial compensation. The picturesque medieval fortifications and the old patina of the building were lost in a restoration, otherwise unfortunate also, dating from 1855 and the following years.

While Saint-Sernin is most important as an accomplished example of Pilgrimage architecture, its carvings figure prominently in the history of Romanesque sculpture.[15] A series of marble plaques in a heavy style have been built into the ambulatory wall of Saint-Sernin. They are datable to 1096 or earlier [121]. At the crossing there is a marble altar slab bordered by

exquisite small figures which is believed to be the high altar slab dedicated by Pope Urban II in 1096. The plaques and the altar, which are in Pyrenean marble, make it easy to trace the sculptural development from French Catalonia (Saint-Genis-des-Fontaines, 1020-1; Arles-sur-Tech, 1046) by way of the ambulatory figures and altar (1096) to the Ascension on the Porte de Miègeville at Saint-Sernin (*c.* 1110) and so to Cluny (*c.* 1112) and to the wonderful portal of Moissac (*c.* 1115).[16]

Conservative French writers claim a primacy for Toulouse in the re-creation of monumental sculpture in stone. Yet the precious wreckage of older sculptures shows that monumental sculpture in stone did not really cease with Antiquity. The Anglian and Irish crosses, late Saxon reliefs in England, figure sculpture dated about 1065 at St Emmeram, Regensburg; at St

Martin, Tours; and at the Panteón de los Reyes of San Isidoro, León, still exist; other important ensembles (the tomb of St Front, Périgueux, 1077, and the carvings of San Facundo, Sahagún, 1080-96) have been lost. A re-study of the material will show that Cluniac spirituality and love of the arts did a great deal to give increasing cogency to the sculptural themes in the late eleventh century.

SANTIAGO DE COMPOSTELA, GOAL OF THE PILGRIMAGE

The modern pilgrim may come up the Via Francígena ('Frenchmen's Way') to Santiago de Compostela as his predecessors have done for a thousand years and more. He will find a charming city of rain-washed granite which has changed very little since the eighteenth century,

122. Santiago de Compostela, Puerta de las Platerías, 1078 and later

123. Santiago de Compostela,
restoration study of original scheme,
c. 1075, c. 1100, etc. (K.J.C.).
Small flying buttresses of apse
and battlements added after 1117

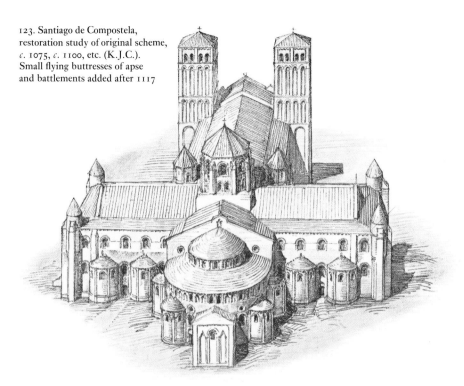

because the provincial government was long ago installed at busy La Coruña, and indifferent communications have discouraged modern developments at Santiago.[17]

The splendid old cathedral[18] [113(5), 114, 122–6] still dominates the whole of the city, as it has from the very beginning. It was not entirely finished until the end of the eighteenth century, by which time its medieval forms had been disguised on the exterior and partly on the interior, for harmony with the grandiose spirit of that gorgeous age. The western façade (of the 'Obradoiro') flanked by the palace of the archbishop on the north and the cloister edifice on the south, is a magnificent design in Churrigueresque. With typical Spanish art, the flanking structures are kept relatively simple in order to give full value to the extraordinarily elaborate frontispiece of the church. The whole great façade, 524 feet in width, gains greatly from the fact that the supposed tomb of St James, the nucleus of all Santiago, is located within the building about twenty-five feet above the level of the plaza, so that a high basement storey was necessary beneath the western range of buildings. The unfinished towers of the façade were carried up in masterly Churrigueresque – one for the bells, the other for the *carraca* or Easter rattle – to a height of 232 feet; also, a heavy tower of defence adjoining the transept was augmented in a similar way, and provided with a clock.

A Renaissance stairway and platform give access to the church from the western plaza. Once past the door, the visitor is surrounded by Romanesque work, and engulfed in an atmo-

sphere full of warmth and dignity. The west end has an interesting crypt, which sustains the main vestibule and with it the triple Pórtico de la Gloria, richly embellished by carvings. It is a late and beautiful flowering of Pilgrimage sculpture, in arrangement, though not in subject, freely inspired from the great Cluniac portal at Vézelay [124, 163]. It was carved and installed (1168–88) by a master named Matthew, shown in prayer on the base of the median jamb. Formerly the outer archways were open, and the three great doorways, each with jamb figures, the sculptured great tympanum, and archivolts all touched with colour, were seen from the plaza in the cavernous shadow of the vestibule. The vaulting of the vestibule supports a tribune which is carried up as the central motif of the façade. Therefore at Santiago we have essentially the old Carolingian westwork augmented by the portal sculptures, and by the monumental tower pair.

The original scheme for the front called for these same elements, but the carvings of the portal were on the exterior wall, and there were two arches corresponding to the nave. The spandrels of these arches had a Transfiguration – showing St James of course – carved in relief. This old scheme has been preserved at the transept portals, and that at the south now contains carvings from the west portal and the north portal, as we know from the Pilgrim's Guide by Aymery Picaud, where they are appreciatively described. The north façade of the transept was entirely rebuilt between 1757 and 1770, but (as remarked) it still has its paired entrance doorways and preserves its medieval name, the Puerta Francígena; the adjoining Plaza de la Azabachería still recalls the pilgrim souvenirs of jet (*azabache*) which used to be sold there. The south façade is still largely medieval, and it is named after the silversmiths' shops (*platerías*) which are even now in the old location near by. Between these façades stretches the magnificent 240-foot transept, lengthened by the clock tower

to 259 feet, with a clear interior length of 213 feet – one of the finest of all Romanesque interiors. Its altars (in chapels at the east), together with those of the ambulatory, were dedicated in 1105; old work was cleared out of it in 1112, and it was finished soon after. All of this work, and the sanctuary too, is marked by cusped and mitred arches which savour of Moorish influence.

The scheme for the new cathedral was worked out shortly after 1071 by Diego Peláez, bishop of Santiago; preliminary work had been done by 1077, when the property lines involved at the east end of the church were settled. On the Puerta de las Platerías the ceremonial beginning or the juridical foundation of the church is recalled by a bold inscription of unusual form, giving the date V Ides of July, Era 1116 (11 July 1078), but a good deal of the existing work on the portal is later. Many carvings have the general character of sculptures of 1090–5. There is a beautiful statue of St James which was given by Alfonso VI (d. 1109) together with at least one fine relief from the Transfiguration Portal. The frieze and jamb reliefs are somewhat disordered, and it is certain that the portal has been rebuilt – once probably after a serious town insurrection and cathedral fire of 1117, and later, when the west and north portals were remade.

Bishop Diego Peláez was deposed in 1088, accused of complicity in a plot to invite William of Normandy's intervention in the disturbed politics of the Kingdom. Diego Gelmírez took over as administrator (1093), bishop (1100, 1101), and archbishop (1120). Repairing, vaulting, and fortifying the existing parts of the cathedral involved a considerable effort for him after 1117. Nevertheless, in 1124 or 1128, the 'greater part' of the church having then been built, Archbishop Gelmírez recommended the construction of a cloister. It was doubtless of the usual Romanesque type, rather small in scale, and so it was replaced in the sixteenth

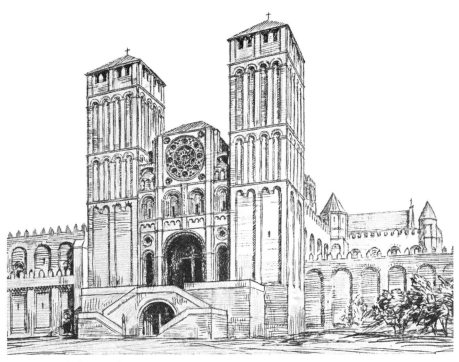

124. Santiago de Compostela,
restoration study of façade as remodelled 1168–1211;
north tower finished later (K.J.C.)

century. Works were still in progress at the west end of the church when Aymery Picaud visited it in 1131 (or 1120?); it promised to be very handsome, as he says.

The visitor entering the nave from Master Matthew's vestibule through the Pórtico de la Gloria sees the entire length of the nave, crossing, and sanctuary without interruption – an open axial vista of 250 feet, the total exterior length of the cathedral, including the present approach stairway, being 365 feet.

It is a great moment for the lover of the Middle Ages, when he finds himself within the soft light and shadow of that harmonious nave, gazing towards the high altar which has been the focus of pilgrim devotion for so long. The altar and its surroundings have been enriched by Baroque fittings, and the vista is framed by two splendid Baroque organs at the head of the nave, all bright with gilding, silver, and colour; nevertheless the interior is dominated by the old Romanesque work in brown granite – the even rhythm of the nave bays, the elegant proportions of the aisle arches, the sophistication of the gallery arches with their rounded tympana and slender paired shafts. A flood of light marks the crossing tower. An enormous censer, the Botafumeiro, is swung from a support inside this at festival time, emitting great clouds of aromatic smoke as it describes a 150-foot arc above the heads of the multitude. This is but one feature of the extraordinarily rich liturgical tradition of Santiago, which dates in its present form from Baroque times. The popular aspects

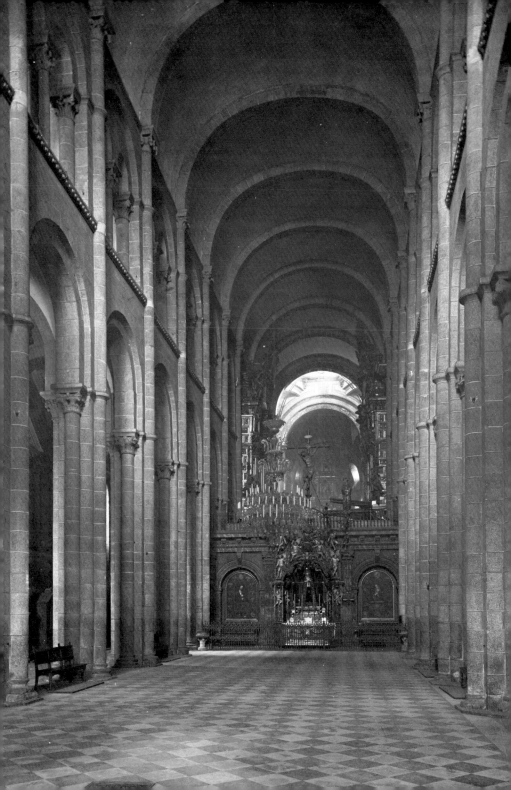

of the festival also possess great interest – the fiesta, the fireworks, the procession with *gigantones*, two of which do a dance in the cathedral sanctuary after the great high mass of St James's day, and the general outpouring of devotion and spirits – all are sweet with time and memories.

From the early twelfth century until quite recently there was a walled-in 'coro' at the east end of the nave [125]. This monastic feature was introduced by Diego Gelmírez, who organized the canons, to the number of seventy-two (including seven with the privileged title of cardinals) as a community under the Augustinian regime. Santiago was apparently the first cathedral to have such a coro, and set the fashion in Spain. The opening up of the nave at Santiago has permitted excavations which are revealing the old church of 879–96 built by Alfonso III in the Asturian style, of which the church of Lourosa in Portugal is perhaps the best existing representative [54C].[19] The raised area in the sanctuary rests in part on the foundations of the tomb which the hermit Pelayo brought to notice in 813.

The Romanesque ambulatory and radiating chapels took over the site of the ninth-century Benedictine church, as agreed in the negotiations of 1077.

The charming and very exceptional central chapel has the inscription *Regnante Adefonso tempore Didaci* – in the time of Bishop Diego Peláez (who undertook the building) and Alfonso VI the King (who was generous to Santiago – but even more so towards Cluny, to whose prayers he believed he owed his life during the preceding murderous dynastic struggle).

It was he who, under Cluniac influence (1072), outlawed the Mozarabic liturgy in Spain; under him, as the Kingdom advanced southward, many Burgundian knights and Cluniac ecclesiastics aided in settling and organizing new territories. As a thank-offering for the capture of the old Visigothic capital of the peninsula, Toledo (25 May 1085), he gave immense subsidies which paid for about one-half of the abbey church of Cluny, as we shall later see. This conjuncture, however, was unfortunate for Santiago. Archbishop Diego Gelmírez in the heroic age wished to make the see pri-

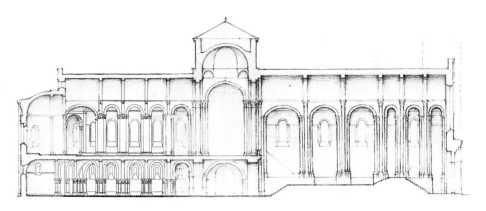

125 (*left*). Santiago de Compostela, nave from the west, *c.* 1075–1150, showing the traditional monastic coro, now destroyed

125A. Saintes, Saint-Eutrope, 1081–96. Raised choir for monastic services [138]. Pilgrim crypt [139] opened wide on nave stepped for visibility (destroyed 1802)

matial; he was a personal friend of Calixtus II, and it looked as if he might be successful, but the Cluniac Bernardo, archbishop of Toledo after the recapture, kept the ancient primatial dignity for the old capital city.

Within the present extensive residence of the archbishop of Santiago, north of the cathedral, there are remains of the palace which Diego Gelmírez built.[20] Its plan is in the shape of a ⊥ with the cross-bar a west range continuing the line of the cathedral façade. The guard hall and school were towards the Plaza de la Azabachería. An interesting old kitchen and stairs connect with two handsome halls in the west range. The lower one has two lines of groin vaulting supported by a median range of slender and elegant piers; the upper room is a splendid open festival hall, its late medieval vault springing from corbels ornamented by sculptures of the musicians and the instruments which used to be heard there [126]. The uppermost parts of the palace have been rebuilt, but are known to have been fortified, and connected by a bridge with the upper works of the cathedral, which also bristled with crenellations, added in consequence of the dramatic town uprising in 1117.

When the magnificent old battler of a bishop died, in 1139 or 1140, after forty-odd years of command at Compostela, his palace and the cloister were probably complete, and the cathe-

126. Santiago de Compostela, Archbishop's Palace–Festival Hall, largely fourteenth century

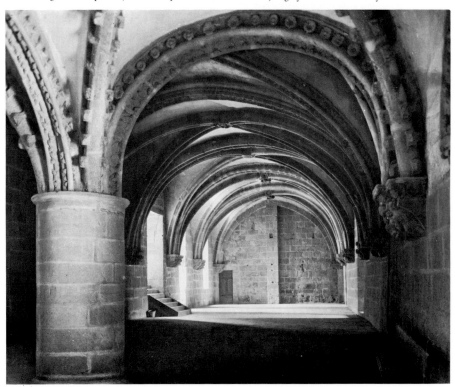

dral was complete enough by 1152 for the surrender of certain contingent revenues; but at that time the Pórtico de la Gloria, the upper parts of the western towers, and two grim but handsome fortified towers on the east side of the transept remained to be constructed. Through all these and subsequent changes, the beauty of the original building, the vitality of the spirit which created it, and the enchantment of the Pilgrimage continue to be felt.

Before leaving the Pilgrimage, it ought to be remarked that the great churches which we have seen served as sources for the design of many churches on a smaller scale. No other buildings presented the full Pilgrimage formula, but excerpts from that formula, varying from region to region and from building to building, are seen in much interesting twelfth-century work. Several conspicuous Auvergnat Romanesque churches so much resemble the Pilgrimage type that older historians, not aware of the significant role of Saint-Bénigne at Dijon and St Martin

at Tours, supposed that the Pilgrimage type originated in Auvergne. Actually the Pilgrimage Roads ran through the area of six or seven regional schools of architecture to which we shall refer in much more detail.

Mention should also be made of the accommodations which were provided for pilgrims.[21] Abbeys and priories on the road normally received pilgrims in their hospices or their guest houses according to the travellers' condition; there were also, from an early period, hospices which were built with the pilgrims especially in mind. The earliest hospice certainly mentioned is that of Orense, near Santiago, 886; others are mentioned in 905 (Tuñon), 1010 (Antoñana), 1052 (Nájera), and after this they become numerous. In general large open halls were provided for sleeping [106], special chapels had divine service, and special charities took care of the needs of sickness, destitution, and death when the pilgrims encountered those misfortunes in their pious journeying.

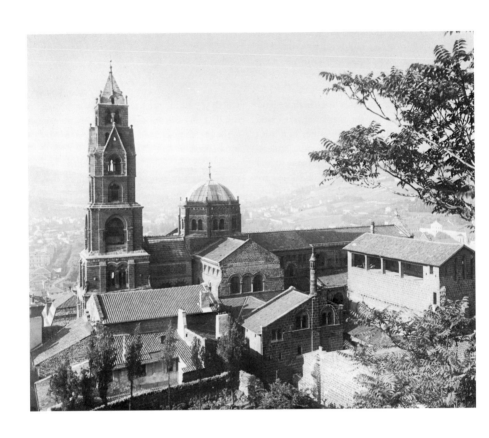

127. Le Puy Cathedral, cloister and tower, from above; largely twelfth century

REFLEX FROM THE PILGRIMAGE

The architecture of the five great churches of the Pilgrimage Roads was inter-regional, international in style, and concerned with a great movement towards Spain. Mention has already been made in the preceding chapter of architectural designs along the way which are dependent on the Pilgrimage type of church, and of the fact that French master masons and sculptors worked on many Spanish buildings. But it most not be forgotten that most of the pilgrims and artisans returned home; if there was a genuine flow of Pilgrimage architecture and sculpture, a counterflow should also be discoverable.[1]

Émile Mâle was discerning in the matter. He sensed that a veritable tide of influence from Moslem Spain – from the mosque of Córdoba in particular – flowed along the Pilgrimage Roads into France, and added spice to numberless Romanesque designs on or near these routes.[2]

Le Puy presents a special case. It was continuously an important city, and it has a long record of significant contacts with more southerly regions, including Moslem Spain. Coins of Moslem tenor minted at Le Puy and found in the peninsula are proofs of a lively and continuing exchange. Le Puy was early aware of Santiago de Compostela; Bishop Godescalc of Le Puy brought the first large recorded group of pilgrims there, nearly 200 monks, in 951, as we have seen. One of the two southern Pilgrimage Roads ran through Le Puy and Moissac. Moslem influence, confessed by striking cusped forms in arches and doorways, appears in both places.

The cathedral of Le Puy [127, 128] is the most notable French monument in which

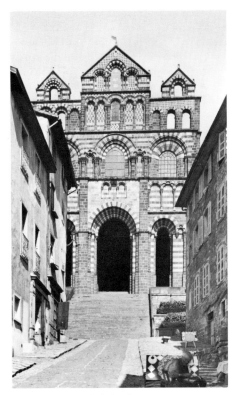

128. Le Puy Cathedral, façade, twelfth century (restored)

Moorish influence is strong. It is the noblest building in the Auvergnat district of Velay, which being volcanic has provided a spectacular situation for the cathedral, and a fine but rather grim granite, black and red, of which to build it. The church, begun in the eleventh century, has a rather simple cruciform plan. At the head of the axis stands a handsome staged tower of the

Limousin type, with arches, setbacks, and gables like those at Saint-Martial in Limoges and other churches of the region. The sanctuary and transepts of Le Puy are comparatively plain, though the crossing has a lantern with octagonal vaulting. The old part of the nave consists of two plain bays, with octagonal domical vaults on squinches. It is reached by stairs from the ascending slope below the church. In the twelfth century the nave was extended out over the slope, forming an imposing open porch – a sort of crypt – which presents three cavernous portals beneath the end wall of the nave and aisles of the church. This is a very handsome design, whether seen from a distance or at the head of the steep slope as one approaches from the west. The crypt porch, gable, and wall belfries recall Santiago, but the detail has many Moorish features, like zebra stripings in the coursed ashlar and the voussoirs, pattern-work masonry panels, pointed arches, decorative cusped arches, and flatly-carved wooden doors with Cufic inscriptions. This façade is clearly a twelfth-century conception like the west parts of the nave. The nave bays are stubby oblongs in plan, and divided from one another by diaphragm arches. There are corbel tables on the flank at the level of these arches; above, an intermediate stage has columns, arches, and niche-head squinches which gracefully make the transition to an octagon, on which an octagonal domical vault is set. There are unmistakable Moslem reminiscences here. This is also true of the south porch of the church, and to a lesser degree of the cloister, where particoloured masonry appears also. In all there are nearly a hundred carved capitals of Moslem type at Le Puy. The granitic hardness of the material has gained suavity from its Romanesque and oriental ambient without losing the vigour of form appropriate to a cathedral design on such a picturesque site.

The decorative cusped arches and zebra work are represented in Le Puy itself at the portal of the chapel of Saint-Michel de l'Aiguilhe, and doubtless its successful use at Le Puy encouraged imitation elsewhere. Cluniac designers became interested in these motifs also; the cusped arches of the triforium of the great church (1088 ff.) and of the main portal (1106-12) at Cluny are well known. The portal had *alfiz* or bordered spandrel panels like a Moorish mihrab or city gate. A surprising number of churches in the vicinity of Le Puy, the Pilgrimage Roads, and Cluny, have cusped arches at the portals – La Souterraine, Moissac, Montbron, and Ganagobie being important Cluniac examples.[3] Polyfoil windows and triforium arches had their vogue also – Saint-Étienne at Nevers, Cluny [154, 155], and Sainte-Croix at La Charité-sur-Loire being Cluniac examples. The zebra-work appears in the transverse arches of Vézelay [140]. Lobed soffit panels like miniature Moorish lobed domes appear, together with chisel-curl eaves brackets, at Notre-Dame-du-Port in Clermont-Ferrand, and were seen formerly in Saint-Bénigne at Dijon. In general such features gave warmth and spice to the style wherever they were used. By contrast the rather rough basilicas of the north seem very Germanic, and the typical churches of Burgundy and Provence very Roman.

The transformation of Saint-Philibert at Tournus [101, 102] into a fireproof building brought about the construction of transverse tunnel vaults which may have a Moslem or Asturian connexion, and an elegant dome over niche-head squinches resembling those of Le Puy, early in the twelfth century. Two such domes were built at about the same time near the entrance of Saint-Front at Périgueux [225].

A corresponding process of transformation produced an even more remarkable construction at Saint-Hilaire, Poitiers[4] [129, 130]. The tomb of St Hilaire, teacher of St Martin, attracted a pilgrimage, and about 1025 a vast church was undertaken, in which Queen Emma of England, Walter Coorland the Norman archi-

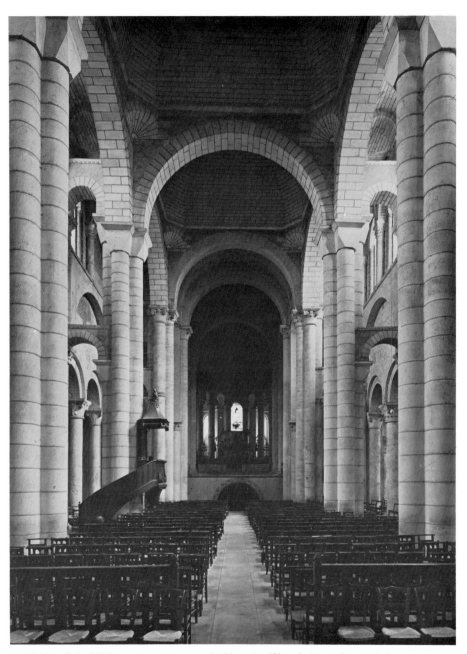

129. Poitiers, Saint-Hilaire, nave, *c.* 1025–49, vaulted later (twelfth and nineteenth centuries)

130. Poitiers, Saint-Hilaire, aisle,
c. 1025-49,
vaulted later (twelfth and nineteenth centuries)

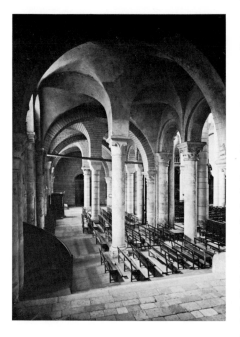

tect, and perhaps Bishop Fulbert of Chartres were concerned. Although the new nave and aisles in their first state had only recently been begun on an enlarged scheme which incorporated the fine old free-standing tower, the building, wooden-roofed, was dedicated in the year 1049. Its colossal open interior space, terminating in a hemicycle about the altar, was quite Roman in its ample grandeur.

About 1130-68 the church was rebuilt and vaulted in a strange way; two files of piers were contrived to divide the nave longitudinally into three parts, of equal height, leaving the middle bays square in plan, and the lateral bays very narrow. The nave piers, strengthened by charming interior buttresses in the form of little arched bridges, were kept very slender and unobstructive, yet strong enough to sustain a series of octagonal domical vaults on diaphragm arches and squinches which covered the central part of the nave.

Here, as at Le Puy, the scheme has oriental undertones – even after a nineteenth-century rebuilding necessitated by a partial demolition in the Revolutionary era. Oriental undertones are felt in the aisles also, for these are of double width, and vaulted, bay by bay, with a peculiar compound groin vault supported, somewhat like the vault of San Baudelio de Berlanga in Spain [57], by a tree-like central column and trumpet. The effect, though achieved with Romanesque detail, has a strange Moorish cachet, and reminds one of the groping solutions of the Mozarabic architects two centuries earlier.

At the head of the nave just described there is a spacious transept, also vaulted after it was first built, and beyond that a handsome dark apse with ambulatory and radiating chapels, all of twelfth-century construction.[5]

The Moslem type of vault which appears in perfected form at the mihrab of the mosque of Córdoba (961) [131], has exercised much fascination. It was imitated in Spanish Gothic

131. Mihrab of the mosque of Córdoba, Moslem ribbed and lobed vault, 961

vaults, and it comes into the reflex architecture of the Pilgrimage. The odd destroyed church of Saint-Pé-de-Bigorre[6] had such a vault in a tall staged tower decorated with cusped arches; the church of L'Hôpital-Saint-Blaise near by also has such a vault which still exists, and a more perfect example is to be found in Navarre, in the conventional but handsome octagonal church of the Holy Sepulchre in Torres del Río[7] [132, 133].

It is an open question also whether the square domical vaults of towers like the Romanesque belfry of the cathedral of Oviedo (about 1100), the transeptal tower of St Martin at Tours [115], and one of the façade towers of Bayeux (about 1070) do not represent a reflex of Moslem engineering; for the ribs support the middle of the vaulting panels in the Moorish fashion, not the angles, as in Roman and typical Roman-

esque work. Moorish-looking interlaced ribs and lobed vaulting severies continue to appear even in Early Gothic times, but not in monuments of importance.

Oriental connexions through Spain by way of the Pilgrimage are, however, only a part of the story. North Africa and Sicily had their effect on Romanesque architecture also; the pointed arch and the approximate catenary shape for tunnel vaulting came from the Near East. Being structural – rather than decorative, like almost all the reflex architecture of the Pilgrimage – these Near Eastern motifs powerfully transformed Romanesque architecture, as we shall see in Burgundy, Normandy, and the Île-de-France. The tide of structural influence from the Near East is a part of the prehistory of Gothic architecture, and as such will be analysed in a later chapter.

132 (opposite) and 133. Torres del Río, church of the Holy Sepulchre, twelfth century, vault and exterior

THE ROLE OF CLUNY

IN THE HISTORY OF ROMANESQUE ARCHITECTURE

THE EARLY ABBOTS;
THE 'ÉCOLE CLUNISIENNE'

Cluny[1] lies in southern Burgundy, nearly due west from Geneva and about sixty miles north of Lyon, in a region which was relatively less disturbed during the invasions and local wars than most of France. From the time of Clovis onward it tended to gravitate towards France, but for a long time it was on the borders of the Empire, and maintained close relationships there. It had easy communications in both directions.

Cluniacum, said to be a Roman station, was a villa under the Franks, and a possession of the family of Charlemagne. At the beginning of the tenth century it was the favourite hunting lodge of William Duke of Aquitaine and Marquis of Gothia, lying near the north-eastern extremity of his dominions. At the end of a vigorous, un-quiet life, he gave the domain to the noble Berno, abbot of Baume and Gigny in the Franche-Comté de Bourgogne, in order that a reformed monastery might be established.

When the monks came to Cluny they found a rural villa of the Roman type which had per-sisted in the region, and can be recognized even to-day. In the tenth century the countryside was dotted, though sparsely, with such estab-lishments, traditionally possessing a court with a master's dwelling, its immediate depen-dencies, and a chapel. This part of the villa was temporarily used as the monastery, and soon (915-27?) the first monastic church, Cluny I, was built just to the north of it. There were also, of course, the various barns, shops, and living quarters required by the agricultural exploita-tion, which continued under the new auspices with servants, peasants, and serfs, as before. Little change was made in their existence, ex-cept that their lot under a monastic regime was probably more fortunate than under lay control.

A remarkable foundation charter had been issued in solemn conclave at Bourges, the ec-clesiastical metropolis of Aquitaine, on 11 Sept-ember 910, which in laying the groundwork for the new institution placed it under tribute to the Holy See. The Pope might intervene if the house became gravely disordered, but other-wise it was 'exempt' from any ecclesiastical or lay interference. The charter was confirmed with this provision – most important for the future – by Pope John X (914-28). The monas-tery acquired the right of sanctuary in 994, and its privileges were further supplemented by Gregory V (997 or 998) and by John XIX (1024).[2]

It so happened that Cluny's first abbot, Berno (910-27), was at the same time abbot of several other monasteries, each one independent. But his successor Odo (927-42), by virtue of a papal privilege issued by John XI in 931, began to bring monasteries under the rule of the abbot of Cluny *as such*. This was a novelty among the Benedictines, since the Rule envisaged separate and independent houses. Because of it, how-ever, Cluny was enabled to become by far the most important of the earlier exempt monas-teries. The disadvantages of the Cluniac system lay in understandable local jealousy of, and resistance to, the ever-increasing exempt insti-tution, and in the perennial faults of large-scale centralized administration.

Odo's abbacy was decisive in this matter. He was a saintly man, open-hearted, and of great warmth and personal charm. He left his position as precentor for the canons of St Martin at Tours to seek a more austere life at Baume, and came with a group of serious monks to Cluny, where he became novice master. As a poet, musician, and preceptor in music he was a lover of the arts. Under him the abiding spiritual life of Cluny was so greatly enriched that it became possible to send colonies of Cluniac monks to reform other monasteries, some of which became dependent on Cluny, and the group was further extended by the foundation of new Cluniac priories. The wonderful Cluniac chant went with them everywhere. In principle, all monks were professed at Cluny itself.

This process continued, and so produced a spreading network of monasteries which is properly called the Congregation of Cluny, under the rule of Aymard (942-c. 963), Mayeul (c. 963-94), and Odilo (994-1048).[3] There was an increasing group-consciousness, resembling that of an 'Order' in the modern sense. St Hugh (1049-1109) had a strong centralizing policy which prepared the way for strictly-organized institutions like the Cistercian and later Orders. At its zenith Cluny controlled about 1450 houses, of which about 200 had some importance.

There can be no doubt that the Congregation and Order of Cluny constituted a cultural unit within the boundaries of Western churchmanship. It would be easier to recognize this if its art had not not been scattered, forgotten, lost. The distinguished career of the Cluniacs as builders has been obscured by the length of time (more than two centuries) over which their medieval building campaigns extended, and by the fact that their achievements came into architectural history without being recognized as Cluniac.

Viollet-le-Duc, writing more than a century ago, at a time when many exact relationships in architectural history were not yet understood, stated his belief that the Cluniac monks like the Cistercians were sent out with *poncifs* – copies, that is, of master plans – which could not be modified. Cluniac practice was of course much more liberal, especially with regard to churches. It appears that there was an archive of plans at Cluny, useful, especially, for the layout of priories. Viollet-le-Duc was accused of inventing an *école clunisienne*.[4] The phrase was ill-fated, because later French art historians have come to use the term *école* for such groups as early Cistercian monastic architecture, which had a remarkable inter-regional unity during the first century of that Order's existence. By their constant repetition of the statement that there is no *école clunisienne*, these writers have obscured the fact that unified groups do exist among the buildings which were constructed by the Cluniacs during the two Romanesque centuries.

The situation has been clarified by the devoted labours of Dr Joan Evans. Over the years she has carefully identified, in very many cases visited, Cluniac works of architecture, and has published them as such.[5] It was a matter of surprise even to her that after all that has happened in 800 years since the full flowering of Cluny, there are still remains (greater or less in extent) of 325 Cluniac establishments, representing nearly a quarter of the whole number, and all the areas where the Order did its work.

To avoid confusion, we follow the French authors, and refer to these buildings as 'groups', five in number.

First of all there was a widely diffused group based on the church called Cluny II (c.955–c. 1000) and the adjoining monastery (c. 995–1045) [103–5], which have been referred to in our chapter on Burgundian Developments in France between 900 and 1050. These constructions, with the great expansion of the Cluniac monasteries (subject and associated), became, so to speak, paradigms – sometimes closely, sometimes loosely followed. The dimensioned

description of the monastery at Cluny preserved in the Farfa Consuetudinary of 1043 witnesses to this fact, as does the actual form of the monastery of SS. Peter and Paul at Hirsau.

Shortly after 1030 a *second* 'group' of Cluniac churches began to appear – churches of substantial construction with a generous use of ashlar. They were planned with aisled naves, wide, towered transepts, ambulatories with radiating chapels (or apse échelons; in less ambitious examples, three apses), substantial grouped piers, capitals carved with leafage and grotesques, stout tunnel vaults with transverse arches at the highest level, groin vaults over the aisles, usually a low clerestory, sometimes a gallery; often portal carvings of some interest, and decorative arcading. The examples with apse échelon include Charlieu II (*c.* 1030–94) [143, 144, 164, 165], Payerne (*c.* 1040–1100) [135], and various parish churches near Cluny, after 1040; the examples with apse, ambulatory, and radiating chapels come later. There were various reductions of this general type also – some without clerestory in the nave, some with quadrant vaults over the aisles.

In addition to the two 'groups' just mentioned, there are, during the abbacy of Hugh of Semur and later, three other groups which may be distinguished. The *third* group is related to Sainte-Madeleine, Vézelay, the *fourth* to the new chapel of St Mary near the Infirmary at Cluny, and the *fifth* to the great church there.

The Cluniacs were more zealous for uniformity in customs, discipline, and liturgy than in architecture. Therefore in addition to the 'series designs' noted above there are other special groups representative of the local architecture, which varied from region to region. In the conventual structures which the monks built for their own habitation, local variation was less likely to occur. Such structures among the Cluniacs of the Romanesque period were wooden-roofed and almost uniformly simple and unassuming, though well-built. They had a natural tendency to unity because of the uniformity of the Customs; and wherever they are preserved, they breathe the same warm but austere spirit.

In the churches, built for divine worship, the predisposition of the Cluniacs was, by contrast, for magnificence. They had a common ideal of handsome planning, solid, enduring fabric, and of masonry vaulting. This unity transcends to a large degree the variations in general form, silhouette, lighting, colour, and decoration. It needs to be reiterated that the Cluniac psalmody, admired and imitated throughout western Europe, was most beautiful when sung in vaulted – especially tunnel-vaulted – churches. Thence, a general stimulus for vaulting.

ABBOT HUGH OF SEMUR

Abbot Hugh was one of the great builders of all time. He had an early and deep vocation to the monastic life, which led him to Cluny in 1041, aged seventeen, or perhaps in 1043. In 1048, at the death of Abbot Odilo, he was already grand prior of the mother house; early in 1049 he was elected abbot, at the age of twenty-five. He ruled a constantly expanding Congregation and Order of Cluny for sixty years, until his death in 1109. His friendly dignity gained the affection of the people, ecclesiastics, and princes alike.

Monastic chroniclers, with their accounts of puerile miracles, hardly help us to judge Hugh's true abilities and accomplishment. What he did was to build a real monastic empire which fitted admirably into the feudal pattern of the age – a consolidated, centralized international monastic organism, ideally made up of 'exempt' houses like Cluny itself. Houses of the Order multiplied within its old areas in the region of the Saône, Loire, Garonne, and their tributaries; expansion took place in the regions of the Seine, the Somme, and in the Germanic lands, and to a lesser extent in England, Italy, and Spain.

Hugh's fame as a builder echoes in the Cluniac antiphon for 29 April, his anniversary and

festival day – *Quomodo amplificemus illum, qui in diebus suis aedificavit domum et exaltavit templum sanctum Domino*, which was sung in many majestic naves which he himself had built. During three-score years of journeying on visitations, he must have seen nearly all the famous structures – some of them Roman – then existing in western Europe. Abbot Hugh himself must have approved (personally or by directives) the plans for some thousands of individual buildings. Their high quality can leave no doubt that Abbot Hugh had an intelligent interest in building, and favoured good building. This fact in turn had a favourable effect on the building industry in general over a large area of western Europe, where monastic architecture still ranked highest in order of importance. Even where the Cluniac monks reformed a monastery which

retained or regained its independence, new buildings were likely to be built at the beginning of the new regime, when Cluniac influence was strongest; in addition large numbers of ecclesiastical works (some of them parish churches owned by the Order) would be affected to some extent by notable Cluniac designs built in their vicinity.

Church designs based on Cluny II continued to multiply under Abbot Hugh. Of small churches around Cluny a style related to Cluny II appears modestly at the former priory of Blanot (*c.* 1050) or more importantly at Chapaize[6] (*c.* 1050 and later) [134].

Among the related buildings of consequence at a distance from Cluny are Gigny (late eleventh century) and Baume (probably twelfth century) from which monasteries Berno and his followers

134. Chapaize, church (not Cluniac),
c. 1050 and twelfth century, from the east

135. Payerne, priory church,
c. 1040–*c.* 1100, nave

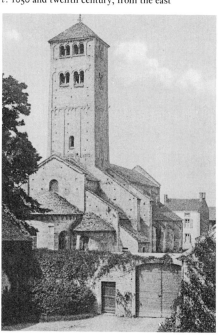

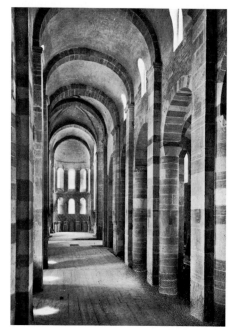

had gone forth to colonize Cluny in 910. Gigny was within the Order when the handsome new church was built; Baume came in later. At La Charité-sur-Loire, 'eldest daughter of Cluny', a church of similar plan was built, *c.* 1059–1107. At Champvoux, near La Charité, the chevet, dated about 1060, closely recalls Cluny II.

At Payerne in Switzerland[7] [135] Odilo started to rebuild, but the church as we now have it (very well restored, and surely the finest Romanesque church in Switzerland) dates from about 1040 to 1100, that is, almost entirely from the time of Abbot Hugh. It is tunnel-vaulted, as Cluny II came to be. Romainmôtier near by, a good example of the First Romanesque style on a plan resembling that of Cluny II, was carried forward with tunnel vaulting *c.* 1080.[8]

This period saw considerable influence in Switzerland of the sister Congregation of Hirsau, where the life and the liturgy were closely modelled on that of Cluny; and this fact may be traced to a certain extent in architecture. Abbot William of Hirsau is doubtless responsible for certain resemblances between Cluny II and Allerheiligen (1078 ff.) [136] at Schaffhausen, for example, and Ulrich of Zell for those at Rueggisberg and elsewhere. Ulrich, formerly Abbot Hugh's secretary, had transmitted the customs to Hirsau.

Buildings of the Hirsau Congregation have a certain unity of character, and rightly or wrongly they go by the name of 'Hirsauer Schule'.[9] There is always a marked German cachet – even at Hirsau itself, where the plan is closer to that of Cluny II than one would expect from the mere fact of similar Customs. Substantial masonry, heavy mouldings, and (ordinarily) simple ornament characterize their buildings. Columnar shafts of slightly conical rather than cylindrical form and block capitals are used. The roofs, as originally in the nave of Cluny II, are wooden; the corridors flanking the sanctuary, though opening inward through arcades, as at Cluny II, are frequently terminated by a flat wall at the

east, like the 'crypts' at Cluny II. The atrium, the paired towers, and the basilican narthex appear also, in somewhat Cluniac form. Apparently, for example, the old church of St Aurelius at Hirsau (1059–71) was made over about 1120, somewhat increasing its resemblance in plan to Cluny II.

By that time the important abbey church of SS. Peter and Paul at Hirsau had been built by Abbot William. It was closer to the pattern of Cluny II, though much later in date (1082–91), more finished in its fabric, and larger in scale, the axial length being 320 feet over all. Excavations indicate three recesses in the east wall of the sanctuary for the three matutinal altars of the Cluniac use which stood side by side, as in the round apse of Cluny II. Unlike Cluny, the church had two such recesses in each of the

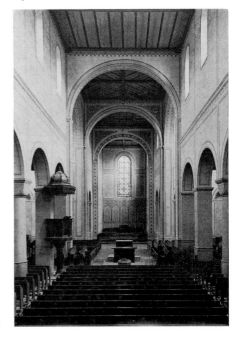

136. Schaffhausen Minster (Allerheiligen), 1078 and later

lateral compartments; the latter opened on the sanctuary through three arches – and this was as at Cluny. The atrium was built and rebuilt between 1095 and 1120, by which time it had been covered over to form a narthex fronted by two western towers with doorways between, like that of Cluny II. The church and monastery were ruined in 1692, leaving little beyond one of the western towers (the Eulenturm) and lines of old wall-work to represent the Romanesque era.

A suggestion of Cluny II is also found at San Juan de la Peña, the national pantheon of Aragon, where the monastery was reformed by Cluny as early as 1014 (or 1022), the church being dedicated in 1094.[10] Certain other monasteries followed the Cluniac rule, but the Spaniards were then, as now, jealous of their independence, and most of such monasteries were

137. Leyre, San Salvador, dedicated 1057; the nave vault Gothic, not Cluniac

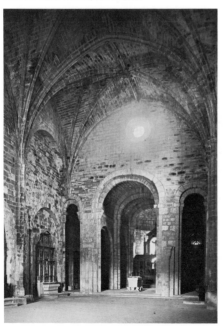

associated with, rather than submitted to, Cluny. It is impossible now to study the expansion of Cluniac architecture in Spain because the major abbey churches have been destroyed – Oña (1033), Nájera (1056), Sahagún (c. 1080–99), and Carrión de los Condes (1076, 1095). However, San Salvador at Leyre remains, and it is a Spanish version of the Lady Chapel near the infirmary, finished in 1085, at Cluny [137]. San Pons de Corbeira also remains, a handsome building in the Lombardo-Catalan First Romanesque style (though dated about 1080). The pretty niches in the interior of its apse may have been suggested from Souvigny, near Cluny.[11]

We must suppose that the Cluniac architecture of Lombardy was local in type.[12] Sixty-three possessions in north Italy were confirmed to Cluny by Pope Urban II in 1095, at the time when the Lombard rib-vaulting was being developed. Obviously the Cluniac order must have had something to do with the spread of rib-vaulting westward from Italy, for derivative forms appear in the remarkable crypt at Saint-Gilles (after 1140) [189], and perhaps in the even more remarkable west tower, with upper chamber, of Moissac, dated about 1130 [168]. But, most unfortunately, reconstructions have all but obliterated the Cluniac buildings in Lombardy. This is true even at the principal house, San Benedetto Po, where we would be happy to see the buildings raised by its famous patroness the Countess Matilda – friend to Pope Gregory VII, to Abbot Hugh and to the abbot's godson, Emperor Henry IV. She was hostess to them all when they met, as history records, at Canossa in 1077.

In France, as in Spain and Italy, the phenomenon of localism appears in Cluniac architecture – Saint-Eutrope at Saintes (1081–96) [125A, 138, 139] and Montierneuf, near Poitiers (1076–96), being redolent of the Pilgrimage and of the west of France, Châtel-Montagne (c. 1100) of the Auvergne, Layrac (1072–85) and Moirax (c. 1090) of the south of France.

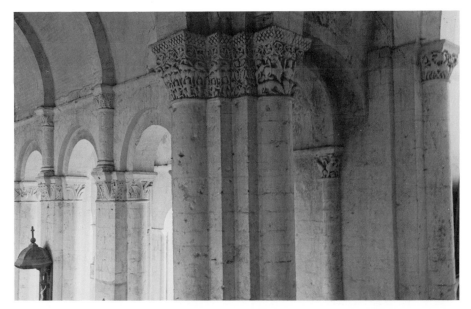

138 and 139. Saintes, Saint-Eutrope, upper part of choir, dedicated 1096, and crypt, 1081-96

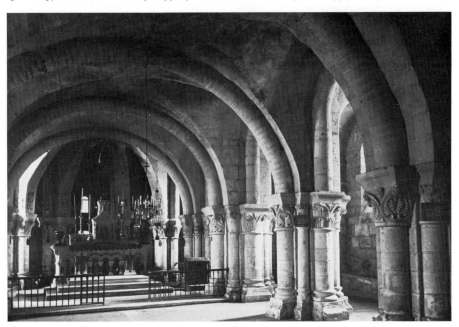

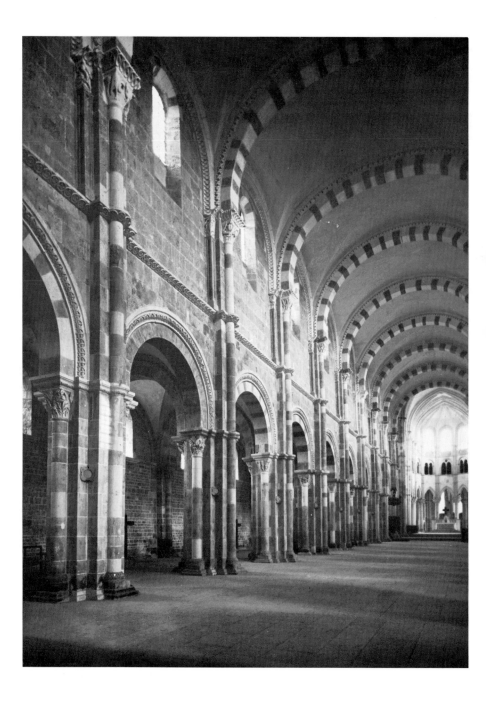

Notable for its local Burgundian character is the famous pilgrimage church of the Madeleine at Vézelay [140, 141, 158, 162, 163], located at the head of the Limoges-Périgueux road to Compostela. It was built during an ephemeral Cluniac regime (1096–1137). An altar was consecrated in a new east end (1104). About 1115 a western extension was started; then the old Carolingian church burned out, between (1120), and was replaced before the dedication (1132).[13] The church was the first one built on a generous scale in France where the nave and aisles are covered by groin vaults divided bay by bay with transverse arches. The design may derive from the older portions, dated near the end of the eleventh century, of the Cluniac priory church of Charlieu or from that of Anzy-le-Duc, dependent on Saint-Martin, Autun. Forerunner of the local Burgundian 'half-Gothic', the nave of Vézelay is very handsome, 'mural' in character. There is no triforium; the generous clerestory windows come under ramping lateral penetrations in the groin vault of the nave.[14] The architectural line of descent from Vézelay ultimately leads to the international Gothic style of the Cistercians, which will be considered in a later chapter.

As historical studies accumulate, the role of Cluny in the creation of the mature style of Romanesque architecture becomes clearer, in

140 and 141. Vézelay, Sainte-Madeleine, interior of nave, c. 1104–32, and air view

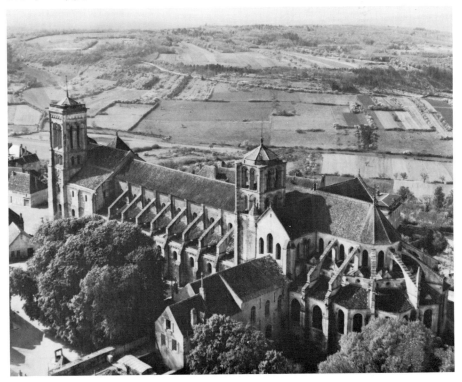

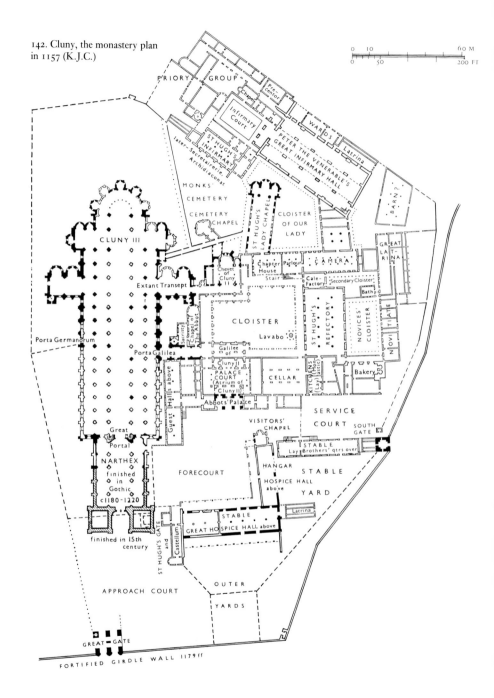

142. Cluny, the monastery plan in 1157 (K.J.C.)

various projects which Abbot Hugh undoubtedly held dear. Largeness of conception and nobility of scale characterize these works. The difference between early Romanesque and mature Romanesque *scale* is at once apparent in Abbot Hugh's enlargement of the monks' quarters at Cluny, and later on in Cluny III, the definitive church of the monastery – all according to an impressive general plan [142]. In 1042 there were about seventy professed monks at Cluny, a fairly usual number, but under Abbot Hugh the number had increased to 200 by 1085, and there was a further increase to about 300 in 1109, at the death of Abbot Hugh. Vast new constructions were therefore needed, not only in the monks' own part of the convent, but in accessory buildings for agricultural exploitation, for storage, for menial services, and especially in those for visitors.[15]

A part of the hospice built by Abbot Hugh, in the great forecourt of the monastery, still survives. The upper storey of it is large enough to serve as the municipal theatre of modern Cluny. Originally it was 49 feet wide and 179 feet long, substantially but plainly built, in 1077–9; it had a stable at least 100 feet long; the dormitory above it had an impressive unobstructed interior space 31 feet high from the floor to the eaves, or 48 feet to the ridge. Another indication of grand scale at Cluny comes about the year 1080, when the refectory of the monks was trebled in size and decorated with an immense fresco painting of the Last Judgement; furthermore, under Abbot Hugh the monks' dormitory was extended by one-third in area. It remained a plain room. When further augmented by Abbot Peter the Venerable in the twelfth century, it measured 34 by 220 feet, and 26 feet in height to the eaves. The capacious new Lady Chapel of 1083–5 – 130 feet long – has been mentioned; the infirmary was also considerably enlarged. (Dimensions here are in English measure.)

Church designs for the priories of Saint-Fortunat at Charlieu, Saint-Pierre at Souvigny, and Saint-Étienne at Nevers also show the increasing scale of Cluniac architecture.

At Charlieu,[16] the little tenth-century church was replaced after 1030 more or less on the lines of Cluny II. However, it surpassed its prototype, being substantially built with generous use of ashlar stone, and planned from the beginning for heavy tunnel vaulting over a clerestory. The façade, under way by the time of the dedication (1094), was embellished by a fine portal. To judge by its handsome lines, elegant proportions, and other similarities, the façade at Charlieu was designed by one of the architects who worked on the new abbey church begun in 1088 at Cluny[17] [143, 144].

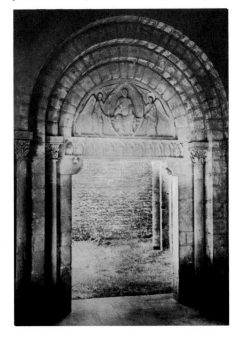

143. Charlieu, Saint-Fortunat, dedicated 1094, inner portal of narthex (main door of nave), *c.* 1088–90

144. Charlieu, Saint-Fortunat, dedicated 1094, section of nave and elevation of original façade (Sunderland)

145 *(below, right)*. Nevers, Saint-Étienne, largely *c.* 1083–97, nave

146 *(opposite)*. Nevers, Saint-Étienne, largely *c.* 1083–97, east view, with the towers restored according to an old drawing

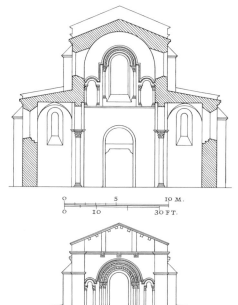

```
0        5       10 M.
|----+----|----+----|
0      10         30 FT.
```

church possessed a double-aisled nave 80 feet wide overall, double transepts, and of course apse, ambulatory, and radiating chapels.[18]

The works at the Cluniac priory of Saint-Étienne, Nevers[19] [145, 146], are a clear sign that Romanesque architecture had indeed achieved maturity. The beautifully articulated plan of Saint-Étienne, with apse, ambulatory and radiating chapels, transept, and nave gracefully disposed, was carried up in a superstructure of fine ashlar masonry, which made it possible to diminish the bulk of the interior supports and carry the nave to a considerable height, with a remarkable ribbed semicircular tunnel vault over a clerestory. Elegant arcaded screens strengthen the transept near the crossing tower. In plan, the church is a reduction of the Pilgrimage type,

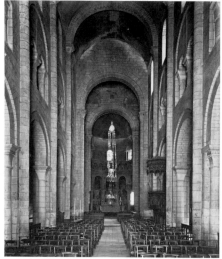

The same increasing scale is exemplified in the successive churches at the important priory of Souvigny. The old church of 920, rebuilt about 1034, was 120 feet long and 20 feet wide. The new one, dedicated complete in 1063, was 270 feet long, and from 1090 onward this was increased to about 310 feet; the imposing definitive

and resembles works of near-by Auvergne; in section also the nave is like that of a Pilgrimage church in that the galleries have quadrant vaulting, but the gallery arches do not have the pretty paired columns which grace the Pilgrimage church galleries. On the other hand the Pilgrimage-type naves, imposing as they were,

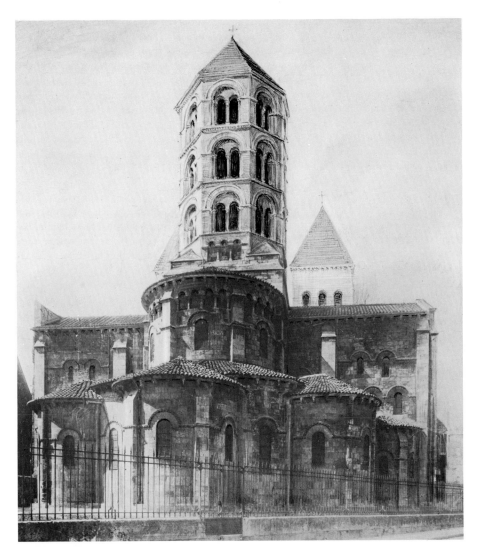

did not venture a clerestory under the high vault. At the Revolution the three handsome towers of Saint-Étienne, disposed after the pattern of Cluny II, were demolished, and thus the church lost the airy silhouette which it had had for 700 years. Saint-Étienne became Cluniac in 1068. After the monastic offices had been re-built, the church was taken in hand about 1083 under the stimulus of large gifts, and it is reported as complete with its towers at the time of its dedication (15 December 1097).

A Roman Imperial architect and an Early Christian architect would both respect this building, for it has all the advantages which either

Roman or Early Christian architecture could give to church construction. At the same time the designer showed perfect command of what the Carolingian age had created. He brought all these elements to a new and self-consistent canon of expression and proportion which is full of energy, confidence, and serenity – a mature new style worthy to take its place on a par with the older styles. There is no trace of archaism here, and no problem posed by the designer remains unsolved.

*

Though Saint-Étienne at Nevers provided a complete 'statement' of mature Romanesque architecture, more was required at Cluny itself, because the church building there had a transcendent role to play. To the monks whose devotion centred there, it was an earthly represent-

ative of the celestial Jerusalem – 'a place where the dwellers on high would tread, if it could be believed that human abiding-places of this sort are pleasing to them'. When the great new church and its monastery were fully shaped and walled, after 1180, the group with its cluster of fifteen towers on and about the church actually looked like medieval symbolic drawings of the Holy City. One thinks of Bernard de Morlaas, of Cluny, who gained here his vision of Jerusalem the Golden –

Urbs Sion aurea, patria lactea, cive decora . . .

The Ecclesia Major, Cluny III,[20] was the hearth of the whole spiritual household of the Cluniac Order. It made a great sensation when it was built; 'indeed they celebrate as if at Easter every day, because they have merited to go into that Galilee' says Abbot Hugh's bio-

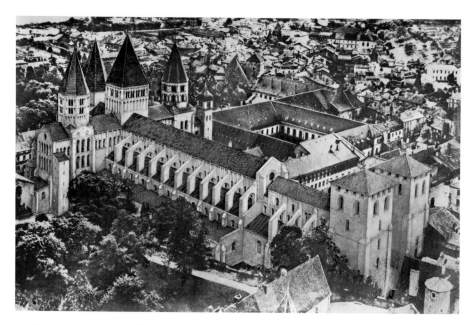

147. Cluny, restoration of the abbey church as in 1798, drawn in on a contemporary air view

148 *(opposite)*. Cluny Abbey, restoration study: bird's-eye view from the south-east as in 1157 (K.J.C.)

grapher, of the monks. Even at a late period one feels this admiration, for Mabillon writes (1682): 'If you see its majesty a hundred times, you are overwhelmed on each occasion' – the classic Romanesque [147–52, 154, 155, 157, 167].

Cluny III represented the monastic achievement in building better than any other edifice. Actually it could have held the entire membership, standing, of the Cluniac Order, had the Order ever been assembled.[21] The great church must be understood in these terms, as a focus for the devotion of the whole Order, and logically a more splendid building than any which Abbot Hugh had seen in forty years of journeying throughout western Europe. It was planned as early as 1085, and its first great patron was Alfonso VI of Spain, whom Abbot Hugh saw in Burgos at Eastertide 1090. Even before 1090 Alfonso had sent Abbot Hugh ten thousand

'talents' as a thank-offering for the capture of Toledo on 25 May 1085.[22]

Preparations for the building of Cluny III probably began in that year or in 1086. As the monastery had been building almost continuously for decades, no new crew had to be formed, nor any new arrangements improvised for materials and transport. One suspects a new direction in the works from about 1075 onward, because the 340-millimetre foot of Abbot Odilo's time was then given up in favour of the 295-millimetre Roman foot.

Influence from Desiderius's Montecassino (1066–75) is practically certain. The 295-millimetre foot is basic there, along with unusual pointed arches and vaults, a strict mathematical layout, and exceptionally exact setting-out, all of which reappear in Cluny III (see below, pp. 362–3).

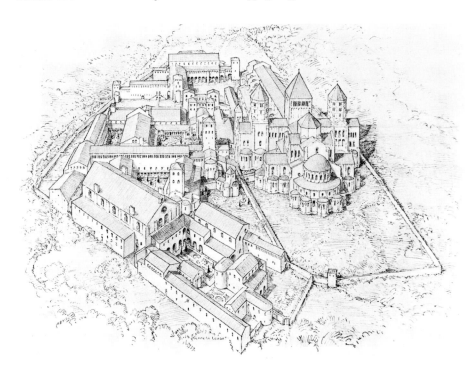

Careful study of the existing remains above and below the surface has revealed a rather strict mathematical layout and a modular system in the design of Cluny III. Relationships of this kind are well known in medieval churches, and Viollet-le-Duc has a good deal to say about them,[23] but the information which we have in respect to Cluny III is unusually clear and convincing because of copious exact measurements taken in the excavations.

The architect was a monk of Cluny - Gunzo, a retired abbot of Baume and a musician (*psalmista praecipuus*). He probably settled the general scheme. His gifted collaborator Hézelon (d. 1123) is reported as a mathematician, and as 'labouring long' to achieve the work. The great design exemplifies both the *proportio* and the *symmetria* of Vitruvius, whose *De Architectura* was in the Abbey library. *Proportio postulates a principal dimension in orderly relationship with its components.* At Cluny III the fundamental stem of the church, 531 feet long, was portioned off in 'perfect numbers', 6 (centre to chord of the apse), 1, plus 28 (the sanctuary bay), and 496 (the choral and processional part of the church, extending to the western foundation bench). Simple fractions of 496 determined the projection of all salient elements in the plan (248, 124, 62, 31, 15½ feet). In the superstructure the 600-foot length was so divided that the various parts made up 400, 300, 250, 200, 150, 100, 50, and 25-foot sections. Again, the high vault of the nave, 100 feet to the point, was systematically related to the interior impost levels (at 80, 66⅔, 40, and 25 feet). Vitruvian *symmetria postulates a minor unit, repeated in building up the design.* Cluny III, in this sense, had modules of 5, 7 (symbolic), 8⅓, 25, and 31 feet.[24] Tolerances never exceed four inches.

The plan of Cluny III was the first to have full-scale double transepts in the chevet. This arrangement made it possible to transfer the choir from Cluny II as early as 1098, and to accommodate, near the high altar, the great

assemblies of the Chapters General (1212 monks in 1132). Through Lewes Priory after 1090 the double transept passed to England, and thereafter, with Canterbury (*c.* 1097 ff.), to English Gothic.

Construction of the church, once begun, went forward with unusual speed, on 'an admirable plan', as Peter the Venerable says, 'which distinguishes the church from all others on the globe'. Hézelon probably managed the building enterprise. The official *fundatio* of the church dates from 30 September 1088. Five altars in the chevet were dedicated on 25 October 1095, when the Cluniac Pope Urban II, a refugee from the activities of the antipope Clement III in Rome, was on his way to Le Puy and Clermont-Ferrand to preach the First Crusade. The two transepts had been finished by 14 March 1100, when Pedro de Roda, bishop of Pamplona and one of the active French reforming clergy in Spain, consecrated the chapel of St Gabriel in the existing stair tower attached to the great transept. The west front of the main nave [157] was built (1107-15) before the adjoining interior bays, but these were complete and vaulted by 1121, according to the original scheme of Abbot Hugh's architects.

Meanwhile Pope Gelasius II, driven from Rome by partisans of the Emperor Henry V, had taken refuge in Cluny (1119). He died there, and the six cardinals of his suite, still at Cluny, had met and chosen Guy de Bourgogne, archbishop of Vienne, to be Gelasius II's successor. He took the name of Calixtus II. We have heard of him before: the Pilgrimage Codex of Calixtus was ascribed to him. After an interval he returned to Cluny, where he canonized Abbot Hugh in 1120. In the great church a partial fall of vaulting in the nave, 1125, was quickly repaired. The general dedication of the church and the vast new monastic group was performed by Pope Innocent II on 25 October 1130.[25]

The bold massing of Cluny III was very expressive [149]. Chapels and stepped forms

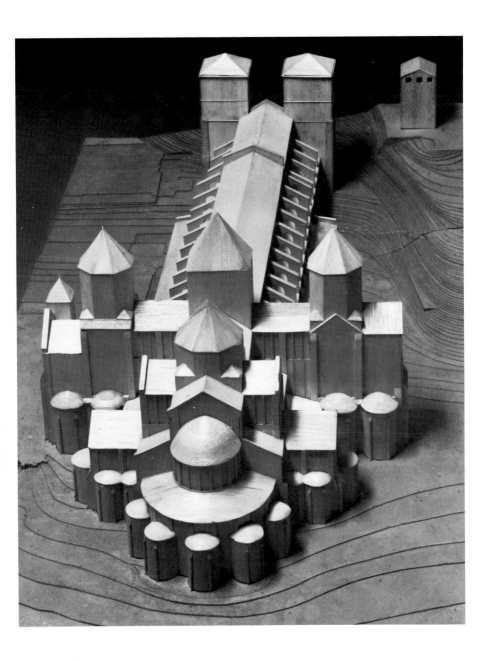

149. Cluny, third abbey church, east view of model

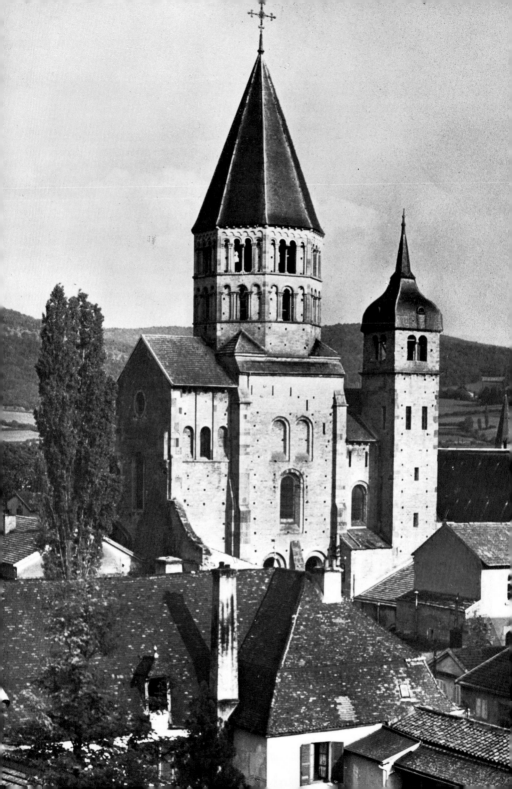

built up, like an enormously augmented Germigny-des-Prés, in the minor transept; four chapels and four towers gave vertical movement to the great transept [150]. These aspiring forms were clustered in the part of the building which was devoted to prayer. The nave, with the narthex beyond, used for processions, gave a tremendous contrasting horizontal to the composition, which brought up at the massive

150 (opposite). Cluny, third abbey church, exterior of extant south arm of great transept, c. 1095–1100

151. Cluny, third abbey church, 1088–c. 1121, restoration study of transverse section of nave (K.J.C.). The three-arched bay at the right still exists, and appears in illustration 150

western towers. The scheme was thus a combination of the central type, the double-transept type, and the basilican type of church. In design the building brought together the grandeur of Roman work, the abounding vigour of Carolingian work, and a dynamic quality which makes it an authentic forerunner of Gothic architecture in certain particulars.

The masonry walls at Cluny have substantial dimensions. Curved and screen walls in various parts of the design were nearly four feet in thickness; the outer wall of the nave aisles was six feet, and the nave clerestory wall (pierced by many windows) eight feet [151]. The piers, of which there were sixty in the main church, measured about eight feet on the axis. The vaulting, however, was very light – the cells

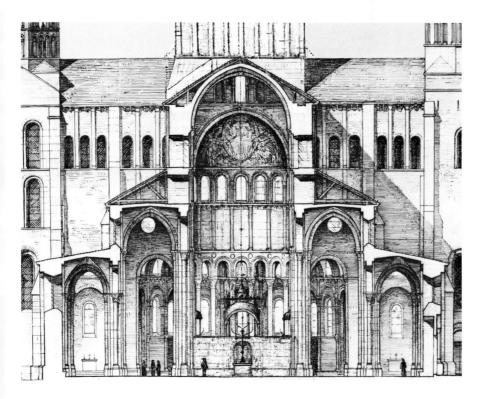

152. Cluny, third abbey church, capitals and shafts from the sanctuary
(as placed in the former abbey granary), c. 1095

being from thirteen to eighteen inches in thickness, and slightly pinched or pointed in shape, like oriental vaults, as a means of diminishing their thrust [151]. This functional application is a step towards Gothic vaulting, as is the ingenious inward corbelling of the walls under the high vault (mentioned below), which cleverly increased the wall's resistance to vaulting thrusts. Thus it was possible for the architect to venture a nave vault with its crown from 100 to nearly 103 Roman feet above the pavement over a span of thirty-five; the proportion is very close to the perfect Gothic proportion of the cathedral of Reims, with dimensions about one-sixth less. The tunnel vault was indeed a venture, at this great height, and above a many-windowed clerestory, but it is known to have produced the wonderful acoustical effects which were desired.

The sanctuary of Cluny III – head, centre, focus of all – was the boldest, most interesting, and most beautiful part of the church [151, 152, 153B, 154]. The apse was tall, and slender in proportion, not quite as high as the main vault. Five elegant radiating chapels looked in upon the ambulatory, which had clerestory windows on the outer side to correspond with the tall graceful arches opening into the sanctuary. Interesting small sculptures of the Vices and Psychomachia on the outer wall contrasted with larger motifs on the column capitals, where an allegory of the monastic life, virtues, and divine praise formed a beautiful semicircle about the two chief altars. This enclosing arcade had eight free-standing columns.[26]

The ends of the apse arcade rested on two capitals which were placed to the left and right, respectively, of the two altars in the sanctuary. These altars themselves were included with the capitals in another allegory. The Fall was represented to the left, and the Sacrifice of Abraham (prefiguring the eucharistic sacrifice) at the right. Incense rose, symbolically, from the altars past the allegorical carvings of the arcade to a vast fresco of Christ in glory with the celestial choirs on the apse vault. This painting, like the mosaic figures at Cefalù and Monreale [277], dominated the whole nave of the church, an open length of 425 Roman or 411·3 English feet. The subject invested the nave with a grave dignity which we may sense in the contemporary fresco of the monks' chapel at Berzé-la-Ville [153A], where Abbot Hugh loved to go for repose at the end of his life.[27]

The apse which has just been described was remarkably light and ingenious in construction, *ad miraculum suffulta*, as Mabillon says. The design of the typical interior bays occurred singly in the adjoining sanctuary, paired in the

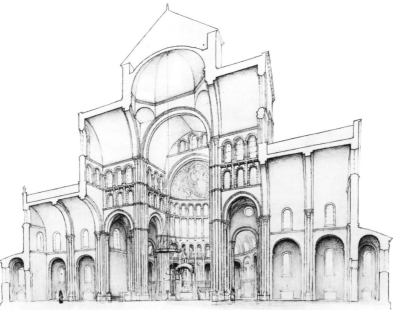

153(A) Berzé-la-Ville, apsidal fresco, *c.* 1100; (B) Cluny III, analytical section of minor transept, showing altars of the sanctuary and all the eleven absidioles of the chevet (K.J.C.)

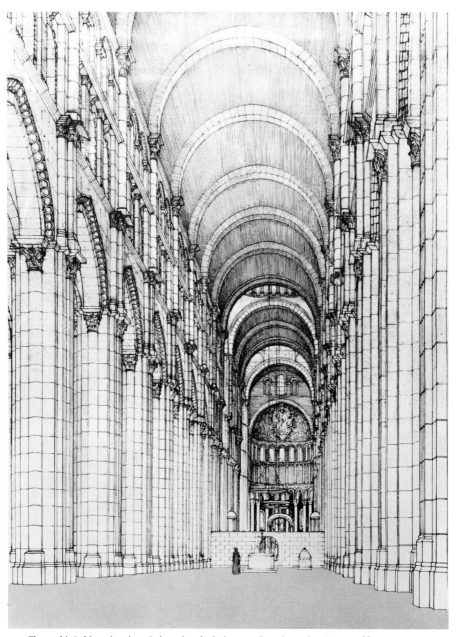

154. Cluny, third abbey church, strictly archaeological restoration of nave interior, *c*. 1088-1130

choir between the two transepts, and in a noble range of eleven bays in the great nave [154]. The capitals, to judge by the seventy-five examples which still exist, were almost all Corinthianesque, with hardly any figure sculpture and very few grotesques. Figure sculpture was obviously confined, by programme, almost entirely to the allegorical ensembles in the apse and at the west portals.

Throughout the church the piers were grouped piers, reduced in the upper storey of the nave (through ingenious wall corbelling) to a single engaged shaft under the vaulting arch. The aisle bays had pointed arches, here used, it is believed, under oriental influence transmitted through Montecassino, and presenting the pointed arch for the first time in large numbers in a Western church design [154, 155, 167]. The pointed arch facilitated vault construction in the aisles. Another indication of oriental influence was the decorative use of horseshoe lobes on the arches of the triforium [155]. The pilasters of the triforium and the arcade of the clerestory (resting on pretty paired colonnettes) aided in inching the wall outward to receive the thrusts of the vaults. The beautiful effect of this interior design led to its being reproduced with greater or less fidelity at Paray-le-Monial [156] (a 'pocket edition' of Cluny, dated roughly about 1110), Autun Cathedral (1120 and later) [161], La Charité-sur-Loire (about 1125) [166], and Beaune (about 1150). All these interiors are strictly Romanesque in its classic phase, but they are already of Gothic proportions, and approach the Gothic aesthetic.[28]

The conditions which caused Gothic architecture to develop were already present at the close of Abbot Hugh's career. Restriction of local war, increasing competence in the administrative cadres of the great feudal officers, the remedying of precarious economic conditions, the improvement of communications, were beneficent to all, including the monas-

155. Cluny, third abbey church, interior of extant south arm of great transept, c. 1095–1100

teries. However, the general development of trade, with profitable fairs, syndicates, and exchanges, together with the growth in urban population and civic consciousness everywhere, the granting of civic charters which favoured organized urban progress, and the transfer of effective intellectual activity to the urban centres – to cathedral schools and incipient universities – tended to leave the abbeys in a backwater where they could prosper quietly to be sure, but where henceforth they had only a minor or conservative role to play in the creation of the

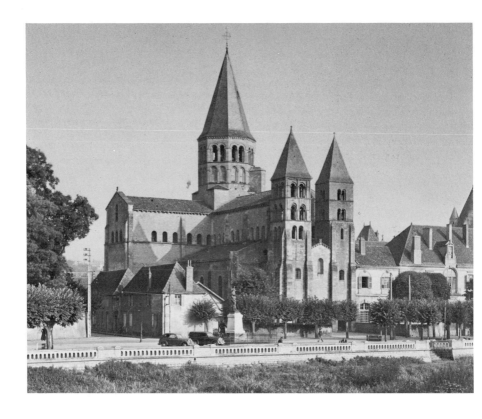

later medieval Europe. The Europe which depended on the monasteries, and had a monastic ideal, passed away within a generation of Abbot Hugh.

ABBOT PONS, OR PONTIUS, DE MELGUEIL

The successor of Abbot Hugh in 1109 was a flashing young Provençal, Pons de Melgueil, a near relative of Pope Paschal II with other fine connexions, who had attracted the abbot, and was required to pass only a single day in the novitiate when he entered Cluny monastery. Though he was a postulant at the old Cluniac house of Saint-Pons-de-Thomières, and was prior at Saint-Martial, Limoges, he does not

belong to the spiritual line of Odo, Mayeul, Odilo, and Hugh; he was forced out by reform sentiment in the monastery. Yet the cumulative achievement of the older men gave Cluny a glittering moment before the abdication and disgrace (1122), intrusive return to his functions, defiance, and death (from Roman fever, excommunicate and in prison, 1126) of Abbot Pons.

He carried the magnificent portals at Cluny to completion about 1113 [157]. They stood three in line, but the central one, forty feet wide and sixty-two feet high, was much larger and more imposing than the others. Though this work comes only ten years after the allegorical capitals of the sanctuary, and though at least

156 *(opposite)*. Paray-le-Monial, priory church, *c.* 1100, from the south-west

157. Cluny, third abbey church, restoration study of the façade of the main nave, later masked, *c.* 1107–15. The main portal (*c.* 1106–08–10) inspired the great works at Vézelay, Moissac, and Autun

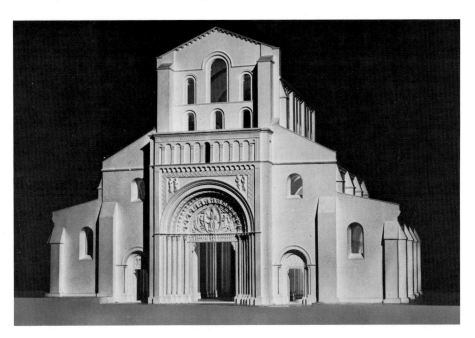

one of the sculptors worked in both places, the carving was more mature in character – much bolder in composition, with very slender figures nearly free-standing in relief. The portal, deeply embrasured, had nook shafts, and a Moorish *alfiz* border about the recessed arches. The *petit marbre*, a soft mottled limestone used in the eastern parts of the building, the flat, almost stucco-like calligraphic modelling of the figural sculpture there, and the accompanying classical acanthus gave way, as the building advanced westward, to harder stone, stronger relief, and more medieval leafage.[29]

The Great Portal at Cluny is a capital loss, for its indicated date makes it the first of the allegorical portals on a really grand scale.

Between them, the portals of Vézelay [158, 163], Perrecy-les-Forges, and Bellenaves suggest what the great composition was like.

In the thickness of the wall at the top of the Great Portal there was lodged a charming little chapel of St Michael, warder of doors, most cleverly constructed (like the main apse), and its tiny round sanctuary projected like an oriel into the main nave [167]. It was the reduction, almost to the dimensions of a delightful architectural toy, of the Chapel of the Saviour at Saint-Riquier; indeed the deep embrasuring made the portal itself project outward from the façade like a flat oblong chapel. Above the chapel were big windows which lighted the nave until the narthex was built, and beyond the lateral

portals were buttresses built in rat-tail so that the narthex walls might later be firmly joined. The flowering of sculpture was general within the Order of Cluny under Abbot Pons. It brings us again to one of the most beloved and beautiful of the medieval sites – Vézelay, set on its hill above a wonderful panorama of opulent Burgundian countryside. In design, the church [140, 141, 158, 162, 163] represents Burgundian localism in the time of Abbot Hugh. As already reported, the church received its nave largely after Pontius's abbacy, being carried forward after a fire of 1120 to completion and dedication in 1132. The ponderous Romanesque groin vaults over the new nave were not well built or well abutted, and gave much trouble. In con-

Cluny to Vézelay when the two major sculptural ensembles at Cluny had been finished. At this time (1115–20) the 'ordo' of Vézelay was in charge of Pierre de Montboissier, a great lover of the arts, later (1122) abbot of Cluny.

The many picturesque capitals in the nave at Vézelay have a popular appeal which is fitting in a church of pilgrimage. The west portals are more theological. They are to be dated a little before the fire of 1120, and consequently come near the end of Pontius's abbacy. Three doorways give entrance from the narthex to the nave and aisles. The central portal [158] is adorned with one of the greatest masterpieces of medieval relief sculpture – a singularly arresting conception of the role of the Saviour in trans-

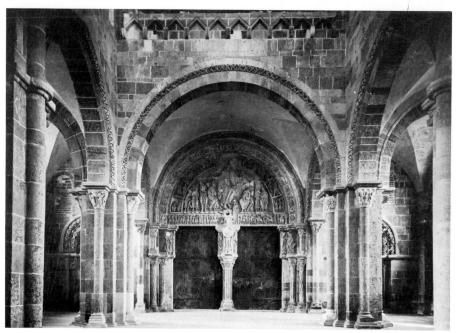

trast with Cluny the capitals in the nave of the church are enriched by figure sculptures. These are in the style of Cluny, and it is considered certain that designers and carvers went from

mitting his redeeming grace and the evangel to all the world. St John the Baptist on the median jamb and the Apostles set above the lateral columns, though perfectly Romanesque, give a

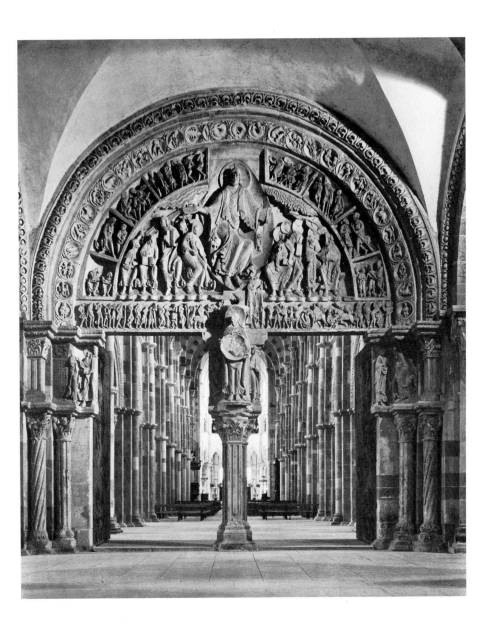

158A and B. Vézelay, Sainte-Madeleine, main portal, *c.* 1118

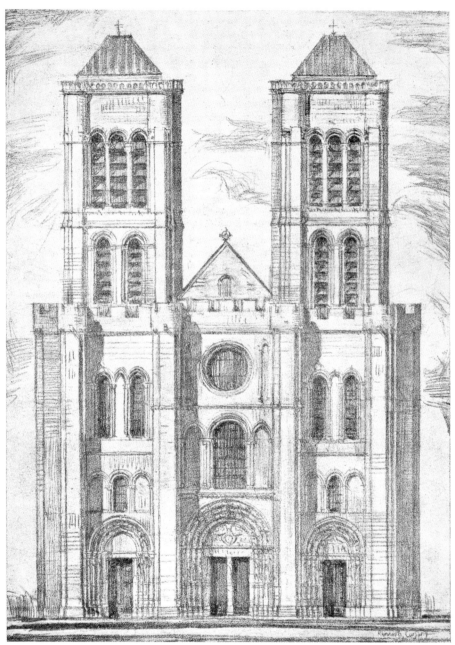

159. Saint-Denis, abbey church, restoration study of façade, with intended north tower, c. 1135–40 (K.J.C.)

hint of the role which jamb figures will assume in Gothic times, beginning at Chartres and Saint-Denis within half a generation.

We have already seen, in the Pórtico de la Gloria of Santiago de Compostela (1168-88) [124], a derivative of this portal which was intended (as Cluny and Vézelay were not) to participate in the external articulation of the building. The change is adumbrated in the façade designed for La Charité-sur-Loire about 1130-5 [166], and it comes in the still half-Romanesque portals of Saint-Denis built for Abbot Suger from about 1135 to 1140 [159]. Meanwhile a whole series of the twelve Apostles (an 'apostolado') had been created as pier sculptures for the chapter-house of the cathedral of Saint-Étienne at Toulouse (about 1117).

More important still, the memorable portal at the priory of Moissac [160] had been built.

At first (about 1115-20?) the intention was, perhaps, to place it at the front of the old nave built by Abbot Hugh (1063) - a Provençal affair with three parallel tunnel vaults, now replaced. Almost immediately (about 1120-30) an interesting rib-vaulted porch with an upper chapel was built in front of the church - an interpretation of the Saint-Riquier motif. At that time the great carvings were located on the flank of the porch with some lateral arcading and minor reliefs added. The work was completed during the abbacy of Peter the Venerable of Cluny, before the death of Abbot Roger of Moissac.

ABBOT PETER THE VENERABLE

Pierre de Montboissier, the gentle-spirited and beloved successor of the unfortunate Pontius, ruled from 1122 to 1156, and he was the last

160. Moissac, priory church, flank, with portal, *c*. 1115-30 and later

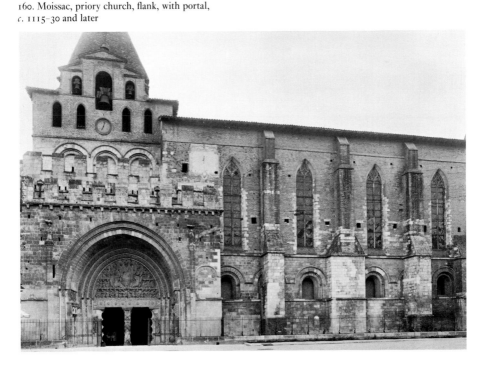

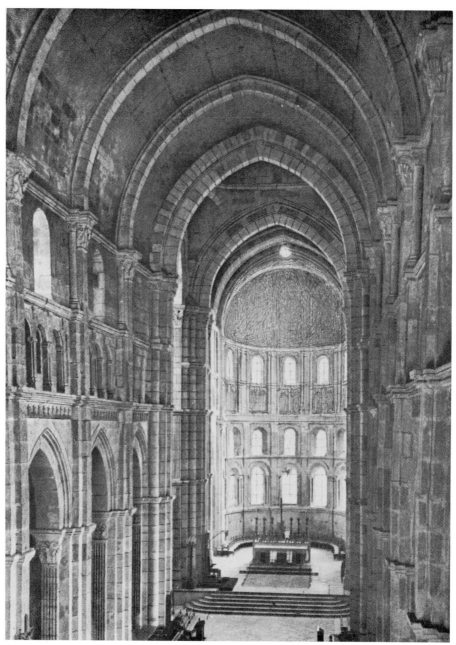

161. Autun Cathedral, with apse windows redrawn in hypothetical original form
(details subject to re-study and revision), *c.* 1120–30

great abbot of Cluny. With difficulty he maintained the Order against internal disaffection, Cistercian competition, and the general shift of the times which diminished the role of monasticism. But under him the Order yet served architecture and sculpture well.

Works of great beauty were carried out in his time in middle and southern France – portals at Beaulieu (in the Corrèze, about 1125–30), at Carennac (about 1130; also a cloister), and (from about 1140 onward), at the façade of the important church of Saint-Gilles, the imposing triple portal finished about 1170 – one of the noblest works which the late Romanesque has bequeathed to us [187, 188]. Other notable works in the Midi are series of capitals at La Daurade in Toulouse, Saint-Pons, and Mozac, and at Ganagobie where there are a portal and considerable conventual remains (c. 1130–50).

The ruin which fell in later times on Cluniac architecture may be seen equally at La Daurade, at Saint-Gilles, and at Ganagobie.[30]

Rich and beautiful work was done in Burgundy also. The cathedral of Autun[31] [161], coniuncta of Cluny, was rebuilt beginning about 1120 on a simple plan, but with an interior elevation derived from Cluny III. The first dedication occurred in 1130. The building has sculptures of quite exceptional importance and beauty in the capitals of the nave and the west portal. The latter is by Gislebertus, who can be traced from Cluny via Vézelay to Autun, and it dates from about 1135. The strange exaggerations and popular appeal of this work, as well as its dramatic placing above a flight of steps in an open narthex (of 1178 and later), make it a notable example of Baroque tendencies in the Romanesque period.

162. Vézelay, Sainte-Madeleine, Chapel of St Michael (narthex), c. 1135(?)

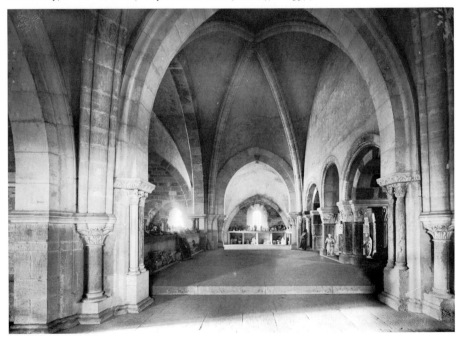

Turning once more to the monasteries, we find that the main church at Vézelay was finished, and a narthex added [162]; there was a dedication in 1132.[32] The narthex had an exterior portal (replaced by a modern one) [163],

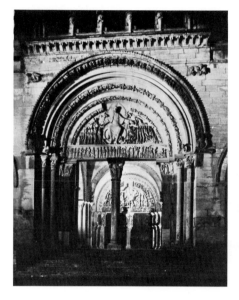

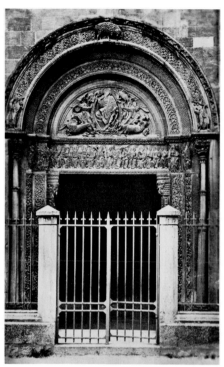

and two towers were planned, so that, with its bay of rib-vaulting, it is an interesting Burgundian contemporary of Saint-Denis, on the verge of Gothic architecture. At the priory of Charlieu[33] also a narthex was built in front of Abbot Hugh's church façade and adorned with a remarkable lateral portal dated about 1135 which is unsurpassed as an example of the Baroque spirit in Romanesque art [164, 165]. At Saint-Lazare, Avallon,[34] the portal of about 1150 (partly rebuilt) even after much damage to the figure sculpture, still shows the same restless spirit. The highly elaborate detail and involved composition here and in other late portals indicate very clearly that the Burgundian Romanesque art had run through a complete stylistic cycle from primitive at Saint-Bénigne, Dijon, to

163 *(above left)*. Vézelay, Sainte-Madeleine, exterior portal (with modern carvings) and interior portal (*c.* 1118) of narthex

164 *(above)* and 165. Charlieu, Saint-Fortunat, outer portal of narthex and narthex from the west, *c.* 1135

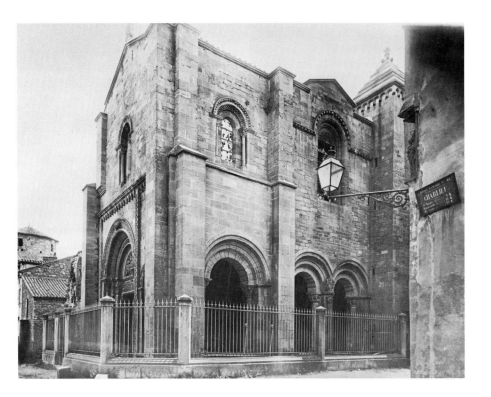

classic at Cluny, and then, by 1140 or 1150, to a style which depended on exaggeration and movement for its effectiveness. The main architectural lines of the narthex at Charlieu show Baroque tendencies in their rather wilful asymmetries, and the search for piquant patterns of light, half light, and shadow.

The great priory of La Charité-sur-Loire, called 'the eldest daughter of Cluny', had a large filiation of priories of its own, anticipating some of the features of the Cistercian filiations. The importance of the priory led to a grandiose project of rebuilding begun about 1125,[35] with the intention of transforming the older church (an enriched version of Cluny II, as has been remarked) into a modified version of Cluny III incorporating the monumental new façade

scheme of paired towers and rich exterior sculptured portals. In consequence the older chevet of échelon-type was rebuilt with a handsome ambulatory and five radiating chapels; the nave was lengthened, a fine big antechurch was undertaken, and a great façade was begun. If it had been completed it would have had two breathtaking towers, each with a spire, each with two sculptured portals, flanking a larger portal on the axis of the church. This façade scheme with five sculptured portals in line [166] beneath paired towers was the forerunner of the huge Gothic frontispiece of Bourges.[36]

However, the Order of Cluny was now faltering. Only one of the façade towers at La Charité was built; most of the area of the antechurch remained open, as a sort of atrium, and the

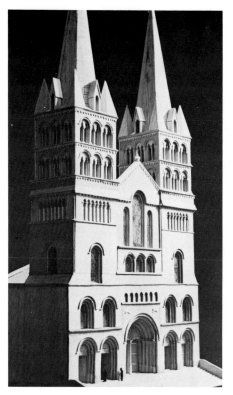

north aisle of the antechurch, the only one to be built, served as narthex and parish church. Partial ruin in the religious wars and long neglect have been the lot of this splendid building. At Vézelay it was the same – the west front of the church was never finished. At Cluny two bays of the narthex were built, beginning about 1122, but the rest dragged on for a century (to 1220–5), and another century passed before both of the western towers were completed (between 1324 and 1342); even then one was rebuilt and a painted wooden porch was placed between them a century later still (between 1424 and 1457).

Abbot Peter the Venerable's work on the great church is interesting as showing early premonitions of the Gothic style [149, 151, 167]. After the fall of a part of the nave vault in 1125, massive pierced buttresses, like very heavy flying buttresses, were added at the clerestory level.

166 *(left)*. La Charité-sur-Loire, projected façade for priory narthex, *c.* 1130–5 (Hilberry)

167 *(below)*. Cluny, third abbey church, restoration study of longitudinal section of west end of nave, and of narthex, eleventh and twelfth centuries (K.J.C.)

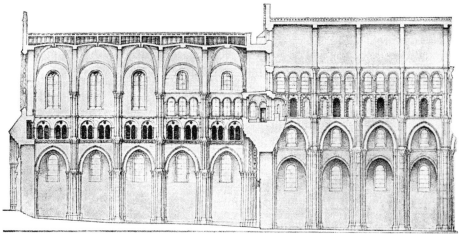

This may have occurred as early as 1130. It is interesting to note that flying buttresses were quite generally used in a special manner, or when trouble developed in the vaulting, until about the time when the vault of Sens Cathedral was built, from *c.* 1155 on. By that time the new Gothic vaulting had shown that it needed buttressing even more than the older and heavier Romanesque vaults. Peter the Venerable, possibly as early as 1132, built vaults over two eastern bays of the narthex, without flying buttresses. The type of these vaults – rib vaults with high, ramping, scoop-shaped lateral penetrations – was much used in Early Gothic architecture. These ribs made it easier to build neat, well-shaped cells or individual vaulting areas; they made it possible easily to build a thinner, lighter vault; and they warped the vaulting stresses down to the wall and spur buttresses between the windows of successive bays. At Cluny the narthex was completed with such vaults about 1220; the thirteenth-century windows were larger and flying buttresses were added, but the effect was still rather Romanesque. Details of the west front show that the architect was aware of the gorgeous new High Gothic which was being created in the Île-de-France – at the cathedrals of Chartres, Soissons, Reims, and Amiens – but that he preferred the less evolved local Burgundian version of Gothic.

The expansion of Cluny into the Île-de-France, where the admirably organic and articulated Gothic style arose, was the work of Abbot Hugh, but the interesting buildings date from the time of Peter the Venerable. What role precisely Cluny played in the creation of the new style is difficult to decide.

The most famous Cluniac rib-vaulted constructions are in the south. After the oddly premonitory crypt of Saint-Eutrope, Saintes (1081–96) [139], there follow the tower porch at Moissac [160, 168] and the crypt of Saint-Gilles-du-Gard [189]. While as vaults they are

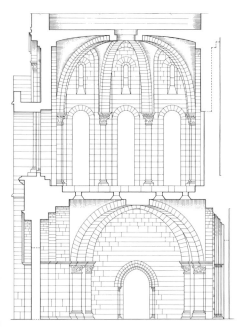

168. Moissac, priory church, section of western tower, *c.* 1130

relatively early in date, they are not progressive in conception.[37]

Moissac had possessions in Spain and was well placed for contacts with Lombardy; in the porch we find a somewhat Lombardic-looking rib vault carried out about 1120–5 in fine Cluniac stone masonry, while in the chapel above there is a rather Moorish-looking radiate vault built about 1125–30 with twelve heavy ribs, equally French in its fabric. The crypt of Saint-Gilles-du-Gard (1116–70) has a logical succession of heavy groin vaults on substantial ribs which may be related to contemporary rib-vaulting in Lombardy. The conclusion is inescapable that the ribs at Moissac and Saint-

Gilles were Romanesque in conception – introduced for extra bulk and strength – not, like the convincingly Gothic vaults of the north at the time (1120–40), to facilitate a light, articulated construction.

The vaults at the east end of the narthex at Cluny probably owe something to a knowledge of Moslem ribbed and lobed vaulting, but it is not certain that this was transmitted by Cluniac contacts. It is usual in the early Gothic works of the Île-de-France. Among these there are numbered the churches of several Cluniac priories: Airaines (Somme), about 1120–35; Marolles-en-Brie, 1125 or a little later; Saint-Martin-des-Champs, Paris, 1132–40 (nave later) [169]; Noël-Saint-Martin (a priory attached to Saint-Martin-des-Champs), where there was a series of constructions between 1100 and 1150; Saint-Leu-d'Esserent, dated about 1150 to

169. Paris, Saint-Martin-des-Champs, interior, *c.* 1132–40

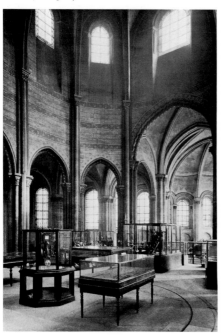

1170.[38] On this Early Gothic series of Cluniac buildings the Norman chevron ornament often appears – a clear sign of influence from the region which prepared the rib vault for the Île-de-France.

The test probably comes in Saint-Martin-des-Champs, Paris, given by Philip I of France to Cluny in 1079. Its loyalty to Cluny is shown in a curious way by the architecture: the church plan (1132) is an ingenious reduction based on various elements of the church and chapels at Cluny, which seems to show that the designer's heart was at the mother house, and not in the progressive buildings of his contemporaries in the Île-de-France.

The axial absidiole at Saint-Martin-des-Champs is a trefoil, of which the lateral apses suggest a minor transept. Its vault is a series of ramping scoop-shaped cells on ribs, rather like those of the eastern bays of the narthex at Cluny. An ambulatory with radiating chapels leads to a projection resembling a second transept, in obvious reminiscence of the major transept at Cluny. In this part of the building there are peaked groin vaults without ribs, like those in the aisles at Cluny. The ribbed apse vault at Saint-Martin is normal for the region about the middle of the century, but the nave is open, single, and wooden-roofed, like that of Abbot Hugh's Lady Chapel, Notre-Dame-de-l'Infirmerie, at Cluny (1085) [142]. Saint-Martin-des-Champs was under construction at the very same time as Suger's new work at Saint-Denis, which was conceived as a Gothic building, and intended to have novel forms (about 1135 to 1144).[39]

On the face of this showing (to speak now in general terms) it would appear that the Cluniacs had really solved their own architectural problem by the early twelfth century. This involved pushing their developed pattern of a great Romanesque church far towards the general form which the great Gothic churches were to take, and consequently the structural ex-

pedients which made Gothic possible were welcome in Cluniac architecture. In their use of the rib-vault at Moissac, Saint-Gilles, and in the Île-de-France, the forms confess the regions from which the idea came into the architecture of the Order, and also into Gothic architecture. But the Cluniac monks did not desire to have churches of novel Gothic form, and as far as we know they never did any Gothic vaulting of crucial importance. They never built a building, except perhaps Saint-Leu-d'Esserent, which would really show that they cared for the new idea. In Cluniac eyes the Gothic was for some time merely a local and regional style like any other. If the architect of Saint-Martin-des-Champs had been really interested in rib-vaulting, his building instead of Saint-Denis might have been the first of all recognizably Gothic churches.

Burgundians, partly from temperament, had a rooted preference for their grand old monastic Romanesque. The 'half-Gothic' which we have seen in several of the Cluniac buildings was also used elsewhere. It gained by the aesthetic effects which were worked out in the Île-de-France without giving up the substantial mural values pleasing to the Burgundians, as to their Rhenish cousins.

The Burgundian half-Gothic attracted the attention of Bernard of Clairvaux (himself a Burgundian, born within sight of Dijon) because of its austere and practical character. He made a sober version of it the standard architecture for Cistercian monasteries all over Europe. Cîteaux [171] and Clairvaux themselves, the lost major Cistercian churches in Burgundy – vast and noble constructions which began to take definitive form near the end of the period dominated by Bernard of Clairvaux (d. 1153) and Peter the Venerable of Cluny (d. 1156) – cry aloud for such a study as has been possible for the Mediaeval Academy of America at Cluny. It will be impossible to do justice to Burgundian architecture until Cîteaux and Clairvaux are fully known. Yet the lover of Burgundy feels suddenly warm and at home in places as far from Burgundy and from one another as Beirut, Bellapais, Alcobaça, Poblet, Fountains, Linköping, Maulbronn, and Fossanova, where the suave Burgundian architecture brought by the Cistercians stands, beautifully exemplified.

THE CISTERCIANS AND THEIR ARCHITECTURE

The years which saw the growth of the Pilgrimage to Santiago and the development of the Order of Cluny witnessed a general spiritual revival in the monastic world. Several other orders of importance were founded at the time – Grandmont by Étienne de Muret in 1074; Molesme by its first abbot, Robert, in 1075; both founders were canonized. The Carthusian Order was founded by St Bruno in 1084, Fontevrault by Robert d'Arbrissel in 1096, and Citeaux by Robert of Molesme in 1098. The Premonstratensians followed in 1120, founded by St Norbert, and linked with the Cistercians.

Molesme, though independent, followed the rule of Cluny. It had many outside contacts and became the centre of a group of about sixty priories, and so lost the other-worldly atmosphere which its founder abbot desired. Therefore, in 1098, at the age of seventy, he fared forth with twenty-one devoted companions. They established themselves about fifteen miles south of Dijon at Citeaux, a wooded swampy solitude given by Renaud, viscount of Beaune. In 1099 Abbot Robert, though the papal legate had given him permission to leave Molesme, was requested, in terms which he could hardly refuse, to return to Molesme. There, after reforming the monastery, he died in 1111.

From 1099 to 1109 the 'New Monastery' was led by Albéric, the first canonical abbot, who formed its spiritual temper. After Albéric it was led for a quarter of a century (1109–34) by a saintly Englishman of great spiritual power, Abbot Stephen Harding. Both men were in the original group which went to Citeaux. The beginnings were very difficult, but the protection of the Holy See (1100) and generosity on the part of the Burgundian ducal house enabled the monks to continue.

In 1112 or 1113 Bernard, a very religiously inclined youth of twenty-two, offered himself and thirty companions, including several of his relatives. In 1115 he became founder and abbot of Clairvaux, a Cistercian daughter house about fifty-five miles northerly from Dijon. Meanwhile other Cistercian houses had been founded at La Ferté (1113) and Pontigny (1114); Morimond (1115) completed the original group of daughter houses. Pope Calixtus II confirmed the constitution of *Charta Caritatis Monasterii Cisterciensis* in 1119.

Even while Abbot Stephen Harding ruled Citeaux, the forceful character of Bernard of Clairvaux projected the latter into ecclesiastical and international politics, and greatly aided the growth of the Cistercian Order, which, while it was not founded 'against' Cluny, drew the more austerely devoted spirits, and thus accelerated the decline of the elder Order. There were 30 Cistercian monasteries at the death of Abbot Stephen (1134), 343 at the death of Bernard of Clairvaux (1153), and 694 by the year 1200, including many monasteries which associated themselves by accepting utter submission in the new Order. The total reached 742 at one time.[1]

Under Bernard's influence the Cistercian Order became uniformitarian, with all details of existence rigidly prescribed in so far as was possible; with a tight organization and frequent inspectorial visits. Each Cistercian house was dependent on the one which founded it, and there were four chief 'filiations'. This scheme of control proved superior to the Cluniac system of centring all responsibility for the whole Order

in the one abbot of Cluny itself. The strong conformism of the Cistercian houses made it easy to allow them considerable autonomy, with the Chapter General at Cîteaux legislating for the entire Order. Cistercian policy (again in contrast to Cluniac) called for harmony with the local episcopate, and much good came of the cordial relations between the two.

The Cistercian monasteries were situated in remote places. They suffered therefore less than

out arbitrarily, but according to the character of the terrain. These overriding principles explain irregular orientation in the churches and the frequent occurrence of cloisters in the north. The basic pattern of the plan was that of St Gall and Cluny, but certain details differed [17, 170]. The Cistercian churches (after 1134 uniformly dedicated to the Virgin) had no crypts or towers, and were rather angular in plan, with the night stair to the dormitory starting in the

170. Fontenay Abbey, 1139–47

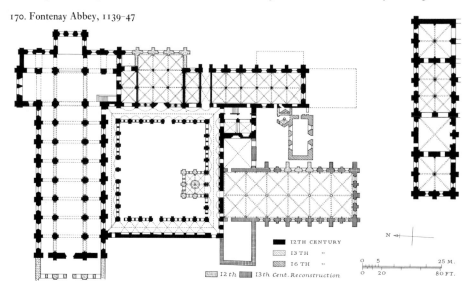

12TH CENTURY
13 TH "
16 TH "
12 th 13 th Cent. Reconstruction

N →

O 5 25 M.
O 20 80 FT.

other monastic architecture from Revolutionary demolitions, and it is still possible to gain a fairly complete idea of what a Cistercian monastery was like.[2] The standardized and repetitious character of early Cistercian architecture is immediately evident everywhere. Almost all works dated before 1200 may be understood from two or three of the early French examples.

Cistercian sites were invariably secluded, well watered, and so set that the waters could be impounded above the area chosen for the conventual buildings. The church was placed on the highest ground. The other structures, though uniform in their workings, were not laid

adjacent transept. The ground storeys of the conventual buildings were regularly vaulted. Pavilion-like fountain houses covered the lavabos in the cloisters, and the refectories were set with the axis perpendicular to that of the church instead of parallel. Novices were regularly lodged at the end of the east range of the cloister. Professed monks were not allowed to enter their quarters, which occupied the traditional place of the camera. The traditional public court adjoining the west range of the cloister buildings was reduced to a passage-way (open to the sky) for the lay brethren ('conversi'). Their building had its traditional place west of the passage,

which led to the church, where they occupied the west end of the nave. No provision was made for the public in Cistercian church plans. The fact that women and children were never admitted to the monastery enclosures led to the provision of a chapel and accommodations for them – and for other guests – at the gate. The Cistercians did not relish intrusions in the early period, though visitors of mark were cared for.[3]

The Cistercian monastic groups were often long under construction. At first the monks would live in structures of temporary character, perhaps intended for menial use later on. Outside builders were employed, but the monks became independent (or nearly so) of the outside world at the earliest possible moment. Much of the actual designing and building was done in the communities themselves. The aim was to have the community able by craftsmanship and husbandry to supply all its own needs. The choir hours, much lengthened since Charlemagne's time, were shortened or re-scheduled for this purpose. Numerous lay brethren (up to 300 in large monasteries) were recruited for farm and shop work. Close contact with the soil made the Cistercians excellent farmers; improved methods were widely propagated through the Order, and thereby accrued to the advantage of all western Europe. They developed an organized system for the sale of farm produce and animals which aided in the commercial development of the age, but also gave Mammon his opportunity, so that when the Mendicant Orders began to draw many of the most devotional vocations in the thirteenth century, the Cistercian monasteries came to be very much like all the rest.

Conformity with the established norms was required in the Cistercian buildings of the great epoch. A monk from anywhere in the Cistercian world would feel himself entirely at home within half an hour at a Cistercian house anywhere else. There were several excellent architects in the Order during its formative period – Geoffroi

d'Ainai; Achard; Gérard, brother of St Bernard. Their orderly planning and their austere interpretation of the Burgundian half-Gothic, unadorned, became, through Bernard's preference, the architecture of the Order. In consequence the style spread radially, with the Order, in every direction as far as French influence reached – to the British Isles, Scandinavia, Poland, central Europe, Iberia, Italy, and Palestine – but in a somewhat immobilized form which persisted until the High Gothic of the Île-de-France was adopted in its stead. In many regions the international Cistercian half-Gothic prepared the way for Gothic architecture somewhat as the pervading Lombardic First Romanesque had done in former times for the Second or Great Romanesque style.

The early period of Cistercian building was indeed severe. Sculptural embellishments were forbidden in 1124, in which year also it was decided to omit illuminations from the manuscripts. Indumentaria, sculptures, and liturgical objects came under very austere regulations. Bold or ambitious proportions and architectural bravura of any kind were not tolerated in the buildings. Stone towers were forbidden in 1157 on the churches, which at most had small functional belfry pinnacles. In 1182 it was directed that any existing windows of coloured glass in Cistercian churches should be removed within three years. Ornamental pavements were frowned on, and in many cases removed by order. But all the monasteries were excellently built, and though the effects are rather heavy, quite generally they have a lily-like atmosphere of simplicity which has very great charms. The small original churches were perfectly forthright; the later ones (before the High Gothic), even when they were of great size, showed their derivation from the simple prototypes and did not use any devices conceived for picturesque or dramatic appeal.

The earliest churches were very plain. At Citeaux a small wooden church was succeeded

in 1106 by a rectangular tunnel-vaulted stone church about sixteen feet wide and fifty feet long. This simple type of plan was soon augmented by angular lateral chapels making a dwarf transept, or by a transept with such chapels. Clairvaux, just after 1115, had a square church with stone walls divided into nave and aisles by wooden posts supporting a wooden roof. Later the churches were regularly vaulted, and wooden roofing was confined to the conventual structures. Both the aisleless and the aisled plans persisted. The Ourscamp of 1134 (aisleless) had transepts and a round apse. Angular chapels collected about both of these latter elements in later plans, with the necessary ambulatories. There are numerous cases where

local tradition has affected many details of both plan and elevation without destroying the Cistercian air of the buildings, because the masonry (fine ashlar) has an unmistakable Cistercian character. The fact that the Cistercians forbade their masters to work outside the Order tended to accentuate this special character.

At Citeaux [171] and Clairvaux[4] the conventual churches were a barometer of the growth of the Order. The great church at Citeaux was a part of the general rebuilding there, carried through between 1125 and 1150. The church underwent a consecration of some sort about 1148 and another in 1193, by which time it was completed with a much enlarged sanctuary. It was cruciform with an aisle carried all round,

171. Citeaux, monastery,
from a drawing made before destruction

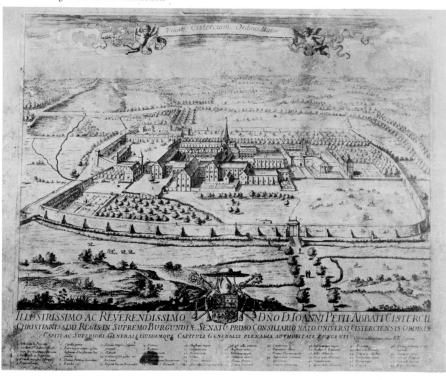

except at the south-west corner of the transept and also at the west front and at the north end of the transept, where the aisle was replaced by porches. The sanctuary was angular, and its angular ambulatory was surrounded by angular chapels. The church was destroyed at the Revolution.

At Clairvaux the original monastery was entirely insufficient by 1133, and new buildings of immense extent were undertaken near by. The church plan provided a rather shallow angular sanctuary with three shallow rectangular chapels at each side, all opening into a transept. Five more rectangular chapels and the bay devoted to the night stair occupied the other side of the transept, with a tunnel-vaulted nave and

gave the church a clerestory, a Gothic ribbed high vault, and a range of flying buttresses, as well as a polygonal apse and ambulatory surrounded by angular radiating chapels inside a polygonal periphery wall. The sanctuary at Pontigny was rebuilt in somewhat similar form about 1185-1210. Thus Pontigny has a special claim to be esteemed as the best existing representative of the great church at Clairvaux, destroyed at the Revolution.[5]

However, the 'Bernardian' plan, which stands for St Bernard's own preference, is that which was built at Fontenay[6] [170] in 1139-47.[7] The church at Fontenay, with the adjoining (and somewhat later) cloister and monastic buildings, is the oldest Cistercian ensemble in existence

172. Fontenay Abbey,
founded in 1119, from the air

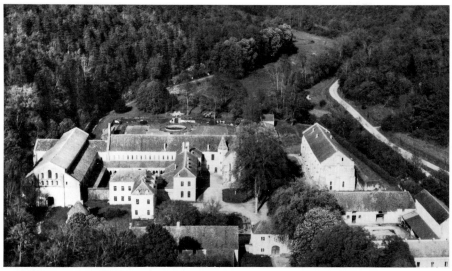

aisles axially placed. This plan, augmented by chapels along the ends of the transept, was used at Pontigny [176, 177] in 1140 ff., but the latter church was finished with a rib-vaulted nave about 1170. Rebuilding at Clairvaux between 1153 and the definitive consecration of 1174

[172-5]. The site is girdled by wooded hills in a lovely setting, and the various edifices are roomily set within an enclosure wall. A beautifully proportioned façade presents the church, with ashlar stone and an austere portal; elsewhere in the church and conventual buildings ashlar spur

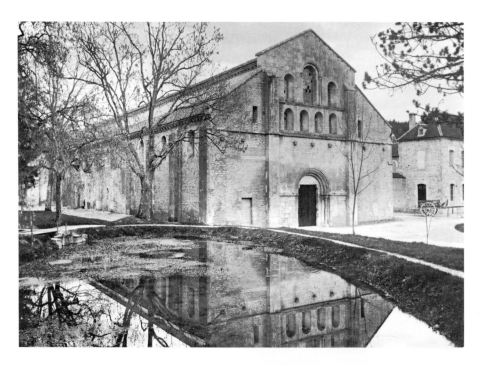

173 and 174. Fontenay, abbey church,
view from the north-west and interior, 1139-47

175 *(opposite)*. Fontenay Abbey,
view from the chapter-house into the cloister, *c.* 1147

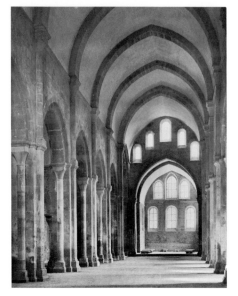

buttresses, with rougher stone wall-work be-
tween, are the rule. Bishop Everard of Norwich
was the patron of Fontenay.

The church gains most of its light from the
façade windows and the corresponding ones at
the crossing and in the sanctuary, since there is
no clerestory; but for the windows at the ends,
the nave would be like a cavern. An admirable
pointed tunnel vault with transverse arches
covers it, irreproachably abutted by pointed
transverse tunnel vaults over the aisles. The
transept is lower and narrower than the nave,
and covered by a pointed tunnel vault in the

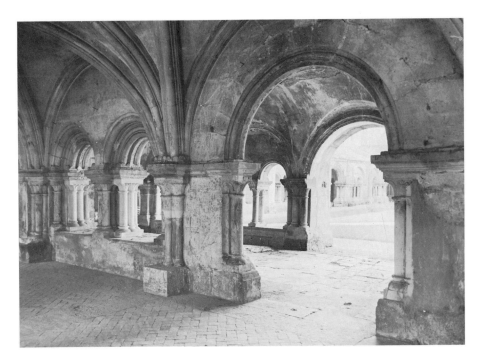

same way. The nave continues into the square-ended principal sanctuary. Acoustically the church is remarkable, like a Cluniac church, on account of its tunnel vault, and in this connection we note that St Bernard loved music.

The stone night stair leads as usual from the south transept of the church to the adjoining monks' dormitory, now blocked up but originally open, under a fine open arched truss roof. The refectory was placed in the customary Cistercian position opposite a fountain house on the south side of the cloister, with its axis perpendicular to that of the church. Other parts of the monastic ensemble are arranged in traditional ways; this is true of the forge building at Fontenay – a handsome affair by the rivulet – placed to the south-east of the cloister, as it might have been in earlier times.

In contrast to the dark and heavy church, the noble round-arched, tunnel-vaulted cloister, the

chapter-house, and the camera (a work room beneath the dormitory) seem very light and open, though the latter are substantially vaulted by square bays of rib-vaulting with columnar supports [175]. The repeating square bays of this construction are as typically Cistercian as the angularity of the church plans. These bays, marked by uniform spur buttresses on wall after wall throughout the scheme, have a curious look of being mass-produced.

Repetitive bays had of course been used before in architecture, but it was a new thing to use repeated bays of rib-vaulting with the logical insistence which was later to characterize Gothic design. But austere ideals and conservatism prevented the Cistercian architects from developing the full potentialities of the new type of vault. Their designs are called 'half-Gothic' because this type of vault could be so much more effectively applied (as indeed it was with

bravura in the full Gothic of the Île-de-France) to highly evolved types of plan and elevation. Individual bays were freely made square, oblong, triangular, or trapezoidal in shape, tall or short in elevation, as the most elaborate compositions required. For example, the Cistercians, requiring clear glass in their church windows, did not have reason to make them large. The Gothic stained-glass windows, from Suger's time (1140) for more than a century, were so dark that even openings of maximum size gave a barely sufficient light for the church interiors. Thus the Gothic walls became sheets of glass stretching between and supported by slender piers, just as the cells of the vault became thin membranes, bowed up slightly for ease in building and extra strength, between slender over-arching ribs. Full exploitation of light rib systems, the development of shell-thin vaulting cells of ashlar, and the creation of flying buttresses to sustain vaults set high on slender piers, put the builders of the Île-de-France ahead of the Cistercian builders by 1175, if not before.

The church of Pontigny [176–8] is a good example of the Cistercian use of Gothic before the overwhelming achievements of the High Gothic made the Cistercian style seem old-fashioned and provincial. Begun about 1140 on a variant of the usual plan, the church was

176. Pontigny, abbey church, founded in 1114

built with a dwarf transept and an angular east end, and continued into a very handsome nave, simple, generous in proportion, and lighted by a clerestory over lower and narrower aisles with concealed flying buttresses. Delicate and fastidious proportioning, deft handling of the grouped piers and simple rib-vaulting make the church at once impressive, alive, and serene. The typically Cistercian nave is happily combined with an austere chevet which replaced the original one about 1185-1210. There is an ambulatory with trapezoidal radiating chapels, so simply laid out that only the moulding profiles betray its late date.

At Pontigny the windows, though modern, exemplify the Cistercian taste. There are typical and beautiful patterns in the leading, with the usual plain glass – that is, except for a sprinkling of small jewels of colour, which was permissible. The whole effect of the interior is of extraordinary calm and religious serenity, virginal in sweetness and purity.[8]

The façade, sparingly adorned with Gothic arcading, is pleasant to look upon. Yet no one can fully understand Pontigny and the Cistercians without seeing the building from the opulent surrounding fields – a handsome warmhued bulk which really seems to belong to the soil; no towered or cathedral shape could have such union with the earth [176, 177].

177. Pontigny, abbey church, façade, c. 1150

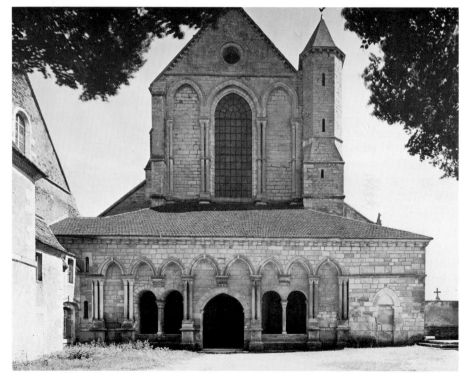

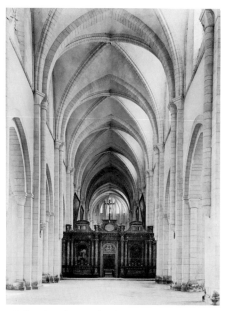

178. Pontigny, abbey church, interior, c. 1140–1210

For all its unity, Cistercian architecture is subtly differentiated region by region. In the south, the heritage of Roman largeness combines beautifully with the Cistercian theme of simplicity, forthrightness, and good construction.

At Silvacane,[9] founded in 1147, we feel the south of France. The abbey buildings survive as an extraordinarily complete and impressive group. The south-French love for coursed block masonry is manifest here, where, in a design of quite Roman amplitude, the ashlar is unusually fine throughout, and gives character to every vista of the interior. The church, begun about 1170, has the very same dignity which one feels in the Pont du Gard. It is extraordinarily fine in acoustics, as is usual where the nave is tunnel-vaulted.

Las Huelgas, near Burgos in Castile, is another good example of Cistercian stonework,

though of rather mediocre design.[10] Poblet and Santas Creus in Catalonia have excellent Cistercian qualities. At Poblet (founded 1151), much the larger and more prosperous, these qualities continued to influence the general design of successive works until the end of the Middle Ages. The early architects of Poblet had given the example for this in the main church, which was built about 1180–96. There is a perfectly Romanesque pointed tunnel vault with transverse arches over the nave, despite its being contemporary with the nave of Notre-Dame in Paris. Many parts of the monastic buildings are in a very much simplified and sunburned Gothic, but the Romanesque spirit lives on in almost all the work. There is excellent vaulting in the chapter-house, the refectory [179], the library, and the cellar; and the great dormitories with pointed diaphragm arches supporting wooden roofing are extraordinarily impressive [180]. The establishment was long desolate after the social uprisings of 1822–35. It is very impressive as now restored and re-peopled, yet it satisfied the requirement set forth in the epigram, namely that it takes a really good building to make a fine ruin.[11]

Alcobaça in Portugal has one of the best, as well as one of the most remote, Cistercian churches. The building was begun on a grand scale in 1158 and finished in 1223. Its interior, spacious and beautifully proportioned, has a remarkable combination of classic serenity, Cistercian simplicity, Romanesque forthrightness, and budding Gothic verve. Compared with contemporary work in Paris – for it is roughly contemporary with Notre-Dame – Alcobaça represents an archaic scheme, the 'three-naved' church, often called the hall church.[11]

This church type results from the use of the repetitive rib-vaulted bay, in such a way that the nave vault is abutted by aisle vaults only a little narrower and lower than itself. The aisle vaults in their turn are abutted by spur buttresses. The engineering problems are simple, and the type

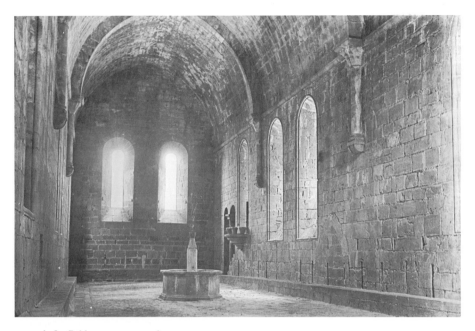

179 and 180. Poblet, monastery, refectory
and dormitory, thirteenth century

is stable. Large windows placed high in the walls light these churches. The piers are grouped, and with the ribs branching out above them, look like lines of trees. This arrangement gives great prominence to the windows in the apse, which are the only windows visible in an eastward view.

San Galgano,[12] near Siena, may be cited. The church there is the ruin of a construction begun in 1218 – still in the Burgundian half-Gothic style at a time when the cathedral design of Amiens (the boldest High Gothic church which proved to be stable as originally built) was only two years in the future.

Fossanova, another of the Cistercian sites in Italy (it is prettily set near Rome), also suffered from abandonment (1812), but it was repossessed by monks in 1935, and is now happily in use again – as an abbey. It is very Burgundian in feeling and detail. At the crossing there is an odd staged tower, partly of Renaissance date, which

181. Chiaravalle Milanese, abbey church, dedicated in 1196

would seem to represent, in more permanent form, the lost wooden belfry turrets which Cistercian churches usually possessed. The church at Fossanova dates from the years 1179 to 1208.[13]

In Lombardy, where brick has been a basic material since Antiquity, the Cistercians of Chiaravalle Milanese used brick, like their neighbours. Shortly after the foundation of 1136 a church was started, of which the transepts remain, though in altered form. Ultimately a huge and unattractive octagonal lantern and belfry was raised at the crossing, perhaps even after the

dedication which was celebrated in 1196 [181]. In the nave big domed-up rib-vaults of Lombard type were built, beginning perhaps as early as 1160.

By this time Lombard brick architecture had reached northern Germany,[14] in Premonstratensian work (Jerichow, dated perhaps after 1150, being the earliest example) [182, 183], perhaps under Cistercian influence. The region lacks stone, but the clays burn to excellent brick of a deep red or wine colour. The severity of line and the excellent workmanship continued as the brick style spread (*Backsteingotik*), and acquired

more and more affirmative local feeling. The abbey church of Chorin (about 1200) is a Cistercian example.

The church buildings of the earliest Cistercian monasteries in Germany[15] – almost all of them of the filiation of Morimond – were often local in type, although the first (Kamp, near Krefeld, 1123) appears to have had the early simple plan used by the Order, but Marienthal (1138–46) has a columnar basilica. Heilsbronn, founded in 1132, Cistercian in 1141, has a church belonging to the School of Hirsau; Georgenthal, dated about 1150, has an apse échelon;

Walderbach (1143–70 and later) has a hall church; and all these schemes are represented by several other examplas.

The important abbey of Maulbronn[16] [184] marked a new departure in the buildings erected between 1146 and 1178, and carried forward later on. The whole group is very well constructed in stone, and has given a good account of itself. With the years and progressive reconstructions the monastic buildings have acquired a ponderous German look, but the oldest work (1146–78) is strongly Burgundian in feeling. A Gothic east window and Gothic vaulting some-

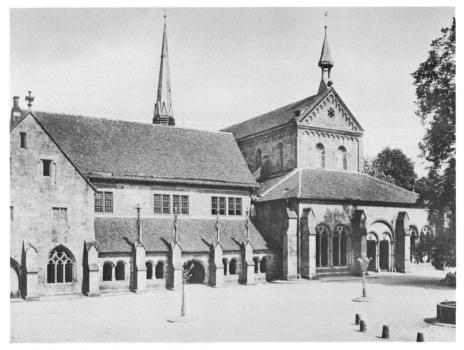

184. Maulbronn Abbey, forecourt, 1146-78 and later

what dilute the Romanesque of the church, but it retains its old plan – with an altar of the Cross in the nave, an arched stone choir enclosure, stalls, and an angular sanctuary. The façade has a marked Burgundian flavour, and has preserved a low exterior porch across the front, this element being fairly common in Cistercian buildings.[17] There are two typical belfry pinnacles.

Cistercian forms with a German weightiness in mass and detail are well represented by many examples. Among them Eberbach (by exception founded from Cîteaux) is particularly well preserved and imposing. It is dated *c.* 1150-80.

In leaving German Cistercian work, it is worth while to repeat what has been said regarding the imprint which the Burgundian half-Gothic left in the minds of local architects. The bravura of French designers, with wonderful

flair, exploited the Gothic system to the ultimate, but for a long time few German designers or clients really cared for the novel effects. The Germans, in their love of substantial masonry, which warms the massive walls of Speyer Cathedral and the rosy cliffs of the *Backsteingotik*, clung to the tradition of the half-Gothic. Traces of this feeling are easy to find in their interpretation of the more mature French Gothic, which comes first at the new cathedral of Magdeburg in 1209.

English connexions with the Cistercian Order go back to the beginning.[18] Abbot Stephen Harding of Cîteaux and Bishop Everard of Norwich, who built Fontenay, have been mentioned. The Cistercian style appealed to the English, as it did to the Germans; the English had a finer flair for this architecture, built beauti-

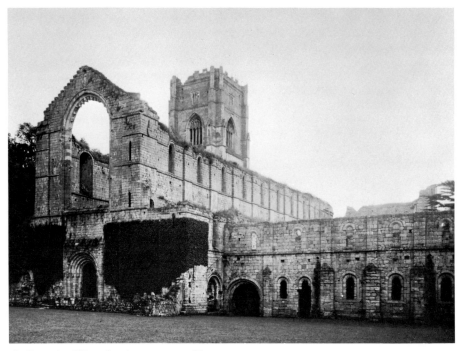

185. Fountains Abbey, church, *c.* 1135-50 and later

fully in it, and transmitted some of its attractive qualities to the succeeding Early English Gothic style. Details about it belong to another volume in this series.[19] It must suffice here to mention Waverley Abbey, founded in 1128, as an example of the simplest form of Cistercian plan – an aisleless nave and square-ended sanctuary, a short transept, and a simple square-ended chapel opening upon the transept to either side of the sanctuary; Tintern, founded in 1131, as an example of the same plan with two chapels to either side, and consequently a longer transept; and Fountains as the ruin of a large abbey partly Norman and partly Burgundian half-Gothic in style. The church was built about 1135-50. Its original sanctuary was replaced by the famous Chapel of the Nine Altars, 1204-47, a prime example of the Early English Gothic style.

There are very extensive remains, adjoining the church, of the monks' quarters, beautifully maintained [185]. Finally a word must be said about Buckfast Abbey as rebuilt in 1907-22, for this rebuilding has yielded much information regarding medieval conditions. At Buckfast one or two men with simple training in construction formed a crew and ultimately erected an elaborate church on the surviving medieval foundations. In like manner a group of medieval monks intending to build an abbey might bring to the site a plan for the whole future establishment; a few monks with experience could train a crew of monks and brethren during the erection of the simple buildings required in the beginning, and then proceed to the more difficult works, with occasional help from sister monasteries and travelling artisans.

THE MATURE ROMANESQUE
OF MIDDLE AND SOUTHERN FRANCE

CHAPTER 12

GENERAL CONSIDERATIONS

IN REGARD TO THE REGIONAL SCHOOLS

The Romanesque is a style of fascinating by-ways and local schools. This has been its charm for many lovers of the arts, and, in consequence, the historians have generally analysed it as a series of quasi-independent regional phenomena. Yet the great movements and the chief institutions of Romanesque times with their architecture were inter-regional, as we have seen; our exposition has indeed been planned to emphasize this fact. In monuments of more than regional significance we have already encountered all, or nearly all, the architectural motifs which we shall find, variously combined, in the architectural by-ways which we now undertake to explore.

The various local 'schools' differ from one another in the basic building materials, in the choices which the practical men and decorators made in handling those materials, and in the emphasis given to the various aspects of the design. These variables introduce more differences than might, at first sight, be supposed.

For example, Roman elements occur in all the regional schools – but the Roman elements may be structural, functional, compositional, decorative. Oriental elements, Byzantine ele-ments, Northern elements almost invariably appear, in the same varied ways, and with differing emphasis.

It is usual to find in each region some principal monument which has been imitated throughout the area, thus creating a sort of architectural family and a certain regional unity. However, certain areas have more than one such source monument, and the result is a compound local school.

A system of classification for the schools of mature Romanesque architecture must rest on unities of various sorts. It is generally true that in the northern region, where the population was predominantly Germanic, the buildings – churches and all – continued to be erected with relatively simple plans and decoration, with bold massing and articulation of relatively simple shapes; active silhouette broken by tower and pinnacle forms; steep roofing (natural to the North), heavy stone wall-work, and, where it occurs, heavy vaulting. In the Romance area the preference was for more sophisticated buildings, with a wider background in artistic history. In the South there were many developments along functional lines which are interesting, and

there was a marked readiness to absorb Moslem or Byzantine elements. This is markedly true in the French and Norman dominions.

There is also a valid division between conservative (or passive), and active schools: Rome and Provence, still Latin in the Romanesque period, accepted little that was new from outside, but built handsomely in a conservative manner, while Burgundy created and exported several interesting types; the neighbouring Berry, although it contained Bourges, the ecclesiastical capital of Aquitaine, produced little – in fact, the centre of France has been called a 'dumping ground' because so much was received, without synthesis, from adjoining regions.

The materials for building also point out a significant classification. The Netherlands and the northern parts of Germany, France, Italy, and Spain all have axcellent brick-clays of which the engineers and architects took advantage. Only Italy and Provence had easily available marble as a luxury material. Even in the brick-building regions stone is obtainable, though often with difficulty and expense, and usually it is limestone. Sandstone, less attractive and durable, less rewarding to the sculptor and the architect, abounds in England (along with flints, chalky limestone, and brick-clays which were exploited later). Southern Germany and Rhineland France have fairly good sandstone. The Auvergne and the Limousin (exceptionally) have granite and volcanic stone. Elsewhere in France there is excellent limestone (e.g. the Caen stone of Normandy which was exported to England even in Romanesque times), beautifully textured and a delight to the carver's chisel: crisp mouldings and decorative work have been the result. These French limestones weather to fine buff, pale brown, and grey tints. Similar stones in Italy (north and south) tend to weather to deeper browns. This is true also of the east-Adriatic and Spanish limestones. North-western Spain and Portugal have granite.

The foregoing geological classification is worth bearing in mind; for the really good engineers and architects always make designs with a propar regard for their materials. The bolder differences called forth by basically differing materials, and the nuances which come where the materials are more similar, add greatly to the interest of the Romanesque style as a whole.

Geographical, political, and chronological classifications are generally easier to grasp. In the history of Romanesque architecture one may say that Italy was important first, because the basilica and the First Romanesque style spread from there. The old Neustria and Austrasia were important next – Neustria for its originality (Tours, Germigny-des-Prés, Grandlieu, Saint-Riquier, Corbie, Reims, and Sens are all there) and Austrasia for its creation of the Rhenish style (Aachen and Mainz, Fulda and Lorsch are there; a concurrent style existed as far east as Hungary in later times).

Following the achievements of the Carolingian centuries, Burgundy came to first importance in architecture. The reasons were, as we have seen, the dynamic spread, from Burgundian centres, of federative monasticism (chiefly in the eleventh and twelfth centuries) and the Burgundian designers' great ability to synthesize architectural ideas. These ideas came from the neighbouring regions of Neustria, Austrasia, Aquitania, Provence, and Italy, and certain oriental influences were welcomed too. Vaulting made progress; so also in Languedoc, which flowered after the middle of the eleventh century, and is responsible for an impressive daughter school in Spain. Italy meanwhile became an architectural kaleidoscope. In the Two Sicilies an eclectic school showed how varied Romanesque architecture could be under strong Byzantine and Moslem influence; in Tuscany and Venetia how rich it could be; certain developments of vaulting in Lombardy were, in combination with other elements, instrumental

in starting the Anglo-Norman school on proto-Gothic developments before the end of the eleventh century.

In the first third of the twelfth century, men and ideas were drawn from all quarters – especially Normandy and Burgundy – to the Île-de-France, there to bring about the creation of Gothic in a region where the Romanesque had for a long time been uninspired and uninteresting. Other regions with more accomplished local styles continued to employ them effectively until the Gothic from the Île-de-France appeared in the twelfth or thirteenth century.

From that time onward, it became the function of the Romanesque local styles to influence and to modulate the incoming Gothic – to domesticate it, so to speak, in respect of mason work, lighting, roofing, and decoration. While the Burgundian half-Gothic of the Cistercians was, like ancient Roman building, applicable everywhere with little change, the fully characterized Gothic of the Île-de-France achieved better results abroad when it accepted something from the heritage of the local styles.

Dividing Romanesque architecture summarily on national lines yields the following classification:

The Italian styles, in spite of certain novel developments, are backward-looking: in Lombardy, to the First Romanesque style; in the Veneto to the Byzantine; in central Italy to Early Christendom; and in the Two Sicilies – eclectic – to the Early Christian, Moslem, Byzantine, Lombard, and German styles.

The German and related mature Romanesque styles are conservative, and all bear the obvious imprint of the great earlier developments (already considered) in the Rhineland.

Though not independent, the Spanish-Portuguese and the English styles are sufficiently characterized, each in its own way, to merit national standing.

But in the actual development of Romanesque, France is most fecund. By general consent there were seven individual regional schools in medieval France.

The France of the eleventh century did not properly include Brittany or any important territories beyond the Somme, the Meuse, the Saône, and the Rhône. These rivers were approximately at the boundaries of the Empire. Carolingian Austrasia remained Imperial, and what is sometimes (because of later French cultural and political expansion) called the eighth French school – that of the Rhineland, or of the East – developed there in a German ambient.

For our purposes it will be most convenient to undertake first the study of middle and southern France, with its schools of (A) Burgundy; (B) Provence; (C) the Loire region and western France, under the headings: (1) the Loire River area; (2) Poitou, with Anjou, Saintonge, and the South-West; (3) Périgord and the domed churches of Aquitaine; (D) Auvergne; (E) Languedoc. The school of the East (F) will be taken up with the architecture of the Empire, Normandy (G) and the school of Paris and the North (H), when we approach the Gothic style.

THE KINGDOM OF ARLES, AND BURGUNDY

In the area of the old Carolingian Provence and Burgundy, technically only ducal Burgundy was French; the remainder had become a loosely-held part of the medieval Empire by the historical accident of bequest in 1032.[1] The Kingdom had an underlying Latinity. Traditional and easy communications offered by the great valleys of the Rhône and the Saône give a unity to this area which shows in many ways in its architecture. The renaissance of Roman forms was particularly appropriate and felicitous here. However, there is a strong tincture of Carolingian and Rhenish influence in the north: hence the area produced two great schools of Romanesque architecture: (1) in ducal Burgundy, where the fusion of northern and southern elements is remarkable, and (2) in Provence, where the Roman tradition is especially strong.

DUCAL BURGUNDY

In an earlier chapter we have observed Burgundy as a crossroads unusually open to outside influences, and unusually gifted with imagination for profiting by them and synthesizing them. Immense resources were available in men and money from outside the region for building in Romanesque times, and the important churches represent not one, but several, great types.

Roman influence came up the Rhône Valley from Provence and Septimania. One feels Rome subtly still as far north as Mâcon, which was for a long time just south of the boundary of ducal Burgundy but within the borders of Romanesque France. Ducal Burgundy formed a part of the historic metropolitan archbishopric of Lyon, which was divided between Romanesque

France and the Empire, but belonged architecturally to ducal Burgundy. This was true also of the archbishopric of Vienne, which was in the Empire but bordered on the Rhône. The eastern parts of this archbishopric bordered on Italy and served as a natural avenue of Lombardic influence, with Milan only a hundred-odd miles away. Besançon, the northern archbishopric of the Kingdom of Arles, was open to Burgundian influence, especially in the Franche-Comté, but the eastern parts, actually bordering on the Rhine, were understandably German in their architecture.

Since the building types in Burgundy are so various, and their components so widely used in Romanesque architecture, it is worth while to undertake an analysis of the elements. Burgundian practice is well up to the best general level in the Romanesque period, and many of the observations which will be made here on structural matters are applicable elsewhere.

Types of Plan

The *basilican plan* and general arrangement for churches have continued in use in Burgundy ever since Early Christian times without interruption, although strongly modified by medieval plan features and vaulting.

The primitive medieval nave-and-chancel or 'barn' type of church, resembling St Benedict's Chapel at Saint-Riquier [5], is represented by a number of smaller churches in Burgundy – Saint-Laurent, Tournus (built before the year 1000), being the most interesting preserved example.

The *rotunda* is not unusual in Burgundy. Its major representatives (at Auxerre, Sens, Char-

lieu, and especially Dijon [107–9]) have already been analysed; they are regularly connected with crypts and ambulatories, and thus are satellite rather than independent construction. Burgundian Romanesque and Gothic churches tend to have a special accent on the axial absidiole, which probably represents a reduction of the rotunda.

The *Greek cross plan* and its approximations are rare in Burgundy. The cemetery chapel at Cluny (1064; destroyed) provided a rather solitary example of its independent use. Cluny III was an exceptional building. The chevet, including the minor transept, was, in effect, a church of the central type, so disposed as to give extra capacity for large assemblages. Each arm of the great transept was like the 'tower nave' of a Saxon church. The 'double transept' at Cluny is believed to have been the first; the scheme was communicated to England through Lewes Priory, and thence to English Gothic.

The '*double-ender*' plan, which was used by the Early Christians of North Africa, and afterwards in Germany, is represented in the cathedral of Nevers on the Burgundian border. The eastern apse has been replaced in the Gothic style, but the western one, together with handsome arcaded transeptal screens, has been preserved. The date of 1029 is given for this work. Saint-Vorles at Châtillon-sur-Seine (dated about 980–1000, with a later vault) is triapsidal, transepted, provided with nave and aisles, and has the wreck of a sort of westwork which recalls Carolingian and German work. The impact of the Empire on Burgundian work seems in fact surprisingly small, but it may perhaps be felt in the double transept and the octagonal towers of St Hugh's Cluny.

Features in Plan

All Romanesque features of church planning occur in some form in Burgundian edifices, typically as enrichments of the basilican scheme.

Apses are regularly semicircular, lighted by three windows, and covered by semi-domes, round-arched or pointed. They are as a rule a little lower than the adjoining, typical, vaulted sanctuary bays. Ordinarily the churches are triapsidal, with lateral apses attached to the transept. This simple arrangement was sufficient even for so notable a building as the twelfth-century cathedral of Autun [161], because, like other early twelfth-century cathedrals, it had not yet become the focus of guild activities and various popular religious devotions. Gothic lateral chapels were added here, as at Notre-Dame in Paris, for such purposes.

Crypts are important, as we have seen, in the Early Romanesque of Burgundy (Dijon [107]; Tournus [102]; Saint-Savinen, Sens; Saint-Germain, Auxerre 26B]). Mention should be made of the handsome and well-built crypt of the cathedral of Auxerre (c. 1025–30) [112] which is precocious in its architectural forms, perhaps because of influence from the Loire. The crypt has beautifully composed grouped piers and fine vaulting, with moulded ashlar ribs. Nevers Cathedral has a similar crypt dated about 1029. Burial crypts are unusual in Burgundy, which did not have many Early Christian saints besides Germanus (Auxerre), Benignus (Dijon), Valerianus (Tournus), Fortunatus (Charlieu), and Savinianus (Sens). The much quoted 'cryptae' of Cluny II were secretaria or lateral sacristy chambers, not subterranean; 'crypta' may mean a vaulted chamber above ground.[2]

The *ambulatory with radiating chapels* came early to Burgundy, and was long confined to the most notable monastic buildings with crypts. It was, however, not much used in Burgundy, even in Gothic times, outside the monasteries. One exceptional church, Bois-Sainte-Marie, perhaps under the influence of early Charlieu, has an ambulatory without radiating chapels.

The *apse échelon* occurs in Burgundy, and Cluny II, with the earliest échelon in the region,

was doubtless influential in its widespread use. Anzy-le-Duc has an excellent example, still preserved, with a small apse, reminiscent of a rotunda, opening from the central absidiole.

Sanctuary bays were placed singly in front of the apses of Burgundian churches of any pretension at all.

Stalls were regularly placed at the head of the naves, in monastic churches, within a low-walled enclosure. Ordinarily two or three bays sufficed for this choir.

Transepts are usual in Burgundian church plans. Sometimes they are 'dwarf' transepts (not as high as the nave), and they are often 'included' (not extended beyond the flank lines of the plan), in which case they may have pitch roofs like the aisles, as at Chapaize [134]. However, the transepts also often project and have striking façades (Paray-le-Monial [156]; Autun Cathedral). The longer transepts were built to provide additional absidioles.[3]

The '*archiepiscopal cross plan*' (with two transepts east of the nave) apparently originated at Cluny [142], to permit large assemblies in choir. It spread to England (Lewes Priory, Canterbury, York, and Salisbury Cathedrals).

The *crossing* in Burgundy, often oblong rather than square, regularly has an octagonal domical (or 'cloister') vault on squinches, and the vault is sometimes pierced with small windows.

Naves are aisleless in modest churches. Though sometimes roofed in wood, they are typically vaulted in Burgundy – the result of Roman heritage and probably also for reasons of acoustics. Small tunnel-vaulted churches of Romanesque proportions respond amazingly to the liturgical chant; even a few voices will fill such a building with rich resonances which are hardly obtainable in a wooden-roofed room.

It is obvious that certain of the Burgundian naves were built cheaply for capacity. Saint-Marcel and the later Infirmary Chapel at Cluny (like the near-by church of Beaujeu and many others belonging to the school of the Loire and

the region of Bourges, where the scheme was an established type) have triapsidal chevets and transepts with towers, to which wide wooden-trussed naves were added – naves twice as wide, more or less, as the chancel. The effect, though spacious, is rather barn-like.

The proportioning of Burgundian naves varies greatly. There is a continuous tradition for Roman sturdiness and amplitude, which runs from the basilicas through Saint-Bénigne and Vézelay to the Cistercians, with a placid rhythm in the division of broadly proportioned, individual bays. There is a tendency, noted especially in the parish churches, but also at Vézelay, and in Cistercian work, to use a two-storey interior elevation.

The Cluniac group of Burgundian churches often has emphasis on the verticals. At Cluny III the height of the transverse arches was three times their width and the individual bays were about four times as high as they were wide.

In the Burgundian naves, lighting by clerestory windows is usual, but in many instances of vaulted churches they have been omitted or blocked up for safety's sake. In such buildings, if they are short, the west windows of the nave give a sufficient light. The naves of ordinary parish churches tend, in fact, to be short, but in monastic buildings the processional liturgies (much developed in Burgundy) caused the construction of very long naves which influenced those of other regions.

Aisles are the rule in buildings of any importance, unless the naves have uncommon width. Exceptionally Saint-Bénigne at Dijon, Cluny III, and Souvigny had two aisles at each side of the nave. Aisles are almost invariably covered by bays of groin vaulting (occasionally quadrant vaults) separated by transverse arches which are buttressed by pilaster strips or spur buttresses. Ordinarily each aisle bay has a window.

Towers and *pinnacles* are normal on Burgundian churches, and are invariably an attractive feature of the design. The number of towers

varies greatly, and with it the silhouette (always interesting) of the buildings. The tower shapes are sober and dignified, and the openings, usually with attractive ornament, are always well disposed. Authentic Romanesque tower roofs had pyramids of low pitch (as a rule less than forty-five degrees, except on pinnacles), until the twelfth century was well advanced. Towers in the tradition of the heavy Roman *turris*, built up from the ground, are square in plan. *Pignacula*, often somewhat too large to be called 'pinnacles' in the modern sense, may start from the roof level, and are frequently octagonal.

Tall and graceful crossing towers, quadrangular or octagonal in plan, are a constant feature of the churches. A belfry in several stages is often set over a lantern with tiny windows at the crossing. Bell cages, where they occur, rest on the crossing vault. The belfry stages were always roofed in wood, sometimes covered in the Middle Ages with tile, sometimes with 'laves' (laminae of stone).

In Burgundy, paired western towers occur much less frequently than crossing towers; we may say that generally paired western towers were associated with galilee porches of monastic inspiration. Single western towers are unusual. Stair turrets of varying size enliven the silhouettes of many churches; they may be square or round. Saint-Bénigne at Dijon was exceptional in having three pairs of stair turrets, symmetrically placed. Cluny III had two great square belfry towers at the façade, two square stair turrets, of which one was carried only to the clerestory level, together with four *pignacula* of great size – one oblong, and three of octagonal shape.

Porches and *nartheces* are features of the more ambitious churches, as a rule; more modest buildings rarely possess them.

Portals of embrasured form, in one, two, or several orders, with nook shafts, are a common and attractive feature even of modest churches.

They have characteristic carved lintels, tympana, and moulded enclosing arches. Only modest examples, or those under Cistercian influence, were left plain. The proportions are in almost all cases excellent.

Details of Superstructure

The *wall-work* of early Romanesque Burgundy, to be understood, requires a knowledge of mason work in the Loire region. At first, the execution, both of walls and of vaulting, was rather rough. Ashlar stone was used, rather exceptionally, in the crypt of Saint-Philibert, Tournus, before 979, and ashlar spur buttresses occur in the same work. The rough vault, never stuccoed, still shows the marks of the small boards used as centering. Division of vaulting bays by arches of ashlar stone may have first come in systematically with the Lombards, about 980–1000. Ashlar was used more and more from that time onward. Late in the twelfth century walls and vaults both were increasingly faced with ashlar, which in Gothic work was indispensable. Where ashlar was used, the *stucco* which regularly surfaced the rougher old construction would not adhere properly, and was omitted.

The walls, even early walls, in Burgundy show a high level of craftsmanship. The region is blessed with an abundance of excellent limestone ranging from white to pale buff in colour, which weathers to beautiful toasted browns and soft greys. An exception is the pink stone of Préty, used at Saint-Philibert, Tournus.[4]

At Cluny III the typical ashlar blocks are about three feet high, with very narrow mortar joints ($\frac{3}{16}$ of an inch). However, these dimensions are exceptional; the ordinary joints are thicker and the ordinary coursing is narrower. Common walls are faced with *moellon*, relatively small stones trimmed roughly to shape. A few early walls show the use of rough stones with occasional herringbone work; a few show hori-

zontal bands of ashlar work, introduced for strength. Insufficient credit is given to the skill of the Burgundian masons in finding the proper materials and making exceptionally good mortar.

Piers of oblong plan occur early in the Burgundian churches, as do cruciform piers, which persist. Square nuclei have three-quarter columns adossed to them in mature work. Cruciform nuclei have three-quarter columns and/or fluted pilasters attached to them in Cluny III and related buildings. Ashlar is early used. Cylindrical piers of *moellon* occur early (Saint-Philibert at Tournus, Chapaize).

Columnar shafts were used from early times for support; examples occur at Saint-Bénigne, Dijon, and in the Charlieu chapter-house, as well as in Cluny III and buildings related to it. Monolithic limestone shafts up to twenty feet in length are easily quarried in Burgundy, but difficulties of transport prevented their wide use; the columns, as in classic times, were ordinarily built up of drums. The capitals are sometimes surprisingly close to the antique Corinthian, but simplified, and Corinthianesque forms are more usual. Structural columns are not fluted, but decorative columns and pilasters often are – in the twelfth century with quite unconventional detail in the form of bevels, zigzags, chevrons, reeding, cymas, and beading. Such details show the influence of imaginative manuscript painters and metal workers.

The *mouldings* in ordinary buildings are simple and far from subtle, but the best work has classicizing mouldings of great beauty.[5] The string courses show beak mouldings derived from the classic cyma; column bases are sometimes close to the Roman form of the Attic base. The gradual transition to the Gothic derivatives of these profiles can easily be traced in Burgundy.

The Burgundians had a great rage for decorative *arcading* which was unquestionably of classical origin. Simple at first, the arcading became very elaborate and multiplied with the passage of time. In the second half of the twelfth century it was very luxuriant indeed, being carried out with decorative pilasters and complicated mouldings. Moslem influence, coming perhaps by way of the Auvergne, brought in *cusping*. Very spicy decorative effects were achieved by its use. The Lombard *corbel table* survived throughout the various phases of Burgundian Romanesque, and was used effectively in the almost Baroque designs of the middle of the twelfth century.

The *sculptural decoration* of Burgundian Romanesque buildings was not rich in the early period. The Lombardic work employs simple capitals trimmed down in concave fashion at the angles, so that triangles result on the faces of the capitals instead of semicircles as so much more frequently in Lombardy. In unpretentious work these capitals are built up of courses. Few grotesques occur, though there are some interesting examples; leafage predominates so generally – and rather unskilful leafage in fact – that one must suppose the importation of highly trained carvers (almost certainly from the marble-cutting regions of France, and most probably of Italy), when the sophisticated Cluniac *atelier* was created. Some of the capitals show the influence of medieval manuscript decoration. The fine earlier acanthus leafage at Cluny III (so like ancient *acanthus mollis*), as well as the exceptional delicacy and classical character of the earlier moulding profiles at Cluny III, would be accounted for, if we might suppose that fine craftsmen came from Montecassino, Pisa, Venice, or possibly Moslem Spain, which has yielded beautiful carvings in an almost Romanesque style. These men surely worked under French direction, however; for the savour of the designs is unmistakably French.

Cistercian architectural asceticism made itself felt instantly in Burgundy. Simple column capitals and austere portals with blank tympana appear on many churches not belonging to the Order. Their reserved character accords well

with the sober outlines which the Burgundian Romanesque churches generally exhibit.

Vaulting in Burgundy followed Roman models until well into the Gothic period, though 'half-Gothic' rib-vaults began to appear sporadically in Burgundy as soon, or almost as soon, as in the Île-de-France. The Romanesque vaults are in laminated stone, rough, with thick joints, thick cells, and stuccoed soffits.

Centering was used in building the Burgundian vaults. This was supported on heavier timbering, as may be seen at Lärbro in Gotland [350, 351], where a fourteenth-century vault of Romanesque type in the church tower still retains its centering *in situ*.

Wooden *tie-pieces* set at the springing, bay by bay, were a common means of maintaining the vault safely in position, while the masonry solidified. They were intended to be removed. The tie-pieces were doubtless useful in supporting a workmen's platform during construction. Timbers were apparently embedded in certain walls to give longitudinal strength at high levels. This occurs in the dormitory of the Cluniac priory of Lewes in England. It is not good practice, for the buried timbers suffer from dry rot and lose their strength; then the wall is weaker than it would be if it were constructed entirely of stone.

The tunnel vault and its derivatives were almost exclusively used in Burgundy, except for the apses, which of course have round or pointed semi-domes. Since both round and pointed arches are used in the arcading, we find round-arched and pointed tunnel vaulting (commonly used in the naves and transepts) together with round and pointed groin vaulting (regularly in the aisles, occasionally in the naves). The trumpet squinches and the octagonal domical vaults which occur normally at the crossings are, like groin vaulting, derived from the tunnel vault. Exceptional are the niche-head squinches and dome of Saint Philibert, Tournus, built somewhat before 1120.

The groin vaults have on the whole stood up better than the tunnel vaults. Strong mortar kept both types secure for some time, but the tunnel vault was the more difficult to abut successfully, and with time almost all the examples have become deformed or have actually failed. Auxiliary buttresses, not originally planned, have helped to keep several of the important vaults in place.

The tunnel vaults often have the roofing of *laves* laid directly on the vault cells, loading the haunches. However, roofing of laves or tile on timber supports over an air-space often covers tunnel vaulting, as it invariably does vaults of groined or domical form.

The high vaults of Romanesque Burgundy form an interesting study in themselves. Mention has already been made of Cluny II (vaulted about 1000) and Saint-Bénigne (1001–17). The sober and powerful vaults of the narthex at Tournus (about 960) precede them both. The upper stage of the narthex, dated perhaps about 1019, has quadrant-vaulted aisles with diaphragms between the bays, and a tunnel vault with transverse arches over a clerestory between. Pilaster strips stiffen the wall on the exterior, in the Lombard manner.[6]

With Cluny III the pointed arch was brought in. This permitted a cleverer and thinner groin vault, more easily built, and it gave a more scientific profile to the high vault. The optimum profile is a catenary, which avoids all deformation stress in the vault cells.[7] But where, as at Cluny, the clerestory walls were wrongly located over the piers, the vault had to be propped up with flying buttresses.

This is perhaps the place to introduce a brief consideration of *civil architecture*,[8] slight as the remains are. In Burgundy the Roman cities shrank within their walls and decreased in population, so that for a long time new construction for secular purposes was not on a high level. Stone was doubtless much more used in Burgundy than farther north, where, as in early

medieval England, the village church might be the only building of brick or stone in a settlement. Many of the community functions of to-day had been taken over by ecclesiastical or manorial establishments, and most of the towns were so small, until the twelfth century, that their functions did not require highly individualized buildings. With the twelfth-century revival this was changed.

Cluny, which was early chartered (about 1100), possesses a charming old building of the late Romanesque period which is said mistakenly to have served a civic purpose as the abbey mint. It has a big-arched ground floor, where there was a forge of some sort; simple apartments occupied an intermediate floor; a loft above them provided storage.

A serious conflagration in 1159 destroyed many houses at Cluny. Surviving still are several of the more or less standardized dwellings which were built to replace them [186]. The lots are relatively narrow, and the houses, built with party walls, were placed at the sidewalk line. Cellars were provided with interior access. Space was allotted for a garden plot at the rear. The characteristic stone façades are handsomely proportioned and well built, but the interior construction was of wood.

At the ground floor a generous pointed arch opens upon a shop, a work room, or a stable, and beside it a narrow square-headed opening gives upon the stairway which leads to the apartments on the floor above. The shop occupies about half the ground-floor area, extending beyond the stairway to give access to a corridor leading to the kitchen (at the back of the house, with a big open fireplace at one end). The intervening space between the shop, the corridor, and the kitchen is an open court with a well in it – essentially an outdoor room.

In these houses at Cluny a charming range of two-light windows divided by columns and set off by small piers gives light across the whole front of the upper storey. This storey is divided

186. Cluny, characteristic house, after 1159

by the court into two or three rooms; it would be provided with one or two hooded fireplaces, and would have a storage loft above, under a roof with a dormer opening and broadly overhanging eaves. It is a very attractive medieval house type, and always appears in general accounts of French medieval domestic architecture.

Cluny, built on two sides of the abbey enclosure, had a very simple street system. Ultimately an outer wall, with three gates, was built – each gate leading to a small plaza. As far as we know, the old Romanesque towns were, similarly, quite simple. Sometimes they were laid out in rings, around a church or castle, but on flat ground they were often rectilinear, and the 'bastides' later inherited this mode.

When a more official architecture developed, it was naturally dependent on monastic architecture to a considerable extent. The abbeys had been building walls, gates, gatehouses, halls of various sorts, garners, and mills. We must infer that municipal constructions of the sort were simple at first, like those of the monks, and that when they came to be embellished, the ornament was what we have seen on the churches. This observation is borne out by the 'Manécanterie' at Lyon, a twelfth-century work which served as a choir-school annexe to the cathedral, but it might equally have been built as a municipal hall of some sort.

The countryside architecture of Romanesque Burgundy must be divined from later buildings which have obviously kept something of their earlier form. The village of Blanot, near Mâcon, looking down on its enchanting little valley, must be more than a little like a Romanesque village. The manors and granges of the region are not Romanesque, but their orientation, their simple arrangement about courtyards of low barn-like structures is clearly traditional. At Berzé-la-Ville the grange of the Cluniac monks has been rebuilt, but the old court has its original location and the remarkable chapel built in the days of St Hugh still dominates it. At Berzé-le-Châtel near by, the castle has been rebuilt, but gives a hint of older forms, as does the Château des Moines at Lourdon, in spite of partial rebuilding and advancing ruin. Rural Burgundy is still largely Romanesque in its visual effect.

The Romanesque style which we have thus described was cherished by the Burgundians. Much of its character was bequeathed to the 'half-Gothic', as one may see at a glance when visiting the majestic thirteenth-century interior of the cathedral of Langres, so splendid and so strong. Even the better examples of Burgundian Renaissance and Baroque church architecture have about them a certain warmth and simple, recollected quality which is akin to the Roman-

esque. The medieval revivals of the nineteenth century produced little of interest in Burgundy, but the country churches were often carried out in a sort of Romanesque or half-Gothic style which blends well, in the smiling opulent landscape, with the churches which remain to us from the tenth, eleventh, and twelfth centuries.

PROVENCE

The essential Latinity of Provence is well shown in its Romanesque architecture. The region was temporarily a possession of the Visigoths (480 ff.), Ostrogoths (510 ff.), Franks (537 and later), Arabs (before 739), and the Empire, with interludes of local independence; it was even under Spanish rule, without losing its basically Roman character. Arles was a natural choice as capital of the medieval kingdom; for it was the capital of Roman Gaul in the fifth century, and its bishopric was then the primatial see.

Important examples of fifth-century ecclesiastical architecture still exist in the region; for instance, the church of Saint-Pierre, at Vienne, now a museum, was in fact a vastly spacious fifth- or sixth-century wooden-roofed church, the oldest extant in France. It is erroneously supposed to have had tribunes. Interior roof supports had to be built in 924-6, providing two lines of tall, slender arches on plain oblong piers, with a Carolingian pierced screen wall above, providing support for a pitch roof of ordinary form. The church was, as we believe, an example with the unobstructed interior space which was usual in the Roman Imperial throne halls, like the 'Basilica' ('royal house') in Trier. These very spacious naves appear as a Romanesque church type. Since the reconstruction of 924-6 (probably caused by weakened trusses), Saint-Pierre has had aisles nearly as high as the nave, which has no clerestory. It is thus a primitive sort of 'hall church'.

Saint-Laurent, Grenoble, has a well-preserved crypt dating from the eighth century

which is one of the most interesting of its type, quatrefoil in plan. It was built into a late antique cemeterial complex, and a church was constructed over it about 1012.

Again, the cathedral of Vaison has three apses of horseshoe plan, ascribed to the Merovingian period; but between 1010 and 1030, and once more in the thirteenth century, the church was rebuilt, so that it has the general character of later Romanesque buildings.[9]

The early abbeys are unexpectedly disappointing. At Saint-Victor at Marseille, which has an august history going back to its founder John Cassian (414), there is now a stout, well-built, two-towered, crenellated exterior – a good example of tardy Romanesque, restored in modern times. The upper church is of the thirteenth century, incorporating parts of an older building dedicated in 1040. Beneath it there are fifth-century remains of unarchitectural character, but one can trace a stubby three-aisled basilica with a large square atrium in front of it – a layout which recalls the church of Santa Maria Antiqua in Rome.

Lérins, near Antibes and Cannes, though charming, is also disappointing; for nothing remains of the Early Christian period, when the monastery was one of the most important in western Europe. On the Île-Saint-Honorat there is a trefoil chapel dedicated to the Trinity, an eleventh-century work, and there are eleventh- or twelfth-century sections in the picturesque but much rebuilt fortifications of the island.

Records have come down to us regarding tenth- and eleventh-century building at other abbeys and cathedrals, but the remains are slight.

The really flourishing period for Provençal architecture came in the twelfth century, when the cities were acquiring local independence. Many older buildings of importance were replaced with maturer works in consequence. The classicizing tendency is unmistakable, increasing rather than diminishing as the twelfth century advanced; it was full and strong at the beginning of the thirteenth century, but lost strength during the ensuing disasters, and because of the general expansion of Gothic art.

Some traces of influence from neighbouring Burgundy are to be observed, it is believed, in the cathedral of Valence, near Vienne, where Urban II performed a dedication in 1095.[10] The former cathedral of Saint-Paul-Trois-Châteaux,[11] a mid twelfth-century work, has a certain relationship to Paray-le-Monial and Cluny

187. Saint-Gilles-du-Gard, priory church, plan of the church before destruction

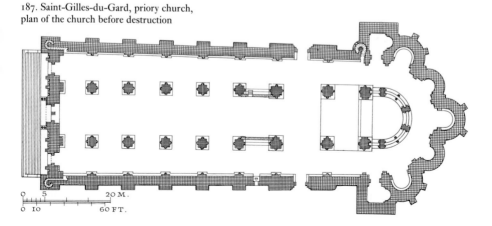

```
 0    5           20 M.
 ├┼┼┼┼┼─┼───┼───┤
 0   10          60 FT.
```

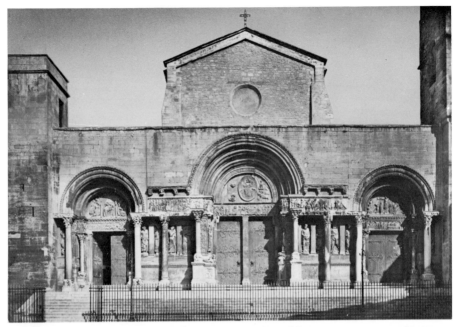

188. Saint-Gilles-du-Gard, priory church, façade, c. 1170; gable much later

189. Saint-Gilles-du-Gard, priory church, c. 1116–70, crypt

III, though the aisles are covered with quad-
rant vaults, and the apse has pretty radiating
decorative ribs in the Provençal manner.

The plan of Saint-Gilles-du-Gard,[12] a great
Cluniac priory and pilgrimage centre, had aisles,
a transept, and an apse with radiating chapels –
all features which are exceptional in Provence
[187-9]. It is conjectured that the vast crypt, at
the cloister level, and exceptionally placed under
the nave, may represent a Cluniac church begun
after 1077. In this Urban II consecrated an altar
in 1096. A new start was made c. 1116. Before
1142, apparently, it was decided to transform
the western part of this church (then either un-
finished, or in ruins) into the existing crypt,
and build an ambitious church at the higher
level; an arrangement which occurs at the great
pilgrimage churches of Le Puy and Santiago de
Compostela. The east end of Saint-Gilles, now
ruinous, was probably well along by 1135, and
the west front with its splendid three west
portals, under way by 1142, was completed a
generation or more later, perhaps as late as
1195. The rib vaults of the crypt have already
been mentioned; they now sustain the pave-
ment of a rather piteous church – a seventeenth-
century reconstruction covering only a part of
the area of the Cluniac church.

190. Saint-Gilles-du-Gard, façade of house,
twelfth century

In passing we should note the façade of a
spacious three-storey house of the twelfth cen-
tury, not far from the abbey at Saint-Gilles[13]
[190]. It is well built of ashlar, and picturesquely
sheltered by a broad overhanging roof. It re-
sembles, on a grander scale, those houses which
we have observed at Cluny, and it is hardly
more elaborate in its arrangements. There are
three large square-headed openings on the
ground floor. The lintels, and two lines of paired
window openings above, are composed within
strong horizontal mouldings, like great friezes
running across the design. Plain segmental re-
lieving arches take the load off the lintels of the
ground storey; decorative arches are cut into
the lintels of the paired windows above, and

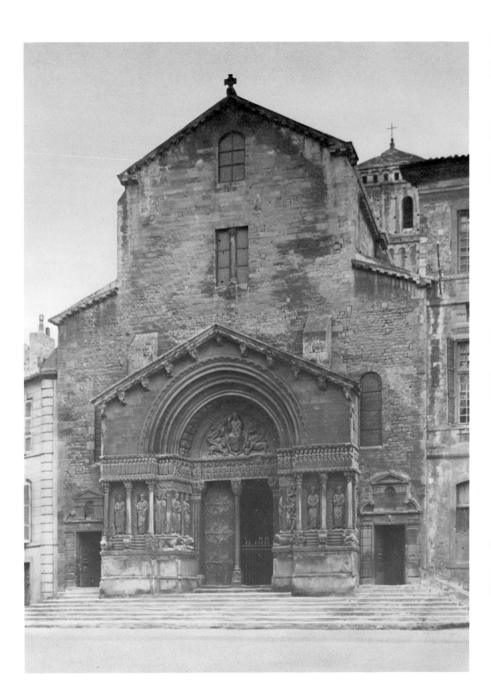

effectively enrich the composition. This façade is one of the finest of its kind.

Because of similarity in the sculptures, mention of Saint-Gilles inevitably calls to mind the former cathedral of Saint-Trophîme at Arles[14] [191-3]. Here, as in the old monasteries, one looks in vain for evidence of the early ecclesiastical importance of the site. Tenth-century constructions (c. 950-72) at the head of the nave were largely replaced by a new sanctuary in the fifteenth century, the old nave having meanwhile been rebuilt, and embellished (about 1170-80) by the remarkable west portal. This is set against a plain basilican façade. The portal seems half Roman because of its gable, its classic columnar forms, and the rather stumpy classic-looking statuary. It contrasts strangely with the tall, austere interior of the church, though the latter is carried out in the excellent ashlar of Provence. Its division into nave and aisles is not typical of the region, nor are the very tall proportions and rather obstructive piers. The transept (partly of the tenth century) is of simple design and relatively slight projection. The arches at the crossing are relatively low, as is usual, and the old apses were no higher.

Over the crossing at Arles rises one of the finest of the Provençal Romanesque towers [192]. Formerly the main apse of the church stood below it, immediately to the east. The tower has three principal stages, almost cubical in shape, and has strong set-backs which give it a vigorous profile. Its decoration is unassuming – pilaster strips and arched corbel tables on the two lower stages, Corinthian pilasters above, with an ingenious pierced frieze and a corbelled cornice. Good proportion gives it a grace which is surprising in such a heavy design.

191 *(left)* and 192. Arles, Saint-Trophîme, façade, *c.* 1170-80, and cloister garth and tower, largely twelfth century

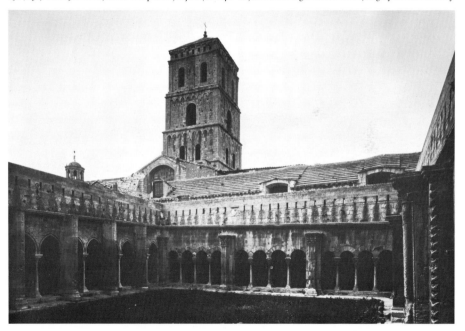

Beside the church there is one of the finest cloisters in France, though of late date (about 1183, finished, perhaps, about 1389, in the Gothic style) [193]. The piers and spur buttresses are very heavy, for the cloister walks are covered by substantial stone-ribbed quadrant vaulting. The designer beautifully lightened the effect by giving the Romanesque spur buttresses the form of fluted Corinthian square

with bold, lively, and varied Corinthianesque capitals of great beauty.

Among other fine churches which deserve mention is the monastery church of Montmajour.[15] Its affiliation with Cluny and its location on a Pilgrimage route account for the spacious crypt with a central rotunda, an ambulatory, and radiating chapels. Above the crypt level it is an imposing and beautifully built

193. Arles, Saint-Trophime,
Romanesque cloister walk, c. 1183

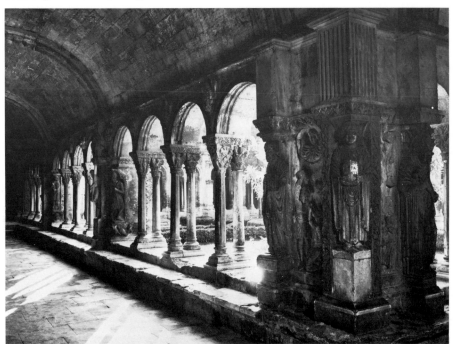

columns, by adorning the piers with bold figures on the interior corners, and by placing relief panels on the adjacent wall surfaces. The Romanesque bays of the cloister open upon the garth through deep and richly moulded round arches. The supporting columns are in pairs, set on a plinth and carrying an elegant impost. Some of the shafts are round, others octagonal,

aisleless church of very pure and austere form, gracious, ample, and satisfyingly classical. Apparently the construction of this great church was started as early as 1117, but consecration did not take place until 1153. A very simple but substantial and well-proportioned cloister adjoins the church, and at a little distance there is a famous cruciform chapel of almost classical

appearance, built about 1200 (Sainte-Croix). The group gains much from its lovely and remote situation.

Much better known is the cathedral of Avignon,[16] also aisleless [194, 195]. It stands on an eminence beside the heavy irregular mass of the huge fourteenth-century Papal Palace. A handsome Renaissance stairway contributes to the dignity of the church, which is, however, infringed by an unfortunate nineteenth-century votive statue set like a pinnacle on the tower.[17]

The entrance porch of the cathedral is of surprisingly Roman form and surprisingly late date (about 1200). The tower behind it is in part rebuilt, but without injury to its essentially Roman dignity. A date of 1069 is given for the

194. Avignon Cathedral, c. 1140-60 and later (porch c. 1200).
The pedestal and the statue on the tower are a distressing modern addition

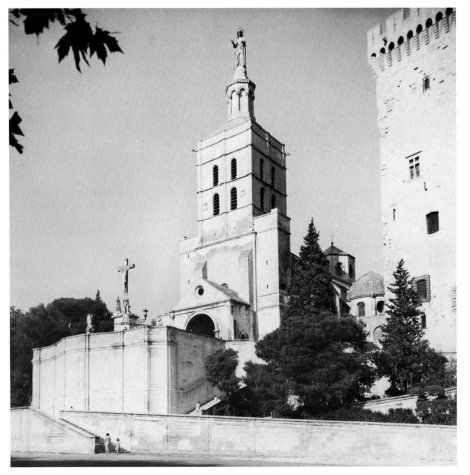

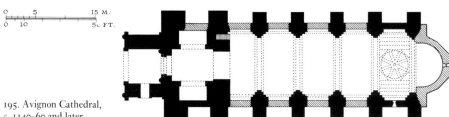

195. Avignon Cathedral,
c. 1140–60 and later

church proper, but universally set aside because of the mature character of the masonry and sculpture. The nave is of ample proportions, and handsomely covered by a pointed tunnel vault with transverse arches. The lateral mouldings, arcading, and nook shafts which support this vault and the ribs are particularly rich and beautiful, being consonant with a date from about 1140 to 1160. Lovely marble capitals, carved with rare delicacy and beauty, still survive from a cloister of this period. An odd feature of the building is an octagonal lantern sustained on longitudinal 'encorbelled arches' sprung between the vault arches at the head of

the nave. Thus this cathedral is a tardy example of the type with two axial towers which we found in the fifth century at the church of St Martin of Tours.

In passing, reference should be made to the famous bridge, now broken, of Saint-Bénézet [196]. This is the 'dancing' bridge named in the delightful old song, and it has a picturesque chapel which is largely contemporary. The arches and piers of the bridge are fine examples of heavy block masonry construction. The date is 1177–85 and later.

Orange Cathedral[18] is another of the cavernous, rather dark aisleless Provençal churches.

196. Avignon, Pont-Saint-Bénézet, 1177–85 and later

197. Saint-Pons-de-Thomières, priory church,
interior, 1164 and later

Here, too, we find a pointed vault. Saint-Gabriel has a smaller church which is similar.

Aix,[19] an ancient city also, has lost its old cathedral of 1070–1103 (except an aisle, the baptistery, and a cloister), in favour of a florid Gothic edifice. The cloister is of the twelfth century, and more ordinary in form than that of Arles – being small, unvaulted, and provided with piers only at the four corners; but it is gay with paired columns, and richly carved.

Largely because of the sculptural relationships, Septimania or Gothia (the ancient Gallia Narbonensis) is assigned to the Romanesque school of Languedoc. However, part of it, Rous-sillon, is actually French Catalonia, which has a character of its own, though Provençal influence extends into this region. Alet Cathedral, for example, has an apse which is polygonal exteriorly, and decorated with Corinthianesque corner columns in Provençal style.

Saint-Pons-de-Thomières,[20] important in the history of sculpture, has a fine church with a typical Provençal interior of 1164 and later – aisleless, ample in proportion, and covered by a monumental pointed tunnel vault with transverse arches [197]. Fortifications of Gothic date but Romanesque character have left the church with an interesting interior gallery, and a machi-

colated exterior gallery carried on a handsome applied arcade. The building was probably crenellated also.

The precipitous austerity of the cathedral of Agde and the huge solidity of that of Maguelone[21] – both carried out in monumental ashlar – seem to have something Provençal about them. Agde, a construction of the middle of the twelfth century, was fortified in consequence of royal permission granted in 1173.

Saint-Guilhem-le-Désert[22] (eleventh and twelfth centuries) is picturesquely set in a mountain valley above Aniane. The church, well known, is Lombardic, rather than Provençal or Languedocian. It is stoutly built and completely vaulted over a satisfactory clerestory. The sanctuary – wider, later, and more finished than the nave – represents an intended reconstruction which was planned to sweep away the earlier work completely. Saint-Guilhem had a very fine cloister, with carvings of Provençal character. This cloister has been partly re-erected at The Cloisters in New York, where multitudes have learned from it the charms of these old monastic courts.

We may now proceed to examine the characteristics of typical Provençal churches, noting first of all the scarcity of interesting monastic churches, and the abundance of interesting cathedral buildings – the result of historical processes in the region. The towns were achieving strong civic consciousness and were making important progress in self-government during the twelfth century, when most of the mature Provençal Romanesque buildings were built.

Types of Plan

The southern French cathedral of the twelfth century was not a highly evolved building, partly because the southern dioceses are small. Consequently the church plans are simple; certain ambitious buildings, such as the cathedral at Arles, are aisled and triapsidal, like the basilicas, but these are unusual. Trefoil plans occur, but are also unusual; the aisleless church with one apse at the head of it is preponderant. Apse exteriors are regularly polygonal, with columns or pilasters decorating the angles; they are semicircular and arcaded on the interior. Nave walls are strongly articulated by interior arcading and exterior spur buttresses of substantial construction. There is sometimes a transept, with a tower over the crossing – or, failing a transept, over the bay immediately preceding the apse. This bay and the apse are often lower than the rest of the nave. Porches are rare, but do occur (as in the cathedral of Avignon, and the Lombardic lateral portal of the cathedral of Embrun). The portals sometimes take classical form (Carpentras, Saint-Gabriel, Saint-Quinin at Vaison, Saint-Restitut[23]), but important examples are embrasured and enriched by tympanum sculpture and other reliefs, as well as by columns and statuary set on plinths which project in front of the façades (Arles, Saint-Gilles; Sainte-Marthe at Tarascon has a similar portal with architectural embellishment only).

Details of Superstructure

If one remembers that the buildings which we have been considering are contemporary with the Early Gothic constructions at Chartres Cathedral (1135–80) and Paris Cathedral (the sanctuary arm in its original form, 1163–77) they appear conservative. But they show high competence on the part of the architects, builders, and decorators, whose designs, strongly impregnated with the provincial Roman traditions of the region, have a convincing solidity, generous proportions, and (as a rule) a fine sense of ample interior space.

Fine block masonry in limestone, resembling Roman work, was used in the better constructions, and it gives them great dignity. Marble was used for many decorative carvings. Sculptured figures and accessory elements strongly

recall Roman provincial works, though the compositions are medieval. The carving can be heavy and dull, but in the finest examples the design is lively and the chiselling admirable.

The *naves* of Provençal churches are covered by substantial, usually pointed, tunnel vaults with transverse arches. The *aisles* are divided by arches and covered with quadrant vaulting (as at Arles) or ramping parallel tunnel vaulting (as at the cathedral of Vaison). The aisles were kept narrow, and the nave vaulting relatively low, supported on interior arcading and provided with stout spur buttresses. Since large windows were not needed, *clerestories* could be

built under the nave vaulting without danger. Because of the mild climate of the region, it is possible to pave the extrados of masonry vaulting, forming a roof terrace, and thus to dispense with an exterior roof. But ordinarily there is a sheltering *roof* covered with round tile in the Roman manner. Bells are very often hung not in towers, but in gabled walls pierced with arches (wall belfries, belfry walls, or bell-cotes). *Crypts* occur in churches which attracted a pilgrimage.

At Les-Saintes-Maries-de-la-Mer[24] [198] there is a two-storey church of pilgrimage, provided with a crypt, which makes a third level.

198. Les Saintes-Maries-de-la-Mer, fortified church, twelfth century

A fourth was created by paving the upper vault; surrounded by battlements, this terrace made the building a citadel and fortress, which is not really unusual in Provence. The turret over the sanctuary is surmounted by a belfry wall of bold outline. More unusual are the Italianate *towers* of Puissalicon (free-standing), Uzès (round, and pierced by openings with paired arches under an enclosing arch) and Cruas[25] (about 1098; an amusing round lantern on a rounded crossing tower).

Returning to the interiors, we find that cruciform *piers* are the usual supports – or wall arcading in aisleless buildings. Deep *interior recesses* with transverse vaults occur in the aisleless churches (Cavaillon); pier forms (Le Thor), and columnar shafts are also used in this situation. The piers usually have dosserets, and often a small column replaces the angular dosseret at the top of the pier (Digne, Avignon).[26] Some examples are very elegant indeed, and sophisticated, the warm classical feeling being made piquant by a touch of medieval imagination. The same is true of the mouldings.

A Roman architect visiting Provence in Romanesque times would have seen much which would have pleased his fancy by its engaging novelty in exploiting Late Classic forms; he would have seen little or nothing which he could not have understood or admired. Even the towers have a Roman matter-of-factness about them; the roofs maintain the flat slope of Antiquity and are covered with tile; lovely vineyards, orchards, and pines embower the monuments, and enchanting atmospheric effects caress them – as in ancient times.

AQUITANIA, WITH BORDERING AREAS ON THE LOIRE

AND THE MEDITERRANEAN

West of Burgundy and Provence lies the area of Carolingian Aquitania, with the related Loire and Septimanian regions adjoining it. Important parts of the metropolitan archbishoprics of Tours and Sens are within it; the metropolitan archbishoprics of Bourges (which claimed primacy in Aquitaine), Bordeaux, Auch, and Narbonne are included entire.

Aquitania might well have been a nation in medieval times, as it was before Caesar's conquest, but involved historic processes prevented the constitution of this state. The weakness of the Visigoths, who could not hold it with Spain, left it open to Frankish conquest. While the Franks were able to drive out the Moors, they were unable to protect the area from the Vikings, who inflicted terrible damage. Assimilated to France, its western part passed to the English by the historical accident of a marriage, and had to be reconquered; a promising development of independence in the south was suffocated by French conquest in the Albigensian War.

The great rivers have kept it accessible to ideas, and to trade, even from the Orient. The Pyrenees have not prevented continuing contacts with Spain. There have been centres of intellectual, spiritual, and artistic life at Tours, Poitiers, Fleury (or Saint-Benoît-sur-Loire), Limoges, Clermont, and Toulouse, but there never was one commanding centre for all Aquitania. The related territory is made up of areas which are richly varied in topography, climate, building materials, and ethnic types – all of them full of character and interest. On account of easy communication, the architectural areas interpenetrate one another, with the result that the grouping of their monuments into convenient regional schools has caused art historians much puzzlement.

The clearest of the suggested classifications sets off Languedoc, the Limousin, and Velay as one architectural school, Auvergne as another, and subdivides into 'groups' the architecture of the vast and varied district remaining in the West of France, stretching from the south-west to southern Brittany.[1]

Three architectural 'groups' are recognized in the school of the West of France, in the following regions: (1) The Loire area, to which the river itself gives a certain unity; it consists of south Brittany, Touraine, Sologne, Orléanais, Berry, and Bourbonnais; (2) Poitou, which with Anjou, Saintonge, and the south-west forms a more compact architectural group; (3) Périgord and the Angoumois. The argument for considering the three groups as one greater school is interesting. It rests on the fact that there is a quite unusually high proportion of aisleless churches – large and small, important and modest, early and late – in the area: some 650 to 700 aisleless to about 100 with aisles; moreover, aisled churches often have a special type of wide nave, and the others can most often, though not always, be ascribed to outside influence.[2]

In the inclusive greater school of the Loire and the West of France there was a search for monumental and fireproof solutions through the development of this aisleless type, as resources and requirements both increased during the later eleventh century and in the course of the twelfth.

These works may fairly be considered as 'variations on an architectural theme'. The origin of the theme is perhaps to be sought in large Roman wooden-roofed open halls like the Temple of Augustus in Rome and the Basilica in Trier, which had very impressive unobstructed interior space.

The theme of the region is thus to be recognized in those edifices which have a very wide wooden-roofed barn-like nave – without aisles, as often in Berry; or with aisles, as at Saint-Hilaire, Poitiers, St Fulbert's Chartres, and the old cathedral of Bourges. It is to be recognized in those churches which have a wide tunnel-vaulted nave, plain or with transverse arches; and in those which by the use of parallel tunnel vaults cover an ample nave with only slender and unobstructive supports, as in Poitou. The theme is equally to be recognized in the buildings which cover an open nave with a succession of domes, in Périgord and near by, and those with domed-up rib vaults, which were introduced about 1145 in Anjou to replace domed construction.

In order to make the development clear, we refer here to certain works in the region which underlie the mature Romanesque of the area.

THE WEST OF FRANCE

The Loire Group

This area was really the heir of the active architectural school of Carolingian Neustria. The Norman raids, however, devastated northern Neustria. During the period of recovery after the Norman settlement (911), Burgundian and Lombard ecclesiastics greatly influenced Norman churchmanship and architecture. This, and the conquest of England, gave a strong and distinct orientation to the Norman school of Romanesque architecture, which might otherwise have been more like that of the southern part of Carolingian Neustria.

The Loire area, carrying on old Neustrian traditions, was active in architecture; it continued to be a source of architectural ideas and good mason work; it transmitted many influences to the Norman region, and it borrowed, especially in the west. Lacking unity, it is considered a weak *school* during the mature Romanesque period – paradoxically; because the great buildings, though heterogeneous, exemplify such important architectural elements.

Odo of Cluny seems to refer to the wide-nave 'theme church' of the region in a difficult text, a sermon delivered about 908 in the church of St Martin at Tours, referring to the building as it was before 903 (and, probably, before 851): 'The previous builders wished it to be arranged with arcaded passages, because the structure, though very wide, with the crowds pressing is habitually so constricted that they overturn the choir benches and the little gates, in spite of themselves.'[3] This text, sometimes quoted as proof of an early ambulatory at St Martin, merely indicates that aisles were required to augment this wide-naved church because of exceptional crowds.[4]

The beautiful stone-work of the early period of building in the Loire country continued to be used and improved. Walls are ordinarily of fine white or buff limestone, with ashlar blocks neatly cut to a rather stubby shape and well laid up with excellent mortar; they are articulated by shallow buttresses, and occasionally show panels of rougher stones (like those of the filling or hearting of the wall) which, with their uneven contours and wide joints, enliven the surface. Also, wall areas of carefully shaped facing-stones in a pattern, and decorative panel mouldings occur frequently.[5]

The important little church of Saint-Généroux, probably built after 950 [199], shows excellent though restored examples of plain and patterned wall-work. It is more important, however, for its plan, originally a notable example of the wide-naved theme (subsequently divided

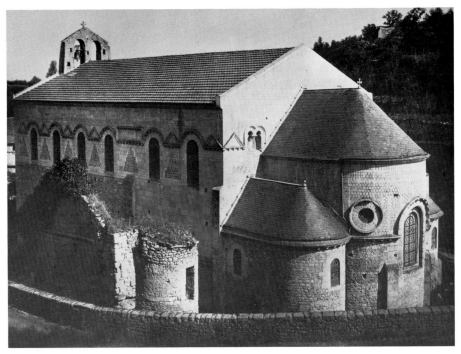

199. Saint-Généroux, church, *c.* 950

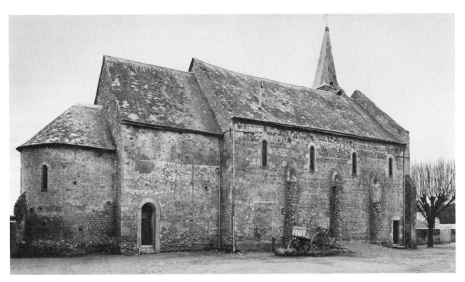

200. Autrèche, church, tenth century

into three). A Carolingian flying screen still divides the nave from the transept, which formerly had dwarf arms extending beyond the nave wall line. The sanctuaries are in échelon. The small parish church at Autrèche [200] is a good example of the wooden-roofed nave-and-chancel type of structure which must have been very widely built on a modest scale in the tenth century. The wall is stayed on the exterior by semi-cylindrical buttresses of a type which later becomes familiar on the tall Norman interiors. At Cravant the church (perhaps dating from the tenth century) has unusually good patterned wall-work.

Almost as imposing as St Martin of Tours, the cathedral (1012 ff.) and the church of Saint-Aignan (c. 1018 ff.) at Orléans represented the grandeur of the early school on the middle course of the river. Both buildings were large in scale, basilican in arrangement, and provided with apse, ambulatory, and radiating chapels.

201. Saint-Benoît-sur-Loire, abbey church, c. 1080-twelfth century.
Note flying buttresses of apse (p. 491, Note 47)

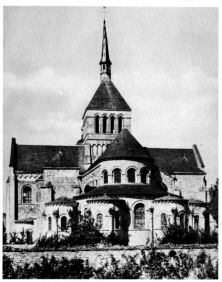

The crypt of Saint-Aignan, with this layout, is still in existence. According to an eleventh-century text[6] it was copied from that of Clermont-Ferrand (946), but its forms are more mature.

The old abbey of Fleury, or Saint-Benoît-sur-Loire (also on the middle course of the river, near Germigny-des-Prés), erected a remarkable church of the mature style in the course of a century following the 1060s [201-4]. It exemplifies the ideas of the school better than any other building, and embodies an august history. In 673, during the desolation of Montecassino (581-714), the bones of St Benedict were brought to Fleury, where they are still venerated. (It seems that in 749, at the request of Pope Zachary and Pepin the Short on behalf of Montecassino, a small parcel was returned.) A pilgrimage to 'Saint-Benoît-sur-Loire' developed. Gaucelin (illegitimate son of Hugh Capet) became abbot in 1004. He and a notable abbey school gave lustre to the house; its influence extended to England and Spain. The medieval abbey buildings have long since been replaced, but, except for the mutilation of its western tower, the church still exists in a very perfect state. Its composition begins with the mutilated tower-porch just mentioned, which lost its upper stage as punishment to the monks for resisting their first commendatory abbot (1525-7). The middle stage survives as a disused Chapel of St Michael, and the open ground stage serves, as it always has, to shelter the main entrance door of the church. This, of course, is a development of the fortified entrance-way-and-chapel tower which we have followed all the way from the church of St Martin at Tours, built near the same river in 466-72. The example at Saint-Benoît-sur-Loire is admirably substantial, vaulted in nine compartments over four interior supports on each level, with elaborate sculptured capitals.

The nave beyond is of Romanesque construction with a pair of groin-vaulted aisles. It

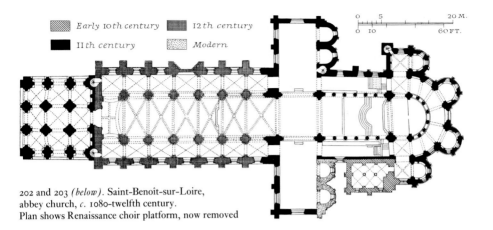

202 and 203 *(below)*. Saint-Benoît-sur-Loire,
abbey church, *c.* 1080-twelfth century.
Plan shows Renaissance choir platform, now removed

was perhaps wooden-roofed before being cover-
ed by the existing Gothic vault. Following the
nave is a Romanesque transept with a tall cross-
ing tower (which makes it, like St Martin, a
church with two axial towers); following this
there is a handsome long sanctuary bay flanked
by a pair of aisles, all tunnel-vaulted above two
files of columns. Then, with its chord on the east
line of a dwarf transept marked by two engaging
dwarf towers, comes a spacious apse with am-
bulatory and two radiating chapels (the number
being even, as it would be in Auvergne). The

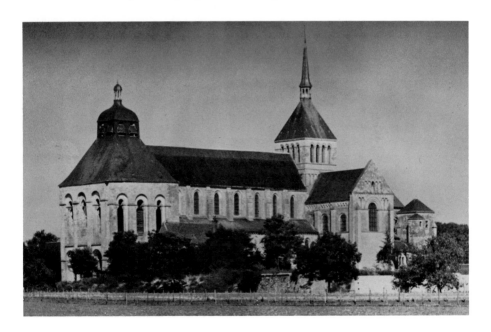

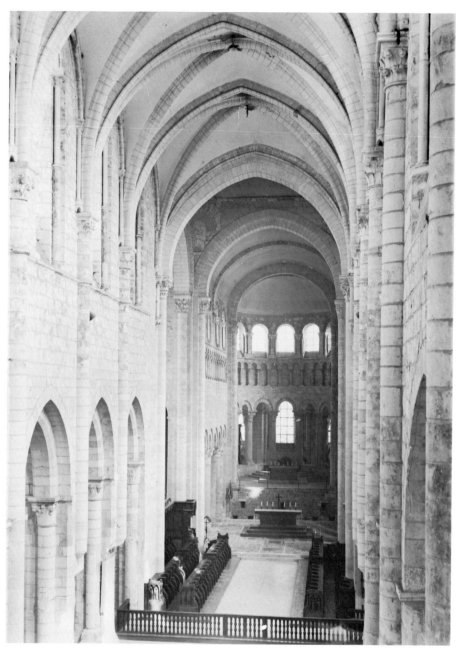

204. Saint-Benoît-sur-Loire, abbey church, *c*. 1080–twelfth century

apse pavement is raised above a spacious crypt which has three windows (reopened) looking on the sanctuary bay.

The building has a clerestory throughout. Deformations show that this has put a strain on the walls of the apse end. The tower-porch may represent the famous tower which Abbot Gaucelin began to erect about 1020. If so, it has surely been rebuilt; the richer carvings of the ground storey seem to belong to a later date – the late eleventh century, perhaps. Figured capitals in the upper stage indicate a date of about 1070-80. Doubtless the tower resembled fine examples at Ébreuil [205], Germigny-l'Exempt, and in the Poitevin area Lesterps, before it was mutilated.[7] The sanctuary (its pavement now lowered to the old level) re-

205. Ébreuil, church, tower and porch, twelfth century

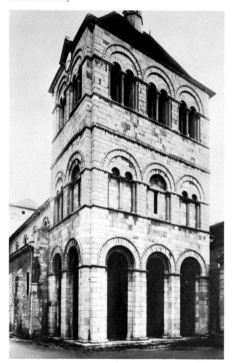

sembles the chevet of the church of Saint-Genou, which is also long, tunnel-like, well lighted, and columnar. Both have engaging blind arcading, with baluster columns, as a decorative frieze above the main arcade.[8]

Saint-Benoît-sur-Loire as we know it began to come into being about 1071. It suffered from fire in 1095, but there was a dedication in 1108 which must have seen the essential parts of the building complete, though construction continued until about 1130.

On the borders of Burgundy, and showing clear Burgundian influence in the beautiful sculptured portal, Saint-Benoît's priory of Perrecy-les-Forges has a fine twelfth-century tower-porch in the style of the Loire region, giving entrance to a typical church of archaic form, dated in the eleventh century. This church is as good an example of the interpenetration of Ligerine and Cluniac influences as the more famous examples, La Charité-sur-Loire and Saint-Étienne, Nevers. The carved portal is a beautiful example, dated about 1105.

Among the Cluniac priories, the church of Bourbon-Lancy gives a good idea of Cluny II as interpreted in the Loire region.

At La Charité-sur-Loire[9] the original building, begun in 1059 or shortly after, had an apse échelon. The chevet was enlarged when the building was reconstructed (following the dedication of 1107) to resemble Cluny III. The sanctuary is deep, with several bays, beyond which it has a fine apse and an ambulatory with five radiating chapels, somewhat more logically planned than those at Cluny. There is much greater emphasis than at Cluny on the columns (rather stout) which sustain the apse wall, and the apse itself reaches the height of the sanctuary vault. In these deviations from Cluny, the architect of La Charité, doubtless trained in the Loire region, followed local custom.

The great north-west tower at La Charité [166] was perhaps begun about 1130 and finished late in the century. While the design does not

depart greatly from Burgundian models, it has a type of arcading which was used with great effectiveness in the Loire country, and never with nobler, richer, or more imposing effect than here. The tower is seen from great distances in sweeping views over the river, which makes a wonderful big bow near La Charité.

Châteaumeillant[10] has a Benedictine church with various features which parallel those of La Charité. It is a fine example on a smaller scale, and has not undergone the disasters which have injured the greater building.

We easily recognize the same activity and energetic character in the designs for Saint-Étienne, Nevers[11] (1068-97) [145, 146]. As noted, this was an important Cluniac priory; its architectural influence spread to smaller houses which it possessed in the region. The architect drew upon Burgundian and Pilgrimage themes, and in his nave, where he introduced a clerestory under the tunnel vault, he surpassed his models. The smaller churches which abound in the region, Cluniac or not, have the same crisp air. Here the aisleless churches with projecting transepts and fairly tall crossing towers often make similar Burgundian buildings seem rather placid by comparison.[12]

The open-naved, wooden-roofed 'theme church' of western France, early suggested at Saint-Généroux [199], was magnificently represented on a grand scale about 1005-40 in the important church of Beaulieu-les-Loches (near the Loire River; later remade as a vaulted hall church, now partly rebuilt, partly ruined). A later and typical example, extant near Bourges, is the church of Les Aix d'Angillon[13] (twelfth century). A contemporary example between Cluny and Lyon, almost at the southeastern extremity of the school of the Loire, is the church of Beaujeu.[14]

A noteworthy aisleless church is Saint-Ours at Loches[15] [206], interesting for its two Romanesque axial towers, but even more so for the two hollow octagonal spires in ashlar masonry,

206 (below). Loches, Saint-Ours, before 1168

207 (opposite). Neuvy-Saint-Sépulcre, church, founded 1042

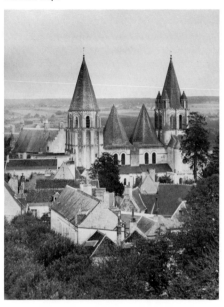

dated before 1168, which cover its nave. There is an obvious connexion here with the wide naves of Périgord and near by, unobstructed, and covered with domes, which we shall consider presently. Meanwhile we take up other exceptional buildings.

A very elegant aisled twelfth-century church with the aisles practically as high as the nave exists at Saint-Révérien.[16] This was a Cluniac priory, and the church has pointed arch and vault construction which looks Cluniac, but the basic inspiration comes from the school of Poitou, where tunnel-vaulted hall churches abound. Saint-Révérien has some groin vaulting at the east end (and necessarily in the ambulatory) along with semi-domes over the apse and radiating chapels as is usual everywhere. The church is beautifully lighted and elegantly open. The graceful columns of the apse are echoed in

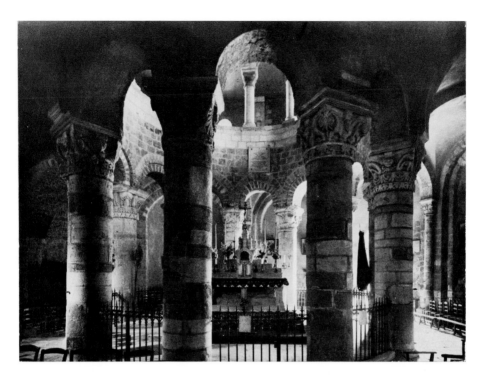

the median columns of a double bay in the nave, which otherwise has slender piers as supports of pointed tunnel vaulting with transverse arches.

The rotunda develops in the Loire region with Carolingian precedent; for example, at Ferrières-en-Gâtinais there are in the parish church traces of an octagon (inspired from that of Aachen) which was built for Alcuin's old monastery.

Saint-Bénigne at Dijon [108, 109] and the Dome of the Rock in Jerusalem inspired the boldest of the rotundas in the Loire region – that built in the early twelfth century for the powerful abbey of Charroux,[17] and now a ruin. The central well of the rotunda survives as an openwork tower, with a crypt at its base, forming a platform on which, as in a Templars' Church, the principal altar was set. In addition

there was an aisled sanctuary, with ambulatory and radiating chapels; there was also a long nave with a Gothic façade, and recent excavations have uncovered remains of a transept. The four arms of the church were pushed out, so to speak, from the central well by the two annular aisles. This ensemble must have produced an interesting but rather riotous architectural effect.

The church of Neuvy-Saint-Sépulcre[18] [207] possesses a simpler rotunda, intended to be ad instar – in the likeness – of the Holy Sepulchre. Neuvy-Saint-Sépulcre originated in a foundation of 1042, when the Holy Sepulchre was in ruins. However, the building was known through manuscripts and pilgrims. Construction was begun in 1045 or 1046 when Constantine Monomachos was rebuilding the original rotunda (1045-8). The existing nave at Neuvy

is of the eleventh century, and the rotunda may be in large part. It was formerly encircled by residences, stout fortifications, and a moat.[19]

Mention of these rotundas offers the occasion for an excursion to Brittany; for the only notable Romanesque building in that region is Sainte-Croix at Quimperlé,[20] dated 1187 but restored after a collapse in 1862. It is related to both Charroux and Neuvy-Saint-Sépulcre. The nucleus of the building is a vaulted square bay of heavy construction, surrounded by a ponderous round aisle, and made cruciform by four vaulted extensions. It is rather rough and provincial in execution.

That Breton Romanesque churches should have connexions with the group of the Loire is understandable when we remember that Tours was the Breton ecclesiastical metropolis, and that commerce and other communications were easier by the waters south of the peninsula than from Normandy or overland. Only Rennes and its region had close connexions with Normandy.

Limestone was actually imported from the Charente for building; engineers and architects followed the same route. The church of Saint-Sauveur at Dinan has Poitevin character, and we find the ambulatory – usually a witness to influence from Touraine – at Loctudy, at Landévennec, and at Saint-Gildas-de-Rhuis, where Pierre Abélard was abbot, and had an insurrection among the monks on his hands in 1138.

The old cathedrals in the greater cities were in many cases Romanesque, but they have been replaced; no first-rate Romanesque monuments remain in the region.

＊

Before leaving the group of the Loire for Poitou, it will be well to look at several fine monuments of military architecture which have connexions with both regions. The new-built fortifications of the early medieval period in western Europe were typically in wood. Fulk Nerra's masonry

donjon at Langeais (c. 1000) inaugurates a great series in stone and a long period of high achievement by the French engineers.

Chinon[21] on the Vienne has a strong situation, and it was important even in Celtic times. Largely because of its strength as a fortress, the history of Chinon is studded with great names – Clovis; Geoffroy Martel of Anjou; Henry II Plantagenet and Richard Cœur de Lion of England; Charles VII of France and Joan of Arc; Rabelais; Richelieu. In the 'Château du Milieu' is the site of the Roman castrum and the ward (unusually long for its width) of the early medieval fortress. The twelfth-century Grand Logis or royal dwelling where Henry II Plantagenet died in 1189 and where in 1429 Charles VII received Joan of Arc, is rebuilt, and a ruin. Other old towers and walls have also been much rebuilt and augmented; with later additions the château is a most imposing array of military works.

A much better idea of military architecture in the Romanesque period is given by the splendid tower at Beaugency, and the two towers in the donjon at Loches[22] [208]. Beaugency is roughly square; the larger tower at Loches measures about eighty by forty-five feet, twice the dimensions of the smaller. When first built all of them measured about 130 feet in height. Their sheer precipitous walls are in excellent ashlar with slightly projecting buttresses – pilaster strips at Beaugency, and semi-cylinders at Loches. In both cases the exteriors are strictly business-like, with no search for the grace which one usually perceives in a monument of the Loire region.

The plan of the towers is the usual one for the age: it merely called for simple open rooms one above another, with floors of timber, small windows, and fireplaces. The example at Beaugency, dated in the eleventh century, is the most admired of its type in France. At Loches the Romanesque construction of the eleventh and twelfth centuries is now girdled by other

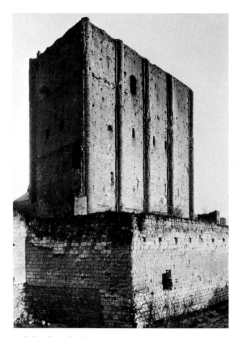

208. Loches, donjon, *c.* 1100

fying institution, such as the Burgundian school had, to bring it to a focus. Instead, old motifs flowed up and down the river, and outside motifs flowed into the valley from the watershed. Another simile might be that of a tree with grafted branches of various sorts. One sap makes them all live; the sap, in the group of the Loire, is the lively inheritance of Carolingian ideas and Neustrian tradition.

The Architectural Group of Poitou, with Anjou, Saintonge, and the South-West

The greatest historical, spiritual, and intellectual centre of this region – the western part of Carolingian Aquitania – was Poitiers. It was an important city under the Romans. Resounding military victories were won near by in early medieval times, none more important than that of Charles Martel over the Saracens in 732. There was a brilliant court at Poitiers in the Romanesque period. The eminence of the church of Poitiers goes back to its Early Christian bishop, Hilary, whose shrine has been a place of pilgrimage throughout succeeding centuries. The baptistery of Poitiers is one of the oldest buildings of its kind.

One of the main routes of the Way of St James (Paris–Orléans–Bordeaux) passed through Poitiers, and unquestionably contributed to the spread of Poitevin architectural motifs to the south-west of France and to northern Spain. Only at Santiago de Compostela were the Spaniards able to build in the grandest French Romanesque style; elsewhere they often built in simpler forms which can be traced back to Poitou and its region.

Excellent limestone is available in the area of the Poitevin school; it is white, weathering pleasantly to buffs and warm greys. The stonecutting and mason-work are excellent, but the designers kept to early solutions of vaulting and compositional problems in the twelfth century. Poitevin designers were seeking and achieving

works which, though very simple, confess their late date by significant details such as the almond-shaped plan of the projecting towers. The severer character of earlier medieval work is clearly shown by comparing the rounded towers of Loches with the frowning semicircular towers of the château at Angers, built after 1180, and indeed largely in the thirteenth century by Philippe-Auguste and Louis IX. The upper parts of the towers and certain outlying works have been destroyed, so that the effect is rather of a Romanesque than a Gothic château. It should be noted, however, that there is no such thing as a school of the Loire in military architecture; that was inter-regional like the wars which brought it into being, and it was for the most part the work of engineers.

From the report we have made, it is obvious that the architectural group of the Loire is not easily summarized. There was no great uni-

magnificent Romanesque decorative effects at the time when the practical ground-work of Gothic architecture was being laid in Burgundy and the Île-de-France.

Poitou was early concerned with effects of clear interior space, as the old nave of Saint-Hilaire in Poitiers indicates. By the middle of the eleventh century forward-looking designers began to take an interest in vaulting problems.

The former abbey church of Lesterps[23] presents an early example of the solution of the problem of the vaulted church of basilican plan which was widely adopted in Poitou. If the clerestory be given up – and it may be in this region – the nave supports may be more slender, and consequently less obstructive. With the aisles approaching the nave in height, the general effect of such a building is that of an ample hall with generous space in it, justifying the usual name 'hall church'. Such interiors are less dramatic and less brilliantly lighted than the typical basilica, but have a space-beauty of their own. At Lesterps [209] the present nave just east of the tower porch already mentioned represents a church of 1032 which was damaged by fire about 1040 and continued very handsomely, in fine austere forms with noble and simple geometry, as a hall church, covered by semicircular tunnel vaulting with transverse arches. This work was dedicated in 1070.

The wide wooden-roofed nave of Beaulieu-les-Loches was divided by two files of piers and covered by three parallel tunnel vaults about 1080, and the church thus became a hall church.[24]

Thus before the twelfth century began, there was a satisfactory type of Poitevin church with the western arm covered by three parallel tunnel vaults. Of these the middle one is regularly somewhat higher and wider than the others. This nave is (except for end windows) dependent on openings placed high in the aisles for its light. The scheme is an old one which was used by the Romans; it was early adopted for

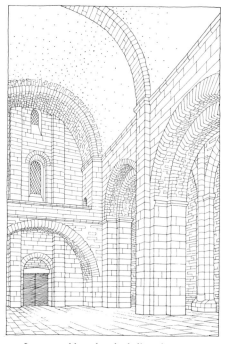

209. Lesterps, abbey church, dedicated 1070

crypts, and appears above ground in Catalan churches before the year 1000. In Poitou superstructures of this type achieved a quite new sense of ample scale and openness, with rich decoration on the façades, but their plans remained relatively simple in most cases.

As the twelfth century advanced, pointed arches and vaults took the place of semicircular ones, with good effect, as we may see in the tall tunnel vault with transverse arches at Chauvigny (begun after 1100).[25] To be sure the pointed nave has its most dramatic and breathtaking expression when the vault is seen floating above a pool of light from a clerestory, but it is true that a shadowed nave vault, such as we see in this Poitevin type of church, imparts to a religious building a sense of gentle sheltering mystery. Statical problems are very much sim-

plified by the hall church arrangement. Slender cylindrical piers, or grouped piers with applied columns, like stilts can carry the 'crushing' weight of the high vault, since the lateral vaults are perfectly placed to absorb thrust. Inward thrust from the aisle vaults partly neutralizes the thrust of the high vaults. Transverse arches in the vaults strengthen them; responds in the aisle walls and stout spur buttresses easily carry the thrusts to the ground. Sometimes there is arcading between the open buttresses on the flanks of a building. Such arcading makes for a stiffer wall over the window openings, and supports the crenellations if the building is fortified. The roofing is carried over nave and aisles together in a vast two-sloped turtle-back – a simple form which obviates much trouble in maintenance.

This type of church spread far and wide on its own merits.

A much admired example of the Poitevin style stands handsomely at Saint-Savin-sur-Gartempe [210]. The church, though now parochial, was built by a powerful abbey; it is visible from considerable distances because a very slender and beautiful Gothic spire carries the west front to a great height – 312 feet. The lower part of this construction is a Romanesque axial entrance tower which goes back, at least, to 1060. Beyond are the nave, transept with crossing tower, apse, ambulatory, and radiating chapels.

According to the most recent studies, the oldest parts of the church proper (apse, ambulatory, radiating chapels and transept, at the east) are to be dated about 1060–75. Perhaps there was originally an open wooden-roofed nave, extended about 1075–85 by the construction of the western bays of the existing nave, but demolished about 1095 to make way for the six existing eastern bays, which were finished by 1115. This nave, more generous in dimension than the chevet, has wide, high, groin-vaulted aisles; the central nave is tunnel-vaulted, with the three western bays, only, carried by grouped

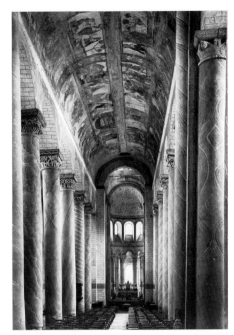

210. Saint-Savin-sur-Gartempe, abbey church, c. 1060–1115, nave

piers and separated by transverse arches. The six plain, later bays, supported on really splendid great cylindrical columns, were built contemporaneously with Cluny III and Durham Cathedral. This part of the nave is quite comparable in artistic quality to Cluny III and Durham: it was most beautifully designed for adornment by the ever-memorable series of frescoes called the Bible of St Savin, which is one of the finest works of its kind. The paintings, tawny and reddish-brown in tonality, are supplemented by others in the crypt and the narthex, and by a striking 'marbling' of the piers. They make up an ensemble which is still singularly complete and perfect.[26]

Poitiers has lost an early example of the hall or three-nave church through the reworking of the Montierneuf[27] (1075) [251], but it retains

(though in a disappointing setting which emphasizes unfortunate additions, and with distasteful restored interior polychromy) the fine church of Notre-Dame-la-Grande[28] [211, 212], datable perhaps to 1130-45, or at any rate to the first half of the twelfth century.

Notre-Dame-la-Grande, in spite of its name, is not a very large church. It has an apse carried

columns on each side) and the arches above show a lavish use of decorated voussoirs designed individually with radiating motifs. Lateral decorative arcading of similar character, but pointed, encloses paired arches with blank tympana, and above all three enclosing arches runs a system of spandrels embellished with figure sculpture and crowned by an elaborate

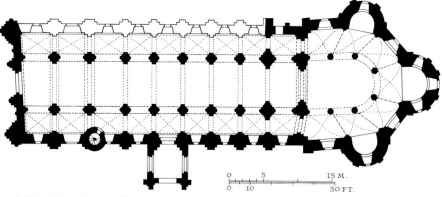

211. Poitiers, Notre-Dame-la-Grande, c. 1130-45

on cylindrical columns and an ambulatory of polygonal exterior plan, with three radiating chapels. This construction is attached to an intermediate bay with a crossing tower, and a typical round-arched dark nave. The aisles are covered with groin vaulting throughout. Spur buttresses and applied arcading give a typical Poitevin lateral elevation, and the old part of the building is covered with the usual slab-sided roof in two slopes.

The façade is very typical of the later Poitevin façades; it is generally accepted as a sort of paradigm, though it is perhaps the richest and finest of them all. The profile, basilican, does not correspond to the roof behind it, but gives emphasis to the three axial motives of the composition. The doorway is typical of the region; it has no lintel or tympanum, and is enclosed in four orders of stumpy columns (two bundles of

arched corbel table. The axial motive of the middle register is a vast window, with two zones of arcading to each side. The arcading here encloses statuary, and is richly bordered. Once more an elaborate corbel table marks a stage in the composition, but it is broken by the richly bordered window arch, and thus prepares the eye for the pedimental string course, which engages a huge, richly carved and bordered vesica on the axis of the upper stage or pediment. The entire pedimental stage is faced with interesting patterned masonry and capped by a pommel. This whole composition has an oriental richness about it – perhaps the richness of a Byzantine ivory casket rather than that of Moslem architecture, but the oriental suggestion is unmistakable. The taste for it probably owes something to actual oriental trade, the Crusades, and the reflex from the Pilgrimage to Santiago.

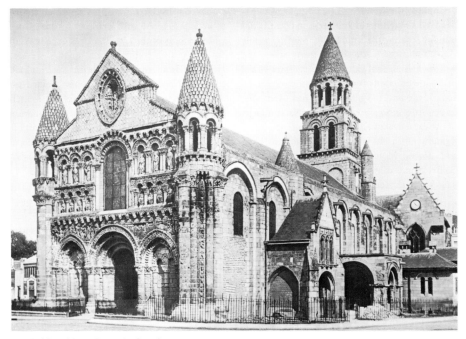

212. Poitiers, Notre-Dame-la-Grande, c. 1130-45

On Notre-Dame-la-Grande the corner turrets are of typical form also. Bundles of three engaged columns set just back from the corners support a stubby drum engaged with the façade on each side, and with the flanks of the building at the eaves level. Above each drum there is an open cylindrical arcaded stage capped with a conoidal roof and pommel. The roofs are as usual built of radiating stones with slanting fronts. Each slanting front has an integral imbrication or scallop projecting from it. The faces of the imbrications are vertical, so that a jolly inverted fish-scale pattern results. Such roofs drain easily between the imbrications, but the vertical joints in the troughs often give trouble. The crossing tower of Notre-Dame-la-Grande has a similar roof above a cylindrical arcaded and columnar upper stage, which rests on an arcaded square intermediate belfry stage, in

turn supported by an arcaded square stage which houses the crossing vault. Tower, turrets, and imbrications are repeated, with variations, elsewhere – and are, in fact, characteristic of the Poitevin architectural group. They spread to the medieval domed churches of Périgord, and thence in modern times to the Sacré-Cœur in Paris.

The bundle of shafts with a pinnacle which we have seen as the motif of the corner turrets of Notre-Dame-la-Grande has an interesting history. Used independently, it is the theme of the charming 'Lantern of the Dead' in Fenioux. It appears, restored (with variations), in the Abbey kitchen at Fontevrault [224]. More important, it comes in prettily as a corner ornament in the church towers and lanterns with diminishing stages which began to appear about 1100 in Poitou and elsewhere. There is a ruined

example at the Montierneuf, Poitiers, which is believed to be one of the earliest [251]. Four bundles, each with its pinnacle, stood gracefully above the corners of a square tower stage, and beside the diagonal sides of an octagonal stage, making a felicitous transition to the pyramidal roof of the latter. This pattern was used, on a larger scale, in Spain – at the crossing 'cimborio' of the cathedral of Zamora [250] and derivative monuments; at the Martorana in Palermo [272], and derivative monuments also in Norman Sicily. Some of the derivatives are as late in date as the thirteenth century.

At this point we should consider briefly how the architectural group of Poitou interpenetrates with that of Anjou and that of Périgord, all within the greater school of the West of France. An example is Sainte-Radegonde, Poitiers, a church of pilgrimage built from about 1090 onward.[29] Its plan includes apse, ambulatory, radiating chapels, and a very characteristic tower-porch which is accepted as a model of the Poitevin version of that historic element. At Sainte-Radegonde the nave is spa-

cious, of considerable width – a Gothic reconstruction covered with octopartite domed-up ribbed vaults of the type that was developed in Anjou. As if in compensation for this, we find Cunault, near Angers, built in the Poitevin style, and we shall find that the domed-up Angevin octopartite ribbed vaults are related to the Aquitanian domed churches. It is because of such interpenetration of these western architectural groups that French critics prefer to consider the school of the west of France as an inclusive unit.

Pursuing this matter in Anjou brings us to its capital, Angers, the seat of a dynasty important in French, English, and Levantine history.

For Saint-Martin at Angers, an old foundation, a remarkable church (now lacking its nave) was created by reconstruction shortly after 1012.[30] The building was laid out, as were many in the west country, on a very simple plan: four aisleless arms of a great cross. The northern, southern, and eastern arms of the church terminated in apses. Over the crossing a somewhat warped pendentive dome was built, by 1075,

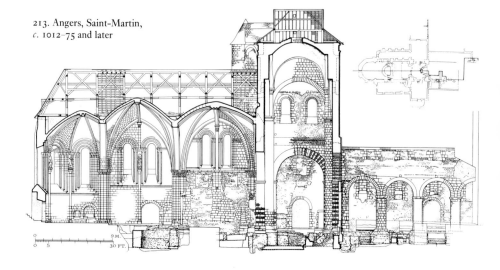

213. Angers, Saint-Martin,
c. 1012–75 and later

if not earlier; and this structure, still in place, is considered to be the oldest large French Romanesque dome in existence [213]. It is reported to be in rubble and 'pottery', which would suggest a Late Roman derivation. This dome still serves as the support of a rather heavy block of masonry doubtless intended to carry a belfry or *turritus apex*. The ability to construct such a dome, almost free-standing at a considerable height (where it has given a good account of itself for nearly 900 years), makes the achievement of the splendid twelfth-century domes of the abbey church of Fontevrault, near Angers, and the Périgordine domes, seem less strange; and it helps also to explain the Angevin domed-up rib vaults to which a preliminary reference has been made.

Best known of all the buildings which exemplify the great aisleless cross in plan, and at the same time the Angevin rib vault, is the cathedral of Angers itself[31] [214, 215]. Its scale is much larger than that of Saint-Martin in the same city, but the plan is even simpler. The original cathedral was begun shortly after 1010

and dedicated in 1025, when the dramatic campaign of expansion of the County of Anjou was beginning. The church had a wooden-roofed wide nave, transept, apse, ambulatory, and shallow oblong radiating chapels. In the twelfth century it was progressively rebuilt, preserving some of the old nave walls. The new work was started about 1150, continued by the Plantagenets (who held Anjou from 1154 to 1200), and finished, except for details, under the French about 1240.

The twelfth-century nave, which exists almost unchanged, consists of three tremendous domed-up square groined bays with the usual diagonal ribs of the Early Gothic style. They are in ashlar with relatively thin cells and span about 52 feet, the first in France to have so generous a dimension. Their historical importance as evidence of Poitevin and Angevin engineering ingenuity is very considerable. The vaults combined the advantages of the rib-vault of the Île-de-France with the advantages of thin ashlar domed construction. This type of vault was much built in the Angevin region and in

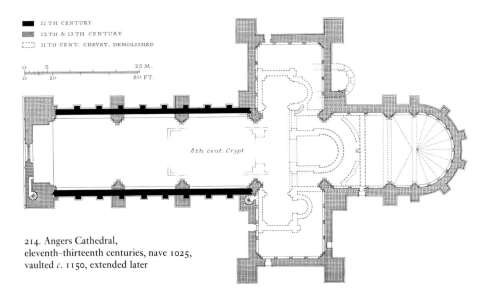

■ II TH CENTURY

▦ 12 TH & 13 TH CENTURY

▢ II TH CENT. CHEVET, DEMOLISHED

0 5 25 M.

0 20 80 FT.

8th cent. Crypt

214. Angers Cathedral,
eleventh–thirteenth centuries, nave 1025,
vaulted *c.* 1150, extended later

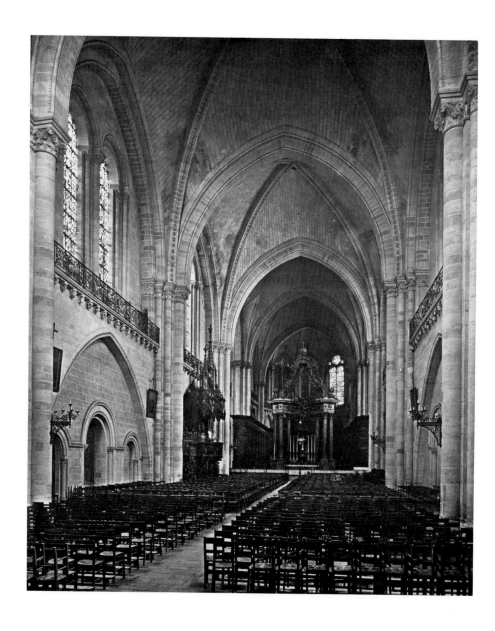

215. Angers Cathedral, eleventh–thirteenth centuries, nave 1025, vaulted *c.* 1150, extended later

Spain. Later Gothic developments include technically interesting rib systems.

The transept of Angers Cathedral (including the crossing) consists of three bays with an aggregate interior length of about 148 feet; similarly vaulted – the technique, however, is maturer, and the vaults have the characteristic Angevin octopartite division, with ridge ribs. (The octopartite division looks, in plan, like the Union Jack.) A similar square bay and the semi-circular apse, with eight triangular cells, bring the interior length of the church on the main axis close to 295 feet. The height to the soffit of the transverse arches is about 69 feet, which is equal to that of the Romanesque nave of Santiago, where, however, the width is only about 29 feet. The crowns of the cells at Angers reach a height of about 86 feet. The stout spur buttresses have always maintained these magnificent vaults safely in position.

The great interior space of Angers Cathedral has a simplicity which is almost Roman, though the dimensions fall short of the greatest Roman works (the nave of the Basilica Nova of Maxentius and Constantine measured 83 feet in the clear, 120 feet in height, 240 feet in length; the lateral tunnel vaults are 63 feet high). In spite of the Gothic tincture given by the pointed arches, the linear quality of the details, and the odd feeling that the church is like a small building magnified, here is a monument which an Imperial architect would have understood and enjoyed.

Not so the façade of Angers Cathedral, which makes a definite compromise with Gothic forms. The blocky front has a central portal in the style of Chartres, above which is a triplet with a fine big Early Gothic window in the centre. At each side, a tower with stage upon stage of decorative arcading rises to a tall Gothic flèche, as if Angers were a pinched and narrow cathedral of basilican plan in the Île-de-France. The space between the towers and above the great window is occupied by Renaissance motifs arranged to produce a medieval silhouette. The axial square tower gives an effect somewhat like a screen, such as was planned for Noyon Cathedral in the unexecuted arcade between the belfries of the western towers. The whole mass of the three western towers at Angers resembles a westwork – appropriately enough in a cathedral where the plan is almost simple enough to be Carolingian.

Returning from Angers and the north to Poitou, we find a radiation of the Poitevin types to the west, the east, the south-east, and the south-west also. The buildings were almost all built in the twelfth century, when the country was well organized and prosperous. The various features of the Poitevin style as we have found them in the capital occur, engagingly counterchanged, in a multitude of smaller buildings which have a very direct appeal.[32] It is often possible to savour these churches in an undisturbed old setting. One comes to accept a certain awkwardness which often results from the simple naive plans, and to enjoy, even in rustic examples, the luxuriant carving, the rather riotous arcading, and the hierarchies of plump columns which catch a soft ripple of light for the façades.

Round and pointed arches were often used together, but there was a constant relative increase in the latter as the twelfth century advanced. Where tunnel vaulting has been used, the naves have often become deformed or have lost their vaults, due to inexpert workmanship or faulty mortar. This is true even for spans of the order of twenty feet; the domes, which we shall consider presently, have held up much better, even over spans of double the width.

Close to Poitiers there are several well-known examples. At Civray, the imposing façade has among its sculptures part of a horseman, supposed to represent Constantine, and accepted into the iconography of the region; Gençay and Montmorillon also deserve mention. To the north-west of Poitiers there are interesting examples at Parthenay, Saint-Jouin-de-Marnes,

and Airvault. Melle, to the south-west of Poitiers, has two very charming and typical churches – Saint-Hilaire, and Saint-Pierre, which is one of the most elegantly composed of all. It has a fine apse and crossing tower. Châteauneuf-sur-Charente, south of Melle and Poitiers, has a good church with a fine façade. Like Civray, it has a Constantine. Not far distant is Saint-Michel-'d'Entraigues', an octofoil chapel (1137) with a famous relief of the Archangel conquering his antagonist. We are here on the borders of the Saintonge.

The church of Aulnay-de-Saintonge is well known also; it is of late date and well preserved. The amusingly carved voussoirs of the arches have the motifs radiating, as is usual in the style, rather than in sequence up the arch, which is typical of Gothic. The church at Aulnay [216,

217] has a handsome pointed tunnel vault over the nave, a handsome crossing tower, and a dignified apse.

At Saintes (from which the Saintonge takes its name) there exists, in a very much reduced state, the Cluniac priory church of Saint-Eutrope, begun about 1081 [138, 139]. The crypt, a goal of pilgrimage, is in its original elaborate form, substantially constructed, with aisles, apse, ambulatory, and radiating chapels. The raised choir (for monastic liturgies) communicated with aisles, and thus with the remarkable nave, stepped all round and opened on the crypt [125A], so that pilgrim throngs could see and hear services performed at the shrine.[33]

The former convent church of Sainte-Marie-des-Dames at Saintes is, appropriately, more local in feeling. The façade is rich with arcading

216. Aulnay, church, twelfth century

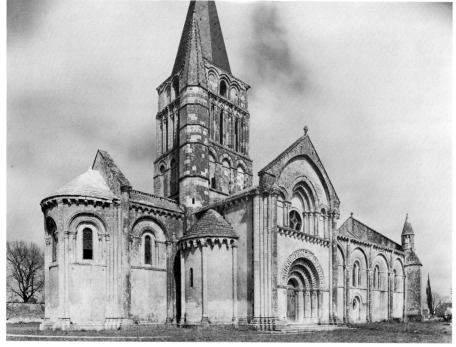

in the Poitevin manner, and the main door has quite marvellously carved capitals and orders of radiating voussoirs. The nave is covered by a series of domes. The crossing tower, characteristically Poitevin and closely resembling that of Notre-Dame-la-Grande at Poitiers, has an imbricated roof.

On a longer radius from Poitiers, we find a series of interesting longitudinal buildings near Angoulême, in which the naves are covered with tunnel vaulting (Montmoreau, Mouthiers, Puypéroux, Montbron).

The stream of influence can of course also be traced from Poitou to Bordeaux (Sainte-Croix); to Petit-Palais, near Bordeaux, with a charming façade; to Moirax, near Agen, to Oloron, near Pau, and so on into Spain. The monuments are sparser in the south-west, which has always been more lonely, and in places almost desolate. Reflex influence from Spain shows itself more strongly here, as for example in the vaults of Mozarabic style, at L'Hôpital-Saint-Blaise, Saint-Pé-de-Bigorre, and Sainte-Croix at Oloron-Sainte-Marie.[34]

Périgord: the Aquitanian Group of Domed Churches

We present the domed churches of Aquitania as the third subgroup in the school of the west of France. The question of both the origin and the classification of the domed churches of Périgord and near by has long been vexed. 'It is difficult to understand why so essential a feature as the roofing of a whole church with domes should not in itself warrant the placing of the domed-

217. Aulnay, church, twelfth century

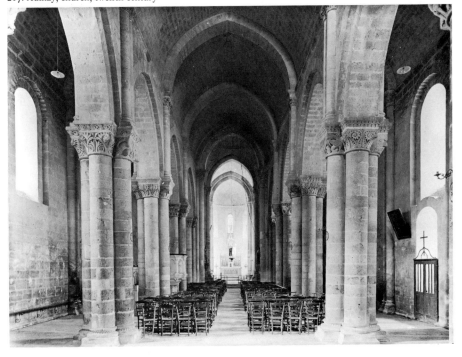

church type in a separate school,' wrote Sir Alfred Clapham (who was by training an architect), 'but it is argued that the adoption of domes was more or less accidental, and is an episode merely in the architectural history of a school which began without them and only adopted them in a comparatively small number of churches even in Périgord. Furthermore it is argued that the general ordinance of these domed churches, apart from their roof system, is indistinguishable from other churches of the school.'[35]

It should be mentioned that the group extends far outside Périgord, and that seventy-seven examples are known to have been built, of which sixty still exist (thirty in Périgord and the rest scattered all the way from Fontevrault in the Loire country to Agen on the Garonne). Otherwise this is a very fair statement, and it justifies the classification of the domed churches as a subgroup within the school of the West of France.[36]

Although we have the eleventh-century crossing dome at Saint-Martin in Angers [213], unfortunately there is no text which indicates the beginnings of the Aquitanian church type with domes arranged in series over the naves and transepts. There is now good reason for believing that Saint-Front at Périgueux had an early dome, built over and around the constricted sanctuary of an old 'Latin' basilica – really a church dated about 984 to 1047. The spectacular church with five domes [225–7], by far the most conspicuous example of the Périgordine group, was a special development. Pressure from pilgrim throngs probably induced the construction, by 1060–70, of the original dome, which had round great arches and other archaic features. The other four domes seem to have been envisioned at this time. Inexpert masonry in their lower portions gave way to better work in domes on pointed great arches which were built after the Latin basilica was burnt out in 1120.[37]

Angoulême Cathedral [221, 222], the other famous example, was begun about 1105. It is only partly covered by domes, but the scheme is clearly not archaic, though the domes in the nave, covered by a conventional two-slope roof, look like a utilitarian solution, adopted to avoid the use of a long tunnel vault (difficult to abut).

Whether by direct suggestion or not, the solution in the nave of Angoulême Cathedral is the old oriental solution of reduplicated domes, commonly used for centuries previously in ordinary structures such as cisterns, store-rooms, bazaars, baths, and the like. Camille Enlart was persuaded that the inspiration was Cypriote, for there were churches of similar character in Cyprus at the time, accessible through pilgrimage movements.[38]

The oldest of the Aquitanian domes are simple and rather uninspired in design. There is practical justification for them in the fact that only about a third of the tunnel vaults of the Poitevin type – even those of moderate span – have held, whereas sixty out of the seventy-seven domed churches, including several of the largest examples, still have their twelfth-century cupolas. The builders' instinct, the character of the stone, and the quality of the mortar – utilitarian elements all – would thus account for the use of domes in this region, rather than an aesthetic preference. Perhaps the acoustical effects were admired.[39]

The excellent architects who chose domed construction built it in their own way, using pointed arches of ashlar on the four sides of each bay to support pendentives of peculiar form, also in ashlar. Unquestionably the pendentives were suggested ultimately by Byzantine work, but the reverse curvature in the profile of the pendentive, resulting from geometrical relations with the pointed arch, is special to the Aquitanian domes. The actual shells of the older cupolas are in rubble stuccoed over on the interior, like ordinary Romanesque vaults of the period.

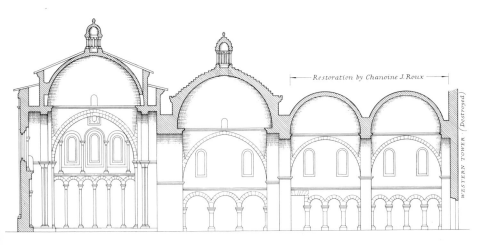

Several of the oldest churches in the Aquitanian group consist simply of a file of domes, plus an apse and absidioles.[40] A mere straight row of four domed units on unpierced interior piers formed the cathedral of Saint-Étienne-de-la-Cité in Périgueux [218]. The two original domes, probably built somewhat before 1100, have been demolished; two more elaborate ones, dated before and after 1150, are still in position. They show low vertical drums externally.

Another simple early example is the cathedral of Cahors [219], which also appears to have been begun shortly before 1100; there was a dedication in 1119, but the construction was probably incomplete at that time. The scheme at Cahors consists of no more than two enormous and awkwardly proportioned rubble domes within low ashlar-faced drums, carried on pendentives, pointed arches, and unpierced wall piers of ashlar, with the vast interior space thus created continuing into a capacious open apse with three radiating chapels. The west front, which is rather like a Saxon westwork, and the lateral portal, which is Burgundian in style, hardly prepare the visitor for an interior with a clear span of sixty-five feet. It is easy to see how the southerners, accustomed to the warmth and

218. Périgueux, Saint-Étienne-de-la-Cité, c. 1100, 1150

219. Cahors Cathedral, dedicated incomplete in 1119, flank and portal

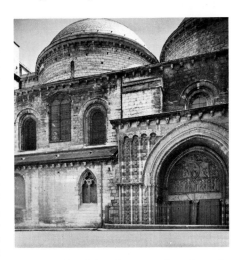

openness of such interiors, were in no haste for Gothic, though at Cahors the east end of the cathedral was rebuilt in that style.

Cahors was an important centre, and its cathedral served as a model for a family of somewhat similar buildings in the region. Among

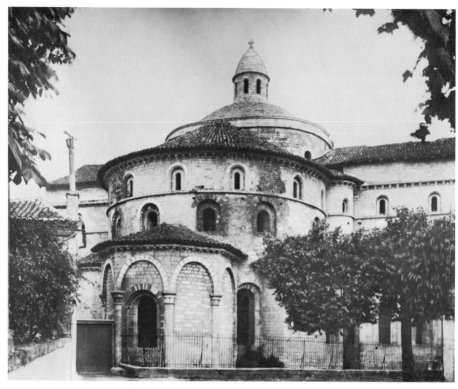

220. Souillac, church, apse and transept, *c.* 1130

these is Souillac [220], which also has two domed bays and a capacious apse with three radiating chapels opening directly upon it. Souillac is better proportioned than Cahors, and it is provided with a transept; the date is about 1130. The building is generally known for the marvellous carvings set into the west wall of the nave and obviously made for a portal which was never brought to completion.

Angoulême Cathedral,[41] previously mentioned [221, 222], is another type-church, in this case influenced from Poitou. The façade is a rich example of the Poitevin style, with much arcading and interesting figural carvings, the whole front being composed as a vision of the Second Coming of Christ. Abadie the restorer contaminated the design with regrettable additions – tympanum sculptures over the main doorway, an awkward arcade at the top of the frontispiece; two unfortunate western towers, and the lantern, all with imbricated roofs. The interior was also restored, at the cost of its old patina and much of its medieval savour; and this is likewise true of the east end.

The range of four domes on the main axis is very impressive. They are supported in the usual way on solid wall piers, pointed arches, and pendentives. The fourth dome is the lantern. Beyond it a tunnel-vaulted bay extends to the open main apse, which is augmented by four

radiating chapels, and which also has an axial window.

Each arm of the transept at Angoulême is covered by a bay of tunnel vaulting. Each has an eastern absidiole and a cruciform domed chapel beyond. The upper stages of these chapels are lanterns, each one much resembling a bay of the nave at Le Puy Cathedral, or the crossing at Saint-Philibert, Tournus. The northerly chapel has a tall and characteristic arcaded staged tower over it – suggested, perhaps, by the arcaded belfries which were being built at the time in Rome, as we shall see later. Its mate to the south was destroyed, else the cathedral would still be in the rather restricted class of churches with towers at the transept ends (Cuxa and St Martin of Tours in their later period; Old Sarum and Exeter Cathedrals, where the towers form the entire transeptal projections; the Gothic example at Barcelona Cathedral). So composed, the whole design of Angoulême Cathedral obviously came to a handsome climax at the east, where the four radiating and two transeptal absidioles, the generous arcaded principal apse, the dome at the crossing, and the two terminal towers of the transept produced a very striking symmetrical group.

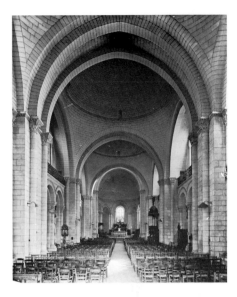

221 and 222. Angoulême Cathedral, 1105–28 and later

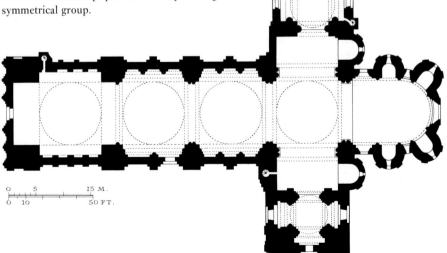

0 5 15 M.

0 10 50 FT.

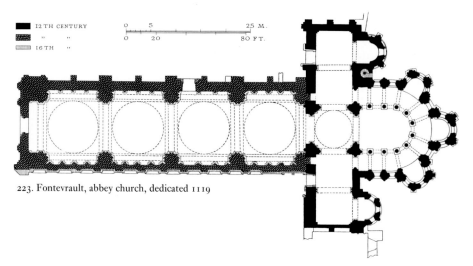

0 5 25 M.
0 20 80 FT.

223. Fontevrault, abbey church, dedicated 1119

Angoulême also had its family of related churches; in certain aspects Souillac [220] and Solignac (about 1130) are in its ambient. Their transepts and apses resemble Angoulême, though their naves are shorter. Gensac has its file of four domes in reduced dimension. Bordeaux Cathedral was prepared for large domes over the nave, but Gothic vaults were built instead.

Angoulême was begun about 1105, and the nave was at least partly vaulted in 1128, which suggests that the smaller examples fall near the middle of the century. By this time the technique had quite definitely improved – proportions were better, ornament was better disposed, and some of the domes were carried out in ashlar (this is the case for all the domes at Angoulême Cathedral except one).

One of the grandest of the domed churches was built for the abbey of Fontevrault – Plantagenet royal pantheon, with the tombs of Henry II, Eleanor, Richard I, Isabella [223]. Founded by Robert of Arbrissel about 1100 as a double abbey, with an abbess ruling the community, it became the centre of a small but not unimportant Order (fifty-seven houses in all, 3000 nuns by 1117, when Robert of Arbrissel died). Fontevrault is located near Angers in the Loire country, and, appealing to the highest nobility, it prospered.[42] It is easy to see why the abbey church is a noble and fastidiously designed building. In 1119 it was dedicated by Pope Calixtus II. At that time surely the beautiful chevet was complete. The splendid church is about 275 feet in length. Its spacious nave of four bays, begun about 1125, is aisleless, and wider than the crossing, as is so often the case in the Loire region. Four domes of modern construction, built about 1910 to replace those destroyed while the building was serving military uses, rest upon the old pendentives. A change in proportions between chevet and nave has suggested that domes were not originally planned: it is quite possible that the original project called for a hall arrangement. The supports for the domes are very stout wall piers with attached columns in pairs. The capitals are excellent examples of carving in the Poitevin-Angevin style. The transept, with a crossing tower, has two absidioles. It is covered by tunnel vaults with transverse arches, as is the well-proportioned ambulatory with three radiating chapels. The high vault of the sanctuary is semicircular. Fontevrault is decorated after the manner of the

churches of Poitou and Anjou, and its eclectic design is one of the good reasons for considering the Aquitanian group of domes as belonging, after all, with Anjou and Poitou.

Before leaving Fontevrault we should mention the abbey kitchen [224], the only important part of the conventual buildings to survive. It is in the form of an octagonal tower, with a (restored) hollow stone spire serving as roof, many chimneys, and a pinnacle at the top which brings the height to about ninety feet. The hollow stone spire makes one think of Saint-Ours at Loches [206]; the bundle of columns at the pinnacle recalls Périgord, and these two items confirm the unity – in variety – of the styles which we have been studying.

After this account of the Aquitanian domed style, Saint-Front at Périgueux[43] [225-7] seems like an outsider, which in fact it now is; for the Greek cross plan, with its pierced wall piers, was obviously inspired from St Mark's in Venice (1063-94), the latter church being at that time still unsheathed with marble and mosaic, and, though built in brick, much more like the Aquitanian churches with their bare stone-work than is the case at present.

The new arrangements were so unusual, and they are so little understood, due to later rebuilding at Saint-Front, that it is worth while to describe them.

One entered from the west through the porch of the basilica, but its nave, after the fire, was roofless, and it became a forecourt, recalling the atria which we have seen at Cluny II and at SS. Peter and Paul, Hirsau. As at Hirsau, there was a plan to make the atrium into a covered narthex. Piers were built in the four corners of the atrium space at Périgueux, but a dome was never built over them. Instead they were made into pylons, two of which flank the entrance to the atrium, while the others flank the entrance to the church, beneath the great tower.

This great tower, of classic form, is perhaps the most imposing of all the tower porches. It replaces an eleventh-century lantern. The ground storey passage-way to the nave, between flanking aisles, has two elaborate domical vaults like those which we have found singly at the transept ends of Angoulême Cathedral, and also, in sequence, over the nave of the cathedral of Le Puy. The tower porch with its pylons and aisles is massed rather like a westwork, but the great shaft is very classical in feeling, built up in stages with set-backs, and ornamented with pilaster and pedimental motifs. The tower terminates in a tremendous drum of columns covered by an imbricated conoidal roof. It was fairly well restored by Boeswillwald.

Once past this extraordinary tower porch, the pilgrim found himself under the spacious westernmost dome of the main church and near the high altar. There over the tomb of St Front stood the remarkable shrine (by Guinamundus, a monk of La Chaise-Dieu, 1077) intended for

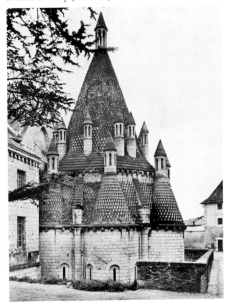

224. Fontevrault Abbey, kitchen, twelfth century (restored)

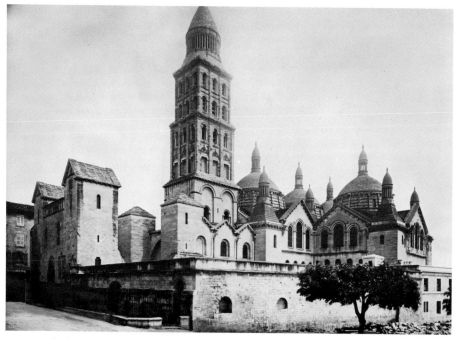

225 to 227. Périgueux Cathedral, largely after 1120,
view from the south-west, view across transept,
twelfth century, rebuilt nineteenth century, and plan

the relics of the saint, and there Aymery
Picaud, who wrote the Pilgrim's Guide to San-
tiago, saw and admired it. The shrine was a hol-
low turret with a dome and gables, richly
decorated with figure and animal sculpture, and
enamels.[44] Fragmentary remains exist.

In 1077, with a sanctuary dome, an impressive
and workable pilgrimage church existed. Then
three new domes were added transversely, and
beyond the crossing a fifth and easternmost
dome was built – really at the foot of the nave,
for the church now had reverse orientation. The
traditional orientation, reinstated for a time, was
later given up, however, and a chapel extended
eastward on the axis until modern times, when
it was replaced by a pseudo-Romanesque apse.
The high altar has been transferred once more

to this part of the building, and there are now
practically no traces of the old sanctuary at the
west. In fact Abadie's restoration spoiled the
church.[45]

Thus we leave the style of the West of France.
It is interesting to speculate on the question as
to whether a synthesis of its varied elements
would ever have been achieved if Gothic art had
not been invented, or if the region had achieved
true national status with one great capital of its
own. As it is, the exportation of the style to
Spain, the interesting development of Gothic
ribbed dome structure, and the experiments
with wide-nave construction, the decisively im-
portant hall-church scheme, and the architec-
tural use of sculpture deserve to be better known
and more widely appreciated than they are.

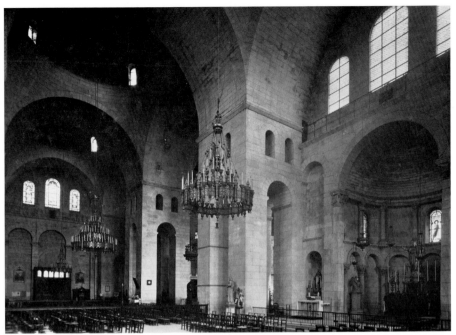

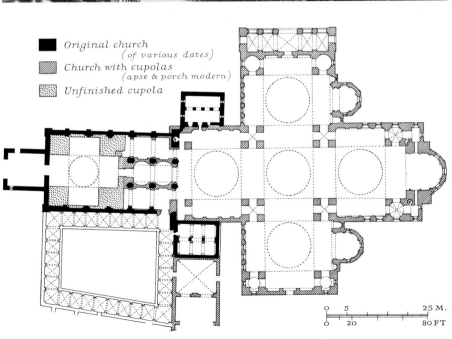

Original church
(of various dates)

Church with cupolas
(apse & porch modern)

Unfinished cupola

0 5 25 M.

0 20 80 FT

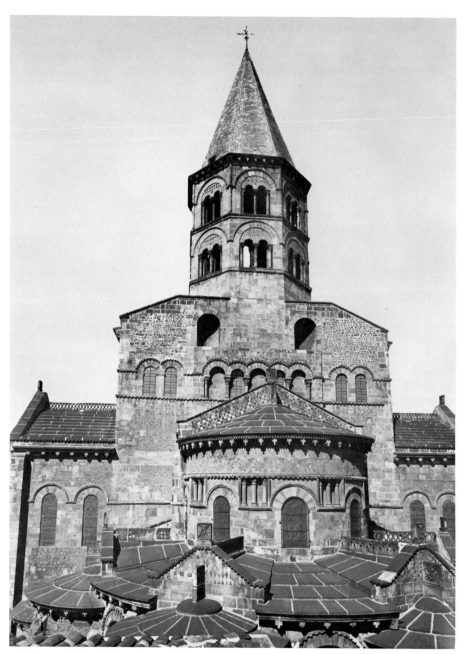

228. Clermont-Ferrand, Notre-Dame-du-Port, twelfth century

THE SCHOOL OF AUVERGNE

Within the eastern limits of Carolingian Aquitania, near Burgundy and the upper course of the Loire, lies the beautiful land of Auvergne, bordered on one side by the Limousin, and on the other by Velay. In great contrast to the west of France, it is a compact district, and it has a highly characterized series of church buildings of mature design which the French historians call the School of Auvergne.[1]

The type church is Notre-Dame-du-Port at Clermont-Ferrand [228-30]; it is not an early work, as was formerly believed, but rather of the first half of the twelfth century, although there is a record of some reconstruction about 1185.

In exterior aspect the church is bold, and its elements are well articulated. It has apse, ambulatory, and radiating chapels set against the precipitous east wall of a characteristic Auvergnat 'lantern transept', made by raising the bays which flank the crossing vault so that a range of windows may be carried around the three outer sides above the ridge level of the transept arms [230]. Pent roofs slope upward on the flanking bays, and between them, over the crossing vault, rises an octagonal belfry. The crossing vault is supported on the east by the window wall above the apse, but on the other three sides by Carolingian interior flying screens. West of the transept lies the nave, with aisles and galleries but no clerestory; beyond the nave is a sort of westwork with narthex and tribune under a modern axial tower of appropriate design.

Entering the church, we find before us an austere nave of four bays with a plain tunnel vault. The nave wall is divided in two on each side by an applied column rising from a cruciform pier; these columns serve as interior buttresses, but there is no transverse arch above them. The other piers of the nave proper have two shafts each for the aisle arcade, and one for the transverse arch which separates the aisle bays of groin vaulting. A quadrant vault covers the gallery cut into bays by diaphragm arches and opening into the nave through triple arcades bay by bay. These are cusped, and suggest some sort of oriental influence, and they repeat the form of the Carolingian flying screens under the crossing tower (where also the piers have, logically, four applied shafts). The apse has the same height as the crossing arches, and so have the projecting bays (each with a chapel) of the transept, but the lantern-transept is, of course, much higher.

There is a much-restored crypt under Notre-Dame-du-Port – a somewhat unusual feature for the region. The crypt repeats the main lines of the apse, ambulatory, and radiating chapels above, but the chamber under the sanctuary is groin-vaulted in small bays carried on stout columns. These are set so as to form a sort of inner ambulatory; four of the columns are placed under the altar. The whole arrangement recalls Aléaume's Clermont Cathedral of 946. In the church above, the apse and the sanctuary bay are not separated by a transverse arch, nor are the groin-vaulted bays of the ambulatory. Eight columns support the apse and ambulatory. The exterior wall of the ambulatory is logically divided into nine bays, of which four are occupied by round radiating chapels, and the other five in the usual way by windows, including the axial one. This is common in Auvergne, and it is remarked that the arrangement occurs in churches dedicated to the Virgin, whether the absidioles number two or four,

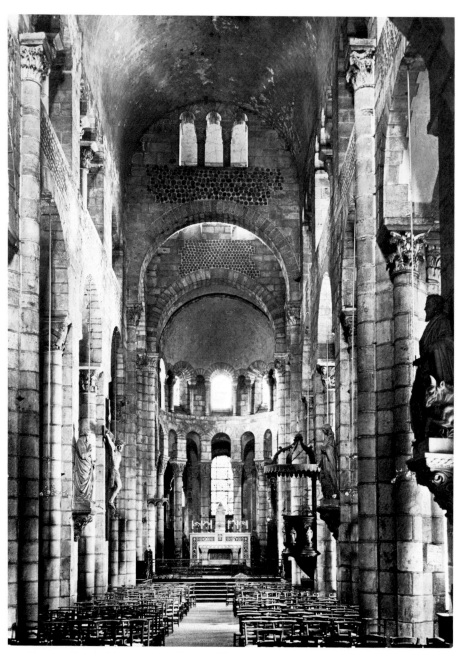

229. Clermont-Ferrand, Notre-Dame-du-Port, twelfth century

whereas with other dedications an axial radiating chapel (sometimes oblong) is introduced. One finds an amusing variety in the buttresses of the chapels – some being plain spur buttresses, others columnar. The transepts have spur buttresses; the nave has an arcade above spur buttresses.

There is patterned wall-work of a simple sort in the interior of Notre-Dame-du-Port, and much more elaborate embellishment of this kind on the exterior. The local building material is an arkose or granite, which allows of very pretty accents in red, brown, grey, or black, arranged in panels. Star forms occur, along with diapers and stripes. Round and mitred arcading is used, and also shallow sunk panels enlivened by toy-like decorative columns and chisel-curl eaves-brackets which bring a little oriental spice to the design. In general the picturesque old structure in the refractory local building material seems indeed more to belong in the rocky countryside of Auvergne than in the tyre-

230. Clermont-Ferrand, Notre-Dame-du-Port, twelfth century

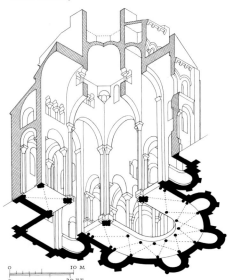

making metropolis of France which Clermont-Ferrand now is.

Notre-Dame-du-Port is a very satisfactory paradigm for a cluster of churches within a radius of about twenty miles of the city. Ennezat, the oldest of the group, will be mentioned again. It is differentiated from the rest by an indefinable flavour of the Loire country. Saint-Nectaire perhaps comes next, about 1080, then others – Saint-Saturnin (without radiating chapels), Orcival (built about 1100, with rebuilding about 1168), Issoire (c. 1130-50), Saint-Amable at Riom, Mozac (a Cluniac priory), and last of all Brioude.

The background of the Auvergnat type-church is interesting, but not entirely clear. The ambulatory is old in the region, brought in from the Loire, and this may be true of the lantern-transept also, for something of the sort may have existed at Beaulieu-les-Loches (1005; much rebuilt). Structurally the lantern-transept recalls Germigny-des-Prés (about 806) with its flying screens; in silhouette it recalls Saint-Riquier (793-805), plus transept arms and minus the flanking round stair towers. The westworks are ultimately connected with Saint-Riquier also. There is a tenth-century example in Auvergne, at Chamalières. The general formula of the Auvergnat church, with its vaulting, appears to have been settled by the time the archaic-looking little church at Ennezat was built, probably not long after its foundation as a collegiate church between 1061 and 1078. One suspects that the eleventh-century cathedral of Clermont (which succeeded Aléaume's building), was the critical design. It is known to have had an ambulatory with four radiating chapels. Wherever it was, the key design must have had this motif and transept arms of equal height composed against the precipitous bulk of a lantern-transept with a lofty belfry as its pinnacle.

There is a strong tradition for early architectural and sculptural work connected with the abbey of La Chaise-Dieu, where there is now a

beautiful Gothic church. The abbey was founded in 1043 by Robert de Turlande, a canon of Saint-Julien at Brioude, and confirmed by diplomas of 1052. It is reported that the abbey was responsible for the construction of 100 churches in the vicinity; eventually the number of monasteries submitted to or allied with La Chaise-Dieu reached 400. The abbey is remembered for work on the roads, and for developments in husbandry prefiguring those of the Cistercians. There are no identifiable remains of architectural or sculptural work, but there is notice that Théodard, a master mason, and two sculptors were sent to Saint-Gemme in 1079, and that Guinamundus, a goldsmith and enameller of La Chaise-Dieu, made the tomb structure for the relics of St Front at Périgueux in 1077, as already remarked.[2]

Apart from the group of churches just considered, there are some few interesting examples in Auvergne – Volvic and others without galleries. Royat is aisleless, and fortified – a bold, rather awkward building full of character. These minor churches taken with the group about Clermont have undoubted interest but they are not sufficient to make a grand school such as those we have studied previously. The Auvergnat school early entered into the nomenclature of schools. Representing (after a fashion) the Pilgrimage type of which so many great examples, proportionately, have been lost, it will probably remain in the conventional list. Except for its rather shadowy but indubitable early importance, the Auvergne manner should be noted merely as a subgroup under the School of Languedoc.

THE SCHOOL OF LANGUEDOC

The remaining area of Carolingian Aquitania is Languedoc plus the Limousin, to which (because it became part of the County of Toulouse) Septimania or Gothia is to be added. Here the most glorious of the South French schools of Romanesque architecture and sculpture was created. Rightly so, for it was one of the glowing areas of early medieval civilization. 'Bientôt la rafale venue du nord tua cette floraison,' says Enlart of the Albigensian Crusade and the Inquisition (1209-45) which permanently injured the country and left a mark on the Church.

A defect of the plan of our exposition of Romanesque architecture is that it takes the greatest monuments created by Languedoc from the local school, and puts them in the general history of architecture with other works of equal importance. We have already given an account of the creation of the Pilgrimage type of church, which was matured in Languedoc (Saint-Martial at Limoges [113], Sainte-Foi at Conques [113, 116-18], and Saint-Sernin at Toulouse [113, 119-21], with Santiago Cathedral [113, 114, 122-5] (1078-1211) as an extraterritorial member of the school. Reference has also been made to the Cistercians, who built magnificently in Languedoc.

However, even without the principal monuments which have been analysed elsewhere, Languedoc has a considerable number of notable examples to show. They represent a fascinating interweaving of influences from the acknowledged masterpieces, and from the various regions bordering on Languedoc.

Toulouse, which was to be the centre of Languedoc, had a chequered early history. It was a capital city for the Visigoths (419), Merovingians (628), and Carolingians (781). The

Normans captured it during a foray of 848, and the famous marriage of Henry of Anjou to Eleanor of Aquitaine technically brought it under English dominion. Its true history was written under the Counts of Toulouse between 852 and 1209. Limoges in the Romanesque age was ruled (918 to 1264) by the Dukes of Aquitaine. Oriental influences came there, as to Le Puy.

Because of the early date of Saint-Martial at Limoges (about 1000-95 and later) [113] it is perhaps well to begin with churches in the Limousin which are related to the Pilgrimage group. Among these the abbey church of Beaulieu in the Corrèze[1] is surely the most interesting. It is much like a Pilgrimage church with the triforium of the nave reduced to the scale of the usual apsidal triforium, thus omitting the charming enclosing arches above the paired arches which are so harmonious a feature of the Pilgrimage interiors. Beaulieu has a remarkable lateral portal of about 1138, rather like that of Moissac, and hooded, like Moissac. The aisle, ambulatory, and vaulting arches at Beaulieu are pointed, and the portal has an elegant frame in three orders of pointed arches, but the round arch nevertheless persists in the building.

Saint-Léonard[2] is another simplified example of the Pilgrimage formula, though it is a rather confused building now on account of later additions. It has a high vault abutted by quadrant vaults, and the chevet has apse, ambulatory, and radiating chapels. There are remains of a small rotunda. The finest feature of the church is the adjoining tower, built about 1150, which belongs to a series found in this region - at Saint-Martial, Limoges, the cathedral of Le Puy [127], and Brantôme, to name the more important examples. At Saint-Martial the charac-

teristic upper stages were an addition of rather later date built on the old western tower-porch. In the other examples the design was integral: at Le Puy, east of the sanctuary, at Brantôme and Saint-Léonard beside the church.

The towers are all interesting studies in transition from a square base to a pointed roof.[3] Saint-Léonard is a straightforward example, and analysis of it will do for all. The tower is square, with two openings on each side of the lower storeys, but the second stage has a slight reveal at the corner, which sets the profile back a little, because the square has, in effect, small nicks taken out of the corners. This effect is repeated at the third stage, where the arcade rests on round piers. The fourth stage is boldly set back above a slope, but has a steep-gabled element breaking forward. Above the spring-line of this gable the tower is octagonal, set point-wise – that is, with arrises on the cardinal and diagonal axes of the tower. A little buttress cleverly fills in the angle on the diagonal beside the gable. There are two arcaded stages of the octagon, then a frieze-like band with a simple pyramid above.

At Uzerche (in a church of similar tunnel-and-quadrant construction) a related tower has half-gables set beside the characteristic steep gabled element. The half-gables, joining similar half-gables on the adjacent sides of the tower, form interesting acroteria. At Uzerche the octagon is set flatwise; at Brantôme the upper part of the tower is square, and this is the case with the much more elaborate tower of the cathedral of Le Puy, which has eight arched stages beneath the pyramid.

The octagonal tower set point-wise has interesting later variants in the Limousin.[4] Such towers rise sheer, stage upon stage, from a square base, with polygonal tourelles covering the angles of the square, tangent to the tower and carried up the full height of the shaft. An octagonal pyramid of steep slope terminates the main tower and each of the tourelles. The cathe-

dral of Limoges, Saint-Michel-aux-Lions, and Saint-Pierre-Peyroux have attractive specimens of this type of tower. The lower part of the cathedral tower is Romanesque; the lowest of the octagonal stages is transitional to Gothic, 1191; the upper parts have been rebuilt in Gothic with a strong Romanesque feeling.

Le Dorat[5] is another striking church in the Limousin region which is related to the Pilgrimage group. Like Saint-Martial, it is a church with two axial towers, and it has reminiscences of Saint-Riquier, but it is a twelfth-century church. There is a bold staged lantern and belfry tower over the crossing, the tower being octagonal in shape and set point-wise. The apse, ambulatory, and radiating chapels beyond it are set against a long transept, which is happily accented by two turrets. These turrets, with the crossing tower, recall the old Saint-Riquier arrangement. At the west end there is partial reminiscence of Saint-Riquier in a heavy tower (which contains a dome) symmetrically flanked by two charming octagonal turrets set point-wise. Substantial spur buttresses contribute to a vigorous pyramidal effect in this part of the building. The main portal is plain, two-arched, with no sculpture on the tympanum, but very handsomely bordered by four orders of cusped arches, and flanked by two tall lancet-shaped recesses. The cusped arches reappear on the lantern tower, and are considered, of course, as an indication of Spanish influence. (La Souterraine[6] has a similar façade, with engaging asymmetries.) The plan of Le Dorat is, except for the westwork, much like that of Saint-Étienne at Nevers. Le Dorat has no clerestory, except in the apse. Its lantern tower is especially interesting, for it has spherical pendentives, and a dome of circular plan.

Moissac is related somewhat to Le Dorat through the heavy western tower. It has already been said that Moissac was first planned (it is believed) as a hall church, then covered by domes, and finally reconstructed with the pre-

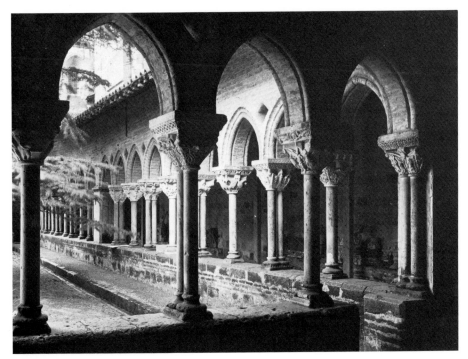

231. Moissac, priory church, cloister,
c. 1100, later reworked

sent Gothic vaults [160]. The famous cloister [231] was also reconstructed in the Gothic period. Moulded and pointed arches of red brick now rest on the Romanesque impost blocks which are so beautifully carved, and so gracefully sustained by the Romanesque columns, alternately single and in pairs, with rich and imaginative capitals. The handsome slabs with large figure reliefs of c. 1100 still have their places at the corner piers. The rebuilt cloister, with its beautiful garth, is very poetic indeed.

Toulouse, the capital of Languedoc, has suffered greatly from demolition and reconstruction. The most elaborate cloister in Languedoc was that of La Daurade in Toulouse; it was demolished in 1813, and only specimens of the carvings remain.[7]

In spite of the prestige of the Pilgrimage formula, which was brought to a climax in Saint-Sernin at Toulouse,[8] the new half-Romanesque cathedral of Toulouse, begun in 1211,[9] was radically different in type. It marked a stage in the development of the characteristic wide-naved Gothic of south France and Catalonia. In these vast interior spaces we have a new version of the wide naves which produced such remarkable effects in Carolingian and Romanesque times. This kind of Gothic retained Romanesque proportions, and used a version of Romanesque interior buttressing to make possible maximum Gothic vaulting spans.

The church of Bénévent-l'Abbaye[10] in the Limousin is related to the Pilgrimage type through its apse, ambulatory, and radiating

chapels, but the nave is like Cistercian work because of its pointed banded tunnel vault, stoutly abutted by pointed transverse tunnel vaults bay by bay. Narrow piercings between successive bays and a timid clerestory, now blocked up, show a concern for solidity. The church dates from the twelfth century. Cistercian architecture when it came (as at Silvanès, Sénanque[11]) was at home among such buildings, for it is structurally similar.

This abutment system of interior recesses, when developed vertically, yielded the efficient interior buttress system of southern Gothic. Structurally it is rather like aqueduct construction with screen walls at the back and Gothic vaults sprung between. In a way it is like the Pantheon in Rome, where in effect aqueduct-like arches and supports form a circumference, with the dome turned between them.

With clever abutment such as the flying buttresses developed in the Île-de-France after 1175, Gothic naves could go high. With stout spur buttresses or interior recesses they could be given great breadth. Thus it was possible to achieve on a grand scale the very spacious naves of ample Romanesque proportions which were preferred in southern France, Catalonia, and Italy. This is the system which was employed in the Toulousan cathedral of 1211, perhaps the first example of its type.[11] The span of sixty-four feet was achieved in brick construction with immense square rib-vaulted bays, boldly domed up over plain rectangular ribs, like Lombard Romanesque vaults. The low proportions and the detail are very different from those of the High Gothic cathedral of Reims, started in the same year. Yet there is in the now mutilated and unlovely work at Toulouse a good promise of Albi and Gerona (where the widest Gothic span, seventy-three feet, was reached).[12]

It is significant that the development of this type of building, with its Romanesque tincture, was continued after the standard High Gothic of the Île-de-France had been introduced at Narbonne in 1272, Limoges in 1273, and Toulouse itself – though the destruction of the cathedral of 1211 was planned, and partly achieved, during the works undertaken in 1273.

Carcassonne shows the persistence of two Romanesque schemes. The Gothic Saint-Vincent (fourteenth century and later) has a single-nave span of sixty-eight feet, the widest in all France. On the other hand, the western limb of the former cathedral of Saint-Nazaire, in the Cité, is a hall church dating back to 1096 in its beginnings. The light and beautiful transept and apse of the thirteenth century respect the disposition, heights, and proportions of the old building – presenting, in glowing contrast, the openness and light which Gothic bravura made possible.[13]

Along the Mediterranean coast the influence of the Pilgrimage type in the Romanesque of Languedoc was weak; conversely, Lombard and Catalan influences were strong, as already indicated. In this very southern ambient and climate the differentiations which make a building seem French had no great occasion to develop. Yet, perhaps because of the persistence of lovingly sculptured ornament, there is some flavour of Languedoc about these works.

The cathedral of Elne,[14] in French Catalonia, is perhaps the best example. It is an eleventh-century conception, interrupted in execution and carried on, consistently, at a later time. The nave has a semicirular banded tunnel vault carried on piers with cruciform nuclei and attached shafts or pilasters. Thus there are three orders of arches in the aisle arcade, for the transverse arches are single and the nave has no clerestory. The effect is very substantial and good. The aisles have quadrant vaults divided into bays by diaphragm arches; shallow arcading decorates the exterior walls of the aisles. At and near the façade there is rib vaulting, a sign of late date, but the frontispiece has two crenellated towers of traditional Lombardic form. One is much heavier than the other, but they compose

handsomely. There is a fine and characteristic cloister attached to the church. The church of Arles-sur-Tech was rebuilt with similar vaulting in this period (consecration, 1157). There are other picturesque works in the mountain country farther west, but space does not suffice for their consideration.

＊

How shall we achieve an orderly statement and explanation of the wonderful flowering of Romanesque architecture and sculpture which we have found in the eleventh and twelfth centuries in Carolingian Aquitania and its bordering lands on the Loire and the Mediterranean?

It is clear that there was an underlying development, alive with Carolingian energy, in the Loire region, in the ninth and tenth centuries. This radiated northward into the region where Gothic architecture was to be created, as we shall see later. Its radiation to the south and east may be roughly traced by the churches which have ambulatories, often two axial towers, and, in the earlier examples, the typical masonry wall-work; we find many such in Burgundy and Aquitania proper.

Obviously also the First Romanesque area contributed to the architectural formation of Aquitania. Serious study of lost early monuments will have to be undertaken before this flow of influences can be clarified, but one discerns that it must have been drawn on in developing the sculpture, and in vaulting basilican schemes above the ground level. Catalan vaulting (already fairly advanced at the end of the tenth century), early sculpture north of the Pyrenees, and Burgundian developments under First Romanesque impact appear to have flowed into Aquitania.

Oriental influences flowed in too, from Moslem Spain as early as the tenth century, from the Near East in Crusader times. Auvergne, which had the earliest on record of such peninsular contacts (Bishop Godescalc and his 200 monks, 951), retained the strongest imprint, but oriental motifs – cusped arches; ribs in connexion with domes and domical vaults; repetitive octagonal domical vaults and domes; perhaps also imbricated roofing – were peppered about the whole Aquitanian region and absorbed into the eleventh- and twelfth-century style. Catalonia, which was in actual contact with the Moors, shows surprisingly little trace of their influence, though their carvers may have aided in the re-creation of sculptural technique during the tenth century, reinforcing perhaps a lingering tradition in Septimania or Gothia.

The centres of power, mostly secular, began to gain focus about the year 1000, if not before, in the Aquitanian area, and type-monuments appeared which were to affect regional building for several centuries after that. There is, however, also the inter-regional influence of the monks of Cluny in their building enterprises and a Roman heritage, also. The area of Cluniac westward expansion until the end of Odilo's abbacy (1049) was almost coterminous with Aquitania,[15] the domain of their founder Duke William. Abbot Odilo is well known as a builder in various regions. The vision of the Cluniac monks can surely be credited with an important part in the impulse which brought about consistently larger, more majestic, and better vaulted church buildings, and some of the skill and success of the regional schools must be due to the stimulation of wide knowledge which came with the presence of the Cluniacs, and the tide of Pilgrimage contacts.

Thus in Anjou a successful combination of the principles of ribbed and of domed construction was made. In Poitou quite surprisingly monumental effects were early achieved with columnar supports and 'hall church' vaulting, which had hardly, in previous times, achieved any really noble effects. The later application of grouped piers and pointed arches to this scheme opened up a whole panorama of interesting effects, and these, together with Angevin vaults

further developed, were successfully drawn on in Gothic work – indeed at the cathedral of Poitiers itself, as well as later, with great art, in the developed hall churches of South France, Spain, and Germany. In Périgord a quite pedestrian and utilitarian scheme of dome construction developed special and monumental effects of genuine interest, quite apart from the achievement of building the cathedral of Périgueux. The same resilience of spirit shows in the lively, original, and monumental tower and lantern forms, though the towers failed to multiply over the churches as they did in Burgundy and the North.

In decorative works there was a notable skill of every sort. There are successful imitations of provincial Roman work, carvings which have the strong bulk of early medieval work, and others which suggest the subtle refinement of Byzantine or oriental works in ivory such as were treasured by the artists' patrons and known to the designers themselves. In Anjou and Poitou the column-bundles, leafage, arcading, and mouldings are treated with such consciousness of envelope, such delicacy of undercutting

and scale, such tirelessness of fancy in treating the simple vocabulary of leaves and scrolls, that the effects are the equivalent of orientalism. The great sculptures of the School of Toulouse have a fuller clarity, often an overpowering intensity, and they gain vastly as decoration from the stylized form and subtle rippling surfaces, so sweet to the light, in which they parallel oriental and Byzantine works.

With all this, the fundamental architectural types created in the area of Carolingian Aquitania were not magnified or elaborated beyond measure. They always remained eminently practical. This is the key to their usefulness in frontier country like Early Romanesque Spain, or the Crusaders' Holy Land. Both these areas were architectural provinces of Burgundy, Poitou, and Languedoc. The Romanesque of Aquitania showed a remarkable expansive power. In the movement towards Spain which started seriously in the early eleventh century, and in the Crusades which began in 1097, the French took their architecture with them, and built it with a local nuance, but retained the special stamp of French genius on it.

THE MATURE ROMANESQUE ARCHITECTURE
OF SPAIN, PORTUGAL, AND THE HOLY LAND

CHAPTER 17

STYLES DEPENDENT ON THE MOORS AND ON LOMBARDY

All Christian Spain ultimately succumbed to French architectural genius, as the Gothic cathedrals of León, Barcelona, and Seville clearly show. But the northern kingdoms were building in the French Romanesque style as early as 1050.

Catalonia remained an active province of the Lombardic style until the advent of Gothic – the Gothic of Cîteaux, and that of Languedoc, referred to in the preceding chapter.

The Christians in the Moorish part of Spain worked in the Mozarabic style before the tenth century, as we have seen. In the following period they did not greatly develop their church art, except at Toledo, which for a time was semi-independent. The 'Mudéjar' style, that is, the Moorish style in Christian service, appears to have been worked out in Toledo before the conquest (1085), and drawn on as Christian buildings multiplied in the middle and southern parts of the peninsula, where the Mudéjar was most appropriate to local conditions.[1] For us its interest is largely confined to brickwork and wall patterning in the sophisticated Moorish fashion.

The Mudéjar was outside the current of French architecture, and the Catalan Romanesque always maintained a certain indepen-

dence – even in Cistercian works. Hence these two styles will be considered before we resume our study of the expansion of French architecture to the other lands which had been Moslem.

MUDÉJAR ROMANESQUE ARCHITECTURE
IN BRICK

The eleventh- and twelfth-century victories of the Christian kingdoms in Spain advanced their frontiers well south of the equator of the peninsula, except in the hinterland of Valencia. The area subject to the Christians was nearly doubled in two hundred years. The new conquests were progressively more settled in character, and more densely populated, with large Moorish and Jewish contingents in the population.

Moorish masons in these regions built very successfully in brick. Señor Gómez-Moreno makes the point that ordinary building must have proceeded as before, with ordinary Moorish craftsmen.[2] Clever Moorish craftsmen learned the Christian style, and ultimately Christian craftsmen learned the Moorish style – which was, after all, different rather than foreign.

In the earlier period an ambitious Romanesque work for the reconquered area would in-

volve all the difficulties attendant on imported craftsmen – from Poitou, Languedoc, Burgundy – or Spanish craftsmen from the north, with similar training; such works were not numerous. Romanesque architecture in fact never reached Toledo at all; that was the centre of the Mudéjar style, and, as time wore on, the Spaniards became less dependent on foreigners. When possible, it was natural for them to profit by the experience of the Moorish and Mudéjar builders in newly occupied areas, and to develop Romanesque variations on the Mudéjar style, built, like the originals, largely in brick, but organically Romanesque rather than oriental. Actually the decorative pilaster strips and decorative arcading which characterize the Mudéjar style are based ultimately on the very same elements which were developed in the Lombardo-Catalan First Romanesque style. In Spain the pattern work on the pale-brown brick walls, with the spicy shadows of decorative cusped and interlaced arches, gives an oriental nuance to the ripple of sunshine which plays upon them.

Many of the Mudéjar churches are modest aisleless affairs, with polygonal apses, generally preceded by a tunnel-vaulted sanctuary bay which carries the tower if there is one. The naves, and the aisles if present, are usually roofed in wood. Moorish 'artesonados' with twin tie-beams often occur as nave ceilings.

Mozarabic brick workers were among the settlers when Quintana, near Sahagún[3] and León, was repopulated in the tenth century, and this point is a likely starting-place for the brick-building style of Castile. Early examples are lacking; they were doubtless utilitarian, and, in church architecture, replaced because of their modest scale.

The Cluniac abbey of Sahagún, though stone-built, had the brick chapel of San Mancio, built about 1100. This is a simple design, and one of the older preserved Mudéjar works. San Tirso at Sahagún [232], twelfth century, is much like a First Romanesque church in brick, except that

the round-arched decorative arcading is set in Moorish-looking oblong panels. San Lorenzo at Sahagún and the Peregrina come later, in the thirteenth century, and have the cusping and pointed arches which become ever more frequent in this work. Toro has corresponding simple examples, the Cristo de las Batallas and San Lorenzo, dated about 1200. La Lugareja at Arévalo is a similar work, Cistercian, and dated in the thirteenth century.[4]

The oldest preserved example at Toledo is the extension, dated about 1087, of a tenth-century mosque called El Cristo de la Luz, where Alfonso VI paused when he entered the city on 25 May 1085.[5] Here there is a round-arched decorative arcade in the lower register, and a cusped range above. Later examples, like Santiago del Arrabal (c. 1256), Santo Tomé, Santa Fé (thirteenth century), and others are more purely oriental. San Román at Toledo, for instance, is perfectly Moorish in style: a clear case of eclecticism, for it was dedicated in 1221 by Archbishop Roderigo Jiménez de Rada, who laid the cornerstone of the Gothic cathedral in 1227.

This same mixture of styles is perceptible in the southern area – at Seville, Granada, and beyond, and to some extent in the north during the Gothic period. A remarkable development of the Mudéjar style with strong Romanesque reminiscences took place in the Ebro Valley during the Gothic age, and continued into the Renaissance. Teruel has splendid examples of the fourteenth century, and there was a wonderful flowering in Zaragoza and near by. The development did not end with Gothic times, as the handsome belfry and crossing tower of the cathedral of Tarazona bear witness (1519–27). There is even one example in America – a fountain house of 1563 in the public square of Chiapa de Corza in Mexico.

The Mudéjar style offers an interesting parallel and contrast to the 'brick Gothic' or *Backsteingotik* of Germany. The latter style

232. Sahagún, San Tirso, twelfth century, from the east

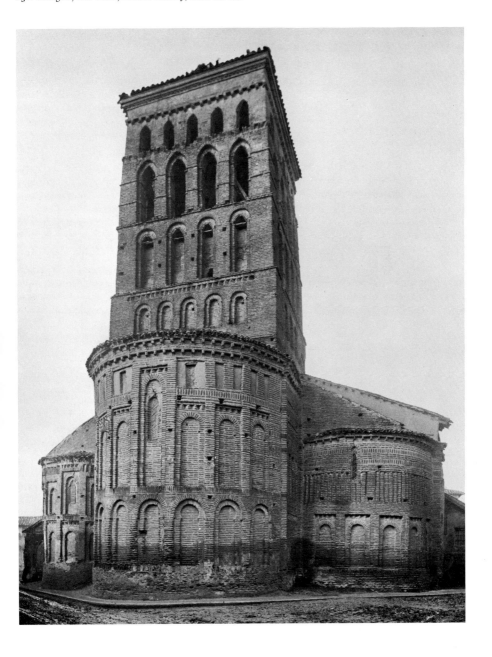

started with actual Lombard Romanesque elements about the middle of the twelfth century, and developed interesting forms appropriate to brick. Its simplicity accords well with the severe Baltic country where it flourished. Later, like the Mudéjar style, it became playful and introduced Gothic motifs.

THE MATURE CATALAN ROMANESQUE STYLE

Ramón Berenguer III, Count of Barcelona (1096–1131), was master of the whole Mediterranean coast-line from the Ebro to Nice. Under him French influences filtered into the architectural sculpture in Catalonia, but in general the area retained its Lombardic style, which had dominated since the tenth century. The increase of means, in Catalonia as elsewhere in the eleventh and twelfth centuries, permitted an improvement in craftsmanship, particularly in the use of fine ashlar masonry for interior and exterior walls. The later churches are generous in scale, and ordinarily vaulted; they are in many cases richly embellished – occasionally with tympanum reliefs, usually with carved capitals, and they often have cloisters, richly carved and unfailingly poetic. Reminiscences of the Mozarabic style are unusual, but there is an indefinable half-oriental warmth in the buildings which must owe something ultimately to the Moors.

San Clemente of Tahull,[6] well known for its paintings, is almost archaic for its date (1132). It is a perfectly plain triapsidal wooden-roofed basilica without even a clerestory. The handsome square tower is traditionally Lombard.

French influence in Catalonia may, as usual, be traced by the ambulatory and radiating chapels (rare in Romanesque Catalonia) and by sculptural style. San Juan de las Abadesas[7] shows the old scheme of a tight cruciform plan of surprisingly grand scale expanded by an ambulatory and radiating chapels (later rebuilt

differently) and embellished with sculpture in the French manner; the dates probably fall between 1114 and 1150. Yet despite its French elements the resulting building does not seem French. Nor does San Pedro at Besalú. (It has an ambulatory with niches in the outer wall serving as radiating chapels; the apse arcade is doubled, like the supports of a cloister.) Santa María of Vilabertrán, dated about 1100, resembles a simple Provençal or Burgundian church. Like many such buildings in France, it has quadrant vaulted aisles, a semicircular tunnel vault with transverse arches in the nave, with a timid clerestory, but it has Lombardic ornament on the exterior and a cloister of Lombardic character.

Of the group of cloisters which multiplied in the twelfth century, a few are noticed here,[8] being connected with interesting churches: San Pedro Galligans, Gerona (about 1130), Santa María de l'Estany (1133), San Cugat del Vallés (about 1150); the cathedral of Gerona (nearly contemporary); San Benito de Bages (well after 1150, probably incorporating carvings which belonged to the cloister of 972), and, beside the charming little late Lombardic church of San Pablo del Campo in Barcelona, a tiny cloister of about 1200, to which cusped arches give an odd oriental look. The visitor who makes the rounds of these and others like them experiences one of the delights of the medieval travelling ecclesiastic, who moved from monastery to monastery and saw something of life in the cloister wherever he went. The monastery of Ripoll has an attractive cloister also, in two storeys, but the important sculptural monument there is the elaborate portal of the monastery church. The cloister may be as early as 1125 and the portal as late as 1175. They were added, of course, to the remarkable church of 1032, which we have mentioned previously.

In 1135 Catalonia was joined to the crown of Aragon, but the union did not bring about a new

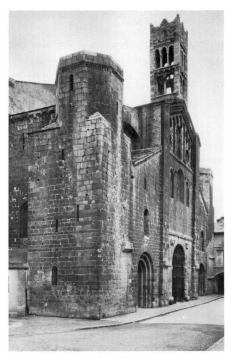

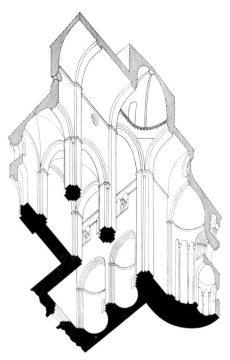

233. Seo de Urgel Cathedral, 1131-75
and later, from the north-west

234. Seo de Urgel Cathedral, 1131-75
and later, analytical section

orientation in architecture. The Catalans think of the later twelfth century as a rather decadent period in this art. So it is that the chief great enterprise of the time, the cathedral of the Seo de Urgel [233, 234], is in various ways like a maturer and more finished version of Ripoll, and in the lineage of San Vicente, Cardona (c. 1020-40), San Pons de Corbeira (c. 1080), and San Jaime de Frontanyá (1070).[9]

The grand old cathedral of 1131-75 at the Seo de Urgel[10] has a T-shaped plan rather like that of Ripoll, but simpler. It is laid out with tremendous stout walls in fine ashlar masonry. The walls of the transept ends serve as the actual bases of two heavy towers (containing compartments which open into the transept), the east walls of the transept also being thick enough to contain its four absidioles, and those of the apse thick enough to contain a small horseshoe-shaped axial rotunda. In the massive nave there are two files of cruciform piers with nook-shafts, supporting banded tunnel vaulting in the transept and nave, groin vaulting in the aisles. The crossing is covered by a curious four-ribbed dome carried on squinches and shallow pendentives. The nave has a clerestory of pretty paired arches supported on paired shafts like those of a cloister. The front of the building was planned for two square stair turrets, which with the huge transeptal towers and the twelve-sided lantern would mark a strong silhouette against the sky. Not the least remark-

able thing about the building is its almost pure Lombard style, especially on the exterior, where the design with its decorative arcading, apse gallery, and other features might easily be mistaken for an actual Lombard building of the early or middle twelfth century.

Completion of the roofs, towers, and dome was in fact contracted for in 1175 between the Chapter on one part, and Raimundus with four *lambardos* on the other: *lambardus* at the time signifying no more than *mason*. But the style of the edifice shows that masonry of the Lombard type was expected, as it had been for centuries in Catalonia.

The conservative character of the builders in Catalonia cannot be too much emphasized. The Cluniac possessions, though the first gift dates back to 966, were never active or important. Therefore, after the Lombards and the Provençaux, the first ensuing wave of foreign influence was the Cistercian style, which came in because of the interest which the new dynasty (of Aragon, since 1135) early evinced in the reform of Cîteaux. The Burgundian half-Gothic – in France so relatively conservative – in Catalonia marks an advance.

Poblet,[11] already mentioned in our brief survey of Cistercian architecture, was founded in 1151, and it became the Aragonese dynastic pantheon, which explains its fine construction and its vast developmant. The pointed tunnel vault with transverse arches is of undiluted Romanesque form. Surprising as it is in relation to its contemporary, the vault of Notre-Dame in Paris (about 1175–95), it was quite natural in the Catalonia of that age, where the rib vaults of the aisles of Poblet were, on the contrary, surprising. Throughout the vast extent of the later medieval buildings at Poblet there is more than a hint of Romanesque character in the wall-work and massing, while the playful Gothic tracery has a half-oriental sparkle, and occurs often in windows with slender shafts and elegant

narrow openings, like those of the Moorish *ajimez*.

In passing, the other great Catalan Cistercian foundation should be mentioned – Santas Creus (1157), also provided with an austere and characteristic church which builds up into a beautiful octagonal cimborio or crossing tower of Gothic date.[12]

Tarragona Cathedral, begun in 1171,[13] is the heir of all these tendencies. Metropolitan archiepiscopal establishment in a city with many Roman remains, the church has the resolute sturdiness of the most invincible Roman or Provençal construction. Though finished in Gothic times, the excellent ashlar masonry has Romanesque character. The plan has the arrangement of a much smaller French church of the apse échelon type (nave of five bays, single projecting apsidal transept bays, with sanctuary bay and triapsidal chevet beyond). The resulting effect of magnification is awkward in various respects, but imposing, since heavy forms derived from the Cistercian style (with Poitevin influence, perhaps, in the column-bundle piers) were used with fair consistency in the lower parts of the building, and the exterior, flat-roofed, is blocky and plain like a Provençal building. The cloister is surprisingly Burgundian – with Cistercian architectural forms, and carvings in the Cluniac tradition. Here and elsewhere in the cathedral establishment there are oriental touches. Of course, being fully vaulted only in 1287, and dedicated complete only in 1331, the building has Gothic details also: in the west portal, the window tracery, and the (characteristic) octagonal crossing tower.

The old cathedral of Lérida[14] [235], boldly set on a great rock which dominates the modern town, is a somewhat more consistent example of this same solid, sunburned late half-Gothic architecture (1203–78). Its plan is simpler than that of Tarragona (an échelon of five apses to the east of the transept; handsome cimborio of

235. Lérida Cathedral, 1203-78, view from the west portal into the cathedral

236. Lérida, Exchange, thirteenth century

transitional style; heavily-built nave of three bays) except that a Gothic cloister somewhat larger than the church was added at the west. The cloister, which really serves as an atrium, has a great portal of its own. The former canons' quarters are at the north; at the south-west corner there is a tall octagonal tower set pointwise, like the Limousin towers – and still, early in the fourteenth century, more than half Romanesque.

Valencia, though temporarily captured and ruled by the Cid (that is, Saïd, Lord; 1094-9) was not really incorporated into the Aragonese-Catalan dominions until 1238. A Romanesque cathedral was begun there in 1262,[15] quite a natural thing in the capital of that conservative architectural province. The rich doorways of the building which have survived a later reconstruction are very elegantly embrasured, with many nook-shafts, and ornaments of Moor-

ish style. Certain other details can only be Norman in origin, and are doubtless connected with Sicily, where actual Aragonese rule began in 1282.

Some remains of medieval civic and domestic work of the Romanesque period exist in Catalonia, but the fine examples (the Archbishop's Palace in Barcelona, the Exchange in Lérida [236]), do not antedate the thirteenth century, when urbanism really begins in the region. But an occasional donjon ('Torre de Homenaje') with ward and enclosure walls, perhaps also towers, has survived, along with city houses in Mur, Solsona, Vich, Besalú, and Gerona. Sometimes in the back-country villages, where the church is likely still to be Romanesque, there is a medieval imprint yet remaining on the simple houses, porticoes, and overhanging eaves. The Romanesque stamp on Catalonia is indeed extraordinary.

STYLES DEPENDENT ON FRANCE

PRELIMINARY CONSIDERATIONS

Conservatism in Catalonia prevented an early or effective spread of French Romanesque architecture to the region. It was quite the reverse in the Christian states to the west, in spite of the apparent barrier of the Pyrenees. The southward advance of the doughty Spanish kings and soldiers produced a splendid opportunity for immigration, and religious aspects of the war turned it into a crusade. French participation in such crusades has usually been accompanied by good and practical results of some sort, and the story of them is often written in architecture.

The war of reconquest began at Covadonga in 718. It increasingly gained French recruits as the Pilgrimage to Santiago de Compostela flourished. Actually the conquering Christian kingdoms offered profitable opportunities to adventurers because the population of Christian north Spain was not large enough to stand the drain of expansion. The area of the Christian kingdoms trebled in the eleventh century. When the great cities fell, many faithful Moslems were displaced, their room being taken by Castilians and French. This occurred after the reconquest of Toledo (1085), Huesca (1086), Valencia (1094), and Zaragoza (1118).

It was the same with the native Church: problems on an entirely new scale were presented to it, and foreign ecclesiastics with suitable experience had to be called to fill the great posts. The Isidorian church was overflooded by this tide, and Romanized before the end of the eleventh century. So ecclesiastics as well as pilgrims, knights, and settlers flowed through

the passes into the Peninsula. A large proportion of them were southern Frenchmen – in particular from Poitou, Languedoc, and Burgundy.

Benedictinism and Carolingian monasticism early filtered into middle and western north Spain, but were not really effective until the coming of the Cluniacs under Sancho the Great (970–1035), King of Navarre.[1]

Sancho's grandson, Alfonso VI (1065–1109), the great patron of Santiago and Cluny, reassembled the Kingdom (parcelled in accordance with Sancho the Great's bequests) and enlarged it. He continued the ecclesiastical policy of Sancho, as we know. Sahagún, the greatest monastery in Castile, was associated with Cluny, and its abbot, Bernard of Agen, became primate after the capture of Toledo in 1085 and the resuscitation of its ancient ecclesiastical dignity.

The court became gallicized, not only in politics and religion, but also in blood. Four of the consorts of Alfonso VI were Frenchwomen, and several of his children made French marriages; French chivalry flowered at the court, and so it was that the arbiters of taste and the patrons of art were by nature fitted to desire French creations, though not quite to the exclusion of sophisticated Moslem works.

Alfonso's son-in-law, Raymond of Burgundy, is known to have brought twenty French masons to work on the walls of Ávila (1090) [244]. Alfonso VII (1126–57) founded a number of Cistercian monasteries in Castile, Aragon, and Galicia, which of course meant an influx of the usual Burgundian half-Gothic. Under Alfonso VII's son, Sancho III (1157–8), the Order of Calatrava was founded for the defence of the

frontier, under the Cistercian Rule. Sancho III's son, Alfonso VIII (1158-1214), married a daughter of Henry of Anjou (who had by his marriage with Eleanor of Aquitaine acquired that great territory which long interested English royalty as much as the Island) and this union further opened Spain to influences from France. In 1212, at Las Navas de Tolosa, only about 100 miles from Córdoba, Alfonso VIII won the victory which insured an ultimate triumph (1492) against the Moors. Meanwhile Burgundian dynasts were advancing the conquest of Portugal. Military struggles in which Archbishop Diego Gelmírez of Santiago was incidentally concerned, resulted in the independence of the country under Affonso I in 1143. In 1147, with the help of pilgrims, he captured Lisbon. All modern Portugal had been conquered from the Moors by 1279.

In spite of the obvious French sources of style in northern Spain, and the presence of considerable numbers of French craftsmen, the Spanish monuments really are Spanish, and not servile copies. What precisely gives the subtle nuance it is difficult or impossible to say. Fastidious taste, formed in the presence of Moorish art, doubtless counts for something. Mozarabic architecture and Moslem craftsmen had some slight influence. Traditional skill in exploiting effects of sun and shadow; simpler bulks, and the indefinable play of relationships between the buildings and their austere, always mountainous surroundings or background may be mentioned as involved in the imprint which the Spanish spirit made on the new incoming type of building. Spain, even with a gallicized court, never became French, and it was the same with the architecture. This nuance is always to be understood, even when not mentioned, in the ensuing discussions.

ARAGON AND NAVARRE

In the formative period of Romanesque architecture these two mountain kingdoms received many architectural impulses from abroad, due to their contacts with the Pilgrimage and with Cluny. Parts of Aragon possess brick Romanesque and Mudéjar architecture, and this is occasionally echoed in stone buildings, like the eleventh-century church towers of Lárrede and Gavín.[2] Lombardic design is well represented in the cathedral of Roda de Ribagorça (1056-67). Ecclesiastical connexions brought a French orientation. Cluniac monks came about 1020, but the earliest Cluniac church still existing is San Salvador at Leyre[3] (already noted) [137]. It is wonderfully set in a mountain valley. The eastern parts of the church had been built by 1057. They are notable for the handsome use of (somewhat irregular) ashlar stone – in many regions still an unusual thing at this date. The vaulted crypt somewhat recalls Saint-Martin-du-Canigou, but it is more original. Stumpy columns support hairpin-like transverse arches under the vault with very picturesque effect. The main triapsidal sanctuary, with parallel tunnel vaults, recalls Languedoc. By the twelfth century a wide nave was added, like those of the Loire; it now has fine Gothic vaults. The royal Augustinian foundation at Siresa built (also somewhat in the style of Languedoc) a tunnel-vaulted aisleless cruciform church in 1082.

Jaca Cathedral[4] [237] inaugurated a distinctive local school or group of Romanesque architecture. The city became the capital of Aragon in 1054, and King Ramiro laid out a programme of development including the cathedral, which was to be (perhaps only in part) a vaulted structure. A Council is said to have been held in the building in 1063, but there is no assurance that the fabric was then advanced. The basic design is very elegant, but so eclectic as to suggest that a Spaniard was the architect.

237. Jaca Cathedral, in use 1063, finished later

At the entrance of the cathedral there is a tunnel-vaulted porch of two bays, formerly open at the sides, with an interesting west portal – Burgundian in general style like the porch, but with lions and the XP monogram (later copied in the region) on the tympanum. The nave and aisles have beautiful sixteenth-century star vaulting, but the relatively light original construction predicates a Romanesque roof in wood. The nave bays are double (except the westernmost one) with elegant round columns as intermediate supports between grouped piers. There is a haunting reminiscence of the Loire region in the design, but only imperfect comparisons can be made (Saint-Savinien at Sens; Saint-Benoît-sur-Loire; the abbey church of Jumièges, 1040–67, which was influenced from the Loire; the cathedral of Auxerre, where

the crypt of 1030 has cylindrical plinths under the piers, like those of Jaca Cathedral). Above the arcade the wall at Jaca is plain, with a single clerestory window over each opening in the aisle arcade.

There is an 'included transept' with tunnel vaulting in the arms, and a fine stone dome – the latter slightly distorted to fit over an octagon made by trumpet squinches. A rib rises from the middle of each side of the octagon in Moorish fashion. Intermediate bays of tunnel vaulting beyond the transept preceded three Romanesque apses, of which the central one has been replaced.

Thorny archaeological problems are posed by the building because of the excellence of its construction and the luxuriance, vivacity, and great merit of its sculptural decoration. The older French architectural historians were prone to post-date such structures, but newer studies have pushed the ensemble of dates back by twenty or thirty years. Noting that two of the column capitals in the interior of the church are even now in a blocky condition, never having been carved, we may suppse that the carving was delayed at Jaca until about 1070. The high quality of the fabric, so unexpected in a remote place, would be due to the personal interest of the King, and his excellent choice of a master builder.

The influence of Jaca Cathedral radiated through the district; we find an echo of its plan, and perhaps of its structure, in the fine ruined Castilian abbey church of Arlanza, dated about 1080 to 1100.

Loarre[5] [238, 239], also showing the influence of Jaca Cathedral, has the finest Romanesque castle in Spain, a bluff mass of walls and towers beautifully set on a rocky spur, commanding gorgeous views of the Gállego Valley and its mountain barriers. Parts of the castle antedate an establishment of Augustinian canons there, sanctioned by the Pope in 1071. The church,

238. Loarre, castle, *c.* 1095

which now dominates the whole group, has an epitaph of 1095 carved in the lower part, which probably indicates that construction was well on towards completion at that time.

Approach to the church is through a long ascending stair corridor to the castle ward, and thence by a lateral portal into the central bay of the church. To the west of this is an irregular tunnel-vaulted bay, and to the east a very elegant arcaded apse, the architectural lines being delicately marked by billet mouldings. The central bay itself rises through a combination of oriental faceted fan squinches, broad trumpet squinches, and shallow pendentives pierced with oculi, to a hemispherical dome – all in first-class ashlar which has endured well.

The sculptured capitals, placed on shafts under the great arches beside the windows, and in the decorative arcade, resemble Toulousan carvings of the time. The architecture, though close in detail to that of Languedoc and Poitou, has a half-oriental warmth and seems very Spanish. The aesthetic and acoustical effect of the interior is dramatic, in Spanish fashion; the abrupt verticality of the middle bay is startling as one enters, without harm to the graciousness or harmonious proportions of the interior. On the exterior the domed bay has a stubby octagonal tower, brought to a square base over the squinches by 'broach' roofs – small half-pyramids, that is. The eastern crossing of Cluny III had a somewhat similar roof, and the type became common in Aragon.[6]

Relationships with Pamplona Cathedral in Navarre cannot be traced, owing to the destruction of that important Romanesque building,

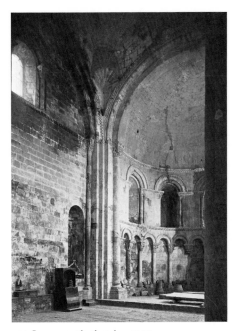

239. Loarre, castle chapel, c. 1095

erected by Pedro de Roda, a Cluniac reforming bishop, who is known to have been at Cluny in the year 1100. One of his masters was Stephen, who worked on the cathedral at Santiago. Unquestionably the old cathedral of Pamplona, if it existed, would throw interesting light on the tangled architectural history of its period.

In passing, it is worth while to mention a few stylistically complex buildings which, with the Mudéjar work, show foreign architectural currents in this region of Aragon and Navarre, even at a late date. There is, for instance, the half-Gothic-half-Poitevin Santa María la Real at Sangüesa[7] (1131 and later). The half-Moorish Santo Sepulcro in Torres del Río[8] (already referred to [132, 133]; late twelfth century) ought to be mentioned, as well as the supposed Templar octagon at Eunate[9] – the last, by rare ex-

ception, being set in an octagonal open space, screened off somewhat like a classical building in its *temenos*, or like the Dome of the Rock in Jerusalem, which probably inspired the general form of this and similar buildings. Strongly under Cistercian and Poitevin influence in plan is the half-Gothic cathedral of Tudela,[10] where the high altar was consecrated in 1204. A consistent style was maintained on the interior, although the building was not finished until about 1275. As in Catalonia, the tardy half-Gothic was successfully absorbed; Lérida and Tarragona are the comparable examples.

LEÓN, CASTILE, AND GALICIA

Union with Navarre and Aragon, and ever-increasing relationships with France, stirred a very interesting artistic revival in the western kingdoms. León (in the Asturias) already had a national style of architecture, which we have studied. The capital city, León itself since 914, rallied after destruction by Almanzor in 996, and undoubtedly initiated a new architectural revival like that which had stirred Oviedo two centuries before. Both León and Castile had some peaceable contact with the Moors, and Mozarabic works existed in both areas before the Romanesque style was introduced.

The earliest existing fragment of Romanesque architecture in the region is an extension to the Visigothic crypt of the cathedral of Palencia. Dated 1034, it is in excellent ashlar work, and has a clever arcade in the apse vault which shows competence on the part of the builders at this early date.

In León unknown masters of real genius extended the little old church of St John Baptist and San Pelayo de Córdoba between 1054 and 1067 to form a portico and the royal pantheon. The church, later rebuilt, became the church of San Isidoro [240-2] when the relics of the great Doctor of Seville were brought to it.[11] This and

other changes have left the new work of 1054–67 as a retired chapel, whereas in origin the pantheon was a kind of inner narthex with a

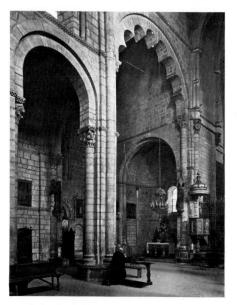

240. León, San Isidoro, 1054–twelfth century

tribune above it. The portico was placed on its north flank, and extended also along the west side, with the solid mass of the city wall just to the west of the passage-way.

The 'Pórtico de los Reyes' thus enclosed two sides of the 'Panteón de los Reyes'. The latter, one of the finest and best preserved works of its kind, is really a special version of the Carolingian burial porch which we have seen at Saint-Riquier (where Angilbert was buried), and at Saint-Denis (where Pepin the Short was laid away) – and also a special version of the tower-porches which we have seen in the Loire region – at St Martin of Tours (466–70 and about 1050) and Saint-Benoît-sur-Loire (dated in its present form shortly after 1067).

The Panteón de los Reyes is actually more accomplished than any existing French work

of the time. Its oblong area is divided into six compartments over two ample columnar supports; they and the numerous wall responds have capitals which are among the best and most interesting of their period. The well-designed system of domed-up groin vaults just above them has remarkable fresco decoration, extraordinarily well preserved, which was painted about 1175.

The church of San Isidoro was progressively rebuilt, and ultimately vaulted by the architect Petrus Deustamben. The central one of its three generous apses has been replaced but the handsome lateral apses are still in place, with interesting sculptural decoration. The transept, tunnel-vaulted, extends beyond the lateral apses, and opens into the nave through vast cusped arches, above which the high vault (carried airily over a clerestory in the nave) is prolonged. This is very competent work of the end of the eleventh century and the beginning of the twelfth. The carving, especially on the lateral portal, shows progress beyond the point reached in the Panteón de los Reyes in the earlier period.

We now turn to other important Romanesque works of the Leonese school.

A church resembling San Isidoro was built (*c.* 1065–85) as the cathedral of León, but demolished to make way for the present beautiful Gothic building, under the pavement of which the old foundations came to light in 1884–8.[12]

San Martín at Frómista[13] is a sort of paradigm for the Leonese school. Frómista, like León, is on the Pilgrimage route to Santiago de Compostela. A monastery was being built there by Doña Mayor, widow of Sancho the Great of Navarre, when the dowager Queen's testament was written, in 1066. This date does not strictly apply to the church, and it may be that the extraordinarily vivacious sculptures date from the latter years of the eleventh century. The ensemble of the building is very harmonious and dignified, though it suffers from having been over-restored a generation ago. The plan

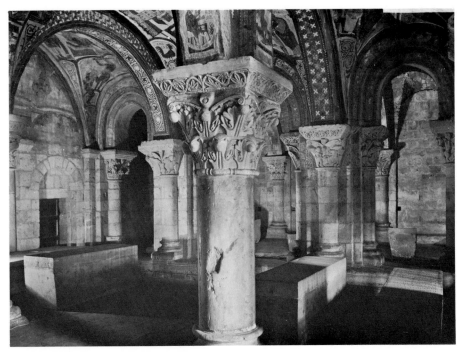

241. León, San Isidoro, Panteón de los Reyes, 1054–67

242. León, San Isidoro, 1054–twelfth century

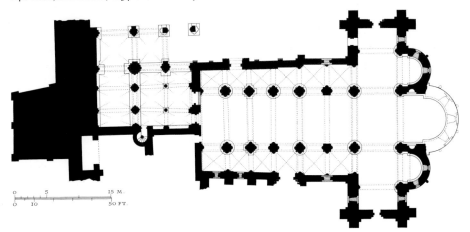

is triapsidal, and rather short, with an octagonal lantern tower over a tunnel-vaulted transept; the nave has no clerestory, but is covered by a tunnel vault with transverse arches, carried, with the similar vaulting of the aisles, on logical grouped piers. The resulting building resembles a Poitevin hall church. The abrupt verticals of the pair of cylindrical stair turrets at the west, and the boldness of the lantern give it special character.

It is quite clear that León could not have made the leap from Mozarabic to Romanesque without France, but the exact incidence of the influence is not easy to determine. There are, as in the case of the Panteón de los Reyes, credible signs of connexions with the Loire region, nourished by the pilgrimage to the tomb of St Martin (a popular saint in Spain) and re-inforced by contacts with French pilgrims to Santiago. Even more evident are the indices of Poitevin influence. The southward expansion of the Poitevin style has already been the subject of comment. It is exemplified in the cathedral of Ciudad Rodrigo [243] where also the nave is vaulted with Angevin ribbed domes; in the various churches at Soria; at Oviedo in the later constructions of the Cámara Santa, beautifully embellished with figure sculptures [58], and at Santiago de Compostela in the church of Santa María del Sar (1144); also, in the portal, the Christ in Glory, and the 'Apostolado' (1165) of the façade at Carrión de los Condes.[14]

Of these buildings, the cathedral of Ciudad Rodrigo is by far the most interesting – and the latest in date (1165–1230), proof of continuing contacts with western France. The interior has domed-up rib-vaults resembling Angevin construction, carried on substantial piers which remind one of the column-bundles of Poitou.

The great effort made in Romanesque times by warriors, settlers, and ecclesiastics from Burgundy makes it natural to expect the work of Burgundian architects and sculptors. Although in Burgundy itself the style was capable of the

243. Ciudad Rodrigo Cathedral, nave, twelfth century

grandest effects, it was never applied by itself in a really large-scale Spanish building. Either it was used by a Spanish architect in an eclectic composition, or by a Burgundian master in one episode of a long-continued building enterprise. The Spaniards never developed a Romanesque style strong enough to exclude all importations from the design of large works.

Usually, as the great Spanish buildings went forward, the imported forms were progressively hispanized, or, through change of plan, other forms were brought in to modify the design (not always to its advantage).

A good example of this process, with Burgundian forms involved, is offered by the cathedral of Santiago de Compostela [113, 114, 122–6], to which reference in detail has already been made. The main theme of Santiago was first achieved in Languedoc, but the axial chapel of

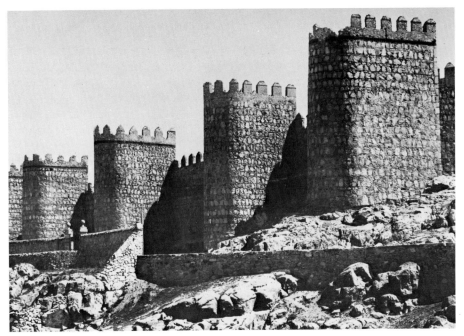

244. Ávila, city wall, begun 1090

San Salvador, off the ambulatory, seems rather Auvergnat or Provençal. Cusped arches there and elsewhere in the building give a Moorish tang. The corner turrets of the transept suggest Poitou (Notre-Dame-la-Grande at Poitiers) [212], as do the western towers (resembling the north-east tower of the cathedral of Angoulême), but the turrets at the east end of the nave, being set pointwise, suggest the Limousin. The original west front of Santiago Cathedral was finished off rather like that of Le Puy [128], but the Pórtico de la Gloria was inspired from Burgundy. In a way, one feels the effect of the funnel-shaped map of the Pilgrimage Roads in France – with its spout at Santiago delivering a variety of French regional features. The eclecticism of Santiago indicates a Spanish architect.

In passing one should mention an inferior copy of the Pórtico de la Gloria in the cathedral of Orense;[15] there are other cases of inspiration from France at second hand which have evident weaknesses.

We turn now to other examples where Burgundian influence is strong. It is certainly felt at San Millán in Segovia, at the elegant church of Santiago del Burgo, in Zamora, and at the delightful wooden-roofed church of Aguas Santas, where the covering is sustained by nave arcades carrying screens and diaphragm arches.[16]

Burgundy is strongly felt also at Ávila:[17] Raymond of Burgundy brought French masons to start works there, and something of their tradition survived. The walls of Ávila [244], at which they laboured beginning in 1090, when the city was in process of being repopulated after the conquest, are still complete and little obstructed by subsequent construction. They present a

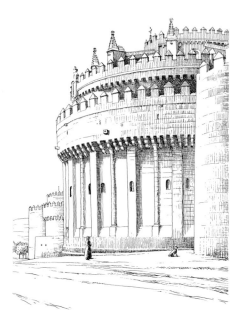

245. Ávila Cathedral, twelfth century or later, east view, without parasite structures (K.J.C.)

magnificent Spanish ensemble earlier in date than Carcassonne, and not nearly so much restored.

The Romanesque cathedral, now replaced, was close to the city wall, and quite possibly it was planned as a defence work from the beginning. A normal triapsidal plan (judging by structural lines which the present Gothic cathedral has inherited) would have joined and perhaps extended past the line of curtain wall east of the cathedral. In the rebuilding, the transept was apparently enlarged eastward, and a spacious new apse, ambulatory, and radiating chapels were erected within a vast semicircular projection which contained these elements and also continued the line of defences: indeed augmented them; for the projection has three battlemented passage-ways and a machicolated gallery of bold design. This work is of Gothic date, but it has Romanesque character, and is magnificently imposing [245].

San Vicente at Ávila[18] [246-8], a pilgrimage church, was begun shortly before 1109, and continued, with interruptions, to Gothic times. It has a plan which became classic in Spain - sanctuary triapsidal, applied with short sanctuary bays to a long transept with oblong bays projecting well beyond the aisles; a lantern tower at the crossing, and a relatively long nave. The nave of San Vicente has six bays, groin-vaulted, with ribs on the high vault. It is augmented by a very Spanish lateral porch and (exceptionally) by a tall open vaulted narthex bay like a great hood between the western towers. The tower bays open laterally upon the axial bay, and thus suggest an exterior western transept.[19]

There are other Burgundian features about San Vicente - the square crossing tower, the pier forms, the high nave with half-Gothic vaulting. The gorgeous western portal, partly Burgundian, partly Poitevin in inspiration, is one of the very finest in Spain; it is of about 1150.

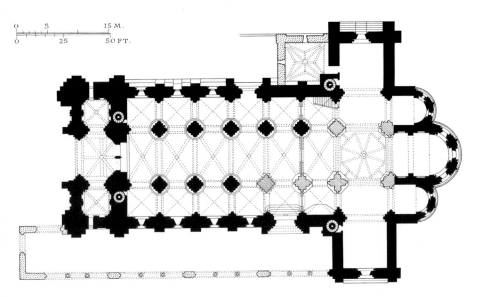

246 and 247. Ávila, San Vicente, *c.* 1109 and later

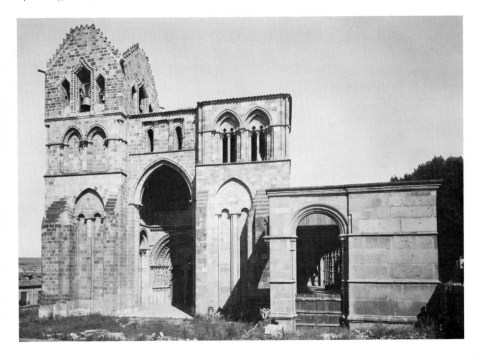

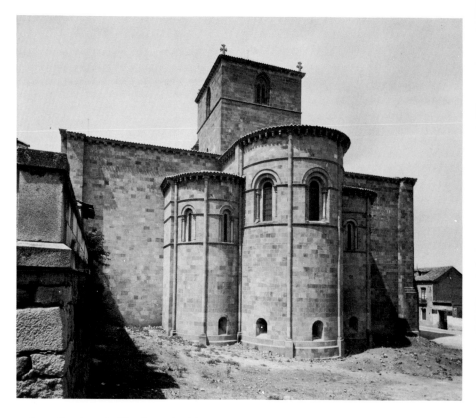

Santo Domingo de Silos is another site asso-
ciated with fine sculpture. The lost church
(almost entirely replaced between 1756 and
1816) was apparently a small building dating in
part from the lifetime of St Domingo (d. 1073)
but enlarged at both ends. There was a dedi-
cation in 1088. As finished, the church had a
layout somewhat resembling that of San Vicente
at Ávila. But the interest at Silos must always
have been in the remarkable cloister [249]. It is
now two storeys in height, and in use by the
community planted at Silos in the nineteenth
century. The most beautiful of its carvings are
those on the north and east walks at the lower
level, and they are the oldest – not dating before
St Domingo's death in 1073 as Arthur Kingsley

Porter supposed, but quite credibly in the period
1085-1100.[20]

The church of Santillana del Mar, near San-
tander, is another in this series of triapsidal
Romanesque buildings. Dating from the twelfth
century (and continued perhaps even into the
thirteenth), it shows the Spanish love for a style
once received and given a Spanish cachet. Santa
Marta de Tera shows this in another way: in a
building dated 1129 the plan (a simple cross),
the buttress system, the massing, and the decor-
ative zoning are surprisingly like those of a fine
late Visigothic church, such as Quintanilla de
las Viñas – but the striking thing is that both the
masonry and the detail are accomplished Ro-
manesque.[21]

248 *(opposite)*. Ávila, San Vicente, *c.* 1109 and later

249. *(below)*. Santo Domingo de Silos, *c.* 1085-1100 and later, cloister

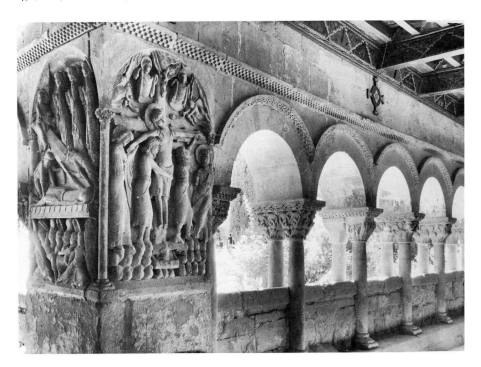

Another traditional element is the Spanish south porch – connected perhaps, but not demonstrably, with the lateral porches of Syrian Early Christian churches. In and near Segovia and Burgos there is a charming group of such porches: Sepúlveda, 1093 ff., Gormaz, Jaramillo de la Fuente, San Millán, and – with a characteristic tower – San Esteban, at Segovia. This is all twelfth-century work.[22]

On the Duero and to the south, near the western border of the old Kingdom of León (the present Hispano-Portuguese border), there is a group of half-Gothic churches which have a strong and unmistakably Spanish character. The latter include simple, traditional Romanesque triapsidal plans (with shallow sanctuaries

because the cathedrals and collegiate churches have the canons' choir at the head of the nave in Spain); very heavy walls and piers in unexceptionable ashlar masonry; ribbed dome construction resembling Angevin vaults; marked emphasis on elaborate lantern towers (at the crossing); and a superficial orientalism in the decoration. These buildings stand in western Spain, as Lérida and Tarragona do in their respective districts, for the Romanesque and transitional Gothic as received together in Spain, absorbed, and marked indelibly with national characteristics.

The cathedral of Zamora[23] [250] is probably the oldest of the group of the Duero to be realized in its present form. It was begun in 1152 and

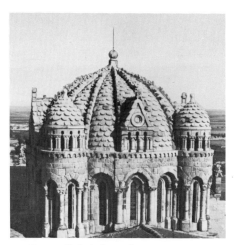

250. Zamora Cathedral, crossing tower, *c.* 1174

dedicated in 1174. Gudiol and Gaya Nuño think that the architect was not a Spaniard, perhaps because the orientalism of the Bishop's Door and the crossing tower is self-conscious and exaggerated rather than intimately understood. Yet the building is eclectic as Spanish designers' work often is. The transept façade has a strong Poitevin imprint; the interior is simple and perfect Burgundian half-Gothic. It has been shown in an excellent study[24] that the lantern at the crossing was inspired in part by the dome over the Crusaders' transept at the Church of the Holy Sepulchre in Jerusalem (dedicated in 1149), though the pendentives and the gored panels in the ribbed dome are special variants of French and Moslem work respectively.

Shortly after its first construction, corner turrets and axial gables were added to the crossing tower at Zamora, and thus its exterior came to resemble the crossing tower of the Montierneuf at Poitiers, a very influential design [251]. One window of the lantern was obscured by each of the four corner turrets, leaving twelve windows open – three between each pair of tur-

rets. The vault of the lantern is a single shell of ashlar work with a rib over each of the sixteen piers, and a gore over each of the sixteen windows. The ribs have cresting which is drawn up in an ogee curve to the apex of the tower. The gores and the spirelets (which repeat the ogee curve) both have a scale pattern on the stone roofing.

At the west end of Zamora Cathedral there is, for constrast, a very simple and imposing square tower. The east end has unfortunately been rebuilt, but without spoiling the building.

Near by, in the collegiate church of Toro, the lantern of Zamora and the more famous one which had meanwhile been built at Salamanca Cathedral inspired a handsome but less exotic design. The church at Toro was built in the period 1160-1240, almost exactly that of the cathedral of Notre-Dame in Paris. The heavy Romanesque walls and piers of Toro, its triapsidal chevet with short three-bay nave, short tunnel-vaulted transept arms and ribbed lobular and domed vaults, are in marked contrast to the Parisian building, which was already on the threshold of the High Gothic style.

The lantern at Toro has two storeys of windows, like that of Salamanca, but it is finished off rather lamely by a flat drum and simple tile roof. There is a great show of cusping on the windows of the drum, contrasting with ball ornament on the corner turrets.

There are two lateral portals and an axial porch at Toro. The north portal has three figured archivolts, two of cusping with a figure in every cusp, and all radiating like the figures of a Poitevin portal, but set off by alternating archivolts of Moorish leafage.[25]

The spread of the characteristic lantern motif of Zamora in the Duero region brought it to Salamanca, where it is represented, with variations, in the crossing tower and the former chapter-house of the Old Cathedral, both dated shortly before 1200. The last important medieval example is the thirteenth-century chapter-

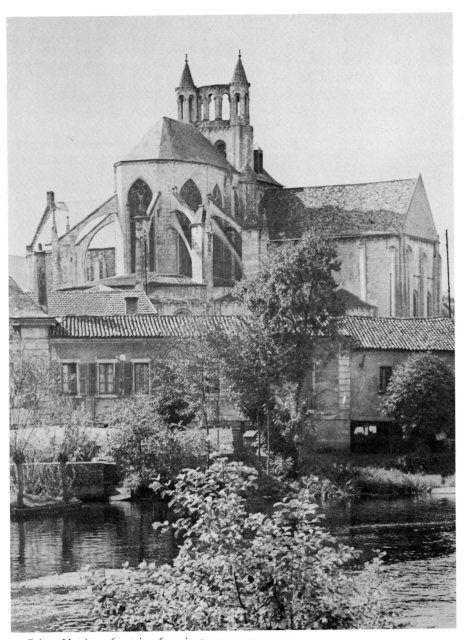

251. Poiters, Montierneuf, remains of crossing tower *c.* 1140

house of the cathedral of Plasencia, where it is called 'el Melón' because of the lobes in the vault.

Instinctively one feels that the great lantern-tower of the old cathedral of Salamanca [252, 253] is the masterpiece of the series. The aesthe-tic background of the cathedral as a whole is as varied as that of Zamora, but a greater harmony was achieved at Salamanca. The church was the greatest ornament of Salamanca when the city's early contributions to intellectual life and legal development were being made about 1200.

252 and 253. Salamanca, Old Cathedral, Torre del Gallo, shortly before 1200

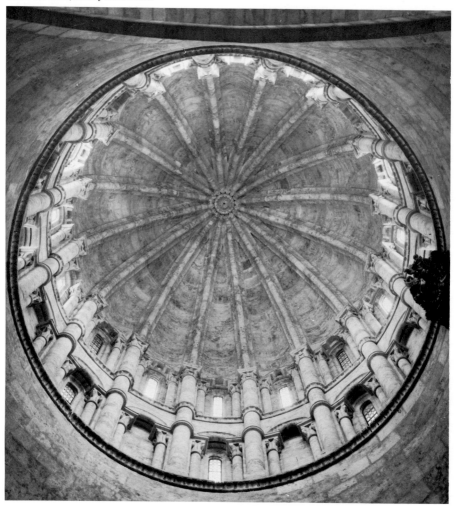

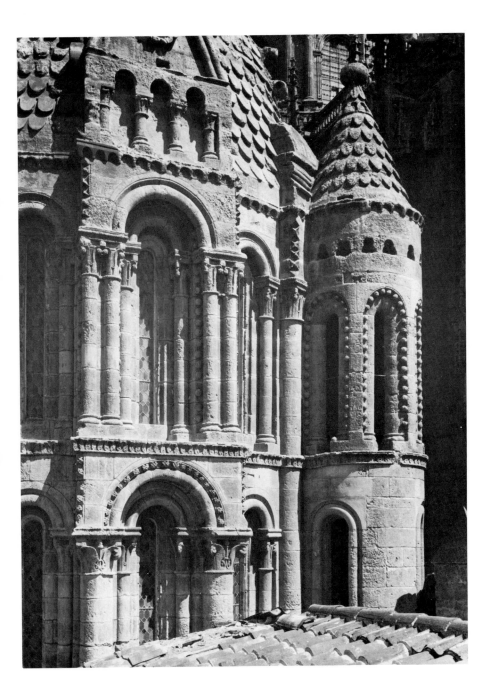

Salamanca, an ancient Roman town, was held by the Moors until about 1050. Under Alfonso VI a special effort was made about 1100 to develop it, and it was repopulated under Raymond of Burgundy. The architecture of the cathedral may owe something to a tradition started by a French archbishop, Jerónimo of Périgord, before 1125. Anticipations of its elements are found in Poitou, Languedoc, and Burgundy, but the building possesses a mature spirit of its own as an accomplished Spanish work of art [254]. The warm but proud and unyielding mass of the beautiful procession of nave piers makes one forget that their originals are Poitevin; the grave and severe succession of pointed

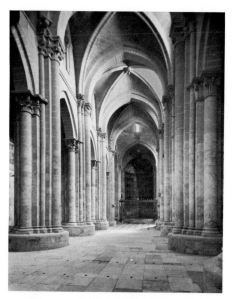

254. Salamanca, Old Cathedral, nave,
twelfth century

nave arches, clerestory windows, and half-Gothic vaults makes one forget that they are Burgundian and Angevin; the crossing tower, though suggested by that of Zamora, and ultimately by the crossing tower of the Montierneuf at Poiters, is too deeply stamped with the origin-

ality of its architect, Pedro Petriz, to be anything but Spanish.[26]

The building was begun about 1152 and finished early in the thirteenth century. Pedro Petriz is mentioned in 1163 or 1164 in the will of a Salamantine ecclesiastic Vela who directed the sale of various assets for the work of the cimborio 'sic quomodo dixerit Petrus Petriz que debet esse'. A Peter was master of the works in 1182, 1192, 1202, and 1207. Gudiol and Gaya Nuño believe that the first master (responsible for the generous layout, with an outer porch, five nave bays, and a transept extending a full bay to each side of the nave and the triapsidal sanctuary) was influenced by the School of Ávila; that Pedro Petriz, who took over the building when the walls had been raised to a certain height, possessed more genius, and a bent towards Zamora.

Among Spaniards the crossing tower goes under the name of Torre del Gallo because of its weather cock. The tower has two storeys of windows under a lobulated ribbed vault of sixteen cells which carries a slightly convex eight-sided fish-scale roof of stone with crockets on the arrises. This roof is in fact a separate shell of corbel construction weighing down the haunches of the ribbed dome. The interspace was filled with rubble. The thrusts of the dome are picked up by wide pilaster-like forms behind the corner turrets, and by a projecting bay enclosing the middle window on each of the cardinal sides of the tower. The bays are loaded by well-designed gables, the turrets by conical roofs which increase their resistance as buttresses, and break the silhouette of the tower in the most admirable manner. The construction of the enormous new Late Gothic cathedral, begun in 1513, involved clipping the north transept and aisle of the old church, but one may be sure that the architects who left the remainder of the building in place did so because of the general affection in which it has always been held.

There remains for our consideration the area about Santiago de Compostela.[27] The rural Romanesque of Galicia has a rare charm, but there is no first-rate building in that remote region apart from Santiago. The various movements which produced the Romanesque of Spain – including Santiago Cathedral itself – are reflected in these minor buildings. The cathedral of Túy, for instance, still has its battlements. Lugo and Orense Cathedrals are tardy Romanesque and half-Gothic – indeed the flavour of Romanesque is preserved even to the fifteenth century in rural Galician works.

Santa María del Campo in La Coruña and Santa María at Cambre in the province have a local interest. They are, in fact, rather like the handsome Romanesque of near-by Portugal, which is worthy of study on its own account.

PORTUGAL

It might have been expected that Portugal, as the Reconquest went forward, would become a part of Christian Spain, in spite of its somewhat more Celtic stock and the rather more oriental character of the country. The County of Portugal (Portucalia, taking its name from O Porto, the Port) was retaken in 1055–64, and Alfonso VI of Spain gave it to Henry of Burgundy in 1095 as a part of the dowry of his daughter Teresa. This gave Alfonso VI a certain protection against the Moors, who still held considerable territories to the west of his dominions. On Alfonso VI's death in 1109 separatism developed at once. The French colonizers, who only succeeded in gallicizing the court in Spain, reached independent status in Portugal. In 1143, under Henry of Burgundy's son, Affonso I Henriques, Portugal achieved an independence which was only lost (and temporarily) to Philip II and Napoleon I.

Affonso Henriques extended the country southward from the old boundary on the Mondego to the Tagus, where with crusader help he captured Lisbon in 1147 and held it, despite Moorish resurgence which gave much trouble to Sancho I, his successor (1185–1211). After struggles with the Moors, the Spaniards, and Pope Innocent III, the definitive boundaries of continental Portugal were reached and the kingly office assumed by Affonso III in 1263. During this process the Portuguese followed the policy of repopulation with foreigners (many of them French pilgrims and adventurers) which was so successful in Spain. It was Affonso I Henriques, ruler from 1128 to 1185, who built the enduring core of the state, as his grandfather Alfonso VI had done in Spain. Many of the Romanesque churches date from this prosperous and effective reign.

Affonso Henriques's birthplace, the castle of Guimarães, is really the cradle of Portugal. It goes back to 927, but was rebuilt by Henry I about 1100, and may still be seen to-day, the finest example of Romanesque fortification in Portugal – if not in the Peninsula. Its bold austere battlemented towers are full of the severity of the time, and enormously picturesque. Near by is the little nave-and-chancel church of São Miguel do Castelo, where, probably, Affonso Henriques was baptized in 1111.[28]

The rise of the towns, which occurred in the twelfth and thirteenth centuries in Portugal, is aptly illustrated by a contemporary monument (about 1200) – the Domus Municipalis or Council Hall at Bragança [255]. This unique example of civic architecture (in plan rather like a five-sided pocket, on account of an irregular site) is placed over a cistern adjoining the castle church. In function it resembled an abbey chapter-house; like a chapter-house it has a stone bench running entirely around it. The interior is two-naved, and wooden-roofed. Thus it was possible to carry a gallery with thirty-eight windows entirely round it at the top of the wall – a rare motif among existing buildings, but already reported in Abbot Odilo's dormitory at Cluny [104]. The parallel between the two constructions of 1035

and 1200 points to the relative conservatism of civic architecture.[29]

Braga, the capital of Portugal from 1093 to 1147, was placed in the ecclesiastical province of Santiago, when the archbishopric was set up in 1120 at the expense of the ancient dignity of influences we find that the detail is Romanesque. The same is true for the church of Cedofeita in Oporto (1120?); at Ferreira the new influences have brought a Poitevin apse.[30]

The local building material, granite, is of course similar to that in Galicia; hence the

255. Bragança, Municipal Hall, c. 1200

Mérida; but this merely recognized an existing state of affairs. Artistic influences had long been coming from Asturias and Galicia. We have indicated that the tenth-century church of Lourosa is the best existing representative of the Santiago Cathedral which was built between 863 and 896. The simpler Romanesque churches carry on the scheme so often used in the small Asturian buildings, of a nave, and a smaller shed-like sanctuary beyond (e.g. São Miguel do Castelo at Guimarães, c. 1100); but under new

Portuguese buildings as a rule, like the Galician, are wisely kept simple, and where elaborate sculptural effects are (by exception) sought for, the forms show the limitations of the hard material very clearly.

Pilgrimage and Burgundian Romanesque influences show themselves in the more ambitious Portuguese buildings.[31] São Salvador, Travanca (c. 1150?) and São Pedro, Rates (after 1152) are triapsidal – Travanca with the traditional deep rectangular apse on the axis. Both churches have

256. Coimbra Cathedral, begun 1162,
from the north-west

the familiar grouped piers and pointed arches,
though they were never vaulted. Even more
naturally do Pilgrimage and Burgundian influ-
ences come to the cathedrals which were built
progressively as the conquest and repopulation
went forward, until, south of the Duero, the late
date brings in Gothic architecture instead.

Something remains of the cathedral of Braga,
a triapsidal building originally begun about
1100, and connected with Santiago through the
legend that São Pedro de Rates, a supposed dis-

ciple of St James, was the original founder of the
church in Braga. At Oporto a similar triapsidal
cathedral church has been almost completely
transformed.

At Lisbon there has been much rebuilding,
but the cathedral has been understandingly
restored to something like its original form. It
stands prettily on a slope and still dominates its
quarter with a well-proportioned two-tower
façade and porch. The nave has an aisle to each
side; there is a transept with a lantern, and,

beyond, an ambulatory of Gothic ribbed construction with radiating chapels. There were English and Flemings in the pilgrim band which captured the city in 1147, and it was one of the Englishmen, Ralph of Hastings, who began the construction of the cathedral in 1150. The church is, however, not an English building; it has the Latin character and the fastidious warmth which we have mentioned in speaking of the finest Spanish Romanesque buildings.[32]

Lisbon Cathedral shared two masters, Robert and Bernardo, with the cathedral of Coimbra[33] [256], now called the Sé Velha because its function has been transferred to a newer building. Work was begun on the Sé Velha in 1162, just after Santiago Cathedral was finished. In this case the Portuguese architects produced a characteristic variation on the theme of Santiago de Compostela. The resulting church has a plan resembling that of San Vicente at Ávila [246] – five nave bays, a transept with a terminal projecting bay at each end, and three apses – but the superstructure, suffused with an elegance which betokens an appreciation of the delicacy of Moslem art on the part of its designers and craftsmen, has a very different temper from the robust Burgundian San Vicente and the opulent Languedocian Santiago. Decorative additions by 'João de Ruão' (Jean de Rouen) and his school early in the sixteenth century have made the building interesting to historians of Early Renaissance architecture without really spoiling it. It still retains its severe west front, with corner turrets and a projecting shallow tower-like mass comprehending the deeply embrasured main portal and west window of the church. Except for a corbel table over the portal and small arches at the windows, the walls rise sheer, and they are crowned vigorously and prettily with Moorish battlements (cubes or square parallelepipeda above the parapet, finished with pyramidal blocks). On account of the mild climate of Coimbra, it was possible to pave

the vault of the cathedral and thus make a fighting platform there.

The interior, especially when seen from the quadrant-vaulted gallery above the aisles, is very elegant and harmonious. The gallery is supported of course on the groin vaulting of the aisles, and there is a tunnel vault with transverse arches over the nave, which is without a clerestory. The lantern, square and rib-vaulted, is carried high, and the light which it sheds on the head end of the church is a happy feature of the interior effect.

Évora, being in the south beyond the Tagus, was not captured from the Moors until 1166, when the sanctuary of Paris Cathedral was already under construction. At Évora a spacious cathedral was started in the Romanesque style in 1185 or 1186 and consecrated in 1204, ten years after the sanctuary at Chartres had been begun in the High Gothic style. Évora Cathedral has the last of the peninsular cimborios in the Romanesque tradition, built about 1283 when the wonderful chevet of Beauvais Cathedral was being reconstructed. Yet the cathedral of Évora is hardly more than half-Gothic, with ribbed domes over the aisles, and a strong Cistercian or other Burgundian influence in the plan and in many of the details. The church has a nave and aisles of six bays, the transept extending beyond them. The sanctuary has been rebuilt, unfortunately in the eighteenth, and not in a Gothic century; for the Romanesque was still beloved in Portugal during the Gothic period.[34]

The great qualities of the very spacious Cistercian abbey church at Alcobaça, to which reference has already been made, are Romanesque qualities, although the church was built between 1158 and 1223. One might well call the hall church (here so magnificently represented in sturdy ribbed construction) a transfiguration, by the genius of Poitou, of the First Romanesque hall church type which we have followed in

modest examples of the tenth and eleventh centuries.

Not only do we find this outstanding example of Cistercian architecture here at Alcobaça in remote Portugal, but in addition the Templars are represented by one of the finest of their buildings still existing – the church of the Convento do Cristo at Tomar [257, 258].[35] Gualdino Pais was elected Grand Master of the Order of the Temple in Portugal in 1150, and it was he who fortified Tomar, at the time still close to the Moorish frontier. The church goes back to 1162, with the addition of a nave in the fantastic late Portuguese Gothic and transitional style called Manuelino.

THE TEMPLARS AND THE HOSPITALLERS

Since we are about to follow French Romanesque architecture to the Near East, this is an appropriate place to consider the reflex from another pilgrimage – the great international pilgrimage and series of Crusades to the Holy Land. These movements were greatly facilitated, and serious help was given to individuals and to the Christian Levantine states, by the military Orders of Templars and Hospitallers. Both Orders had dependencies in Europe which served pilgrims and wayfarers, encouraged recruitment, and provided income for the great work of defence, protection, and charitable care which the Orders performed in the East Mediterranean area.

The 'Poor Knights of the Christ and the Temple of Solomon' are remembered for considerable works of building. The Order was founded by Hugh of Payns, a Burgundian, and Godefroy of Saint-Omer in the north of France. In 1119 they undertook the obligation to protect pilgrims on the Palestinian roads. Joined soon after by other knights, they banded themselves together to live in chastity, obedience, and poverty according to the rule of St Benedict,

giving up the frivolous chivalry of the day 'to fight for the true and supreme King'. They had many recruits from the vagabond crowd of 'rogues and impious men, robbers and sacrilegious, murderers, perjurers and adulterers' (to give St Bernard's list) who overflooded the Holy Land in search of salvation and plunder, which were both available there. St Bernard sponsored the movement; its rule was sanctioned at the Council of Troyes, and soon the Order was established in almost all the kingdoms of Latin Christendom. Before long it had rich endowments and exceptional privileges; it became a powerful international institution with establishments wherever crusading enthusiasm could be stirred.

At Jerusalem quarters were early given to the Templars in Baldwin II's palace adjoining the Dome of the Rock, 685–91 (miscalled the Mosque of Omar) and the 'Distant' Mosque el Aqsa (eighth century, 1035, and later), both on the imposing rock platform where Solomon's Temple and the later temples all had stood. Both of the mosques (churches under the Crusaders) and on occasion the porticoes of the Temple platform entered into the Templars' pattern for church building in the Order.

The mosque called the Dome of the Rock is a great masterpiece of Moslem architecture, ultimately inspired from the Rotunda of the Anastasis at the Church of the Holy Sepulchre. It takes one part of its name from a wood-built central dome carried on a cylindrical wall pierced by columnar arcades. The dome covers a rocky outcrop sacred to the Moslems because Mohammed is said to have ascended to heaven from it; but the rock is believed to have been sacred in Jewish times also. Only the clergy might enter the domed sanctuary; other worshippers remained in the aisles (also wooden-roofed) which envelop the cylinder, but are bounded by an octagonal exterior wall. This arrangement of central rotunda and annular aisle

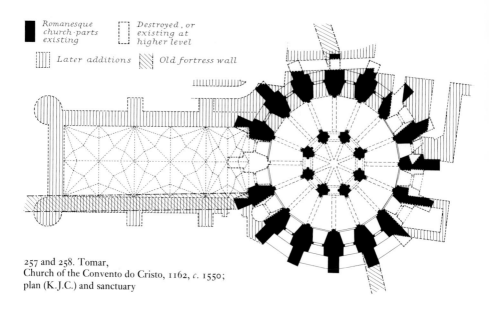

Romanesque church-parts existing

Destroyed, or existing at higher level

Later additions

Old fortress wall

257 and 258. Tomar,
Church of the Convento do Cristo, 1162, *c.* 1550;
plan (K.J.C.) and sanctuary

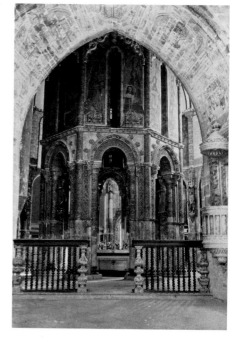

was used by the Templars in a limited number of their most important churches, and often augmented later by a choir or nave, or by both.

The Templars built vaulted churches in the Romanesque or Gothic idiom of their times, and quite lost the enchantment of their oriental originals. Like Cistercian architecture, the Templars' works tend to be monotonous, and not one of them ever rated high as an architectural masterpiece. The real architectural genius of the West never took on the Templars' problem as such. Their establishments were like contemporary conventual structures, with little or nothing specifically Templar, except, occasionally, the church.

The great Templar church of the Convento do Cristo at Tomar[35] [257, 258], already mentioned, is a notable exception. The older part of the church, begun between 1150 and 1162, has a sixteen-sided exterior aisle wrapped round an arched octagonal tower-like structure which serves as sanctuary. The style here is half-Gothic.

In the Templar church of the Vera Cruz at Segovia in Spain the ambulatory is sixteen-sided; the small central compartment is two-storeyed, and there are projecting apses toward the east – like those of a normal church. The date 1208 is given for this building.[36]

The Templars flourished in Navarre under Sancho the Wise (1150–94). The octagon at Eunate may well belong to his time. Eunate[37] is situated near Puente la Reina, where the Pilgrimage Roads from France all joined. It was a pilgrims' burial church, not a Templars' church, though clearly built under the influence of the Templars. The octagon is well proportioned, but it has no interior compartment; it is rib-vaulted, and has a rib-vaulted apse at the east. The church stands free in a remarkable arcaded court which recalls (with a difference) the porticoes of the Temple platform in Jerusalem; but

the connexion is not proved and the arrangement is not in its original condition.

The odd arcaded court, with some Moslem detail, which stands beside the little wide-naved church of San Juan de Duero may be related to Eunate, or perhaps to the atrium of a mosque. The church belonged to the Hospitallers of St John of Jerusalem, another of the military orders.

More familiar among the Templars' churches is the octagon at Laon, in northern France[38] [259], dated about 1160; this church has already been mentioned. The greatest church of the Templars in France was that in Paris, destroyed at the Revolution. It was built as a rotunda about 1150, but extended by a porch and a vast choir later on.

In England one well-known Templar shrine survives, the Temple Church, London, con-

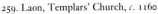

259. Laon, Templars' Church, c. 1160

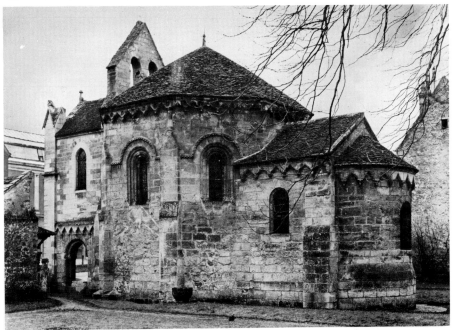

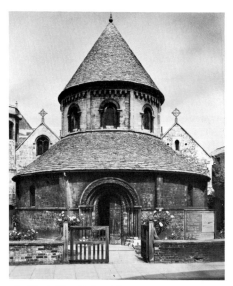

260. Cambridge, St Sepulchre, c. 1130

secrated in 1185, along with three related churches – the Norman rotunda of St Sepulchre, Cambridge (built about 1130) [260]; St Sepulchre, Northampton; and the supposed Hospitallers' church of Little Maplestead (c. 1119–1272, later rebuilt). The Temple Church, London, is a good example of the Early English Gothic style, with strong Burgundian and other Romanesque reminiscences. An oblong choir was added in the Gothic style about 1240.[39]

No Templar 'Commandery' survives complete, but such a group would be easily understandable on the basis of what we know of monastic architecture. The knights themselves would have quarters resembling those of a monastery of the time, integrated with the church. Quarters like those of the monastery servants would be provided for the servitors and garrison. Some establishments were like manors. In Palestine the Templars manned Crusader fortifications; they frequently built and strengthened castles, as need arose.

After the suppression of the Templars, the bulk of their property passed to the Order of the Knights Hospitallers of St John of Jerusalem (by 1320). The Hospitallers actually antedated the Templars, having been organized about 1113. Gerard, the first Master of 'that House of God the Hospital for the support of pilgrims and the necessities of the Poor', was confirmed by Pope Pascal II in February of that year. The pilgrims were often both poor and sick; the Hospitallers especially cared for such unfortunates in their 'Palace of the Sick' in Jerusalem. The hospice was located just south of the Church of the Holy Sepulchre, by Santa Maria Latina, and it soon had accommodation for 750 sick poor. In 1160 John of Würzburg reports 2000 sick and wounded being cared for there, with a mortality of fifty a day.

The Hospitallers fought also; they held, among others, the great fortresses at the Krak des Chevaliers (after 1142; c. 1200) [261], and Margat (c. 1200) 'with many towers that seemed to sustain the sky . . . eagles and vultures alone could reach its ramparts'.[40]

In Europe the Hospitallers had vast possessions, with myriads of buildings of all sorts, secular and ecclesiastical, but no characteristic architecture. One striking Commandery is preserved, at Saint-André at Luz, 1260.[41] It does not include a hospice, but its grim still half-Romanesque forms and its fortified church are otherwise very expressive. At this late period the Hospitallers also participated in the construction of bastides, but the latter are properly studied under the heading of civic planning and design in the Gothic epoch.

THE HOLY LAND

Examples of French Romanesque architecture still exist in the Holy Land as witnesses to the Crusades, which, though a spiritual movement, resulted in the establishment of a number of Latin states ruled by French dynasts – really a

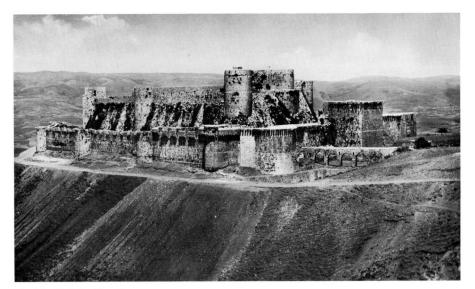

261. The Krak des Chevaliers, *c*. 1200

loose colonial empire attached to France by blood, history, and sentiment. It was a French Pope, Urban II, who, after a journey from Parma through France along a route burgeoning with new Romanesque churches, preached the First Crusade at Clermont-Ferrand on 26 November 1095. In the presence of fourteen archbishops, about 250 bishops and about 400 abbots from France, Italy, and Spain, he pronounced a remarkable address in Romance, making a dramatic call upon French piety and chivalric pride. The response was enormous, and it had the effect of re-uniting Western Christendom behind Urban II at the expense of the Antipope Clement III.

There was precedent for the enterprise in a force gathered in 1074 by Gregory VII, although the troops were not sent to the Near East. It was Urban's plea that the Crusade should be an organized expedition, but the great waves of emotion which were generated sent throngs eastward prematurely, with great losses and suffering. Later the Templars and Hospitallers mitigated such distress somewhat. A great military effort came early; by 1097 there were 150,000 soldiers in Constantinople on their way to the Holy Land, whereas in 1064 a group of 7000 pilgrims including the archbishop of Mainz was considered remarkable in point of numbers.

With considerable support from the fleets of the Italian maritime cities the Crusader hosts advanced, and captured Jerusalem on 15 July 1099, two weeks before Urban II died. They had not made well-reasoned arrangements for the government of their territories, and were thus at the mercy of internecine jealousies, while the Moslems, disunited in 1099, reassembled their strength. The Crusaders missed their early opportunity to capture Damascus and Aleppo, which would have cut the Moslem dominions in two; consequently the defence of Christian Palestine was much more difficult, and ultimately hopeless. Perfidy and brigandage by

irresponsible Christians made it necessary for the Moslems to destroy the Crusader states. Jerusalem itself was lost in 1187, and its Kingdom came to an end in 1244.

A theocratic government was first attempted under the former bishop of Pisa, Daimbert, who had accompanied Urban II to France, and assisted in the consecration at Cluny III in 1095. He came to Palestine with the Pisan fleet, and unsuccessfully tried to set up a state like the Papal Patrimony. The ecclesiastical interest, however, was always strong, and after the manner of its kind, succeeded in gaining considerable fiscal advantages. This meant ample resources for building.

The best-known construction which resulted is the Crusader enlargement of the Church of the Holy Sepulchre[42] [262, 263]. The original

Constantinian Martyrion had been destroyed, and the Rotunda twice rebuilt – in 614-29 by the Patriarch Modestos, and in 1045-8 by the Emperor Constantine Monomachos. He restored the Tomb of Christ, the Rotunda about it, and the ambulatory with radiating chapels on its western side – besides which he added new apses on the eastern side of the Rotunda. The Crusaders replaced these apses with a long transept entered through the famous double portal of its south façade, which is for us by far the most familiar aspect of the church. The façade is flanked on the east by a small domed vestibule, and on the west by a belfry tower. At the crossing of the transept, on the east-west axis of the Rotunda of the Anastasis, a small dome was built (the model for the lantern at Zamora) and the east-west axis was further

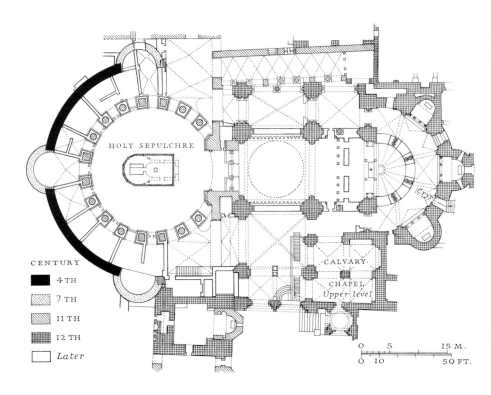

HOLY SEPULCHRE

CENTURY

■ 4TH

▨ 7TH

▨ 11TH

▨ 12TH

☐ Later

CALVARY

CHAPEL
Upper level

0 5 15 M.
0 10 50 FT.

262 *(opposite)* and 263. Jerusalem, Church of the Holy Sepulchre, dedicated 1149, plan and façade of Crusaders' transept

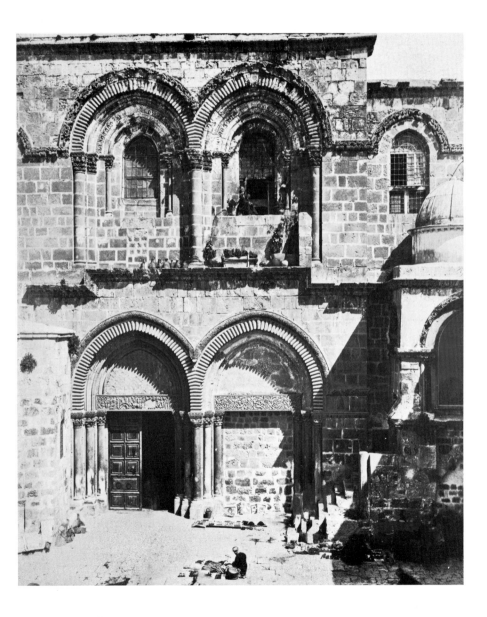

prolonged across a choir to a new eastern apse surrounded by an ambulatory and radiating chapels. Thus the new portion of the church was in effect like the transept and chevet of a Pilgrimage church. The ambulatory was required in order to provide communication with earlier shrines on the site. Beyond the apse, the crypt of the Martyrion basilica survived as the Chapel of St Helena, and a sub-crypt opening downward to the east from it was none other than the grotto where, according to tradition, the relics of the Holy Cross were found by the Empress Helena in 326. Beside the choir on the south, and served by the choir ambulatory, a raised chapel was built over the traditional Rock of Calvary. Exterior access to the Calvary chapel was through the small domed vestibule already mentioned. The dome of the Chapel of St Helena projected upward into the garth of the cloister of a monastery built for Augustinian canons who served the Holy Sepulchre; this lay to the east of the new apse.

This work has largely survived, though disfigured in parts, and much of the rest is at present under restoration. There is a considerable though not disturbing variety in style and fabric. Fine Syrian limestone is the material used, and the original work is beautifully cut.

Four reigning sovereigns of French nationality were present, during the Second Crusade, at the dedication of the new work, which took place on 15 July 1149, the fiftieth anniversary of the fall of the city in 1099. It is likely that the building was complete at the time, although there was no special need for the Crusaders to build in a hurry – the Rotunda of 1045–8 which they took over was a fairly spacious building. The existing work is very complex stylistically: there is a range all the way from the classicism of the transept cornices through the half-Provençal-half-Poitevin transept and sanctuary to the Gothic bell-tower. The high vault of the transept is ribbed, and its design has an odd Burgundian flavour. The dome is of Levantine

form. It is much to be hoped that there may be a sympathetic restoration of the Crusader work and the Rotunda, where Constantine Monomachos's work was buried within clumsy arcading after a fire of 1808. The old building retains a certain dignity in spite of all its disasters and the divisioning which has been necessary in order to accommodate the various sects which possess rights in the building. Its greatest moment is at the Orthodox Easter, with the traditional ceremony of the new Easter fire, brought from the tomb to the multitude waiting, in the darkened Rotunda, with their candles ready for the symbolic light.

The beautiful south doorways of the transept of the Church of the Holy Sepulchre are exceptional in their richness. The carved lintels, with scroll-work and figures, recall early twelfth-century Toulousan work.[43]

Crusader masonry is fine, and the buildings make their point by excellence of construction, on which account they are in many cases still preserved entire with but little change. In form and execution they are comparable to good French work; the designers were obviously men in close communication with the motherland. Many churches were in Cistercian or Burgundian half-Gothic style, though with the terrace roofs which the climate permits. The cathedral of Beirut (now the chief old mosque of the city) is fairly typical. It has a dignified nave of five bays with a tunnel vault with transverse arches and a clerestory. The aisles are groin-vaulted, and the east end is triapsidal. Pointed arches are used; and this, too, is quite general in the Crusader churches. Tyre, Caesarea, and Sebastieh have transepts. Tortosa has chapels arranged like the Orthodox prothesis and diaconicon; the Cluniac priory church on Mount Tabor (now destroyed) had western towers provided with small interior chapels. Apses enclosed in blocky masses of masonry (as is occasionally the case in Provence) occur at Nazareth, Ramleh, Mount Tabor, Tortosa, Caesarea. Groin-vaulted naves

are unusual, but do occur, for instance, at St Anne in Jerusalem. St Anne has a crossing with a dome on pendentives resembling those of Périgord, which is also unusual.[44]

These buildings have somehow kept alive the religious aspect of the Crusade, too often forgotten in the tales of ignoble competitions, greed, perfidy, jealousy, suffering of innocent Moslem folk and waste of human resources, which are such conspicuous features of Crusader history. Arab observers seem to indicate that the population of the Christian states was relatively well off, and the shrines which still remain breathe of a satisfying religious life.

In passing, Cyprus should be mentioned. It was conquered by Richard Cœur de Lion in 1191, on his way to the Holy Land during the Third Crusade, and sold to Guy de Lusignan; the Lusignans held it until 1489. Bellapais Abbey, Cistercian in character though dated c. 1324-9, remains, with several castles, as a memorial to their regime.[45]

EXCHANGE OF INFLUENCES:
THE PROBLEM OF ARMENIA

Sir Alfred Clapham, in his excellent book *Romanesque Architecture in Western Europe*, takes occasion in the chapter on the Holy Land and the East to consider the theories of oriental influence on Romanesque architecture. He was, quite rightly, a convinced 'Westerner' inclined to place high discounts on theories of direct influence, except where trustworthy historical information is available. This is the case with the Templar churches, where the Western imitation is admittedly very imperfect. Supposed derivations too often repose on guesswork and superficial resemblances.

Stress was laid by Sir Alfred on the point that intercourse between East and West suffered no interruption at the fall of the Western Empire, and that the reconquest under Justinian rendered Eastern influence in Italy and parts of

Spain stronger than it had been before. This was true also of the Moslem conquests and the Iconoclastic troubles, which expatriated vast numbers of Greeks – some of them artists, some of them patrons with a taste for Eastern art. The Ottonian Byzantinism affected architecture but little. By Ottonian times divergences between East and West were strong in churchmanship and monastic practice – especially strong at the time when Romanesque architecture was being formed. Consequently, at that time the actual oriental influence was relatively small, beyond what was being absorbed by a sort of architectural osmosis.

Critics with sound architectural training – and Sir Alfred was one – are little impressed by superficial and literary resemblances when practical and structural elements do not correspond. This objection is valid in the case of Armenian architecture, which is the most subtle, finished, and impressive of all the proto-Romanesque styles.

The Armenian architects dealt with the same elements and many of the same conditions as the Romanesque architects of the West. They developed parallel solutions at an earlier period, and since they faced their buildings with ashlar, the superficial appearance of the buildings is sometimes quite similar to Romanesque. One of the most notable buildings in this respect is the cathedral of Ani (989-1001) by Trdat. This is a domed basilica possessing grouped piers; pointed arches, ribs, and vault; decorative exterior arcading somewhat resembling Pisan work, and (before its destruction) a graceful crossing tower with a dome on drum and pendentives. The Armenian church designs most typically 'build up' into domes and towers of this type. The noticeable lack of this arrangement in supposed imitations counts heavily against the idea of direct influence from Armenia on the Occident.

Similar doubt attends the idea of direct influence from Armenian ribbed vault construc-

tion to the West. The history of this sort of vault construction in Armenia begins with Surb Hripsimé at Valarshapat (618), where twelve decorative ribs exist, probably suggested by St Sophia in Constantinople, but forming (in groups of three) the arms of a large decorative cross on the soffit of the dome. The Romanesque-looking Armenian ribbed work of the tenth century is a passing phase; for the development continues into ingenious combinations of ribs arranged (sometimes over four supports) like a printer's sign for space ($\#$) with a turret at the summit, centrally placed. In fact, the Armenians were always interested in centralized rib schemes, and these have had only slight influence in the West.

It is known that the Armenians were good masons, and perhaps something of the fine quality of the Crusader churches in Syria is due to them; but the Syrians, equally, are good masons, and doubtless good masons came from France. It is significant that when the French patrons were actually close to Armenia and its architecture – and indeed there were Armenians in Jerusalem also – the architectural influence was nil, or but little more. Instead, we have an 'école d'outre-mer' which is very largely Burgundian and Provençal French.

An authentic case of influence from the Near East on the Romanesque and Gothic world is offered by the fortifications. The Crusaders learned 'the hard way' about Byzantine and Arab improvments on ancient Roman fortification, which was all, or nearly all, the Westerners knew. French developments of these Near-Eastern motifs in fortification became in the end real architectural features of the French châteaux, and occasionally of the churches. The increasing scale of warfare in the West – for it became national in scope in the course of the twelfth century – would in any case have brought about innovations and improvements spontaneously in the Occident, because of the high

order of talent attracted to the problem, and the vast resources made available for reasoned programmes of defence.

The early Crusader castles in Palestine had traditional square or oblong donjons, within angular surrounding walls strengthened by oblong towers. The perennial shortage of manpower for fighting in the Holy Land made efficient design imperative. Much was learned from local examples of Byzantine and Arab fortification, and from experienced engineers of the area. Progressive improvements – including round towers, taluses, other devices, concentric arrangements, and regional signalling between castles – taught a lesson to the West.

Richard I Cœur de Lion of England, son of Eleanor of Aquitaine and Henry II, after practical experience on the Third Crusade, built the finest of the twelfth-century castles in France – Château-Gaillard on the Seine at Les Andelys, not far from Rouen (1196–7). It had projecting towers, three successive wards, of which the inner had walls with successive convex projections to increase the effectiveness of defenders' fire, and a central donjon. It prefigured the concentric castles which were developed in the thirteenth century and built, in imposing array, by the Crusader knights in Syria (including the Krak des Chevaliers and Margat). Further developments of machicolated galleries, brattices, crenellations, applied to the royal and noble residences, gradually gave to such structures the picturesque and unmistakable character which we associate with the late medieval château. But the development was functional, and the picturesqueness was genuine, not romantic.

With this comment on the reflex from the Crusades, we leave the Holy Land, and also for a time the regions where French influence was paramount, in order to take up the subject of mature Romanesque architecture in the great areas associated within the Holy Roman Empire.

MATURE ROMANESQUE ARCHITECTURE IN THE LANDS ASSOCIATED WITHIN THE HOLY ROMAN EMPIRE

INTRODUCTION TO CHAPTERS 19-22

The areas which are to be considered in Part Six have a very loose geographical and stylistic connexion. They offer a magnificent architectural panorama of local developments based on the primitive Romanesque of the respective regions.

They developed spectacularly in scale, richness, and superior craftsmanship from the local Early Romanesque styles, but lacked the inventive drive which eventually achieved the definitive solution (in France) of the essential vaulting problem. Gothic architecture might have come out of a number of the schools which we are about to analyse – the components of Gothic were there; but the established styles had given a fairly good account of themselves, and the hold of tradition was too strong. A certain unity will be given to our exposition by mention of the features which the respective styles contributed to the development of Gothic architecture.

The order to be followed is geographical, beginning with the Two Sicilies and proceeding northward through Italy and, after an excursion to Dalmatia and Hungary, northward again to the Germanic lands.

It needs to be emphasized that this account is purely topographical, and not developmental. Each local group has its own history – but the strands which are interwoven represent stylistic impulses which we have seen appearing in the great styles – the styles already treated as our principal theme.

THE TWO SICILIES

APULIA

As to the Holy Land, so also to south Italy and Sicily, Romanesque architecture came because of fabulous French adventuring. The mountain barrier of the Apennines and the Abruzzi, together with the stagnant Papal state, kept off influences from the north – except what might come through the pilgrimage to Monte Gargano, and later to Bari – while the brilliance of Byzantine and Moslem civilization was reflected from the south and east, then in close maritime and political contact with south Italy and Sicily. The Eastern Empire had gradually lost the Beneventan and Salernitan areas to local duke-

doms, and the island to the Arabs in 917, but retained Apulia, Calabria, and the Basilicata. Beginning about 1030 several sons of Tancred of Hauteville or Hautteville-la-Guichard, near Coutances in Normandy, came into the south Italian area at the head of Norman bands, and by 1041 had a strong hold on Apulia. One of the sons, Robert Guiscard, who arrived in 1046, was by 1059 recognized as Duke of Apulia and Calabria; also as future Duke of Sicily, as he said, 'if the grace of God and St Peter help me'. The same year marks the consecration of the first church at the abbey of Venosa, which was built to be the family pantheon. In 1061-91 Sicily was conquered; Roger II, Count of Sicily,

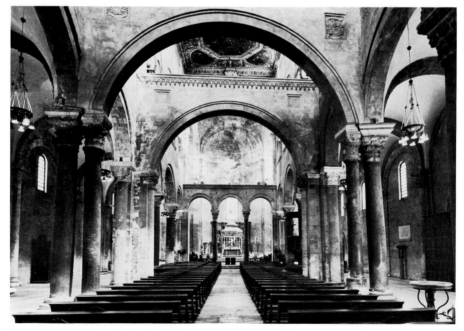

264. Bari, San Nicola, under construction 1089

obtained the title of King in 1130; he united and filled out the Norman possessions on the mainland by 1137, but in 1194 they passed to the Empire. The area passed to the Roman from the Byzantine patriarchate in the pontificate of Urban II, and saw hosts of the First Crusade depart in 1096–7.

The first serious beginnings of Romanesque architecture came at this time, and Lombard influence, which had played upon Normandy itself, is felt in Apulia in the oldest Norman church of importance in the south of Italy. The building in question, San Nicola at Bari[1] [264–6], stands as the head of a regional stylistic

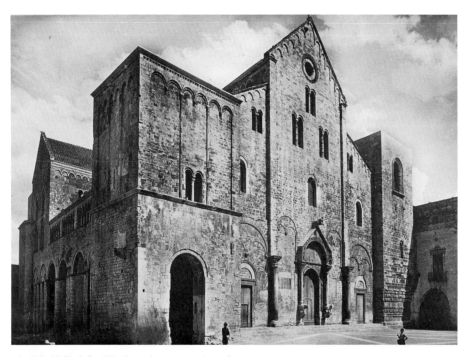

265 and 266. Bari, San Nicola, under construction 1089

group localized on the east coast of Norman Italy.

The relics of the venerable wonderworker St Nicholas, bishop of Myra in Anatolia – so much in honour with the Greeks and Russians, and known to us as Santa Claus – had been abstracted from his tomb in the ancient cathedral and brought in 1087 to Bari, where they still are, in a sanctuary which was already building in 1089, under Benedictine auspices, to receive them.

As an architectural composition San Nicola is sophisticated and eclectic with the traces of a mature individual personality in the design, rather than the signs of development within the frame of a tradition.

The church was planned from the first as a pilgrimage church; here, as earlier at Saint-Bénigne, Dijon, that meant a large crypt, with groin vaults *en quadrille,* supported on columns, Lombard fashion. Access to the crypt was arranged by stairways opening into the eastern-most bays of the church aisles, where there were suitable lateral entrances. This part of the church, with its superstructure, was finished in 1098, when Pope Urban II held the Council of Bari in the building. A large part of the church was built and embellished by 1132, but the work dragged on to a dedication in 1196 – a fact which explains irregularities in the western towers. With these towers San Nicola became, in intention at least, a four-tower church (one tower at each corner), and perhaps the original of a Hungarian group of such buildings. Almost certainly, however, the fine great bulks of the western towers – one Lombard in appearance, the other half-oriental – were not part of the first design, though the sheer precipice of masonry which they make, flanking the strong basilican profile of the church, is very effective.

If San Nicola was indeed at first intended to have only the two slender sentinel towers at the eastern corners, beyond the crossing, it would originally have resembled Sant'Abbondio at Como (*c.* 1063-95) [300]. However, one of the tower pair has never been completed. The aisles were vaulted, as at the cathedral of Pisa (1063 ff.). Disorders in the western bays of this con-struction have caused the intrusion of low dia-phragm arches spoiling the effect of the west end of the great nave, which was intended to rise free, as the eastern part does, to the wooden-trussed roof above. The handsome range of arched spur buttresses on the flanks, rather like those of a Poitevin church, has taken care of the outward thrust of the aisle vaulting. Above it there is a rich arcaded wall-gallery at the tri-forium level – an early example of this motif, which became very common in Lombardy. The triforium space itself, as at Pisa, opens upon the nave through a series of triple arches under en-closing arches; above there is a simple clere-story, as at Pisa. Analysis thus shows that the debt of the building to Pisa Cathedral is more real than apparent.

A further debt to Tuscany is evident in the nave, divided into two major bays, each corres-ponding (as at San Miniato al Monte, Florence [290]) to three aisle bays carried on columns. As at San Miniato there is a grouped pier at the junction between the major bays, and it is pos-sible that a diaphragm arch was intended (as at San Miniato) though never executed.

It seems likely that the western major bay was designed specifically for the congregation at ser-vices. There are three portals at the façade, and there is a lateral portal in each aisle at the head of this major bay. The eastern major bay of the nave would then serve specifically for the *schola cantorum* of the monks, marked off from the public – thus leaving the flanking aisles and portals for access to the pilgrimage crypt.

The transept opens behind a triumphal arch which frames the altar and the apse. In addition, there is an open three-arched screen which serves to mark off the monks' choir from the transept, and at the same time to strengthen the supports of the crossing tower (an octagonal lantern on squinches). The high altar, with a baldacchino, is placed beneath, as often in Early Christian times. The modern arrangement of flanking stalls keeps this area clear for the clergy, but in the Romanesque period the whole tran-sept of a Benedictine church would normally be reserved for the monks' devotions. This may still be sensed in San Nicola, where, logically enough, there are no transept portals.

Each arm of the transept has an absidiole; the main apse has a synthronon in the Early Chris-

tian manner, with a bishop's throne on axis. The Bari Throne, as it is called, has an interesting place in the history of Romanesque sculpture; for, dated 1098, it is a mature work of Guglielmus, one of the men who first renewed the art in Italy. It is possible that he invented the well-known motif of a church portal with its columns carried on the backs of animals; at any rate the motif appears in San Nicola at Bari, with the animals in the form of corbels.[2]

It remains to mention the box-like wall which encloses all the apses of San Nicola, and makes a sheer straight east wall for the church, embellished by the rich window of the main apse, and intended to have the slender twin towers rising above it at the corners. It was a Roman-

esque addition, perhaps suggested by the Lateran transept [283]. The wall has shallow arcading with a half-Pisan, half-Lombard look about it, well related to the more vigorous buttress arcading, the gallery, and the portals.

Not the least charm of San Nicola is its handsome ashlar masonry. The stone-work, finely cut, has mellowed to a warm soft greyish brown, active in texture and with lovely surface effects in the sunshine. This beautiful stone was generally available, and its use characterizes the whole series of buildings related to San Nicola, very greatly to their advantage.

The general design of San Nicola was quickly absorbed into Apulian architecture, and the resulting family of buildings constitutes a very

267 *(opposite)*. Trani Cathedral, begun 1098, from the west

268. Alberobello, trulli (corbelled domes), traditional

attractive regional group ranged along and near the coast north-westerly from Bari. The notable examples are all cathedrals. Several of them stand boldly with their sentinel towers close to the water's edge on the Adriatic shore, and thus add to the picturesqueness of the towns. Most closely related to San Nicola are the cathedrals of Barletta (begun about 1139, under way in 1153, and enlarged in a different style in the fourteenth century), Bari (begun after 1156, under way in 1179), Bitonto (begun 1175; portal 1200), Ruvo (twelfth century), and Bitetto (more or less contemporary).[3]

Less clearly from Bari is the filiation of the cathedral of Trani[4] [267], begun in 1098 and dedicated to St Nicholas the Pilgrim, an idiot boy unable to say anything but *Kyrie eleison*, who attracted pious attention. This pilgrimage church has a complete crypt; there is a fine west porch leading to bronze doors; there is a single bold western tower. The wooden-roofed basilican nave has an included transept; the east end has no towers or 'box' – only three projecting round apses. Beautifully weathered, the building is very handsome in a setting which has hardly changed since it was built. The detail is largely Lombard.

To this rather Lombard group of Normano-Italian buildings may be added a sporadic domed group. Domes had been used for a long time in the 'heel' of Italy, as at Alberobello [268], for utilitarian constructions.[5]

Molfetta Cathedral [269], like that of Trani, has Lombard detail, and is set close to the water. Like the churches at Bari, it has slender paired eastern towers, but the nave is covered with three domes in line, and the aisles are quadrant-vaulted: a most unusual arrangement. The date falls late in the twelfth century (1162 ff., with some reconstruction about 1300).

The repeated dome occurs also in the cathedral of San Sabino in Canosa, dating from 1100 and later. Here at Canosa is also the domed classicizing tomb (1111-18) of the restless and faithless crusader Bohemond, son of Robert Guiscard.[6]

Tuscan influences flowed, rather parsimoniously, into Norman Italy too.[7] Troia Cathedral, for historical reasons, is Tuscan in style,

269. Molfetta Cathedral, 1162 and later, from the north-west

except perhaps on the exterior of the apse, which is sufficiently like that of Kalat Seman in Syria to raise the question of Eastern influence – not necessarily through the Crusades; for the church was begun in 1093, and was well along in 1127 [270].

Siponto Cathedral (twelfth century) has Tuscan exterior arcading also, but the church is an abrupt square block, very oriental-

interesting, except for a later campanile and a domed tomb or baptistery (c. 1180).

So far we have seen little or no French influence in this architecture of the Norman dynasts. The latter were fighting men, and their entourage was far too mixed to have any artistic orientation. Moreover, when the Haute-villes left Normandy, the Norman school was as yet hardly constituted – its great early monu-

270. Troia Cathedral, begun 1093,
upper part of west façade

looking in mass. It has a rich portal in the Lombard style, and thus is suitably eclectic for the region.

The great shrine of St Michael of Monte Gargano, or Monte Sant'Angelo, resulted from a vision of the archangel seen by a bishop of Siponto in 491. The site is not architecturally

ment, Jumièges [357–9], dates from 1037–66. The Norman French were then still under strong influences from the Loire, from Burgundy, and from Lombardy, on which the south-Italian Normans also drew.

In the later period after 1050, there is occasional French influence in Norman Italy.

This is the case at Venosa (begun after 1100 and never finished or dilapidated, so that it shows the technique of Romanesque building) and in Acerenza (related to Venosa). Aversa,[8] not far from Naples, has a cathedral dating from about 1150, containing an archaic-looking rib-vaulted ambulatory, which would seem to be ultimately of French inspiration, though with the church of San Clemente at Torre dei Passieri, Teramo (1178–82), which has a half-Burgundian triple porch, it may have acquired the ribs through Lombard influence.[9]

Rivoira believed that the ambulatory at the cathedral of Aversa dated back to 1049–56, and Arthur Kingsley Porter was led to give considerable emphasis to the sculptures of San Nicola, Bari, as early examples due to Pilgrimage connexions; but the remoteness of the Apulian school, and the fact that the civilization of the Two Sicilies was hardly a Romanesque civilization, make this Romanesque really a Romanesque *in partibus*, of which the reflex influence elsewhere was perceptible, but not great.

THE BASILICATA

Worthy of notice is a small group of churches in Calabria. 'Roccella di Squillace', near the site of Cassiodorus's sixth-century monastery of Vivarium, has an imposing ruin of rather Byzantine character, in some ways like the tenth- and eleventh-century churches in the capital. The policy of the Normans, who acquired this region in 1057, was counter to the Orthodox Church. The plan of Roccella di Squillace, with a crypt, a wide transept, and a wide wooden-roofed nave, seems Western, probably of the late eleventh century.[10]

'La Cattolica' (Catholicon, the chief church of a monastery) of Stilò, near the coast, closely resembles the later rustic Byzantine which is found in the Balkans, and may date from the fourteenth century, though it is often dated

earlier.[11] It is one of a group of churches which are basically versions of the Byzantine four-column church.

Another Byzantine reminiscence is that of St Nilus of Rossano, who, driven from the region by the Saracens, carried the Eastern (Basilian) monastic rule to Grottaferrata, near Rome, where Otto III, perhaps remembering his Byzantine mother Theophano, aided in founding a monastery (1004) which is still Basilian, though under papal auspices.

SICILY

The fantastic history of this island guaranteed it an exotic architecture. Very little of real importance to the history of architecture was built, as far as we know, between Greek and Norman days, though the successive Roman, Byzantine, and Moslem regimes left their mark. The Normans, who conquered Sicily in 1061–91, have left monuments of great dignity but composite style. Like their English cousins, they achieved, with papal sanction, a tight control of the church, and intelligently prevented friction between the Latins, the Orthodox, and the Moslems. New episcopal sees were set up and staffed with Latin ecclesiastics. The half-Moslem-half-Byzantine charm of the place affected them, the court, and the architects profoundly, and their Romanesque architecture absorbed, with much grace, the alien elements. This mode of building was still in vogue when the Two Sicilies were united to the Empire, 1194.

Court architecture[12] naturally inclined to Moslem models; for the Normans of the court were human after all, and the Moslem palaces were designed to house a life of sophisticated refinement such as was hardly known in the north. The Favera, Menani, La Ziza, and La Cuba are known examples – Palermitan buildings in which the oriental lords of Sicily would have been very much at home. The local

271. Palermo, Palatine Chapel, 1132–89

272. Palermo, the Martorana, 1143-51 and later, flank

building material, none other than the *poros* (rough limestone) which the ancient Greeks used for their temples, adapted itself very happily to the new architectural mode. In it decorative Moslem arcading and pattern-work looked well; it combined happily with stucco for panelled effects, and with marble and mosaic for rich interiors. One finds in these designs, without seeming contradiction, the round Roman arch, the interlaced Norman arches which make pointed-arch patterns, the Moslem pointed arch, and rib work. There are decorative details where Romanesque, Moslem, and Byzantine motives frolic together; there are columns of classic proportion taking their part in compositions with Byzantine mosaics and Moslem domes, honeycomb roof artesonados and stalactite ceilings. All are brilliant in Mediterranean sunshine and glowing with warmth; for the limestone walls weather to enchanting toasted browns, buffs, and greys, richly contrasting with the azure sky and

bowers of orange, lemon, and palm trees. Roger II acquired territories on the mainland of Africa, which accentuated the orientalism of his dominions and naturally came to expression in the architecture.

It has been very reasonably suggested that the Orthodox in the Greek parts of the island had for two hundred years been assimilating Moslem and Byzantine architectural motifs, achieving a *savoir-faire* by which the Norman architects early profited.[13]

A famous example of varied architectural combination is the Palatine Chapel in Palermo[14] [271], actually within what remains of the royal palace there. It was built by Roger II between 1132 and 1143, and dedicated to St Peter; really it is a miniature church, with slender columns of marble dividing the nave from the aisles of a triapsidal basilican plan. The columns and the lavish wall mosaics – applied, except for some restoration, between 1143 and 1189 – are purely Byzantine in style. Tall pointed arches of Moslem form, and an elaborate stalactite ceiling over the nave are the oriental components in this design.

The 'Martorana'[15] [272], really the church of Santa Maria del Ammiraglio, built and decorated between 1143 and 1151 for King Roger II's great admiral George of Antioch, was dedicated to the Virgin 'with much love, and as a small and unworthy recompense' – so the inscription says. Later building has disturbed the original entrance system. An axial porch (still existing, and marked by a late tower) gave upon an atrium and narthex, as in an Early Christian church; however, beyond the narthex the building was arranged and decorated like a Byzantine four-column church, except that the pointed arches and the squinches of the dome were of Moslem design. The tower (fourteenth century) is basically like the crossing tower of the Montierneuf at Poitiers [251]. Perhaps there is influence from the Salmantine school of

crossing towers here. Wherever originated, the tower design of the Martorana has been half-orientalized, and developed towards the form which we shall find in the dramatic clusters of turrets at Palermo Cathedral later on.

San Giovanni degli Eremiti,[16] of 1132, has on the church (a simple block of a building of austere oriental exterior form) a series of Moslem domes which are hemispherical, and placed without mouldings on short cylindrical drums. The tower terminates coquettishly in a similar dome. There is a poetic cloister. San

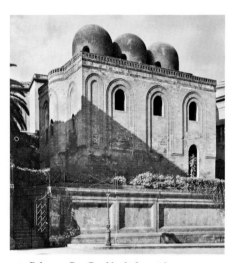

273. Palermo, San Cataldo, before 1161

Cataldo [273], essentially similar to San Giovanni, was built as a synagogue and taken over as a church in 1161. Exotic and unchurchly as it is, with Moslem domes and decorative pointed arcading, it does not seem out of place as an ecclesiastical building in Palermo.

Meanwhile, in 1131, construction of the cathedral of Cefalù had been begun[17] [274]. Its patron, Count Roger II, was accorded the title of King by the antipope Anacletus II, and for this alliance was excommunicated in 1139 by

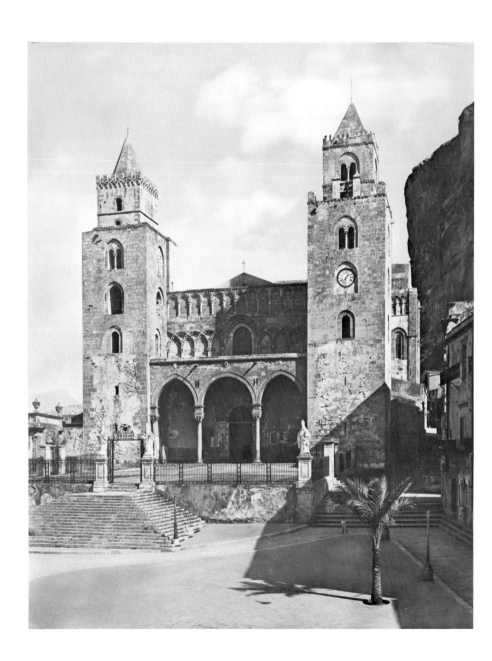

274 and 275. Cefalù Cathedral, begun 1131

Pope Innocent II, but the situation was regularized in 1140. Cefalù was served by a chapter of Augustinian canons. For them a pretty cloister was built, in the style of the church, just to the north. After Roger II's time the great project at Cefalù languished; ultimately the royal pantheon was established in Palermo, and even King Roger's sarcophagus was transferred there from this, his tomb-church.

In plan Cefalù Cathedral is very handsome [275]. The walls are substantial. The east end has a sanctuary covered by groin vaulting and a pointed semi-dome; flanking it are two deep tunnel-vaulted chapels. The transept, slightly projecting, is covered partly by tunnel vaulting and partly by wooden roofing. These parts of the church had been finished and decorated in 1148, but there is much later work – the nave was built between 1180 and 1200 on a reduced plan, and the wooden-trussed roofing of the nave was restored in 1263; the façade dates

from 1240, with some rebuilding in the fifteenth century.

The exterior of the cathedral is perhaps the finest in all the Sicilian Romanesque. Two handsome towers, like North-African minarets in design, flank an elegant columnar porch with three pointed arches, behind which appears the façade wall of the church, decorated with Norman interlaced arches. The nave and aisles are of course basilican – columnar shafts mark off the aisles, which are groin-vaulted, with lateral arcading. In the nave proper, the roof is at a lower level than was at first intended. The transept is carried higher than the nave, more than at Montecassino on the mainland; the sanctuary beyond it, though Byzantine in plan and decoration, is Romanesque in structure, proportion, and exterior decoration. The great Christ of the semi-dome, singularly impressive, is one of the finest Byzantine mosaics to be found anywhere. It is a perfectly pure example of the Second Golden Age, and goes

0 5 15 M.
0 10 50 FT.

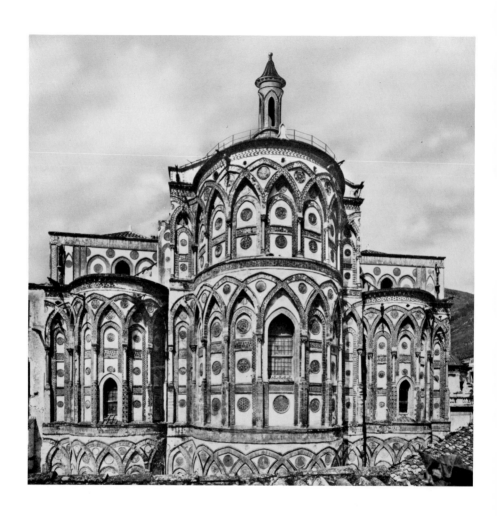

276 and 277. Monreale Cathedral, begun 1174

back to originals in Constantinople. The minor subjects are also of great interest and beauty.

The cathedral of Santa Maria la Nuova in Monreale[18] [276-8] is the climax of Sicilian Romanesque architecture. The see was established and the cathedral built by King William II as a counterpoise to the power of the

their decorative character – and consequently quite the reverse of the development in the north of France, which at this very time was systematizing the flying buttress and ushering in the accomplished phase of Early Gothic. There is no sign of this architectural progress at Monreale. Fires were not so frequent in the

archbishop of Palermo. It was served by Benedictines from La Cava on the mainland, where the monks observed the Cluniac rule, and for them an interesting conventual structure was raised to the south of the church. This building and the exterior of the church are in a markedly local Romanesque style; integrated so happily that one is not so conscious of stylistic 'ingredients' as in many of the Siculo-Norman edifices.

However, it must be said that the motifs are a rather riotous growth, interesting largely for

south as in the north, so that it was admissible to risk wooden-trussed roofing over the wide spans. The Moslem type of all-but-pointed vault and the Moslem pointed arch were sufficiently stable for the narrower spans.

Monreale Cathedral was apparently started in 1174; in 1176 deeds and endowments were deposited on the high altar, and in 1182 the fabric was substantially complete. The site, up the Conca d'Oro from Palermo, is one of great beauty, but the church exterior is not as fine as that of Cefalù – for the interlacing pointed

arches on the apse are overwrought Roman-
esque Baroque; the two blocky tower bases
have disparate and not altogether pleasing
terminations; and the heavy portico of 1770
between the towers is very inappropriate.[19]

The interior, however, is perfect. The plan
is Romanesque, with nave, aisles, transept,
deep sanctuary and deep flanking chapels; the
superstructure follows Early Christian lines in
the basilican nave, which is divided from the
aisles by classic Corinthian columns (though
with Moslem pointed arches). The style is
Romanesque in the transept and sanctuary,
where pointed arches are used also. The decora-
tion is Byzantine (in the mosaics) and Moslem
(the marble dado of the aisles, the polychrome
ceiling). No attempt was made to fuse the
styles: they are here independent, and in
conjunction.[20]

The cathedral at Monreale has a very
beautiful cloister enclosed within the blocky
series of monastic buildings on the south side
of the church. This cloister is dated 1172–89.
Possibly refugee sculptors came here after the
fall of Jerusalem in 1187; the work was surely
finished by 1200. The cloister has twenty-five

278. Monreale Cathedral, cloister, 1172–89

279 *(opposite)*. Palermo Cathedral, 1172–fifteenth century, south façade

arches of the Moslem pointed form on each side of a square garth. One corner of the garth is taken up with the lavatory of the monks, a square fountain house. The fountain, which has a large circular basin fed by tiny streams from a central column, is perhaps the most charming of its kind. The columns supporting the arcade are set in pairs, alternately plain and decorated with delightful and fanciful motifs – scroll-work, chevrons, fluting, spiral bands, and mosaic. This remarkable work, approaching the thirteenth century in date, is better fused in style than older buildings.

As the twelfth and thirteenth centuries advanced, the Sicilian designers achieved a strange but satisfying exotic style – exuberant, delighting in spicy decoration which was beautifully handled. Its great monument was the cathedral of Palermo, rebuilt in 1172–85 by Archbishop Walter of the Mill (Gualterio Offamilio, 1169–85). The gorgeously modelled south façade, with its rich arcading and cresting [279], is a prime example of the style. Perhaps we may recognize the influence of the Hohenstaufen domination (1194–1266) in the airy spires at the four corners of the cathedral, and

in the fantastic group of turrets joined by a bridge to the west façade (1300–59), for they have strange, belated reminiscences of the Carolingian westwork at Saint-Riquier. The south portal dates from 1425, and its great porch from later in the same century. Unfortunately the interior was spoiled by rebuilding between 1781 and 1801, but it contains the royal and imperial tombs of the dynasty, including that of the Emperor Frederick II. They seem strangely lost in the plaster whiteness of the rather austere Baroque interior. Sicily's own riotous, warm, medieval style would fit them much better.[21]

CAMPANIA AND NEIGHBOURING REGIONS

The Normans acquired Aversa and its region about 1030; Capua (in which region Montecassino lies) in 1058, Gaeta in 1063; the regions about Benevento and Salerno, including Amalfi, in 1077; Naples, finally, in 1137.

By far the most important shrine in the region was Montecassino, with its august memories of St Benedict. The monastery, founded in 529, had been restored after barbarian desolations (Lombards, 581; Saracens, 883), and subsequent to 950 it flourished again. An elegant interpretation of the much rebuilt Renaissance church and conventual buildings has replaced, on the same sites, the structures destroyed in the Second World War.

The great Abbot Desiderius assumed office when the Norman regime was beginning. He gathered a pleiad of important churchmen, scholars, and artists about him, and made the abbey a light to its age, as recounted by his excellent archivist and biographer Leo of Ostia.[22] Desiderius laboured to re-establish the fine arts in Italy, where 'Mistress Latinitas had been wanting in the skill of these arts . . . for five hundred years, and more; and by the effort of this man, with the inspiration and help of God, merited to regain it in our time.' Desiderius imported objects of art from Constantinople, called artists thence, and actually made provision for training Italians and others in the various arts.

Great resources were available to him (in part surely from the Normans), and Desiderius undertook a general rebuilding of the monastery in the ninth year of his abbacy, 1066. The dimensioned description in Leo of Ostia's chronicle leaves no doubt that the main parts of the church and monastery, though rebuilt in the fourteenth century and later, retained Desiderius's scheme down to modern times. By means of parallel examples – buildings obviously inspired in various features by Montecassino – it has been possible to make a trustworthy restoration [280]. In 1071 the church was dedicated *maximo trepudio* – 'with the greatest possible stir' – in the presence of numerous ranking ecclesiastics; knowledge of it instantly spread far, and Montecassino continued to draw visitors of mark.

The layout was obviously taken from Old St Peter's in Rome [3], with monumental stair, propylaea, atrium, and T-shaped basilica, though on a much smaller scale (roughly one-third linear; single aisle at each side; no screened recesses at the ends of the transept, which was triapsidal; a heavy, stumpy bell-tower of local type at the north-east corner of the atrium). Actual materials were brought from Rome, and some of these were carried up the great slope by the faithful – an anticipation of the cart cults of Gothic cathedrals.

Several features of Desiderius's church were novel, and they should be noted here. Some of the builders were from Amalfi, then at the summit of its power as a widely ramified commercial republic, with stations in Cairo, Jerusalem, Cyprus, Constantinople, Alexandria, and Tunis. The city, ruined so soon after, must have shown these oriental connexions in its architecture. It is our belief that the novelties at Montecassino which have oriental character-

280. Montecassino Abbey, restoration study as in 1075 (K.J.C.)

istics were due to this influence; and in fact some of these features are anticipated in existing North-African work.

For example, about 1050 the inner portico of the Great Mosque at Mahdia (Tunisia) had pointed arches and peculiar groin vaults, with arrises nearly straight, as at Sant'Angelo in Formis, a priory of Montecassino.

Desiderius's propylaeum and church porch, each with five arches, are reported as having *fornices spiculos* – 'lanceolate' arches or vaults, with a very blunt point if they were like the single remaining original pointed vault in the south pylon of the outer porch,[23] which I measured before the destruction. The porch of Sant'Angelo in Formis,[24] though later than the church of 1058–75 and more oriental in feeling, is a somewhat unskilful conflation of the two porticoes at Montecassino [280–2]. The pointed arch and vault were well established in Egypt by the tenth century. Egyptian arches, even to this day, are constructed over a rough filling carried by straight sticks forming a mitre, and the arches, brought up to the apex of the mitre,

naturally take pointed shapes. The character-istic straight arrises of the groin vaults of the porch of Sant'Angelo in Formis [281] were doubtless formed over diagonal mitres.

Abbot Hugh of Cluny visited Montecassino in 1083. Greatly interested in building (as we have seen), he, or an architect in his suite, supposedly transmitted the novel features to Cluny III, the building of which began by 1088. Unquestionably the oriental pointed arch, the Byzantine and oriental pinched vault, approxi-mately of catenary profile, and the straight-arris groin vault were rationalized by Desiderius's and Hugh's engineers. They marked a distinct step forward in Romanesque engineering, and perhaps started the process which eventually created the new Gothic type of engineering. The fortune of the pointed arch and vault was made when they were applied, to the number of nearly two hundred, at Cluny. As far as we are able to make out at present, they went there from Montecassino.

Desiderius's porch had plaster-work decora-tion, presumably also Moslem, and bronze

281 and 282. Sant'Angelo in Formis, founded 1058, finished *c.* 1073–5

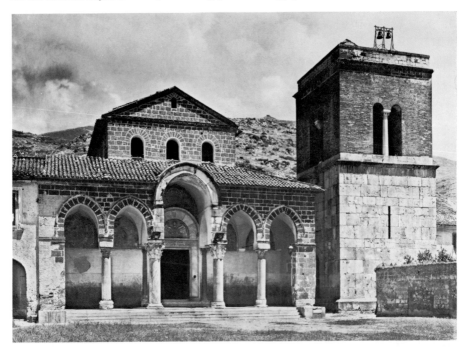

plates from Constantinople on the door-valves; a decorative lunette was over each of the doorways, in the Byzantine manner; and the interior was frescoed in Byzantine style. Thus we have here in 1066–75 an apposition of styles like that which we find in Sicily a century later.

In levelling the rocky ridge to make a place for the basilica, a tomb understood to be that of St Benedict was discovered about ten feet under the surface. The monks at Montecassino in their recent excavations have corroborated this, but the grave was emptied (in 703?), when relics supposed to be those of St Benedict were taken to Fleury-sur-Loire after the Lombard desolation. To retain the newly-discovered tomb untouched, the transept pavement was established eight steps above that of the nave. Desiderius built a cenotaph, destroyed later,

with most of the tomb, when the high altar was moved here.

The paintings of the interior may be judged by those of Sant'Angelo in Formis, a Desiderian church (as remarked) [282]. The whole interior here is painted in the Cassinese style. It is believed that this style was taken up by Cluny; the chapel of Berzé-la-Ville survives as a witness. [25]

The dynamic features of Montecassino, then, were taken up and developed in Burgundy. But in the main the abbey church was a conservative building, and the conservative aspects of it are reflected in the cathedrals of Salerno (dedicated in 1084), Benevento (rebuilt 1114–1279), Ravello (by 1156), and Amalfi (Romanesque, to 1276; rebuilt). All are basilican. Besides these there are many rustic reductions

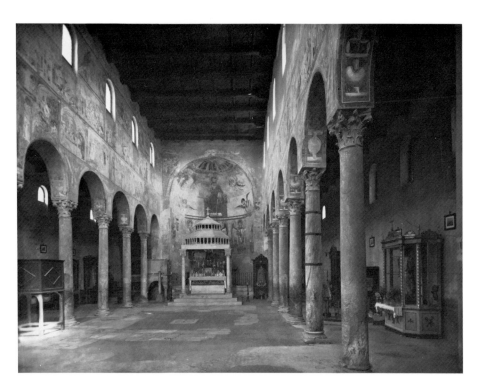

of the motif – including the church of the town of Aquino, where St Thomas Aquinas was born, and Minuto.

In the region there are many elaborate pulpits,[26] usually of white marble with mosaic and *opus Alexandrinum* insets, in medieval Roman style. Examples dated before 1200 exist at Ravello (after 1095), La Cava (after 1146), and Salerno (between 1153 and 1181). They show, as does the basilican architecture, that architecturally this part of the Two Sicilies is a Roman province – but the attentive eye will find Byzantine and Moslem details in them. The pulpits are parapeted platforms carried on columns and reached by flights of steps; usually there is a projection with a lectern where the actual reading is done. Many baldacchinos in marble have also been preserved. Such furni-

ture is often very picturesque, where the workmanship is rustic and the air is of folk art.

On the other hand, this architectural and sculptural tradition was the basis of the revival of antique style in the works of the Emperor Frederick II.[27] His gate at Capua (1233–40) was built in Roman-style ashlar and adorned with classical busts, of which the Pietro della Vigna is the best known. Such classicism was doubtless suggested by the ancient memories of Capua and the imperial office; it is a witness to the catholic taste of the Emperor, and it may represent also a reaction against the exotic, overblown Romanesque of Sicily. It was obviously the training-ground for Nicola Pisano (*c.* 1225–78), son of 'Petrus de Apulia', author of the classicizing pulpit of 1259 which we shall find in Pisa.

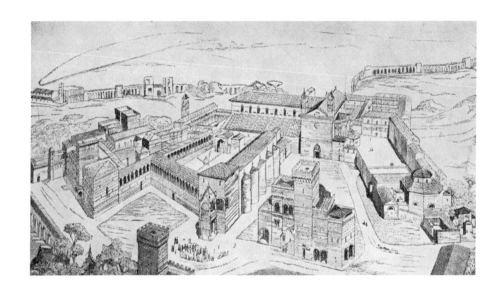

283. Rome, Lateran Church and Palace, restoration study as in *c.* 1450 (Rohault de Fleury)

CENTRAL ITALY

ROME AND THE PAPAL STATE

The removal of the capital of the Empire from Rome in the fourth century, the barbarian dislocations, the rule of the City as a part of the Byzantine exarchate; the coming of Greek and Syrian Popes; the struggles of local nobles, the commune, the pontiffs, and the emperors – not to mention the malaria and the burning of a part of the City by Robert Guiscard – all make a tragic story. In such a history there is little room for interesting building. Architectural style remained so stagnant in Rome that the church of San Clemente, rebuilt after Robert Guiscard's fire of 1084, was mistaken for the fourth-century church on the site, until the ruins of that building under the present church were suspected (1847) and excavated (1857-61).

Though it figured in the military struggles of the Middle Ages, Old St Peter's [3] escaped destruction, only to be demolished piecemeal between 1450 and 1585 to make way for the present church. Recent excavations have revealed the history of its apse, where the altar, if present, stood until about 600 in front of the *Memoria Apostolica*, a small ancient recess at the pavement level. By the seventh century the apse pavement had been raised to the top of the memoria, and the high altar established above the latter. A semicircular corridor was formed, contiguous to the apse at the original pavement level and giving access to an axial corridor by which the memoria could be reached from behind.[1] This arrangement underlies the primitive Lombard crypts, and contains the germ of the ambulatory scheme.

The cathedral of the Saviour, built under Constantine, and overthrown by an earthquake in 896, was rebuilt between 904 and 928 by Sergius III and John X as San Giovanni in Laterano, without losing its rank.[2] It was further rebuilt after suffering gravely from fires in 1308 and 1361. The apse, though damaged, retained its old ambulatory, laid out in the ninth century (or possibly in the fourth) without radiating chapels [283]. This august example probably had some influence on the development of ambulatories at the main pavement level during the Middle Ages. It was destroyed only in 1876; the medieval transept and nave had been masked by Renaissance and Baroque additions.

Near by was the Lateran Palace, replaced in 1585-6. The venerable older building [283] was in various forms the papal palace for nearly twelve centuries, though from the time of Gregory IX (1227-41) malarial conditions in the district led to the transfer of the actual pontifical residence to the Vatican Palace.[3] The medieval building (resulting from progressive reconstruction of the palace of the Laterani, given by Constantine to Pope Miltiades) was much larger than the present one, and more open in construction. It had a great many rooms with apsidal recesses, and these included several ceremonial halls. Of all this, only the terminal apse of the Triclinium survives as a sort of pavilion, by the Scala Santa.[4]

The monastery adjoining the Lateran had a long history. It was the refuge of the Benedictines of Montecassino, when their own monastery was destroyed by the Lombards in 581, and was their first establishment in Rome. The pretty cloister, in the Roman Romanesque style, was built about 1227, Pietro Vassalletto and his son being the masters.[5] The garth, square, has a fountain head in the middle of a garden; the

walks, on all four sides, are now groin-vaulted. The L-shaped corner piers terminate ranges of supports, including four oblong piers between each pair. A classical entablature with a Cosmatesque frieze is carried entirely around the cloister above them. Each interval between two piers has five graceful arches carried on four pairs of slender columns above a parapet – the middle pairs in each case being twisted. It was an easy step from this thirteenth-century work to some of the Early Renaissance cloisters.

Cosmati and Cosmatesque work, just mentioned, takes its name from a Roman family which flourished after 1150. They did one serious work of architecture, the portico, in the Ionic style, of the cathedral of Civita-Castellana, near Rome,[6] which is almost perfectly classical in design, though built in 1210 by Lorenzo and

Jacopo Cosmati. It has the characteristic decorative marble and mosaic ornament which is an index of the Cosmati style. They and others working in the same manner developed the ancient type of *opus Alexandrinum* as ornament for cloisters, pulpits, chancels, Paschal candlesticks, thrones, tombs, altars, and the like.

The most familiar type of *opus Alexandrinum* appears in the beautiful Roman church pavements. They are made of slabs of white marble and disks of coloured marble (often porphyry) with lines of gold and coloured mosaic set in the bordering slabs as an embellishment. Abbot Desiderius had such a pavement made for Montecassino. A beautiful example – one of many in the city – exists at Santa Maria in Cosmedin in Rome; it is dated about 1100 [284; see also 285].[7]

284. Rome, Santa Maria in Cosmedin, interior, *c.* 1100 (restored)

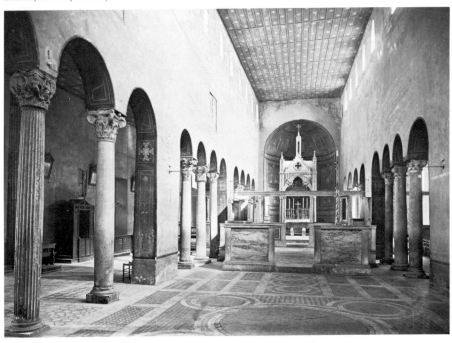

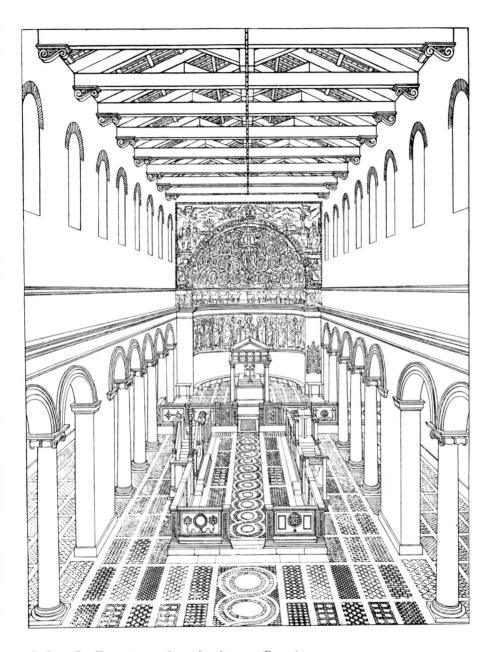

285. Rome, San Clemente, restoration study as in *c.* 1100 (Bunsen)

Cosmati work applied to church furniture is naturally more delicate in scale than the pavements, and this is true of the cloisters also. While in general the columns are Corinthianesque, as is usual everywhere in the Middle Ages, the Ionic and Composite appear frequently, and in important works. Elsewhere these orders were little used until Renaissance times. Columnar forms are ordinarily much enriched: often the shafts are 'Salmonic' (twisted), and straight or spiral fluting was regularly garnished with mosaics set in running designs, especially star patterns. For a long time classical reminiscences were strong in Cosmati work, but it was also used in conjunction with Romanesque themes, as·in the cloister of Monreale, and eventually in Gothic designs.

Very handsome baldacchinos, sometimes in Cosmatesque work, were made at this time. They are square or nearly square in plan; they have four corner columns with connecting architraves, above which there is a staged open-work turret with small columns; they ordinarily terminate in an octagonal pyramid, with orb and cross. Thus a playful 'turritus apex' took the place of the dome which is usual in Byzantine baldacchinos. Beautiful examples are to be seen at San Lorenzo fuori le Mura (1148 and later), San Giorgio in Velabro, Santa Maria in Trastevere, San Clemente (where the top is gabled [285]), and Santa Maria in Cosmedin [284] (a Gothic design), all in Rome. The baldacchinos in south Italy – at Bari, for example [264] – are inferior in design, proportion, and execution to the Roman works, but they and the pulpits often have a naive lush attractiveness.

Few churches have preserved the old arrangement of stalls, namely, a chancel marked off by a parapet at the head of the nave, as at San Clemente [285], with its auxiliaries of pulpits, lecterns, and Paschal candlestick. The canons or monks used to stand inside these enclosures, though in the eleventh or twelfth century stalls began to be provided, as by Gelmírez at Santiago de Compostela. Originally such stalls were in stone, but wood was later introduced for comfort, and canopies were built to prevent draughts. The old chancel built by Pope John VIII (872) was re-used at San Clemente, when that church was rebuilt by Paschal II. Santa Sabina also has the old choir arrangement, recently restored with fragments dating back to about 825. Occasionally, in the monasteries, fald-stools *(formulas)* are mentioned; they must have been often used.

Although there was a great deal of disturbance in Rome during the struggle over the Investitures, the vigour of the Papacy induced a certain amount of building. Very little recalls Gregory VII, Victor II, or Urban II, but several interesting churches are connected with Paschal II (1099–1118).

It was he who rebuilt San Clemente (ruined in 1084 during the siege of the city by Robert Guiscard), and the works continued to about 1130. The resulting church[8] [285] now has adventitious Baroque decorations, but the old arrangements are clear. The old propylaeum and atrium are not greatly changed; the orientation is reversed, as it was in the fourth-century basilica. The nave still shows the original alternation of piers and Ionic columnar supports. It has a clerestory. The head end is triapsidal, with a raised central platform. The semi-dome has a quite lovely mosaic with patterns of rinceaux in gold against a dark ground, perhaps a work of the twelfth century. Below, there is a marble throne on the axis, with a synthronon for lower clergy extending along the apse wall to either side. The altar is beneath a beautiful baldacchino, and the celebrant, with his back to the throne, officiates at the west side or back of the altar, looking eastward toward the choir in the nave (previously mentioned) and the congregation. The front of the apse platform is pierced, beneath the altar, by a fenestrella giving upon a space for relics. The arrangement is an unusually perfect example of the Constantinian disposition of the sanctuary elements.[9]

The chancel or choir of San Clemente, dating from about 872 as already indicated, may be called a *schola cantorum* also, because here the main body of the monks or canons would gather for their office, which was sung. Such liturgical offices have readings from Scripture at intervals, and for these the pulpits were provided – one to each side used for the epistle and gospel during the mass, and a lectern for use in readings directed towards the congregational space.

The church of the Santi Quattro Incoronati was likewise rebuilt by Paschal II, 1099–1106 or 1112, by which time the rather stumpy campanile was finished. San Bartolomeo was also rebuilt, about 1113; the tower, however, dates from about 1218. San Giorgio in Velabro and Santa Pudenziana have towers which may fairly be ascribed to the twelfth century. The towers of Santa Maria in Cosmedin [286] and Santa Maria in Trastevere may have been built before

286. Rome, Santa Maria in Cosmedin,
façade, *c.* 1120, tower *c.* 1200 (restored)

1200. The tower of SS. Giovanni e Paolo is dated to 1206, that of Santa Cecilia to 1220, and that of Santa Maria Maggiore to 1378.

Rome has thirty-six of these campanili, all very true to type. The one which is most advantageously placed stands at the façade of the church of Santa Maria in Cosmedin. This is an old building incorporating a Roman corn hall, but it is basilican; it was the church to which Gelasius II was attached from 1079 until his elevation (1118) to the Papacy. After Gelasius's death (1119) Calixtus II continued repairs and embellishments. The interior, well restored with a ceiling and a *schola cantorum*, is archaic in feeling because of the piers in the colonnade and the small clerestory windows. The fine pavement dates from the time of Gelasius or Calixtus. At the cost of a very jolly Baroque frontispiece in stucco, the façade has been restored to its old condition, as of about 1120, with a porch in front of an open narthex, and a chamber above. Brick is the constructional material, as usual in Rome. The tower, hardly changed in 800 years, has seven storeys above the windowless shaft which reaches to the eaves line of the church nave. Each of the seven storeys has arcading, with the impost line carried as a string course around the tower; each stage also has a brick cornice, gracefully proportioned. The lower storeys, logically more substantial, have fewer openings, and piers; the upper storeys have triple openings with marble mid-wall shafts. Some of the Roman towers have ceramic insets, but this is not the case at Santa Maria in Cosmedin.[10]

Santa Maria in Trastevere, with a fine tower of 1148, is still essentially the church built by Innocent II as a thankoffering for his success over the antipope Anacletus II. It was finished under Eugene III, the first Cistercian pope, about 1150. The intervening Lucius II (1144-5) was the restorer of Santa Croce in Gerusalemme, near the Lateran. Santa Prassede, remarkable for ninth-century mosaics and the beautiful chapel of San Zeno (822), received its reinforcement of diaphragm arches in the twelfth century. SS. Giovanni e Paolo, burned in 1084, was restored (by exception in the Lombard style) largely by Hadrian IV (1154-9, the only English Pope); the tower is, however, in the Roman style, and dated 1206.[11]

At San Lorenzo fuori le Mura a simple, very austere cloister was built for the Cistercians about 1190. In the monastery at St Paul's outside the Walls, a new cloister was built about 1200, similar to the Lateran cloister which we have mentioned.[12]

The Torre delle Milizie[13] is a private fortification dated about 1200, or later. More interesting is the miscalled House of Rienzi, near Santa Maria in Cosmedin, a strangely embellished brick tower-base where the architect (perhaps about 1100) used unconventional means (partly Moslem in inspiration?) to enrich the design.

This completes the list of Romanesque designs of importance existing in Rome, and emphasizes the conservative character of the city in architecture. Burgundian half-Gothic did not come in until about 1280, and then uniquely in Santa Maria sopra Minerva, finished *c.* 1300. The French High Gothic is not represented at all. By 1402 Brunelleschi and Donatello were in Rome together, studying Antiquity in order to bring about the Renaissance.

TUSCANY

Florence, where the Renaissance was to begin, had monuments less faithful to the antique style than contemporary Roman works, but hardly less classical in spirit. The area covered by the Tuscan Romanesque school includes the Duchy, Sardinia (which the Pisans conquered), and some special monuments in the northern and southern parts of the Italian peninsula. Essentially the style covers the dominions and represents the effective reign of the great Countess

Matilda (1046–1115), well remembered not only as an energetic pro-papal political figure, but also as an enlightened ruler, patron of the arts and bibliophile, the personal friend of Hildebrand and Anselm. She encouraged the Lombard towns, and favoured the development of the schools of Bologna, then among the greatest in Europe, where active progress was being made in civil and canon law, and in medicine.

While architecture does not necessarily reflect such conditons, the 'Roman-mindedness' of the great sovereign made it natural that the Roman style should be at home in her domain. It is no less natural – given the active temper of the period – that creative differentiations should appear, as they did particularly in Florence and

Pisa. Endowed with a classical sense, and able to profit by an excellent tradition of fine workmanship, moreover, provided with good building stone and the means to use the easily available marble, the architects put a special stamp on a considerable number of fine buildings, particularly churches.

Florence prospered in the age of Matilda, and characteristic works were created there. Recent studies have brought down the very early dates (1013, 1018) assigned to conspicuous Romanesque works without disturbing the relative importance of the buildings.

In coming to Florence we instantly encounter the controversy over the date of the Baptistery of San Giovanni[14] [287,288], the vault of which

287. Florence, Baptistery,
exterior, fifth (?), eleventh, and twelfth centuries

288. Florence, Baptistery,
interior, superficially eleventh and twelfth centuries

was studied as a model for the 'dome' of the present cathedral, the first great vaulting enterprise of the Renaissance.

San Giovanni is octagonal in plan, with an oblong extension on the western side, where formerly there was an apse. There are doors on the south, north, and east sides, filled respectively by the memorable valves of Andrea Pisano (1330) and Lorenzo Ghiberti (1401-24, 1447-52). From wall to wall it measures about 90 feet English, or close to 93 Roman feet.

While proximity to the city wall suggests that the cathedral of Santa Maria del Fiore may occupy an Early Christian cathedral site, in fact the see was not moved from San Lorenzo (according to documents brought forward by Franklin Toker) until the ninth century. Nor-

mally a baptistery would first be built at that time, and the familiar opinion that the octagon was the original cathedral building would seem to be untenable.

The oldest documented remains are those of the early-sixth-century basilica of Santa Reparata. We recognized a stretch of segmental foundation wall within the octagon as the remains of a hemicycle at the west end of the original atrium. The active bishop Andreas (869-93) is credited with moving the see, building the early octagon, and installing the relics of St Zenobius, so that the basilica became a pilgrimage church.[15]

Foundations show that the original octagon, a relatively small building, lacked aisles around the central space. However, two episodes in the

construction of the present building are indi-
cated - a median joint divides the foundation
lengthwise.

To the east of the early octagon there was an
atrium, now represented by the street, and be-
yond the atrium stood (as before) the basilica of
Santa Reparata, originally built in the sixth
century. For a long period it served as the
cathedral building. The remains may be seen
in an archaeological crypt which has been ar-
ranged near the west end of the nave at Santa
Maria del Fiore, the present cathedral.

Santa Reparata was augmented in various
ways: the sanctuary level was raised; the apse
was flanked, as commonly in Imperial churches,
by two towers. A transept and probably also a
crossing tower were built.

Beginning early in the eleventh century, both
churches were rebuilt on a slightly larger scale,
respecting the old locations. At San Giovanni
the core of the existing octagon was built,
replacing the earlier baptistery with a clear open
space. The walls sheathe an aqueduct-like
construction bent around the eight angles. The
new basilica, also wooden-roofed, was more sub-
stantial but resembled the old design in many
ways. This work was deducated in 1059 by
Gebhard of Burgundy, the Florentine bishop
who, at the time, in Florence, was elected as the
reforming pope Nicholas II (1059-61). In this
election the present rule of having the pope
elected by the cardinals alone was introduced.

About the year 1200 the interior of San
Giovanni was given its present character and
covered by the existing vault. The better to
sustain this vault, the present system of columns
and arches was applied to the inside of the walls
of the octagon of 1059, resting on contiguous
foundations just within the octagon of 1059. In
the new upper structure a series of arches,
three to a typical bay, carry the remarkable
cupola and the buttress-like external ribs which
support the roofing. The exterior attica dates
from this period, but the arcading below which

sheathes the octagon of 1059 seems later, for it
corresponds to the upper arcading on the
present cathedral.

The latter building was planned by Arnolfo
di Cambio about 1296 to replace Santa Reparata.
Arnolfo's design, already started, was con-
siderably augmented in scale about 1355.
Though Gothic, its interior thus became almost
Roman in grandeur, and this great building
presented Brunelleschi with his opportunity to
construct, in 1420-36, the first splendid monu-
ment of the Renaissance.

The Baptistery's Corinthian columnar and
pilaster orders, with entablature or arcades, and
its parti-coloured marble veneering became and
continued to be usual in the Florentine area
until the Gothic came. Parti-coloured marble,
coffered panel work, and paving slabs of great
beauty and delicacy (exemplified also at San
Miniato, Florence) were made as time passed.
Some importation of the zebra-work of Pisa
occurred - as on the corners of the Baptistery,
which before 1293 showed the structural
'macigno' stone.

The interior of the Baptistery is dignified.
Pairs of handsome free-standing columns be-
tween pairs of pilasters at the angles of the octa-
gon sustain an entablature in the lower storey.
Each column or pilaster of the ground storey
has a pilaster above it, with the entablature
above serving to mark the spring of the great
octagonal vault. The recesses of the aqueduct-
like structural arches of the wall are masked by
pretty bifora between marble parapets and
parti-coloured panels. The vast mosaic above,
and the extraordinary parti-coloured pavement
beneath, both belong to the thirteenth century.

San Miniato al Monte[16] [289-91] is the most
remarkable Florentine basilica. It became a
Benedictine abbey church in 1018, and by 1090
a new church was essentially complete, though
the façade was finished in the twelfth century
and the pavement dates from 1207. There is an
interesting open groin-vaulted crypt which en-

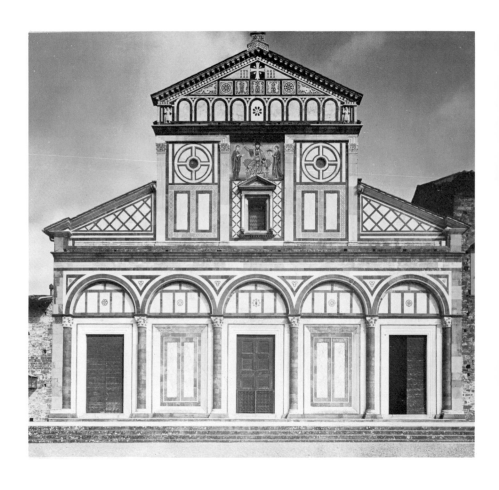

289. Florence, San Miniato, façade, 1062 and twelfth century

tails a raised sanctuary. The nave has a series of three three-arched bays with three clerestory windows and four trusses in each, divided by diaphragm arches on grouped piers. The apse has a decorative arcade, with a mosaic on the semi-dome; the façade also has a decorative arcade with a mosaic above. Marble veneering and the brightly painted ceiling and trusses add to the colourful effect.

San Miniato is believed to have inspired the façades of the Badia at Fiesole (late twelfth century, though the church was given to the Bene-

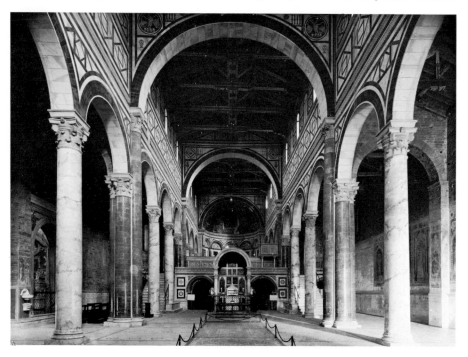

290 and 291. Florence, San Miniato, interior, finished 1062–90, and plan

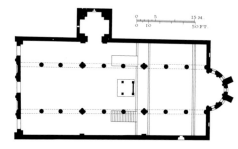

dictines in 1018), and the collegiate church of St Andrew in Empoli (twelfth century).

Smaller churches in Florence and the surrounding region are much simpler. They have a great deal of bare stone-work, but possess the classical dignity and good proportion which are generally characteristic of Florentine buildings.

The year 1062 was signalized by an overwhelming victory of the Pisan navy in a battle off Palermo. This action marked a final success in a long war against the Saracens of Sicily, whom the Pisans, with the Genoese, had fought to a standstill in Sardinia, and driven from that island.

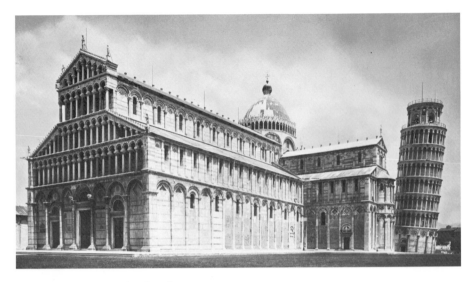

292 and 293. Pisa Cathedral, 1063, 1089-1272

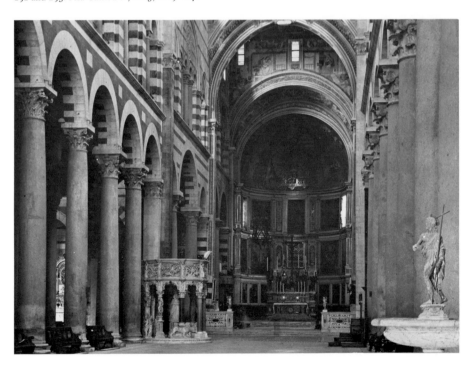

In the following year, 1063, the Pisans began their memorable cathedral [292-4]. The foundations of the church were laid in an open site, where a large free-standing baptistery (1153 ff.), belfry (1174 ff.), and Campo Santo (1278 ff.) joined it to make one of the finest examples of grouped cathedral buildings. All the buildings are faced with marble panelling, arcading, and colonnades; they have weathered beautifully, and they stand as a splendid monument to the grandeur of the Pisan republic.[17]

The cathedral was designed by Buschetus or Boschetto. Building began in earnest about 1089. A consecration was performed by Gelasius II in 1118. A fairly homogeneous westward extension of the nave by Rainaldus was not finished until 1261-72. The plan is an elaboration of the basilican layout - really the conjunc-

tion of three basilicas, each with a gallery: the great double-aisled nave is intersected by a transept formed of two single-aisled minor basilicas set front to front, with the domed crossing of the great nave between them [295]. Each of the minor basilicas was provided with an apse of its own at the outward extremity, and with returned aisles at its inward end. These returned aisles coalesce with the inner aisles of the great nave, screen off the transeptal basilicas, and provide extra support for the oval dome (on squinches and shallow pendentives) at the crossing. The aisles are groin-vaulted; the galleries are covered in wood. Except at the extremities, the aisles and galleries are continuous around the building.

Like many other great structures which have initiated a group or school, the cathedral of Pisa

294. Pisa, cathedral group from the air, 1063-1350

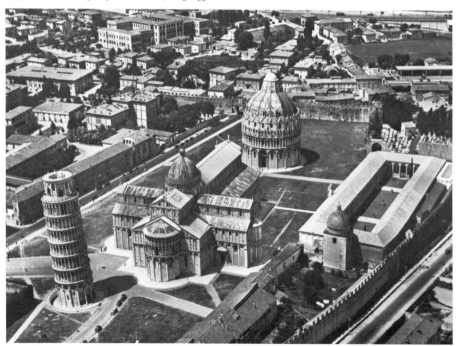

295. Pisa Cathedral, 1063, 1089-1272

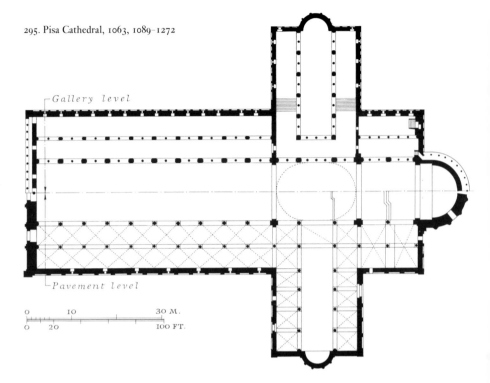

Gallery level

Pavement level

0 10 30 M.
0 20 100 FT.

is, within an embracing unity, stylistically composite. Its beautifully sheathed marble exterior has decorative arcades and pilaster ranges which were probably suggested from Rome and Florence, rather than (as has been suggested) from Armenian works remote in time and place, and different in design. The four-storied arcading of the façade, finished in the thirteenth century, probably reflects Lombard free-standing gallery work. Such arcading in marble, free-standing or applied, becomes the sign manual of the Pisan school, especially when accompanied with square panels set point upwards in the tympana of the arches. The nave arcade of the church is set on a magnificent range of antique columns, purely Roman in style, with slablike impost blocks. The upper part of the nave has zebra work (ultimately inspired from the classical *opus mixtum*) which becomes only too

familiar in Tuscan Romanesque and Gothic. A pointed triumphal arch terminates the nave, but the arches beyond are round, and the mosaic of the apse is clearly in the Byzantine tradition.

The baptistery, designed by Diotisalvi [294], has reminiscences of Roman antiquity, and of the Holy Land, to which the Pisan merchant marine was transporting crusaders and pilgrims at the time of its construction. The scheme is like that of the Rotunda of the Anastasis in Jerusalem, but the detail is Pisan, and the interior is vaulted. The original vault is a truncated cone, with its eye now closed; the outer vault (later) is a dome [296A]. Both types of roof, in wood, have protected the Anastasis. The older carving on the building is very beautiful, and very classical in spite of its date (1153 and later); Nicola Pisano participated in the remodelling of the exterior in the Gothic style (1250-65).[18]

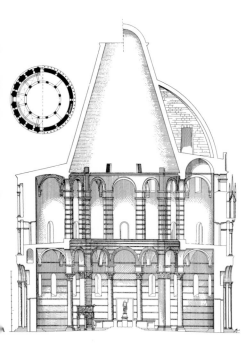

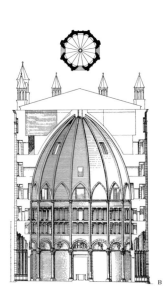

296. Sections of baptisteries:
A. Pisa, 1153–1265,
comparative half-sections with half-plans
B. Parma, 1196, section, with plan

The great Pisan belfry [292] is cylindrical like the old belfries in Ravenna, but much more elaborate, being faced with marble and embellished with six storeys of decorative marble gallery arcading. Unfortunately it was built with insufficient foundations on ground of uneven resistance, and was carried forward in spite of early settlement. Loading the upper side and bending the shaft (which as a result has somewhat the shape of a banana) were unavailing to arrest progressive deviation from the perpendicular, and this has only recently been stopped by a modern foundation. The building is consistent in style with the baptistery and the cathedral, although carried forward as late as 1271 (by Gerardo). The motif is essentially that of the galleried façade of the cathedral enveloping the cylindrical shaft of the tower. The bell chamber at the top dates from about 1350. As thus finished the tower is 179 feet high, and it is slightly more than thirteen feet out of plumb.

The Campo Santo [294] is the fourth of the great buildings in the cathedral close at Pisa, and it is said that the earth covering the garth is indeed holy, having been brought from Palestine as ballast in Pisan ships. Although the Campo Santo was largely built (by Giovanni di Simone) in 1278–83, and has Italian Gothic arches and tracery, it is laid out like an elongated classical atrium. Later it was decorated with famous frescoes, which made it like a classical stoa poecile. In passing one should note that the word *atrium* came to mean *cemetery* in medieval Latin. Both the usage and the architecture are medievalized in this very beautiful example. (It suffered greatly in the Second World War.)

In the city, the characteristics which we have noted in the cathedral group are further exem-

297. San Gimignano, general view of towers,
largely twelfth and thirteenth centuries

plified. San Paolo a Ripa d'Arno (begun about
1210) is a smaller and severer version of the
great church. The very much be-striped and be-
pinnacled miniature church of Santa Maria
della Spina (a thorn from the crown of thorns),
1325-7, shows how something of the spirit of
the Cathedral Romanesque lived on in Tuscan
Gothic.[19]

Lucca has a beautiful series of churches in the
Pisan style, including the cathedral of San Mar-
tino, which, through its possession of the 'Volto
Santo' from the eleventh century onward, be-
came a place of pilgrimage. Though the interior
of the church is Gothic, our architectural interest

is in the Pisan Romanesque façade, with a nar-
thex, dated about 1204. San Michele, also Pisan,
dates from 1143 to the fourteenth century. San
Frediano, 1112-47, has a striking mosaic on the
façade, and is more Roman. All are basilican in
scheme, and employ marble, as is usual in
Tuscany.[20]

The expansion of the Tuscan school was very
considerable. In Sardinia it is found with little
change.[21] An Early Christian domed cruciform
church survives, in part, in San Saturno, Cagliari
(fifth century), and there are rather rough later
examples in the same style, well vaulted. But
from the eleventh to the fourteenth century

many wooden-roofed basilicas in the Pisan style were built. Among these we may mention San Gavino at Porto Torres (late eleventh century to *c*. 1111; by exception a 'double-ender'), the Trinità di Saccargia at Codrongianus (1116 and *c*. 1180–1200), and Santa Maria di Castello at Cagliari (*c*. 1200–*c*. 1300).

On the mainland the Pisan Romanesque spread far beyond the boundaries of the Republic. The style is exemplified in parts of the cathedral of Genoa (1199 and later); at Pistoia in the church of San Giovanni fuor civitas, twelfth century (three stages of Pisan arcading on the long flank of the church); at Arezzo in the 'Pieve' or parish church (ranges of columnar galleries on the façade of the church, above an applied arcade; in stone, 1216). Massa Marittima Cathedral was built, still in the Pisan Romanesque style, in 1228–67. Other examples are San Giusto at Bazzano in the Abruzzi, and, farther on, the cathedral of Troia in Apulia (1093 to the thirteenth century) which we have already seen[22] [270].

Before quitting central Italy we should mention three sites of special interest. At the abbey of Sant'Antimo, near Siena, a Burgundian-looking church with apse, ambulatory, and radiating chapels, embellished, too, with sculpture in the Toulousan style, was begun about 1118. Burgundian architectural influence before the arrival of the Cistercians is almost unheard-of, and Sant'Antimo is not well explained. It was not Cluniac.[23] At San Galgano between Siena and Massa Marittima the Cistercians built their chief house in Tuscany. The church there (already mentioned) dates from 1224.

The remaining site is near Siena also, namely, San Gimignano, which still has thirteen tall towers (out of 48, or traditionally 76) which were raised as private fortifications from the twelfth century onward [297]. Such towers also serve as refuges from the frequent conflagrations which desolated the wood-built and crowded cities of the time. At San Gimignano, as elsewhere, the towers are square in plan, and rise sheer with no ornament and very few openings. Such individual citadels were built in great numbers during the intense struggles and competitions of medieval civic life. At San Gimignano the towers of the Salvucci are ascribed to the twelfth century. The Palazzo Comunale (1288–1323) has a tower 173 feet high with a mark beyond which private towers might not rise.[24]

Florence is reported to have had 150 such towers, and Lucca 'rose like a forest'. As the desolated cities were rebuilt, better construction, with greater use of masonry in the houses, rendered the towers less necessary. Because of their considerable bulk and their tendency to tip when not well founded, almost all the towers have now been destroyed. By exception, the tower of the Asinelli family (1109–19; 320 feet high; four feet out of plumb) and the Torre Garisenda (1110; ten feet out of plumb; never finished) are to be seen in Bologna, which formerly had about 180 private towers.

Of the Countess Matilda's ancestral castle on a rocky fastness near Reggio Emilia – Canossa, so much in the news of 1077 – practically nothing remains. In general the fortifications of the region are very much later in date.

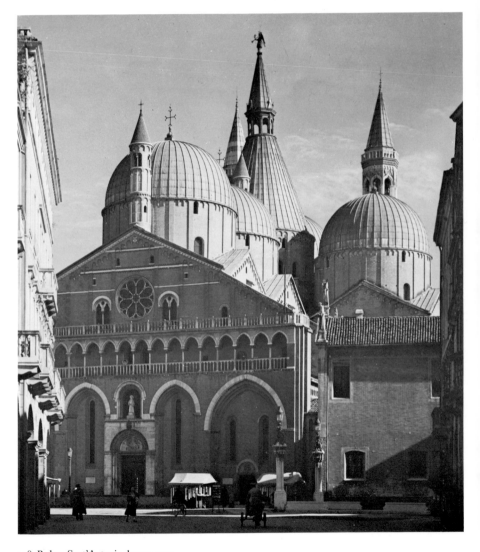

298. Padua, Sant'Antonio, begun 1231

NORTHERN ITALY

VENICE

Constant relationships with the Byzantine East gave Venetian architecture a Byzantine cast which is as easily perceptible as the classicism of Rome and Tuscany. This shows itself most fully in the church of San Marco,[1] begun in 1063, not as the bishop's seat but as the ducal chapel; it is the shrine for relics of the Evangelist St Mark, brought to Venice from Alexandria in 828, and housed in a cruciform church after 976. The old tower in the Piazza, which fell in 1902, and was afterwards rebuilt, was associated with this building. The new church of 1063 was dedicated in 1095, but it was not finished with its mosaic embellishment until well into the twelfth century. As first built, it was almost purely Byzantine in style, and undoubtedly due in large part to Byzantine architects and craftsmen. The standard of workmanship is very high, especially for the time.

The church is a good example of the type known as the 'cross of domes' or composite cruciform five-domed church, for it has five domed units so combined (with apse and nave extension) as to mark a great cross in ground-plan. This was the arrangement of Justinian and Theodora's imperial mausoleum church of the Holy Apostles in Constantinople, and Justinian's church built at the tomb of St John the Evangelist in Ephesus, both of which have been destroyed. San Marco differs from the original in lacking a gallery, in having the sanctuary in the eastern limb of the cross (rather than central), in having windows in the domes covering the limbs of the cross, and, of course, in the later additions of pointed and Renaissance style. The projecting pierced piers go back to the Byzan-

tine originals, and were transmitted, as we have seen, to Saint-Front at Périgueux. A Byzantine church would probably not have large mosaic subjects on the pier walls, below the spring of the vault, but otherwise the decorative scheme runs true to type. The marble veneer of the interior, now patinated to a beautiful soft brown, is actually made of slabs which were almost white when applied. Much of the furniture of the church is Byzantine in style also.

No 'school' developed out of the construction of San Marco in Venice. The building, beautiful as it was, had very little direct effect – a sure sign that its architects were Byzantine, and out of touch with Italy. The Byzantine mosaicists, not so far removed in sentiment, were more influential.

At Padua 'Il Santo' (the church of Sant'Antonio) was laid out (1231) in somewhat the same way, but interiorly faced with handsome ashlar, and exteriorly carried out with Lombard brickwork and detail[2] [298, 299]. At Torcello, Santa Fosca (perhaps dated 1011) is a much Italianized version, with exterior galleries, of a centralized Byzantine squinch church type. Perhaps there is something of Byzantine subtlety in the handsome but simple basilican cathedral (641, rebuilt in 864 and again about 1008). The serene interior is still arranged as Desiderius's basilica at Montecassino was. The tower beside it is very elegant, and enriched with tall decorative arcading, which is essentially Lombard, but related to Byzantine work. It recalls the original shape of the tower of San Marco on the Piazza in Venice.[3] Perhaps something of the elegance of the church at Murano (a cruciform building with a beautifully arcaded and galleried apse, finished about 1140) comes from the Byzantine contact also.

299. Padua, Sant'Antonio, begun 1231

But the fact that the Lombard style flooded in so close to San Marco in Venice is proof of the artistic maturity of north Italy.

LOMBARDY

The great alluvial plain of the Po and the Adige in which Lombardy lies is revealed by a mere glance at the map as a natural corridor. The Po itself is navigable from near the confluence of the River Sesia, for 337 miles to its mouth. This was a great aid to trade in the Middle Ages, when land transport was so difficult. Maritime Venice connected Lombardy with southern Italy and the Near East. A system of Alpine passes centring upon Milan facilitated connexions with the North. We have already seen how architectural ideas moved from Ravenna through this corridor towards Spain, France, Switzerland, and Germany.

A magnificent row of towns existed even in antiquity in the Po Valley. After a decline, trade developed and they increased greatly in population and urban consciousness – particularly in the eleventh and twelfth centuries, so that they were capable of confronting Frederick Barbarossa with their Lombard League (1168–83) when that Emperor sought to regain rights which had lapsed during the period of papal and imperial anarchy.

In Lombardy the older Romanesque buildings present difficult chronological problems. There are two schools of archaeological thought – one inclined to stress early examples supposedly traceable to the eleventh century; the other inclined to assign the greater share of

existing Romanesque works to the period of the League and afterwards.[4]

Because of its alluvial character, the region builds in brick. The clay burns to enchanting pinks and browns in the eastern part of the valley, and to full, beautiful, bright, rich reds in the region about Milan. Sources of stone are, however, never very remote, and easy communication made it possible to use that material freely, often in combination with brick. The stone is rather grey and gritty; hence, for better effect, marble and breccia (also obtainable) were used when the means allowed it. Though Venetian architecture was little imitated, the gaiety of Venetian colour and rich materials had its effect on the mainland design.

Architecturally, as we have seen, the region had international importance by the year 800. Its style of that time, the Lombardo-Catalan First Romanesque, did not change much as it matured. It was used in larger, more substantial buildings of much better workmanship, with more ambitious vaults, and enriched by more elaborate mouldings, galleries, and sculptural motifs, but it shows little trace of outside influence.

Two striking features developed, however: the square belfry tower, and the rib vault. Of course Roman towers – stubby *turres* – had been built in Lombardy. The series of monumental church towers appears to begin with San Lorenzo in Milan (about 400, later very extensively rebuilt). The church, a quatrefoil, has four corner towers, with projecting apses between three of the pairs. This scheme of an apse between a tower pair was taken up in Germany (Fulda, about 790, and many others subsequently).

It is the tall Lombard tower built specifically as a belfry, with pilaster strips and corbel tables as decoration, which appears to owe something to Rome, the Exarchate, and the Byzantines. The great belfry of Old St Peter's in Rome, built into the propylaeum range [3], largely in 755–65,

was undoubtedly very influential. The plain old Monks' Tower beside Sant'Ambrogio in Milan [302] is one of the oldest now in existence (tenth century) though the belfry is modern. San Satiro in Milan has a characteristic example, dated 1043 rather than contemporaneously with the church. Belfries multiplied in the eleventh century because of improvements in bell casting, and increase of means made it possible for many churches to have sets of bells. Conspicuous among the typical Lombard towers of early date and mature design is that of Pomposa (1063), built by Abbot Guido of Ravenna [301]. It has nine stages, marked by pilaster strips, applied shafting, and arched corbel tables. Originally the openings on each side increased from one narrow loophole at the bottom to four generous arches in the belfry.[5]

While within the Po Valley one feels Lombardy as a great corridor, in the north one is conscious of the radiating mountain passes and the reflex influences from Germanic lands. The Lombard belfry was represented on the Piedmontese cathedrals of Ivrea and Aosta by the early eleventh century. There is a fine example of paired belfry towers on the church of Sant'Abbondio at Como in north Lombardy [300]. It replaced an interesting Early Christian structure which has been traced by excavation. The new church, built of stone, was begun about 1063 and dedicated in 1095.[6] The deep sanctuary has two bays of rib vaulting and a ribbed apse; laterally there are two groined bays to each side at the entrance of the sanctuary; each has an apse in the thickness of the wall, and over this pair of little sanctuaries, one at each side, the tall, active bulks of the belfry towers rise. The church has a dignified basilican façade and a generous clerestory in the nave which, like the double aisles, is roofed in wood. It is well known as a typical example of the use of decorative applied shafting, pilaster strips, and corbel tables for articulation of the design, and for the enrichment of the wall surface. The wooden roofing of

the nave is both archaic and prophetic; for after the earthquake of 1117 many fine naves were roofed on wooden truss-work to avoid the risk of falling vaults.

In passing, the trefoil plan and the vaults of San Fedele at Como should be mentioned, for these are said to have been influenced from the north. The aisles are carried entirely around the transepts to the triapsidal east end, perhaps in partial imitation of St Mary in Capitol at Cologne (1045–65; somewhat rebuilt later). The date of San Fedele apparently falls, for most of its present structure, in the early twelfth century. If so, San Fedele has an early example of the developed Lombard eaves gallery which we have noted previously at San Nicola in Bari. The earliest definitely dated, fully developed ex-

ample is claimed – against conservative protest – for the church of San Giacomo in Como (1095–1117).[7]

We now turn to a consideration of Lombard rib vaulting, a much more difficult subject. It involves some questions of date and scope of influences which may never be solved, because of lost monuments.

For us it is sufficient to say that about 1050 there was, over a wide area, stretching all the way from Armenia through the Near East to Italy, Spain, and France, a great interest in rib vaults of various sorts – ribbed tunnel, domical or cloister, ribbed groin, and compound vaults. The original impulse was Byzantine (the dome of St Sophia is the first ambitious ribbed vault); later the idea was taken up by the Moslems and

300. Como, Sant'Abbondio,
c. 1063–95, south flank

301. Pomposa, church and tower, 1063, from the west

used successfully though sporadically by them. The Armenians first applied it systematically to church architecture, beginning early in the seventh century. Trdat, the Armenian architect who repaired the vault of St Sophia about 975, was one of the innovators in the 'Second Period of Bloom' of Armenian architecture. Afterwards (perhaps in the eleventh century?) the Armenians developed (especially for nartheces) a clever compound vault with the ribs arranged in plan like a printer's sign for space (#). The narthex of the church at Casale Monferrato, so arranged, but dated about 1200, is late enough to show Armenian influence of this sort operating through the Crusades, but it is not possible to trace definite influence from Armenia either at the critical time (about 1050) or upon the critical form (groin vaulting).[8] At most, oriental contacts may have stirred the originality of Western builders, and led them to develop their own essentially Roman inheritance.

Traces of a Lombard ribbed groin vault claimed for 1040 exist in the ruined older part of the former abbey church of Sannazzaro Sesia (north-west of Milan and Novara). The original church, reported as founded in 1040, has been replaced, but there are remains of a brick narthex with two-storey groin-vaulted aisles flanking an open nave, and clear indications that the tribune was (as at Vézelay, about 1140) carried across the open nave at the east end of the narthex. Only this axial tribune bay had ribs, and they rested on terracotta capitals of archiac form. Herringbone work and pebbles in the construction also give it an archaic air. Such wall-work usually indicates a ninth-, tenth-, or early eleventh-century date. Restoration work has shown that this wall was not integral, and that the narthex may be of the twelfth century. While Sesia is on the border of the Milanese area, the first Lombard ribbed groin vaults were most probably built farther east, in or near Milan.[9]

In view of Moslem rib constructions, it is worth noting that the piers at Sannazzaro Sesia are rather like Moslem piers turned through forty-five degrees. Again, the aisle and tribune vaults still existing have strongly salient arrises. In the oblong groin vault bridging the nave, the addition of diagonal ribs produced a much better system of intersections and made the vault easier to construct, in addition to enriching it. Oddly enough at Vézelay the high vault above the tribune actually has diagonal ribs also, though the other bays do not (dated about 1140); at Sant'Ambrogio in Milan, as well, the narthex has ribs, though the other bays of the atrium (dated about 1098) do not.

Note should be taken that Ivrea Cathedral, twenty-five miles from Sannazzaro Sesia, was rebuilt after 962 and before 1001 on a large scale, and with an ambulatory. Without minimizing the importance of the mountain barrier, we may say that the intervening Kingdom of Arles united rather than divided Lombardy and France, for by the year 1000 very interesting and clever structural work (including a remarkable narthex) was done in the Lombard style at Saint-Philibert, Tournus, scarcely 250 miles northwest from the Milanese area. William of Dijon, who did such important architectural work at Saint-Bénigne (1001-18), came from Volpiano (forty miles distant) and Novara (only twenty miles distant from this same region). However, these works at Tournus and Dijon do not possess rib vaults, and would seem to show that the Lombard ribbed groin vault does not date back to the early years of the eleventh century.

In Lombard churches the aisle arches are often paired, with an intermediate column between the successive piers. The columns are very practical and unobstructive supports, while the piers provide bases for interior wall buttressing. Consequently the Lombard designers often thought of their naves in terms of double bays – the more so because the aisles were about half the width of the nave, and divided into square bays. The nave, if it had double bays, was rhythmically divided into nearly square units.

The shaft-like interior buttresses rising from the grouped piers sometimes carried diaphragm arches, which further emphasized the bay composition. Thus the way was prepared for large square bays of groin vaulting, resembling in some ways the large vaults of the Basilica of Maxentius and Constantine and the thermal establishments in Rome.

The square vaulted bays, inherited from Rome, begin their medieval history in the crypts, where they are used *en quadrille* (as in Moslem work). Agliate, near Milan [65], already mentioned, has an archaic eleventh-century example. The vaulting itself is in rubble, with arches between the bays. In early work these are 'disappearing arches' at their base, for the impost blocks of the columnar supports were relatively small, and wall responds were shallow or lacking. For the arches between bays of aisle vaulting in the churches, the primitive T-shaped grouped nave-arcade pier developed spontaneously, since there were three arches for it to support. When transverse diaphragm arches were planned to span the nave, there were four arches to support, and the pier thereupon quite naturally developed a cruciform plan (SS. Felice e Fortunato, Vicenza, *c.* 1000; Lomello, *c.* 1025, with diaphragm arches resembling Carolingian flying screens; San Carpoforo, Como, 1028–40;[10] compare San Miniato al Monte, Florence [290], where the applied elements are round, *c.* 1062 ff.). Further development in the vault suggested the addition of logical elements in the piers. Nook shafts on the diagonal appeared when diagonal ribs were introduced.

Since the aisle bays vaulted without ribs obviously indicate what unsupported area the engineers could conveniently vault, it is worth noting that a criss-cross of ribs in the double bays of the nave would divide such bays into four triangles, each equal in area to a square aisle bay. A stout arched centering was erected under each arch and rib; false-work between provided a support for the rubble of the vault

while it was being constructed, and also in the period of weeks or months during which it solidified. The Lombards built these vaults as ponderous dome-like affairs which were not good to look at or easy to abut [303–6]. Actually the ribs neutralized the advantage of domed construction, for they brought to the angles of the vault strong concentrations of thrust which were neither understood nor prepared for. This was particularly dangerous in large-scale high vaults, and in consequence such vaults have not behaved well. Partisans of early dating suppose that many early vaults of this type failed during the severe earthquake of 1117, but that examples continued (though less frequently) to be built. Partisans of later dating assign such vaults in general to a generation or more after 1117. Lighter vaulting, built more or less in the French Gothic manner, superseded the ponderous Lombard type late in the thirteenth century. Many important churches which had been wooden-roofed were successfully vaulted at that time.

There is no specific documentary reference to early ribbed high vaults, though, by what one might call 'historical dead reckoning' – considering the whole great revival of the mid eleventh century – these were due to appear in some important building projects about 1065 or 75 or 85. But it is practically certain that the original examples are lost, and the more conservative methods of study indicate a later date.

For the creation of the form, it would only be necessary, as we easily perceive, for an engineer to imagine auxiliary ribs like the usual arches of the little groin vaults in the crypts, but placed on the diagonal at the suggestion, probably, of Roman groin vaulting (where, to be sure, the arris ribs are not auxiliary construction, but integral). Since the engineers were already building substantial centering under the arches of conventional vaulting, the diagonal centering which is so useful in facilitating the construction of big bays was easily imagined,

302. Milan, Sant'Ambrogio, from the west,
tenth century–after 1181

along with the nook shafts in the piers for the permanent support of the diagonal ribs.

The historically important church of Sant' Ambrogio in Milan [302–5] is a convenient example of the developed form of this architecture and engineering. Here the Lombard Kings and German Emperors were crowned with the Iron Crown, which is now at Monza.

Unfortunately the dating of the church is largely conjectural, but it is usually accepted as representing what the Lombard engineers and designers were able to plan and undertake about 1080.[11] As early as 1196, however, the vaults were being repaired, and the high vault may

not actually have been built earlier than 1117.

We have referred to the building previously by mention of the old apse which with its introductory bay of tunnel vaulting (an early example) was left intact, while the wooden-roofed basilican nave was replaced by a completely vaulted, aisled structure of brick with stuccoed brick and rubble vaults. It is approached through a spacious atrium with bold arches and spur buttresses [302]. This seems to be dated about 1098 by an inscription, though it has been rebuilt to a certain extent. It joins the church in a handsome narthex, which, with its tribune, is included under a wide sweeping gable.

303 and 304. Milan, Sant'Ambrogio, ninth, eleventh, and twelfth centuries (restored 1863)

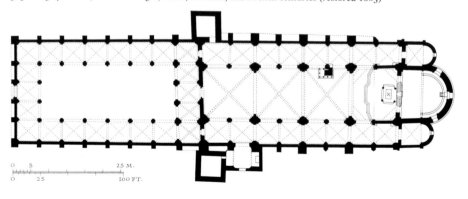

O 5 25 M.

O 25 100 FT.

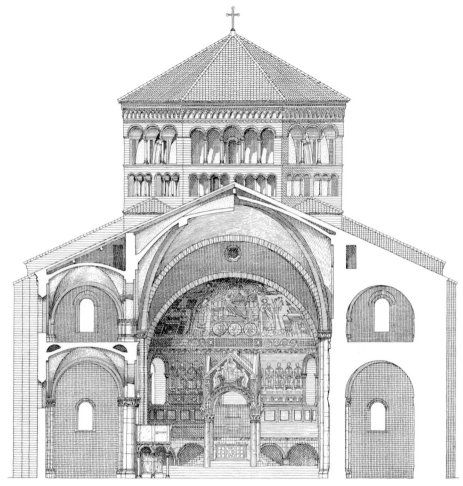

305. Milan, Sant'Ambrogio, transverse half-sections,
eleventh and twelfth centuries

The church was served, not always peaceably, by a community of monks and a chapter of canons. Each had a cloister. To the south stands the very simple Monks' Tower (tenth century) and to the north the very handsome Canons' Tower of 1123, interrupted in 1128, and finished according to the original scheme after 1181 – a sophisticated design which is much admired and very typical. It has pilaster strips and applied shafting, with corbel tables to divide it into five stages above the eaves of the church. The only large openings are three arches on each side of the lofty bell chamber. The late date explains its similarity to the beautiful belfry of San Francesco at Assisi (after 1228).

The masonry indicates that the atrium was already finished when the tower was undertaken in 1123, but the westernmost bay of the

nave was not, for its north wall joined that of the tower, and the vaults of the aisles and triforium gallery were subsequently built against the combined wall. According to documents, the old nave was still in use in 1067; and the new nave already in 1093.[12] We must admit this and suppose that special conditions prevented completion of the westernmost bay of the nave, where it joins the tower.

to have been in use in 1130 with the altar rehabilitated, the date of 1128 for the first completion of Sant'Ambrogio appears to be reasonable. Frankl, however, delays it until 1178 (with repairs as early as 1196).

Sant'Ambrogio has a richly carved and embrasured main door-way. Upon entering the

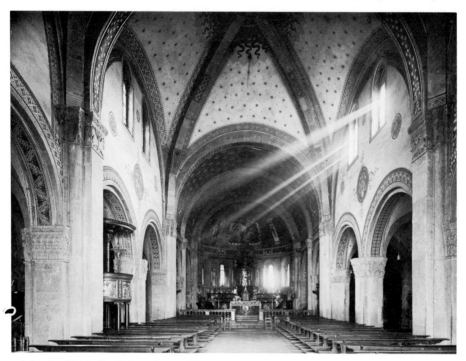

306. Rivolta d'Adda, San Sigismondo, 1099(?)

In the nave of Sant'Ambrogio, double bays of domed-up rib vaulting were planned from the first. Conservative archaeologists hesitate to put their actual construction before the earthquake of 1117. In 1128 revenues which had gone to the monks, presumably for building, were reassigned to the canons, and since the nave appears

building, the visitor sees three great bays of domed-up ribbed quadripartite vaulting, much rebuilt, but probably like the original late eleventh- or early twelfth-century vaults. The fourth bay, beyond, was formerly covered like the others, but subsequently carried up as an octagonal lantern. The aisles are covered by unribbed groin vaults; so also is the triforium gallery, where they are ill placed to receive the

thrust of the vast ribbed bays of the nave. The supports are logically designed, and consequently the 'system' is alternate, with slenderer intermediate supports – not columns, but appropriately articulated grouped piers. Each pair of main piers supports not only its share of the vaulting, but also a substantial buttressing wall which rises to the roofing, directly above the transverse arch. Such walls, by isolating the separate bays of wooden roof construction, would arrest a fire there. The big vaulting bays are harmoniously composed, but lack the processional quality of tunnel vaulting. Unquestionably the church was very dark before the construction of the lantern; for there is no clerestory.[13]

Mention should be made of Early Christian churches in Milan, rebuilt in the mature Lombard Romanesque style – the Basilica Apostolorum and San Simpliciano particularly.

Rivolta d'Adda has in the church of San Sigismondo, dated 1099(?), authentic early Lombard domed-up rib-vaults [306]. The church is instructive, in that the east end is covered by two windowless bays of semicircular tunnel vaulting with transverse arches. Beyond these come two nave-bays of rib vaulting, which are very irregular in curvature – in parts almost conical. This shows inexperience and, though admittedly rustic, cautions us against accepting very early dates for the rib construction. Here, owing to smallness, a clerestory is possible.[14]

In the great church of San Michele at Pavia[15] [307] we have a stone counterpart of Sant'Ambrogio in Milan. It was built slowly, from about the year 1100 to about 1160, over a cruciform plan and was provided originally with a small clerestory. The church has a semi-dome and a big single quadripartite bay at the east; the transept has its absidioles simply cut into the substantial east wall, with a crossing covered by an octagonal domical vault on squinches, and arms by tunnel vaulting without transverse arches; the aisles and galleries are covered by

unribbed groin vaulting; the nave was intended for two big domed-up double bays of rib vaulting, but was actually covered by oblong single bays in the French manner. The cliff-like stone façade, with a single sweeping gable fronting both nave and aisles, is very famous, and very interesting for its friezes of beast sculpture. The

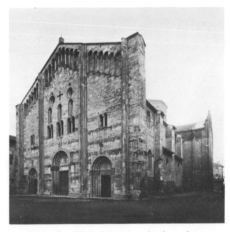

307. Pavia, San Michele, c. 1100–60, from the west

façade is articulated by shafting and dosserets which form shallow buttresses, and is adorned at the top by a fine arcaded gallery. There is singular power in this design; and this comment may be made generally on works in the Milanese area.

Quitting the region about Milan for Emilia, we find two excellent examples of Lombard style in Piacenza. San Savino, dedicated in 1107, has an apse with a tunnel-vaulted sanctuary bay, followed by three big double bays of rib vaulting, each with a single clerestory window on each side, and accompanying unribbed aisle bays. The interior has much vigour and harmonious proportions. The critics who date Lombard vaulting conservatively assign the dedication of 1107 to the crypt, which is a fine and spacious

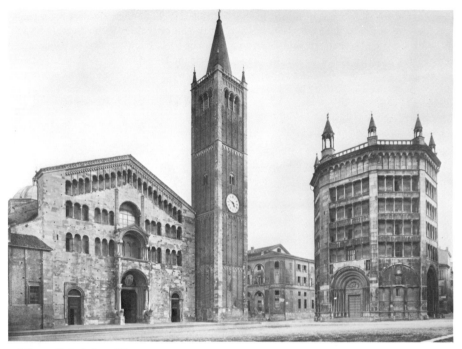

308. Parma Cathedral, twelfth century

example. The date might better be applied to the tunnel-vaulted sanctuary, in which case the big double bays of rib vaulting might be later – perhaps (inevitably!) after the earthquake of 1117. It is an admirable example of the large Lombard parish church.[16]

Piacenza Cathedral,[17] begun by 1122, in use by 1158, and finished, with some rebuilding, in the thirteenth century, is one of the grand row of Emilian cathedrals. It has a wide transept with apses at the ends, like the transept of Pisa, and screened, as at Pisa, from the main nave. The bold exterior forms of the church at the east are dramatized happily by a series of Gothic pinnacles (in brick, like the later constructions in the church). There is a single big brick tower, of the usual sort, to the north of the nave. The

façade is, like the older work in the cathedral, carried out in stone. It has the usual sweeping wide gable, galleries, and three porches with the columns carried on the backs of animals. Each porch has a recess and tribune above it. The Gothic style appears in a dignified rose window. Here and there in the fine masculine interior there is a touch of the Gothic, but the effects are Romanesque. The nave has big rib-vaulted bays with a clerestory (except for the traditional tunnel-vaulted sanctuary bay), also the usual octagonal domical vault on squinches at the crossing, and a spacious crypt under the raised choir. The effect, both exterior and interior, is very impressive.

In Parma Cathedral[18] [308] we have another splendid example. There was a dedication in

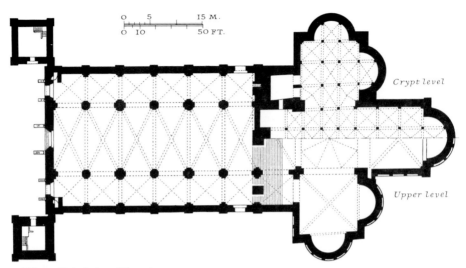

Crypt level

Upper level

309. Parma Cathedral, twelfth century

1106, but the earthquake of 1117 was disastrous, and only parts of the old work were retained in the magnificent rebuilding. The church was laid out as a great cross in plan [309], with a huge crypt recalling that at Speyer Cathedral. The crypt is covered by a quadrille of groin-vaulted bays. Here, as at the principal level, the crossing, the sanctuary bay, and both arms of the transept are practically square; the transept terminates in apses at the ends, and each arm has an eastern apse nearly as large as the principal apse. On the exterior this produces a powerful composition of semicylindrical and cubical forms building up to an octagonal lantern. The apses, the transept, the sanctuary bay, and the tower are all enriched by galleries.

The western limb, vaulted in 1162, has seven bays with square groin vaults in the aisles; there are uniform oblong ribbed bays, now sustained by tie-rods, over an arcaded triforium gallery and a clerestory, in the nave. This uniform system marks the surrender of the traditional

Lombard scheme which we have found in Sant' Ambrogio and elsewhere; it is in line with French developments, though in France all the vaults would be ribbed, the construction would be lighter, and the clerestory windows would of necessity (on account of the climate) be larger. The weightiness of Parma is in the Italian tradition.

At the façade the design, built of stone, maintains the Lombard character intact. There is a precipitous great wall carried up to a tremendous sweeping gable, boldly accentuated by a rich cornice and a continuous stepped gallery between pylon-like verticals at the corners. The horizontal is masterfully introduced by two less open horizontal galleries and the three portals, while the projecting central portal with its tribunes and buttresses, and the big oculus pierced between the latter, give a vertical accent.

This striking façade was augmented by two towers, still representing the old tradition of the free-standing belfry, since they are not inte-

grated with the nave, but planted at a short distance from the church, like the pair at Sant' Ambrogio in Milan. The towers have their rear walls in line with the façade wall of the church, so that they project both in width and in depth. They contrast in colour; for only the corner pilaster strips, the corbel tables, and the openings are in stone, the rest being of red brick. The north tower was carried up only half a stage; the fourth stage of the other is capped by a Gothic belfry in stone, and that in turn by pinnacles and a tall pyramidal roof of active profile but late date.

To the south-west near this tower stands the baptistery of the cathedral, built of brick and stone in the twelfth-century style, although not finished until the thirteenth [296B, 308]. There are rich portals and other sculptures by 'Benedetto miscalled Antelami' (in Mr Porter's phrase). The sculptor is believed to be the author of the building, which was begun in 1196. It has, above the ground storey, four stages of gallery colonnades between strong spur buttresses (at the corners); a decorative arcade and arched corbel table, plus corner pinnacles, terminate the design. Perhaps the colonnaded galleries were suggested by the façade of Pisa Cathedral, which was being finished at the time. The interior also has colonnaded galleries, two in number, coming above the portals and their intervening niches – and below a ribbed vault of eight compartments. The font is of conventional form, with steps and an octagonal parapet. Monumental baptisteries of this sort are rare in the Middle Ages; they recall the time when baptism was an episcopal function, and when large numbers of catechumens were baptized together at Eastertide.

Cremona[19] has a similar cathedral group begun in 1129-43 with the church, but the transept arms date only from 1288 and were not finished until about 1342. This transept, the crossing, and the choir arm are very impressive

in compositional mass. The building is largely of brick, with a façade of stone. This is in part Romanesque, but it is adorned by a Gothic portal, pierced by a Gothic rose window, and capped by huge scrolls of Renaissance design with a Renaissance arcade, pediment, and pinnacle on the axis. A vast tower of Gothic date rises to the north, and a large baptistery of 1167 is set at the south and west. The ensemble has bold scale and is singularly apposite in showing how the grand qualities of the Lombard Romanesque lived on into the Gothic and Renaissance periods.

There are, of course, great numbers of smaller buildings, each with something of interest, which cannot be taken up in a general work of this sort. Passing mention only can be made of the substantial rotunda of the old cathedral in Brescia (about 1115); San Pietro in Cielo Aureo at Pavia, dedicated in 1132, finished about 1180; Sant'Eustorgio at Milan, with fragments dating back to 1040, but made over into a vaulted hall church, with uniform domed-up groin vaults, after 1178; Ferrara Cathedral, with a fine portal of 1135; Verona Cathedral, with sculptures by Niccolò, dated about 1135; the cathedral of Borgo San Donnino, with sculptures by Benedetto Antelami; San Pietro at Asti and San Salvatore at Almenno, both circular churches of the eleventh century (a rare form in Lombardy).[20]

As a fine example of the twelfth-century wooden-roofed church in Lombardy, there can be no happier choice than San Zeno Maggiore in Verona[21] [310, 311]. The structure incorporates fragments dating back to about 1030, but the building which we know took character about 1123-35, and was long under way. Fine marble, now beautifully patinated, was used freely in its construction. The façade is much admired for its harmonious proportioning, with basilican profile; its embellishments in the form of marble reliefs near the door (dated about

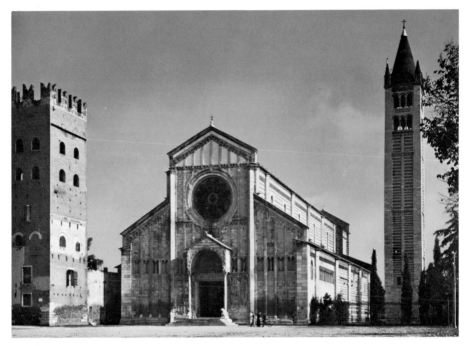

310. Verona, San Zeno, *c.* 1123 and later

1140; by artists named Niccolò and Guglielmo) and bronze door valves (incorporating early eleventh-century elements) are well known. Familiar also is the soaring tower, set to the south of the church near its east end.

The interior is basilican, with a relatively small clerestory and no triforium. The nave, covered by a beautiful Gothic trefoil ceiling, is laid out in a series of bays, divided by interior buttresses which rise from compound piers. These bays are irregular because of the delays in building. There is a very narrow single bay just inside the façade; then there follow, between compound piers, a three-arched bay, and three two-arched bays, all with columnar shafts as intermediate supports. The succeeding bay is single-arched. The absidioles at the head of

the aisles opened into this bay, which served as a sort of dwarf transept. The same bay and its neighbour, plus a vaulted square sanctuary bay and apse of Gothic date, form a fine Lombard 'high choir'. Bridge-like stairs to it, in the aisles, span a descending flight which extends the whole width of the church and leads to a magnificent crypt beneath the 'high choir'. The crypt opens through three generous arches upon the stairway leading from the nave, and a large part of it is actually visible from the nave. The liturgy, seen across the depression, gains somewhat in dignity because the sanctuary platform is elevated and somewhat remote. Lecterns for the readings are effectively placed on the parapet here and in a number of other churches with similar crypts.

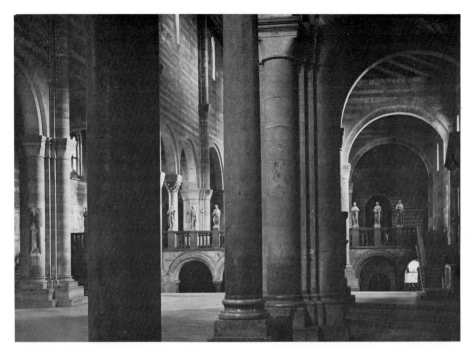

311. Verona, San Zeno, c. 1123 and later

The arrangement just described is, of course, the fullest possible and most monumental development of the old crypt and high choir scheme which we saw in its beginnings at Old St Peter's (about 600), Sant'Apollinare in Classe, Ravenna (ninth century), and Sant'Ambrogio in Milan (about 940), all places of pilgrimage.

This further reference to pilgrimage may serve to introduce the group known as Santo Stefano in Bologna,[22] really a Lombard Romanesque red-brick version of the Holy Sepulchre. The octagonal church representing the Anastasis has a twelve-sided central structure. It is rather rough work, dating from about 1150. Adjoining it is a court of 1142 which represents the Holy Garden (covered, in Jerusalem, by the Crusader transept dedicated in 1149). The ad-

joining church of San Pietro is more or less contemporary. The interior of San Pietro is disappointing, but the façade is one of the best of its kind.

With this we conclude our general study of the Romanesque church architecture of Lombardy. But we must go far in order to reach the farthest limits of the style – for echoes of it penetrated to Dalmatia (and on into Serbia as we have seen), Hungary, Germany (and on into Russia, as already mentioned), the Netherlands, Scandinavia, and even, in some degree, to the north of France. It shared eastern Italy with designs partly dependent on the Tuscan style, all the way to Apulia.

One Lombard monument will be best understood in this combined Lombardo-Tuscan am-

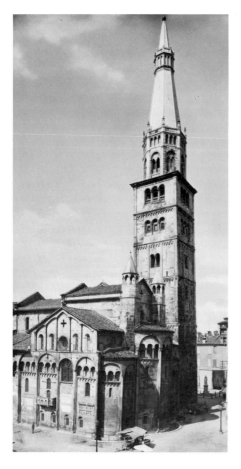

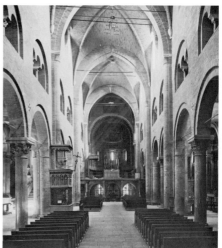

Miniato [291] and San Nicola [266] in its four big double bays, with intermediate columnar supports, a triforium (though false) with triple arches under enclosing arches, a clerestory, diaphragm arches, and wooden roofing. Each diaphragm arch carries a parapet which has been built up well above the ridge level as a precaution against the spread of fire starting in the intermediate wooden roofing. Like San Nicola at Bari, Modena Cathedral has an 'included' transept. Only in Gothic times (1437, 1446, and later) did the church receive its vaulting. There

bient – namely, the cathedral of the city of Modena, which, though Lombard, was actually within the dominions of the Countess Matilda of Tuscany and thus particularly open to Tuscan influence [312, 313]. The building was begun in 1099.[23]

Tuscan influence, and doubtless the successful design of San Nicola at Bari (begun 1087-9) [264, 265], explain the otherwise surprising lack of Lombard rib vaulting in this important work which has rather emphatic Lombard stylistic details. Actually the plan [314] recalls San

is only one tower, of Lombard type, set north of the transept. It carries a Gothic spire. The sentinel towers of San Nicola are reduced to a pair of turrets above the apse.

Lanfranco was the architect, and, to judge by his building, an independent and very personal designer. Under him doubtless the crypt was finished (1106), and he is supposably responsible for the ordonnance of the interior, which is all in warm red brick, as well as for the exterior, which is all in fine ashlar. Strongly marked arcading which is Pisan rather than

Apulian in feeling encloses, rather than supports (as at Bari), a gallery. This, with rather aggressive triple arches in each bay, makes a circuit of the building except above the main portal. As in the case of a few other buildings of the very end of the eleventh century, we feel a definite impress of the designer's personality, in this case so strong that the design was carried through to the dedication of 1184 and the completion of the lateral Porta Regia (1209-21) with very little change, beyond the introduction of a big rose window in the façade.

312 to 314.
Modena Cathedral,
begun 1099,
exterior, interior,
and plan

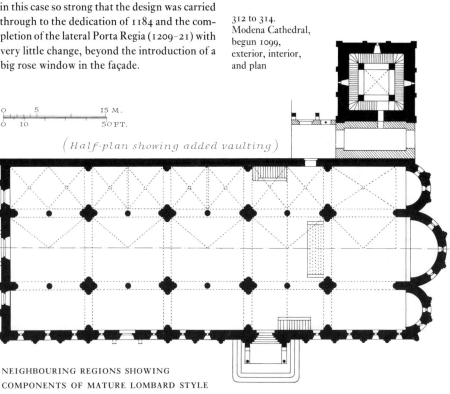

```
0    5          15 M.
0   10         50 FT.
```

(*Half-plan showing added vaulting*)

NEIGHBOURING REGIONS SHOWING
COMPONENTS OF MATURE LOMBARD STYLE

Eastern and Middle Italy

Echoes of Lombardy in Liguria (Genoa Cathedral, twelfth to thirteenth century) and Sardinia (Uta, twelfth century) are slight. In Rome itself SS. Giovanni e Paolo (about 1155) is the only example; however, in the region near by, examples are more numerous and they often show interesting combinations.

Anagni Cathedral[24] has a strong Lombard exterior, but the interior is of Roman character, possessing a throne of 1263 by Vassalletto, whom we have met in the cloister of St John Lateran in Rome. At Arezzo[25] the 'Pieve' (parish church) has an exterior which is Pisan, while the interior is Lombard, with double bays and a

raised choir. Ancona Cathedral (dedicated in 1128, largely finished in 1189) has a cruciform plan with apsidal ends on the transept, and zebra-work masonry, all of which recalls Pisa, but the general feeling of the superstructure, with its lion-backed portico, is Lombard. The fine church of Santa Maria di Portonuovo near Ancona is Lombard (twelfth century, sometimes dated earlier) with a dome, but arranged in plan like a Norman church.

Farfa (Fara Sabina)[26] is a disappointment, though there is now, once more, a monastery established at the place where the famous Consuetudinary of 1043 was found. Architecturally there is nothing recognizably Cluniac in what remains. There is a single old tower, with three Carolingian lower storeys, an intermediate stage

dated about 1089–99, and three later stages above. Apparently there was a sort of western transept with something like a 'Helmhaus' above it. The surviving constructions are rather simple in form and Lombard in feeling. A subterranean corridor with paintings has been found, and further excavations would no doubt be rewarding.

At Spoleto the façade of San Pietro[27] (twelfth to fourteenth century) is rich with arcading and sculptured panels, somewhat in the manner of San Zeno in Verona. Over the main door is an exceptional horseshoe-shaped tympanum. The three portals are flanked by projecting beasts, but without the Lombard columns and hood.

Most attractive and best known among this group of churches are San Pietro and · Santa

315. Tuscania, San Pietro,
eleventh and twelfth centuries

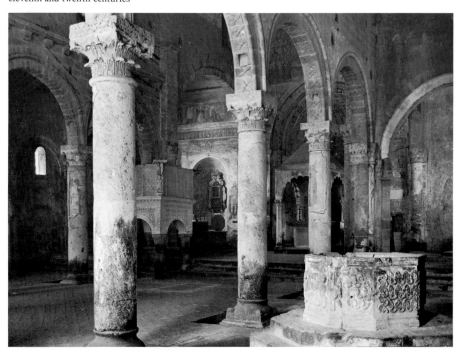

Maria Maggiore at Tuscania (formerly called Toscanella).[28] San Pietro [315] appears to be the earlier, and archaisms have led Rivoira to assign parts of it to the eighth century. It is a three-aisled, wooden-roofed columnar basilica, built of stone. There is an interesting crypt of the end of the eleventh century, supporting a well-proportioned triapsidal raised sanctuary. The main baldacchino dates from 1093. Constructional work on the church continued to a conclusion about 1200 at the west front. The façade is overwrought, with reminiscences of Burgundy, Tuscany, Lombardy, and even perhaps Spain in the rose window and its flanking *ajimez* windows. The best effects at San Pietro are in its powerful nave, where the protruding voussoirs of the aisle give a singu-

larly vigorous effect, and the view to the raised sanctuary is indeed impressive.

Santa Maria Maggiore [316], with a free-standing square Lombard tower, has a similar though simpler and finer façade which has been much copied in modern times. It has a rather barn-like nave with exceptional dwarf transept arms at the head; beyond is the sanctuary, with a Moslem touch in the cusped arches of the baldacchino, and a Byzantine touch in the extensive painting above the chancel arch, which matches the transept arches and thus suggests a centralized scheme. Santa Maria was begun, it is believed, in the eleventh century, and finished in 1206.

Influences projected forth from Lombardy and Tuscany, which engendered the interesting

316. Tuscania, Santa Maria Maggiore,
eleventh century–1206, façade and tower

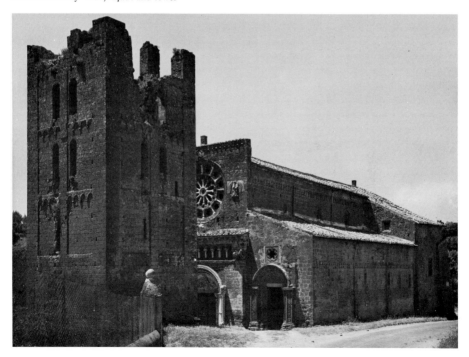

local works just reviewed, also operated across the Adriatic Sea, and there produced a number of interesting churches in mixed style, but (as in Italy) with strong Lombard emphasis.

Croatia and Hungary

In the period which concerns us these two areas were architectural provinces of Lombardy and eastern Italy. Architectural influence from Burgundy began with the Cistercians, in 1142, but monuments earlier than 1200 have not survived. Villard de Honnecourt had visited Hungary by 1235, and French Gothic influence doubtless came in with him. Some German architectural influences had come during the reign of King Andrew and Queen Gertrude (d. 1213), but with a strong Lombard imprint upon them. Influences flowed naturally along the Danube, and later through Croatia.

We have heard of the Hungarians before, as unwelcome pagan visitors to Burgundy in 937 and 954. In 955 Emperor Otto the Great administered a crushing defeat to them, and they were converted to Christianity as a result of stipulations in the peace treaty of 973. The reigning Duke was baptized, and the Church was organized under his son Stephen, whose reign began in 997. Pope Sylvester II (Gerbert, whom we have followed from Reims to Catalonia, to Otto III's entourage, and finally to Rome), recognized Stephen as King in 1001. Stephen died in 1038, and was canonized in 1083. In his time ten dioceses were created, and an interesting system of crossroad churches was instituted, with ten villages responsible for each church. A palatine church was built at Székesfehérvár (Alba Regalis, or Stuhlweissenburg, south-west of Budapest) for King Stephen. His great sarcophagus now has a place of honour in the museum there, but all his buildings have been destroyed. The kingdom, which might have been conquered for the

Empire but for the struggle over the Investitures, was able to abstract itself from its troubles by becoming a fief of the Holy See under Gregory VII (1076), and to conquer Croatia – thus acquiring a stretch of the Dalmatian coast – during the ensuing confusion (1102). Later the kingdom also included Transylvania, and it extended almost to Cracow in the north, almost to Vienna in the west. In this great region the Hungarians constructed, with a local savour, buildings basically related to Lombard, German, Burgundian, and other French models. The plans, however, even in ambitious buildings, remained relatively simple.

The mountain barrier has always forbiddingly blocked off the interior of Croatia from the Adriatic, but the coastal region was already under Lombard architectural influence even in the Carolingian period, as already noted. The stream of Lombard influence continued to flow in the mature Romanesque period, when it was augmented by that of Tuscany, as in the case, already considered, of middle and southern Italy. The Croatian area, though theoretically Byzantine, was then too remote to be influenced by Byzantine architecture, except through the Exarchate. Easy navigation of the Adriatic encouraged contacts with all of eastern Italy. Definite Apulian influence (itself partly Tuscan and Lombard) can be traced also, especially in the baldacchinos of the churches.

There is a succession of striking cathedral towers on the islands and mainland of the coast, which mark it as the twin sentinel towers mark the coast of Apulia. They are Lombard in general character. One of the best known of these towers was built beside the mausoleum of Diocletian at Split (Spalato), then, as now, the cathedral; another, in the Ravennate style, was constructed at Zadar (Zara) Cathedral in 1105.

St Mary, the cathedral of Zadar, has a Lombard east end, but the west end is Pisan,

marking a change in artistic orientation before
its dedication in 1285. San Crisogono at Zadar,
rebuilt in 1175, is a more consistent Lombard
example.[29] Rab (Arbe) presents another am-
biguous example – with an ambulatory
(eleventh century) – inspired perhaps from
Santo Stefano at Verona (990). In general the
constructional methods appear to be Lombard.
The building material is good ashlar stone and
rubble.

There are rich doorways also, more or less
Lombard in form. The finest of them, though
it has some Gothic leafage, is essentially tardy
eclectic Romanesque of 1240. This is the
western doorway of Trogir (Traù) Cathedral
by Radovan, a Slav sculptor. The door has
projecting lions, but, as at Spoleto in Italy, they
have no columns above them. The tympanum,
a Nativity, recalls Venetian work. The rough
execution and the late date make it essentially a
piece of folk art. It is charming in its place; in
fact the island of Trogir is a place of enchant-
ment.[30]

Turning now to the properly Hungarian
monuments,[31] we note that the Benedictines
came in 999 and afterwards as genuine agri-
cultural colonists, and greatly improved the
economic basis of the still distracted country.
The western connexions of these monks are
architecturally acknowledged in the oldest of
their abbeys, Vértesszenkereszt (or Vértes, west
of Budapest; 1146), and in the second cathedral
of Kalocsa (south of Budapest; after 1150),
where traces of ambulatory and radiating chapels
have been revealed by excavations.

The Cistercians, welcomed and much fav-
oured beginning about 1180, did their usual
part, as in western Europe, and the other orders
joined them. The oldest surviving Cistercian
work, at Kercz (founded in 1202; in Transyl-
vania, now a ruin), is of the usual type, except
that the church apse is polygonal; Apátfalva
(founded in 1232) is normal Cistercian work.

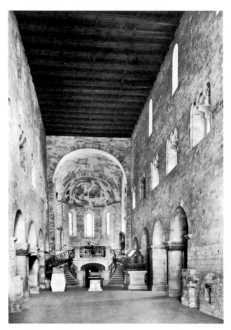

317. Prague (Bohemia), St George, 1142 ff.

A curiosity of the region, from the eleventh
century on, and known partly from excavations,
is a relatively large number of round and poly-
foil churches, often with Lombard detail, and
usually connected with local courts. Romanes-
que architecture has an eastern fringe of these
central-plan churches which extends, by way of
Bohemia, as far as Bornholm.

Lombard influence shows strongly in the pre-
sent cathedral of Pécs (Fünfkirchen, near the
Drava River and the old boundary of Croatia)
[318]. The church was burned in 1064, restored
about 1150, and in 1881-91. The plan is tri-
apsidal, with seven big bays – three for the
sanctuary and Lombard crypt, three for the
open nave, and one, at the west, for vestibules
and a tribune. This plan looks rather like that of
San Nicola at Bari or Modena Cathedral, but

318. Pécs Cathedral, c. 1150 ff.

without the transept and without columns between the piers. It is a four-tower church – that is to say, a church with a tower on each of its four corners. There are two towers attached outside the aisles just west of the apses, and two flank the main front in a similar way. (This arrangement looks oddly like an augmentation of the scheme for the west front of the Ottonian cathedral built after 994 at Augsburg, not far from the Danube. Quite unusually for Germany, this building had a pair of square belfry towers set north and south, respectively, of the west façade, with a western apse terminating the nave between. The similarity between Augsburg and Pécs may be fortuitous.) In any case the church at Pécs has many features which are Lombard, even to the raised choir. The western gallery, however, is characteristic in the Hungarian Romanesque.

The striking scheme of four towers was used also at Székesfehérvár (where St Stephen had

built the palatine church) and Esztergom (Gran, where St Stephen was buried; it lies near the great bend in the Danube north of Budapest, and its Romanesque church is known from excavations). At Székesfehérvár and Esztergom the towers are within the rectangle of the plan. The foundation of these churches is ascribed by Gál to 1030–60, but it is certain that the actual, existing structures were not begun early, or soon finished. Though we may recognize the sources of Hungarian Romanesque, we are always conscious of its vigour and its local feeling.

Esztergom Cathedral, for instance, was rebuilt under Bela III (1173–96) and later, and had a portal with columns on the backs of lions (1200–9), showing a continuation of Lombard influence. In contrast there is Bela III's palatine chapel, with two portals of Burgundian character. The Burgundian component, which came early to Hungarian architecture, was very persistent. The apse of the chapel, however, is in

transitional Gothic, and reminds us that Queen Anne was French; likewise, later, Queen Marguerite, a sister of Philip Augustus. Indeed, the dynasty, through papal intervention, became Angevin in 1308.

The capable Hungarian art historian G. Entz identifies influences from the upper Rhineland, from Alsace, and from South Germany in the twelfth century and later times. The principal existing architectural examples showing a tincture of these influences in our period are a series of important Benedictine and Premonstratensian abbey churches, almost all near the river. These with their dates are: Lébény (not very far from Vienna, 1199–1212, 1242 ff.), Jaák (or Ják, almost south of Vienna, near the frontier, 1210–56, with an elaborate half-Romanesque portal dated about 1250), Türje (south of Lébény, near Lake Balatón; about 1240), and Zsámbék (near Budapest; before 1258). These were 'Sippenklöster' (nobles' foundations). They and their derivatives are basilican in plan, single apsed or triapsidal at the east, with no transept. The western towers are paired, and set over the end bays of the aisles, with openings into both the nave and the aisles, as at the cathedral of Strassburg and its extensive related group in middle Germany.

The cathedral of Gyulafehérvár (Karlsburg or Alba Julia in Transylvania) was finished in its original form shortly before the Tartar invasion of 1241–2. It was partly rebuilt afterwards, but the new work does not disguise a Romanesque plan, Lombard and German. The sanctuary has been lengthened, but the two semicircular transeptal absidioles remain as before. The sanctuary bay, crossing, and two transept arms are covered by square rib vaults; the nave has three double bays, with alternately stout and slender supports; two big western towers rise boldly with a high open square groin-vaulted porch sprung between them, and a still half-Romanesque pointed main doorway is set in the façade wall. The reconstruction after

1242 was not rapid. It was still under way in 1287, and one feels that by then the Gothic of Hungary, like its Romanesque, had become a sort of folk art, delightfully local in feeling. Yet it is said that a French master, John, son of Tyno of Saint-Dié, was at work in 1287. Villard de Honnecourt's visit was in 1235.

Upper Burgundy and Neighbouring Areas (Savoy, Switzerland)

There is a special charm to the mountain churches in the north of Lombardy and on the Alpine slopes which descend towards the north. The region had been a part of the old Kingdom of Arles or of Burgundy, with bordering areas in Italy and Swabia. Here, as in Catalonia, Andorra, and rural Burgundy, the forms of the First Romanesque proved tenacious, and they still give character to the countryside. On the upland slopes the modest 'barn' church with a single tower, as well as the nave-and-chancel church with a similar tower, continue in use, and are admirable in silhouette against the gigantic mountain masses. The steep roofs necessitated by severe weather give them a sharply individual character. Typically, the churches are well constructed of stone, and they are often vaulted, though in many cases the vaults were built after the Romanesque period. The towers, also, often represent a later moment, for the south-German and Austrian Baroque flourished in Switzerland too. The belfries of the mountain churches often have very pretty and effective Baroque silhouettes. Apart from the mountain churches, the region hardly has an architecture of its own. The towns were not large, and no great movement was centred here. The abbey of Allerheiligen, Schaffhausen [136], was under Cluniac influence, and, with Cluniac Payerne [135] and Romainmôtier, represents the traditional Cluniac forms, though with Germanic differentiations in superstructure and detail. Giornico, a

mountain church with paintings (*c.* 1100), is strongly Lombard.

The combination of influences in this crossroads area is easily observed at the largest of the Romanesque cathedrals of the region, that of Basel,[32] at the border of the old Kingdom of Arles or of Burgundy. This church has the general feeling of a Rhineland church, which indeed it is. In it there are some remains of a great church consecrated in the presence of Henry II in 1019; for this edifice the famous golden altar frontal now in Paris was made. But the building was replaced after a fire of 1185, and the new interior is vaulted, pointed arches being used, as in near-by Burgundy. This present cathedral is cruciform and has a pair of integrated western towers, suggested perhaps from Strassburg, a little farther down the stream [79]. The elaborate 'Galluspforte' at Basel Cathedral is named for St Gall, the pioneer missionary of the region; basically Burgundian in design, it is a handsome but rather uninspired twelfth-century work, somewhat rebuilt and augmented.

GERMANY, WITH THE NETHERLANDS AND FLANDERS

In an earlier part of this volume we have given an account of the chief monuments of German Romanesque up to the end of the Franconian rule. Under the new Hohenstaufen dynasty, which ruled from 1138 to 1268, the country achieved greater maturity in political matters, and embarked upon a large programme of expansion, colonization, and evangelization. There was a regularly authorized crusade against the Slavs in 1147, followed by a long process of expansion at the expense of these neighbours which was only undone when the Third Reich fell.

Frederick Barbarossa (1152-90) considered himself the heir of Constantine, Justinian, and Charlemagne; and he did something after the manner of each to make Germany powerful and prosperous. His son Henry VI (1190-7) brought the Holy Roman Empire to its maximum ideally and territorially. These two great moments are faithfully reflected in architecture. But the Emperors had dreams of general union and universal dominion which could not be realized because of irreconcilable Italy, and the competing, mutually exclusive ideals of the Papacy, especially under Pope Innocent III (1198-1216).

The diverse architectural influences which had been interwoven to form German Romanesque became mature in the course of the eleventh century and were brought to a fuller maturity in the twelfth, under a new and forceful play of influences from Lombardy and Burgundy.

We find the powerful Carolingian architectural strain continuing. Proof of this is the general design, comparable to Saint-Riquier, of many of the greatest churches in their later form - Mainz, Worms, and Speyer Cathedrals among them. There are many other examples - none more imposing than St Gertrude at Nyfels or Nivelles[1] [319, 320], now lying within the Belgian borders, yet related, perhaps (through its massive façade) to a group of churches in Saxony [323-5]. The building was burnt out in the last war. It has a great wooden-roofed nave (now handsomely restored), an interesting vaulted sanctuary, and an imposing westwork, dating basically from the eleventh century. The Palatine Chapel at Aachen also served as an inspiration in this period; the octagonal Ottmarsheim in Alsace (dedicated 1049) is an example intermediate in date; Nijmegen is of the twelfth

319. Nivelles, St Gertrude,
eleventh century and later, from the south-west,
as restored after war damage.

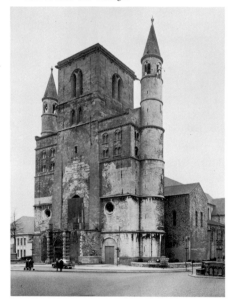

century. Something of the influence of Aachen survives in the two-storey open-well churches and chapels of the twelfth century.

The Lombard international First Romanesque component of the old architecture opened the way for mature Lombard influences.

The influence of Cluny continued, though with diminished force. It had come to Germany graphically, ecclesiastically, and stylistically with Hirsau; the date of foundation is 1095, and after a preliminary dedication of 1099 construction continued until 1127 or later. Paulinzelle, a little later still, shows some influence from Cluny III.[3]

The special influence of Burgundy came strongly to Germany with the Cistercians before

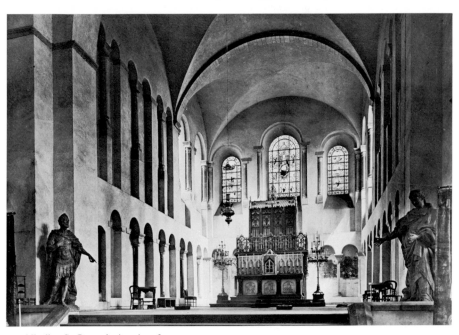

320. Nivelles, St Gertrude, interior of sanctuary, dedicated 1046

under the auspices of the Emperor Henry II, Bishop Meinwerk of Paderborn, and Abbot William of Hirsau, who reformed about 130 houses in Switzerland and Germany, yet even then the specifically architectural influence had not been strong. The 'Hirsauer Schule', based partly on Cluny II, is really German in many ways, and, according to recent opinion, perhaps not sufficiently close-knit to be called a School.[2] Mention should, however, be made of the handsome church of Alpirsbach, associated geographically

the middle of the twelfth century.[4] Kamp, near Krefeld, was the first Cistercian foundation in Germany (1123), and its plan appears to have been the simple early plan used by the Order. But for some time, in the early period, the architecture of the German Cistercians was often local in type. Maulbronn (1146–78) [184] marked a new era by following the fully developed, well-established, strongly Burgundian Cistercian models, though with German weightiness in mass and detail.

of it as arranged *schemate longobardino*.[5] Richer mouldings and greater elaboration of parts resulted from Lombard influence. For example, the handsome two-storey church of Schwarzrheindorf,[6] near Bonn (cruciform, trefoil, with a central well, *c.* 1150), has what is said to be an early German example of the fully developed eaves gallery of Lombard character [321], and

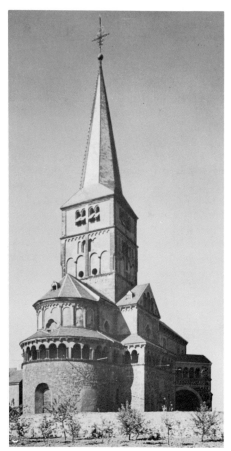

321. Schwarzrheindorf, double church, *c.* 1150

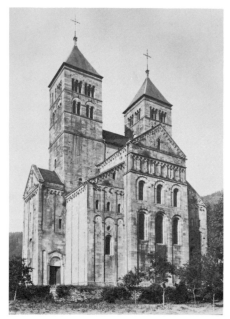

322. Murbach, abbey church, twelfth century (nave destroyed)

In France, meanwhile, Cistercian architecture absorbed the somewhat inert rib vault of the Burgundian half-Gothic, which was represented by about 1160 at Clairvaux, as we have seen, and the authority of this design brought ribbed construction into Germany.

Concurrently there was an influx of mature Lombard Romanesque motifs to Germany. The trefoil plan has been thought (doubtfully) to be a case in point; at any rate the medieval description of the trefoil of Klosterrath (Rolduc) speaks

the motif had been used on the Minster at Bonn before the dedication of 1166. At the same time the rib vault was making its progress: witness St Patroklus, Soest, before the dedication of 1166; Worms Cathedral, after 1171; Schwarzrheindorf, in the extension of 1173; Murbach[7] [322], twelfth century – now only a fragment of the beautifully proportioned great church which formerly existed at this historic site – with rich arcading, and paired towers comparable to those of Sant'Abbondio in Como [300].

The Romanesque thus matured is characteristically weighty, sometimes almost to the point of clumsiness. Many of the examples suffered greatly from over-restoration in the nineteenth century, but the mass of accomplishment in Romanesque before the true Gothic became dominant in Germany (not before 1250, though Magdeburg Cathedral, begun in 1209, shows the first Gothic forms) was very great: so great indeed as to imprint its character on the country. It is no accident that St George at Limburg on the Lahn[8] is inwardly rather like Laon Cathedral, while exteriorly it is a notable example of German Romanesque, elegant and beautifully composed – and its dedication date is 1235.

In order to deal understandably with such a large number and variety of buildings over so extended an area and chronological scale, it will be necessary to divide the subject geographically and morphologically.

The areas at the east and north of Germany within the Empire have relatively little to contribute to our study; we therefore all but omit Moravia, Bohemia (excepting Prague [317]) and Prussia from our consideration, and divide the remainder into (A) South Germany, with Bavaria and Swabia, including Alsace; (B) Saxony, with Westphalia, Eastphalia, and Thuringia; (C) the Lower Rhine and the Main country (Franconia, Upper Lorraine, and Lower Lorraine).

SOUTH GERMANY

This region is traversed by the upper waters of the Rhine and the Danube, natural connecting links with Lorraine and Hungary respectively. The parts of the south-German region which are most important architecturally lie in the ecclesiastical province of Mainz. The metropolitan archbishopric of Mainz also included the important central and northern bishoprics of Speyer, Worms, Würzburg, Paderborn, and Hildesheim; also Strassburg.

The important south-German churches are basilican in form, but there are many small centralized structures of the twelfth and thirteenth centuries. Some are chapels satellite to large churches. Others, well represented by a fine example of 1210, with an apsidal element, at Hartberg in Styria, are cemetery chapels or charnel houses. Still others are palace and castle chapels. These latter are typically of two storeys, like Schwarzrheindorf [321]. The idea goes back to the Rhineland and Aachen, where, as regularly in chapels of this sort (including the Sainte-Chapelle in Paris, the Chapel at Versailles, and St Stephen's Chapel in London), the ruler and his suite are provided for at the upper level. These south-German churches are smaller than the examples just mentioned. They often consist of nine compartments, with the middle one open from the ground floor up through the second level, and carried, above this open central space, upward to a dominant central tower. It has been estimated[9] that over 100 of these centralized chapels existed in Bavaria, the Austrian provinces, and Bohemia. The type was represented in the castle at Nuremberg. A simpler plan, triapsidal, was represented at St George, Regensburg.

St Jakob (otherwise called, from its founding by Irish monks, the Schottenkirche), Regensburg (dated about 1180), has a lateral portal, quite unusually elaborate for the era and the region. This church is a columnar basilica, with groin-vaulted aisles and vaulted triapsidal sanctuary; there is, however, no transept: the building is, so to speak, continuous from end to end, like the Hungarian cathedral of Pécs (which is a parallel example, dating from about 1150, and possibly related to this German type). Pécs, however, has piers; and it should be remarked that simple piers are of frequent occurrence in the south-German churches.[10]

In Late Romanesque times South Germany profusely employed Lombard decorative motifs. Typical arcading and bands enrich the church

exteriors, as at All Saints' Chapel, Regensburg (also a trefoil; *c.* 1150), and Gurk Cathedral, to mention only two among a considerable number of examples.[11]

SAXONY AND NEIGHBOURING REGIONS

In Saxony (with Westphalia, Eastphalia, and Thuringia) there are several groups of churches to interest us. As in the south, they are basilican in layout, with several varieties of the basilican plan. Local variations give them great savour and character.

The 'Saxon façade' in particular is interesting and imposing. It is related to the façade type with two integrated towers (Strassburg, 1015) [79], but gives prominence to an intermediate structure which is as deep as the towers, and is very often carried above them. This produces a tall, rather flat, but bulky and strongly profiled mass which terminates the church at the west in monumental fashion, and, if the church is a large one, it declares itself strongly in the silhouette of the whole city. Some of the examples have already been mentioned, others will be found in the Lower Rhine area and in Sweden.

At Wimpfen im Tal,[12] Franconia, the middle structure is emphasized in that it is placed as it were on a bridge over the west porch; this arrangement is exceptional, but the early date of Wimpfen (before 998, but rebuilt in the twelfth century) suggests it as an intermediate example.

Gandersheim[13] in Saxony has perhaps the handsomest example of the façade type which we have under consideration [323]. The church was rebuilt after a fire which occurred between

323. Gandersheim, church, west front, late eleventh century

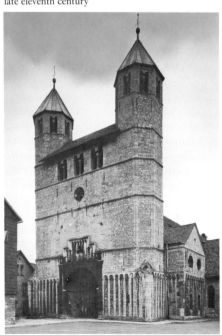

324. Minden Cathedral, eleventh and twelfth centuries, façade

1063 and 1095. There is a great show of arcading in the lower register, and above that a veritable precipice cut by simple horizontal string courses into four stages, bevelled at the corners. These bevels are carried up into octagonal towers, each with a shaft, a belfry stage, and a pyramidal roof. Between the towers, and just below the shaft, there are three twin openings with mid-wall colonnettes, admirably placed with respect to the similar openings in the belfries and the tunnel-like portal directly below.

The Minden Cathedral of 1064 had two towers, between which, in the twelfth century, a taller oblong belfry was built, forming a handsomely stepped mass [324]. This same process changed the front part of the Carolingian westwork of Corvey on the Weser into something like a 'Saxon façade'.[14]

At St Patroklus in Soest[15] [325] the corner towers are reduced to the merest pinnacles between the gables of a stout belfry tower which has a porch and gallery wrapped around three sides of it. The existing church was built, with groin vaults, in the second half of the twelfth century, and the astonishing great western tower just mentioned is ascribed to the year 1200 or thereabouts.

Freckenhorst[16] has an equally astonishing façade, dating from 1116–29. A plain ground storey with a single relatively small portal is flanked by the bases of two cylindrical towers, each advanced slightly, and provided with an entrance doorway. The central mass rises sheer to a tall hip roof, with three stages of belfry openings. Each stage has two twin mid-wall-shaft windows. The cylindrical towers, enveloped at the base by decorative arcading, are plain through a part of their height, above which the cylinders (now disengaged by a set-back of the main belfry) rise to two stages with twin mid-wall-shaft windows. Their conical roofs are set upon eaves a little higher than the eaves of the main belfry. Behind this imposing and beauti-

fully profiled great westwork the nave and aisles of the church extend to the transept, beyond which is the sanctuary flanked by two tall square towers.

The evident love of towered masses recalls the primitive examples of the type which we have examined in Saxon England. Evidently the same spirit informs them all, allowing for the sophistications and outside influences in the mature Romanesque of Germany.

It is hard to doubt that something of the old spirit underlies the warm yet austere charm of the fine basilican constructions in Saxony. Simplicity of form; weightiness in details like mouldings and capitals; excellent masonry, adherence to traditional – even Carolingian – ideals: these are the notes of the style.

Hildesheim Cathedral (dedicated in 1061) has been rebuilt, but St Michael [84], already

325 *(opposite)*. Soest, St Patroklus, western tower, *c*. 1200

326 *(above)*. Hildesheim, St Godehard, 1133-72

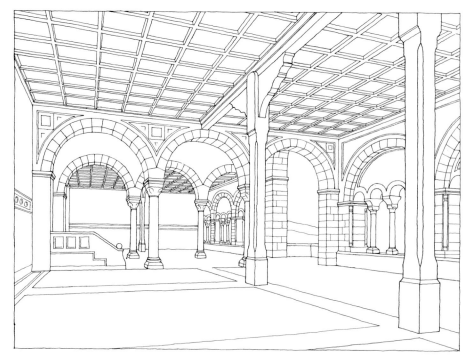

327 and 328. Goslar, the Pfalz, rebuilt after 1132, restoration study as in *c.* 1150 and exterior; see also 94

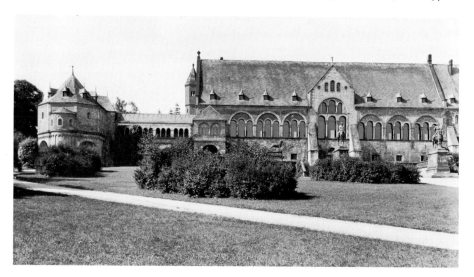

described, partly remodelled under Bishop Adelog (1171-90) and well restored recently, stands well for the accomplishment of the school. It is singularly impressive. It had a wooden-roofed apse, which is unusual, and a painted ceiling, of medieval date. Important among its features was a remarkable sculptured choir-screen dating from Bishop Adelog's period (1186). Examples of richly decorated cubical capitals occur, on the pairs of columns between piers which support the nave wall in *dreiachsigem Stützenwechsel*, as the neat German phrase has it. This type of support is of course common in the German basilicas[17] [82, 83]. (St Michael suffered severely in the last war.)

St Godehard[18] at Hildesheim (1133-72) [326] is a similar building, differing in that it has a masonry apse vault, an ambulatory with radiating chapels, an octagonal crossing tower, and paired western towers. It has preserved a stucco tympanum which is a notable example of that sort of sculpture – seldom seen at present, but practised importantly by the Germans from the time of Saint-Riquier onwards.[19]

In Goslar, the old Imperial Diet town, the cathedral (dating from about 1040 and later, destroyed in modern times) was vaulted, in a heavy manner, at a rather late date. Its rather archaic 'Saxon façade' stood symbolically at the foot of a long easterly slope which was used for vast official assemblages.

Placed transversely at the top of the slope, the old Pfalz,[20] dating originally, as already reported, from about 1050, and restored after a collapse of 1132, still exists (over-restored, 1873) [327, 328]. The ground floor is enclosed, and could be heated upon occasion. The main hall, on the upper level, is a tremendous two-naved wooden-roofed affair with a central throne room marked off by parallel arcades, and communicating with a balcony. The throne room and the lateral parts open upon the outdoor assembly place through characteristic double and triple arches, now glazed, under enclosing arches. The sober best

qualities of German twelfth-century architecture may be discerned here. At the south end of the building there are imperial apartments, which include the interesting two-storey chapel of St Ulrich, cruciform in plan, and balancing the older Chapel of our Lady set near the north end of the palace. The cathedral bounded the east side of the assembly area.

Another great house, widely known to opera-goers because of the 'Sängersaal', is the Wartburg, picturesquely placed on a height near Eisenach. Actually Elizabeth's 'teure Halle' was superposed on the original residence of the twelfth century [329] not long after the first construction. It added greatly to the amenity of the building. The structure as first built had three spacious rooms in enfilade on each of two levels, fronted by a graceful arcaded gallery of lighter construction, with direct exterior access from the courtyard. The main room on the ground floor (central and larger than the others) was a kitchen, and the large room above it was the original hall. The structure was much rebuilt in 1838-67.

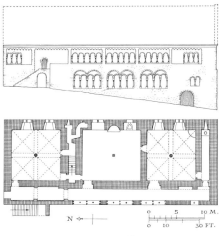

329. Eisenach, Wartburg, twelfth century, restoration study

In Trier the Frankenturm (dated about 1050) shows what the Romanesque tower-house was like, with single superposed rooms. One is likely to forget how widely distributed and how important this city type of residence really was, because so few examples have survived.

In Saxony the vaulting of church naves comes tardily. The older vaults are half-Cistercian, half-Lombard, with domed-up rib vaults over double bays, and the churches themselves, even at a late date, are Romanesque in conception, with relatively simple exteriors, heavy wallwork, relatively small windows, and 'mural values' in the interior design. Magdeburg Cathedral, begun in 1209, counts as a true Gothic church, the first in Germany. Yet at Münster in Westphalia, when the cathedral was vaulted in a rebuilding of 1225–65, the result recalls French transitional churches like the cathedral of Angers (nave vaulted about 1150) [215], though Münster has aisles, and Germanic detail.[21]

Under Lombard inspiration and Burgundian auspices, brick construction appeared in north Germany, and, largely because of the penury of good building stone, spread all along the German Baltic coast, into Poland, and even to regions near Pskov in Russia, before 1220.[22] The available clays burn to a fine red brick; good mortar is obtainable, and from the beginning the German bricklayers possessed a magnificent sense of their craft. The church at Jerichow, not far from Magdeburg and on the borders of Brandenburg, was built about 1150, with most admirably severe lines and good proportions, for a Premonstratensian house of Augustinian canons[23] [182, 183]. The building is wooden-roofed, basilican in plan, and round-arched.

Brandenburg Cathedral, only about forty miles from Jerichow, had brick construction under way in 1165, Lübeck Cathedral in 1173.

It was natural that the pointed arch should soon appear, and with it the name of *Backsteingotik*; the rib vault was introduced (Lehnin, c. 1200–70); tracery motifs came with increas-ing Gothic influence. Charming and ingenious translations of the Gothic elements were made into brick and terracotta for the embellishment of the buildings, and stucco panels brightened the walls with near-Gothic patterns. The Cistercian abbeys of Lehnin and Chorin[24] (1273–1334) are both good examples of this, as are the great churches and town halls of Danzig and Lübeck. *Backsteingotik* is in fact the first really successful German Gothic – for the imitative works in stone of the early period invariably fall far short of their originals in the Île-de-France.

The Teutonic Knights logically adopted the *Backsteingotik* as their architecture, and imposing monuments like Marienburg (1276 and c. 1320–1400) and Marienwerder (c. 1340)[25] speak mutely of their action. A large number of the Hansa cities were in north Germany, and in neighbouring regions subject to north-German influence, and if that inter-municipal mercantile commonwealth may be said to have a national architecture, it was the *Backsteingotik*.

In our judgement the best of the *Backsteingotik* is not surpassed by any but the finest of the late, mature, and characteristically German Gothic buildings. The qualities which the earlier German Gothic inherited through the Romanesque from Carolingian building do not often combine well with the Gallic qualities of French Gothic. But the Germanic qualities, under the limitations of brick-work, are at an advantage in the *Backsteingotik*. The wine-coloured precipices of brick breaking into sharp spires and pinnacles of coppery green are in every way as fine as the massive stone walls of the Rhenish cathedrals and abbeys. The excellent preservation of the buildings after periods from 600 to 900 years should also be counted heavily in their favour. Symptomatic is the fact that great architects of the twentieth century like Ragnar Östberg, Josef Olbrich, and Dominikus Boehm have drawn on the *Backsteingotik* style, sensing its elemental force and authentic grandeur.

THE LOWER RHINE-MAIN DISTRICT

The Scheldt–Meuse–Moselle–Rhine region, with its extension along the Main, is the old-established part of Germany, where Roman traditions are stronger and fine building has its longest and most distinguished history. The territories lie in the venerable ecclesiastical provinces of Cologne, Trier, and Mainz. In earlier parts of this volume many of the most important buildings have been mentioned, because first-rate works appear early in the region. Maturity of style is early here as well. Maria Laach, founded in 1093, has already been described; the church (largely built between 1130 and 1156) [92, 93] is accomplished though austere in style, and the latest parts have, as mature German Romanesque generally has, a Lombard tinge.

What remains is to show how in the period of full Romanesque maturity the architecture here was, as Sir Alfred Clapham so aptly said, 'Carolingian forms clothed in Lombard guise.' Somehow the placid spirit of Hersfeld and Limburg on the Haardt, along with the frank grandeur of Würzburg Cathedral and St Gertrude at Nivelles [319, 320], was transmitted to these later buildings.

The Franconian cathedrals of Trier [330] and Speyer acquired their 'Lombard guise' only in the latest works of construction. Worms and Mainz were more profoundly affected by the new movement.

The early eleventh-century cathedral of Worms[26] [331] is said to 'live on' in the present one, in that the foundations are the same. A consecration of 1181 marks a stage of the rebuilding at the east; the polygonal western choir was be-

330. Trier Cathedral,
largely eleventh and twelfth centuries, from the west,
Liebfrauenkirche c. 1240–53

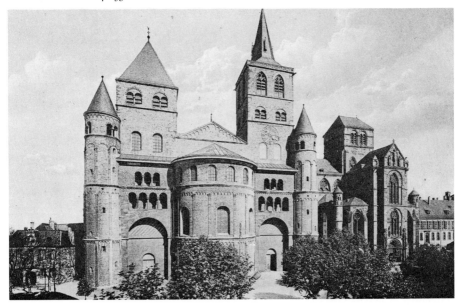

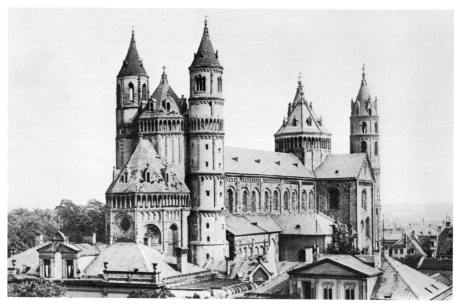

331. Worms Cathedral, eleventh, twelfth, and thirteenth centuries, from the south-west

gun in 1234 in Lombard half-Gothic. The nave has five very sturdy double bays with rib vaulting above an arcade system rather like that of Speyer. Tie-rods have been necessary in order to keep these vaults secure, as flying buttresses have never been built for them. The belfry of the north-west tower is frankly Gothic, but the architect respected the old scheme, which called for round towers of equal weight flanking an octagonal tower of larger girth but inferior height. These round towers are on a transverse axis, flanking a sanctuary bay with (exceptionally) an octagonal tower over it, whereas those at the east are staggered, for the round towers are one bay east of the transept and its corresponding octagon. The apse is included within a straight east wall, and the towers are tangent to the line of this wall, which again is unusual. This arrangement results in a very successful tower system.

Mainz Cathedral,[27] the grand old metropolitan church of middle Germany [78, 332], is about equal to Speyer Cathedral in magnitude, but the effect is rather different. The red sandstone gives it warmth; the richness of the twelfth- and thirteenth-century articulation gives it movement [333, 334]. This work on the building was done between 1181 and 1239, though actually the eastern crossing tower was carried up in Gothic and then replaced in Romanesque Revival style, the top of the western crossing tower having meanwhile been rebuilt in Troubadour Gothic (1769–74). Two old round towers dating from the cathedral of 1009–32 at Mainz terminate the axis of the western transept, which with its central octagonal tower and western apse makes an imposing front. At the east there are a more imposing transept and octagon, with a trefoil sanctuary beyond, accentuated by a pair of slender octagonal towers, all enriched by arcading and galleries. The huge bulk of the cathedral stands up grandly above the town, and is visible for many miles in the valley of the Main, which, as

332. Mainz Cathedral, restoration study as in the twelfth century (Kautzsch)

333 and 334. Mainz Cathedral, eleventh century, much rebuilt after 1181

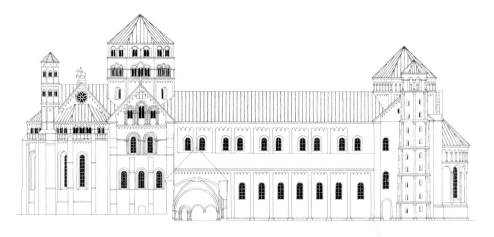

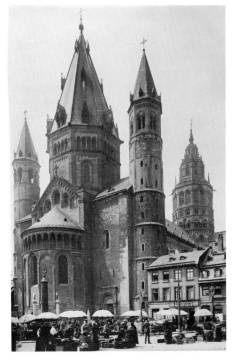

it approaches the confluence with the Rhine, flows nearly straight towards the church.

The interior, covered by rib vaulting in double bays above a generous clerestory, has a tremendous aqueduct-like arcade on each side of the nave, with vaulted aisles beyond. The effect is overwhelming because of its vast scale, which makes one forget the rather dry design. The trefoil which has just been mentioned is sometimes thought to have replaced an earlier one; at any rate the trefoil motif was established in the Rhineland by the eleventh century, and it underwent a special development there. Supposedly the trefoil scheme came from Lombardy – Early Christian Lombardy – to the region.[28]

In the Rhineland the key church of trefoil plan is St Mary in Capitol at Cologne[29] [335–7]. A sanctuary which was the scene of the dedica-

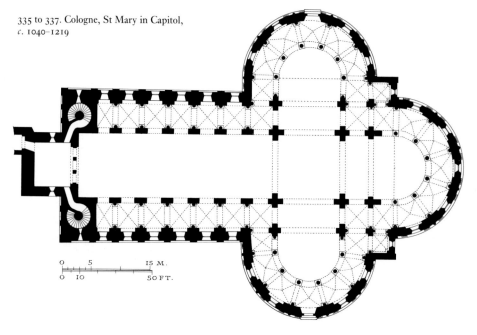

335 to 337. Cologne, St Mary in Capitol, c. 1040–1219

0 5 15 M.

0 10 50 FT.

tion of the church by Pope Leo IX in 1049 was attached to a wooden-roofed nave and aisles begun about 1040. Before the definitive consecration in 1069 the old apse had been replaced by a new chevet, consisting of a vaulted apse and a transept with crossing tower and vaulted apses. The nave remained unvaulted, but groin-vaulted aisles were carried all around the building, except at the west end. The façade, with its projecting tower and lateral stair turrets, recalls the Palatine Chapel at Aachen. With the construction of this façade St Mary became an example of the old church type with two axial towers. Like a Lombard church, it has a vast crypt, which, however (unlike a Lombard crypt), is closed at the west – being approached by narrow stairways from the transept arms.

Actually the effect at St Mary in Capitol is very different from that of its supposed model the (now largely rebuilt) church of San Lorenzo in Milan. There the main space is, so to speak, unified, rounded, and centralized. St Mary lacks galleries, which in San Lorenzo aid in binding in the central space; St Mary has a strong axial movement, both longitudinal and transverse, which is lacking at San Lorenzo.

St Mary in Capitol became more Lombard in character during a reconstruction at the end of the twelfth century or the beginning of the thirteenth: the exterior, formerly rather austere, was enriched with arcading. The vaulting of the transept and sanctuary was completed at that time, and the nave then received the first sexpartite vault in Germany (1219).

The church of the Apostles in Cologne is a variation on the theme of St Mary in Capitol, dated about 1190 and later[30] [338]. In spite of its tardy date, the chevet is rich with Romanes-

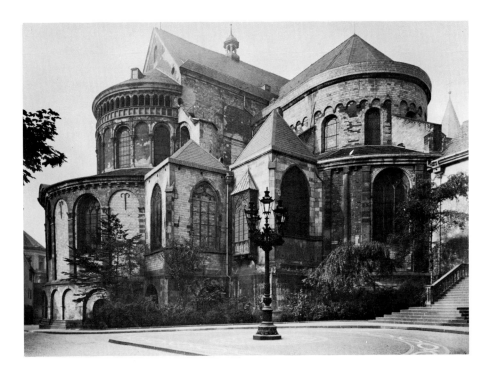

338 *(below)*. Cologne, Church of the Apostles,
c. 1190 and later, from the east
(small cupola and eastern spires not replaced
in post-war restoration)

339 *(right)*. Tournai Cathedral, nave and transept
from the south-west, 1110, 1165 ff.

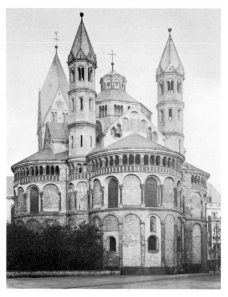

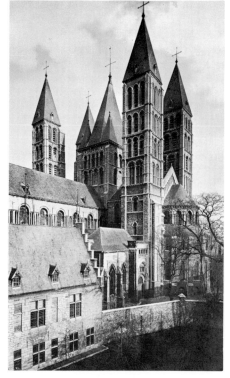

que arcading and Lombard eaves galleries. The
trefoil does not have an ambulatory. Its main
apse is flanked by a pair of slender cylindrical
stair towers which are carried high above the
crossing tower. At the west a deep bay under
and behind the axial entrance tower joins the
western transept in making a sort of angular
trefoil. The eastern part of the church is vaulted
like that of St Mary in Capitol, in the Romanes-
que manner; the nave has sexpartite vaults and
the west end quadripartite and seven-part
vaults, rather like those of the much earlier
church of Sainte-Trinité at Caen.

The axial tower and the eastern stair turrets
have each individual face finished off with a
sharp triangular gable, as is usual in Germany
at this time. Ridges rise sharply to the apex of
the tower from each gable. Sometimes there is
only a single roof-slope between adjacent gables,
as in the western tower of the church of the
Apostles; otherwise there is a valley between.
A particularly outrageous example of this latter
sort of roofing was built over the central oct-
agon of Charlemagne's Palatine Chapel at
Aachen [7, 8]. The facets are carried up in a
curve to a central pinnacle. This type of roof is
little admired and rarely imitated outside Ger-
many.

The trefoil had a much happier history. It
was used in other churches at Cologne – Gross
St Martin (1185 ff.), and (one might mention in
passing) the Romanesque St Gereon,[31] where
the sanctuary extended eastward from a polyfoil
nave half-Gothic in style (1191).

340. Tournai Cathedral, nave 1110, chevet 1165
and thirteenth century, nave vault modern

341. Andernach, church, *c.* 1200

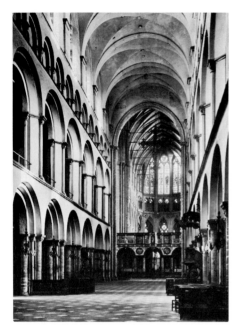

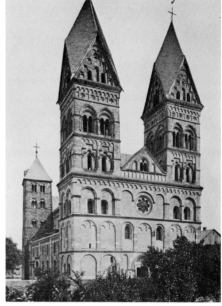

THE NETHERLANDS

From Cologne the trefoil passed by way of
Flanders to a number of cathedrals – that of the
former Merovingian capital city of Tournai on
the Scheldt (then just over the border of the
Empire, in France, and flourishing with textile
prosperity) and also Cambrai, Thérouanne,
Noyon, and Soissons. The cathedral of Tour-
nai[32] [339, 340] deserves especial mention for
its remarkable Early Gothic development of the
trefoil. As at St Mary in Capitol, an old nave
was augmented to the east. The nave is an aston-
ishingly conservative round-arched wooden-
roofed construction of 1110. This nave, which
still exists entire, has aisles, gallery, triforium
passage (at the level of the roof-space over the

gallery), and clerestory. All four of these levels
were carried into the trefoil begun about 1165
with rib vaulting – a good example of the Early
Gothic four-storey interior elevation.

Tournai is also notable for its exterior devel-
opment of the trefoil by means of towers. This
is not surprising, for it is only seventy-five miles
by air from Saint-Riquier in a country which
has loved its towers ever since Carolingian days.
Tournai reproduced the Rhenish two-tower
apsidal façade in tall proportions at each end of
the transept and presumably at the root of the
main apse which was destroyed in 1242; there is
also a lantern tower at the crossing: thus the
trefoil was planned for seven towers. Moreover,
there are clear signs that two towers were in-
tended, rather than the existing pinnacles, at

the west end of the nave. Thus was created, with true logic of place, the pattern of the nine-towered cathedral which was in the mind of more than one great French designer of the thirteenth century, but never fully realized. (Lujan Cathedral, in Argentina, lacks but one spire.)

This excursion from the Rhineland has in a way pointed out a lack which one feels, in the end, in German Romanesque – a lack of sophistication and what the French call 'adresse'. When one reads the comments of German critics on the great German works, it is clear that their overwhelming simplicity and strength call forth the deepest response. There is a significant difference between Tournai Cathedral and the fine Romanesque church at Andernach (dated about 1200) [341].[33] Andernach is a four-tower church strikingly silhouetted, but basically naive in arrangement. Tournai Cathedral also has the four towers, which are contemporaneous; they, like the towers of Andernach, are built up of many stages, but are subtly arranged to emphasize the vertical flow of their line, and they break more easily into the sky. They are *composed* – within the individual tower, and in respect to a reference point, the crossing tower, which by contrast makes them appear taller and more graceful still.

Grandest, perhaps, among the cathedrals of the Netherlands is St Servaas at Maastricht.[34] Like the other churches to be mentioned, it reflects the twelfth-century prosperity in the Rhine country. It has an apse with paired towers, as is so frequent in the Rhine country; the west end has a spacious narthex with an elaborate chapel above it. The westwork, heavy at the base like that of St Patroklus at Soest, blossoms energetically into three towers. Our Lady at Maastricht (largely *c.* 1150) has, similarly, an apse between two towers, and at the west a remarkable precipitous westwork of blocky form dated about 1000, which is flanked by another, rounded, pair of towers. Both churches have

interiors in the Rhenish style of the twelfth century, with Gothic vaulting. The Münster at Roermond is a more active, Gothic-vaulted version of the Apostles' Church in Cologne (also twelfth century); Rolduc[28] (1169) makes one think of Speyer, with its substantial piers and heavy Romanesque vault. St Peter at Utrecht and the former abbey at Susteren have some of the savour of Hildesheim, for both are in a simple German style, both date back in origin to about 1050, and both are unvaulted.[35]

Much reconstruction in the prosperous Gothic period has left us only a few great Romanesque monuments in the Netherlands and Flanders, beyond the examples already mentioned, but there are a number which merit a passing reference, such as the church of Soignies, near Nivelles,[36] which like the great church at the latter place, already mentioned, stands up grandly with its bold towers.

Liège[37] was important in Romanesque times, and notable for two churches in particular – St John the Evangelist (a rotunda of 982 inspired from Aachen, but quite made over) and Saint-Barthélemy. The interior of Saint-Barthélemy has been rebuilt, but the exterior has retained its Romanesque character. The church was founded in 1010; however, the present basilica is much later. There is an imposing westwork. The interior preserves its original arrangement with transept and three apses.

In various places, like Huy (near Liège), there are Gothic buildings which perpetuate Romanesque schemes, often by the incorporation of actual Romanesque remains. They are a tribute to the influences which the area received from Carolingian Saint-Riquier and the imperial Rhine, rather than evidence of local creativeness.

*

With this we close our exposition of the Romanesque architecture in the broad lands controlled by the Holy Roman Empire. As we remarked in the beginning, it has been a view of an architec-

tural kaleidoscope. That very fact is of course an expression of the essentially heterogeneous character of the Empire, and the growing diversity of the cultural areas within it which made the Empire itself impracticable. Unity in architecture comes of cultural unity. Cultural unity in the Church existed, of course, but it was not inclusive enough to hold the European area together. Exclusivism in the Church had its effect in putting new movements of decisive importance outside the ecclesiastical pale; the new activities were carried on more and more in the vernacular language, and thus the Empire lost its common Latin tongue. The strength of the Empire is nowhere better expressed than in the imposing churches which we have just visited in the Rhine country, where its basic power resided always. These great monuments can still help us to understand the grandeur of the medieval imperial ideal, and to forget the misfortunes which prevented the ideal from being realized.

MATURE ROMANESQUE ARCHITECTURE IN
SCANDINAVIA, BRITAIN, AND NORTHERN FRANCE

CHAPTER 23

SCANDINAVIA

Reference has already been made to the remark-able framed wooden churches of Scandinavia, pre-Romanesque in style, though showing Romanesque influences. In Scandinavia wood has continued to be an important building material for structures of all sorts, and, as in Russia, solid log-wall construction was developed and widely used for both secular and ecclesiastical structures, especially in the north.

The advent of Romanesque architecture is marked by the use of masonry, at first almost exclusively for church buildings. Its coming corresponds with an era of intense activity and wide foreign contacts, including the temporary political unity achieved under Cnut.[1] An ineffaceable character was given to Scandinavian Romanesque architecture by the heavy walls, steep roofing, and simple forms necessitated by the climate, and by the fact that early mason-work was carried out very largely under north-European influence. Indeed Gothic architecture in Scandinavia shows strong survivals of Romanesque forms, and such survivals are easily recognized in Renaissance and modern work also. Scandinavian critics are right in saying that, while the elements from abroad become simpler – often rustic, and in the case of sculpture, crude – they are combined to make a new

and vigorously characterized art.

During the formative medieval period, Denmark was in the ecclesiastical province of Hamburg-Bremen (from about 950 until 1103), and thus was basically influenced from Germany. The Norwegian Church was set up about 995 from England, and the architecture shows this, though ecclesiastically Norway was under Hamburg-Bremen, and then under Lund (1103-52). Sweden, under Lund (1103-64), was influenced from Germany, and also, through Norway, by England. There are sufficient differences in the architecture to justify considering the Scandinavian countries separately.

DENMARK[2]

The monumental masonry architecture of Denmark begins at the same period as the infiltration of Norman Romanesque into England. As with Edward the Confessor's Westminster, however, the buildings have been replaced. The earliest Danish group centred in and about Roskilde, near Copenhagen, on the isle of Zealand. There the cathedral, due to the labour of Bishops Vilhelm (1060-74) and Svend Nordmand (1074-88), showed German influences in its aisled nave, its aisleless chancel, and its square west end,

342 *(below)* and 343 *(right)*. Lund Cathedral, consecrated 1146, much rebuilt later; exterior, and interior before modern 'restoration'

344 *(far right)*. Østerlar, Bornholm, church, twelfth century (?)

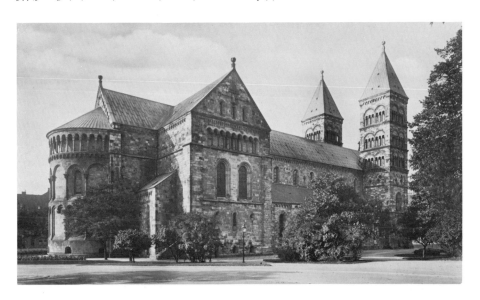

projecting between two towers. The rebuilding of Roskilde in brick Gothic, begun about 1175 on a much larger scale, shows a continuation of German influence, though the interior is French in spirit. Venge church, Benedictine, is believed to show English influence because of its small transept with narrow entrances, and its square chancel.

German and Lombard influence became paramount in the construction of the cathedrals of Dalby (*c.* 1060) and Lund (*c.* 1080), in Skåne (across the Sund from Zealand, now in Sweden), of Viborg (in northern Jutland) and Ribe (southern Jutland). Their influence, in turn, radiated from the three corners of the country.

Dalby has a Saxon look about it, though a westwork of 1124–34, built after Augustinian canons took over, oddly resembles Cluniac architecture. In the region there are various re-flections of Dalby and the westwork theme. Ribe (*c.* 1130) recalls the Romanesque of Cologne, but with an echo of the old pagan art in the carvings of the portal. Viborg, latest of the group, and built in granite, reflects Lund (then, and for a long time afterward, still Danish).

Lund is a complex building [342, 343]. The scheme of *c.* 1080 was augmented after the church became the seat of a metropolitan (1103); Donatus, presumably a Lombard, was the architect. The altars of a remarkable crypt in Lombard style were dedicated in 1123, 1126, and 1131; the high altar, in a tunnel-vaulted sanctuary, was consecrated in 1146; the handsome apse (of that date) has fine exterior arcading, including an eaves gallery. The nave has a double bay system, and is supposed to have had groin vaults, but the vault was built on a Westphalian model after a fire of 1234, and again, somewhat

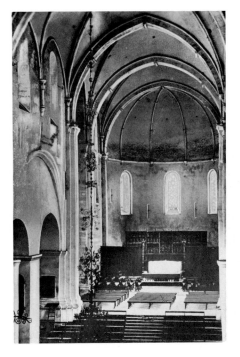

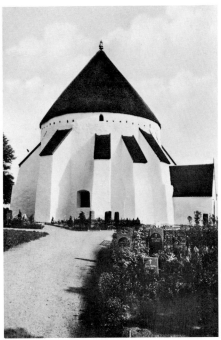

arbitrarily, in the nineteenth century, when there was a general restoration. The western pair of towers, begun about 1150, were finished in Lombard style during the restoration. Old photographs make one regret the simpler, more austere, and obviously provincial building which lost so much of its local savour at that time.[3]

The small churches frequently have the traditional northern barn-like nave and chancel form, often augmented by a tower. Many are in brick, which Denmark owes to Germany and ultimately to Lombardy.

Brick architecture was introduced into the Danish church under Waldemar the Great (1157–82) and Archbishop Absolon (d. 1201). Good examples of this period exist on the isle of Zealand – Ringsted, Sorø Abbeys; also Vitskøl (in Jutland, Cistercian).[4] It is said that of 2000 parish churches in Denmark, over 1800

were built before 1250. Since this is a period of strong German influence, there is a marked German Romanesque imprint on the ecclesiastical architecture of the whole country. A Dutch nuance is introduced by stepped gables in brick, Netherlandish fashion.

A series of round churches makes an interesting episode in the medieval architecture of Denmark.[5] Their plan may perhaps be a result of King Sigurd's great pilgrimage to Jerusalem (1107–11). There are four important and characteristic Danish round churches on the isle of Bornholm, dated between 1050 and 1300 – Ny, Nylar, St Olof, Østerlar [344]. These buildings have single central piers and annular vaults, apsidal extensions, and upper stages (now covered by conical roofs) which were fitted for defence. Others are more elaborate. At Horne (on Fyen), Torsager (of brick, in Jutland),

Bjernede, near Sorø (on Zealand), and Store Heddinge (octagonal, on Zealand) the churches have interior piers, an upper stage, and a central tower. They would be like the German palace chapels but for the fact that the central area is vaulted at the level of the lower aisles. Ledøje on Zealand, however, has an open well. Kalundborg on Zealand has the most monumental example, for there are four tangent octagonal towers on the major axes in addition to the central tower.[6]

SWEDEN

Medieval Sweden arose from a union of Scandinavians and Goths. By the year 1000 there was a strong kingdom established in and about Uppsala. The first apostle to Sweden was St Ansgar (d. about 865) who laboured in the region of Lake Mälar with ephemeral results. It was two centuries later that St Sigfrid and others from England established here the first Christian settlements of importance in Sweden, not far north of the present Stockholm.

As in Norway, there were wooden churches, but none has come down from the earliest period. Södra Råda, dated about 1300, survives; it is a barn-type nave and chancel church with solid log walls.[7]

As in Denmark, there is an interesting flow of influences from abroad in the masonry architecture. The work is often rather crude – but novel, effective, and energetic combinations were made, and the prevailing simplicity of the works gives them an austere charm.

The coming in of foreign influences is perfectly exemplified on the isle of Gotland, which was Swedish from about the year 1000, and centred in Visby, one of the Hansa cities.[8] Visby had active relations with all Scandinavia, the Rhineland, Westphalia, France, England, Russia, Byzantium, and even Persia. The Russians had a church there, and Russian influence may account for the 'icon churches', with carved exteriors (like those of the School of Vladimir), which once existed on the Island. Its heroic age ended with Danish conquest in 1361.

Visby Cathedral, the finest of all the many old churches on Gotland, is the old German national church of St Mary, first built in the twelfth century, rebuilt and dedicated in 1225. Its western tower and its pair of slenderer eastern towers flanking an angular sanctuary now have Baroque belfries, but the form of the building, despite

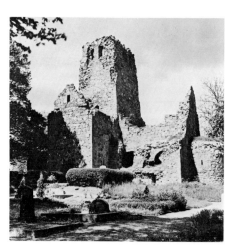

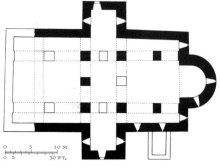

345 and 346. Sigtuna, St Olaf, c. 1100–35

Gothic windows, is unmistakably Romanesque. The church of the Holy Spirit is a novel interpretation of the motif of Schwarzrheindorf.

On the mainland, Sigtuna, which is near Lake Mälar, early became a bishop's see. Influence came in from England with missionaries and returning Scandinavians; at any rate the Swedish historians find Anglo-Saxon and Norman traits in the two church ruins, dated between 1080 and 1135. The stone-work is vigorous, but rather rough.[9]

St Peter (c. 1080–1100) is an oddity, a *cloisonné* or compartmented church with two axial towers. The compartment under the crossing communicates with the nave by a narrow door, and by three similar doors with the sanctuary and two transept-like chapels, each with an apse. There was some sort of westwork, now replaced by an altar recess, so that access to the nave is lateral. The more ambitious St Olaf (c. 1100–35) [345, 346] also has the crossing tower still preserved. There are two arches under each side of it – those at the west giving upon a short nave, those at the east upon a sanctuary of nearly equal length, while those at the side under the tower take their places in the arcades which bound the inner sides of the aisles. The lateral entrances,

the screening-off of the sanctuaries and their narrow access, together with an angular weightiness in plan, recall Anglo-Saxon examples.

Moved about 1135 from Sigtuna to the old royal centre of Uppsala, now Gamla (Old) Uppsala, the see became archiepiscopal in 1164.' Pagan rites were still held as late as 1084 in the old Temple 'glistening with gold', which was replaced, on the same site, by the new cathedral about 1134–50[10] [347, 348]. Like St Peter, Sigtuna, the church had sanctuary and transeptal extensions in the form of compartments with apses, while the screened crossing compartment, with tower, and the basilican nave, were like those of St Olaf: all, however, on a larger scale. This church was burned about 1245, and has been rebuilt as an aisleless vaulted church of powerful form on the area formerly occupied by the crossing and the sanctuary.

At Husaby in Skaraborg [349] the memories are of St Sigfrid and his companions, but the church, dated about 1150, comes in the period when German influence was strong. The westwork looks like a Saxon façade, a common feature especially in Skåne.[11]

At Varnhem Abbey,[12] where excavations have brought the substructures of the conventual

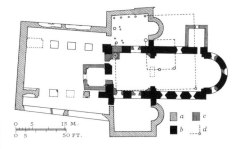

a. Nave, aisles, transept foundations, traced by excavations
b. Extant parts of cathedral, still used as a church
c. Additions, largely medieval, to close in and augment the present church
d. Traces of temple, found by excavations; see 36c

347 and 348. Gamla Uppsala, former cathedral, c. 1134–50, thirteenth century

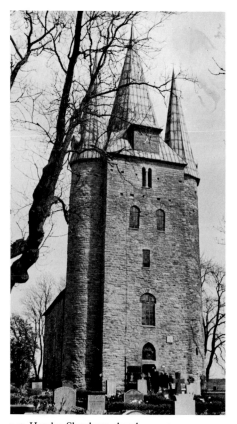

349. Husaby, Skaraborg, church, c. 1150

buildings to light south of the church, the mona-
stery was founded about 1150 by a colony from
Alvastra, the first Cistercian monastery in
Sweden (1143). The church, dated c. 1235-60,
is a kind of Northern Pontigny – smaller in
scale, but relatively heavier and simpler.

In Östergötland, Vreta monastery church[12]
was begun after 1100 as a simple little basilica
with transepts; before 1162 a small royal burial
chapel of centralized plan and a new cruciform
east end had been added. In the year mentioned
a Cistercian monastery was founded here, and
the monks doubtless found the austerity of the
church to their liking.

In the smaller churches throughout medieval
Sweden the same characteristics are present.
Even as late as the fourteenth century, churches
of Romanesque character were being built as a
matter of course, and they fit beautifully into
the northern landscape. They usually have a
round apse, a higher sanctuary compartment, a
still higher nave, and ordinarily a fairly tall
tower. Except for the towers, the movement of
the designs is strongly horizontal, and surpris-
ingly recalls such traditional buildings as
Autrèche (tenth century) in the Loire country
[200]. The interior vaulting is heavy, strongly
reminiscent of Romanesque, and never carried
very high, so that the interior proportions are
spacious. This description applies to the four-
teenth-century church at Lärbro on the isle of
Gotland,[13] already cited as possessing still a
Romanesque-type vault with its centering intact
[350, 351]. In such late buildings the vaulting is
at most half-Gothic except in metropolitan
examples. The ornament is spare and sober, a
folk art.

The Swedes took this style to Finland, as they
expanded their power on the east shore of the
Baltic. The oldest Finnish churches in masonry
come after 1200, but in many ways they are still
Romanesque.[14] The style lives on unrecognized,
but really unforgotten, in much of the later
architecture throughout Scandinavia.

NORWAY[15]

It is to be remembered that the Shetlands,
Orkneys, and northern Scotland were under
Norse control in the eleventh century, so that
the British Isles seemed less remote from
Nidaros or Trondheim than Denmark and the
Continent. Hence the coming of English church-
men to Norway in the middle of the tenth
century. It is doubtful if any structures of con-
sequence were built for the Church before 955.

Mast churches continued in use, with vari-
ations, even in the thirteenth century and later.

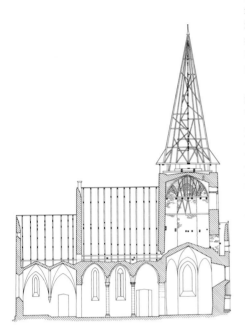

350 and 351. Lärbro, Gotland,
church, longitudinal section, fourteenth century,
and vault of Romanesque type with original centering

Ringebu and Lom are examples, both aug-
mented by log-wall or vertical planked elements
in the 1630s, and by tall Gothic spires. Uvdal,
also thirteenth-century, was twice lengthened
(the chancel in 1684), and became cruciform
(like the augmented Ringebu and Lom) in 1720.

When important church building in stone be-
gan in Norway about 1100, the Norse West
worked in a derivative Anglo-Norman style.
Such work is found at St Magnus Cathedral,
Kirkwall, Orkney (1137 to the thirteenth cen-
tury), which has understandable similarities to
Durham Cathedral (cylindrical piers, square
chapels east of the transept). Stavanger Cathe-
dral resembles a large aisled Anglo-Norman
church, but with an ample western porch, and
no transept (about 1150; sanctuary of 1272–
1303 with a pair of flanking eastern towers).

Bergen Cathedral, somewhat farther to the
north, appears to have been a slightly earlier
example of Anglo-Norman influence, but the
vault is of the thirteenth century.

At Nidaros (Trondheim) a small church had
been erected over the tomb of St Olaf by Olaf
Kyrre (1066–93). The see was raised to archi-
episcopal status in 1152. A transept of Anglo-
Norman character was then built to the west of
the tomb-church. This was at least partly
finished when one of the existing transeptal
chapels was consecrated in 1161. The corres-
ponding nave, never completed, gave way to a
Gothic construction, and the tomb-church was
replaced in the thirteenth century by a Gothic
version, completed by 1320, of the rotunda of
Saint-Bénigne, Dijon, as has already been
noted; like Saint-Bénigne, it was a great place of
pilgrimage.[16]

Cluniac influence (perhaps operating through
Hirsau, if not Norman England) was felt in the
south and east of Norway, where influence from
Germany and Denmark was necessarily very
strong. When the pilgrim King Sigurd was
buried there in 1130, Oslo Cathedral was already
under way as an aisled building with transept,

central tower, sanctuary, and apse with flanking chapels; Hamar Cathedral, built after 1152, was a somewhat similar building with generous cylindrical nave piers, and two western towers. Both these buildings are in ruins. More fortunate is Ringsaker (1113–30 and later), an unusual building, with quadrant-vaulted aisles, tunnel-vaulted nave, long narrow transept, deep sanctuary, and crossing tower. Here and elsewhere, when vaulting is present, it is not carried very high, so that the interior proportions are broad and spacious.

Many rustic churches dot the Norwegian countryside. They are of simple masonry construction, ordinarily wooden-roofed, sometimes with timber gables. Basically there is a barn-shaped nave, with a smaller barn-shaped chancel beyond a narrow chancel arch as so often in Saxon England. In contrast to the stave churches, these designs have a strong horizontal movement. To their basic elements may be added a barn-like western porch, a semicircular apse, a wooden pinnacle. The original windows were neither large nor numerous. An interesting example of c. 1050 or a little later exists at Hvaler, with trusses of Romanesque slope and membering; it is more usual to find a Gothic slope.

NORTHERN FRANCE AND NORMAN ENGLAND

FRENCH ROMANESQUE OF THE SCHOOL OF THE EAST, OR RHINELAND FRANCE

In Rhineland France we are still within the borders of the old Carolingian Austrasia. The modern classification of its architecture as the French School of the East does not disguise the German forcefulness in works of the Rhineland, and this made itself felt far towards the west, though with progressively less emphasis. The German 'double-ender' scheme, for instance, penetrated as far as the cathedrals of Verdun, Besançon, and Nevers, the westwork as far as Châtillon-sur-Seine.

However, there is earlier French precedent for both the schemes which have just been cited as examples, and it is sometimes difficult to judge whether Rhenish influence was direct, or whether it merely reinforced local tendencies. This is the case with the motif of paired towers flanking an apse, traced (as round stair towers) as far back as Saint-Riquier. Because of the undoubted power of the Rhenish style, it is reasonable to admit its influence in this matter, even as far away as Paris. In Alsace, the Rhenish style dominates; Neuweiler, Rosheim, Andlau, the examples previously cited, and others, are evidence of this.[1]

THE ROYAL DOMAIN (ÎLE-DE-FRANCE) AND CHAMPAGNE

Farther west, near the borders of Carolingian Neustria, a more French touch is discernible in the designs. In Champagne, for example, Montier-en-Der (c. 982) and Vignory (c. 1050 [97]; with false triforia resembling Carolingian screens between the nave and aisles) have a French tallness of nave proportions and are easily grouped with Saint-Remi at Reims (1005 ff.) [111] for that reason, and because of the relatively low aisle arcades and screen arches. The ambulatory and radiating chapels of Vignory are of the French type, as already noted; indeed Vignory was a priory of Saint-Bénigne, Dijon.

Champagne and the Île-de-France in Early Romanesque times formed a sort of bridge between the Rhenish and the Loire regions. The area included Reims, Laon, Beauvais, Saint-Denis, Paris, Melun, Sens, Orléans, and Bourges, with Chartres and Tours at no great distance. Some imposing Carolingian buildings survived; the orderly government and growing power of the early Capetians had showed itself in the construction of large and important churches, and as a result, no really notable works appear to have been needed, or built, in the late eleventh century, when the architectural developments were so interesting elsewhere.[2]

The problem of modernizing the shrines of the Île-de-France did not become acute until the twelfth century, when the breath of new intellectual life was drawn in Paris. Then the same type of intellect which created scholasticism was focused on the problems of great church architecture. What began as a local differentiation of the Romanesque style in ordinary buildings with a clever type of rib vaulting, became a new style through the reasoned, novel, and systematic development and exploitation of such vaulting. From the moment of Suger's new design for Saint-Denis (about 1135) the face of Western architecture began to change.[3]

The Romanesque school of the Île-de-France found the way to maturity – and immortality – through the patient work of the masons in the region bounded by Reims, Provins, Sens, Étampes, Mantes, Gournay, Saint-Quentin, and Laon. They discovered the best use of the fine local stone – cut to shape so that the mortar joints and the vaulting cells could be thin, slightly swelling, and built up of arches resting on, rather than engaged with, the supporting rib structure [379, 380]. When the pointed arch was introduced about 1125–30, chiefly under Burgundian influence, this type of vault became decisively better, and capable of more spectacular development, than any other type in use at the time. Since under Norman, or perhaps Lombard inspiration, an element in the pier was provided for each rib of the vault, the way was opened for a spectacular aesthetic development based on linear and symbolic upward movement. This explains why the Burgundian

352. Paris, Saint-Germain-des-Prés, eleventh and twelfth centuries

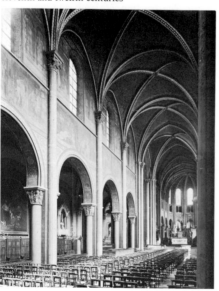

half-Gothic was left behind at once; its vaults were of rough stone with thick mortar joints, and the ribs often ended apologetically in a *fuseau* or bevel over the pier.[4]

While very little remains of the work of this critical time, owing to wars[5] and reconstruction, a few buildings merit our attention.

In Paris, Saint-Germain-des-Prés[6] [352] still shows, amid much Gothic rebuilding, and a seventeenth-century pseudo-Gothic vault, the old axial entrance tower of 990–1014, together with the nave and aisles of a church dating back perhaps to about 1050. The nave had uniform bays, with semicylindrical interior buttresses between large clerestory windows, beneath a wooden roof. It incorporates reproductions of carved capitals (the originals are now in the Cluny Museum) which need to be studied in connexion with the contemporary German revival of sculpture. The church had a transept ending in absidioles, and an apse échelon. There was a pair of towers flanking the apse, which again recalls German practice.

The same tower arrangement occurs at Morienval, near Compiègne, dated about 1050,[7] except for the famous ambulatory added in the Early Gothic style about 1122. The interior has a Carolingian flying screen across the nave, and the aisles are groin-vaulted. It was planned to build a tunnel vault over the sanctuary bay between the towers, but a substantial rib vault was erected instead.

In this bridge-territory between the Rhenish and the Loire regions, one may cite other instances of elements which follow a German pattern – as in the pretty narthex at Urcel – but the future of the School of the Île-de-France was not bound up with Germany. It was to flower as Gothic, in the glow of great Norman Romanesque, inspired at an early period from the Loire country, and developed in the Duchy and in England; meanwhile, there was much hesitation. The plain little church of Saint-Loup-de-Naud (*c.* 1050–1150) is an apt illustration. There

the high vault, unribbed at the east, changes experimentally from bay to bay, being finished with four rib vaults; there is also a Gothic portal sheltered under a characteristic rib-vaulted porch. Cerny-en-Laonnais [353] has diaphragm arches over the nave.[8]

Another church of the period, honest rather than inspiring, is Saint-Étienne at Beauvais [354], an aisled building of c. 1125-40 with an ungainly later sanctuary. The building has a rich lateral portal, and a famous representation of the Wheel of Fortune about the circular window of the north transept. There is perceptible progress between the archaic aisle vaults of c. 1125 and the high vault of c. 1140.[9]

In plan, the small churches which remain to us generally have naves with aisles; the transepts have absidioles; the sanctuary may terminate in a straight wall, or with an apse. The portals are columnar, but their sculpture is simple; there are porches occasionally. The towers are picturesque features of the landscape, and their pretty design does much to redeem the churches. Some towers are at the façade (this is the case at Morienval), others at the crossing (as in the case of Saint-Ayoul, Provins), or flanking the choir – single, as in the case of Tracy-le-Val (an exceptional octagon), or paired, as at Morienval. Saint-Remi, Reims, has a pair of façade towers, or rather turrets, of Romanesque origin. The eastern towers of Morienval are typical, being built up stage upon stage with arcading over a square plan. In the regions of Beauce, Brie, the Soissonnais, and the Île-de-France, the openings are flanked by flat buttresses, but such buttresses are not characteristic in Champagne, Bar, and Lorraine. The workmanship is mediocre in the older buildings, and the ornament (chevrons, frets, stars, and geometrical designs, together with corbel tables) is far from inspired. How different was the future!

353. Cerny-en-Laonnais, church, c. 1100

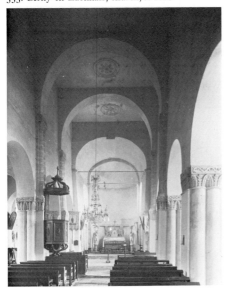

354. Beauvais, Saint-Étienne, c. 1125-40

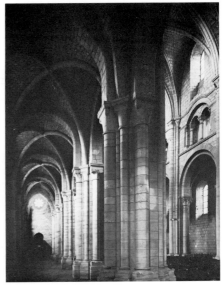

NORMANDY[10]

The Northmen, once settled (911) and converted to Christianity, undertook to build a state. As usual, there are traces of this in the architecture. Jumièges, a great abbey founded in 654 by St Philibert, whose name we have heard so often, had declined during the period of the invasion, but Duke William Longsword restored it (934 and later).[11] The west end of the church of Saint-Pierre, fairly well preserved in the abbey ruin, while it is small in scale, represents this moment, and already shows the unmistakable verve which Norman Romanesque architecture was to possess so abundantly [355]. The two western towers (mentioned in 954, now ruinous), the tribune between the towers, the triforium passage, and the excellent ashlar work all had a dramatic future in Norman church architecture. The fine limestone of Caen, which is unsurpassed, and related stones were advantageous; being skilled at water transport, the Normans made them generally available for fine building, even in England.

Ethnic connexions with Denmark encouraged communications and engendered multiple maritime and other contacts along the intervening shores and rivers, including of course the Rhineland. The powerful Ottonian architecture of that region undoubtedly influenced the Normans to some extent – in their feeling for grand scale, and their predilection for 'cubical' capitals.

Through Maine the Normans had a bridge to the Loire country with its important, dynamic architectural heritage, the force of which was somehow communicated to the Normans. Bur-

355. Jumièges, ruin of abbey church
of Saint-Pierre, c. 934 and later

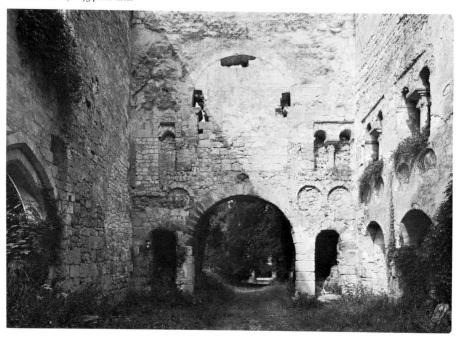

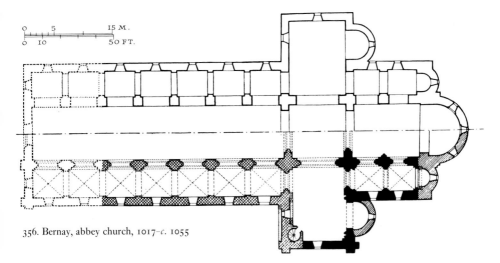

356. Bernay, abbey church, 1017–c. 1055

gundian architectural influence came to Normandy in 1002, when, at the invitation of Duke Richard II, William of Dijon sent monks from Saint-Bénigne to reform the Norman monasteries. It was doubtless in this way that the scheme of Cluny II became one of the themes of Norman Romanesque architecture, beginning with the abbey church of Bernay.

Bernay,[12] under construction from 1017 to about 1055, was grander in scale than Cluny II,

built of better masonry, and more elaborate in certain details, such as oblong piers augmented by engaged columns, a decorative arcade suggestive of a triforium, and sculptured capitals of a rather crude but interesting sort [356]. The latter have some relationship to early Cluniac sculptured capitals. One of them is signed ISEMBARDUS ME FECI·. Later, however, the Normans preferred the Germanic and Lombard 'cubical' capital and simple forms from the

357. Jumièges,
abbey church of Notre-Dame, 1037–66

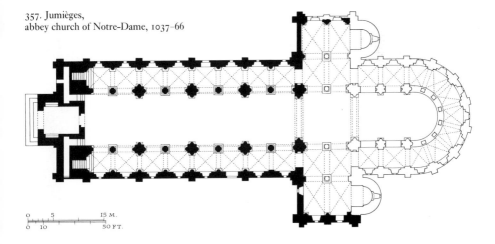

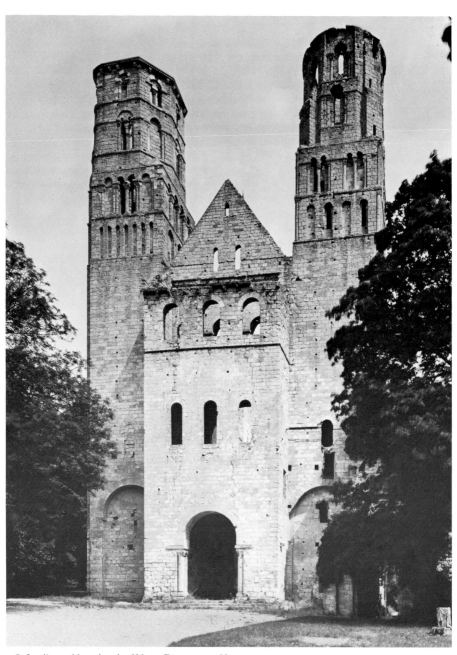

358. Jumièges, abbey church of Notre-Dame, 1037–66

Loire area. The mouldings have some connexion with those of the crypt of Auxerre [112], perhaps through the Loire region. Bernay stands at the head of a whole group of fine Anglo-Norman abbey and parish churches.

A second great group was soon formed. Before 1037 an ambitious cathedral with apse, ambulatory, and radiating chapels in the style of the Loire country was begun at Rouen. It was dedicated in 1063.[13]

Into this ambient came the great Lanfranc (1039) and other Lombard ecclesiastics, open-ing the way for influence from their very interesting part of the world. At the abbey of Bec in 1045 Lanfranc set up a school which soon achieved international importance. The chief Norman monasteries became important organs of the flourishing new feudal state.

Thus we understand the grand scale and noble design of the later abbey church of Notre-Dame at Jumièges[11] [357-9]. This church was begun in 1037 and finished in 1066, but not dedicated until 1067, because Duke William, whose presence was desired at the ceremony, had an errand in England. The façade of the abbey church is made up of two substantial square towers with octagonal upper stages (double on one side, single with buttresses and

359. Interior elevations: (A) Jumièges, abbey church of Notre-Dame, 1037-66, nave; (B) Durham Cathedral, 1093-9, choir

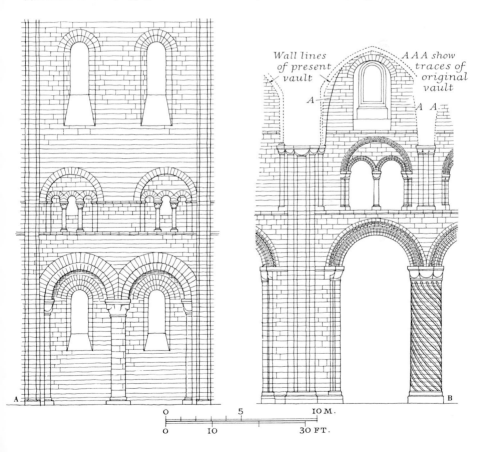

Wall lines of present vault

A A A show traces of original vault

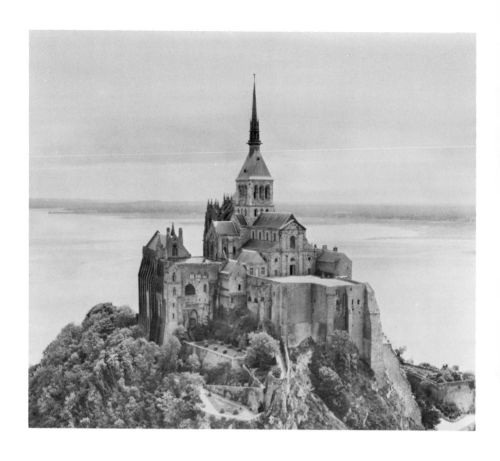

360. Mont-Saint-Michel Abbey, 1024–1228 and later, air view

a circular stage on the other), a projecting porch and tribune, and the nave wall with its gable. The nave, begun in 1052, has four generous and handsomely dimensioned double bays with intermediate columnar supports and grouped piers from which internal buttresses formerly rose to the top of the nave wall. The aisles and the tribunes (opening through triplet arches on the nave) are made up of square bays divided by transverse arches, and groin-vaulted without ribs. The tribunes were continued, supported similarly, as platform chapels, one in each arm of the transept, and thence eastward over piers flanking the sanctuary to a small gallery around the apse, which had an ambulatory without radiating chapels. The nave and transept – perhaps also the sanctuary – had wooden roofing, and at the crossing there were four great arches, supporting a magnificent lantern tower of two stages, also roofed in wood. Roofing in wood permitted energetic tall proportions and a vast clerestory. The stout walls of fine large ashlar blocks are one of the beauties of the building, which is harmonious in proportion and very simple in detail. Capitals of a good rudimentary Corinthian shape received painted decoration. The Norman Romanesque was now mature, except for the problem of the high vault, which was satisfactorily solved in a generation more.

Jumièges was only one of a notable series of churches built at the time; the abbeys of Mont-Saint-Michel (1024–84) [360, 361] and Bec (*c.* 1066–77) together with the cathedrals of Rouen (*c.* 1037–63), Coutances (*c.* 1030–91), Bayeux (before 1049, to 1077, rebuilt with an elaborate arcade in the twelfth century, and then again in the Gothic style), and Évreux (to 1076), were the chief among them. Because almost all these buildings have been lost, it is difficult to follow the growth of the Norman Romanesque style, and to know exactly what features – particularly of vaulting – had been developed at the time when the Conquest gave to Norman architects their stupendous opportunity in England.[14]

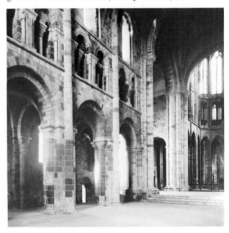

361. Mont-Saint-Michel, abbey church, *c.* 1100

The two great abbeys of Caen show advancing signs of maturity. They were founded by William and Matilda in expiation of their uncanonical marriage (within the forbidden degrees; later dispensed), and are stock examples of the Norman Romanesque on the Continent.

Sainte-Trinité[15] [362, 363], the church connected with Matilda's Abbaye-aux-Dames, was begun in 1062 and had a preliminary dedication in 1066. The Queen was buried in its sanctuary in 1083, but this very handsome part of the church undoubtedly represents an augmentation of the original scheme, suggested perhaps by the royal grandeur of Edward the Confessor's Westminster (*c.* 1050–65). Sainte-

Trinité had an apse échelon, of which the deep northern chapels have been restored, but not the southern pair. The main sanctuary has two grand big bays of unribbed groin vaulting above a clerestory and wall passage, plus a handsome

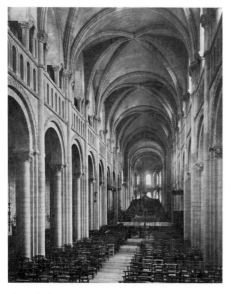

362 and 363. Caen,
Abbaye-aux-Dames, Sainte-Trinité,
begun 1062

apse with a free-standing arcade in two storeys which was probably inspired by Saint-Bénigne at Dijon. There is a broad transept covered by quadripartite rib vaulting (with doubled cells at the ends, making two ingenious cincopartite vaults), then a long nave of which the aisle walls are archaic (of 1066?). The aisles are covered by a (restored) continuous tunnel vault with penetrations; the grouped piers are uniform.

Above the nave arcade the work is later in date and more elaborate in design. It has a decorative triforium, an arcaded clerestory with a wall passage, and a pseudo-sexpartite vault dated perhaps 1115 or earlier (conservatively, 1125). This vault is like a series of big quadripartite ribbed groined double bays with the addition of a transverse diaphragm arch on the axis of each, so that each of the bays has six areas of vaulting surface. Such a vault is called pseudo-sexpartite because the true sexpartite vaulting bay has on each side (instead of a large lateral bay bisected by the vertical diaphragm) a transverse rib and two lateral cells of vaulting. The church has a quadripartite bay over the last unit of the nave proper, and a sexpartite bay between the western tower pair, originally open on the ground stage, but spoiled subsequently by rebuilding. In the roof-space over the aisles the purlins of the roof are supported by light arches

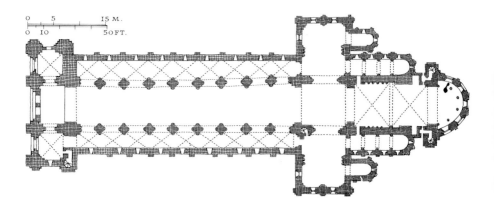

0 5 15 M.
0 10 50 FT.

which resemble flying buttresses and have often been credited wrongly as designed for buttress action. Except at the façade, the church is a very harmonious and beautiful building; its grandeur makes one think of the great German designs. The admirable big groined bays in the sanctuary recall Nivelles [319, 320]; the double bays of the nave recall Rhenish work, and also the Lombard double bays. There are charming derivatives of Sainte-Trinité in the smaller churches of Ouistreham and Bernières.[16]

Saint-Étienne[17] [364-7], the church connected with William's Abbaye-aux-Hommes, still stands up grandly on the outskirts of Caen, though bereft of its medieval conventual structures. It was begun in 1067 or 1068; there was a preliminary consecration in 1073, and others followed in 1077 and 1081. In 1085-95 the monks were already building a similar but smaller church for the parish of Saint-Nicholas in Caen,[18] on a plan basically like that of Cluny II and Bernay. At Saint-Nicholas the chevet, with corridor chapels square-ended on the exterior, and opening upon the sanctuary through twin arches, is believed to repeat that of Saint-Étienne itself, and so it is with the transept absidioles.

Saint-Étienne has a magnificent long nave, which was planned for wooden roofing, though its structure is vaulted at the sides. The aisles are groin-vaulted in square bays with transverse arches; the gallery is quadrant-vaulted, with transverse arches in each case. This justifies the interior buttressing which rises from the grouped piers of the aisle arcade. The projections are alternately complex (a half-column with a dosseret) and a simple half-column, which stopped below the arcaded passage of the clerestory. There was a passage between this clerestory arcade and the window wall – an echo, evidently, of the similar passage in Saint-Bénigne at Dijon. Such passages became a regular feature of the Norman clerestories. The aisles and gallery of Saint-Étienne open upon the nave through uniform arches in two orders. The arcade of the clerestory has been rebuilt to receive the thrusts of, and to support, masonry vaulting in the nave – a sexpartite rib vault (transitional to Gothic) set out in four big double bays.

The nave is extended (by a square bay with three cells on its western side) between two magnificent western towers, finished with quite lovely stone spires in Gothic times. At the crossing of Saint-Étienne there is a lantern with an octopartite rib vault. The adjacent transept has oblong rib-vaulted bays. The sanctuaries were replaced in 1202 by a beautiful and charac-

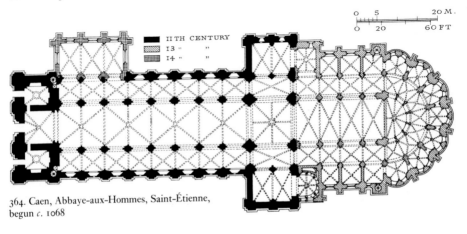

364. Caen, Abbaye-aux-Hommes, Saint-Étienne, begun *c.* 1068

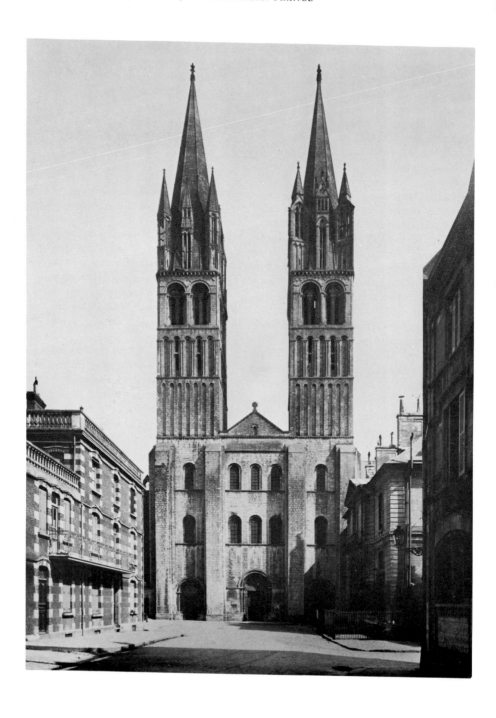

365 and 366. Caen, Abbaye-aux-Hommes, Saint-Étienne, begun *c.* 1068

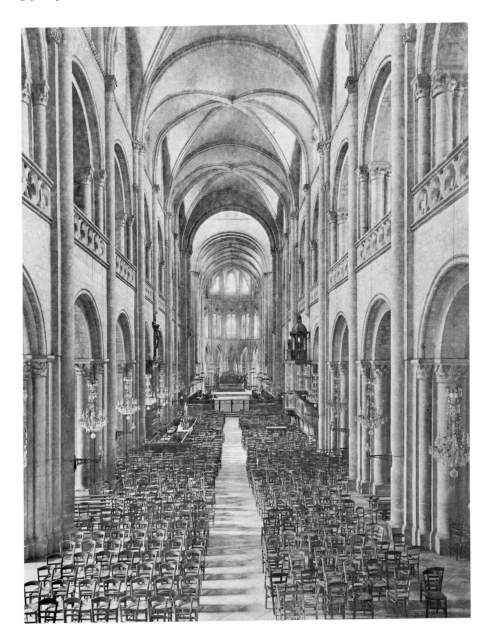

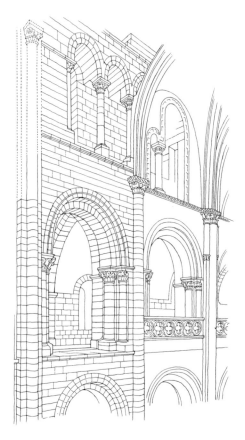

367. Caen, Abbaye-aux-Hommes, Saint-Étienne, application of vaulting, c. 1115 (?)

teristic Norman Gothic design, of fully developed character and local savour.

It is easy to compare the typical Gothic vaulting of the sanctuary with the transitional work in the nave [366]. The big double nave bays are handsome, but the sexpartite vaults are uneasy in design. Nevertheless, due to the prestige of the great Norman works, the sexpartite vault was widely used in Early Gothic work of importance – the cathedrals of Sens, Noyon, Notre-Dame in Paris, and Laon among others, with two square bays of vaulting in each aisle flanking each great sexpartite bay of the high vault. There were also experiments, as in the little church of Bury,[19] with square rib-vaulted nave bays, each with a narrow oblong rib vault in the aisle to either side. Eventually the superior 'processional effect' of uniform nave bays led to the sexpartite vault being given up, except at Bourges, where magnificent bays were built over the nave in the fourteenth century, not to be repeated on that scale until the construction of the nave of St John the Divine, New York, in the twentieth. The normal High Gothic nave has, like the Gothic sanctuary of Saint-Étienne, square bays in the aisles and oblong bays in the high vault.

In Normandy the construction of notable buildings continued in the twelfth century, which was prosperous there, as elsewhere. About 1100, Henry I Beauclerc built a formidable donjon within, and otherwise greatly strengthened, the château begun by William the Conqueror in Caen.[20] It is now modified, but still recognizable as a first-class military work, in the tradition of Beaugency, Loches [208], and Falaise. The age is, however, much better represented by fine churches. Lessay[21] (c. 1090–1135), Cerisy-la-Forêt,[22] after 1150 (which may have had diaphragm arches), and Saint-Vigor, near Bayeux[23] (which most certainly had diaphragm arches across the nave, like Cerny-en-Laonnais [353]), are abbeys in the region of Caen which built well. Near Rouen

the most important example is Saint-Georges at Saint-Martin-de-Boscherville[24] [368, 369], a singularly complete and well-preserved church dated about 1123, rather over-restored in the nineteenth century.

Progress achieved in the art of rib vaulting is, from the point of view of the general history of architecture, the most important achievement of the Norman Romanesque style. How did the advance begin? The question is one of the most difficult to answer, but we venture to propose our solution.

First of all, we record that the French architectural historians now accept John Bilson's demonstrated date of 1093-1104 for the rib-vaulted sanctuary and chancel aisles at Durham Cathedral [359B, 376] in far-northern England.[25] The work must have a Norman background, like Edward the Confessor's vast church at Westminster (c. 1045-50, dedicated in 1065) – but both buildings were more important than any contemporary project in Normandy itself. Perhaps in the creation of these royal buildings some spark of imperial grandeur was communicated, in a way which we can only guess, through the historic contacts of Saxon England and Normandy with the Rhine country, and that must be taken into account in assessing the powers of the style.[26]

To Normandy from the Loire country, about 1070, came the use of auxiliary ribs in the middle of domical ('cloister') vaulted bays (St Martin at Tours, tower chamber, about 1050 [115]; Bayeux, ground storey of the north-west tower of the cathedral, 1077). Bayeux, in the abbey of Saint-Vigor, also had an example of diaphragms over the nave. We believe that when knowledge of the Lombard rib vaults came late in the eleventh century, the Norman builders themselves combined ideas from the three traditions, using Burgundian mouldings which since Bernay (1017) had been at home in Normandy.

Thus the pseudo-sexpartite vault of the nave of Sainte-Trinité in Caen is accounted for, and

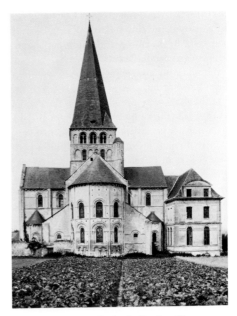

368 and 369. Saint-Martin-de-Boscherville, former abbey church of Saint-Georges, c. 1123; spire Gothic

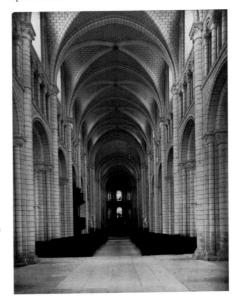

the true sexpartite vault of Saint-Étienne comes as a natural, inventive development, already suggested by the cincopartite vaults of the transept ends at Sainte-Trinité. The nave vaults of Sainte-Trinité and Saint-Étienne have long been dated about 1140 and 1135 respectively, but the dates were proposed when the date of 1128-33 for the high vault of the nave of Durham was not yet accepted.[27] The elder generation of French historians worked out a consistent system of relationships, and a *relative* chronology which must be maintained, but the ensemble of their dates has been proved to be as much as twenty or thirty years too late. The necessary correction gives dates near 1105-15 for the high vaults which replaced wooden roofing over the transepts and naves of the abbeys in Caen.[28] After this, further influence from Burgundy brought in the decisively important pointed arch, used in the rib vault over Durham nave (1128-33) [376, 377]. In the end, after hesitation because of the prestige of Norman work with its double bays, the logic of designers in the Île-de-France established the more beautiful system of uniform oblong bays in the high vault, uniform square bays in the aisles, and light, thin ashlar vaulting cells for them all.

ENGLAND: THE SAXO-NORMAN OVERLAP

The eleventh century found a rather decadent England, better integrated because of the Danish conquest, but not progressing in the rhythm of the Continental countries. Norman influence began to play strongly on the Island with Edward the Confessor (1042-66). The name Saxo-Norman overlap is applied to the period during which Saxon survivals were modified by the new flow of influences. After the Conquest of 1066 the centres became ever more markedly Norman, but refugees, going to the north of England and to Scotland, took the old style with them, and it was there only gradually brought up to date. A related phenomenon produced the highly native designs of Cormac MacCarthy's Chapel at Cashel of the Kings in Ireland (c. 1124-34) [29] and St Regulus (St Rule) at St Andrews in Scotland (c. 1125-30).[29] Each one is a steep-roofed nave-and-chancel church, vaulted, built of improved masonry presenting Norman detail and a slender square tower rather than the traditional round form. But the writing on the wall for the old style appeared as early as Edward the Confessor's Westminster Abbey (c. 1045-50, dedicated in 1065).[30] Excavations show that it was like a typical Norman abbey, grander than anything then existent in England; they show that the conventual buildings were laid out on a Cluniac plan, and that the spirited representation on the Bayeux tapestry conveys, in diagrammatic form, a good idea of the church. It had a western tower pair, six double bays in the nave, a transept with a tall crossing tower, and a sanctuary separated from two parallel chapels, all with apses. Evidently there was no more of Saxon in it than was obligatory because of craft conditions, and this became increasingly true as the years passed.

NORMAN ENGLAND

With the Conquest, society, the government, the Church, and the architecture rapidly became Norman. The Duchy had been cleverly organized as an effective feudal state, and this process proved to be but a dress rehearsal for England. As in Normandy, a group of great Benedictine abbeys became an instrument of policy in the pacification and development of the country. The greatness of the opportunity and the abundance of resources brought it about that the most splendid of Norman churches are to be found in England.

There was a surge of great churches as all ecclesiastical England was renewed and transformed. Following Continental models, the triapsidal plan already exemplified at Westminster Abbey (1045) was used for the new cathedral of

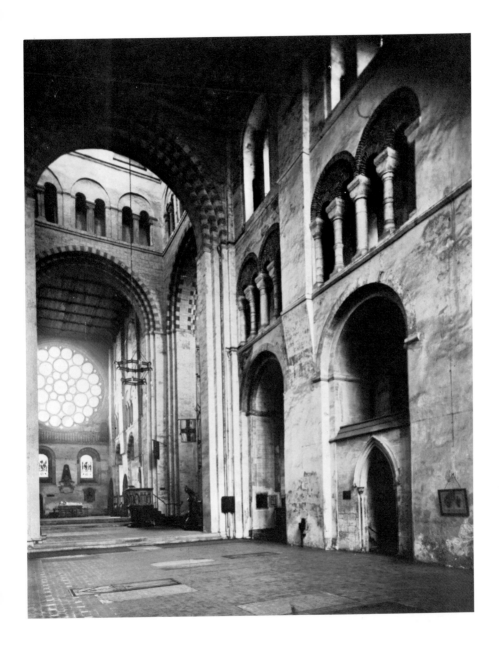

370. St Albans Abbey, transept, after 1077

Canterbury (1070),[31] Lincoln (1072),[32] Old Sarum (1076),[33] Rochester (1077),[34] and the abbeys of Bury St Edmunds (1070),[35] and St Albans (1077) [370].[36] Battle Abbey (1067), the Conqueror's own foundation near Hastings, was colonized by monks from Marmoutier, near Tours, in the 'ambulatory country' and naturally carried onward the Jumièges-Rouen group of Norman works, which now grew by the addition of St Augustine's abbey at Canterbury (1073),[37] the cathedral of Winchester (1079),[38] and that of Worcester (1084).[39] These buildings were begun under the Conqueror, who died in 1087. Other great cathedrals followed immediately – Gloucester (1087) [371],[40] and Norwich (1090),[41] with the ambulatory plan; Ely (c. 1090) and Durham (1093) [359B, 372, 375-7] with the tri-apsidal plan, and every one of them on a magnificent scale.[42]

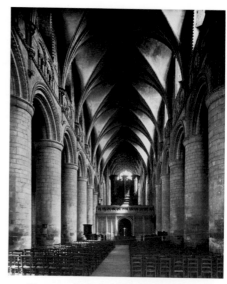

371. Gloucester Cathedral, begun 1087, nave

372. Durham Cathedral, Galilee, c. 1175

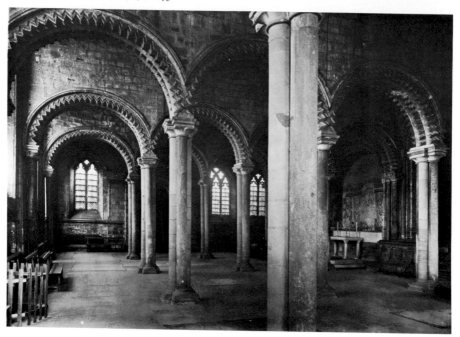

These buildings, as first built, presented few new problems, and since they have all, where still existing, been considerably modified by later additions, their description and analysis is for the most part left to the volume of the *Pelican History of Art* which is entirely devoted to English medieval architecture.[43] Yet they must receive some notice here, for the tremendous undertaking of church and castle building in the Conqueror's time is one of the most striking episodes in the history of medieval architecture. The great works are all extraordinarily bold, simple, and uniform in style. A pause came in the Great Anarchy of Stephen's reign (1135–54), after which a warm, much ornamented late Norman style was used, with the new Cistercian architecture as a becoming foil and contrast. In the great works not only were the dimensions imposing – tremendously long processional naves, extended transepts, relatively deep sanctuaries – but the scale of the smaller parts was generous, particularly so in the thick walls, the stout piers (often cylindrical), and the well-turned arches. Churches before Durham were not specifically planned for vaulting, except perhaps in the apses, aisles, and galleries, which means that the clerestories and galleries could be generous and open under the trussed nave roofs. In the naves particularly there were handsome effects of arcading, stage upon stage, enriched by archivolt mouldings and shafting. The beautiful buff and white limestone (much of it transported from Caen) has retained its original freshness, and is a great beauty of these interiors. Abundant light from the clerestories plays upon the boldly articulated architectural forms, sometimes in simple rhythms, sometimes in double bays, with tall proportions. This is especially true of Ely (*c.* 1090–1180) [374][44] and of Peterborough (1118–*c.* 1200) [373], which has an original painted ceiling. At Ely, Malmesbury, Rochester, and Kilpeck there is tympanum sculpture. At Exeter Cathedral one finds two rich towers (of *c.* 1150) marking the transept

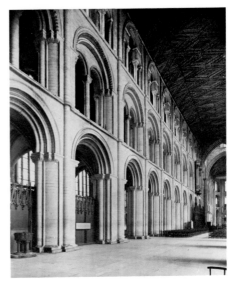

373. Peterborough Cathedral, begun 1118

of a church now memorably rebuilt in Gothic. Legendary Glastonbury perished by fire in 1182, and was rebuilt in overwrought tardy Romanesque and provincial Gothic, but is now ruined.

There was a considerable renewal of parish churches, many of them very simple, and not very different in plan and scale from Saxon works. The nave-and-chancel type continued in use, and was transmitted to Gothic architecture. The characteristic Norman masonry is easy to recognize, and Norman enrichments, particularly the chevron, are effectively used. St Peter at Northampton and Iffley church near Oxford are well-known examples.

Many castles were built in England in Romanesque times – the most notable being, of course, the White Tower in London, which stands practically as it was built (1078–97), though the satellite buildings are much later. Essentially the keep or donjon is a tower house such as we have seen in a very reduced form at

374. Ely Cathedral,
restoration sketch of façade,
twelfth century and later

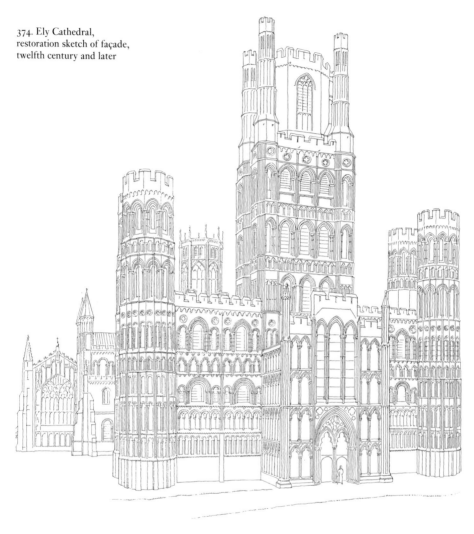

the Tower of Doña Urraca at Covarrubias. The residential parts of the White Tower are framed in wood, with stout fire-walls dividing it into three rectilinear sections, each with four levels. The chapel of St John, with vaulted aisles and galleries supporting a tunnel-vaulted nave, has a rounded apse which projects on the south-east side; it is echoed by a rounded stair-turret on the north-east. The wall-work is of rubble strengthened by quoining and pilaster strips of ashlar which emphasize the angularity of the building. The ward is irregular, but roughly oblong. If one includes the many unarchitectural 'motte-and-bailey' works, close upon twelve hundred castles were built in England and Wales between 1066 and 1189.[45]

The great square keep was used in the twelfth century – notably at Rochester (before

1135); castle-building continued under Henry II (1154-89), with a constantly increasing use of semicircular, circular, and concentric forms suggested by Crusader work and other fortifications in the Near East.

In connexion with residential work, we should note houses, like the Jew's House in Lincoln, which recall arcaded houses on the Continent, such as we have seen at Cluny.

As with the castles, so with the churches: it is the earliest great buildings which are unforgettable. The Canterbury of Lanfranc (1070-7) as augmented by Priors Ernulph and Conrad (c. 1097-1130) was an extraordinary piece of architecture. The wonderful sweep of Norwich Cathedral (1090-1145), both external and internal, is one of the most dramatic things which

Normandy, and Cluny II. Like its elder contemporary, Cluny III, Durham was planned from the beginning to be entirely vaulted, and was brought to completion in the course of thirty-five or forty years (to 1128 or 1133) with only one period of hesitation. Changes since then have for the most part been kindly; the dominating force of the Romanesque design easily carries Gothic additions like the Chapel of Nine Altars (the eastern transept) and the crossing tower. The vast buildings of the cathedral monastery, still complete on the south of the church, yet retain their Romanesque plan, though the constructions are now largely of Gothic date.

Durham is one of the most masculine of church designs [375, 359B]. The modular unit

375. Durham Cathedral, begun 1093

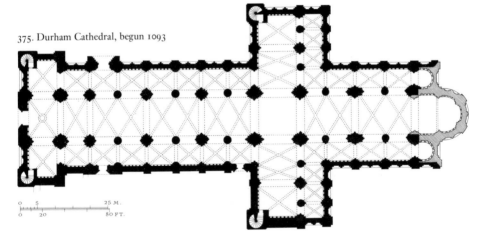

Romanesque architecture can offer; Durham Cathedral was hardly surpassed in its day, and has about it the air of serene finality which belongs of right to the greatest masterpieces. It represents a summit of achievement; it is one of the noblest in scale of Romanesque monuments and one of the most beautifully set.

Begun in 1093, Durham exemplifies the simpler cathedral plan - that related to Bernay in

is the old northern *sajène* (seven feet). Two double bays form the choir, and three more, plus two oblong bays, form the nave [376, 377]; each arm of the transept has a double and a single bay - all magnificently ample in proportion. The vast grouped piers and arches are richly articulated, while the substantial cylindrical intermediate piers are boldly marked with fluting, chevron, and quadrille work. All the

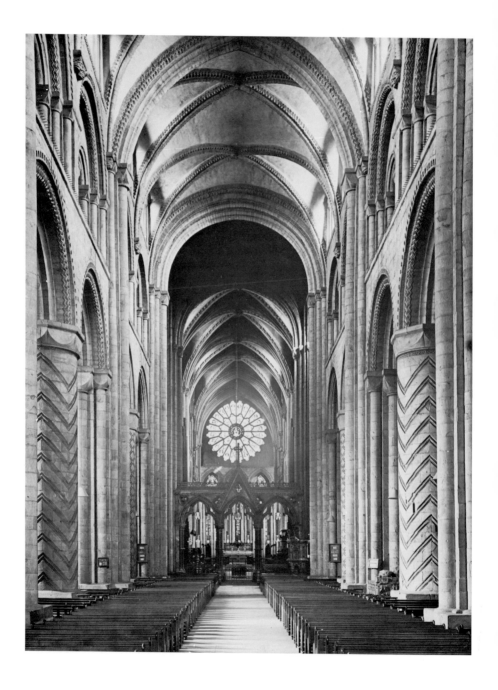

376 and 377. Durham Cathedral, nave, 1093-1133

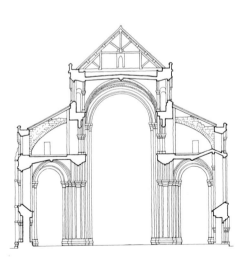

capitals are of the 'cubical' type (that is, trimmed down from a cube to a circular shape at the astragal), and they lose nothing by their vigorous simplicity. The gallery is very handsome, with two arches, each enclosing twin arches, in each double bay. The vaults of these double bays, separated by transverse arches, are seven-part units, well but not perfectly adapted to their supports. They are actually much like sections of tunnel vaulting cut by ribbed penetrations for the clerestory windows. Thus the vault is carried but little higher than the window openings, and is abutted between and below them, instead of above them, as (precariously) at Cluny III.

It was Durham Cathedral, therefore, which made Cluny III obsolete by showing, on the grandest scale, that ribbed high vaulting was possible and practical over wide spans. In both buildings there was partial failure. At Cluny (1125) it was a fall of vaulting in the nave, which was not stable until the addition of the flying buttresses which we have mentioned. At Durham the choir vault of 1099-1104 had to be replaced not, as at Cluny III, because of faulty design – the same sturdy old walls still sustain the successor vault – but because of inexpert construction in the vaulting webs themselves, which were heavily built of rough flattish stones with a wide mortar joint, stuccoed over. This was massive vault construction; it was supported by massive wall construction, and, as such, it was less sophisticated than Cluny III. To be sure, the gallery at Durham, which is wooden-roofed, has the purlins carried on arches (round in the choir, segmental in the nave) which suggest flying buttresses, but they were evidently not conceived as such, since the inner spandrels were not originally carried up to abut the nave wall. Durham, like a great Imperial German building, relied on mass for strength.

What remained to be done in creating the Gothic style as we know it was to take the pro-

portion and sophistication of Cluny III, its relatively thin vaulting, its flying buttresses, joining to them the rib vaulting of Durham, and developing the effective features of each. This was done in the Île-de-France, where the masons became accustomed to build ribbed vaults with thin webs of cut stone, and were disposed to carry further the exploitation of the pointed arch, already suggested at Cluny and Durham.

Gothic architecture was achieved, in intention, by another great and bold, forward-looking project, namely the plan of Abbot Suger, about 1135, to rebuild Saint-Denis – unfortunately not realized, nor, in fact, entirely capable of realization. But it was an astonishing design, as the excavations have shown.[46]

Behind the heavy westwork which still exists (substantially built, and crenellated to make it serviceable as a fortress), and above the substantial, almost Roman ambulatory of the crypt, the church was to have been a double-aisled columnar basilica [378], with the interior supports, except for four piers at the crossing, in the form of four files of slender cylindrical shafts only a foot and a half in diameter, and Roman in aspect. The enclosing wall was to have been relatively thin, and pierced with large lancet windows, above which (if we may judge by the existing absidioles) it was to have been loaded to thicken and strengthen it, making a sort of collar to receive and contain the vaulting thrusts. Exceptionally, flying buttresses are reported on the chord of the apse by 1145. Original vaulting, still in place in the narthex, ambulatory, and radiating chapels, has light ribs, which are easy to construct with simple centering; the surfaces of the severies are slightly swelling, so that they could be built up cleverly, arch by arch, between the ribs, with little if any auxiliary falsework. All in all, this mode of vaulting, mainspring of the Gothic style, was a most admirable

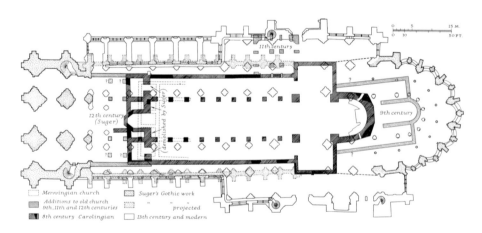

378 (above). Saint-Denis, abbey church, c. 1135–44 and thirteenth century, with predecessor churches. Plan largely based on Crosby's excavations. Later excavations seem to show that the apse was round at the upper level, and that the transept had an element on the east, here shown hypothetically

379A–C (opposite). Saint-Denis, abbey church, vaulting in narthex, c. 1135–40, section of chevet (K.J.C.), and east elevation, showing flying buttresses (K.J.C.) (p. 491, Note 47). Sens, c. 1155, had the first sets flanking a nave

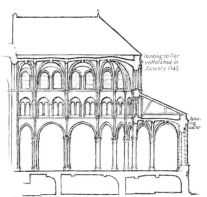

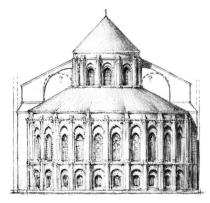

technical development [379, 380] (and illustration 140 right, for the apse at Vézelay, built about 1170, resembles the design of Saint-Denis in important respects).

The designer, in thus rationalizing his wall and vault construction, went beyond Roman-esque procedures. Instead of the conventional enclosing fabric, so weighty that it required massive and obstructive piers, Saint-Denis was planned to have a thin shell of stone and glass, proof against fire, yet so amazingly integrated and disposed as to require no more interior sup-

380. Saint-Denis, abbey church, ambulatory, 1140-4 and thirteenth century

port than the vulnerable wooden-roofed Early Christian basilica.[47]

While the support system was thus much simpler than in Romanesque architecture, the articulated wall and vault were very much more dynamic and complex. The original design of Saint-Denis, with only two flying buttresses, was too bold; it was never finished, and only a fragment survives, but the new mode nevertheless had revolutionary consequences. In well-characterized Gothic structure, the stresses are much more focalized and definite than in Romanesque; they need to be much more definitely known and understood. Every increase in comprehension, as time went on, led to more fully characterized buildings, especially after the introduction of perfected flying buttresses about 1175. Then the impress of trained intellect on the designs became ever stronger.

Whence the fact that the pure Gothic is like a theorem, and the key to understanding it is

that ordered intelligence which flowered in the Gothic centuries. Reims Cathedral, the paradigm of Gothic, is almost an abstraction, lofty and above feeling.

Where the Gothic designs are more humanly felt, it is possible to sense that the architect was in union with the past. In the serenity of the interior of Amiens Cathedral one recognizes a classic nobility like that of the finest Greek and Roman work; in headlong Beauvais the impetuous spirit of Centula and the third Cluny lives again; in Sens and other great southern buildings, one is conscious of the unforgotten geniality and amplitude which came to the Romanesque as one of its most valued legacies from Roman architecture. Not the least precious aspect of the Romanesque is its after-life in a multitude of Gothic buildings cherished for their variety, their warmth, and their graceful conformity to regional traditions which were created by Romanesque genius.

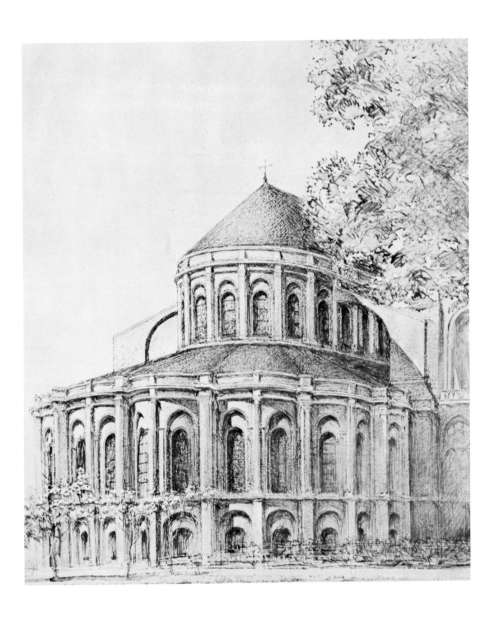

381. Saint-Denis, abbey church, as in *c.* 1144;
perspective interpretation of illustration 379C (K.J.C.)

NOTES

Bold numbers indicate page reference

CHAPTER I

32. 1. A. P. Usher, 'Population and Settlement in Eurasia', *Geographical Review*, XX (1930), 110. Maps in F. van der Meer, *Atlas de la civilisation occidentale*, 2nd ed. (Paris, Brussels, 1952), useful throughout the present volume.

33. 2. See E. Viollet-le-Duc, *Dictionnaire . . .*, 10 vols (Paris, 1859 ff.), 1,245. It is said that by the year 1300, 15,000 bishops, 7000 archbishops, and 24 popes had been spiritually formed by Benedictine monasticism.

3. St Benedict of Aniane wisely undertook research to discover what St Benedict of Nursia's original rule had been; the result was his *Codex Regularum*, which received approval in the imperial Capitulary of 817. This and a set of regulations for the details of daily life – the *Ordo Qualiter* which gives its name to monastic 'Orders' – were enjoined on the generality of monasteries within the Empire with very salutary effect.

34. 4. C. R. Morey, *Christian Art* (London, New York, 1935), 34.

35. 5. H. Stolper, editor, *Bauen in Holz* (Stuttgart, 1937); J. Strzygowski, *Origin of Christian Church Art* (Oxford, 1923); E. Hempel, *Geschichte der deutschen Baukunst* (Munich, 1949), 9; L. Bréhier, *L'Art en France des invasions barbares à l'époque romane* (Paris, n.d. [1930]), 84; F. H. Crossley, *Timber Building in England* (London, 1951); O. Völkers, *Deutsche Hausfibel* (Leipzig, n.d. [1937]).

6. Subconsciously, we must be more familiar than we suppose with this old tradition. There are many signs that framed buildings of oblong shape with fairly steep roofs have been common in Europe north of the Alps since Carolingian days at least. They are now represented all over the area of northern culture by myriads of modest structures – cottages, barns, sheds – so unpretending that few of us realize how important this type actually is, or how dignified it can be. See Walter W. Horn, 'On the Origins of the Mediaeval Bay System', *Journal of the Society of Architectural Historians*, XVII, no. 2 (1958), 2–23.

38. 7. The Gothic Old St Paul's in London, 589 feet long, was built for a city with a population of 20,000 to 50,000 who had 119 other churches. Fourteenth-century York had 11,000 people, who could, if they desired, attend service in the cathedral; and there were 53 other churches.

8. F. Bond, *Gothic Architecture in England* (London and New York, 1906; new ed. 1912).

39. 9. Though it was interesting, the Syrian scheme of pylon towers rarely affected Western church architecture in the earlier epoch. The imposing paired towers of the later church façades seem to have developed independently in the Romanesque period. Before the development of heavy peals of bells there was no practical use for pylons on church façades, and that is doubtless the reason why the great towers appeared tardily, after the pylon scheme had passed out of use.

10. For example the church of Alahan Monastir (Kodja Kalessi), *c*. 450.

40. 11. These many new impulses were active in Gaul in the period when the artistic life of the region was stirred by the flight of artists from Rome at the time of Attila's invasion – as the learned studies of Baldwin Smith and Soper have shown. One of the results was new progress in church architecture. A. C. Soper, 'The Italo-Gallic School of Early Christian Art', *Art Bulletin*, XX (1938), 145.

12. Martin, the well-beloved soldier saint and bishop, whose missionary work had been effective in the evangelization of Gaul, died in 397. Pilgrims early came to visit his tomb, and in 466–70 a church with the usual basilican nave, aisles, galleries, and apse was built there. The original inscription at the main entrance, with other descriptive material given by Gregory of Tours, makes it certain that the church had two towers on the main axis, whereby the traditional classic horizontal was cut through. First there was the 'secure' tower over the entrance-way, needed because Tours and 'Martinople' were then a Frankish enclave in the Visigothic dominions; second, there was near the east end a lantern tower surmounted by a belfry. The second tower was therefore clearly a staged tower or *turritus apex* of the sort which delighted late classic and Carolingian designers, and became the ancestor of the medieval spire [4]. Texts (with an impossible restoration) in J. Quicherat, *Mélanges d'archéologie et d'histoire*, ed. R. de Lasteyrie (Paris, 1886), 11, 30.

CHAPTER 2

43. 1. S. McK. Crosby, *L'Abbaye royale de Saint-Denis* (Paris, 1953), 12.

2. R. Lantier and J. Hubert, *Les Origines de l'art français des temps préhistoriques à l'époque carolingienne* (Paris, 1947), gives the background: *L'Essor du VII^e siècle*, 139.

3. They are known from the fortunate circumstance that a full descriptive text and a seemingly trustworthy drawing were included in the Chronicle of Hariulf, dated 1088, and reproduced before the destruction of the manuscript in 1719. The interesting Carolingian chapels vanished long ago, and the main church, restored before Hariulf saw it and much rebuilt in the period when he wrote, has been totally reconstructed three times since 1131, but the original design had great influence, and no account of Carolingian Romanesque could be complete without it. Two scholars, Georges Durand, in *L'Église de St-Riquier, La Picardie historique et monumentale*, IV (Amiens and Paris, 1907-11), and Wilhelm Effmann, in *Centula. St-Riquier* (Münster, Westphalia, 1912), studied the manuscript material independently and arrived at almost identical conclusions. More recently William Morrison has made a beautiful demountable model, visible on request at the Busch-Reisinger Museum, at Harvard University, giving visual confirmation. Scholars are nearly unanimous in their belief that the archaeological studies have given secure results. There is a hint of possible influence from England coming through Angilbert's friend and colleague Alcuin of York. In one of his poems the head of the Palace School celebrates the minster built at York in 767, which was notable for its height (*haec nimis alta domus*); it was surrounded by *porticus* at the ground level and provided with upper chambers also, affording places for the quite exceptional number of thirty altars in all. Compare the traditional silhouette of Pembridge tower, Herefordshire [30], with Saint-Riquier and Hincmar's Reims.

Oddly enough, San Vitale, Ravenna (well known to the Carolingian court), may be in the background of the design. The two-storey narthex at San Vitale was flanked by cylindrical towers, with the dome visible above and between. At the east [62] the apse was flanked by two pylons, with the dome – in this case the same dome – visible above and between.

44. 4. This dimension for the façade may represent the erroneous height (120 cubits) given in 2 Chronicles, chapter iii, verse 4, for the Temple in Jerusalem, while the court, 100 feet wide with three entrances, may have originated in the vision of the Temple reported in Ezekiel, chapter xl, ff.

45. 5. One might suspect that the miniaturist had exaggerated this tower, but for Hariulf's epithet *ingentem* (gigantic). Other miniatures show less conspicuous square towers at Chartres and Cologne; an old seal shows a squat square staged tower at Chichester. The wooden pyramidal staged part of the tower reported at Saint-Wandrille in 833 was only thirty-five feet high. But all lines of evidence seem to show that the rounded spires reached a considerable height at Saint-Riquier and elsewhere. Convenient plans and data in E. Gall, *Karolingische und ottonische Kirchen* (Burg bei Magdeburg, 1930). Consult Hans Reinhardt and Étienne Fels, 'Étude sur les églises-porches carolingiennes', *Bulletin Monumental*, XCII (1933), 331; XCVI (1937), 425; also G. H. Forsyth, Jr, *The Church of St Martin at Angers* (Princeton, 1953), App. V, and 'St Martin's at Angers and the Evolution of Early Church Towers', in *Art Bulletin*, XXXII (1950), 308.

6. G. H. Forsyth, Jr, *The Church of St Martin*, 216: 'Nam cum totius fere templi fabrica sumtu eximio consummata esset, et turris in media basilica sublimiori aedificaretur opere, quaerabatur trabes, quae in altitudine erigenda erat, in qua omne pyramidis pondus et totius culmen oneris [or operis?] cum tignis inniti posset suis . . . ' (Mirac. S. Wandregisili, in *Monumenta Germaniae historica: Scriptores*, XV, i, p. 407).

46. 7. Angilbert's liturgy for the Rogation Days has come down to us, and we are able to see how, on these festivals, the monastery was spiritually and ceremonially bound into the life of the people and the surrounding villages and countryside. It is difficult for us to realize, at the present, the importance which was attributed to these processions, as well as to the much more frequent processions within the monastery portals and the church proper.

8. St Pantaleon (*c.* 970) [77] and St Mary in Capitol (*c.* 1040) [337] at Cologne; Minden Cathedral (*c.* 1064) [324], Maria Laach (1093-1156) [93], Freckenhorst (1116-29), and Marmoutier in Alsace (twelfth century), are also examples in which influence from Saint-Riquier is to be felt. In the Thiérache and Belgium, near Saint-Riquier, the form became traditional also, and it was carried from France to America.

9. The lozenge-shaped court beyond the Carolingian church of Schaffhausen (p. 136) makes the triangular cloister at Saint-Riquier seem more credible. E. Gall, *Dome und Klosterkirche am Rhein*, pp. 57, 58 (two plans showing the church groups together). If, as now seems certain, the 'cloister' was a·rather large monastic compound, the chapels and their adjacent walls as shown in illustration 5A would be moved to the right considerably (that is, to the south-east).

10. Aachen flourished from the time when Pepin III chose it as a settled residence, about 765, and very shortly before Charlemagne succeeded him (768). Charlemagne had been born there in 742 or 743, and it was his real home. By 788 he had built the palace which was the seat of his lively court, and of the Palace School over which Alcuin of York presided from 782 to 796, making it the intellectual centre of Europe. For the Palatine Chapel, consult P. Clemen, *Die Kunstdenkmäler der Rheinprovinz;* Vol. x, *Aachen, Stadt,* by K. Faymonville (Düsseldorf, 1916); P. Frankl, *Die frühmittelalterliche und romanische Baukunst* (Wildpark-Potsdam, 1926), 16.

48. 11. This chapel crowned the façade and gave it a sacred character. An altar could be set up in the courtyard below upon occasion, and the atrium then became an example of the 'open-top' church, for which there is precedent in Early Christian times. It is still possible to see how this arrangement worked; for traces of the old atrium galleries still exist, the old lines of the façade are easily distinguished, and its crowning feature at present is merely a Gothic version of the original Carolingian reliquary chapel. The Minster at Aachen has an enviable record of stability. In respect to its vaulting types and fabric, it adumbrates Romanesque architecture. However, the typical Romanesque church is basilican; there were many attempts to use the structural scheme of the Minster – the scheme of vaulted aisles, vaulted and screened gallery, clerestory, and high vault of masonry – in a succession of bays over a basilican plan. The aesthetic result was, as in the Palatine Chapel, harmonious, but practically liable to failure, because a long barrel vault tends to sink in the middle, to spread at the sides, and to overturn its supports. The centralized form is much easier to abut.

51. 12. Jean Hubert, 'Germigny-des-Prés', *Congrès Archéologique,* XCIII (Orléans, 1930), 534.

13. It was carefully studied, in spite of great difficulties, for the archaeological congress of 1930.

14. Theodulph of Orléans, who commissioned the oratory, is widely known as the author of the great Easter hymn, 'Hail thee Festival Day'. He was a prominent member of the court at Aachen, became bishop of Orléans, then, in 798, *missus dominicus,* and by 802 abbot of Saint-Benoit-sur-Loire. He was destituted for conspiracy in 818 and died imprisoned in 820. He was a Goth by race, from Septimania, which had continued for some time in the possession of the Visigoths after Clovis and Theodoric had ousted them from other parts of France.

52. 15. Marquis M. de Vogüé, *Syrie centrale. Architecture civile et religieuse du Ier au VIIe siècle,* 6 vols (Paris, 1865-77), 1, 45, and plate VII.

16. S. Der Nersessian, *Armenia and the Byzantine Empire* (Cambridge, Mass., 1945).

17. King Alfred the Great built a church of similar plan at Athelney, now destroyed. (William of Malmesbury, *Gesta Pont.,* 199); A. W. Clapham, *English Romanesque Architecture before the Conquest* (Oxford, 1930), 147.

53. 18. The mosaic of the apse is partly old; the missing tesserae have been supplied in porcelain, without, however, spoiling the composition. It is a very Byzantine-looking representation of the Ark of the Covenant accompanied by angels. In 1869 the winged Celestial Powers were still to be seen represented on the barrel vault in front of the sanctuary. The vertical wall above the apse had striking rinceaux, leafage and borders, but these were destroyed.

19. L. Bréhier, *op. cit.,* 134; R. de Lasteyrie, *L'Architecture religieuse en France à l'époque romane,* 2nd ed. (Paris, 1929), 766.

54. 20. A. W. Clapham, *English Romanesque Architecture before the Conquest* (Oxford, 1930), 17, 40. C. Enlart, *Manuel d'archéologie française,* Part I (Paris, 1919), 126. F. Bond, *Gothic Architecture in England* (London, 1906), 155.

21. Richbod, a member of the Palatine School at Aachen, friend and pupil of Alcuin, archbishop of Trier from 798, served as abbot of Lorsch from 784 to 804, in the period of Charlemagne's epic struggle of conquest against the Saxons (788, 804), the Avars (805), and the Bavarians. Tassilo, Duke and King of the Bavarians, became a monk at Lorsch and died there about 797. It is easy to see how the idea of a triumphal arch could arise under these circumstances.

55. 22. R. Krautheimer, 'The Carolingian Revival of Early Christian Architecture', *Art Bulletin,* XXIV (1942), 1; see also E. Gall, 'L'Abbaye carolingienne de Lorsch', in *Mémorial d'un voyage d'études de la Société nationale des Antiquaires de France en Rhénanie* (Paris, 1953), 57.

23. H. Reinhardt, *Der karolingische Klosterplan von St Gallen (Schweiz); Der St Galler Klosterplan* (St Gallen, 1952); interesting redraught, with directory, in C. Enlart, *Manuel d'archéologie française,* Part II, tome 1 (Paris, 1929), 11. Convincing article by W. Horn and E. Born in *Art Bulletin,* XLVIII (1966), 285-308: 'The "Dimensional Inconsistencies" of the Plan of St Gall...'.

56. 24. E. S. Duckett, *Alcuin, Friend of Charlemagne* (New York, 1951).

25. In Germany there was, as time went on, a wide variety of these introductory elements; towers and porticoes were arranged in different ways, often with an axial chapel facing the main façade of the church, as Ludwig Joutz has well shown in his brochure, *Der*

mittelalterliche Kirchenvorhof in Deutschland (Berlin, 1936).

58. 26. Beyond the curved courtyard [17] another 'double-ender' was reached – an aisleless building about 120 feet long divided into two chapels. These brought the total number of altars in the monastery to twenty-one. The western chapel served the Infirmary, where sick, convalescent, old, and retired monks were cared for. North of the chapels they had a cloister of their own, with the farmerer's rooms, dormitories, calefactories, refectory, and annexe for the kitchen and a bath. The eastern chapel served the symmetrical cloister to the south, where the Novitiate was located. The two calefactories ('warmed rooms') adjoined the eastern apse, each with an exterior furnace from which a flue was carried under a room and out again to an exterior chimney. The master's room and the one adjoining had (in each case) a corner stove, placed like the familiar pottery stoves of a later age. An exterior latrina adjoined the main dormitory in each group.

Probably the placing of these groups on the grand axis of the church served a subtle psychological purpose, strengthening the bonds between the community and these other men who were preparing to enter it or were withdrawn from its activities; moreover, the Infirmary and the Novitiate were like the main cloister buildings in miniature, and had the same sense of enclosure, dominated by the great church.

Having thus followed the main axis of the monastery, we return to the curved outer entrance portico near the cylindrical towers. The south vestibule, already mentioned, gave entrance to the monastery proper, which lay to the south of the church. Adjoining the vestibule was a warmed room serving as lodge for the porter, whose duty it was to receive visitors. In the near-by Almonry he cared for pilgrims who came afoot and the *pauperi*, a group of indigent folk who were lodged and supported by the abbey. This building had an annexe with suitable cooking facilities.

Near the Almonry was the exterior parlour and vestibule of the cloister, noted as the place where the feet of the abbey poor were ceremonially washed on Maundy Thursday. The four spacious walks of the cloister opened through arcading on the garden (*paradisos*), which was the earthly paradise of the monks as its name implies.

As was usual at the time, the community met as a corporation, and for the Rule, in the north walk. (Later, beginning at Cluny ± 1000(?), a special room was provided on the ground floor of the east range.) St Benedict's Rule begins *Ausculta, o fili*, and a chapter of the Rule is heard each day by the Benedictines in their regular assemblies in the 'chapter'-house.

The east range was the most interesting. It had heating arrangements like the domestic calefactories. The monks' dormitory was on the upper floor of this east range of buildings. Surprising to us is the crowding of the beds, which were as close to one another as they would be in the most vulgar dosshouse of our time; but this arrangement was usual in the Middle Ages [106]. Satellite to the east range were an exterior latrina and a bath. Much wry satire has been written because the monks were allowed but few baths a year: ignorant writers do not realize that these were hot baths, like those of the Roman thermae, and were considered an indulgence; the religious kept themselves clean, up to the standards of their age, by cold sponge baths. A room for the personal toilet is indicated in the bathing house on the St Gall plan.

The refectory with its related kitchen was south of the cloister. The St Gall plan indicates the seat of the president (the abbot or his delegate) and other officers on the middle axis of the refectory, and the pulpit, where edifying literature was read during the repast, is marked at the west end of the hall. The meals were almost liturgical. The monk would 'wash his hands in innocency' as he entered – either by aquamanile and basin held at the door, or (as common later) in a lavabo pavilion near by, at the edge of the cloister. The meals began with prayers; at the end the monks would go processionally to the church and finish with devotions there.

The remaining side of the cloister adjoined the cellar, where the St Gall plan shows great tuns sufficiently confessing their contents.

Turning now to the series of buildings north of the church, we find that clerical and lay visitors of quality entered their accommodations through the north vestibule of the curved exterior entrance portico near the cylindrical towers. As on the south side, a lodge for the porter in charge adjoined this vestibule. He was comfortably quartered, with a porch, a warmed reception room, a chamber, and a latrina. Similar accommodation was provided for the schoolmaster, and two warmed rooms of similar size with a long porch, reached through the School, were available for visiting monks.

The porter just mentioned was the guest master, and he cared for visiting personages. The Guest House had quarters for their mounts and their servitors as well as for themselves. The guest hall was a refectory, and the fare (less austere than that of the monks) was provided in a little building not far to the west, which appears to have served as kitchen, pantry, scullery, bake-house, and brew-house all in one. The bedrooms of the guest house, four in number, were warmed; each had a stove and a little retreat; an exterior latrina was provided too.

The School-house had a court of its own. According to the plan there were two entries, two large school-rooms, twelve small school-rooms, and a latrina, all opposite the school-master's lodging. The approach to the School, surprisingly enough, was not exterior, but, symbolically indeed, through the church and thence through the school-master's dwelling.

Charlemagne, it will be remembered, had by capitulary of 789 required the abbeys and cathedrals in the Empire to maintain schools, and he was obeyed. These early schools were intended for clerical education only, and although St Gall was a great monastery, the school building was small – a scant 60 by 75 feet (C. H. Haskins, *The Renaissance of the Twelfth Century*, Cambridge, Mass., 1927, 83, 368, 371, 383).

Beyond the School-house court, and connected with the north transept of the church by a passage, was the Abbot's House. Like the palaces of late Antiquity, it had arcaded outer galleries. The house was heated; it naturally had its own latrina and an annexe for kitchen, bath, and servitors. One is at first surprised to find that the Abbot's House had no direct access from the public entrance to the monastery. However, the abbot of a monastery was always ceremonially, indeed liturgically, received by his monks, and the entrance through the church was therefore natural. Visitors followed the same path, and found the prelate's reception room at the end of the passage leading from the church transept.

Beyond the Abbot's House, just north of the Infirmary, was the medical establishment. There were a heated pharmacy, surgery, and ward for the seasonal blood-letting. Next, towards the east, lay the wards for monks who were gravely ill, with lodgings for the doctor. Finally, at the eastern extremity, there was a garden of medicinal herbs.

'God's Acre' adjoined the Novitiate to the south, filling out the width of the main group of buildings. The kitchen garden with a gardener's house and the yards for chicken and geese, with the lodging of their caretakers, filled out the whole width of the layout.

We have still to consider the buildings devoted to menial operations. The threshing floor and barns were west of the garden and poultry yards. Spacious quarters for the artisans were provided in a big building with two courts, west again from the barns just mentioned. The remaining area had a brewhouse, bakery, pantry, and scullery attached to the monks' kitchen, with the Mill, the Press, and the Kiln not far away – all with quarters for the servitors. The brewery grain was kept, and the barrels were made, in an adjoining structure, also with lodgings. Between the last-named building and the spacious system of yards and buildings for farm animals, field hands, herders, and grooms which was noted at the beginning

of this exposition, lay a building for special livestock – mares and bulls – with the necessary special stabling and attendants' quarters. This area could be reached from the public vestibule which served the cloister buildings and the Almonry as previously noted.

60. 27. Well illustrated in E. Hempel, *op. cit.*, 30.

28. Consult R. Hinks, *Carolingian Art* (London, 1935), 97 ff.; P. Clemen, *Bericht über die Denkmäler deutscher Kunst*, I, 4; *Westdeutsche Zeitschrift für Geschichte und Kunst*, IX (1890), 98 ff.; *Revue de l'Art Chrétien*, LXI (1911), 131 ff.; interesting restoration in E. Hempel, *op. cit.*, 30.

62. 29. E. Hempel, *op. cit.*, 34.

30. J. Hecht, *Der romanische Kirchenbau des Bodenseegebietes*, 2 vols (Basel, 1928), I, 69.

63. 31. It is known, incidentally, that a *Helmhaus* was built at St Gall instead of the western apse shown on the famous plan. The ground-floor vestibule at Corvey has survived entire, and the tribune has not been greatly changed [22, 23].

64. 32. B. M. Apollonj Ghetti, A. Ferrua, E. Josi, E. Kirschbaum, *Esplorazioni sotto la confessione di San Pietro in Vaticano*, 2 vols (Vatican City, 1951); the *Memoria Apostolica*, I, 119, 151, 173, the basilica, I, 147; J. B. Ward-Perkins, 'The Shrine of St Peter and its Twelve Spiral Columns', *Journal of Roman Studies*, XLII (1952), 21; C. Ricci, *Romanesque Architecture in Italy* (London, New York [1925]), viii. Important article on the church: T. C. Bannister, 'The Constantinian Basilica of St Peter at Rome', *Journal of the Society of Architectural Historians*, XXVII, no. 1 (March 1968), 3-32.

65. 33. R. de Lasteyrie, 'L'Église St-Philibert-de-Grandlieu', *Mémoires de l'Académie des Inscriptions et Belles-Lettres*, XXXVIII, 2 (1909).

67. 34. The importance of the original work was recognized when it was built; as Héric the chronicler says, 'ad artifices talium expertissimos res confertur . . et, quasi quodam praeludio, futurae moles magnitudinis ceris brevibus informatur ea pulchritudine, ea subtilitate quae digna angelorum hominumque rege, quae santorum collegio, quae ipsius etiam loci majestate esset.' This, incidentally, is a very early example of the use of a wax model in solving the new architectural problems which liturgical and other developments posed in the Middle Ages.

35. R. Merlet, *The Cathedral of Chartres (Petites Monographies des grands édifices de la France*, Paris, 1926), 14.

68. 36. C. K. Hersey, 'The Church of Saint Martin at Tours (903-1150)', *Art Bulletin*, XXV (1943), 1. The date of 903-18 for the ambulatory and the radiating chapels has been the subject of much controversy, but it is reasonable.

CHAPTER 3

69. 1. G. F. Webb, *Architecture in Britain: The Middle Ages* (London, 1956), chapters 1–2.

70. 2. Webb, *op. cit.*, p. 12; plate 8. There exist near Sénanque a number of old stone constructions closely resembling the churches of Dingle and Skellig Michael. The tradition died out about 1800. W. Horn, 'On the Origins of the Medieval Cloister', *Gesta*, XII (1973), 13–52 (important article).

72. 3. Prior and Gardner, *An Account of Medieval Figure Sculpture in England*, p. 14.

4. Webb, *op. cit.*, chapters 1–2.

5. Webb, *op. cit.*, pp. 1, 9, 10, 17, 87.

73. 6. Webb, *op. cit.*, p. 20; figure 12.

7. Webb, *op. cit.*, pp. 16, 21–5; plate 16; figure 8.

8. Webb, *op. cit.*, pp. 18, 19, 23; figure 10 for plan.

9. Webb, *op. cit.*, p. 23.

10. Webb, *op. cit.*, pp. 16, 20, 24.

11. Webb, *op. cit.*, pp. 21, 22, 24; figure 14 for plan.

12. Webb, *op. cit.*, pp. 21–3.

13. Webb, *op. cit.*, pp. 23–4.

76. 14. Webb, *op. cit.*, pp. 23–4; E. D. C. Jackson and E. G. M. Fletcher, 'The Saxon Church at Bradford-on-Avon', *Journal of the British Archaeological Association*, 3rd series, vol. XVI (1953), 41.

77. 15. The more usual sculptural works of the Saxons were in ivory or precious metals; catalogues and descriptions make it clear that they were indeed numerous in the great churches. Such accessories, rather than plastic elaboration, formed the enrichment of the churches.

16. S. H. Cross, *Slavic Civilization through the Ages* (Cambridge, Mass., 1948), 76; C. Enlart, *op. cit.*, Part II, tome 11 (Paris, 1932), 657, for the ships.

17. J. Strzygowski, *Early Church Art in Northern Europe* (London, 1928), 129; *Svenska Fornminnesplatser*, No. 13: S. Lindqvist, *Gamla Uppsala Fornminnen* (Stockholm, 1929).

81. 18. M. Clemmensen, 'Kirkeruiner fra Nordbotiden m.m. i Julianehab District', *Meddelelser om Grønland* (issued by Kommission for Ledelsen af de Geologiske og Geografiske Underøgelser i Grønland), 47 (Copenhagen, 1911–12), 283; D. Bruun, 'Icelandic Colonization of Greenland', *op. cit.*, 57 (1918), 3, 89, 190; A. Roussell, 'Farms and Churches in the Mediaeval Settlements of Greenland', *op. cit.*, 89 (1941), 19, 45, 80; F. R. Donovan, T. D. Kendrick (consultant), *The Vikings* (New York, 1964), 8–9, 20–1, 34–5, 65, 78–9, 86–8, 90–5, 104, chapter VII (113 ff.). Account, well illustrated, in S. E. Morison, *The European Discovery of America* (New York, 1971), chapter III.

Eric (Upsi) Gnupsson, named bishop in 1112 or 1113, is doubtfully reported as having been lost on a voyage of 1121 to Vinland. Excavations have disproved the fascinating idea that the round stone tower at Newport, Rhode Island, was built as his cathedral. Its supposed model was the Church of the Holy Sepulchre in Jerusalem, to which the bishop's patron, King Sigurd, made a strenuous pilgrimage in 1107–11, stopping at Santiago de Compostela and Constantinople on his journey. Consult P. A. Means, *Newport Tower* (New York, 1942), 203.

84. 19. L. Dietrichson, *Die Holzbaukunst Norwegens* (Dresden, 1893); H. Fett, *Norges Kyrkor i Middelalderen* (Kristiania, 1909); E. Alnaes, G. Eliassen, R. Lund, A. Pedersen, O. Platou, *Norwegian Architecture throughout the Ages* (Oslo, 1950); A. Bugge, *Norwegian Stave Churches*, translated by R. Christophersen (Oslo, 1953); 'The Origin, Development, and Decline of the Norwegian Stave Church', *Acta Archaeologica*, VI (1935), 152.

86. 20. H. Cornell, *Sigtuna och Gamla Uppsala* (1920).

CHAPTER 4

88. 1. A. Bonet Correa, *Spanish Pre-Romanesque Art* (New York ed., Greenwich, Conn., n.d. [1968?]); J. Puig i Cadafalch, *L'Art wisigothique et ses survivances* (Paris, 1961); H. Schlunk, *Arte visigodo. Arte asturiano* (in *Ars Hispaniae, Historia universal del arte hispánico*, II, Part 3, Madrid, 1947), 327 ff.; G. G. King, *Pre-Romanesque Churches of Spain* (Bryn Mawr Monographs, VII, New York, 1924); J. Amador de los Ríos, *Monumentos arquitectónicos de España, Oviedo* (Madrid, 1857–91); for Naranco, G. Menéndez Pidal, 'El Lábaro primitivo de la Reconquista', in *Boletín de la Real Academia de la Historia*, vol. CXXXVI, cuaderno II (offprint, 1955); Madrid Exhibition, 1958 (Catalogue), *Veinte Años de restauración monumental de España* (Madrid, 1958), plates CVI to CXI, CXXVIII; for Lourosa (Portugal), Canon M. de Aguiar Barreitos, *A Igreja de S. Pedro de Lourosa* (Porto, 1934).

93. 2. P. de Pallol, *Hispanic Art of the Visigothic Period* (New York ed., n.d. [1968?]); *Ars Hispaniae*, II, Part 3, 270 ff.; *op. cit.*, III (Madrid, 1951), 355 ff.; M. Gómez-Moreno, *Iglesias mozárabes*, 2 vols (Madrid, 1919); W. M. Whitehill, 'Quintanilla de las Viñas', *Antiquaries Journal*, XVII (1937), 16.

96. 3. F. Iñiguez, 'La Torre de Doña Urraca, en Covarrubias', *Anuario del Cuerpo facultativo de Archiveros, Bibliotecarios y Arqueólogos*, I (1934), 403.

4. J. Puig i Cadafalch, de Falguera, Goday i Casals, *L'arquitectura romànica a Catalunya* (Barcelona, 1909–18); *Ars Hispaniae*, III, 363 ff., and V (Madrid, 1948), 29; J. J. Rorimer, The Metropolitan Museum of Art, *The Cloisters* (New York, 1938), 37.

5. He probably knew Gerbert of Aurillac, later Pope

Sylvester II, and made a long journey with Marinus, Romoald the founder of the Order of Camaldoli, and Pietro Orseolo the great doge of Venice, who rebuilt San Marco after the fire of 976. With such contacts, the strong Italian and French connexions of Oliba Cabreto's son, Abbot Oliba of Ripoll, are easy to understand. *See* J. Pijoan, 'Oliba de Ripoll', *Art Studies*, VI (1928), 81.

97. 6. *Ars Hispaniae*, III, 364 ff.; *op. cit.*, V, 17; Puig i Cadafalch, *op. cit.*

99. 7. Personal communication.

100. 8. *Ars Hispaniae*, III, 389, 391. The paintings, now at Cambridge (Massachusetts) and in New York, allow the strange beauty of that interior to be savoured without a visit to the almost impossibly remote shrine.

9. A. Haupt, *Die älteste Kunst, insbesondere die Baukunst, der Germanen*, 3rd ed. (Berlin, 1935), 94, 183; E. Schaffran, *Die Kunst der Langobarden in Italien* (Jena, 1941), 45; also plans of Agliate, Valpolicella.

102. 10. A. W. Clapham, *Romanesque Architecture in Western Europe* (Oxford, 1936), 4.

11. G. Downey, 'Byzantine Architects - their Training and Methods', *Byzantion*, XVIII (1946-8), 99.

103. 12. C. Ricci, *Romanesque Architecture in Italy* (New York and London [1925]), VI; G. Gerola, 'Le chiese deuterobizantine del Ravennate', *Art Studies*, VIII (1931), Part 2, 215; J. Puig i Cadafalch, *La Géographie et les origines du premier art roman* (Paris, 1935).

104. 13. G. T. Rivoira, *Lombardic Architecture, its Origin, Development, and Derivatives*, 2 vols, 2nd ed. (Oxford, 1934), I, 71; A. K. Porter, *Medieval Architecture, its Origins and Development*, 2 vols (New York, 1909-12), I, 120, 439; C. Ricci, *op. cit.*, IX.

105. 14. Nola in Campania, not far from Naples, seems through the excellence of its bronze in ancient times to be connected with two of the Latin names for bell - *nola* and *campana*. The bells themselves have a history reaching far back into Antiquity and consequently St Paulinus, bishop of Nola (409-32), cannot have invented them, though perhaps he had something to do with introducing their use into public church services. We are on sure ground when we reach the *Regula Monachorum* (perhaps *c.* 442) which refers to bells as used in calling the brethren to office. By the end of the sixth century, if not in the fifth, a bell for the purpose of calling the faithful was mounted above the lantern of St Martin's church in Tours, and rung (it is believed) as monastic bells were regularly rung - from the pavement of the crossing beneath. In the pontificate of Pope Sabinianus (604-6) they were encouraged in Rome. When the bell caught the imagination of ecclesiastics and the people, larger bells than the ancient ones (of cowbell size) were

inevitably made. Before 900 they were expected to be heard at a considerable distance, for they were rung during monastic ceremonial processions outside as well as inside the convents. By the eleventh century a bell weighing 2600 pounds was given to a church in Orléans.

15. We may say parenthetically that Corrado Ricci ascribes the round belfries of Sant'Apollinare in Classe and Sant'Apollinare Nuovo in Ravenna to imitation of the round belfry of San Vitale. Foundation difficulties result when heavy tower masses are joined to other construction; this is sufficient reason for the two belfries being set at a distance from the churches. It seems likely that the precedent established here created the tradition of free-standing belfry towers. Abbot Odo of Cluny reformed Sant'Apollinare in Classe about 936; the Benedictines took over Sant' Apollinare Nuovo in 973, after which date, according to Ricci, the handsome cylindrical belfry was built. A later example, showing the continuity of the tradition, is the half Byzantine church of San Claudio al Chienti, south of Ancona at the border of the former Exarchate. Here the façade, built about 1000, has two cylindrical towers.

16. The façade of Cassiodorus's monastery church of 'Vivarium', near Squillace in Calabria (about 550, as represented in the Bamberg MS. Patr. 61), would have been similar; but, as we have remarked previously, the pylon motif was not popular in Western Christendom. The church of 775 at Saint-Denis apparently had something like pylon towers to the west also; they are slightly referred to by Suger - 'the arched doorway was narrowed on both sides by twin towers, neither very high nor very beautiful.'

17. C. Ricci, *op. cit.*, XVI.

CHAPTER 5

107. 1. G. Downey, 'Byzantine Architects - their Training and Methods', *Byzantion*, XVIII (1946-8), 99.

2. J. Puig i Cadafalch, *La Géographie et les origines du premier art roman* (Paris, 1935), 84.

108. 3. In *The Gothic World*, by John Harvey (London, 1950; 49 ff. and end-papers), there is a very illuminating study on individual Gothic architects whose works are known, so that their movements can be traced.

4. E. Panofsky, *Abbot Suger on the Abbey Church of St Denis and its Art Treasures* (Princeton, 1946), 36, 43, 73, 91.

5. J. Vallery-Radot, *L'Église de la Trinité de Fécamp* (*Petites Monographies des grands édifices de la France*, Paris, 1928), 11.

6. Already considered.

110. 7. Consult Puig i Cadafalch, *op. cit.*, and G. T. Rivoira, *Lombardic Architecture, its Origin, Development, and Derivatives*, 2nd ed. (Oxford, 1934).

111. 8. We have already seen this arrangement in the cathedral of Chartres rebuilt after 858, but only the crypt ambulatory survives at Chartres [96]. This beautiful motif never flourished in Italy, despite the presence of these early examples in two of the chief Lombard cities. It was to be the same with Lombard rib vaulting later on: it took French subtlety to exploit these two great inventions.

9. J. Puig i Cadafalch, *op. cit.*, 210; also Lomello, 241.

10. J. Puig i Cadafalch, *op. cit.*, 256.

112. 11. J. Puig i Cadafalch, de Falguera, Goday i Casals, *L'arquitectura romànica a Catalunya*, 3 vols (Barcelona, 1909–18).

Senyor Puig's affection for, and knowledge of, the monuments of his homeland revealed to him the significance of the scattered survivors of the style elsewhere, and during his political exile he visited these foreign monuments; the result of his studies was his notable *La Géographie et les origines du premier art roman*.

113. 12. J. Puig i Cadafalch, *op. cit.*, 143–7.

115. 13. Oliba was a brother of Guifre, Count of Cerdagne, founder of Saint-Martin-du-Canigou. Count Guifre himself entered the monastery as a monk about fifteen years before his death in 1050. A letter asking prayers for his soul widely circulated in monasteries outside Pyrenean Catalonia.

116. 14. J. Puig i Cadafalch, *op. cit.*; *Ars Hispaniae*, V; J. Pijoan, 'Oliba de Ripoll', *Art Studies*, VI (1928), 81; C. L. Kuhn, *Romanesque Mural Painting of Catalonia* (Cambridge, Mass., 1930), 12.

15. In 967 the famous mathematician Gerbert of Aurillac came to Catalonia. It can hardly be doubted that he worked in the monastery school at Ripoll. Gerbert, after stages in Italy (980–3), and at Reims, became tutor to Emperor Otto III, and Pope, as Sylvester II, in 997. Another example of Ripoll's far-flung influence may be noted in the fact that Arabic numerals appear to have been introduced to Europe through this centre of studies.

16. *Ars Hispaniae*, V, 16.

118. 17. Richly ornamented crosses, reliquaries, altar dossals, and antependia with reliefs were usual features of church sanctuaries in the eleventh century, and added greatly to their emotional appeal. The Christ in Glory accompanied by angels, apostles, or the symbols of the Evangelists was a favourite subject of these works. The apocalyptic prophecy of the Lord's coming in glory after a thousand years (in the year 1000, or in 1033, as they reckoned it) gave importance to that particular subject at this time and might have suggested the transfer of this theme to the church portals.

18. *Ars Hispaniae*, V, 24.

19. P. Deschamps, 'Tables d'autel de marbre . . .', *Mélanges d'histoire du moyen-âge offerts à M. Ferdinand Lot* (Paris, 1925), 137.

119. 20. Well published in *Ars Hispaniae*, VI (Madrid, 1950).

21. *Congrès Archéologique*, CX (1952), 338.

22. P. Frankl, *Die frühmittelalterliche und romanische Baukunst* (Wildpark-Potsdam, 1926), I, *contra*.

120. 23. W. Bornheim gen. Schilling, 'L'Église Saint-Castor à Coblence', *Mémorial d'un voyage d'études de la Société des Antiquaires de France en Rhénanie* (Paris, 1953), 77; E. Hempel, *Geschichte der deutschen Baukunst* (Munich, 1949), 38.

24. During the period of archaeological revivals in the nineteenth century, the old Lombardic architectural motifs were reproduced in new buildings, and thus they have come down to modern times. The Lombardic style has been chosen in order to give an appropriate Italianate character to many recent churches of the Roman Catholic denomination, and thus even in the twentieth century these ancient architectural devices have been widely diffused in North America.

CHAPTER 6

121. 1. It should not be forgotten, however, that the minuscule church of St Wipert at Quedlinburg (dated about 930, and now serving as a crypt under later constructions), though smaller than a thirty-foot square, is a vaulted aisled church, with colonnaded apse, ambulatory, and radiating peripheral recesses. This curious building makes one wonder what its relationship to the contemporary incipient ambulatory development in France might be.

123. 2. According to Dr Pevsner, the oldest in Germany. E. Hempel, *op. cit.*, 44–9.

3. A. Schuchert, 'La Cathédrale de Willigis à Mayence et le musée diocésan', *Mémorial* (cited in note 23 to Chapter 5 above), 71; P. Frankl, *Die frühmittelalterliche und romanische Baukunst*, 62.

124. 4. *Op. cit.*, 52; L. Joutz, *Der mittelalterliche Kirchenvorhof in Deutschland* (Berlin, 1936), 61.

125. 5. P. Frankl, *op. cit.*, 62.

6. *Op. cit.*, 72; H. Schaefer, 'The Origin of the Two-Tower Façade in Romanesque Architecture', *Art Bulletin*, XXVII (1945), 85.

7. E. Hempel, *op. cit.*, 48, 61, 73 ff., 108.

8. The Strassburg scheme was echoed, with a difference, in a series of buildings in middle Germany, stretching all the way from Coblenz (St Castor and St Florian, as of the eleventh century) to Hersfeld (1038-71 ff.) [85], Hildesheim Cathedral (1054-79), Minden Cathedral (1058-80; since modified), and Gandersheim [323] (after 1063 - a very handsome design with octagonal towers). All these sites are in the ecclesiastical province of Mainz except Basel and two or three of the abbeys south of Strassburg; and these latter sites are within a few miles of the borders of the great archbishopric. In fact the paired towers were more and more generally used in south German church design as time went on.

126. 9. *À Cluny . . . Congrès . . . travaux* (Dijon, 1950), 188. The further history of Cluniac architecture in Germany will be considered later, with other churches of the Order. P. Frankl, *op. cit.*, 71.

10. *Op. cit.*, 72, 128; E. Hempel, *op. cit.*, 51.

127. 11. Consult P. Frankl, *op. cit.*, 66 ff., 92; E. Hempel, *op. cit.*, 52.

129. 12. A. K. Porter, *Spanish Romanesque Sculpture* (Florence and Paris, 1928), I, 17.

131. 13. P. Frankl, *op. cit.*, 74; E. Hempel, *op. cit.*, 57.

14. P. Frankl, *op. cit.*, 82; E. Hempel, *op. cit.*, 70.

135. 15. C. R. Morey, *Christian Art* (New York, London, 1935), 39.

16. P. Frankl, *op. cit.*, 78; E. Hempel, *op. cit.*, 58.

17. Th. Kempf, 'Les Premiers Résultats des fouilles de la cathédrale de Trèves', *Mémorial* (cited in Note 23 to Chapter 5), 153. There are excellent and convenient plans for this period in E. Gall, *Karolingische und ottonische Kirchen* (Burg bei Magdeburg, 1930).

136. 18. P. Frankl, *op. cit.*, 189.

19. H. Reinhardt, 'Das erste Münster zu Schaffhausen und die Frage der Doppelturmfassade am Oberrhein', *Anzeiger für Schweizerische Altertumskunde* (1935), 241; see also Note 9 to Chapter 2.

CHAPTER 7

140. 1. The date of 903-18 for the early ambulatory at St Martin has long been considered incorrect or uncertain, but with wider knowledge of similar tenth-century structures, responsible opinion tends to accept it. Difficulties arise from the doubtful interpretation of excavated masonry which was largely destroyed when the present nineteenth-century church was built - after the church of 903-18 and its successor of 997-1014 (rebuilt from about 1050 to 1175) had in turn been destroyed. No superstructure, and no medieval drawings or descriptive texts remain. All restoration studies must be made on the basis of analogies suggested by the reported foundations. Consult C. Hersey, 'The Church of Saint-Martin at Tours (903-1150)', *Art Bulletin, XXV* (1943), 1.

2. Built for the monks of Saint-Bénigne, Dijon, where a highly special ambulatory was built, 1001-1017.

3. L. Bréhier, *L'Art en France des invasions barbares à l'époque romane* (Paris, n.d. [1930]), 140 ff.

141. 4. Consult Abbé M. Chaume, *Recherches d'histoire chrétienne et médiévale* (Dijon, 1947), 163.

145. 5. C. and M. Dickson, *Les Églises romanes de l'ancien diocèse de Chalon* (Mâcon, 1935), 314.

146. 6. J. Pignot, *Histoire de l'abbaye de Cluny*, 3 vols (Autun, Paris, 1868), I, 165.

7. For Cluny, consult *ibid.*; J. Virey, *Les Églises romanes de l'ancien diocèse de Mâcon* (Mâcon, 1934); J. Evans, *Monastic Life at Cluny* (London, 1931); *Romanesque Architecture of the Order of Cluny* (Cambridge, 1938); F.-L. Bruel, *Cluni. Album historique et archéologique* (Mâcon, 1910); K. J. Conant, 'Mediaeval Academy Excavations at Cluny, VIII', *Speculum*, XXIX (1954), 1; *Cluny: Les Églises et la maison du Chef d'Ordre* (Cambridge, Mass., and Mâcon, France, 1968); *Speculum*, XLV, no. 1 (January 1970), 1; P. H. Láng, *Music in Western Civilization* (New York, 1941), especially p. 79.

148. 8. Dom P. Cousin, 'Dévotion mariale des abbés de Cluny', *À Cluny . . .*, 211.

9. We hear of rich reliquaries and other ecclesiastical gear at Cluny, but almost everything has been lost, and little which remains can be identified as Cluniac. This is true also of the manuscripts; little more than tantalizing descriptions survive.

149. 10. G. de Valous, 'L'Ordo Monasterii Sancti Benigni', *À Cluny . . .*, 234; Abbé Chompton, *Histoire de l'église Saint-Bénigne de Dijon* (Dijon, 1900), 85.

151. 11. *Op. cit.*, 94. The high vault of the nave, obviously a tunnel vault, is not specifically mentioned as having been built, and its existence has been doubted because the Lombards did not build long tunnel vaults at the high level. The many immense piers at Saint-Bénigne and the stepped-up stadium-like construction show that it was planned. The Lombards evidently (and rightly) distrusted it, though the span was only 23 feet and the spring only about 35 feet above the pavement. Need of protection from fire, and desire for improved acoustical effects motivated the construction of tunnel-vaulted naves from about 950 in Catalonia and over a wide area in France. Saint-Bénigne was built in wartime.

152. 12. Dr Alice Sunderland Wethey, unpublished

thesis (Radcliffe College). See *Archaeologia*, XCIX (1965), 179 ff. (Plancher engravings, new studies).
153. 13. C. R. Peers and A. W. Clapham, 'St Augustine's Abbey Church, Canterbury, before the Norman Conquest', *Archaeologia*, LXXVII (1928), 201.
154. 14. At that time not far from the border of the Empire.
15. P. Frankl, *op. cit.*, 97, 99.
16. R. Merlet, *The Cathedral of Chartres* (*Petites Monographies des grands édifices de la France*, Paris, 1926), 14.

CHAPTER 8

157. 1. The two quotations are of course from the Prologue of Chaucer's *Canterbury Tales*. For the Pilgrimage, consult G. E. Street (G. G. King, ed.), *Some Account of Gothic Architecture in Spain*, 2 vols (London, New York, Toronto, 1914); G. G. King, *The Way of St James*, 3 vols (New York, 1920); A. K. Porter, *Romanesque Sculpture of the Pilgrimage Roads*, 10 vols (Boston, 1923); L. Vázquez de Parga, J. M. Lacarra, J. Uría Ríu, *Peregrinaciones a Santiago*, 3 vols (Madrid, 1948-9); W. M. Whitehill, *Spanish Romanesque Architecture of the Eleventh Century* (Oxford, 1941); Y. Bottineau, *Les Chemins de Saint-Jacques* (Paris and Grenoble, 1964); K. J. Conant, *The Early Architectural History of the Cathedral of Santiago de Compostela* (Cambridge, Mass., 1926); 'La catedral medieval de Santiago de Compostela', *Cuadernos Americanos*, II (1943), 149; É. Lambert, *Études médiévales*, 4 vols (Toulouse, 1957, IV, figures 5, 19, 20, 21, 22, 24.
2. A. K. Porter, *op. cit.* (see Note 1 above), I, 171.
158. 3. L. Vázquez de Parga, J. M. Lacarra, J. Uría Ríu, *op. cit.* (see Note 1 above), I, 33.
4. L. Vázquez de Parga, J. M. Lacarra, J. Uría Ríu, *op. cit.*, I, 178. Research by Pierre David and René Louis on the authorship of the Pilgrim's Guide yields the fact that the writer, Aymery Picaud, was a secular priest and musician from Parthenay-le-Vieux; he is most probably to be identified as the pseudo-chancellor of the papal court who travelled the Road about 1130, and (unless a text is emended) as the pseudo-canon of Jerusalem who appeared with a female companion and false documents at Santiago in 1139. He gives an alias, Olivier of Iscarni. Iscarni was a villa of Sainte-Marie-Madeleine of Vézelay, close by. Vézelay was then Cluniac to be sure, but – even in defiance to the Pope – almost at war with the mother house of the Order.
159. 5. É. Lambert, 'Ordres et confréries dans l'histoire du pèlerinage de Compostelle', *Annales du Midi*, LV (1943), 369.

162. 6. Consult C. Hersey, 'The Church of Saint-Martin at Tours (903-1150)', *Art Bulletin*, XXV (1943), 1.
7. An interesting primitive Gothic vault was ultimately built, about 1175, over the nave, which meanwhile had been reconstructed with a false triforium and double aisles.
8. The work of 1050 in the transept included a remarkable capital with figural sculpture, a very welcome addition to the examples of carving in the period before the full flowering of Romanesque sculpture. It is perhaps significant that such an early example should be found at St Martin of Tours, where church architecture made so many forward strides.
9. Consult R. de Lasteyrie, *L'Architecture religieuse en France à l'époque romane*, 2nd ed. (Paris, 1929), 251, 448, 779; *L'Abbaye de St-Martial de Limoges* (Paris, 1901). There is also an unpublished Harvard doctoral thesis by F. Roussève.
163. 10. H. Anglès, *La música a Catalunya fins al segle XIII* (Barcelona, 1935).
11. The background of the affair is probably the persistent feeling for local independence; the Cluniacs were rather suffocatingly successful under St Hugh, who is called *briseur de crosses*.
12. Consult R. de Lasteyrie, *L'Architecture religieuse en France à l'époque romane*. Consult Marcel Deyres, 'La Construction de l'Abbatiale Sainte-Foi de Conques', *Bulletin Monumental*, CXXIII (1965), 7-23. Traces show that an earlier, simpler transept and apse were refashioned perhaps about 1100.
13. A. K. Porter, *op. cit.*, illustrations 392-400.
165. 14. A. Auriol, R. Rey, *La Basilique St-Sernin de Toulouse* (Paris, Toulouse, 1930); M. Aubert, 'St-Sernin', *Congrès Archéologique*, XCII (1929), 9.
166. 15. M. Aubert, *La Sculpture française au moyen-âge* (Paris, 1946), 50.
167. 16. The façade of the Cluniac priory church of Charlieu, in Burgundy, started about 1088-94, is the first in which a portal, classically lucid in its iconography, becomes the key of the harmonious general composition of an important church front [143, 144]. The subject (Christ in Glory accompanied by angels in the tympanum, with a lintel showing the Apostles under an arcade) is in the line of development from the mosaic tympanum at Montecassino (about 1071) to Perrecy-les-Forges (1102-5?) to Cluny (the great portal of the third church, about 1106-08-10), and the Cluniac priory of Moissac (the Apocalyptic vision, about 1115).
169. 17. Very happily the entire city of Santiago de Compostela has been classified as a historic monument, and it would be worth visiting for the fact alone that it shows, with singular consistency, what

an eighteenth-century Spanish provincial capital was like. In keeping with a wise policy, new buildings (like those of the growing University) are unobtrusive in design, and discreetly placed in the lovely city picture.

18. Consult K. J. Conant, *The Early Architectural History of the Cathedral of Santiago de Compostela* (Cambridge, Mass., 1926); 'La catedral medieval de Santiago de Compostela', *Cuadernos Americanos*, 11 (1943), 149; *Ars Hispaniae*, V, 205; G. E. Street, *Some Account of Gothic Architecture in Spain*, 2nd ed., 2 vols (London, New York, Toronto, 1914), I, 188 – the classic account of 1863 with annotations.

173. 19. *Ars Hispaniae*, III, 363.

174. 20. V. Lampérez y Romea, 'El palacio episcopal de Santiago', *Boletín de la Sociedad Española de Excursiones*, XXI (1913), 17, or *Arquitectura civil española*, 2 vols (Madrid, 1922), I, 518; *Veinte Años de restauración monumental de España*, plates XLVI, XLVII, CCXVI.

175. 21. L. Vázquez de Parga, J. M. Lacarra, J. Uría Ríu, *op. cit.*, I, 255, 281; É. Lambert, 'Ordres et confréries dans l'histoire du pèlerinage de Compostelle', *Annales du Midi*, LV (1943), 369.

CHAPTER 9

177. 1. Arthur Kingsley Porter, before the new studies on the St Martin of 1050 at Tours, believed that the creative spark of the architecture of the great churches was struck at Santiago, and he believed in early dates for Spanish Romanesque sculpture. This would mean a counterflow of Romanesque architecture and sculpture from Spain. Only at the end of his life did Mr Porter perceive the full importance of Cluny; in consequence his published works, giving an over-large share of influence to Spain, are not representative of his ultimate and more correct opinion.

Yet, by way of the Pilgrimage, Asturian tunnel vaulting may have affected Auvergne: more certainly, Catalan work inspired the tenth-century chapel, tunnel-vaulted with horseshoe section over a span of 18 feet, in the château at Berzé-le-Châtel.

2. É. Mâle, *Art et artistes au moyen-âge* (Paris, 1928), 39.

178. 3. Illustrated in de Lasteyrie, *op. cit.*

4. Consult *Congrès Archéologique*, CIX (1951), 44.

180. 5. By a singular chance this scheme – dark nave, high aisles, nave piers, bridge supports, dark apse, with ambulatory and radiating chapels – was adopted also for the immense cathedral of St John the Divine in New York (1892), as modified in execution after 1911.

183. 6. É. Lambert, *L'Ancienne Église de Saint-Pé de*

Bigorre (Bagnières de Bigorre, 1943).

7. *Ars Hispaniae*, V, 147; É. Lambert, 'Les Voûtes nervées hispano-musulmanes du XIe siècle', *Hespéris* (1928), 147; 'Les Coupoles hispano-mauresques de l'Hôpital-Saint-Blaise et de Sainte-Croix d'Oloron', *L'Architecture*, 10 October 1926, 323.

CHAPTER 10

185. 1. Fully illustrated précis in *Monumentum* (ICOMOS), VII (1971), 11–33.

2. 'Exemption' was a real threat to the territorial integrity of both lay and ecclesiastical jurisdictions. The provision against lay interference enabled an exempt monastery to resist pressures and exactions, particularly as it became stronger. The bishops vainly resisted the provision against episcopal visitation, which specifically violated the fourth canon of the Council of Chalcedon (451). The Popes multiplied the number of exempt monasteries as the tenth century advanced: these monasteries naturally looked Rome-ward and formed an international group devoted to the papal programme and the creation of an effective papal monarchy. J. F. Lemarignier, 'L'Exemption monastique', *À Cluny ... Congrès ... travaux* (Dijon, 1950), 288.

186. 3. Map, *op. cit.*, opposite p. 188.

4. E. Viollet-le-Duc, *Dictionnaire* . . .; e.g. I, 125.

5. J. Evans, *Monastic Life at Cluny* (Oxford, 1931); *Romanesque Architecture of the Order of Cluny* (Cambridge, 1938); *Cluniac Art of the Romanesque Period* (Cambridge, 1950); *Art in Mediaeval France* (Oxford, 1948).

188. 6. Jean Virey, *Les Églises romanes de l'ancien diocèse de Mâcon*. *Cluny et sa région* (Mâcon, 1934), 121.

189. 7. *Congrès Archéologique*, CX (1952), 375.

8. *Op. cit.*, 338.

9. Ulrich of Zell was sent by William of Hirsau to Cluny, and studied the customs so that they might be implanted at Hirsau and a rather large group of subsidiary houses. The *Constitutiones Hirsaugenses* which controlled the life of the institution date from 1088. Consult, as to the Hirsauer Schule, Wolfbernhard Hoffmann, *Hirsau und die 'Hirsauer Bauschule'* (Munich, [1950]), who minimizes Cluniac influence.

190. 10. *Ars Hispaniae*, V, 138. S. Juan de la Peña was the first monastery in Spain to follow Cluniac rule; and, here on 22 March 1071, the Roman rite began to be used – the first success in the campaign of Pope Gregory VII and Abbot Hugh to supplant the venerable Isidorian or Mozarabic rite in the Peninsula.

11. *Ars Hispaniae*, V, 32; Puig i Cadafalch, *La Géographie et les origines du premier art roman* (Paris,

1935), 309.

12. A. K. Porter, *Lombard Architecture*, 4 vols (New Haven, 1915-17).

193. 13. F. Salet, *La Madeleine de Vézelay* (Melun, 1948); C. Oursel, *L'Art roman de Bourgogne* (Dijon, Boston, 1928), 95; *L'Art de Bourgogne* (Paris, Grenoble, 1953), 39 ff.; K. J. Conant, 'Deux traditions dans la chronologie du Roman bourguignon', *Annales de Bourgogne*, vol. 44, no. 2 (175-6), 92-103.

14. Only a small part of the nave is older than 1109. The sanctuary which figured in the dedication of 1104 was replaced in very elegant Early Gothic, about 1175; the wonderful sculpture and the remarkable narthex had been created in the meanwhile. Saint-Andoche at Saulieu is a Cluniac derivative of Vézelay.

195. 15. A suggestion of the medieval relationship between the claustral and the public parts of a monastery is given in the entirely credible account of the meeting between Pope Innocent IV, King Louis IX of France, and the Latin Emperor of Constantinople at Cluny in 1245. The monks lodged all their guests, 2000, without giving up any of their own quarters.

16. Abbé H. Monot, *Charlieu* (Roanne, 1934); E. R. Sunderland, 'The History and Architecture of the Church of St Fortunatus at Charlieu in Burgundy', *Art Bulletin*, XXI (1939), 61; 'Charlieu - first Ambulatory Colonnade?', *Journal of the Society of Architectural Historians*, XII (1953), 3; *Charlieu à l'époque médiévale* (Charlieu, Rhône, Société pour la Connaissance de Charlieu, 1971).

17. In passing, it should be noted again that this was the moment - 1090 to 1100 - when the cloister of the Cluniac priory of Moissac [231] was built in its original form. Cluny never had its equal; Abbot Odilo's simple old cloister long remained in the heart of the abbey buildings at Cluny, though enlarged by Abbot Pontius when the nave of Cluny II was removed.

196. 18. F. Deshoulières, 'Souvigny', *Congrès Archéologique*, CI (1938), 115. A somewhat similar design was built at the Cluniac priory of Lewes in England (1077-88, continuing in the twelfth century), now destroyed. W. St John Hope, 'The Cluniac Priory of St Pancras at Lewes', *Sussex Archaeological Collections*, XLIX (1906), 66.

19. M. Anfray, *L'Architecture religieuse du Nivernais au moyen-âge* (Paris, 1951), 37.

198. 20. J. Virey, *Les Églises romanes de l'ancien diocèse de Mâcon: Cluny et sa région* (Mâcon, 1935); *Millénaire de Cluny*, 2 vols (Mâcon, 1910); F. L. Bruel, *Cluni 910-1910. Album historique et archéologique* (Mâcon, 1910); K. J. Conant, 'Mediaeval Academy Excavations at Cluny, VIII' (with references to earlier articles), *Speculum*, XXIX (1954), 1; and VIII, *ibid.*, and L (1975), 383; 'The Third Church at Cluny',

Medieval Studies in Honor of A. Kingsley Porter, 2 vols (Cambridge, 1939), II, 327; Monograph, *Cluny: Les Églises et la Maison du Chef d'Ordre* (Cambridge, Mass., and Mâcon, France, 1969); Commentary, *Speculum*, XLV (1970), 1; *Viator 2* (Los Angeles, 1971).

199. 21. In fact it did look upon a magnificent procession of 1212 professed monks in 1132, who, 'singing and with heartfelt joy raising their eyes to God, devotedly praised him together,' says the historian Orderic Vital, 'and I write with certainty in this matter, because I had the happiness to be among them.'

22. The abbot and the king died in 1109, on 28 April and 1 July respectively, when only the open nave west of the monks' choir, the narthex, and parts of the towers remained to be built. During a whole year the masses of one of the principal altars of the great church were offered for the repose of Alfonso's soul. Abbot Hugh died piously stretched out in the monastic fashion on a bed of ashes in the new Lady Chapel which he had built at Cluny, and he was buried in a sarcophagus in the new church. An elaborate sculptured tomb was built around and above the sarcophagus about 1120.

200. 23. Viollet-le-Duc, *Dictionnaire*, VII, 532 ff.

24. St Hugh's biographer (before 1114) speaks of a *schema*, stretched cords, and *termini* for Cluny III. A miniature dated about 1180 shows it as laid out with squares set point-wise, and in fact 90-foot squares so arranged are applicable to the plan.

As might be expected of a sacred building, there are symbolic aspects in Cluny III. The 7 is of course the most familiar of symbolic numbers. In Cluny III a seven-branch candlestick stood at the entrance to the sanctuary, where there were in all seven altars, and this part of the church had an insistent 7-foot module. The 153-foot width of the great nave (recalling the Miraculous Draught of Fishes) and the 99-foot width of the narthex (for the Saviour's flock, or, written as IC, for his monogram) are however quite possibly symbolism *a posteriori*. Nor can other Biblical numbers in the list of dimensions (3, 4, 12, 24, 30, 40, 70) be *warranted* as symbolic.

Whether symbolic or not, the 'perfect numbers' 1, 6, 28, 496 occur in the design. The mathematicians of Antiquity called them 'perfect' because they are equal to the sum of their submultiples which are integers. This is true only of 6, 28, and 496 between 1 and 8128. At Cluny III these numbers determined essential positions in the foundations - especially the bench at the top of the foundation where the latter is regularized to prepare for the superstructure and to provide a base for its system of vertical dimensions.

The fractions of 496 which were used to dimension the projection of the salient elements of the plan, in the ratio of 1:2:4:8:16:32, exemplify one of several series known to the philosophers (Plato, Augustine, Boëthius among them) and used at Cluny. The philosophers taught that such aspects of number were essential in the order and stability of the Universe, and to beauty in the arts; therefore an élite among the architects studied number, as fundamental in their work.

Vitruvian *symmetria* is related to the quadrille, an immemorial architectural device which was most probably employed in preparing the plan for the superstructure of Cluny III – using ten by twenty-four 25-foot squares, with certain logical projections. The Baraban Towers, added later, brought the axial length to 187·27 metres, just short of 635 Roman feet.

The exterior dimensions of the narthex, 99 by 140 feet, correspond to the geometry of an atrium of the third Vitruvian type, the basic relationship ($1 : \sqrt{2}$) being extended to the parts (aisle 29, nave 41; nave plus an aisle 70, full width 99 feet).

Vitruvius's own perfect numbers, 6, 10, and 16 ('*perfectissimus*'), are, for practical reasons in Roman measurement, double the Fibonacci series 3:5:8, which approximates mean and extreme ratio. This relationship occurs abundantly at Cluny, as in $15\frac{1}{2}$:25 feet (foundation module to quadrille), in axial dimensions – 50:100 (vertical): 150:250:400 feet, and in the interior elevation – 13:21:34:55:89 feet.

Consult *Speculum*, XXXVIII, I (January 1963), 7–35; *ibid.*, L (1975), no. 3, 783 ff.; also the monograph *Cluny: Les Églises et la Maison du Chef d'Ordre* (1968), for diagrams, details; Otto von Simson, *The Gothic Cathedral* (2nd ed., New York, 1961), 25, 29–33, 37–38 for the intellectual ambient of numerical research; P. H. Scholfield, *The Theory of Proportion in Architecture* (Cambridge, 1958), 15–32. Thorough-going study of an Augustan town near Trieste, with evidence for Vitruvian procedures, M. Detoni, T. Kurent, 'The Modular Reconstruction of Emona', in *Situla*, I (J. Kastelic, ed., Ljubljana, National Museum, 1963).

25. Innocent, too, was a refugee from Rome, where the antipope Anacletus II, a former monk of Cluny, held the city. In 1131 Bernard of Clairvaux was asked to choose between the two Popes, and this moment, when the choleric leader of the new and rival Order of Cîteaux became arbiter, marks the beginning of the twilight for Cluny.

204. 26. The allegory is perhaps the first of its kind in sculpture (1088–95) and it has not the cogency of later iconographical schemes, yet its very occurrence in this august position advanced the idea of allegorical sculpture towards its fruition in the Gothic age.

27. The fresco at Berzé-la-Ville is the only one of a considerable number of frescoes of this period in and about Cluny which has been preserved to us. It is on the basis of this painting and recovered fragments of the apsidal fresco of Cluny that the series is judged to be under strong Byzantine and Italian influence, through Montecassino. For Berzé-la-Ville references, see J. Virey, *Les Églises romanes de l'ancien diocèse de Mâcon* (Mâcon, 1934), 84.

207. 28. Characteristically Gothic also is one particular detail at Cluny. The window walls beneath the towers of the great transept were set under discharging arches so that the wall itself served only as a screen.

209. 29. Authors who are not fully aware of these and other technical details, which have become known in the long campaign and study of Cluny (1926–69) under the auspices of the Mediaeval Academy of America, consistently misdate both groups of sculptures, and repeat conventional mistakes which were made before the basic importance of Cluny was fully realized. The French critics have been surprisingly purblind with regard to this, the most glorious of their monastic houses – though to be sure it must be judged from mere fragments. Émile Mâle, for instance, misjudging an authoritative description of 1750, and also a drawing of *c.* 1800, declared that the great portal of Cluny III was copied from that of Moissac, and proposed that the Cluny sculpture was thus dependent on that of Languedoc. We now know that the Cluny portal was very different, and that it was earlier than the portal at Moissac.

215. 30. Consult J. Evans, *Cluniac Art of the Romanesque Period* (Cambridge, 1950), and M. Aubert, *La Sculpture française au moyen-âge* (Paris, 1946).

31. C. Oursel, *L'Art roman de Bourgogne* (Dijon, Boston, 1928), 85 ff.

216. 32. *Annales de Bourgogne, op. cit.,* 99–103.

33. E. R. Sunderland, *op. cit.* in *Art Bulletin*, XXI (1939), 61.

34. C. Oursel, *op. cit.,* 109.

217. 35. M. Anfray, *op. cit.,* 62; R. [Suter-] Raeber, *La Charité-sur-Loire* (Winterthur, Switzerland, 1964); J. Vallery-Radot, 'L'Ancienne Prieuriale Notre-Dame à La Charité-sur-Loire. L'Architecture', *Congrès Archéologique*, CXXV (1967), 43–85; *Archeologia* (Dijon), no. 70 (May 1974), 56–9.

36. This in turn inspired the façade of St John the Divine in New York.

219. 37. M. Aubert, 'Les Plus Anciennes Croisées d'ogives', *Bulletin Monumental*, XCIII (1934), 5, 137; illustrations in J. Evans, *Romanesque Architecture of the Order of Cluny* (Cambridge, 1938). Viollet-le-Duc, *Dictionnaire*, IX, 506–12, works at Sens, *c.* 1155–70 ff.

220. 38 and 39. *Ibid.*

CHAPTER 11

223. 1. Bernard of Clairvaux was a sincere man, whose view was strictly limited by the dogmatic and institutional horizon of Western medieval Christianity. He wished for conforming devotion and not learning in his monks, and above all an exact observance of the Rule of St Benedict in every particular. His prestige was very high in 1145, when Eugene III, the first Cistercian pope, was elected, and in 1146, when he preached the Second Crusade, but the failure of the Crusade and his ill health shadowed his later years.

224. 2. Consult, for Cistercian architecture, M. Aubert, *L'Architecture cistercienne en France*, 2 vols (Paris, 1947), a book based on years of devoted labour. Also J. Bilson, 'The Architecture of the Cistercians', *Archaeological Journal*, LXVI (1909), 185; A. H. Thompson, A. W. Clapham, H. G. Leask, 'The Cistercian Order in Ireland', *Archaeological Journal*, LXXXVIII (1931), 1; S. Curman, *Cistercienserordens Byggnadskonst* (Stockholm, 1912); H.-P. Eydoux, *L'Architecture des églises cisterciennes d'Allemagne* (Paris, 1952).

225. 3. Oddly enough there were more individual Cistercian nunneries than monasteries - about 900 in all. Owing to various circumstances they proved ephemeral; their building groups conformed imperfectly to the standard pattern, and they contributed nothing to the architecture of the Order. Of all which remain in France, only Blanches (near Mortain, Manche) may be as early as 1200. Their flourishing period was in the thirteenth century.

226. 4. Consult M. Aubert, *op. cit.*, I, 190, 212.

227. 5. M. Aubert, *op. cit.*, I, 130-1, 186.

6. M. Aubert, *op. cit.*, I, 157.

7. It has a shallow square sanctuary with three shallow rectangular chapels (communicating by arches) to each side, opening on a transept, with an aisled nave. Over seventy Cistercian churches of this type have been listed by Curman; they are spread throughout western Europe, and have inspired many close variants. The abbey at Fontenay was founded in 1119, and the existing church was begun by Everard, bishop of Norwich, with English funds.

231. 8. The Cistercian glass appears to be an austere interpretation of the Carolingian and Romanesque tradition. See the restored Carolingian panel from Séry-les-Mézières, illustrated in R. de Lasteyrie, *L'Architecture religieuse en France à l'époque romane*, 2nd ed., 811 (a cross; yellow, green, and grisaille).

232. 9. M. Aubert, *op. cit.*, I, 124.

10. For Spanish Cistercian work, consult V. Lampérez y Romea, *Historia de la arquitectura cristiana*

española en la edad media, 2nd ed., 3 vols (Madrid, 1930); *Ars Hispaniae*, VII.

11. L. Doménech y Montaner, *Historia y arquitectura del monasterio de Poblet* (Barcelona, 1927; in Catalan, 1925); É. Lambert, *L'Art gothique en Espagne aux XIIe et XIIIe siècles* (Paris, 1931), 89; E. Korrodi, *Monumentos do Portugal*, No. 4 (Porto, 1929); J. Harvey, *The Gothic World, 1100-1600* (London, New York, Toronto, Sydney, 1950), 106.

233. 12. For Italian Cistercian work, consult P. Frankl, *Die frühmittelalterliche und romanische Baukunst* (Wildpark-Potsdam, 1926), 272; for San Galgano, A. Canastrelli, *L'abbazia di San Galgano* (Florence, 1896).

234. 13. It has august memories, for St Thomas Aquinas died here on 7 March 1274.

14. E. Hempel, *Geschichte der deutschen Baukunst* (Munich, 1949), 177.

235. 15. For German Cistercian work, consult H.-P. Eydoux, *op. cit.*

16. E. Hempel, *op. cit.*, 150.

236. 17. Indeed the old plans of Cîteaux and Clairvaux indicate this feature; such a porch still exists at Pontigny, and the façade at Fossanova has strips of rattail where it was intended to attach a similar porch.

18. For English Cistercian work, consult J. Bilson, *op. cit.*; E. Sharpe, *The Architecture of the Cistercians* (London, 1875); D. Knowles, J. K. S. St Joseph, *Monastic Sites from the Air* (Cambridge, 1952).

237. 19. G. F. Webb, *Architecture in Britain: The Middle Ages* (London, 1956).

CHAPTER 13

243. 1. West of this area lay Carolingian Aquitania, to which, because of multiple relationships in medieval times, we add Septimania or Gothia, and the Loire region with its extension Brittany (which belonged to the ecclesiastical province of Tours).

244. 2. In the eleventh century it became permissible to 'exalt' buried relics, which were consequently exhumed and placed in monumental reliquaries in the upper churches. Crypts were thenceforth rarely built, except where the terrain or a special need for chapels indicated it. Nevertheless Vézelay has a Gothic crypt under the sanctuary, which was rebuilt about 1175.

245. 3. In French, a *transept* is to be understood as consisting of the two arms, *bras*, north and south, with the crossing (*carré du transept*). In English the word may refer to one of the arms alone. The French usage is recommended.

246. 4. Burgundian stone varies considerably in hardness; some of it is chalky, some of it splits easily, and

so is not suitable for exterior wall-work. Inferior stone of this sort was used in the hearting of walls. The stone which splits easily into laminae on exposure is the source of the 'laves' used, without mortar, for roofing. (Slate did not appear in Burgundy until the fifteenth century.) Certain quarries yielded very large blocks; for instance the tympanum of the Great Portal of Cluny III was cut from a single block about 10 feet high, 18 feet wide, and 3 feet thick, which weighed 25 tons or more. The supporting lintel was about 24 feet long, and both stones were brought about a mile from quarry to church.

247. 5. The fine carvers of mouldings were never numerous; later work even at Cluny lacks the warmth of classic envelope and the delicacy which the finest works have. Outside Cluny the rough local work improved as men from the *atelier* of Cluny became available. The same is true of the figure sculptors.

248. 6. This high vault is interesting because the original wooden ties, with metallic anchors in the vault to prevent spreading, are still in place. At Vézelay the remains can be seen, where the timbers were sawed off.

7. This profile had been discovered empirically in Mesopotamia and Egypt by 3000 B.C., and it was used as a matter of course in oriental buildings of all sorts. The chances are that it came to Burgundy from oriental sources in the eleventh century. At Cluny both the approximate catenary and the pointed sections were used.

8. Consult, for domestic architecture, C. Enlart, *Manuel d'archéologie française*, 5 vols, 2nd ed. (Paris, 1919–32), Part II, tome I, 53. Consult also E. Viollet-le-Duc, *Dictionnaire raisonné*, VI, 214; 'Maison', illustrates the tower house (exemplified in the Tower of Doña Urraca in Covarrubias – our illustration 53), the Cluny town houses, and others; there is supplementary material in I, 43; III, 111, 200; IV, 209. See also, for drawings, A. de Baudot, A. Perrault-Dabot, *Archives de la Commission des Monuments historiques*, 5 vols (Paris, 1898–1903).

251. 9. R. de Lasteyrie, *L'Architecture religieuse en France à l'époque romane*, 2nd ed. (Paris, 1929), illustrates Saint-Pierre, Vienne, at p. 44, Saint-Laurent, Grenoble, at p. 46, and the cathedral of Vaison at pp. 182, 413. Grenoble, excavations, *Bulletin Monumental*, CXXIV (1966), 187–9

10. É. Mâle, *Art et artistes au moyen-âge* (Paris, 1928), 69.

11. R. de Lasteyrie, *op. cit.*, 412, 414.

253. 12. *Congrès Archéologique*, CVIII (1950), 104.

13. A. de Baudot, A. Perrault-Dabot, *op. cit.*, V, plate 23.

255. 14. R. de Lasteyrie, *op. cit.*, 421.

256. 15. R. de Lasteyrie, *op. cit.*, 305, 782.

257. 16. R. de Lasteyrie, *op. cit.*, 417.

17. A good deal of work was done on the interior of the church in 1670–2.

258. 18. R. Rey, *L'Art roman et ses origines* (Toulouse, Paris, 1945), 306.

259. 19. *Congrès Archéologique*, XCV (1932), 9.

20. *Op. cit.*, CVIII (1950), 271.

260. 21. *Op. cit.*, CVIII (1950), 201.

22. *Op. cit.*, CVIII (1950), 60.

23. R. de Lasteyrie, *op. cit.*: Carpentras, p. 410; Saint-Quinin, Vaison, p. 411; Saint-Restitut, p. 416; R. Rey, *op. cit.*: Saint-Gabriel, Saint-Restitut, p. 307.

261. 24. A. de Baudot, A. Perrault-Dabot, *op. cit.*, V, 15.

262. 25. M. Aubert, J. Verrier, *L'Architecture française des origines à la fin de l'époque romane* (Paris, 1941): Puissalicon, Uzès, p. 64; R. de Lasteyrie, *op. cit.*: Cruas, p. 244.

26. M. Aubert, J. Verrier, *op. cit.*: Cavaillon, Le Thor, Avignon Cathedral, p. 63; R. de Lasteyrie, *op. cit.*: Digne, p. 240; Avignon Cathedral, p. 619.

CHAPTER 14

263. 1. M. Aubert, J. Verrier, *L'Architecture française des origines à la fin de l'époque romane* (Paris, 1941), 51.

2. This is the case with a number of Cluniac priories near La Charité-sur-Loire and Nevers, for example.

264. 3. 'In arcuatis porticibus voluerunt eam prisci constructores architectari, quoniam domus illa, quamvis latissima sit, turbis tamen sese imprimentibus tantum solet esse angusta ut antipodia chori et angiposticulas, quamvis nolentes, subruant.'

4. Influences from St Martin are indubitable. Its ambulatory and axial tower-porch are re-echoed as far afield as Morienval (c. 1050 ff. and 1122 ff.). Tower-porch at Saint-Martin-d'Ainay, Lyon (1102 ff.).

5. The fact that wall-work elsewhere (except perhaps in Germany) was usually inferior until late in the eleventh century tends to give the early buildings of the Loire region an oddly mature look. The idea of patterned wall-work was of course inherited from antique constructions like the baptistery of Poitiers (fourth and seventh centuries); it is well represented at Cravant (formerly dated about 900), and the technique was transmitted to mature Romanesque buildings such as Saint-Étienne at Nevers. Wall patterning also appears north of the Loire, as for example on the façade of Le Mans Cathedral (1165).

266. 6. 'Caput autem istius monasterii [sancti Aniani] fecit miro opere, in similitudinem monasterii Sancte

Marie, matris Domini, et San[c]torum Agricole et Vitalis in Claromonte constituti' (Bruel, *Recueil de textes*, I, 56); *Congrès Archéologique*, XCIII (1930), 52. The date may be as early as 989; conservative dates for the church are 1010–29.

269. 7. *Congrès Archéologique*, CI (1938), 329; M. Genermont, P. Pradel, *Les Églises de l'Allier* (in series, *Les Églises de France*, Paris, 1938), 92–8; for Lesterps, see R. Rey, *op. cit.*, 174.

8. R. de Lasteyrie, *L'Architecture religieuse en France à l'époque romane*, 337.

9. See Chapter 10, Note 35.

270. 10. A. de Baudot, A. Perrault-Dabot, *op. cit.*, IV, plate 33.

11. See Chapter 10, Note 19.

12. Reflex influence from the Loire region is probably responsible for the character of St Hugh's infirmary chapel, dedicated in 1085, and Saint-Marcel (eleventh and twelfth centuries) in Cluny. Each was an example of the west French 'theme church', designed with a very wide, rather barn-like nave attached to a vaulted transept with crossing tower and triapsidal sanctuary – the opening into the transept from the nave often being supplemented by smaller lateral openings. The Cluniacs built this type of church, with variations, as far afield as Leyre (1057, with a later nave) and San Juan de la Peña (twelfth century) in Spain, as already noted.

13. For Saint-Généroux, see A. de Baudot, A. Perrault-Dabot, *op. cit.*, II, 2; for Beaulieu-les-Loches, see *Congrès Archéologique*, CVI (1948), 126; for Les Aix-d'Angillon, see M. Aubert, J. Verrier, *op. cit.*, 55.

14. J. Virey, *Les Églises romanes de l'ancien diocèse de Mâcon* (Mâcon, 1934), 77.

15. *Bulletin Monumental*, LXXXIII (1924), 5.

16. M. Anfray, *L'Architecture religieuse du Nivernais au moyen-âge. Les Églises romanes* (Paris, 1951), 168.

271. 17. *Congrès Archéologique*, CIX (1951), 353.

18. A. de Baudot, A. Perrault-Dabot, *op. cit.*, IV, plate 39.

272. 19. The church has recently been re-roofed in traditional style.

20. *Op. cit.*, II, plate 5.

21. *Congrès Archéologique*, CVI (1948), 342.

22. *Op. cit.*, XCIII (1930), 335; CVI (1948), 111.

274. 23. R. Rey, *op. cit.*, 174.

24. Subsequently this western arm of hall type was ruined, but the head end of the church, with an interesting ambulatory dated about 1040, still exists in fairly complete form. The transept (early eleventh century) and the tower (twelfth century) have in-

teresting arcaded decoration which communicates much grace to the design.

25. *Congrès Archéologique*, CIX (1951), 251.

275. 26. *Op. cit.*, 421, 437. It must be remembered that satisfyingly complete cycles, like that of Saint-Savin, were not very common in the large churches, though there were many fine paintings, especially in the apses (as at Cluny III). Smaller buildings – chapels in particular – were more likely to have ensembles of paintings. The Loire region has been fortunate in the preservation of such paintings: Montoire, Poncé, Saint-Jacques-des-Guérets, Tavant, Vic, and Montmorillon are located there. P. H. Michel, *Romanesque Wall Paintings in France*, translated by Joan Evans (London, 1950).

27. *Op. cit.*, 118.

276. 28. *Op. cit.*, 9.

278. 29. *Op. cit.*, 96.

30. G. H. Forsyth, Jr, *The Church of St Martin at Angers* (Princeton, 1953), and 'St Martin's at Angers and the Evolution of Early Mediaeval Church Towers', *Art Bulletin*, XXXII (1950), 308.

279. 31. Chanoine C. Urceau, *La Cathédrale d'Angers* (*Petites Monographies des grands édifices de la France*, Paris, 1929); R. de Lasteyrie, *L'Architecture religieuse en France à l'époque gothique*, II, 85, 87.

281. 32. For the buildings mentioned in the sequel, consult R. de Lasteyrie, *L'Architecture religieuse en France à l'époque romane*, 453–64, and R. Crozet, *L'Art roman en Poitou* (Paris, 1948).

282. 33. J. Evans, *Romanesque Architecture of the Order of Cluny* (Cambridge, 1938), 84, 104; figures 119, 120.

283. 34. See Chapter 9, Note 7.

284. 35. A. W. Clapham, *Romanesque Architecture in Western Europe* (Oxford, 1936), 86.

36. M. Aubert, J. Verrier, *L'Architecture française des origines à la fin de l'époque romane* (Paris, 1941), 51; R. de Lasteyrie, *op. cit.*, 475, 788, interesting map, 790; R. Rey, *La Cathédrale de Cahors et les origines de l'architecture à coupoles d'Aquitaine* (Cahors, 1925).

37. Chanoine J. Roux, *La Basilique St-Front de Périgueux* (Périgueux, n.d. [1920]). Canon Roux's early date (dedication, 1047) for the whole scheme has not been accepted; see *Congrès Archéologique*, LXXXX (1927), 45. Yet M. Aubert's date is certainly too late; he missed the early characteristics of the original dome, seen in the pre-restoration photograph which is reproduced as plate 36 on page 190 in the monograph by Canon Roux, who was the diocesan architect. Valuable illustrations and commentary in F. de Verneilh, *L'Architecture byzantine en France* (Paris, 1851).

38. C. Enlart, *Manuel d'archéologie française*, Part I, 233, and 'Les Églises à coupoles d'Aquitaine et de Chypre', *Gazette des Beaux-Arts*, 68th year (5th period, vol. XIII - 1926), I, 129; R. de Lasteyrie, *op. cit.*, 798.

39. M. Aubert, J. Verrier, *op. cit.*, 52.

285. 40. This was the case with the Cluniac priory of Moissac, where the domes seem to have replaced an unsatisfactory system of parallel tunnel vaults of 1063, but the domes, perhaps because of inexperience on the part of the builders, were later replaced by Gothic vaulting.

286. 41. *Congrès Archéologique*, LXXXX (1927), 45; R. de Lasteyrie, *L'Architecture religieuse en France à l'époque gothique*, 2nd ed., 2 vols (Paris, 1926-7), II, 84, 86, 87, 88.

288. 42. Henry II, Count of Anjou in 1151, Duke of Poitou, Guienne, and Gascony in 1152 through his famous marriage with Eleanor of Aquitaine, and in 1154 undisputed King of England, chose Fontevrault as his burial-place, and here he rested in 1189; here Richard I Cœur de Lion joined him in 1199, and Eleanor in 1204. Fourteen of the abbesses were princesses, and several had royal blood.

289. 43. Chanoine J. Roux, *op. cit.*

290. 44. One surviving fragment illustrated in *Congrès Archéologique*, LXXXX (1927), 52, and I have seen another in the Louvre.

45. The nineteenth-century restoration, by Abadie, was far too arbitrary and radical. The ashlar was different in scale and texture; the arches over the pierced piers were rather sharply pointed and had much more character than the modern counterfeits. The domes were originally of rubble, and the exterior pyramids above the pierced piers of the church were plain; the four minor domes had only small imbricated 'top-knots', and only the central one had a columnar bundle. The net result was modern masonry with adventitious enrichments. This work of supposed improvement was Abadie's apprenticeship for the theatrical church of the Sacré-Cœur in Paris, which represents Romanesque architecture to far too many innocent people.

CHAPTER 15

293. 1. Consult R. de Lasteyrie, *L'Architecture religieuse en France à l'époque romane*, 435; L. Bréhier, *Le Style roman* (Paris, 1941), 19.

296. 2. Early Auvergnat Romanesque sculpture in stone is subject to the same reserves as the early architecture, though the Majesties (wooden, metal-covered statues of the Virgin) are well authenticated. The ungrateful stone makes carving difficult, but gives an architectural character to the sculpture, particularly the capitals.

CHAPTER 16

297. 1. A. de Baudot, A. Perrault-Dabot, *op. cit.*, IV, plates 64, 65; R. de Lasteyrie, *op. cit.*, 450.

2. A. de Baudot, A. Perrault-Dabot, *op. cit.*, IV, plate 18.

298. 3. Consult R. de Lasteyrie, *op. cit.*, 383, 389, 400.

4. Consult R. de Lasteyrie, *L'Architecture religieuse en France à l'époque gothique*, 2nd ed., 2 vols (Paris, 1926-7), I, 523.

5. R. de Lasteyrie, *L'Architecture religieuse en France à l'époque romane*, 385.

6. J. Evans, *Romanesque Architecture of the Order of Cluny* (Cambridge, 1938), figure 194.

299. 7. It is a pity that so august an abbey, with a history extending back to Early Christian times, should be represented only by unsatisfactory drawings and a few fragments. Regretted also is the chapter-house of the cathedral, Saint-Étienne, similarly represented by its sculptures.

8. A. de Baudot, A. Perrault-Dabot, *op. cit.*, V, plates 51, 52. Bishop Izarne's Romanesque cathedral of 1070 must also have been an interesting building.

9. R. de Lasteyrie, *L'Architecture religieuse en France à l'époque gothique*, II, 121.

10. R. de Lasteyrie, *L'Architecture religieuse en France à l'époque romane*, 248.

300. 11. M. Aubert, *L'Architecture cistercienne en France* (Paris, 1947), I, 262; R. de Lasteyrie, *L'Architecture religieuse en France à l'époque gothique*, II, 119; É. Lambert, *La Cathédrale de Toulouse* (Toulouse, 1947).

12. R. de Lasteyrie, *op. cit.*, II, 118; G. E. Street, *Some Account of Gothic Architecture in Spain*, 2nd ed., 2 vols (London, New York, Toronto, 1914), II, 92, 3.61

13. R. de Lasteyrie, *L'Architecture religieuse en France à l'époque gothique*, I, 350; II, 121, 125.

14. *Ars Hispaniae*, V, 37.

301. 15. Map of Congregation of Cluny in St Odilo's time: *À Cluny . . . Congrès . . . travaux*, opp. p. 188 (Dom P. Cousin, 'L'Expansion clunisienne sous saint Odilon', p. 186).

CHAPTER 17

303. 1. P. de Pallol and M. Hirmer, *Early Medieval Art in Spain* (New York, n.d. [1966?]), have a remarkable survey and beautiful pictures, many in colour; *Ars Hispaniae*, IV, 247 ff.

2. *Op. cit.*, 254.

484 · NOTES

304. 3. *Op. cit.*, 257.
4. *Op. cit.*: Sahagún, p. 257; Toro and La Lugareja de Arévalo, p. 261.
5. *Op. cit.*, 111, 201.
306. 6. *Op. cit.*, v, 33.
7. *Op. cit.*, v, 48.
8. Consult *Ars Hispaniae*, v, 73 ff.
307. 9. One feels in its church building an expression of the power of the See of Urgell in the Pyrenean region at the time; indeed it was so powerful that it became co-suzerain of the Val d'Andorra with the Counts of Foix, and has so continued, since 1278, with the French state.
10. *Ars Hispaniae*, v, 73.
308. 11. L. Doménech y Montaner, *Historia y arquitectura del monasterio de Ripoll* (Barcelona, 1927; in Catalan, 1925); *Ars Hispaniae*, v11, 28 ff.
12. *Ibid.*
13. *Op. cit.*, v, 102.
14. *Op. cit.*, v, 93.
310. 15. *Op. cit.*, v, 102.

CHAPTER 18

311. 1. He extended his sway over León, Castile, and Aragon. It was he who associated the monastery at the Aragonese royal pantheon of San Juan de la Peña with Cluny about 1020, and arranged that the bishops for Aragon should be chosen from among the reformed community. Cluny was at Oña in Castile in 1033.
312. 2. *Ars Hispaniae*, v, 116. In the following series of buildings, one may also consult W. M. Whitehill, *Spanish Romanesque Architecture of the Eleventh Century* (London, 1941; reprinted 1969).
3. *Ars Hispaniae*, v, 119. Gothic vault, not Cluniac.
4. *Op. cit.*, v, 122.
313. 5. *Op cit.*, v, 131.
314. 6. Santa Cruz de la Serós has a fastidiously beautiful church which is somewhat similar to the castle chapel at Loarre. It was built from a legacy of 1095, and was formerly monastic. In plan the church is a stubby cross, and triapsidal. Both the crossing of the church and the dignified transeptal belfry tower have roofs like that at Loarre, giving an unconventional and active silhouette to the building. *Op cit.*, v, 135.
315. 7. *Op. cit.*, v, 145.
8. *Op. cit.*, v, 146.
9. *Op. cit.*, v, 169. M. Élie Lambert believes that the arcade is recomposed, and that the building was a sepulchral chapel. It is near Puente la Reina.
10. *Op. cit.*, v, 173.
11. *Op. cit.*, v, 185.

316. 12. V. Lampérez y Romea, *Historia de la arquitectura cristiana española en la edad media*, 3 vols, 2nd ed. (Madrid, 1930), 1, 368–70.
13. *Ars Hispaniae*, v, 197.
318. 14. R. Rey, *L'Art roman et ses origines* (Toulouse, 1945); *Ars Hispaniae*, v: Ciudad Rodrigo, p. 289; Soria, p. 310; Cámara Santa, Oviedo, p. 327; Santa María del Sar, Santiago, p. 339; Carrión de los Condes, p. 252.
319. 15. *Op. cit.*, v, 354.
16. *Op cit.*: San Millán, Segovia, p. 305; Santiago del Burgo, Zamora, p. 276; Aguas Santas, p. 343.
17. G. E. Street, *Some Account of Gothic Architecture in Spain*, 2nd ed., 2 vols (London, New York, Toronto, 1914), 1, 230; K. J. Conant, 'Two Drawings of the Cathedral of Ávila', *Art Bulletin*, VIII (1926), 191; *Ars Hispaniae*, v, 315.
320. 18. *Op. cit.*, v, 317.
19. A similar arrangement was planned for the cathedral. The origin of the motif of the hooded narthex between towers is difficult to determine. It turns up in a different form at Villasirga and (incomplete) at Santiago in Spain; also at Tewkesbury and Peterborough in England. Something like it is suggested by the west façade of the Palatine Chapel at Aachen, and by certain Saxon façades (Gandersheim, for instance).
322. 20. *Ars Hispaniae*, v, 236. The sculptor was no doubt familiar with Moorish art – no-one has ever treated light rippling on a sophisticated, stylized surface with more skill – and his work has the refined, half-oriental elegance and fastidiousness which we have remarked at Jaca [237], Santa Cruz de la Serós, and Loarre [238, 239]. It is hard to believe that he was not a Spaniard. 'Habiéndose señalado relaciones de estos paneles con obras francesas, italianas y alemanas, importa resaltar su hispanismo neto,' say Gudiol and Gaya Nuño in *Ars Hispaniae* (v, 238), and they are quite justified.
21. *Ars Hispaniae*, v: Santillana del Mar, p. 248; Santa Marta de Tera, p. 226.
323. 22. *Op. cit.*, v: Sepúlveda, p. 296; Gormaz, p. 298; Jaramillo de la Fuente, p. 301; also in Segovia, San Millán, p. 305; and San Esteban, p. 308.
23. *Op. cit.*, v, 262. C. K. Hersey, *The Salmantine Lanterns. Their Origin and Developments* (Cambridge, Mass., 1937), for the whole series of designs.
324. 24. *Op. cit.*, 56.
25. *Ars Hispaniae*, v, 274.
328. 26. *Op. cit.*, v, 265. The Salmantine example attracted the attention of Stanford White, who proposed it for the crossing of Trinity Church in Boston, Massachusetts, an influential design of Henry Hob-

son Richardson, 1872-7. It was built unvaulted, and in that form became very familiar in the United States, where many further variants exist.

329. 27. *Op. cit.*, v, 337.

28. *Op. cit.*, v, 355.

330. 29. *Op. cit.*, v, 371.

30. *Op. cit.*, v: Cedofeita en Oporto, p. 357; Ferreira, p. 366.

31. *Op. cit.*, v: Travanca, p. 357; Rates, p. 364; Braga, p. 367.

332. 32. *Op. cit.*, v, 368.

33. A. de Vasconcelos, *A Sé-velha de Coimbra* (Coimbra, 1930).

34. C. David, *Évora encantadora* (Évora, 1923), 87; *Ars Hispaniae*, v, 370.

333. 35. V. Guimarães, *Thomar* (*Monumentos do Portugal*, No. 2), Porto, 1929; important article by É. Lambert in *Bulletin Monumental*, cii (1954), fasc. 1 and 2, republished as *L'Architecture des Templiers*, Paris, 1955.

335. 36. *Ars Hispaniae*, v, 315.

37. *Op. cit.*, v, 169, 313; É. Lambert, 'Les Églises octogonales de Eunate et de Torres del Río', *Mémoires Henri Basset*, ii.

38. É. Lambert, 'L'Église des Templiers à Laon et les chapelles de plan octogonale', *Revue Archéologique*, 5ᵉ série, t. xxiv (1926), 224.

336. 39. F. Bond, *An Introduction to English Church Architecture* (London, 1913), i, 15 ff.

40. P. Deschamps, *Les Châteaux des croisés en Terre Sainte. Le Crac des Chevaliers*, 2 vols (Paris, 1934).

41. R. de Lasteyrie, *L'Architecture religieuse en France à l'époque gothique*, 2 vols (Paris, 1926-7), 11, 130; R. Fedden, *Crusader Castles* (London, 1950).

338. 42. C. Enlart, *Les Monuments des croisés dans le royaume de Jérusalem*, 4 vols (Paris, 1925-8); Marquis M. de Vogüé, *Les Églises de Terre Sainte* (Paris, 1860); L. H. Vincent, *Jérusalem*, 2 vols: 11, *Jérusalem nouvelle*, with F. M. Abel (Paris, 1912-26); T. S. R. Boase, *Castles and Churches of the Crusading Kingdom* (London, New York, Toronto, 1967).

340. 43. Even more interesting are the powerful carvings of the cathedral of Nazareth, which remained unfinished as a result of the Crusaders' defeat in 1187. They are indubitably French in style and among the most notable of Romanesque sculptured capitals. As a general rule, however, the ornament of the Crusader churches in the Near East, dating from 1120 onwards, is sober as compared with their contemporaries in Europe.

341. 44. C. Enlart, *op. cit.*, and Marquis M. de Vogüé, *op. cit.*, for further reading.

45. J. Harvey, *The Gothic World* (London, New York, Sydney, 1950), 129.

CHAPTER 19

346. 1. The buildings are presented in H. W. Schulz, *Denkmäler der Kunst des Mittelalters in Unteritalien* (Dresden, 1860), and E. Bertaux, *L'Art dans l'Italie méridionale* (Paris, 1904); A. K. Porter, 'Compostela, Bari and Romanesque Architecture', *Art Studies*, i (1923), 7; C. Ricci, *Romanesque Architecture in Italy* (London, New York, n.d. [1925]), 222-9.

348. 2. Acerenza Cathedral, *c.* 1080, has a very early, if not the earliest, example.

349. 3. Derivatives of San Nicola, Bari, C. Ricci, *op. cit.*, 210-34.

4. *Op. cit.*, 205-9.

5. Alberobello [268] and several other localities have stone houses and other buildings called *trulli* (Latin, *trulla*, a ladle; Greek, τροῦλος, a dome) - in effect corbelled beehive-like structures of small, flat stones. Many of these buildings are compound. Their origin is unquestionably oriental; their effect is very picturesque. The Irish clochains (as at Skellig Michael) are somewhat similar [26A].

350. 6. P. Frankl, *Die frühmittelalterliche und romanische Baukunst* (Wildpark-Potsdam, 1926), 263; Canosa, C. Ricci, *op. cit.*, 202-4.

7. *Op. cit.*: Troia, 190-6; Siponto, 199-201.

352. 8. *Op. cit.*, vii.

9. *Op. cit.*, 180-7.

10. E. Bertaux, *op. cit.*, 127.

11. *Op. cit.*, 119.

12. O. Demus, *The Mosaics of Norman Sicily* (New York, 1950), 178; G. U. Arata, *L'architettura arabo-normanna e il rinascimento in Sicilia* (Milan [1914]), 5; *Architettura medioevale in Sicilia* [Novara, 1942].

355. 13. L. T. White, *Latin Monasticism in Norman Sicily* (Cambridge, Mass., 1938), 37.

14. O. Demus, *op. cit.*, 25; G. U. Arata, *L'architettura arabo-normanna e il rinascimento in Sicilia*, 3.

15. O. Demus, *op. cit.*, 73; G. U. Arata, *op. cit.* (in Note 14), 1.

16. *Ibid.*: San Giovanni degli Eremiti, 3; San Cataldo, 4.

17. O. Demus, *op. cit.*, 3; G. U. Arata, *op. cit.* (in Note 14), 2.

359. 18. O. Demus, *op. cit.*, 91; G. U. Arata, *op. cit.* (in Note 14), 7.

360. 19. To compensate, the west portal has fine bronze doors by Bonannus of Pisa (1186); the north portal has a pair of valves by Barisanus of Trani, which are not very different in date.

20. The mosaic ensemble is singularly complete and homogeneous - in conception, character, programme, and date (*c.* 1183-9).

362. 21. O. Demus, *op. cit.*, 188; G. U. Arata, *op. cit.* (in Note 14), 10.

22. H. M. Willard, 'A Project for the Graphic Reconstruction of the Romanesque Abbey of Montecassino', *Speculum*, X (1935), 144, gives detailed references. E. Bertaux, *op. cit.*, 158, 174. Interesting detailed information and pictures in H. Bloch, 'Monte Cassino, Byzantium, and the West in the Earlier Middle Ages', *Dumbarton Oaks Papers*, 3, p. 165; his great monograph is in press. It is not generally realized that Abbot Desiderius (later Pope Victor III) was a nobleman of the region, Lombard by race.

363. 23. Personal observation, before the destruction. Both the old description and the recent excavations show that the original plan was modular, in the proportion of 1 to $1+\sqrt{2}$ $(1:\theta)$.

24. *Op. cit.*, 172; F. Mercier, *Les Primitifs français* (Paris [1932]).

364. 25. Leo of Ostia's Chronicle gives an unusually full account of the liturgical gear and ornaments of Desiderius's church; it may be taken as an indication of what a rich abbey church would have at that period. An antependium for the high altar took thirty-six pounds of gold, with gems and enamel; the other three sides of the altar were enclosed with silver-gilt plates; the minor altars were also enclosed with tabulae. The choir screen had an icon-beam on silver-sheathed columns; the sanctuary lamp-beam and parapet were of bronze; the chancel screen had four columns sheathed with silver, and two silver crosses weighing thirty-six pounds each; the baldacchino had silver-gilt sheathing, and six tall candlesticks sheathed in silver were ranged in front of it on festival days. There were numerous valuable icons, some made in Constantinople, and others at Montecassino. A light-crown of silver nearly ten feet in diameter, with projecting towers prefiguring the celestial Jerusalem, was hung by elaborate chains above the altar of the Cross in the nave; a fine pulpit and a Paschal candlestick were also provided. The pavement was in *opus Alexandrinum* in the traditional Roman style. There were of course other treasures and embellishments elsewhere in the monastery, and the library contained remarkable manuscripts.

Leo specifically states that youngsters of the monastery were trained to execute works in gold, silver, bronze, iron, glass or enamel, ivory, wood, stucco, and stone. Experts in marble, stonework, and mosaic (and perhaps engineers?) were called from Constantinople. Perhaps trained men were sent to Cluny.

365. 26. C. A. Shepard, 'A Chronology of Romanesque Sculpture in Campania', *Art Bulletin*, XXXII (1950), 320.

27. C. Shearer, *The Renaissance of Architecture in Southern Italy* (Cambridge, 1935).

CHAPTER 20

367. 1. See Chapter 2, Note 32.

2. R. Lanciani, *Pagan and Christian Rome* (Boston, 1893), 238.

3. Regarding the malaria which afflicted Rome at the time, consult A. Celli-Fraentzel, 'Comment la Gaule civilisée par Rome se dévoua à l'assainissement de Rome', *Archives de l'Institut Pasteur d'Algérie*, VII (1929), 239.

4. We would willingly visit the historic Chapel of St Nicholas, demolished in 1747. Consult C. R. Morey, *Lost Mosaics and Frescoes of Rome of the Mediaeval Period* (Princeton, 1915), 63 ff.

5. C. Ricci, *op. cit.*, XXVI, 154; R. Lanciani, *op. cit.*, 238.

368. 6. C. Ricci, *op. cit.*, XXVI, 147.

7. Ancient columns, cut like bananas into slices, provided the characteristic disks. Guilloche forms often occur in the borders. Where the design called for it, mosaics and coloured slabs of marble or porphyry in square, lozenge, vesica, or oblong shapes were used. Occasionally, star-shaped or angular designs unmistakably recall Saracenic motives.

370. 8. C. Ricci, *op. cit.*, 162, 164, 165.

9. Before Constantine the Christian churches would appear to have had their sanctuaries toward the east; in many if not all cases, both the priest and the people would face east during the ceremonies, with the priest on the west side of the altar. By accident or design (perhaps because Constantine was a sun-worshipper) the greatest Constantinian churches have their entrances at the east, like temples. In churches built during the vogue of this arrangement – a vogue which was transitory – the priests have kept their traditional position on the western side of the altar, and consequently face the congregation. St Paul's-outside-the-Walls, begun in 386, had its sanctuary toward the east, and orientation has been the rule ever since, until quite recently.

372. 10. Consult C. Ricci, *op. cit.*, 151.

11. Consult C. Ricci, *op. cit.*: SS. Giovanni e Paolo, 149; Santa Prassede, 163; the Incoronati, 153, 160; also W. P. P. Longfellow, *A Cyclopaedia of Works of Architecture in Italy, Greece, and the Levant* (New York, 1895): San Clemente, 378; Santa Croce in Gerusalemme, 381; Santa Maria in Trastevere, 402; for SS. Giovanni e Paolo, 388; see also Rivoira, *Lombardic Architecture*, 2nd ed., 2 vols (Oxford, 1934), II, 141, 228.

12. A. Muñoz, *La Basilica di S. Lorenzo fuori le Mura* (Rome [1944]); C. Ricci, *op. cit.*, 154, 155.

13. A. J. C. Hare, St C. Baddeley, *Walks in Rome* (London, 1913), 321; other monuments interestingly discussed.

373. 14. E. W. Anthony, *Early Florentine Architecture and Decoration* (Cambridge, Mass., 1927); W. Horn, 'Romanesque Churches in Florence', *Art Bulletin*, XXV (1943), 112; H. Woodruff, 'The Iconography and Date of the Mosaics of La Daurade', *op. cit.*, XIII (1931), 80.

374. 15. Antioch (and Kalat Seman) with further oriental influence might have produced something rather like the imagined early Florentine Baptistery. See E. W. Anthony, 'The Florentine Baptistery', *Art Studies*, V (1927), 99-111.

E. Galli reports his excavations (1893-97 and 1912-15) with illustrations in *Rivista d'Arte*, IX (1917), 81-120 and 161-217. His diagrammatic plan omits (as intrusive) the segment of wall which we postulate as forming a part of the original hemicycle. Mr F. Gordon Morrill recognized this and the divided foundation of the octagon.

For the basilica, Franklin Toker, 'Excavations [of Guido Marozzi] below the Cathedral of Florence, 1965-1974', *Gesta*, vol. 14/2 (1975), 17-36. Hemicycles existed in the atria of the Holy Sepulchre, Nea-Anchialos, and Meriamlik.

375. 16. Consult E. W. Anthony and W. Horn, *op. cit.*

379. 17. P. Frankl, *op. cit.*, 123.

380. 18. Within the Baptistery there is a beautiful font (1246) and a famous pulpit by Nicolo Pisano (1260). The pulpit type is based on the Byzantine scheme of a platform, with stairway and parapet, supported on columns. There are examples in Apulia, but the Pisan series, beginning with a pulpit for Pisa Cathedral by Guglielmo (1159-62, now in Cagliari) is better proportioned. Other examples, by Guido of Como, are found in Pistoia Cathedral (1199) and Lucca Cathedral (*c.* 1235).

382. 19. W. P. P. Longfellow, *op. cit.*, 303, 304.

20. Consult C. Ricci, *op. cit.*, 90-8, for the cathedral and related buildings.

21. Consult R. Delogu, *L'architettura del medioevo in Sardegna* (Rome, 1953, *Architetture delle regioni d'Italia*, 1); D. Scano, *Storia dell'arte medievale in Sardegna* (Cagliari, 1907).

383. 22. Consult C. Ricci, *op. cit.*: Porto Torres, pp. xv, 86; Pistoia, p. 89; Arezzo, pp. 88, 105-7; Massa Marittima, pp. 108-9; Bazzano, pp. 174-5.

23. C. Ricci, *op. cit.*, 101-4.

24. C. Ricci, *op. cit.*, 110, 134; P. Frankl, *op. cit.*, 286.

CHAPTER 21

385. 1. F. Ongania, *The Basilica of St Mark in Venice*. Translated by Wm. Scott; 3 parts [Venice] 1888-[1895]; W. P. P. Longfellow, *op. cit.*, 516; Otto Demus, *The Church of San Marco in Venice* (Washington, 1960).

2. W. P. P. Longfellow, *op. cit.*, 263.

3. W. P. P. Longfellow, *op. cit.*, 480.

387. 4. A. K. Porter, *Lombard Architecture*, 4 vols (New Haven, 1915-17); G. T. Rivoira, *op. cit.*, I, 90.

6. By Urban II, on his way to Cluny and Clermont-Ferrand; Rivoira, *op. cit.*, I, 206; A. K. Porter, *op. cit.*, II, 301; P. Frankl, *op. cit.*, 198.

388. 7. *Op. cit.*, 201; A. K. Porter, *op. cit.*, II, 322, 335.

390. 8. *Op. cit.*, II, 251; *Al-Andalus*, III (1935), pl. 8a.

9. A. W. Clapham, *Romanesque Architecture in Western Europe* (Oxford, 1936), 34; A. K. Porter, *op. cit.*, III, 325.

391. 10. A. K. Porter, *op. cit.*, III, 552; II, 500, 313: respectively; P. Frankl, *op. cit.*, 198-202, 218.

392. 11. F. Reggiori, *La basilica di Sant'Ambrogio a Milano* [Florence, 1945]. Sant'Ambrogio and other important Lombard buildings are beautifully illustrated in F. de Dartein, *Étude sur l'architecture lombarde* (Paris, 1865-82). See A. K. Porter, *op. cit.*, II, 532; P. Frankl, *op. cit.*, 208 ff.

395. 12. A. K. Porter, *op. cit.*, II, 555-7.

396. 13. Certain of its remarkable embellishments have already been mentioned. The capitals are not particularly distinguished, but they fit in well with the stout architecture of the building.

14. G. T. Rivoira, *op. cit.*, I, 223; A. K. Porter, *op. cit.*, III, 325.

15. A. K. Porter, *op. cit.*, III, 199.

397. 16. *Op cit.*, III, 260; P. Frankl, *op. cit.*, 200.

17. P. Frankl, *op. cit.*, 205; A. K. Porter, *op. cit.*, III, 240.

18. P. Frankl, *op. cit.*, 211, 254; A. K. Porter, *op. cit.*, III, 133, 148.

399. 19. P. Frankl, *op. cit.*, 210.

20. A. K. Porter, *op. cit.*, respectively II, 197; III, 215; II, 614, 404; III, 466; II, 164, 75; II, 45; P. Frankl, *op. cit.*, 200, 212, 255, 213, 215, 253; Asti, no reference; 251 (in the same respective order).

21. A. K. Porter, *op. cit.*, III, 517; P. Frankl, *op. cit.*, 207.

401. 22. A. K. Porter, *op. cit.*, II, 124.
402. 23. A. K. Porter, *op. cit.*, III, 2; 'Compostela, Bari, and Romanesque Architecture', *Art Studies*, I (1923), 7; P. Frankl, *op. cit.*, 201 ff. At Modena Cathedral the sculptures are remarkable works of Guglielmo, whom Mr Porter believed to have worked at San Nicola at Bari, and to have created (for sculpture) the motif of portal columns carried on the backs of animals, exemplified here and, later, widely in Lombardy.
403. 24. C. Ricci, *op. cit.*, 159, 167, 168.
25. C. Ricci, *op. cit.*, 88, 105-7.
404. 26. Dom G. Croquison, 'I problemi archeologici farfensi', *Rivista di Archeologia Cristiana*, XV (1938), 37.
27. C. Ricci, *op. cit.*, 115-17.
405. 28. C. Ricci, *op. cit.*, 139-43.
407. 29. G. T. Rivoira, *op. cit.*, I, 158.
30. G. T. Rivoira, *op. cit.*, I, 159.
31. Consult L. Gál, *L'Architecture religieuse en Hongrie du XIe au XIIIe siècles* (Paris, 1929); for the church portals, *Travaux des étudiants du Groupe d'Histoire de l'Art* (Paris, Institut d'Art et d'Archéologie, 1928), 61; T. von Bogyay, 'Normanische Invasion - Wiener Bauhütte: Ungarische Romanik', *Forschungen zur Kunstgeschichte und christlichen Kunst im Mittelalter* (Baden Baden, 1953), 273.
More recent works: G. Entz, E. Szakál, 'La Réconstitution du sarcophage du roi Étienne', *Acta Historiae Artium Academiae Scientiarum Hungaricae*, X (1964), 215; G. Entz, 'Die Baukunst Transsylvaniens im 11-13 Jahrhundert', *ibid.*, XIV (1968), 3-48 and 127-75; V. Gervers, 'Les Rotondes de l'époque romane dans la Hongrie médiévale', *Cahiers de la Civilisation Médiévale*, XI, no. 4 (October-December 1968), 521-43; Marijan Zadnikar, 'Romanesque Architecture in Slovenia', *Journal of the Society of Architectural Historians*, XXVIII, no. 2 (May 1969), 99-114.
In near-by Czechoslovakia, the most important Romanesque church is the impressive St George, Prague, of 1142 ff. [317].
410. 32. H. Reinhardt, *Das Münster zu Basel* (*Deutsche Bauten*, vol. 13, Burg bei Magdeburg, 1928).

CHAPTER 22

411. 1. W. Randolph, *The Churches of Belgium* (London, [1919]), 81, 83; M. Laurent, *L'Architecture et la sculpture en Belgique* (Paris, Brussels, 1928), plate 1.
412. 2. W. Hoffmann, *Hirsau und die 'Hirsauer Bauschule'* (Munich, [1950]).
3. E. Hempel, *Geschichte der deutschen Baukunst* (Munich, 1949), 84, for both Alpirsbach and Paulinzelle.

4. H. P. Eydoux, *L'Architecture des églises cisterciennes d'Allemagne* (Paris, 1952), an excellent, well-illustrated handbook.
413. 5. See Note 28; P. Frankl, *op. cit.*, 196; F. A. J. Vermeulen, *Handboek tot de Geschiedenis der Nederlandsche Bouwkunst*, Part I, 2 vols (The Hague, 1923-8), I, 195, 288.
6. P. Frankl, *op. cit.*, 196, 243.
7. For Soest, consult W. Burmeister, W. Hege, *Die westfälischen Dome* (Berlin, 1936); P. Frankl, *op. cit.*, 245 ff.; for Worms Cathedral, consult H. Weigert, W. Hege, *Die Kaiserdome am Mittelrhein*, 2nd ed. (Berlin, 1938), 38; for Murbach, consult P. Frankl, *op. cit.*, 243.
414. 8. E. Hempel, *op. cit.*, 144.
9. By Dehio and von Bezold.
10. P. Frankl, *op. cit.*, 279.
415. 11. P. Frankl, *op. cit.*, 197.
12. P. Frankl, *op. cit.*, 54.
13. P. Frankl, *op. cit.*, 96.
416. 14. W. Burmeister, W. Hege, *op. cit.*, 49; P. Frankl, *op. cit.*, 92.
15. See Note 7.
16. P. Frankl, *op. cit.*, 179-80.
419. 17. P. Frankl, *op. cit.*, 66, 68, 69.
18. P. Frankl, *op. cit.*, 181-3.
19. The cathedral of Freiburg in Saxony is also remarkable for its sculpture - a very elaborate portal of Romanesque character in yellowish sandstone, hence called the Golden Portal. Its date is Gothic (after 1200); the execution is provincial.
Near-by Naumburg has a half-Gothic four-tower church, and Bamberg in Franconia has one similar; both are tardy Romanesque dated about 1200, and imposing in scale.
20. O. Völkers, *Deutsche Hausfibel* (Leipzig [1937]), 31; P. Frankl, *op. cit.*, 84, 226, 284; E. Hempel, *op. cit.*, 71 ff., 93 ff. (interesting illustrations); the Wartburg, O. Völkers, *op. cit.*, 55; E. Hempel, *op. cit.*, 107.
420. 21. P. Frankl, *op. cit.*, 265, 266; W. Burmeister, W. Hege, *op. cit.*, 60.
22. A. Renger-Patzsch, W. Burmeister, *Norddeutsche Backsteindome* (Berlin, 1930); bibliography, E. Hempel, *op. cit.*, 573.
23. St Norbert, who founded the Order at Prémontré (near Laon in northern France, 1120), was St Bernard's personal friend. He later became archbishop of Magdeburg, and it is thought that the pervading Cistercians, who were at the time building in brick in Lombardy (as at Chiaravalle Milanese, founded by St Bernard in 1136), must somehow have been responsible for transmitting the technique.
24. R. Hamann, *Deutsche und französische Kunst im Mittelalter*, II: *Die Baugeschichte der Klosterkirche zu Lehnin . . .* (Marburg, 1923); also E. Hempel, *op. cit.*,

157 ff.; beautiful illustrations of Chorin.

25. E. Hempel, *op. cit.*, 195, 199; bibliography, 574.

421. 26. H. Weigert, W. Hege, *op. cit.*, 37.

422. 27. H. Weigert, W. Hege, *op. cit.*, 26.

424. 28. The chronicle of the abbey of Klosterrath or Rolduc, near Maastricht (already quoted), speaks of the monk Embricus as the builder of the crypt there 'scemate longobardino'. The church was founded in 1104; the crypt, dedicated in 1108, underlies a church finished in 1169 but not dedicated until 1209. In fact the reference may be to the trefoil shape of the crypt, to its large size, or to its architectural character.

29. For this and the other churches of Cologne, consult W. Meyer-Barkhausen, *Das grosse Jahrhundert Kölnischer Kirchenbaukunst* (Cologne, 1952); P. Frankl, *op. cit.*, 55, 89, Hempel, *op. cit.*, 76.

425. 30. P. Frankl, *op. cit.*, 267, 269.

426. 31. P. Frankl, *op. cit.*, 271, 244.

427. 32. P. Clemen, *Belgische Kunstdenkmäler*, 2 vols (Munich, 1923), I, 27.

428. 33. P. Frankl, *op. cit.*, 266, 268.

34. F. A. J. Vermeulen, *op. cit.*, 291.

35. For Romanesque architecture in Holland, the following books ought to be consulted. S. J. Fockema Andreae, E. H. Ter Kuile, M. D. Ozinga, *Duizend Jaar Bouwen in Nederland*, vol 1. *De Bouwkunst van de Middeleeuwen - De Architectuur*, by E. H. Ter Kuile (Amsterdam, 1948; Heemschut Bibliotheek, vol. 3), and M. D. Ozinga, *De Romaanse Kerkelijke Bouwkunst* (*De Schoonheid van ons Land: Bouwkunst*) (Amsterdam, 1949).

36. P. Frankl, *op. cit.*, 58.

37. M. Laurent, *op. cit.*, in Note 1 to this Chapter, plate II.

CHAPTER 23

431. 1. That great conqueror ruled also in England (1017) with some claim to Wales, Scotland, and Ireland - the result of Viking raiding and settlement since 795. Similar activity had forced the French in 911 at Saint-Clair-sur-Epte to settle Rollo as master of Normandy, which thus became something like a part of Scandinavia under French suzerainty. The operation of 1066 was in fact a second Scandinavian conquest of England in an age when these Northmen were at a high crest of vigour and effectiveness. However, they had no cultural power capable of unifying a great empire, and their outlying dominions were lost (Normandy, England, the Two Sicilies, Grand-Ducal Russia).

2. F. Beckett, *Danmarks Kunst* (Copenhagen, 1924, 1927); C. M. Smidt, *Roskilde Domkirkes Middelalderlige Bigningshistorie* (*Nationalmuseets Skrifter Arkaeologisk-Historisk Raekke*, III, Copenhagen, 1949); E.

Lundberg, *Byggnadskonsten i Sverige under Medeltiden, 1000-1400* (Stockholm, 1940); W. Anderson, *Skånes romanska Landskyrkor med breda Västtorn* (Lund, 1926); A. W. Clapham, *Romanesque Architecture in Western Europe* (Oxford, 1936), 189 ff.

433. 3. E. Wrangel, O. Rydbeck, *Lunds Domkyrka*, 3 vols (Lund, 1923); W. Anderson, 'Schonen, Helmarshausen und der Kunstkreis Heinrichs des Löwen', *Marburger Jahrbuch für Kunstwissenschaft*, XI (1938/9), 81.

4. A. W. Clapham, *op. cit.*, 190.

5. E. Lundberg, *op. cit.*, 362 ff.; P. A. Means, *Newport Tower* (New York, 1942), 265, 267, 271 ff.

434. 6. Such round churches were also built elsewhere in Scandinavia. An old seal seems to show a design like that at Kalundborg for the round Benedictine church of Nidarholm, near Nidaros or Trondheim, in Norway. This was built between 1103 and 1135, but has been destroyed, as has the imposing Premonstratensian church of St Olaf at Tønsburg, Norway, based on the Church of the Holy Sepulchre. At Vardsberg in Östergötland, Sweden, the round church has six interior piers which sustain the annular vault and upper platform.

7. Svenska Fornminnesplatser, No. 4, T. O. Nordberg, *Södra Råda Gamla Kyrka* (Stockholm, 1927).

8. E. Lundberg, *op. cit.*, 419 ff., 443.

435. 9. H. Cornell, *Sigtuna och Gamla Uppsala* (Stockholm, 1920); A. W. Clapham, *op. cit.*, 191; E. Lundberg, *op. cit.*, 321, 323.

10. Svenska Fornminnesplatser, No. 13, S. Lindqvist, *Gamla Uppsala Fornminnen* (Stockholm, 1929).

11. E. Lundberg, *op. cit.*, 303; W. Anderson, *Skånes romanska Landskyrkor med breda Västtorn* (Lund, 1926).

12. E. Lundberg, *op. cit.*, 370; Svenska Fornminnesplatser, No. 6, E. Lundberg, *Vreta Kloster* (Stockholm, 1927); *ibid.*, No. 8, A. Forssén, *Varnhem* (Stockholm, 1928).

436. 13. E. Lundberg, *Byggnadskonsten i Sverige under Medeltiden, 1000-1400*, 573. For painting, see W. Anderson, cited in Note 3.

14. Y. Hirn, J. J. Tikkanen, C. Lindberg, A. Anderson, O. Öflund, *Religious Art in Finland during the Middle Ages* (Helsingfors, 1921).

15. A. W. Clapham, *op. cit.*, 193 ff.; H. Fett, *Norges Kirker i Middelalderen* (Kristiania, 1909); E. Alnaes, G. Eliassen, R. Lund, A. Pederson, O. Platou, *Norwegian Architecture throughout the Ages* (Oslo, 1950), which illustrates the churches mentioned and takes up domestic architecture.

437. 16. F. M. Lund, *Ad Quadratum* (London, 1921). Geometrical theory subject to caution.

CHAPTER 24

439. 1. R. Kautzsch, *Romanische Kirchen im Elsass* (Freiburg-im-Breisgau, 1927); M. Aubert, *L'Art religieux en Rhénanie* (Paris, 1924); G. Durand, *Les Églises romanes des Vosges* (Paris, 1913).

2. Reims still retained its Carolingian cathedral, which was to be replaced in the Early Gothic style, and then by the magnificent High Gothic cathedral which we know (see H. Reinhardt, *La Cathédrale de Reims* (Paris, 1963), première partie); Saint-Remi existed then as a vast pilgrimage church of early eleventh-century style. Beauvais in the second half of the eleventh century still retained its early double cathedral of Saint-Pierre and Notre-Dame, of which latter component, the Basse-Œuvre [14], survives in part. Saint-Denis also had a large Carolingian church now replaced in Gothic [378], Orléans had a vast double-aisled cathedral of the eleventh century with apse, ambulatory, and radiating chapels. Paris had a triple cathedral, or church cluster – Saint-Étienne, Notre-Dame, and the baptistery church of Saint-Jean-le-Rond.

3. E. Panofsky, *Gothic Architecture and Scholasticism* (Latrobe, Pa., 1951). Panofsky himself makes the appropriate reservations; E. Panofsky, ed., *Abbot Suger on the Abbey Church of St-Denis and its Art Treasures* (Princeton, 1946); S. McK. Crosby, *L'Abbaye royale de Saint-Denis* (Paris, 1953).

440. 4. M. Aubert, J. Verrier, *L'Architecture française à l'époque gothique* (Paris, 1943), 12. For an engineer's study, based on technical assumptions which do not take sufficiently into account the conditions during construction of the vault, or after the mortar joints have weakened, see V. Sabouret, 'Les Voûtes d'arête nervurées. Rôle simplement décoratif des nervures', and 'L'Évolution de la voûte romane du milieu du XIᵉ siècle au début du XIIᵉ', in *Le Génie civil*, 3 March 1928 and 17 March 1934, respectively. See also *Recherche*, 1 (1939; Institut International de Coopération Intellectuelle, Paris); J. Fitchen, *The Construction of Gothic Cathedrals* (Oxford, 1961), is a very careful study, with useful comments and explanatory appendices applicable to Romanesque architecture.

5. Many which were destroyed in 1914–18 had been studied just previously by Howard Crosby Butler, but his only manuscript was lost overboard, with a corpus of newly made and exact architectural drawings, from a lighter in Alexandria harbour. Thus we are dependent, for much of our knowledge, on older works: C. Enlart, *Monuments religieux de l'architecture romane et de transition dans la région picarde, anciens diocèses d'Amiens et de Boulogne* (Amiens, 1895); E.

Lefèvre-Pontalis, *L'Architecture religieuse dans l'ancien diocèse de Soissons au XIᵉ et au XIIᵉ siècle*, 2 vols (Paris, 1894–7); consult also de Lasteyrie, *L'Architecture religieuse en France à l'époque gothique*, 2 vols (Paris, 1926–7), for the buildings mentioned.

6. J. Hubert, 'Les Dates de construction du clocher-porche et de la nef de Saint-Germain-des-Prés', *Bulletin Monumental*, CVIII (1950), 68; F. Deshoulières, *Éléments datés de l'art roman en France* (Paris, 1936), 11.

7. C. H. Moore, *Development and Character of Gothic Architecture* (London and New York, 1890), 33; M. Aubert, 'Les Plus Anciennes Croisées d'ogives', *Bulletin Monumental*, XCIII (1934), 5, 137.

441. 8. M. Aubert, J. Verrier, *L'Architecture française à l'époque romane*, 46, and *L'Architecture française à l'époque gothique* (Paris, 1943), 12.

9. M. Aubert, 'Les Plus Anciennes Croisées d'ogives', *Bulletin Monumental*, XCIII (1934), 166, 182. In this article the Cluniac examples are mentioned and illustrated (Marolles-en-Brie, Noël-Saint-Martin, Saint-Martin-des-Champs in Paris).

442. 10. Consult V. Ruprich-Robert, *L'Architecture normande aux XIᵉ et XIIᵉ siècles en Normandie et en Angleterre*, 2 vols and plates (Paris, 1884–9); M. Anfray, *L'Architecture normande, son influence dans le Nord de la France aux XIᵉ et XIIᵉ siècles* (Paris, 1939).

11. L.-M. Michon, R. Martin du Gard, *L'Abbaye de Jumièges* (*Petites Monographies des grands édifices de la France*, Paris, 1935).

443. 12. L. Grodecki, 'Bernay', *Bulletin Monumental*, CVIII (1950), 7.

445. 13. É. Lambert, *Caen roman et gothique* (Caen, 1935), 8.

447. 14. É. Lambert, *op. cit.*, 7.

15. É. Lambert, *op. cit.*, 4, 20, 38.

449. 16. R. de Lasteyrie, *L'Architecture religieuse en France à l'époque romane*, 2nd ed. (Paris, 1929), 510; É. Lambert, *op. cit.*, 42, 43. Bernières has a very beautiful Gothic west tower and spire.

17. É. Lambert, *op. cit.*, 4, 10, 33, 44, 53.

18. É. Lambert, *op. cit.*, 7, 16; also 33, a reference to ten other parish churches in Caen, which had been a town of minor importance until William chose it as his capital.

452. 19. M. Aubert, 'Les Plus Anciennes Croisées d'ogives', *Bulletin Monumental*, XCIII (1934), 155, 163.

20. É. Lambert, *op. cit.*, 26.

21. R. de Lasteyrie, *L'Architecture religieuse en France à l'époque romane*, 496, and *L'Architecture religieuse en France à l'époque gothique*, I, 29, 30; II, 71. Dated about 1090–1135.

22. R. de Lasteyrie, *L'Architecture religieuse en France à l'époque romane*, 294 ff., 503 ff., 511. Dated in the second half of the eleventh century.

23. A. W. Clapham, *English Romanesque Architecture after the Conquest* (Oxford, 1934), 6, plate I; É. Lambert, *op. cit.*, 12.

453. 24. R. de Lasteyrie, *L'Architecture religieuse en France à l'époque romane*, 334.

25. J. Bilson, 'Durham Cathedral: the Chronology of its Vaults', *Archaeological Journal*, LXXIX (1922), 101.

26. St Gertrude, Nivelles (dedicated incomplete in *c.* 1046), is in that region, and, though simpler, it has comparable boldness and amplitude of scale. Edward the Confessor's Lorrainer bishops, and perhaps his architects, must have known it or similar buildings.

454. 27. R. de Lasteyrie, *L'Architecture religieuse en France à l'époque romane*, 497, note 1; and *L'Architecture religieuse en France à l'époque gothique*, 1, 30, 31.

28. The corroboration comes in recent discoveries of similar vaults which were not well known to the elder architectural historians: Jumièges chapterhouse, between 1101 and 1109; Mont-Saint-Michel promenoir, the builder being Abbot Roger II from Jumièges. É. Lambert, *op. cit.*, 35.

29. J. Bilson, 'Wharram-le-Street, Yorkshire, and St Rule's Church, St Andrews', *Archaeologia*, LXXIII (1923), 55; G. F. Webb, *op. cit.*, p. 13; plate 12, A and B; figure 6.

30. L. E. Tanner and A. W. Clapham, 'Recent Discoveries in the Nave of Westminster Abbey', *Archaeologia*, LXXXIII (1933), 227.

456. 31. G. F. Webb, *op. cit.*, chapters 2-4; plates 40, A and B, 41A, 54B, 64, A and B, 65, A and B, and 66.

32. G. F. Webb, *op. cit.*, chapters 2-4; plates 25, 47B, 58B, and 68, A and B.

33. G. F. Webb, *op. cit.*, p. 42; figure 28.

34. G. F. Webb, *op. cit.*, pp. 49, 79-80; plates 43B, 69, and 70.

35. G. F. Webb, *op. cit.*, p. 63; plate 56.

36. These buildings are treated in A. W. Clapham, *English Romanesque Architecture after the Conquest*, 21-5, with pertinent bibliographical references; G. F. Webb, *op. cit.*, plates 22A and 46A; figure 15.

37. G. F. Webb, *op. cit.*, pp. 15-18; figure 9.

38. G. F. Webb, *op. cit.*, chapters 2-4; plate 24.

39. G. F. Webb, *op. cit.*, chapter 3; plates 58A and 80; figures 18 and 35.

40. G. F. Webb, *op. cit.*, chapters 2-4; plates 29B and 34, A and B; figure 17.

41. A. W. Clapham, *op. cit.*, 28-35; G. F. Webb, *op. cit.*, chapters 2-4; plates 37, 38A, and 44; figures 26 and 32.

42. See Note 25; G. F. Webb, *op. cit.*, chapters 2-4; plates 29A, 30, 31, 32, 33, A and B, and 42B; figures 22-5.

457. 43. G. F. Webb, *op. cit.*, chapters 1-4.

44. G. F. Webb, *op. cit.*, chapters 2-4; plates 35, A and B, 36, 38B, and 48; figure 36.

458. 45. Sir C. Oman, *Castles* (New York, 1926); S. Toy, *The Castles of Great Britain* (London, 1953).

462. 46. S. McK. Crosby, *L'Abbaye royale de Saint-Denis* (Paris, 1953), 42, 68-9.

464. 47. The loading collar postulated for the nave still exists on the chapels of the ambulatory, with a 'podium' (literally 'balcony') including a projecting eaves arcade and an eaves parapet. The 'podium' was as yet unbuilt around the original sanctuary on 19 January 1143, as we know from Suger's account of a violent storm on that date, during which a service was in progress. The ecclesiastics were much concerned because they knew that the loading collar was lacking ('nullo podio suffulto'), and they saw the temporary window membranes slammed back and forth by blasts of wind, a threat to the clearstory window arches ('titubantibus in alto solis et recentibus arcubus'). Suger also reports that the 'arcus principales' had not yet been carried up to the top of the vault. These were the flying buttresses [379B], so novel as to lack a name of their own. In an apse of this type they are a necessity on the chord, where outward stresses are very pronounced. Such flying buttresses were anticipated in Romanesque at Saint-Benoît-sur-Loire (by *c.* 1100 [201]) and at Santiago de Compostela in the rebuilding of the upper works after 1117 if not earlier [123 and 124].

It is an error to suppose that the commotion was in unfinished rib and vault work, for this absolutely requires a scaffold and platform which hide it from beneath. The individual stones of a Gothic severy are slid down a buttered joint from above, then guided into position, braced if necessary, and the joint struck by a mason working on a platform below.

Text and references in *Revue Bénédictine*, t. LXXXII nos. 3-4 (1972), 208-14 and *Pierre Abélard, Pierre le Vénérable* (Éditions du Centre International de la Recherche Scientifique, no. 546) (Paris, 1975), 727-9. Both have plates. In the latter, on page 729, line 3, please read *nullis renitentes suffragiis* for *nullo podio suffulto*.

BIBLIOGRAPHY

GENERAL WORKS
ON ROMANESQUE ARCHITECTURE,
THE ARTS, ENCYCLOPAEDIAS

ANTHONY, E. W. *Romanesque Frescoes.* Princeton, 1951.

BENOÎT, P. *L'Occident médiéval du romain au roman* (*Manuels d'histoire de l'art. L'Architecture*). Paris, 1933.

BOTTINEAU, Y. *Les Chemins de Saint-Jacques.* Paris, 1964.

BRÉHIER, L. *Le Style roman* (*Collection Arts, styles et techniques*, N. Dufourcq, director). Paris, 1941.

BUSCH, H., and LOHSE, B. *Romanesque Europe* (*Buildings of Europe* series), translated by Peter Gorge. London, 1960.

CLAPHAM, A. W. *Romanesque Architecture in Western Europe.* Oxford, 1936.

CONANT, K. J. 'Romanesque Art and Architecture', *Encyclopaedia Britannica.* 1970.

DEHIO, G., and BEZOLD, G. von. *Die kirchliche Baukunst des Abendlandes.* Stuttgart, 1884–1901.

EVANS, J. (ed.). *The Flowering of the Middle Ages.* New York, Toronto, London, 1966.

FITCHEN, J. *The Construction of Gothic Cathedrals. A Study of Medieval Vault Erection.* Oxford, 1961.

FOCILLON, H. *L'An mil* (Collection Henri Focillon, 11). Paris, 1952.

FOCILLON, H. *The Art of the West*, vol. 1, *Romanesque Art*, translated by Donald King. London, 1963 (vol. 2, *Gothic Art*).

FOURQUIN, G. *Histoire économique de l'Occident médiéval* (*Série Histoire médiéval*, ed. G. Duby). Paris, 1969.

Handbuch der Kunstwissenschaft (Burger-Brinckmann and many others), especially *Baukunst des Mittelalters*: Frankl, P., *Die frühmittelalterliche und romanische Baukunst.* Wildpark-Potsdam, 1926.

HASKINS, C. H. *The Renaissance of the Twelfth Century.* Cambridge, Mass., 1927.

HAWTHORNE, J. G., and SMITH, C. S. *On Divers Arts. The Treatise of Theophilus.* Chicago, 1963.

HEITZ, C. *Recherches sur les rapports entre architecture et liturgie.* Paris, 1963.

JORDAN, R. F. *Baukunst in Europa*, published as *European Architecture in Colour*, London, 1961, and *The World of Great Architecture*, New York, 1961. Translation by C. Ligota.

KNOOP, D., and JONES, G. P. *The Mediaeval Mason.* Manchester, 1933.

KUNSTLER, G. (ed.). *Romanesque Art in Europe.* Greenwich, Conn., 1968.

LAMBERT, É. *Études médiévales.* 4 vols. Toulouse, 1957.

LÁNG, P. H. *Music in Western Civilization.* New York, 1941; London, 1942.

LONGFELLOW, W. P. P. *A Cyclopaedia of Works of Architecture in Italy, Greece, and the Levant.* New York, 1895.

MEER, F. van der. *Atlas de la civilisation occidentale.* 2nd ed. Paris, Brussels, 1952.

MOREY, C. R. *Mediaeval Art.* New York, 1942.

OURSEL, R. *Living Architecture: Romanesque.* New York, 1967.

PHLEPS, H. *Die farbige Architektur bei den Römern und im Mittelalter.* Berlin [1930].

PIJOAN, J. *Summa Artis*, vol. VIII: *Arte bárbaro y prerrománico desde el siglo IV hasta el ano 1000.* Madrid, 1942; vol. IX: *El arte románico: siglos XI y XII.* Madrid, 1944.

PORTER, A. K. *Medieval Architecture: Its Origins and Development.* 2 vols. New York, 1909.

PUIG I CADAFALCH, J. *La Géographie et les origines du premier art roman.* Paris, 1935. (In Catalan, Barcelona, 1932.)

SAALMAN, H. *Medieval Architecture (European Architecture 600–1200).* New York, 1962.

SCHWARZENSKI, H. *Monuments of Romanesque Art.* London, 1954.

SOUCHAL, F. *Art of the Early Middle Ages* (trans. R. E. Wolf and R. Millen). New York, 1968.

STOLPER, H. (ed.). *Bauen in Holz.* Stuttgart [1937].

TALBOT RICE, D. (ed.). *The Dawn of European Civilization: The Dark Ages.* New York, Toronto, London, 1965.

THOMPSON, J. W. *The Medieval Library.* Reprint with supplement. New York and London, 1967.

TIMMERS, J. J. M. *A Handbook of Romanesque Art* (trans. M. Powell). London, 1969.

WARD, C. *Medieval Church Vaulting (Princeton Monographs in Art and Archaeology,* V). Princeton, 1915.

ZARNECKI, G. *Romanik (Belser Stilgeschichte,* Band VI). Stuttgart, 1970.

ZARNECKI, G. *The Monastic Achievement.* London, 1972.

ZARNECKI, G. *Art of the Medieval World (Library of Art History,* I). New York, 1975.

RELATED ARCHITECTURE OF ROMAN AND
EARLY CHRISTIAN TIMES
AND THE DARK AGES – ORIENTAL STYLES

BALTRUSAÏTIS, J. *Le Problème de l'ogive et l'Arménie.* Paris, 1936.

CHADWICK, N. *Celtic Britain.* New York, 1963.

CHOISY, A. *L'Art de bâtir chez les Romains.* Paris, 1873.

CREMA, L. *Significato della architettura romana.* (Suppl. no. 15 of *Bolletino del Centro Studi per la Storia dell'Architettura,* 1959.)

DAVIES, G. G. *The Origin and Development of Early Christian Architecture.* London, 1952.

DER NERSESSIAN, S. *Armenia and the Byzantine Empire. A Brief Study of Armenian Art and Civilization.* Cambridge, Mass., 1945.

HUBERT, J., PORCHER, J., VOLBACH, W. F. *Europe of the Invasions.* New York, 1969.

RIVOIRA, G. T. *Architettura musulmana. Sue origini e suo sviluppo.* Milan, 1914; translated by G. McN. Rushforth as *Moslem Architecture: Its Origins and Development.* Oxford, 1918.

RIVOIRA, G. T. *Roman Architecture and its Principles of Construction under the Empire.* (Italian original, 1918.) Translated by G. McN. Rushforth. Oxford, 1925.

SIMONS, G. *Barbarian Europe.* New York, 1968.

STRZYGOWSKI, J. *Die Baukunst der Armenier und Europa.* 2 vols. Vienna, 1918.

TRAVESI, G. *Architettura paleocristiana milanese.* Milan, 1964.

VINCENT, Père L. H. *Jérusalem.* 2 vols. Paris, 1912–26; vol. II. *Jérusalem nouvelle,* with F. M. Abel, 1912–22.

VOGÜÉ, Marquis M. de. *Syrie centrale. Architecture civile et religieuse du Ier au VIIe siècle.* 6 vols. Paris, 1865–77.

For RECENT GENERAL WORKS see p. 500.

ROMANESQUE ARCHITECTURE
BY MODERN GEOGRAPHICAL DIVISIONS

BELGIUM AND HOLLAND

CLEMEN, P., BAUM, J., CREUTZ, M. *Belgische Kunstdenkmäler.* 2 vols. Munich, 1923.

FIRMIN, B. *De Romaansche Kerkelijke Bouwkunst in West-Vlaanderen.* [Ghent, 1940.]

LAURENT, M. *L'Architecture et la sculpture en Belgique.* Paris, Brussels, 1928.

OZINGA, M. D. *De Romaanse Kerkelijke Bouwkunst.* (*De Schoonheid van ons Land: Bouwkunst.*) Amsterdam, 1949.

RANDOLPH, W. *The Churches of Belgium.* London [1919].

TER KUILE, E. H. *De Bouwkunst van de Middeleeuwen: De Architectuur* (in vol. I of *Duizend Jaar Bouwen in Nederland*). Amsterdam, 1948.

VERMEULEN, F. A. J. *Handboek tot de Geschiedenis der Nederlandsche Bouwkunst,* Part I, 2 vols. The Hague, 1923–8.

ENGLAND AND SCOTLAND

BILSON, J. 'The Architecture of the Cistercians', *Archaeological Journal,* LXVI (1909), 185; issued separately.

BILSON, J. 'Durham Cathedral and the Chronology of its Vaults', *Archaeological Journal,* LXXIX (1922), 101; issued separately.

BOASE, T. S. R. *English Art, 1100–1216 (The Oxford History of English Art).* Oxford, 1953.

BOND, F. *Gothic Architecture in England.* London and New York, 1906; new ed. 1912.

BOND, F. *An Introduction to English Church Architecture from the Eleventh to the Sixteenth Century.* London, 1913.

BROWN, G. Baldwin. *The Arts in Early England.* 6 vols. 2nd ed. London, 1926–37: vol. II: *Anglo-Saxon Architecture.*

CLAPHAM, A. W. *English Romanesque Architecture before the Conquest.* Oxford, 1930.

CLAPHAM, A. W. *English Romanesque Architecture after the Conquest.* Oxford, 1934.

DICKINSON, J. C. *Monastic Life in Medieval England.* London, 1961; New York, 1962.

English Cathedral Series (G. White, C. F. Strange, later E. Bell, editors). Individual volumes. London, 1896 ff.

FISHER, E. A. *The Greater Anglo-Saxon Churches.* London, 1962.

GREEN, A. R., and GREEN, P. M. *Saxon Architecture and Sculpture in Hampshire.* Winchester, 1951.

MACGIBBON, J., and ROSS, T. *Ecclesiastical Architecture of Scotland*. Edinburgh, 1897.

OMAN, Charles. *Castles*. New York, 1926.

PALMER, R. Liddlesdale. *English Monasteries in the Middle Ages*. London, 1930.

RICE, D. Talbot. *English Art, 871–1100 (The Oxford History of English Art)*. Oxford, 1952.

SALZMAN, L. F. *Building in England down to 1540*. Oxford, 1952.

STONE, L. *Sculpture in Britain: The Middle Ages (Pelican History of Art)*. 2nd ed. Harmondsworth, 1972.

TAYLOR, H. M. and J. *Anglo-Saxon Architecture*. 2 vols. Cambridge, 1965.

TOY, Sidney. *The Castles of Great Britain*. London, 1953.

WEBB, G. *Architecture in Britain: The Middle Ages (Pelican History of Art)*. Harmondsworth, 1956.

ZARNECKI, G. *English Romanesque Sculpture, 1066–1140 (Chapters in Art, XVII)*. London, 1951.

ZARNECKI, G. *Later English Romanesque Sculpture, 1140–1210 (Chapters in Art, XXII)*. London, 1953.

FRANCE

1. *General Works on French Romanesque Architecture*

ADAMS, H. *Mont-Saint-Michel and Chartres*. Boston and New York, 1905.

ADHÉMAR, J. *Influences antiques dans l'art du moyen-âge français. Recherches sur les sources et les thèmes d'inspiration*. London, 1937.

AUBERT, M. *L'Art français à l'époque romane: architecture et sculpture*. 4 vols. Paris [1929–32–50]. Plates.

AUBERT, M., and collaborators. *L'Art roman en France*. Paris, 1961.

AUBERT, M., Director. *Les Églises de France. Répertoire historique et archéologique par département*. Paris, 1932 ff. (A collection, by departments, issued at intervals.)

AUBERT, M. *Le Vitrail en France (Collection Arts, styles et techniques, N. Dufourcq, director)*. Paris, 1946.

AUBERT, M., DELAUNEY, R., VERRIER, J. *Table alphabétique des publications de la Société française d'Archéologie (Congrès archéologiques, Bulletin monumental, 1834–1925)*. Paris, 1930. Continuation vol., for 1926–54, AUBERT, collaborators THIBOUT, M., and PILLAULT, R. (1956).

BAUDOT, A. de, PERRAULT-DABOT, A., and others. *Archives de la Commission des Monuments historiques*. 5 vols. Paris, 1898–1904.

BAUM, J. *Romanesque Architecture in France*. 2nd ed. London [1928].

BRÉHIER, L. *L'Art en France des invasions barbares à l'époque romane*. Paris [1930].

BRUTAILS, J.-A. 'La Géographie monumentale de la France aux époques romane et gothique', *Le Moyen-Âge*, 1923.

COLAS, René. *Le Style roman en France*. Paris, 1927.

CROZET, R. *L'Art roman*. Paris, 1962.

DESHOULIÈRES, F. *Au début de l'art roman: les églises de l'onzième siècle en France*. Paris, n.d. [1929].

DESHOULIÈRES, F. *Éléments datés de l'art roman en France (Architecture et arts décoratifs*, Nouvelle Série). Paris, 1936.

ENLART, C. *Manuel d'archéologie française* (in 2 'tomes', subdivided into parts; 5 volumes in all). 2nd ed. Paris, 1919–32.

EVANS, J. *Art in Mediaeval France, 987–1498*. London, 1948.

EVANS, J. *Life in Medieval France*. London, 1957.

FLIPO, V. *Mémento d'archéologie française*. Paris, 1930.

GARDNER, A. *An Introduction to French Church Architecture*. Cambridge, 1938.

GARDNER, A. *Medieval Sculpture in France*. Cambridge, 1931.

GIEURE, M. *Les Églises romanes de France*. 2 vols. Paris, 1953–4.

GROMORT, G. *L'Architecture romane*. 3 vols. Paris, 1928, 1929, 1931.

HARVEY, J. *The Gothic World, 1100–1600: A Survey of Architecture and Art*. London, New York, Toronto, Sydney, 1950; new (paperback) ed. New York, 1969.

HUBERT, J. *L'Architecture religieuse du haut moyen-âge en France*. Paris, 1952.

HUBERT, J. *L'Art pré-roman*. Paris, 1938.

LANTIER, R., and HUBERT, J. *Les Origines de l'art français des temps préhistoriques à l'époque carolingienne*. Paris [1947].

LASTEYRIE, R. de. *L'Architecture religieuse en France à l'époque gothique*. 2 vols. Paris, 1926–7.

LASTEYRIE, R. de. *L'Architecture religieuse en France à l'époque romane*. 2nd ed., edited by Marcel Aubert. Paris, 1929.

LEFÈVRE-PONTALIS, E. *L'Architecture religieuse dans l'ancien diocèse de Soissons au XIe et au XIIe siècle*. 2 vols. Paris, 1894–6.

LEFÈVRE-PONTALIS, E. (Founder), AUBERT, M. (Director). *Petites Monographies des grands édifices de la France*. Paris. A collection, issued at intervals.

LEFRANÇOIS-PILLION, L. *L'Art roman en France*. Paris, n.d. [about 1948]. (*Nouvelle Encyclopédie illustrée de l'art français*.)

LÉON, P. *Les Monuments historiques*. Paris, 1917.

MÂLE, É. *Art et artistes du moyen-âge*. 2nd ed. Paris, 1928.

MÂLE, É. *L'Art religieux du XII^e siècle en France: étude sur les origines de l'iconographie du moyen-âge.* Paris, 1922.

MARKHAM, V. R. *Romanesque France.* London, 1929.

MARTIN, C. *L'Art roman en France.* 3 vols. Paris, 1910 ff.

MORTET, V. *Recueil de textes relatifs à l'histoire de l'architecture et à la condition des architectes en France, au moyen-âge: XI^e-XII^e siècles.* Paris, 1911.

MORTET, V., and DESCHAMPS, P. *Recueil de textes relatifs à l'histoire de l'architecture et à la condition des architects en France au moyen-âge: XII^e-XIII^e siècles.* Paris, 1929.

POBE, M., and GANTNER, J. *L'Art monumental roman en France.* Paris [1955].

REY, R. *L'Art roman et ses origines: archéologie préromane et romane.* Toulouse and Paris, 1945.

Société française d'Archéologie. *Congrès archéologique de France.* All the recent volumes. Caen, then, from 1934 to date, Paris.

Société française d'Archéologie. *Bulletin monumental.* All the recent volumes. Paris.

VALLERY-RADOT, J. *Églises romanes: filiations et échanges d'influences.* Paris, n.d. [1931].

VIOLLET-LE-DUC, E. *Dictionnaire raisonné de l'architecture française du XI^e au XVI^e siècle.* 10 vols. Paris, 1858-68.

a. NORTH

ANFRAY, M. *L'Architecture normande.* Paris, 1939.

CROSBY, S. MCK. *L'Abbaye royale de Saint-Denis.* Paris, 1953.

CROSBY, S. MCK. *The Abbey of Saint-Denis, 475-1122* (one vol. published). New Haven, 1942.

DURAND, G. *L'Église de St-Riquier. La Picardie historique et monumentale*, vol. IV. 1907-11.

EFFMANN, W. *Centula. St-Riquier. Eine Untersuchung zur Geschichte der kirchlichen Baukunst in der Karolingerzeit.* Münster i. W., 1912.

LAMBERT, É. *Caen roman et gothique.* Caen, 1935.

PANOFSKY, E. (ed.). *Abbot Suger on the Abbey Church of St-Denis and its Art Treasures.* Princeton, 1946.

RUPRICH-ROBERT, V. *L'Architecture normande aux XI^e et XII^e siècles en Normandie et en Angleterre.* 2 vols. Paris, 1884-9.

b. SOUTH

AURIOL, A., and REY, R. *La Basilique Saint-Sernin de Toulouse.* Toulouse and Paris, 1930.

BENOÎT, F. *L'Abbaye de St-Victor et l'église de la Major à Marseille (Petites Monographes des grands édifices de la France).* Paris, 1936.

LAMBERT, É. *La Cathédrale de Toulouse.* Toulouse, 1947.

RÉVOIL, H. *L'Architecture romane du Midi de la France.* 3 vols. Paris, 1867-74.

REY, R. *La Sculpture romane languedocienne.* Toulouse, 1936.

REY, R. *Les Vieilles Églises fortifiées du Midi de la France.* Paris, 1925.

SAHUC, J. *L'Art roman à St-Pons-de-Thomières.* Montpellier, 1908.

c. EAST

CHOMPTON, Abbé L. *Histoire de l'église Saint-Bénigne de Dijon.* Dijon, 1900.

CHOMPTON, Abbé L. *Saint-Bénigne de Dijon, les cinq basiliques.* Dijon, 1923.

DICKSON, M. and C. *Les Églises romanes de l'ancien diocèse de Chalon. Cluny et sa région.* Mâcon, 1935.

DURAND, G. *Églises romanes des Vosges.* Paris, 1913.

GRIVOT, D., and ZARNECKI, J. *Gislebertus. Sculptor of Autun.* London and New York, 1961.

KAUTZSCH, R. *Romanische Kirchen im Elsass.* Freiburg-im-Breisgau, 1927.

LÜCKEN, Gottfried von. *Die Anfänge der burgundischen Schule.* Basel, n.d. [about 1922?].

OURSEL, C. *L'Art de Bourgogne.* Paris, Grenoble, 1953.

OURSEL, C. *L'Art roman de Bourgogne, études d'histoire et d'archéologie.* Dijon and Boston, 1928.

VALLERY-RADOT, J. *Saint Philibert de Tournus (L'Inventaire Monumental, no. 1).* Paris, 1955.

VIREY, J. *Les Églises romanes de l'ancien diocèse de Mâcon. Cluny et sa région.* Mâcon, 1935.

d. WEST

BOUFFARD, P. *Sculpteurs de la Saintonge romane.* Paris, 1962.

CHENESSEAU, G. *L'Abbaye de Fleury à Saint-Benoît-sur-Loire.* Paris, 1931.

CROZET, R. *L'Art roman en Poitou.* Paris, 1948.

CROZET, R. *L'Art roman en Saintonge.* Paris, 1971.

FORSYTH, G. *The Church of St Martin at Angers.* Text and atlas. Princeton, 1953.

GEORGE, J., and GUÉRIN-BOUTAUD, A. *Églises romanes de l'ancien diocèse d'Angoulême.* Paris, 1928.

PLAT, Abbé G. *L'Art de bâtir en France, des Romans à l'an 1100, d'après les monuments anciens de la Touraine, de l'Anjou et du Vendômois.* Paris, 1939.

REY, R. *La Cathédrale de Cahors et les origines de l'architecture à coupoles d'Aquitaine.* Paris, 1925.

ROUX, Chanoine J. *La Basilique St-Front de Périgueux.* [Périgueux], 1919.

URSEAU, Chanoine C. *La Cathédrale d'Angers (Petites Monographies des grandes édifices de la France).* Paris, 1929.

e. CENTRE

ANFRAY, M. *L'Architecture religieuse du Nivernais au moyen-âge. Les églises romanes.* Paris, 1951.

FIKRY, A. *Les Influences musulmanes dans l'art roman du Puy.* Paris, 1934.

GAILLARD, G., and collaborators. *Rouergue roman (Zodiaque, La Nuit des Temps,* no. 17). La Pierre-qui-Vire, 1963.

THIOLLIER, F. and N. *L'Architecture religieuse à l'époque romane dans l'ancien diocèse du Puy.* Le Puy, n.d. [1900].

2. *Works on the Chief Monastic Orders including Cluny and Cîteaux*

AUBERT, M. *L'Architecture cistercienne en France.* 2 vols. Paris, 1943; 2nd ed., 1947.

BRUEL, F.-L. *Cluni, 910-1910: album historique et archéologique precédé d'une étude résumée et d'une notice des planches.* Mâcon, 1910.

CHRIST, Y. *Abbayes de France.* Paris, 1955.

CLEMEN, P., GURLITT, C. *Der Klosterbau der Zister-zienser in Belgien.* Berlin, 1916.

CONANT, K. J. *Cluny: Les Églises et la Maison du Chef d'Ordre.* Cambridge, Mass., and Mâcon, France, 1968. Supplement in *Speculum,* XLV, no. 1 (January 1970), 1-39. Also L, no. 3 (July 1975).

DIMIER, Fr. M. A. *Recueil de plans d'églises cister-ciennes.* Paris, 1949.

ESCHAPASSE, M. *L'Architecture bénédictine en Europe* (series *Architectures*). Paris, 1963.

EVANS, J. *Cluniac Art of the Romanesque Period.* Cambridge, 1950.

EVANS, J. *Monastic Life at Cluny, 910-1157.* London, 1931.

EVANS, J. *The Romanesque Architecture of the Order of Cluny.* Cambridge, 1938; new ed., 1971.

EYDOUX, H.-P. *L'Architecture des églises cisterciennes d'Allemagne (Travaux et mémoires des Instituts fran-çais en Allemagne,* 1). Paris, 1952.

FONTAINE, G. *Pontigny, abbaye cistercienne.* Paris, 1928.

HENDERSON, A. E. *Fountains Abbey Then and Now.* London, 1951.

Mâcon, Académie de. *Millénaire de Cluny. Congrès d'histoire et d'archéologie tenu à Cluny les 10, 11, 12 septembre 1910.* 2 vols. Mâcon, 1910.

PIGNOT, J.-H. *Histoire de l'ordre de Cluny depuis la fondation de l'abbaye jusqu'à la mort de Pierre le Vénérable.* 3 vols. Autun and Paris, 1868.

ROSE, H. *Die Baukunst der Zisterzienser.* Munich, 1916.

SCHLOSSER, J. *Die abendländische Klosteranlage des früheren Mittelalters.* Vienna, 1889.

Société des Amis de Cluny. *À Cluny. Congrès scienti-fique. Fêtes et cérémonies liturgiques en l'honneur des saints abbés Odon et Odilon. 9-11 juillet 1949.* (C. Oursel, ed.) Dijon, 1950.

VALOUS, G. de. 'Cluny. L'Abbaye et l'ordre', *Diction-naire d'histoire et de géographie ecclésiastiques,* cols. 35-174 (fascicule 73). Paris, 1953.

VALOUS, G. de. *Le Monachisme clunisienne des origines au XVᵉ siècle: vie intérieure des monastères et organisa-tion de l'ordre.* 2 vols. Ligugé, Paris, 1935.

VALOUS, G. de. *Le Temporel et la situation financière des établissements de l'ordre de Cluny du XIIᵉ au XIVᵉ siècle, particulièrement dans les provinces fran-çaises.* Ligugé, Paris, 1935.

GERMANY

AUBERT, M. *L'Art religieux en Rhénanie.* Paris, 1924.

BEENKEN, H. *Romanische Skulptur in Deutschland (11. und 12. Jahrhundert).* Leipzig, 1924.

BULLOUGH, D. *The Age of Charlemagne.* New York, 1966.

BURMEISTER, W., and HEGE, W. *Die westfälischen Dome.* Berlin, 1936.

CLEMEN, P. *Die Kunstdenkmäler der Stadt Aachen.* Düsseldorf, 1916.

EFFMANN, W. *Die Kirche der Abtei Corvey.* Pader-born, 1929.

GALL, E. *Karolingische und ottonische Kirchen (Deutsche Bauten,* vol. 17). Burg bei Magdeburg, 1930.

GALL, E. *Dome und Klosterkirchen am Rhein.* Munich, 1956.

GRODECKI, L. *L'Architecture ottonienne (Au seuil de l'art roman:* Collection Henri Focillon, IV). Paris, 1958.

HARTWEIN, P. W. *Der Kaiserdom zu Speyer.* Speyer am Rhein, 1927.

HAUPT, A. *Die älteste Kunst, insbesondere die Bau-kunst, der Germanen.* 3rd ed. Berlin, 1935.

HEMPEL, E. *Geschichte der deutschen Baukunst (Deutsche Kunstgeschichte,* Bd. 1). Munich, 1949.

HINKS, R. *Carolingian Art.* London, 1935.

HOFFMANN, W. *Hirsau und die 'Hirsauer Bauschule'.* Munich [1950].

Karl der Grosse, Werk und Wirkung. (Catalogue of the Exhibition, Aachen, 1965, printed by Schwann, Düsseldorf.)

KAUTZSCH, R. 'Der Dom zu Speier', *Staedel-Jahrbuch,* I (1921).

KAUTZSCH, R. *Die romanischen Dome am Rhein.* Leipzig, 1922.

[LOUIS, R.] *Mémorial d'un voyage d'études de la Société nationale des Antiquaires de France en Rhénanie* [juillet 1951]. Paris, 1953.

MEYER-BARKHAUSEN, W. *Das grosse Jahrhundert Kölnischer Kirchenbaukunst.* Cologne, 1952.

RENGER-PATZSCH, A., and BURMEISTER, W. *Norddeutsche Backsteindome.* Berlin, 1930.

SCHROTH, I. *Reichenau.* Lindau and Konstanz, 1956.

VÖLKERS, O. *Deutsche Hausfibel.* Leipzig [1937].

WEIGERT, H., and HEGE, W. *Die Kaiserdome am Mittelrhein.* 2nd ed. Berlin, 1938.

YOUTZ, L. *Der mittelalterliche Kirchenvorhof in Deutschland.* Berlin, 1936.

HUNGARY, WITH DALMATIA

ENTZ, G. Publications in English in *Acta Historiae Artium* (Academiae Scientiarum Hungaricae, Budapest), especially tom. X (1964), XIII (1967), XIV (1968); also, with others, in monographs published by Corvina Press, Budapest (Hungarian National Commission for Unesco).

ENTZ, G. Publications in French in *Cahiers de la Civilisation Médiévale*, IXᵉ année (1966), no. 1, pp. 9–11, and no. 2, pp. 209–19. Maps and plates.

GÁL, L. *L'Architecture religieuse en Hongrie du XIᵉ au XIIIᵉ siècles.* Paris, 1929.

JACKSON, T. G. *Dalmatia, the Quarnero, and Istria.* 3 vols. Oxford, 1887.

MONNERET DE VILLARD, U. *L'architettura romanica in Dalmazia.* Milan, 1910.

IRELAND

CHAMPNEYS, A. C. *Irish Ecclesiastical Architecture.* London and Dublin, 1910.

COCHRANE, R. *Ecclesiatical Remains at Glendalough* (in *Ancient and National Monuments of Ireland*: extract from the *80th Annual Report of the Commission of Public Works in Ireland, 1911–12*). Dublin, 1912.

HENRY, F. *Irish Art during the Viking Invasions (800–1020 A.D.).* Ithaca, N.Y., 1967.

LEASK, H. G. *Irish Churches and Monastic Building. I. The First Phase and the Romanesque.* Dundalk, 1955.

MACALISTER, R. A. S. *The Archaeology of Ireland.* London, 1928.

MAHR, A. *Christian Art in Ancient Ireland.* Dublin, 1932.

PORTER, A. K. *The Crosses and Culture of Ireland.* New Haven and London, 1931.

STOKES, M. *Early Christian Art in Ireland.* Dublin, 1928.

ITALY

ANTHONY, E. W. *Early Florentine Architecture and Decoration.* Cambridge, Mass., 1927.

ARATA, G. U. *L'architettura arabo-normanna e il rinascimento in Sicilia.* Milan [1914].

ARATA, G. U. *Architettura medioevale in Sicilia.* [Novara, 1942.]

BERTAUX, E. *L'Art dans l'Italie méridionale.* Paris, 1904.

CECCHELLI, C. *Monumenti del Friuli dal secolo IV all' XI.* Milan, 1943 ff.

DARTEIN, F. de. *Étude sur l'architecture lombarde.* 1 vol. and atlas. Paris, 1865–82.

DECKER, H. *L'Art roman en Italie*, translated by H. Simondet. Paris, 1958.

DELOGU, R. *L'architettura del medioevo in Sardegna. (Architecture delle regioni d' Italia, 1.)* Rome, 1953.

DEMUS, O. *The Church of San Marco in Venice.* Washington, D.C., 1960.

DEMUS, O. *The Mosaics of Norman Sicily.* New York, 1950.

ENLART, C. *L'Art roman en Italie: l'architecture et la décoration.* Paris, 1924.

ENLART, C. *Origines françaises de l'architecture gothique en Italie.* Paris, 1894.

ONGANIA, F. *The Basilica of St Mark in Venice.* Translated by William Scott; 3 parts. [Venice] 1888–[1895].

PORTER, A. K. *The Construction of Lombard and Gothic Vaults.* New Haven, 1911.

PORTER, A. K. *Lombard Architecture.* 4 vols. New Haven, 1915–17.

REGGIORI, F. *La basilica di Sant' Ambrogio a Milano.* [Florence 1945].

RICCI, C. *Romanesque Architecture in Italy.* London, New York [1925].

RIVOIRA, G. T. *Lombardic Architecture: its Origin, Development, and Derivatives.* Trans. by G. McN. Rushforth. 2 vols. Oxford, 1910; 2nd ed., 1933.

SALMI, M. *L'architettura romanica in Toscana.* Milan, Rome, 1927.

SALMI, M. *L'arte italiana.* 2nd ed. 2 vols. Florence, 1953.

SCANO, D. *Storia dell'arte in Sardegna.* Cagliari, 1907.

SCHAFFRAN, E. *Die Kunst der Langobarden in Italien.* Jena, 1941.

SCHULZ, H. W. *Denkmäler der Kunst des Mittelalters in Unteritalien.* 4 vols. and atlas. Dresden, 1860.

SHEARER, C. *The Renaissance of Architecture in Southern Italy.* Cambridge, 1935.

TOESCA, P. *Storia dell'arte italiana dalle origini alla fine del secolo XIII.* Turin, 1927.

VENTURI, A. *Storia dell'arte italiana, III.* Milan, 1904.
VERZONE, P. *L'architettura religiosa dell'alto medioevo nell'Italia settentrionale.* Milan, 1942.
VERZONE, P. *L'architettura romanica nel Novarese.* 2 vols. Novara, 1935-6.
VERZONE, P. *L'architettura romanica nel Vercellese.* Vercelli, 1934.

LEVANT

BOASE, T. S. R. *Castles and Churches of the Crusading Kingdom.* London, New York, Toronto, 1967.
DESCHAMPS, P. *Les Châteaux des croisés en Terre Sainte. Le Crac des Chevaliers.* Text and album. Paris, 1934.
ENLART, C. *Les Monuments des croisés dans le royaume de Jérusalem. Architecture religieuse et civile.* 4 vols. Paris, 1925-8.
FEDDEN, R. *Crusader Castles.* London, 1950.

SCANDINAVIA

ALNAES, E., ELIASSEN, G., LUND, R., PEDERSEN, A., PLATOU, O. *Norwegian Architecture throughout the Ages.* Oslo, 1950.
ANDERSON, W. *Skånes Romanska Landskyrkor med breda Västtorn.* Lund, 1926.
BOËTHIUS, G. *Den Nordiska Timmerbyggnadskonsten.* Stockholm, 1927.
BOËTHIUS, G. *Hallar, Tempel och Stavkyrkor.* Stockholm, 1931.
BRUUN, D. *Fortidsminder og Nutidshjem paa Island.* Copenhagen, 1928.
BUGGE, A. *Norwegian Stave Churches.* Translated by Ragnar Christophersen. Oslo, 1953.
CURMAN, C., ROOSVAL, J., and others. *Sveriges Kyrkor* (*Konsthistoriskt Inventarium*, a long Academy-sponsored series). Stockholm.
Danish National Museum. *Danish Churches*, in English. (*Danmarks Kirker*, series begun in 1933), Copenhagen. MOLTKE, M., MØLLER, E., *Roskilde Cathedral.* Copenhagen, 1956.
DIETRICHSON, L., *Die Holzbaukunst Norwegens.* Dresden, 1893.
DONOVAN, F. R., and KENDRICK, T. D. (Sir). *The Vikings.* New York, 1964.
FETT, H. *Norges Kirker i Middelalderen.* Kristiania (= Oslo), 1909.
HAHR, A. *Architecture in Sweden.* Stockholm, 1938.
HIRN, Y., TIKKANEN, J. J., LINDBERG, C., ANDERSON, A., ÖFLUND, O. *Religious Art in Finland during the Middle Ages.* Helsingfors, 1921.

JONES, G. *A History of the Vikings.* Oxford, New York, Toronto, 1968.
Kommission for Ledelsen af de Geologiske og Geografiske Undersøgelser i Grønland. *Meddelelser i Grønland.* 57 (Copenhagen, 1918) and 89 (1941).
LINDBERG, C. *Finlands Kyrkor.* Helsingfors, 1935.
LUNDBERG, E. *Byggnadskonsten i Sverige under Medeltiden, 1000-1400.* [Stockholm, 1940.]
Royal Academy of Letters, History and Antiquities. *Old National Monuments of Sweden* (Svenska Fornminnesplatser, series published in Stockholm, in Swedish and English).
 No. 4, Nordberg, T. O. *Södra Råda gamla kyrka.*
 No. 6, Lundberg, E. *Vreta Kloster.*
 No. 8, Forssén, A. *Varnhem.*
 No. 13, Lindqvist, S. *Gamla Uppsala Fornminnen.*
STRZYGOWSKI, J. *Early Church Art in Northern Europe.* London, 1928; New York and London, 1929.

SPAIN

Ars Hispaniae: historia del arte hispánico (Series, still incomplete; see volumes II to VIII). Madrid, 1947 ff.
BONET CORREA, A. *Spanish Pre-Romanesque Art.* New York ed., Greenwich, Conn., n.d. [1968].
CONANT, K. J. *The Early Architectural History of the Cathedral of Santiago de Compostela.* Cambridge, Mass., 1926.
DORREGARAY, José Gil (ed.). *Monumentos arquitectónicos de España.* Madrid, 1859-91 and 1904 (unfinished New Series).
GAILLARD, G. *Les Débuts de la sculpture romane espagnole.* Paris, 1938.
GAILLARD, G. *Premiers Essais de sculpture monumentale en Catalogne aux X^e et XI^e siècles.* Paris, 1938.
GÓMEZ-MORENO, M. *El arte románico español.* Madrid, 1934.
GÓMEZ-MORENO, M. *Iglesias mozárabes.* 2 vols. Madrid, 1919.
HERSEY, Carl K. *The Salmantine Lanterns. Their Origins and Development.* Cambridge, Mass., 1937.
KING, G. G. *Pre-Romanesque Churches of Spain (Bryn Mawr Monographs,* VII). New York, 1924.
LAMBERT, Élie. *L'Art gothique en Espagne aux XII^e et $XIII^e$ siècles.* Paris, 1931.
LAMPÉREZ Y ROMEA, V. *Arquitectura civil española de los siglos I al XVIII.* 2 vols. Madrid, 1922.
LAMPÉREZ Y ROMEA, V. *Historia de la arquitectura cristiana española en la edad media.* 2nd ed. 3 vols. Barcelona and Madrid, 1930.
Madrid Exhibition, 1958—Catalogue: *Veinte Años de restauración monumental de España.* Madrid, 1958.

PALLOL, P. DE, and HIRMER, H. *Early Medieval Art in Spain.* New York ed., n.d. [1968?].

PALLOL, P. DE. *Hispanic Art of the Visigothic Period.* New York ed., n.d. [1968].

PORTER, A. K. *Spanish Romanesque Sculpture.* 2 vols. Florence and Paris, 1928.

PUIG I CADAFALCH, J., DE FALGUERA, GODAY I CASALS. *L'arquitectura romànica a Catalunya.* 3 vols. Barcelona, 1909–18.

PUIG I CADAFALCH, J. *L'art wisigothique et ses survivances.* Paris, 1961.

PUIG I CADAFALCH, J. *La Crypte de la crèche de St Michel de Cuxa. Les Monuments historiques de France,* fasc. 1 and 2. Paris, 1938.

STREET, G. E. *Some Account of Gothic Architecture in Spain.* Text of 1865 in 2nd ed., with additions by G. G. King. London, New York, and Toronto, 1914.

TORRES BALBÁS, L. *El arte de la alta edad media y del período románico en España. (Historia del arte Labor,* vol. VI.) 1934.

VIEILLARD, Jeanne. *Le Guide du pèlerin de Saint-Jacques de Compostelle.* Mâcon, 1938. 2nd ed. 1969.

WHITEHILL, W. M. *Spanish Romanesque Architecture of the Eleventh Century.* London, 1941.

SWITZERLAND

HECHT, J. *Der romanische Kirchenbau des Bodenseegebietes.* Basle, 1928.

JEAN-NESMY, C., and collaborators. *Suisse romane.* (*Zodiaque, La Nuit des temps,* no. 8). La Pierre-qui-Vire, 1958.

MEYER, P. *Schweizerische Münster und Kathedralen des Mittelalters.* Zürich, 1945.

MOULLET, M. *Die Galluspforte des Basler Münsters.* Basle, Leipzig, 1938.

REINHARDT, H. *Das Münster zu Basel (Deutsche Bauten,* vol. 13). Burg-bei-Magdeburg, 1928.

REINHARDT, H. *Der karolingische Klosterplan von St Gallen (Schweiz). Der St Galler Klosterplan.* Historischer Verein des Kantons St Gallen. St Gall, 1952.

SENNHAUSER, H. R. *Romainmôtier und Payerne.* Basel, 1970.

RECENT GENERAL WORKS

BRAUNFELS, W. *Monasteries of Western Europe.* London, 1972.

BROOKE, C., and SWAAN, W. *The Monastic World, 1000–1300.* London, 1974.

COUSIN, Dom Patrice, O.S.B. *Précis d'histoire monastique (Collection La Vie de l'Église,* E. Jarry, director). Tournai, 1959.

CRISTE, Y. *Les Grands Portails Romans.* Geneva, 1969.

HARVEY, J. *Cathedrals of England and Wales.* London, 1974.

KUBACH, H. E. *Romanesque Architecture.* New York, 1975.

MAINSTONE, R. *Developments in Structural Form.* Cambridge, Mass. and London, 1975.

MALRAUX, A., and PARROT, A., eds. *L'Univers des formes – Le Premier Millénaire occidental.*

HUBERT, J., PORCHER, J., VOLBACH, W. F. *Europe of the Invasions (450–750).* New York, 1969.

HUBERT, J., PORCHER, J., VOLBACH, W. F. *The Carolingian Renaissance (750–950).* New York, 1970.

GRODECKI, L., MÜTHERICH, F., TARALON, J., WORMALD, F. *Le Siècle de l'an mil (950–1050).* Paris, 1973.

NEBOLSINE, G. *Journey into Romanesque.* New York, 1969.

NORBERG-SCHULZ, C. *Meaning in Western Architecture.* New York, 1975.

ZARNECKI, G. *The Monastic Achievement.* London, 1972.

ZARNECKI, G. *Art of the Medieval World (Library of Art History,* 1). New York, 1975.

LIST OF ILLUSTRATIONS

INDEX

References to the notes are given only where they indicate matters of special interest or importance: such references are given to the page on which the note occurs, followed by the number of the chapter to which it belongs, and the number of the note. Thus 484(18)[19] indicates page 484, chapter 18, note 19.